*Cities of Ladies*

THE MIDDLE AGES SERIES

Ruth Mazo Karras, Series Editor
Edward Peters, Founding Editor

A complete list of books in the series
is available from the publisher.

# Cities of Ladies

Beguine Communities in
the Medieval Low Countries,
1200–1565

WALTER SIMONS

**PENN**

University of Pennsylvania Press

Philadelphia

10 9 8 7 6 5 4 3 2 1

Published by
University of Pennsylvania Press
Philadelphia, Pennsylvania 19104-4011

Library of Congress Cataloging-in-Publication Data

Simons, Walter.
Cities of ladies : Beguine communities in the medieval low countries, 1200–1565 / Walter Simons.
    p. cm. (The Middle Ages series)
Includes bibliographical references and index.
ISBN: 0-8122-3604-1 (cloth : alk. paper)
    I. Beguines—Benelux countries—History.    II. Monasticism and religious orders for women—
Benelux countries—History—Middle Ages, 600–1500.    III. Benelux countries—Church history.
IV. Church history—Middle Ages, 600–1500.
BX4272.S56    2001        274.92/05/082 21          2012345117

# Contents

# Illustrations and Maps

# Preface

The city of Ghent today is as vibrant as ever. Once Flanders' unruly capital, it now teems with students who rush through its streets on their way to class; tourists who arrive by the busload to pay tribute to van Eyck's Altarpiece at St. Baafs; hordes of workers commuting to the vast industrial plants that border its canal to the Scheldt estuary. But those who wander away from the city and proceed along the old route to Brussels will find on the edge of town a small entryway that leads to a different world. Passing through the gate of the *begijnhof* of Ter Hooie, these visitors will suddenly find themselves in a large, rectangular courtyard surrounded by cobbled streets, and rows of small, simple cottages. On the edge of the green stands a church, and here and there black-robed figures move about. The jostle of the urban center is only a distant hum, and an uncanny silence reigns.

*Begijnhoven*, or beguinages, such as Ter Hooie, are peculiar institutions. Created by and for women not only in Ghent but also in many other cities and towns of the southern Low Countries from the thirteenth century on, they offered single women of all ages an opportunity to lead a religious life of contemplation and prayer while earning a living as laborers or teachers. The *begijnen*, or beguines, did not take solemn religious vows meant to be permanent and were allowed to leave their community if they wished. They were thus not considered nuns, and, in fact, never constituted a religious order. Until the late nineteenth century, these quaint places were of interest only to amateur historians, scholars of folklore, and clever fortune hunters who explored their church vestries, barns, and attics in search for priceless *beguinalia*: a small, decorated cradle, for instance, used to ritually swing the Christ Child during prayer meetings, such as the one that left Louvain's Groot Begijnhof around 1880 and is now in New York's Metropolitan Museum of Art, or pieces of simple, clear-lined furniture not unlike that of New England's Shakers. But no historian of more than local stature would venture into their archives because, after all, beguines were considered rather inconsequential women without history.

At the turn of the twentieth century, local historians engaged in a lively controversy on the question of which city possessed the oldest, primitive beguinage.

In an attempt to clarify the matter, the German clergyman Joseph Greven sys-
tematically examined early thirteenth-century chronicles and other materials in
search for the earliest descriptions of beguine life. He situated the origins of the
beguines in the region of the Brabantine town of Nivelles, but went on to discuss
the possible reasons for the foundation of beguinages. Greven was particularly
struck by the following passage in James of Vitry's second *Sermon to Virgins*,
written in 1229–40:

> A virgin must avoid suspect individuals, times, places, and secret conversations, in order
> to maintain a cautious and honorable behavior and not to give reason to be slandered. . . .
> That is why certain wise and devout virgins, who can no longer remain in their paren-
> tal home among secular and shameless people without great and grave peril, converge
> these days in great numbers to monasteries, which the Lord multiplies over the whole
> world. Those virgins, however, who cannot find monasteries that will accept them, live
> together in one house according to the book of Ecclesiasticus: "Birds resort unto their
> like" [Ecclus. 27:10].[1]

Greven argued that this text revealed the "true origins" of the beguine move-
ment: beguines were nuns *manquées*, women who became beguines because they
could not be nuns. Their vocation was a fundamentally religious one, Greven
maintained, and their history properly belonged to the history of the Church
and of monasticism.[2]

Meanwhile, German historians took an interest in these communities for
very different reasons. Inspired by the first studies of urban demography and
social structure in medieval Germany, they focused on what was soon called,
somewhat erroneously, the *Frauenfrage*: how to explain why women appeared
to outnumber men in German cities of the late Middle Ages. They turned to
another statement on the origins of the beguines, made by a committee of clerics
who visited the beguinage of St. Elizabeth of Ghent in 1328 in order to verify the
orthodoxy of the women:

> Those ladies of good memory, Joan and her sister Margaret, successive countesses of
> Flanders and Hainaut, observed that there were many women in their lands who could
> not conclude a suitable marriage in accordance with their position or that of their kin,
> and considered that daughters of respectable men, noble as well as of middling condition,
> who wished to live in chastity, could not easily be accepted into religious houses, either
> because they were too numerous or because their parents were too poor, and that honor-
> able and noble but impoverished young women would have to go begging or lead a life
> that would put themselves and their families to shame, unless appropriate measures were
> taken. By divine inspiration, as is piously believed, and after obtaining the advice and
> consent of the bishops and other wise men, the countesses then set up in various towns
> of Flanders certain spacious places that are called beguine courts, in which the aforesaid
> women, girls or ladies, were received so that living together therein, they might preserve

their chastity, with or without taking vows, and where they might support and clothe themselves by working a suitable craft without shaming themselves or their families.[3]

It was clear that James of Vitry and the bishop's men at Ghent agreed on several points: they argued that large numbers of young women of the best families, in their desire to live chastely, attempted to join a nunnery, but that many of them could not find a convent that would accept them: there were simply too many candidates. The Ghent report added that the women could not afford the entrance gift, the *dos*, required in most monasteries—an obstacle to their entry that James tactfully omitted. It further differed from James in its assessment of the primary motive that drove women to the convent: it was the inability to conclude a suitable marriage that prompted these women toward the monastic life; when the latter proved impossible, they joined the beguinage. For the scholars of the *Frauenfrage*, this text confirmed the widely held opinion that medieval cities had a "surplus of women." They also viewed beguines in a very different perspective as female craftworkers, who mutually supported themselves in "beguine convents." Beguinages were thus just female versions of guild organizations: beguine history pertained to social history and to the history of women.[4]

In 1935 Herbert Grundmann reoriented the discussion and placed the origins of the beguine movement into a wider cultural context in his authoritative *Religiöse Bewegungen im Mittelalter*.[5] Grundmann drew attention to the common ground that inspired various religious movements of the central Middle Ages, both orthodox and heretical. Women participated on both sides of the divide, he maintained. In fact, Grundmann was the first to speak of a "religious movement by women" (*religiösen Frauenbewegung*) during the Middle Ages. He argued that beguines, like many other women of the late twelfth and thirteenth centuries, pursued the ideal of apostolic poverty that reinvigorated religious thought in the central Middle Ages. Thanks to the innovative approach of Pope Innocent III around the year 1200, beguines and other extraregular (or semireligious) movements gained ecclesiastical approval and remained largely within the fold of the Church.

Recent scholarship on the social context of religious movements and on women's spirituality in medieval Europe has developed and corrected Grundmann's ideas. The Gregorian reform, we now understand, not only changed the relationship between Church and state but also resulted in a growing clericalization of the Church in the eleventh and twelfth centuries, widening the gap between clergy and laity as well as enhancing the sacerdotal dignity and function of the priest. The growing concern with heresy and its persecution also sharpened the sensibilities for religious dissent and soon became, as Robert Moore demonstrated, the very means by which a clerical and bureaucratic elite in Church

and state justified its privileged position.[6] Such lay religious movements as the beguines by definition fitted poorly in the politics of those officials. In addition, Giles Constable has consistently argued that twelfth-century reform in the monastic world was itself highly diverse, a product of sometimes conflicting tendencies in medieval spirituality.[7] Caroline Bynum has powerfully demonstrated how women developed an alternative realm of religious authority and influence centered around the real and metaphorical manipulation of food in the thirteenth and fourteenth centuries, while André Vauchez, Anne Clark, and Barbara Newman, among others, have studied the dynamic relationship between male clerics and female visionaries in the same period—a relationship built on cooperation and mutual respect, but also laden with tension as women's official functions within the Church remained limited.[8] The study of women's religious life in the Middle Ages, and the specific challenges they faced, is now one of the fastest growing fields in monastic history.[9]

While our knowledge of the spirituality of the semireligious—particularly their mystical and visionary writings[10]—in medieval Europe has grown significantly, we still lack information about key aspects of their lives. The present volume returns to the heartland of beguine history, the southern Low Countries, in order to examine the social environment of the medieval beguine: the beguinage or beguine community. My work will therefore be less concerned with prominent beguine writers like Hadewijch and Marguerite Porete, or with the spirituality of their sisters beguines, than with the religious and social forces that shaped their lives and experiences. It considers beguines and their medieval history from three points of view: first, as a religious "movement" of the laity; second, as a movement shaped and promoted by urban conditions; and third, and perhaps most important, as a movement characterized by the gender of its participants.[11] I begin with an introduction to the social and cultural history of the southern Low Countries in the Middle Ages; although primarily intended for readers less familiar with the history of these lands, these pages also assess recent scholarship on women, family, and work in the Low Countries and other parts of northern Europe; they also explore the role of lay men and women in religious reform in the region before the rise of the beguines, and situate the origins of their movement against the background of a confrontation between lay religiosity and clerical authority during the eleventh and twelfth centuries. Chapter 2 follows the beguines from their first gatherings near hospices and hermitages around 1200 to their formal communities, the beguinages, formed after 1230. In Chapter 3, I suggest that beguine life may best be characterized as a retreat from the world that included an active apostolate, supported by manual work in the urban textile industry, and teaching. As I demonstrate in Chapter 4, these communities were composed of women from all social strata but

became gradually dominated by the lower and middle classes; I further argue that the large popular success of beguine life derived from the opportunities it offered for single women to earn a living in a supportive atmosphere through work in the urban textile industry. Chapter 5 explains how and why the movement was condemned as heretical in the early fourteenth century, and examines the ways in which beguine communities nevertheless assured their survival in the Low Countries. In the Conclusion, I will review the significance of beguine communities in the wider context of religious, social, and women's history.

The area of study is formed by the southern Low Countries, roughly present-day Belgium and the French departments of Nord and Pas-de-Calais.[12] The work traces the history of beguine communities from their beginnings around the year 1200 until the outbreak of the Dutch Revolt, in 1565–66. Although many beguinages endured until the nineteenth and even twentieth centuries, the period of the revolt forms a significant break in the history of these communities, as many were abandoned by their inhabitants and destroyed or severely damaged. In those beguinages that survived the years of intense conflict and warfare, beguine life did not resume until the late sixteenth century.[13]

Place-names in this book follow local usage (thus Sint-Truiden in Dutch-speaking Belgium rather than Saint-Trond, and Liège in French-speaking Belgium rather than Luik), with the exception of a few cities better known to English speakers by their French names (e.g., Louvain rather than Leuven) or for which English has adopted its own names (e.g., Brussels rather than Brussel or Bruxelles). English translations of the medieval Vulgate have been made with reference to the Douay (or *Douai*) and Rheims editions of 1609 and 1582. Currency in the late medieval southern Low Countries was characterized by a great variety of coins that circulated throughout the region. In the thirteenth century, most prices and wages were expressed according to a standard set by the Parisian pound (lb. par., or *libra parisiensis* in Latin), subdivided into 20 shillings (s., for *solidi* or *sous*), and 12 pennies (d., for *denarii* or *deniers*), so that 1 pound = 20 shillings = 240 pennies. Regionally, such currency was known as the Flemish pound (lb. fl.), Brabantine pound (lb. brab.), Artesian pound (lb. art.), and so forth. In the course of the fourteenth century, other standards imposed themselves, notably that of the *groot* or *gros* (gr.). Its value stood at 1 pound *groten* (lb. gr.) = 12 lb. par., so that 1 gr. = 12 d. par. Whenever relevant, I have converted prices into average wages of skilled or unskilled laborers.

*   *   *

Research for this book has spanned more than a decade, in which I moved from Europe to North America and consulted a great many people on both sides of

the Atlantic. I am happy that I can finally thank them in print, although I cannot possibly explain how much I owe to each one of them.

In Europe, I received the help of a wonderful circle of former teachers, colleagues, and friends at the Universiteit Gent, Belgium, who continue to make my every stay there a delight for the mind and the heart (not to mention the palate): Marc Boone, Myriam Carlier, Godfried Croenen, Georges Declercq, Thérèse de Hemptinne, Jeroen Deploige, Martine De Reu, Hilde De Ridder-Symoens, Jan Dumolyn, Ann Kelders, Luc Jocqué, Véronique Lambert, Walter and Frieda Prevenier, Peter Stabel, Steven Vanderputten, Jacques Van Keymeulen, and foremost, Ludo and Greta Milis, gave me their expertise, answered countless queries, and made me feel as though I never left. Thanks is also extended to scholars at other institutions in Belgium and the Netherlands, namely, to Alphons van den Bichelaer, Arnoud-Jan Bijsterveld, Wim Blockmans, Pieter Boussemare, Esther Koch, Mariann Naessens, Remco Sleiderink, Wybren Scheepsma, Paul Trio, Herman Van der Wee, and Raf Van Laere for sharing their research with me and providing sound advice.

Several archivists and curators assisted me far beyond the call of duty. I would like to acknowledge in particular Ernest Persoons, General Archivist of Belgium, and Christiane Berkvens-Stevelinck (Bibliotheek Rijksuniversiteit Leiden), Paul Bertrand (Archives de l'État, Liège), Willy Buntinx (Rijksarchief Gent), Ludo Collin (Archief van het Bisdom Gent), Johan Helsen (Stadsarchief Tongeren), Inge Schoups (Stadsarchief Antwerpen), Maurice Vandermaesen (Rijksarchief Brugge), Cyriel Vleeschouwers (Algemeen Rijksarchief Brussel), Christian Von Steiger (Bürgerbibliothek Bern) and the entire staff of the Stadsarchief van Den Bosch (or's-Hertogenbosch). A special word of thanks is due to Michel Van der Eycken of the Rijksarchief Hasselt, who was a terrific "boss."

As others have declared long before me, there is no place on earth quite like the Institute for Advanced Study in Princeton. I was fortunate to meet there distinguished medievalists and early modernists who were an endless source of inspiration: may Robert C. Davis, John Freed, Patrick Geary, Michel Huglo, Paul Hyams, Richard Jackson, Linda Koch, Gary Macy, James H. Marrow, Roberto Rusconi, Katherine Tachau, and André Vauchez discern in these pages a response to their words of wisdom and encouragement. My debt to Giles Constable, who gave me support when I needed it the most, is immeasurable. Joanna Ziegler, Kermit S. Champa, and Judith Tolnick played an important role in my transformation from a staid European scholar into a slightly less staid American academic; I am grateful for their faith in me. I was given the warmest welcome at Dartmouth College's Department of History, whose scholarly environment turned out to be much like the one I had known at Ghent: rigorous but friendly, serious but entertaining, and richly diverse. I could not have hoped

for a better home away from home. To the members of the Medieval Seminar and the Women Studies Program at Dartmouth, who in the past years may have heard a little more about beguines than they normally would, I express my lasting thanks for their suggestions, always insightful, always generous. I am particularly grateful to Amy Hollywood, Monika Otter, Peter Travis, Charles Wood, and my students Niels Barth, Tonya Blackwell, Jennifer Chun, Christina Ritter, and Shervyn von Hoerl, for their help at various stages of the book. I also wish to salute the staff of Dartmouth Baker Library's interlibrary loan office, notably Patricia Carter and Marrianne Hraibi, who cheerfully worked miracles. Dartmouth's Burke grant and a fellowship in 1995–96 allowed me to extend my research of archival materials in Europe; a grant by the Dean of the Faculty in 2000 helped to make publication of this book possible.

Throughout this period, many others gave me suggestions, hints, and pointers to new questions and answers: thanks to Caroline Walker Bynum, Kirsten Christensen, John Coakley, Kaspar Elm, Katherine Gill, Myriam Greilsammer, Jeffrey Hamburger, Martha Howell, Bryce and Mary Lyon, Bernard McGinn, Mary M. McLaughlin, Miri Rubin, Hans-Joachim Schmidt, Alison Stones, and John Van Engen. Parts of the book were based on lectures delivered at the invitation of Thérèse de Hemptinne, Hilde De Ridder-Symoens, Barbara Hanawalt, Ludo Milis, James Murray, and Sheila McNally. I benefited enormously from these meetings.

Peter Arnade, Ellen Kittell, and Michele Koenig read drafts of chapters and offered me their friendly criticism. Jeff Rider volunteered to read the entire manuscript at an early stage and greatly improved it in numerous ways. Without their help this work would have been impossible. I owe much to Anne L. Clark and David Nicholas, readers for the University of Pennsylvania Press, for their careful and constructive reviews, and to Jerry Singerman at the Press, for his continuous interest and patience.

Alex Phelps and Mary Ann Daly, neighbors and friends, stimulated me to think more broadly of what my sources revealed. At home, Jules and Verne kept me company during long hours at the computer; they were helpful editorial assistants, although I wished their feline paws were less deadly accurate in hitting command+delete keys. My wife, Hilde Baert, showed tremendous patience and endured my many soliloquies on beguine history. Her vivid mind, her probing questions, and her experience living in a house at Ghent's beguinage of St. Elizabeth taught me much about life, work, and religion. To my son, Folke, who grew from a small boy to a young man in all those years I devoted to beguine history, this book is fondly dedicated.

# 1. Women, Work, and Religion in the Southern Low Countries

## The Southern Low Countries in the High and Late Middle Ages

Medieval visitors to the southern Low Countries would have been struck first by the variety of the landscape unfolding before them as they crossed the region from west to east. In a journey of a mere 150 miles, they would have traveled from the marshy lowlands of coastal Flanders to the gently rolling wheat fields of Brabant—immortalized by Pieter Brueghel in the sixteenth century—to the Haspengouw, the area of rich farmland between Louvain and Liège settled since the Roman era, or to the Meuse valley with its cities and towns dating from the early Middle Ages. Further to the south and east of Liège they would find their progress hampered by the Ardennes forest, with a few villages scattered along river valleys; turning north they would enter the Kempen, only marginally more hospitable.

This territory was divided into several principalities of diverse size, institutions, customs, and, above all, political allegiance. Theoretically, their rulers—counts, dukes, or bishops—owed fealty to the king of France or Germany: Flanders and the Artois in the west were fiefs of the French crown, whereas the other principalities recognized the German king or emperor as their suzerain (Map 1).[1] By the twelfth century, however, neither the French king nor the German emperor held effective control over these frontier lands. Intensive traffic between the various principalities and the staunch independence of its main cities further weakened the ancient feudal ties with the greater neighboring powers. In the late fourteenth and fifteenth centuries, the Burgundian dukes established their personal rule over a large part of the southern Low Countries, paving the way for their Habsburg successor, Charles V of Spain (1500–1555), to unite them with additional northern principalities to form the Seventeen Provinces of the Netherlands, which he ruled in virtual independence from the Empire. This short period of unity came to an end during the Dutch Revolt (1565–1648), which divided the lands again between a northern, Dutch republic and the southern, now "Spanish" Netherlands. Along with the prince-bishopric of Liège, these would form modern-day Belgium in 1830.[2]

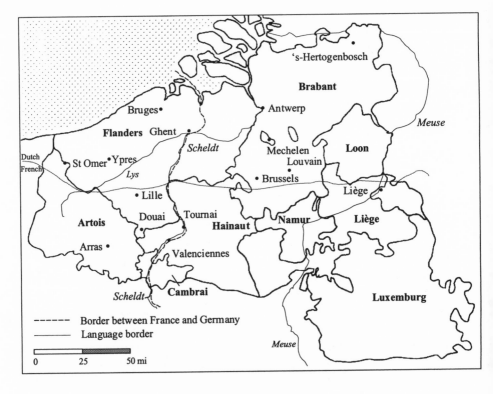

Map 1: The Southern Low Countries in the Thirteenth Century

Throughout the medieval period, customs, law, and institutions varied not only as one crossed the border between principalities but also within each province, as one moved from city to countryside; time, money, and foodstuffs were measured differently in each region, even in towns only a few miles apart.[3] At the end of the period examined here, subjective identification with the larger Burgundian "state" (and its centralizing efforts) must have been very rare indeed. As Wim Blockmans observed, "people around 1400 did not harbor national feelings on the scale of the whole Netherlands; even within each principality such feelings of community remained weak unless an acute outside danger presented itself. One was above all a citizen of a particular town or a member of a village community; wider associations coalesced only around the personality of the prince or the leader of a political party."[4] This explains, historians have argued, why the Burgundian and Habsburg efforts to create a unified state, powerful as they were, met with such strong regional and local resistance.[5]

Despite such regional diversity and deeply entrenched local particularism,

the southern Low Countries did share important traits.[6] They were first of all inhabited by people who were multilingual, or at least, in close contact with both the Romance and Germanic cultural worlds; they were dominated by powerful and independent-minded cities; their population enjoyed a high level of literacy. Together, these key features distinguish southern Netherlandish society from its neighbors to the north, south, and east—largely monolingual, rural, and less advanced—and created a unique and complex, mostly urban environment that determined its social fabric. These features also help us, I would argue, to understand fundamental aspects of gender and religion in the region during the late Middle Ages.

With the exception of Namur, thinly populated Luxembourg, and the small ecclesiastical territories of Tournai and Cambrai, each of the southern Netherlandish principalities was bilingual in the sense that it was populated by both Dutch-speakers and French-speakers. The border between the two languages did not coincide with political boundaries but rather transversed the area along a more or less horizontal line, dividing each principality into northern, Dutch-speaking and southern, French-speaking parts, although the proportions were different in each territory: Dutch-speakers were the majority in Flanders and Brabant but the minority in the Artois and Hainaut.[7] Along with the obvious problems it caused for internal communication within each province, the bilingual composition of the principalities offered distinct advantages because it exposed Dutch-speakers in each region to the influence of French culture and French-speakers to that of Dutch or Germanic culture in the course of their everyday business. The situation also stimulated exchanges in the native language across the political border east or west, which often amounted, among other things, to acts of linguistic survival. The effect of this dual process of cultural traffic was reinforced by the orientation of the main economic trade routes, which either followed the rivers of the Scheldt and Meuse, running in a south-to-north direction, or traversed the area from west to east along the important overland route between Bruges and Cologne. Admittedly dialects within each language group—Flemish, Brabantine, Limburger among the Dutch dialects, Picard and various forms of Walloon among the French—varied to the point that they sometimes rendered communication between western and eastern speakers of the same language difficult. In 1549 parishioners of Dutch-speaking Venlo, in the northeastern corner of our area of study, complained that they could not understand their priest because of his Brabantine speech, although he was a Dutch-speaker born less than forty miles west of Venlo.[8] Certainly calls for native speakers to occupy local offices in state and church were raised occasionally in the course of the fourteenth through sixteenth centuries, but the real cause of friction lay elsewhere: the complaints were often motivated by resistance to

centralizing politics and supraregional decision making rather than by insur-
mountable obstacles to communication. There are, on the contrary, numerous
examples of artists and intellectuals (the fifteenth-century painters Jan van Eyck
and Rogier van der Weyden come to mind) who moved quite easily between
the various provinces in the course of their careers.[9] Artists of that caliber were
part of an international cast of painters, sculptors, and musicians attracted to
cities like Bruges, Ghent, and Brussels because of their extensive civic patronage
and the frequent presence of the ducal court there, but ordinary craftsmen and
merchants from a variety of geographical and linguistic backgrounds crossed
paths in this area as well.[10] It must have been for their use that around 1370 a
Picard schoolteacher in Bruges composed his *Livre des Mestiers*, a basic phrase
book in French and Dutch, which was copied and reissued many times — the En-
glish printer William Caxton used it for his French-English manual, printed in
1483.[11] It was not uncommon to send young children to relatives or schools across
the language border — sometimes in another principality — in order to learn a
second language.[12] The result was not only exposure to cultural influence from
France and Germany, but also intense traffic of people, goods, and ideas inter-
nally, along several axes running from south to north and west to east.[13]

The second characteristic shared by most principalities in the southern Low
Countries was an advanced level of urbanization. Flanders was the land of cities
par excellence: in the fifteenth century up to 36 percent of its total population
lived in cities, a level of urbanization only parts of Italy could match. Even in
Brabant, Hainaut, Namur, and Liège, where cities were generally much smaller,
the urban communities still accounted for about 30 percent of the population.[14]
The southern Low Countries were thus, with northern and central Italy, the most
highly urbanized region of medieval Europe.[15] With a population estimated at
64,000 inhabitants in 1356–1358, Ghent was the second largest city of Europe
north of the Alps, after Paris. Bruges, commercially more prosperous but less
developed industrially, had a population of 46,000 in 1338–1340, comparable
to that of London. The population of Arras, Lille, Douai, Saint-Omer, Tournai,
Ypres, Valenciennes, and Mons, all in the principalities of Flanders, Artois, and
Hainaut, probably reached between 20,000 and 40,000 in this century. Brussels,
in Brabant, saw its population rise from almost 20,000 in 1374 to 33,000 in 1482.
Antwerp's population grew from 15,000 in 1437 to 55,000 in 1526, and it kept on
rising to more than 100,000 in 1568, by which date it was the most important
urban center in northern Europe, along with Paris. Louvain, 's-Hertogenbosch,
and Mechelen numbered about 20,000, 19,000, and more than 25,000 inhabi-
tants respectively, by 1526. Liège had 20,000 to 25,000 inhabitants before its de-
struction in 1468, from which the city was slow to recover.[16]

Population shifts were triggered in the main by the remarkable mobility of

the textile industry, the major industry and source of trade in the Low Countries. Centered at first in the southwestern cities of Saint-Omer, Arras, and Cambrai, the production of woolens expanded to Ghent, Ypres, Bruges, Lille, Douai, and Valenciennes, which outperformed the older centers in the thirteenth century, followed by the Brabantine towns of Mechelen, Louvain, and Brussels around 1300. In the fourteenth century, smaller towns in Flanders and Brabant became powerful manufacturing centers but production also spread to the countryside. The linen industry endured similar changes, from dominance by the greater urban centers to competition from the smaller towns in the fifteenth and sixteenth centuries. To be sure, major cities did not depend on the production of woolen cloth alone. Bruges, the leading international trading center in northwestern Europe in the fourteenth century and the main provider of a wide range of services and goods in Flanders throughout this age, lost ground to other markets like Antwerp only at the end of the fifteenth century. Along the Meuse, cities like Dinant, Namur, and Huy continued to produce copper wares traded over a large area of Europe; toward the end of the fifteenth century, Liège and Namur also became centers of iron production. Many other cities drew their strength as much from their political or administrative roles as from their ability to offer a variety of products for the regional market.[17]

The urban network spanning the southern Low Countries thus underwent various transformations during the period under study but never ceased to impose its imprint on the area as a whole. Like their counterparts in northern Italy, the major cities of Flanders, and to some extent even those of Brabant, attempted to carve up the land into city-states in the course of the fourteenth century, which for a while allowed them economic, political, juridical, and cultural control over the rural hinterland. That "city-state dream" never quite materialized for Ghent, Bruges, and Ypres, largely because the centralizing ambitions and overwhelming resources of the dukes of Burgundy and their Habsburg successors proved to be too formidable. The city-state image permits us, however, to judge the degree to which the leading cities infused the countryside with urban values and integrated rural communities into their own economies.

So vital was their influence in Netherlandish civilization, Herman Pleij has argued, that one of the distinctive features of late medieval Dutch literature was its propagation of stout middle-class values anchored in the survival techniques deployed by innovative townsmen, who "had to be useful, practical-minded, industrious, eager to learn, thrifty, clever, individualistic, opportunistic, moderate, reasonable, modest, and self-controlled."[18] Pleij's notion of a "civilizing offensive" conducted by a determined urban elite against popular and rural culture has been confirmed by Paul Vandenbroeck, whose magisterial study of Hieronymus Bosch found that the visual arts of the Low Countries between about

1400 and 1600 were the vehicle for a coherent cultural program driven by urban elites to discipline individual and collective behavior according to a similar set of values.[19] In this project, the urban elite may have at an early date obtained the support of its rural counterpart, the old landed aristocracy, so that bourgeois and "noble" or courtly cultures of the Low Countries evolved in close symbiosis with each other, culminating in the "bourgeoisizing" (or, in Dutch, *verburgerlijking*) of noble culture in the seventeenth-century Dutch republic.[20]

Closely related to the high degree of urbanization, a third feature of southern Low Country society, its high level of literacy, has received comparatively little attention from historians. Yet it could be the one area in which cities may have inspired rural communities the most, or rather, where they played their role as agents of civilization the most effectively. Starting in the twelfth century, merchants and other powerful groups in the main urban centers successfully challenged the Church, which since the early Middle Ages had controlled all educational institutions, and established secular schools that offered elementary instruction in reading, writing, and arithmetic.[21] Not long afterward it was taken for granted that children of urban dwellers learned to read and write, and that cities subsidized elementary education for children of poor families. By the fifteenth century, the larger cities also organized "higher," or Latin schools comparable to those of the Church, offering instruction in Latin to students between eight and fourteen or sixteen years of age. The main cities thus created a network of public education that was unequaled in Europe, save perhaps for northern and central Italy.[22] New initiatives in schooling carried out from the late fifteenth century onward under the guidance of the *Devotio Moderna* and humanist scholars offered educational opportunities to an even greater number of children, so that travelers to the Low Countries in the mid-sixteenth century noted with admiration that everyone could read and write, and that there was a general interest in learning. True, the Low Countries did not possess an institution of higher learning until 1425, when a university was founded in Louvain, but many young men pursued higher education before that date at the schools of Paris (only a few days' journey away), Bologna, Padua, Orléans, and, after 1388, in nearby Cologne. In the fifteenth century at least 2 percent of the Low Country population had received university training, a high proportion by contemporary standards; by 1521 the university of Louvain was the largest in the Empire.[23]

The high level of literacy found in these lands was all the more remarkable to outsiders because it also applied, with some qualifications, to women of the higher and middle social strata. Elementary schools were usually coeducational. When separate schools for boys and girls existed (in the larger cities), there is no indication that the instruction girls received at this level differed significantly

from that of boys.[24] The real gender gap became apparent at the higher educational level. Although there are notable cases of "higher schools" that girls could attend or that were specifically intended for them, as in Brussels in 1320,[25] and a certain number of women in wealthy families received further training at home or in a convent, far fewer girls than boys, in fact, enjoyed advanced schooling. Fluency in Latin and familiarity with the learned culture preserved only in that language must thus have remained rare among women. Nevertheless, the very existence of a few such "higher" schools for girls proves that there was a certain demand for them. Indeed, the notion that girls should receive such training appears to have been more widespread than might be thought, perhaps because some knowledge of Latin and foreign languages was considered a social and economic asset that would brighten a girl's prospects for marriage. In any case, female literacy was probably more extensive in the Low Countries than in southern Europe. In 1576, a survey in the city of Antwerp registered a total of at least eighty-eight schoolmasters devoted to teaching boys, and seventy schoolmistresses for the basic instruction of girls. During the tumultuous winter months of 1566–67, a probably incomplete survey conducted in Ghent registered forty-eight male and fifteen female teachers. Contemporary ratios in southern Europe were eighty-seven schoolmasters for five schoolmistresses in Lyon between 1490 and 1570, and 258 male teachers for a single female teacher at Venice in 1587.[26] This might explain why at least one Mediterranean male visiting the area in the sixteenth century was disturbed to find women able to discuss intellectual subjects "like wise doctors." [27]

## Household Structure and Gender

What we have learned above urges us to turn to an investigation of gender in the medieval Low Countries, and to question to what extent its specific social environment affected concepts of masculinity and femininity. Although much work needs to be done — in fact *is* being done in several ongoing research projects [28] — to answer these questions conclusively, I shall suggest a few lines along which such an answer might be built.

Families in this region, with few exceptions, belonged to what is usually called the "northern" or "northwestern" European type. These households were headed by the nuclear couple of husband and wife, both of whom had entered marriage rather late, at about twenty-five years of age, and were more or less of equal age. The couple married when financial independence from their parents enabled them to set up a separate household, and they had relatively few children, two or three. A remarkably large proportion of the population never

married at all. With the exception of the noble, rural elite, all social groups in the Low Countries display these characteristics of household formation.[29]

This type of family household contrasts with that common in southern Europe, particularly among the Italian noble and urban elite. There, households tended to be larger, comprising several males of the extended family as well as couples with children. In the southern tradition men and women entered marriage at unequal ages, with men usually in their late twenties marrying women who were ten or more years younger. The newlywed pair did not set up an independent household but resided with the parents of the bride or groom — usually with the latter. The southern model is best known through the well-documented genealogies of the urban elite of north and central Italy, and it is there that the greatest difference in ages between groom and bride — twelve years — has been attested, but as Herlihy and Klapisch-Zuber's exemplary study on fifteenth-century Tuscany has shown, the type was also widespread among the urban middle classes and in the countryside.[30]

In its crudest form, the contrast between the two models suggests a fundamentally different outlook between the north and south of Europe on women's role in the economics of the household. In contrast to the Mediterranean customs, women in Flanders, for instance, could inherit from their parents like their brothers (except in the case of fiefs) and therefore did not need a dowry to marry, which favored the continuity of small enterprises and encouraged women to take a role in them.[31] Women, of course, served as domestic managers in both systems, but it seems fair to say that women participated in providing an income for the household, either within or outside the home, more often in the north than in the south of Europe. In the north, they became suitable marriage partners when they were capable of contributing to the household income, and they thus tended to marry later, whereas in the south — particularly among the wealthier families — they were ready for marriage as soon as they were able to bear children. Even women of the elite families in northern cities engaged in business and contributed to the economics of the family. This is why even the wealthiest "patrician" lineages of ancient pedigree, whose influence in Flemish and Brabantine cities closely resembled that of the great Florentine and Genovese clans, differed from the southern patriciate in their marriage patterns: their household arrangements and relatively advanced age of both partners in marriage conformed to the generic northern model.[32]

The wide involvement of women in economic production may also explain why women formed the majority of the overall population in cities of the southern Low Countries. Data from the sixteenth through eighteenth centuries — far more numerous and detailed than the medieval source material — suggest sex ratios (expressed as the number of adult women in proportion to one hundred

adult men) of 122 (Ypres, 1506), 129 (Louvain, 1597), 141 (Louvain, 1755), 147 (Antwerp, 1755), and even 156 (Mechelen, 1680). Most cities registered a sex ratio between 135 and 142.[33] Although we have only indirect evidence to corroborate it, there can be little doubt that women outnumbered men in cities of the Low Countries (or, generally, of northwestern Europe) in the preceding centuries as well.[34]

The greater number of women in urban communities was not caused, as some older studies have supposed, by a greater male mortality due to disease, public violence, or warfare.[35] Rather it was a structural feature of urban demography in northern Europe and may very well date from the earliest days of urban expansion in the area. Cities depended on a continuous flow of immigrants from the countryside (less often from other cities) to maintain their population, for their natural growth was usually negative.[36] From the rise of the northwestern European city in the eleventh and twelfth centuries until the Industrial Revolution of the late eighteenth and nineteenth centuries, women left the country for the city probably in greater numbers than men. In his standard work on urban historical demography in Europe, Roger Mols even listed the principle as one of the "laws of urban immigration."[37] Women moved to cities—especially to the larger cities and service centers—because they could find employment more easily there in a large array of trades and industries, including housework. They often did so, we assume, at the crucial prenuptial and nuptial age, between twelve and eighteen, and stayed in the city for several years or even for the rest of their lives.[38] Many of them found employment as domestic servants (as maids, cooks, nurses, and nannies). In the generally wealthy cities of the southern Low Countries, the number of domestic servants could indeed be quite high: Pirenne estimated that servants made up about 10 percent of the population of Ypres in 1506.[39] Other young, single women worked in a variety of low-wage occupations in hospital care or in the textile industry. Naturally the flow of rural to urban migration was not continuous or unvarying but depended on the push and pull of factors that drove country people to the city or vice versa at a particular moment. The prospect of finding employment in cities must have looked particularly good for women during the centuries of urban expansion in the Low Countries, that is, from the eleventh through thirteenth centuries. Circumstances were probably less favorable for women workers in the fourteenth and fifteenth centuries, a period of economic contraction in most cities, though its effects were probably not as devastating as has been thought in the past.[40]

The preceding demographic model does not apply to southern Europe, or more precisely, to fourteenth- and fifteenth-century Tuscany, which has supplied most of the data.[41] P. J. P. Goldberg has argued that, whereas northern European conceptions of gender roles included the option for young country women to

work outside the home and even to relocate in search of employment, the south-
ern tradition made such action more difficult.[42] There, girls most often remained
at the parental home until their marriage (in their teens).[43]

In contrast, all our evidence suggests that numerous women were active
participants in the urban economies of the Low Countries during the thirteenth
through fifteenth centuries. Many vignettes taken from archival sources stage
them on market squares and in the streets, running their business, managing
stalls and vending their wares. Law codes, court and guild records, contracts, and
many other sources uncovered for these cities reveal that they were innkeepers,
cloth merchants, painters, fishwives, teachers, and even construction workers
and smiths.[44] Foreign visitors repeatedly expressed surprise or even shock over
the public behavior of women in the southern Low Countries. In some cases
they alleged specific licentiousness, but they were usually made uneasy simply by
women's relative freedom of movement and action.[45] These conditions were not
limited to the city, since many country women regularly frequented city markets
to sell agrarian products. As Claire Billen recently observed in her case study
of late medieval and early modern Binche, rural women visiting the city to sell
their wares shared urban experience and passed it on to the countryside.[46]

These data tell us, of course, little about the social status, professional
standing, or income level of working women, nor do they reflect important
changes over time. Some of these women may have occupied prominent posi-
tions in trade and in a few crafts during the thirteenth, fourteenth, and early
fifteenth centuries, but their numbers declined in the next decades. Throughout
the period, a large number of women worked in low-wage, low-status tasks. Cer-
tain auxiliary crafts of the textile industry at the bottom of the pay scale could
be gender specific to such an extent that city ordinances in Middle Dutch cited
them in their feminine form only.[47] For single women, domestic service pro-
vided a regular income but little chance for social mobility and status; they often
struggled in a precarious position on the margins of poverty and delinquency. In
his study of the population of one Yprois neighborhood in 1506, Pirenne found
that of the eighty-nine heads of households considered "poor" (which in this
case meant truly destitute), sixty-four (or 71 percent) were women.[48] Few his-
torians of women in the Low Countries now doubt that female workers found
the road to positions of higher status on the labor market increasingly closed
off in the transition from the medieval to the early modern era, at a time when
patriarchal order reaffirmed itself in large parts of northwestern Europe.[49]

Although this culture generally allowed women on the public scene because
they were economically productive, it did not do so without friction. The evi-
dence of this tension is quite old—it precedes the well-known cultural wars on
gender in the European Renaissance by almost two centuries. The oldest fabliaux

in French (many of which were written for urban audiences in Artois, southern Flanders, and Hainaut) ridiculed, satirized, but also celebrated conflicts between slow-witted men and sly women, between impaired masculinity and ambitious femininity, as early as the first decades of the thirteenth century.[50] Sources from legal practice teach us that however necessary or productive, a woman's public appearance often signaled potential disorder. Some areas within the city imbued with strong military or political meaning even assumed an exclusively male identity, as did the squares where the town militia and shooting confraternities would meet, and perhaps also the city walls.[51] Women naturally abounded on market squares, both as retailers and buyers, but they could never call these spaces theirs. In 1360, the city magistrate of Brussels prohibited the annual election of a "queen" by the marketwomen and its accompanying female festivities, apparently because it led to aggression against males in the previous years.[52] In other public spaces, a woman's behavior was obviously subject to much greater constraints than was a man's.[53] No aspect of a woman's presence drew the ire of men more than her outward appearance, represented by her dress and her speech. Ironically (but perhaps not wholly surprisingly), while Netherlandish culture in this age greatly appreciated sumptuous dress for men,[54] it never failed to condemn women for dressing to excess. Jan de Weert, the Ypres citizen who wrote the moralist *Nieuwe Doctrinael* in the first half of the fourteenth century, assailed women for parading on feast days coated with thick layers of makeup, in garish clothes and complicated headdresses that "made them look like horned beasts,"[55] a characterization that announces the easy association of women with the animal or disorderly world in Low Country visual and literary imagery of the fifteenth and sixteenth centuries. The *Book of Matheolus*, one of the most virulent misogynist tracts of the Middle Ages, written by a cleric in southwest Flanders in 1290–92, likewise skewered women for their vanity (and monstrous nature) but also for their inorderly use of speech, the cunning sophistry by which they invariably deceived their husbands.[56] A Middle Dutch satirical sketch of urban life, written about 1325, depicted women textile workers of Brussels hanging about the street and verbally harassing male passersby with sly double entendres. After tricking the men into giving them money and drinks, the rambunctious women run off to go ice skating on the canals.[57] Although moralists' invectives against women's immoderate use of adornment and speech were clearly rooted in a learned tradition that goes back to classical antiquity and early Christian theologians like Tertullian, John Chrysostom, and others[58] (whom the late medieval authors surely knew quite well, if only through the thirteenth-century *Roman de la Rose*), court records attest that they continuously received new life in public discourse. In fourteenth-century Ypres, the crimes for which women were most often convicted were prostitution and offenses of speech ("slander" or "gossip").

After a popular revolt at Douai in 1322, two women were convicted along with sixteen men for their part in the rebellion: the women's punishment was to have their tongues cut, because their crime was defined as one of speech.[59]

One major restriction imposed on women in the public sphere resulted from their exclusion from urban politics: civic office in urban communities always eluded women. In fact, the exclusion of women from public office and political authority was one of the main instruments by which urban authorities restricted women's participation in influential trades by the end of the Middle Ages and attempted to relegate their activities to the private sphere of the family.[60]

## Religious Renewal and Dissent Before the Beguines

The social conditions described above go a long way toward explaining the vigor with which religious dissent found expression in these lands, and women participated in it. At the crossroads of multiple outside influences, highly urbanized, with a remarkably mobile and literate population, the southern Low Countries provided fertile ground for the spread of dissenting ideas about Christian religion and its implementation by the Church. Beginning in the eleventh century, at the start of the urban revolution, these ideas inspired reformist initiatives in the religious or monastic life that usually stayed within the boundaries of orthodoxy; occasionally, however, they led to popular movements that openly criticized the Church.[61] Before we examine these antecedents of the beguine movement, however, we must begin by recognizing that part of the problem lay within the Church's own institutions in the region, which were ill-equipped to meet the demands of the laity.

Like elsewhere in Roman Gaul, the ecclesiastical organization of the southern Low Countries, laid out in the course of the fifth to seventh centuries, was modeled on the Roman administration in the area (Map 2). Two church provinces or archbishoprics, overseeing the jurisdictions of several bishops, divided the lands practically in half. Rheims, a French royal see, controlled the dioceses of Thérouanne, Tournai-Noyon, and Arras-Cambrai. These bishoprics covered "crown" Flanders, the Artois, and the Tournaisis, with parts of imperial Flanders, the Cambrésis, and western Brabant. The archdiocese of Cologne, in the Empire, had authority over the diocese of Liège, which comprised most of Brabant, Namur, part of Luxembourg, and the prince-bishopric of Liège itself. A tiny area of northern Flanders fell under the jurisdiction of the bishop of Utrecht, another suffragan of the archbishop of Cologne.

By 1100, social, political, and cultural change had rendered this system

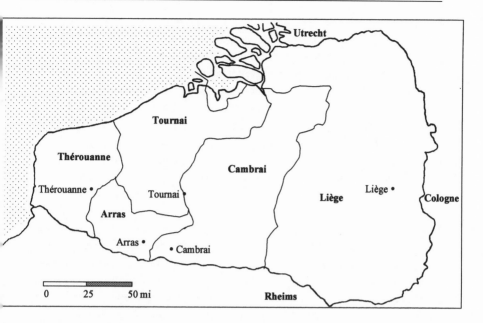

Map 2: Dioceses in the Southern Low Countries, 1146–1559

obsolete. None of the borders between the dioceses coincided with those be-
tween principalities, which were all formed after the ecclesiastical grid was set in
stone, nor did they coincide with the linguistic borders, which had also coagu-
lated at a later date. Most importantly, the diocesan map was unable to accom-
modate the population explosion and urbanization of the eleventh and twelfth
centuries. Two small corrections resulted in the partition of the diocese of Arras
and Cambrai in 1092–94, as well as that of Tournai and Noyon in 1146. But there
the matter rested until a long-awaited structural reform created ten new dioceses
within the space of the six previous ones in 1559–70.[62]

Between the twelfth and sixteenth centuries, the Church in the southern
Low Countries thus operated from poorly located bases within outdated struc-
tures. With the exception of Liège, all the diocesan sees lay at the very edge of
the territory they were supposed to supervise. Located in many cases outside
the principality that occupied most of their territory, bishops' sees were often
controlled by powers that took little interest in the people and politics of the
Low Countries or were even hostile to them. The dioceses of Cambrai, Liège,
and Utrecht, moreover, were cornerstones of the Imperial Church and there-
fore especially hostile to the introduction of reformist, Gregorian ideas.[63] Several
calls to bring the diocesan organization in line with contemporary political, cul-

tural, or economic conditions, like the Flemish request to pope Boniface VIII in 1302–3 to create new dioceses in the county, remained unanswered.[64] Given the problems of communication in this age, these dioceses were obviously too large and too heterogeneous to be effectively managed from such eccentric sees. One suspects that the pastoral task—always the weakest aspect of episcopal administration before Trent—suffered the most, and that a wide spiritual gap separated bishops and higher clergy from their flock.

New religious initiatives spread among laity (and lower clergy) well before they found support at the bishop's court. The ideology of these new movements was centered around the desire for voluntary, religious, or "apostolic" poverty, at the example of the first Christian community at Jerusalem, as described in the Acts of the Apostles, which claimed it rejected personal property of any kind (Acts 2:44–47; 4:32–35). The final goal of voluntary poverty was to open one's mind to the life of perfection, heeding Christ's advice: "If thou wilt be perfect, go sell what thou hast and give to the poor and thou shalt have treasure in heaven. And come follow me" (Matt. 19:21). Yet the definition of voluntary poverty always contained a relative component. It demanded outwardly recognizable acts of austerity and works of charity, but to many of its adherents its main rewards were purely spiritual: it protected the individual from vanity and undue reliance on temporal values. Tadeusz Manteuffel has rightly pointed out that the biblical precepts about wealth and poverty held that one could well be wealthy while owning nothing or be poor while possessing a large fortune (Prov. 13:7 and 22:2).[65] What mattered was the absence of a desire to own temporal goods. The ideal of apostolic poverty might therefore be realized, with some restrictions, as a state of mind rather than as a fact of life. Voluntary poverty was relative in yet another sense because religious groups who claimed to be poor did so, obviously, in relation to others perceived as wealthy. Sometimes the differences would be slight, but to most of the voluntary poor in this age, the concept of poverty implicitly or explicitly contrasted with the lifestyle of the "secular" Church (bishops, parish priests, and members of the lower clergy entrusted with the care of souls and endowed with a personal income from church property); or with the representatives of traditional monasticism, which theoretically excluded personal property but allowed its adherents to live quite comfortably while the community was collectively endowed with sizable if not enormous estates. In either case, electing to be "poor" meant to question, to a lesser or greater degree, the property regime of the established Church.

In the Low Countries, as elsewhere, hermits and "wandering preachers" who adhered to this way of life sometimes initiated new religious orders, like those of Arrouaise and Prémontré.[66] But there were many more whose ambitions did not point that way and who left few traces in the written record. As

Ludo Milis has noted, contemporary sources frequently highlight the role of hermits as founders or new orders, but say little or nothing of them if they failed to provoke large monastic foundations.[67] The tendency, then and now, to ascribe renewal of the Church to charismatic ecclesiastics has obviously obscured the contribution of lay men and women. Lay people were also the main instigators of the Peace of God movements.[68]

Since lay engagement in the new religious movement so often confronted an entrenched clerical establishment in the late eleventh and early twelfth centuries, it is not surprising that the resulting frictions found their way into the sources as the first registered cases of "popular heresy." R. I. Moore, in his most recent work on religious dissent in the West, has called the eleventh- and twelfth-century parish a meeting point of two opposing concepts of community: one locally shaped by its lay members expressing themselves in the vernacular, and another defined as the lowest level of a vertical hierarchy, administered from above by the higher clergy using Latin as the vehicle of communication. Accusations of heresy in the eleventh century, he argued, often took the form of a conflict between the two, with the local parish priest caught in the middle.[69] The early history of heresy in the southern Low Countries illustrates this well.

The first documented cases of heresy occurred in the regions of Arras (1024–25) and Cambrai (1076–77), at that time the most economically advanced areas of the Low Countries. Each case turned on criticism of the leading clergy rather than on dogma. In Arras, lay folk, "unlearned" (since they could not read Latin)[70] but obviously well informed of new currents in spirituality, were condemned for questioning the validity of baptism administered by priests who led an immoral life. They argued that truly religious individuals should abandon the world, reduce the longings of the flesh, and follow the rule of life laid down by the gospel.[71] The local bishop responded to their claims with a learned treatise that underscored the necessity of obedience to episcopal authority and reaffirmed the hierarchical model of a vertical and diocesan "mother" Church, which united past, present, and future Christians in eternity.[72] In the Cambrai case, fifty years later, another layman, Ramihrd of Esquerchin (a village close to Douai), refused to accept the Eucharist from an unworthy priest. In his defense he implied that bishop Gerard II of Cambrai himself had obtained his office through simony — which was true enough. Men in service of bishop Gerard saw to it that he was killed in February 1077.[73]

Such criticism of immoral representatives of the Church hierarchy was eventually voiced by many clerical participants in the "Gregorian reform" movement, the vast effort to liberate the Church from secular tutelage and worldly concerns associated with pope Gregory VII (1073–85), who gave them his support. But others went beyond Gregorian rhetoric. The success of Tanchelm, per-

haps the most famous "heretic" of the Low Countries, lay in his ability to articulate latent disaffection with the institutional Church in the newly settled communities of northern Flanders along the Scheldt estuary in the diocese of Utrecht, particularly in Zeeland, populated by farmers and craftsmen who enjoyed personal freedom and considerable autonomy. An exceptionally gifted speaker, Tanchelm preached against Church corruption, advocating Gregorian-like reform with considerable popular success between 1110 and 1115, but he upset too many conservative strongholds in the Utrecht church when he called on peasants to stop paying tithes to unworthy priests and ridiculed certain sacraments. The Utrecht clergy drummed up enough support against him to have him eliminated in dubious circumstances. His unfavorable reputation among churchmen, even those in favor of reform, points to a fundamental unease about his preaching. His virulent attack on tithes, which found a warm welcome among the nascent villages and towns of Zeeland, may account for that unease, but there is also the strong possibility that Tanchelm was a layman or a cleric in lower orders who was not allowed to preach.[74]

The tension pitting laity and lower clergy against the higher echelons of the Church gained new vigor with the spread of a "new" heresy, Catharism, in the second half of the twelfth century. Drawing on the beliefs and practices of the Bogomils and Paulicians, who were active in the Balkans since the tenth century, and on the powerful legacy of ancient Gnosticism, Catharism postulated the fundamental duality of the universe, divided into an unseen realm of spiritual beings and a visible, material world. An evil power had created the latter, which those who had true insight should eschew—by abstinence of bodily pleasure, celibacy, and missionary activity—in order to gain salvation in the form of a reunion with the creation of the Good God. Though the first sure signs of Cathar belief in the West date only from the 1140s, we may assume that dualist philosophies from the Balkans reached western Europe well before that date, perhaps after or in conjunction with the return of crusaders around 1100. Whatever the means and exact date of transmission, dualist heresies spread widely in the southern Low Countries and turned the region into a hotbed of heretical activity and orthodox counterpropaganda. After their harsh repression in the Low Countries, the Rhineland, and northern France, Cathar groups reassembled in central and finally southern France, where, as is well known, they became quite powerful in the thirteenth century.[75]

The exact influence of Cathar beliefs in the Low Countries is difficult to trace because so few sources are available, and those that exist offer only a perfunctory glimpse.[76] In an undated letter by the cathedral clergy of Liège to a certain pope "L.," probably pope Lucius II (1144–45), the canons of Liège first warned the papacy of a "heresy that manifests itself in so many different ways

that it cannot be identified properly by any one name," but then went on to describe an organization that was typical of Cathar groups as we know them from later sources. The heresy had not only its parallel Church of "priests and bishops, like we have," the canons asserted, but also "distinct ranks among its adherents: there are auditors, being initiated into error, and believers, who have already been led astray," which seems to recall the Cathar "perfect" or religious leaders (including their bishops), and the distinction among their followers between the newly trained (the "auditors") and those whose initiation was deemed complete (the "believers").[77] The spread of Cathar beliefs around 1144 also led to action in the nearby diocese of Cologne, where the Premonstratensian Everwin of Steinfeld left a vivid account of their condemnation. According to Everwin, the "heretics" maintained that their belief "had remained hidden from the time of the martyrs to the present day and had survived in Greece and certain other countries." His testimony is commonly considered the oldest sure reference to Cathars in western Europe.[78] It is largely corroborated by Hildegard of Bingen's *Letter to the Cologne Clergy* (written around 1163), and, in greater detail, by the *Sermons Against the Cathars* of Eckbert of Schönau, written in 1163–64 but based on Eckbert's extensive contact with heretical groups in Bonn and Cologne since about 1148.[79] As Arno Borst and others have noted, Cathar dogma shows only dimly through Eckbert's portrayal of the heretics, which highlights their ascetic way of life in the evangelical fashion.[80] Still, Eckbert is the first to mention that the leaders of these groups called themselves *catharistas*, or "purifiers" (*purgatores*), he helpfully adds, and *catharos*, or "those who are clean" (*mundos*), both terms deriving from the Greek *katharos* or "pure."[81] All of this leaves little doubt that these men and women along the Rhine indeed adhered to Cathar beliefs.

Eckbert's story is particularly valuable for our purposes since he reported that the Cathars were already well known in the Low Countries, where, he said, "they were called *Piphles*."[82] Contemporary sources from Cologne inform us that in 1163, "certain heretics of the Cathar sect, who had come from the southern Low Countries to Cologne, had started to live in the seclusion of a barn near the city, but when neighbors noticed they did not go to church on Sunday, they were found out."[83] The group was cited before the bishop's court and interrogated. When they refused to rescind their views, they were handed over to the secular authorities and burned on 5 August 1163. The trial obviously marked a turning point in local attitudes to Cathars, noted by many chroniclers in the Rhineland. Henceforth, persecution would be vigorous and unremitting. The events also prompted Eckbert to gather his notes from many years and to compose his sermons against Catharism during the following months, in service of those who would combat the new heresy.[84]

Eckbert was not the only one at the time to identify the southern Low Coun-

tries as the birthplace of new heresies associated with Catharism. Between 1153 and 1163 a large number of citizens of Arras known as *Populicani* (an old term of derision for heretics)[85] were suspected of dualist heresy by the local bishop and the archbishop of Rheims. In the decrees issued by a church council held at Rheims in 1157, they were called *Manichei* and *Piphili*.[86] The *Populicani* of Flanders (probably those of Arras) attracted the attention of King Louis IX of France and pope Alexander III in 1162–63.[87] A few years later, about thirty men and women called *Publicani* arrived in England from the southern Low Countries and started to proselytize there, but they were banned as heretics from the city of Oxford and perished during the winter of 1166–67.[88] Meanwhile, back in the Low Countries, the *Populicani* were resolutely persecuted by count Philip of Flanders (1168–91): there were convictions of a heretical priest in Arras in 1172, and of lay men and women in Arras, Ypres, and elsewhere in Flanders in 1182–83 and around 1190. Another heretical priest of Arras suffered seven years of incarceration between 1184 and 1203.[89] The *Populicani* continued to make large numbers of converts in the city of Cambrai and among the nobility of the surrounding countryside around 1180, when John, the first abbot of Cantimpré (1183–c. 1193), preached against them. The *Life of John*, by Thomas of Cantimpré, suggests that they gained ground at least in part because their exemplary way of life contrasted sharply with a dissolute and avaricious clergy.[90] The *vita* relates how one of there prominent converts, the knight Walter of Flos, claimed that he "did not believe in the daily sacraments of the altar," and would not be convinced "by any verbal theory unless he was forced to accept it by what he saw with his own eyes of flesh"; however, upon viewing an image of the Christ Child depicted in the elevated host during mass, he recanted his heresy and took the crusaders' vow.[91] Shortly afterward, we find the full range of accusations later made against the Cathars—radical dualism, use of the *consolamentum*, rejection of the Eucharist and other sacraments—in a sermon preached at Arras between 1183 and about 1200. In the early thirteenth century Catharism had long gone underground in Liège but was still gaining new adherents.[92]

Incomplete and hauntingly laconic as they may be, these sources nonetheless lead to a convincing conclusion. By the 1160s, the southern Low Countries had a certain reputation for religious dissent that spilled over into neighboring regions. By all accounts, a local tradition of reformist outspokenness against abuses in the Church had grafted itself onto a variety of Cathar teachings that had reached the area, at the junction of pan-European trading routes, some time around 1100. The Cathar influence further widened the gap between the Church and its opponents, since it exposed dissenters to a broad philosophy of creation that could serve as a basis for their criticism of Church ethics and operation. Around 1200, the Church thus found itself besieged by a wide range of critics:

some continued to protest the administration of Church sacraments by worldly priests in the fashion of Gregorian reformists, while at the other end of the spectrum, certain dualists displaced orthodox sacraments altogether by the use of the *consolamentum*.

The "heresies" of the Low Countries cannot be explained solely in terms of filiation, with heretical belief unrolling across the map of northwestern Europe as heretical missionaries advanced from the east. New religious ideas not only developed within or in opposition to orthodoxy and were spread by charismatic preachers — from the enigmatic Italian Gondulphus active in Arras before 1024 [93] to Ramihrd and Tanchelm in the late eleventh and early twelfth centuries — but they also sprang from discussion among people of various stations in life who reflected on religious alternatives. Members of the lower clergy continued to appear on the rosters of accused heretics, but the bulk of the reformist and dissenting movements was undoubtedly made up of lay folk; even more, many of the known leaders of these movements may have been lay rather than clerical preachers. Dissenters were also increasingly found in the city rather than in the country. It is in no way surprising that the city of Arras figured prominently in the record of heretical activity, for by the twelfth century, its economy was without question one of the most advanced of the region, with large groups of highly mobile textile workers (those suspicious "weavers" cited as followers of Ramihrd around 1133), [94] a merchant class engaged in long-distance trade, and, as already mentioned, a well-educated population that developed a precocious literary culture in the vernacular.

## Women as Reformers and Heretics

What role did women play in these movements of reform or dissent? On the orthodox side, lay women joined various apostolic groups that practiced the syneisactic monastic life, in which women and men lived in celibacy but in close association with one another. While the new houses of the Arrouaisian, Premonstratensian, and other reformed orders were intended primarily for religious men, almost all of them seem to have attracted large contingents of women. Indeed, some took on the appearance of double monasteries, associations of male and female religious communities in a single monastic complex. Prémontré, the mother house of the Premonstratensian or Norbertine order, comprised both male and female communities from its first institutional organization in 1121 until 1137-41. The Premonstratensian houses of the southern Low Countries, like Averbode and Grimbergen, also included large numbers of female adherents in the twelfth century, as did several other institutions of regular canons. [95]

Women could, in fact, make up a sizable part of the monastic community. In the mid-twelfth century, the monastery of Neufmoustier near Huy consisted of seven clerics, fifteen lay brothers, and twelve "lay sisters." In the Arrouaisian house of Hénin-Liétard, the proportion of female to male religious may even have been about four to one.[96] Our information on these women is extremely scant, however—a good indicator of the fact that the leaders of these new movements or their male followers who chronicled their history did not consider the women's fate central to their enterprise. The status of these women, called sisters (sorores), "ladies" (dominae), "converted women" (conversae), or simply "women" (feminae, mulieres), was also ambivalent. In the Premonstratensian order and in other houses of regular canons of the twelfth century, some of the women resembled nuns since they were strictly cloistered (and subordinated to the men of the community), but others engaged in menial work rather than in choir service. Some conversae lived as recluses or hospital workers within the monastic complex or in its vicinity and appear on the whole to have been rather loosely associated with the main communities.[97]

So numerous were the lay women and men who lived informally as recluses or in another informal, "religious" fashion that the anonymous author of a treatise On the Orders and Callings of the Church, written in Liège in the first half of the twelfth century, devoted the entire second book of his work to them.[98] Lay women (and men) also ran the many new hospitals and other charitable institutions that were founded from the twelfth century onward in the southern Low Countries, especially in the expanding cities; the ecclesiastical status of such caregivers was equally uncertain and remained the subject of debate for centuries.[99] Only rarely do the sources allow more than a fleeting look at these women as individuals, but the little that we do know suggests that some of them founded new religious houses, like the recluse Judith, who stood at the origins of the monastery of canons regular of St. Gilles in Liège around 1080 and had many female followers there, or Ermenburga, who with her more famous brother Odo of Tournai headed the new Benedictine community of St. Martin of Tournai, originally a double monastery, in 1092.[100]

Little is known about the size of the dissenting groups in the southern Low Countries; any attempt at quantification of the women in them must be futile. Ramihrd had followers "of both sexes," while Tanchelm supposedly built his movement on his success among women.[101] Everwin of Steinfeld claimed that among the Cathar believers and perfect of Cologne there were "women, who, they say, are chaste, as well as widows, young maidens and married women"; Hildegard of Bingen lamented the power Cathars had over women.[102] That women joined such groups and sometimes played prominent, openly visible

roles in them, seems well established, though historians are now less convinced than they once were that women supported the Cathar heresy more than men, and less confident about the motives that drew them to Catharism in the first place. Evidence for Cathar communities in thirteenth-century France and Italy indicates that although Cathar women — in stark contrast to orthodox women — originally occupied positions of leadership as preachers or teachers, their initial prominence was probably short-lived and abated as soon as the Cathars developed hierarchical organizations, where men eventually dominated. No woman ever became a Cathar "bishop," and fewer women than men attained the rank of the "perfect."[103] Thirteenth-century sources on Cathar belief in France also indicate features that precluded gender equality in worship and social life. They often include a scathing condemnation of women as vile bodies, with whom male *perfecti* should shun all contact. As far as we know, Cathar teachers did not make such statements until rather late in the history of the movement, but once they started to appear they did so frequently and formed an integral part of Cathar preaching. These ideas also obeyed a certain internal logic: since procreation necessarily resulted in trapping human spirits in evil matter, those who were capable of bearing children also bore the larger responsibility. According to late thirteenth-century Cathar thought, "pregnant women had the devil in their bellies," male *perfecti* administering the *consolamentum* to women were not permitted to touch them for fear of polluting themselves, and women were said to have no chance to enter heaven, "unless they became men."[104] Cathar belief thus appears to have pressed the long-standing association in western thought between women and matter toward its radical conclusion. As Eleanor McLaughlin put it most forcefully with regard to late thirteenth-century Cathar customs, "the cultic practice of the Cathars became even more androcentric than that of medieval Christianity."[105]

Yet the tenets of Cathar belief could also receive a wholly different interpretation that possibly dominated the early stages of the movement. According to this position, sexual difference lay only in the human body, created by an evil force, and those who were truly "pure" should therefore disregard it. This interpretation may have been strong in the twelfth-century, northern, Cathar communities, which seem to have shared with other heretical groups of northern Europe the practice of a communal, ascetic life in which gender distinctions had little significance, in accordance with apostolic prescriptions.[106] Even though the notion of gender equality in a social context was not explicitly stated, the emphasis these groups placed on asceticism, the rejection of material goods, and sexual purity, coupled with the evangelical ideal of the spiritual equality of men and women, may have created an intellectual atmosphere in which women and men

transcended their sex. Cathar communities of the twelfth century may thus have realized in their own way the syneisactic dream of Christian ascetics inspired by the contemporary apostolic movement.

While outsiders initially discussed women's chastity in both movements — the orthodox reformists and the heterodox Cathars — with respect and admiration, they grew more skeptical of it as the twelfth century drew to a close. As Dyan Elliott has pointed out, the spread of learned medical knowledge in the twelfth century reinforced the conviction that women had greater sexual urges and were less able to resist them than men did, a conviction that canonists and theologians did not hesitate to reiterate in their *summae*.[107] The repeated warnings against women's vulnerability eventually prompted pope Boniface VIII to impose strict enclosure as the norm for all nuns at the end of the thirteenth century.[108] Meanwhile, conservative churchmen and monastic reformers advocated measures to protect male religious from the proximity of women. The "syneisactic experiment" came under fire from various ecclesiastical authorities as early as the second quarter of the twelfth century. Writing around 1144, Bernard of Clairvaux, among many others, objected to the common life of men and women practiced by many in the apostolic movement because this lifestyle would breed *scandalum*.[109] All the religious orders that came to the fore in the twelfth century — the Premonstratensians, Arrouaisians, Cistercians, and so on — eventually abandoned the experiment and segregated male and female religious, or simply stopped admitting women.[110]

The doubts about women's chastity in religious movements that touted an informal lifestyle weighed naturally greater on those accused of heresy. Two examples, separated in time by about twenty years, illustrate how churchmen grew increasingly suspicious of women who claimed an asexual lifestyle in such groups, and in the end, equated female chastity outside the convent with Catharism. In 1163, the execution of five Cathars from the Low Countries just outside Cologne was made especially memorable (so memorable, in fact, that it was not only reported in contemporary chronicles but repeated in local histories as late as the sixteenth century) by the extraordinary behavior of a young girl among the condemned. The cleric who left a contemporary account of the events in the so-called *Chronica Regia Coloniensis* recorded that the Cathars were on their way to the pyre, "when the crowd took such pity on the young woman (*juvencula*) that she could have saved herself, if only she had heeded wiser counsel and, terrified by seeing how the others died, had come to her senses. Yet she suddenly escaped from their hands and threw herself on the fire and perished"; the chronicler did not present her as blinded by lust or seduced by evil, as women were wont to be, nor did he accuse her of promiscuity, a standard slur addressed to dissenting groups of mixed gender.[111] This would have been point-

less and possibly counterproductive: many contemporary sources stated that Cathars held virginity in high esteem and even demanded that married couples remain celibate.[112]

The second example shows how differently ecclesiastical observers perceived women's chastity twenty years later. It is taken from a story about the *Populicani* told by canon Gervase of Tilbury. In 1176–80, as a young cleric presumably in minor orders, Gervase spent some time in the entourage of Archbishop William of Rheims. While riding with the Archbishop's party one day in summer, Gervase spotted a young girl working alone in the vineyards outside the city. What happened afterward was recorded in the 1220s by the chronicler Radulf of Coggeshall, to whom Gervase reported the events:

Acting on the eagerness of hot-blooded youth, as I heard from Gervase after he had become a canon, he went over to her and, eyeing her beauty for a while, spoke gallantly to her of the delights of making love. She replied simply and gravely, without looking at him: "God would never wish me to be your lover nor could I be the lover of any man, because if I ever lost my virginity and my body were corrupted, I should without any doubt be condemned to eternal damnation." Upon those words, master Gervase realized at once that she belonged to the blasphemous sect of the *Publicani*.

The archbishop then had her brought in to be questioned about her beliefs, but the girl said she was too ignorant to respond to their objections and called on a "woman teacher (*magistra*) in the city of Rheims who would easily refute them." Indeed this older woman proved to be "very knowledgeable of the whole Scriptures and experienced at this kind of debate, mixing truth and falsehood, and mocking the true exposition according to our faith by her destructive intellect." In the end, the older woman escaped by a magical trick (she was lifted into the sky by a thread of wool that she unrolled from the window), which proved beyond doubt that she was a witch, while the young maiden subsequently suffered burning at the stake in silence, "like those martyrs of Christ whom pagans used to kill for their Christian religion, and died steadfast and gay, but for a wholly different reason."[113]

Gervase's account seems utterly fantastic, but it receives partial confirmation from a more reliable source. The Parisian master, Peter the Chanter, in his *Verbum Abbreviatum* (composed in 1191–92 and reworked into a shorter version by 1197–99), recalled that lay women "in Flanders" had been unjustly suspected and condemned of Catharism solely on the ground that they strongly guarded their chastity and resisted the efforts of clergymen to seduce them.[114] The suspicion stemmed from the Cathar condemnation of marriage and sexuality, which obliged the perfect to either shun members of the other sex completely or observe a form of chaste cohabitation with them. But it coincided with a grow-

ing belief on the part of clergymen that female chastity could be assured solely within the confines of the nunnery, and that any manifestation of it outside the monastic life was fraudulent or inspired by dishonest motives.

Gervase's story, despite its imperfections, vividly illustrates the mounting suspicion of such women. Their very presence among reformist and dissenting groups and their prominent, public role in advocating their ideals—so unlike their passivity in orthodox worship—was unsettling since it endangered male asceticism and undermined clerical leadership. It is, of course, unimportant to what extent Radulf—or rather Gervase—related a real, historical event, although it is not impossible that a young woman was convicted of the heresy of the *Populicani* in Rheims at this time.[115] What must interest us is the juxtaposition in this story of the two female faculties that appeared the most threatening to males in general, and to the clergy in particular: sexuality and the ability to teach, that is, to understand and interpret Scripture. The tension between clergy and lay women is personalized and quite dramatic. Rebuffed by the beautiful but illiterate maiden, Gervase could only seek retribution. After her arrest, another confrontation between the sexes followed, now opposing the archbishop's scholars and an old woman of the sect. She, too, eluded clerical mastery as she manipulated and interpreted scriptural knowledge with greater dexterity than they could. That either woman was able to withstand the assaults of the male—the first sexual, the second intellectual—could only be attributed to the demonic force that commanded the young girl and empowered the old hag. It manifested itself most clearly by the elder woman's magical escape by the most feminine device of all, a ball of yarn. But no clerical reader of Gervase's story would go away from it without realizing that women's chastity and their claims to teaching required official scrutiny.

## Lambert le Bègue

The remarkable case of one dissident cleric, Lambert le Bègue, who was active in Liège in the third quarter of the twelfth century, completes our picture of the religious aspirations of lay men and women in this age. It is particularly important to us because Lambert has long been regarded as the "founder" of the beguines. As will be made clear shortly, the idea is mistaken—the product of a legend construed in local ecclesiastical milieus around 1250 and revived by local historians at the end of the nineteenth century. Still, the evidence that can be gathered from contemporary sources about Lambert and his followers greatly contributes to our understanding of the early beguine movement because it directs us to the workings of reformist and dissident lay communities in the Liège area shortly

before beguines appeared on the scene. It further confirms that ecclesiastical authorities, by 1175, came to distrust any attempt by lay men and women to appropriate a "religious" lifestyle outside the monastery and to interpret Scripture without the formal guidance of a cleric.

Lambert, who came from a modest Liégeois family, was ordained a priest some time before 1164.[116] From his earliest days as pastor of a small church in Liège, probably St. Martin-en-Ile, he caused trouble. Because he refused to pay an increase in the annual tribute for his church to his superiors, the collegiate chapter of St. Paul, they reassigned him to a lesser church on the outskirts of the city, undoubtedly the chapel of St. Christophe.[117] During a local church synod held on 13 March 1166,[118] he spoke up without being invited and launched a fierce diatribe against simony, much to the distress of the higher clergy, including the bishop. In the following years, his continuous jibes at the wicked lives of priests in Liège earned him the scorn of many clerics but also a certain following outside the city. In the early 1170s, he was preaching in Huy against excessive payments for the administration of baptism and other sacraments by the local clergy, when certain members of a monastery of regular canons (Neufmoustier, it has been suggested)[119] mounted a campaign to accuse him of heresy. They claimed that he denied the presence of Christ's body during the Eucharist, that confession and baptism were not necessary for salvation, and water and wine were not needed in the celebration of mass, obviously in an effort to implicate him with Cathars and other dissenters of the age. After being cited before a local Church council entirely hostile to his views, shortly before 1175, he was arrested for heresy by the bishop's authorities; the higher clergy of Liège also stripped of their benefices five parish priests who sympathized with him. At this point the *Antigraphum Petri* ("Peter's Defense"), a polemical treatise denouncing the laxity of the priests in Liège, was sent to pope Calixtus III for an evaluation of its orthodoxy, either because Lambert had been its author, or because he and his followers found in it justification for his teaching. Lambert appealed to Calixtus from prison, while certain Liégeois priests wrote two letters to the pope in his support. Before any further steps were taken in his trial, Lambert escaped from prison and traveled to Calixtus's court outside Rome to plead his innocence. There he composed his major defense, an uneven, but often brilliant, *apologia*, again addressed to Calixtus, in which he recounted his adventures and refuted the allegations made against him. He died shortly afterward, probably in 1177.[120]

In his defense, Lambert recalled that while working at St. Christophe, he always tried to reach out "to everyone who came into contact with me, whether they observed me, questioned me, or heard me preach, in order to extirpate from their hearts the vices of modern times and plant in them the seeds of virtue."[121] He apparently succeeded in doing so since his opponents derided him for draw-

ing his support largely from the ranks of weavers, tanners, in short, of manual
laborers, and for failing to have "preached to the elite." Lambert did not hide the
fact that his father was a mere carpenter, but found in it a ready basis for draw-
ing in his defense several parallels between him and Christ himself—always a
dangerous strategy of course, but Lambert used it sparingly and effectively. Ac-
cused of encouraging neglect of Sunday rest among the working population, he
argued that he himself was only to blame: he had been working on his home one
Sunday when loyal parishioners decided to help him. And why should they not,
he said, rather than to squander their rest by drinking, gambling, and cavorting
with lewd women? Some honest labor on Sunday could not be a sin in itself, but
resting on Sunday to misbehave so badly certainly was.

From these and other arguments in Lambert's known writings, we might
just conclude that his teaching was essentially "puritan."[122] He tried to instill in
his flock a sense of moral discipline and rejected meaningless ritual in accor-
dance with the vanguard of twelfth-century spirituality, which insisted on purity
of intention rather than adherence to formal rules. But like so many other apos-
tolic preachers before him, Lambert reserved his most powerful critique for the
clergy, not the laity. It was the clergy, he said, who indulged in excessive luxu-
ries by wearing "clothes dyed in bright colors" or extravagantly trimmed; who
greedily performed multiple baptisms and demanded money for other liturgi-
cal services in certain villages (where ordinary people presumably could not
afford them); who even incorporated magical practices in the celebration of
mass.[123] His main goals were to mend the ways of the clergy, to redress their au-
thority among the laity (hence his injunctions against simony), and to help them
spread the gospel to the burgeoning middle and lower classes, long neglected by
the established Church. Like many reformists in this age, he explicitly invoked
Christ's example, and at least one of his supporters also referred to the "original
Church" (*primordia nascentis Ecclesie*), unjustly persecuted, to describe Lam-
bert's struggles.[124] Judged by his surviving writings, the sources of his teaching
were perfectly orthodox. They are largely found in the Bible (both the Old and
the New Testaments) and in Augustine; the latter seems in fact the most likely au-
thority from which Lambert derived his praise of field labor on Sunday because
it kept people from obscene dances and drinking parties.[125]

Like Tanchelm or Ramihrd before him, Lambert's success among the laity
contrasted sharply with the opposition he met from the higher clergy. A series
of discrete causes may be invoked to account for Lambert's downfall at Liège.
His preaching contained little to please his superiors and much to upset them,
including frequent and direct criticism of local ecclesiastical practices, which
must have appeared particularly threatening to the Church of Liège, one of the
most conservative dioceses of the Low Countries and long a stronghold of the

Imperial Church.[126] Emboldened by his personal charisma, Lambert bypassed established systems of authority, as when he spontaneously preached a sermon at a local synod without being authorized to do so by the bishop and the cathedral clergy. Concern about the spread of the Cathar heresy in Cologne, Rheims, and Flanders—to name but the known centers—made any critique of established practice suspicious, even when it could not be connected with the feared heresies. Taken separately, none of these factors seems to explain the extreme sanctions imposed by the Liège clergy; taken together, they possibly do.

What might have made Lambert's case special, moreover, were two charges against him that he disputed at length in his final letter to Calixtus. First, his opponents argued that Lambert's "sectarians" (*sectatores*, a pejorative term) did not go to church and did not take communion. The accusation was a serious one, not only because it implied that they failed in a most basic Christian obligation, but also because of its connotations of heresy, a suspicion the term "sectarians" was intended to enforce. Clearly, the canons of St. Paul were informed that alert parishioners had unmasked "Flemish" Cathars at Cologne because they failed to appear in Church in 1163; they must also have known that Cathars preached against the salvific function of the Eucharist.[127] Lambert's reply to the accusation, in his *Apologia*, is remarkable. It seems confused, at first. He denied ever having wished to attract "followers," and said that he did not know if he had any; if he did, he could not vouch for the conduct of these people at the time of writing his letter, since he left Liège quite some time before. Instead, he argued that the notion of creating a following did not apply. With reference to the apostolic injunctions "Woe is unto me if I preach not the gospel"(1 Cor. 9:16) and "As every human hath received grace, ministering the same one to another; as good stewards of the manifold grace of God" (1 Pet. 4:10), he submitted to the pope this philosophy of pastoral care:[128] "I never asked anybody to follow me, but rather to follow Him who died and rose again for them. I do not deny that there have been a few clerics and many lay folk, who have seen my humble dress, moderation in food, contempt for glory and riches, and attention to the purity and care of the divine cult, and thus—'I speak as one less wise' (2 Cor. 11:23)—applied themselves to Christ through me and became followers of His law . . . but they were only 'pursuers of good works' (Titus 2:14)."

Without actually affirming the priesthood of all Christians, Lambert defended his teaching by asserting the right and duty of each Christian to exhort others by good example, again with reference to apostolic writings that celebrated the spiritual union of all Christians with Christ himself.[129] We will see below how influential this idea was among proponents of the beguine movement in the early thirteenth century. Note the peculiarity of his defense: rather than standing on his prerogative as a priest to preach by the special grace of his voca-

tion, he lowered the barriers that separated him from the laity. In his view, the priest was only a *primus inter pares* whose role it was to enhance the didactic and moral capacities of each individual: priests and laity worked together in close cooperation.[130]

Lambert obviously hoped to shift the subject of controversy from his responsibility as the alleged leader of dissenters to his actual conduct as a Christian, which, everyone agreed, was above suspicion. But his defense seemed to confirm the second accusation that he deliberately blurred the distinctions between clergy and laity by "opening the scriptures to the unworthy." This charge, too, would be taken very seriously in twelfth-century Europe, where vernacular renditions of sacred texts were eyed with increasing anxiety, precisely because the Church recognized their potential use by dissenters.[131] Lambert's response is worth quoting in full, since it includes a description of the religious practices he found and encouraged among his flock. Speaking of those who admired him and tried to follow the example of Christ under his guidance, he wrote:

I saw how assiduously and frequently they came to church, how they prayed with greater piety than I did, how honorably and respectfully they conducted themselves, eager to hear the word of God and to practice it as well as they could, compassionate when the Lord's flesh and blood were sacrificed on the altar, as if the universal God again suffered the passion, with sobs and sighs, so that sometimes, when I stood at the altar with a stony heart, it melted as soon as I felt so much love and devotion. What shall I say about the contrition of heart, the copious tears, the respect and fear with which they so often received the body and blood of Christ, approaching without the clamor and jostling that is so common? There they strode forward like a well ordered phalanx—a gratifying sight for the righteous, a terrible one for those who are evil. When I witnessed such discipline and piety, I could only fear that although I might have been their superior in rank, I was their inferior in virtue, and I wished (but I did not act) to be like them, saying "Let my soul die the death of the just, and my last end be like theirs" (Numbers 23: 10). When they returned to their home, they ate soberly and piously; they would spent the rest of the holy days, until vespers, singing psalms, hymns, and religious chants, reflecting upon what they heard in church and urging one another to practice it. Wishing to assist them in their good work, I translated for virgins the Life and Passion of St. Agnes, the virgin martyr of Christ, from Latin into the vernacular, and for all of my followers I likewise translated the Acts of the Apostles, which I have set to verse and interspersed with many exhortations at the right places, so that on holy days, when the world indulges in evil things, they would have the means to eschew its venomous honey. This is why my opponents accused me of opening the Holy Scriptures to the unworthy, forgetting that the Lord said "The kingdom of God shall be given to people yielding its fruits," (Cf. Matt. 21: 43) or that he handed the bread, which the boy brought but did not eat, "to his disciples to be distributed among the people" (Luke 9:16). Furthermore, my opponents own a copy of the book of Psalms with glosses and corroborating citations, translated by a Flemish master. Why is there no uproar about that? Why do they not bring charges

against him? Perhaps it is because no one is "a prophet in his own country" (Luke 4:24), and this master is a foreigner.[132]

Lambert thus reminded the pope that his translations were part of a larger effort to stimulate religious reflection on holy days, and that the true value of his clerical office paled to nothing in comparison with the piety of ordinary lay folk he had encountered. All his priestly office had to offer, in his view (backed by Old Testament sources as well as by the example of Christ), was a mediating function, which he wished to fulfill not only as a liturgical celebrant, as was customary, but also by transmitting knowledge that the clergy left unexploited and these simple folk could bring to fruit. As for the business of translating sacred texts in the vernacular, other clerics had done so too, he argued, without meeting much opposition. We do not know to which "Flemish master" he referred, nor whether that master's work was a translation of the Psalms in Dutch or French, although the latter is more likely since the book circulated in the city of Liège, where French was the native language.[133] Scholarly translations of the Bible (or parts thereof) in the vernacular were not unknown in monastic and cathedral school milieus of the time. There, they were regarded as scholarly texts, providing members of the clergy with vernacular glosses and other citations of the Psalms for use in sermons to the laity.[134] Lambert's description of the Psalms translation rules out the possibility that it was a "psalter," that is, a manuscript for the use of lay folk with the Latin Psalms divided in seven parts and other texts (often in the vernacular) for individual reading during mass, like the devotional manuscripts that became popular in the thirteenth century.[135] Besides, Lambert's testimony proves that the translation of the Psalms by the Flemish master circulated among the higher clergy of Liège rather than with the laity of his parish.[136] For that same reason, his argument may not have come across as forcefully as he wished, since his own translation work could hardly appeal to a similar, scholarly goal for the benefit of the clergy. Yet in his ecclesiological perspective, which tended to deny the superiority of clergy over laity, his point was valid enough: why would translating the Bible in the vernacular be legitimate for clerics, but not for the laity, if the latter lived more virtuously and by contemplating it in the vernacular would put it to better use?

Weak though it may seem in parts, Lambert's defense on the whole effectively undermined all attempts to accuse him of Cathar sympathies. His account featured parishioners who went to church regularly and took communion in large numbers, thus removing the suspicion that they might be influenced by Cathar thought on the body of Christ. It presented a formidable portrait of his flock, united in good works and together deeply responsive to the Eucharist,

like "a well-ordered phalanx." Beginning in the twelfth century, theologians and church leaders pressed upon Christians the need to not only receive the Eucharist at set times but also to prepare for it by penance, good works, and proper demeanor. No pope could have been indifferent to the pleasing spectacle of a congregation so eager to receive the sacrament, yet so well suited to do so.[137] Without in the least compromising the standards he set out for himself, Lambert responded to the attacks with an account of life in a model parish according to the ideals of the *vita apostolica*, an account with which no post-Gregorian pope could find fault.

Neither Lambert nor his opponents suggested that he directed his preaching more to women than to men; if the discrepancy had been prominent, his enemies would surely have publicized it.[138] The belief that he "established" the beguines, first propagated in the mid-thirteenth century and resuscitated in the modern age, is not based on any contemporary evidence and should be excluded categorically. This would undoubtedly have been brought against him in the course of his trial, and there is no evidence that beguines lived in the city of Liège until the early thirteenth century, two or three decades after Lambert's death.[139]

The documents in Lambert's trial leave no doubt, however, that lay men and women in touch with him were greatly interested in studying the Scriptures. The Acts of the Apostles, which he admitted translating for the use of his parishioners, held special significance for reformers in the eleventh and twelfth centuries because they embodied their ideal for the new Church.[140] Lambert's letter, quoted above, clearly proves that some of his parishioners were not only able to read, but also used such books for study in their home; his translation of the Acts in the vernacular, "interspersed with many exhortations at the right places," served exactly that purpose. These people were not fully literate—how could they have been?—in the sense given to that term in the twelfth century, that is, able to understand Latin and communicate within the wider frame of ecclesiastical culture based on such Latin texts. Since Lambert made an effort to translate the Acts in verse form, which facilitated recitation and memorization, he may have intended the translation to be read aloud and committed to memory by those who could not read the vernacular, although the purpose of versification may only have been to reduce the number of manuscript copies needed. Whatever the exact goal of these texts, reading religious tracts was obviously a social experience. Lambert's testimony proves that about 1177, lay men and women of Liège formed communities of readers[141] who with his help acquired instruments to reevaluate the basis of Christian religion, and to practice it without much regard for current ecclesiastical legislation.

Lambert and his followers bear a striking resemblance to the first Waldensians of the Lyons region, who commissioned translations into the vernacular of

the New Testament and a few other authoritative texts of the Christian tradition at about the same time, in 1176–79. Their engagement with those translations brought them into conflict with ecclesiastical authorities, a conflict that escalated in the following decades and drove a large number of them into a lasting underground existence as an alternative Church.[142] At the Third Lateran Council of 1179, the Waldensians received approval of their vow of poverty but did not gain the right to preach. In fact, the council launched the first concerted attack on heresy in the West and could be said to have prepared the even more general measures against heretics issued by the Fourth Lateran Council of 1215.[143] Similarly, Lambert's partisans among the clergy were banned from Liège, others (presumably his lay adherents) were "driven to perjury, or imprisoned, or violently expelled, and all the others except for the more powerful and those who went underground, were persecuted and exposed to insults."[144] In 1203 papal legate and cardinal Guido of Palestrina ordered that in the diocese of Liège, all books on the Scriptures in Dutch or French vernacular be handed over to the bishop of Liège and reviewed, which suggests that translations like Lambert's were still perceived as a threat.[145] Almost thirty years later, in 1230–31, provincial councils in Rheims and Trier again forbade the circulation of vernacular translations of the Scriptures. The Rheims council convicted a local baker, Echard, for his heretical views, presumably because he had used or promoted such translations.[146]

Moreover, even though an important chronological gap exists between the end of Lambert's activity in Liège and the first appearance of beguines there, life in his community bore several similarities to that of thirteenth-century beguines. Intense concentration on the Eucharist, small group gatherings to discuss Scripture, an interest in devotional reading, all of these would be quite common in the early beguine communities and characterized their life well into the fourteenth century. And although Lambert cannot possibly be regarded as an organizer of beguine life, he appears to have been sensitive to the intellectual and devotional needs of his female parishioners. It was for them, he said, that he had translated the Life of Agnes, who was revered for her virgin martyrdom in devout circles of thirteenth-century Liège, including beguines, as we learn from the *Vita Odiliae* (written in 1241–47) and Thomas of Cantimpré's *Vita Lutgardis* (in its final version completed shortly after 1262).[147] At least one beguinage of the diocese of Liège, that of Sint-Truiden, founded in 1258, venerated St. Agnes as its patron saint.[148]

Oral tradition must have kept Lambert's teaching alive, especially in his own parish of St. Christophe. Perhaps some of his clerical followers, initially banished, returned to Liège when Calixtus III reversed his conviction in 1177. After all, someone favorable to his cause copied the entire file used in his de-

fense, including the *Antigraphum Petri*, around 1200.[149] By the 1240s, when several churchmen at Liège promoted the new spiritual trends, the author of the *Vita Odiliae* cherished "Lambert of St. Christophe" as a valiant preacher of reform in the city, who translated the Acts of the Apostles into French, but he did not associate Lambert with the rise of female devotion in Liège, even though he had a great interest in it.[150] The first to do so was Giles of Orval, a Cistercian historian, who about 1250 wrote a *History of the Bishops of Liège*, in which he celebrated (with the *Vita Odiliae* in mind) Lambert as a heroic voice for reform in twelfth-century Liège, when simony had crippled its church; he added that in the French vernacular, Lambert was nicknamed *li beges*, because he was *balbus*, that is, a stammerer, and that the women and girls who "now lead a life of chastity and are called *beguines* in French, derive their name from him."[151] According to Giles, he had been the first preacher to guide these women toward chastity by his personal example at a time when many clerics lived openly with spouses. Lambert's star rose even higher in the following decades, when other Church historians of Liège, following Giles's lead, elevated him from an obscure cleric to an inspired *magister*, "an ardent preacher of a new form of religious life that flourished in Liège and its environs," to quote Albéric of Troisfontaines, another Cistercian chronicler. Further embellishing the legend, Albéric affirmed that Lambert "wrote a book called the *Antigraphum*, designed an Easter Table, and made translations from Latin into French of many books, primarily of saints' lives and of the Acts of the Apostles."[152] At this time, members of Liège's main beguine community at St. Christophe also were taught to honor Lambert as their "founder", who deserved special prayers. In a psalter made around 1255–65 for a beguine of St. Christophe in Liège, on the reverse side of a page displaying a table to compute the date of Easter, there is a portrait of a haloed man, in priest's clothes, holding a banderole with this inscription in Middle French: "I am Lambert, do not think it is a fable, who founded Saint Christophe, and inscribed this table." The caption calls him "lord Lambert," and an inscription above the drawing says: "This honorable man created the beguine status, and he also translated into our language the Letters of Paul"[153] (fig. 1).

The name *beguina* has nothing to do with Lambert, as we will see later. Lambert did not found the beguine movement, nor did he translate the letters of St. Paul. Even the lesser assertion (backed by Albéric's chronicle), that Lambert devised or designed the type of Easter table displayed in the manuscript, is probably not true.[154] Its claims to authenticity notwithstanding ("this is not a fable"), Lambert's portrait in the beguine's manuscript thus contained more than its share of misleading information. It does not require much imagination to understand how, from the mid-thirteenth century onward, clerical authors rationalized and "institutionalized" the growing beguine movement in Liège by

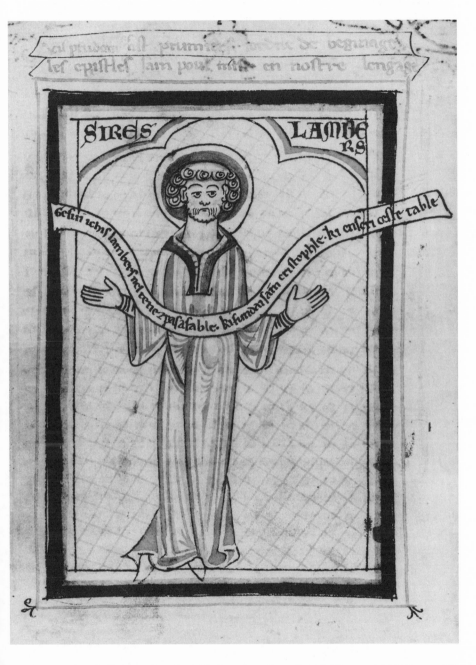

Figure 1. Lambert le Bègue as founder of the beguines. From British Library, Add. MS 21114, fol. 7v, about 1255–65. By permission of the British Library.

assigning it a male clerical founder. They inflated Lambert's reputation to extraordinary proportions. By the late fourteenth century, local historical imagination had turned Lambert into a grand preacher, a wealthy man who had showered the larger Liège community with his spiritual and material riches, and from that time on, Liège venerated him as a local saint, a pious reformer, but above all as the founder of a "new religious order," the beguines, named after himself. This image exerted such an appeal on local medieval and modern historians that they continued to weave an imaginary story of power and influence around Lambert until well into the twentieth century.[155]

Stripped of such fabrications and distortions, Lambert's story offers a startling portrait of a vigorous and ambitious lay religiosity, stradling the border of orthodoxy and heresy, from which the beguine movement was born. His story also confirms that around 1175, new religious currents, inspired by reformist preachers of the *vita apostolica* or by those instructed in the newer dualist beliefs associated with Catharism, publicly challenged the status quo. Lay women took part in the discussion on either side, and their potential for and against orthodoxy must have been evident to all. As Lambert's trial dossier reveals, lay men and women now also had at their disposal written materials in the vernacular to guide them, and on occasion, clerics to defend them.

# 2. The Formation of Beguinages

Around 1200, lay women of the southern Low Countries began to lead a new kind of religious life that became popular rapidly. Its success drew the attention of many contemporary observers. James of Vitry, the famous preacher, moralist, and cardinal (d. 1240), who worked hard to publicize the women's efforts, noted in his *Life of Mary of Oignies* that by 1212, "many holy maidens (*sanctae virgines*) had gathered in different places [of the diocese of Liège] . . . ; they scorned the temptations of the flesh, despised the riches of the world for the love of the heavenly bridegroom in poverty and humility, earning a sparse meal with their own hands. Although their families were wealthy, they preferred to endure hardship and poverty, leaving behind their family and their father's home rather than to abound in riches or to remain in danger amidst worldly pomp."[1] A few years later, between 1225 and 1228, Caesarius of Heisterbach, a Cistercian monk living in the region of Cologne and well informed about goings-on in the Low Countries, affirmed that "Although those [holy] women, whom we know to be very numerous in the diocese of Liège, live among the people wearing lay clothes, they still surpass many of the cloister in the love of God. They live the eremitical life among the crowds, spiritual among the worldly and virginal among those who seek pleasure. As their battle is greater, so is their grace, and a greater crown will await them."[2]

The fame of these lay women, soon to be called "beguines," reached even England. Some time between 1229 and 1235, master Robert Grosseteste (d. 1253) preached a sermon to the Franciscans of Oxford on the value of religious poverty. After the sermon, he admitted privately to one of the friars that, although the Franciscans were highly placed on the ladder of poverty because they lived from begging, there was an even higher rung, closer to celestial perfection, reached by those who lived by the work of their own hands. The beguines now occupy that exalted place, he said, "because they earn their living with their own hands and do not make burdensome demands on the world."[3]

The movement originally presented itself in a variety of forms. Some of these women lived as recluses, others worked as helpers in hospitals and leprosaria. For a few women, a life of penance outside nunneries was transitory, a

station on the way to the more traditional monastic vocation; others left it to get married or for other reasons; still others, increasingly more numerous, practiced the lifestyle for a longer time, often until their death. Contemporary observers were consequently hard pressed to define their way of life and to give them a name. Churchmen sympathetic to the movement called them "religious women" (*mulieres religiosae; religiosae feminae*; i.e., women who led a religious or ascetic life), "holy maidens" or "holy women" (*sanctae virgines* or *mulieres sanctae*), "chaste virgins" (*virgines continentes*) or similar names.[4] Critics "maliciously slandered the ascetic life of these women," wrote James of Vitry, "and when there was nothing more they could do, they made up new names to use against them, just as the Jews called Christ a Samaritan (John 8:48) and called Christians Galileans (Acts 2:7)."[5] One of the terms of derision, "beguines," attested in sources from about 1219–24 on, eventually prevailed in written and spoken discourse and took on a more respectable meaning, but it never entirely lost its pejorative connotations.[6]

In a first period, dating from about 1190 until 1230, beguines gathered informally in loose communities without institutional attachments. This changed around 1230, when beguine groups began to acquire property, adopted sets of regulations to govern their life as a community, and presented themselves to the outside world as religious institutions, either in the form of small "convents," or as larger architectural complexes segregated in some manner from the surrounding urban community, the so-called court beguinages.[7] The two forms of beguine institutions emerged simultaneously and responded to different needs and goals.

## Informal Communities

Despite the claims of various early modern and modern mythologies, the beguine movement was not the creation of a single individual, male or female. Indeed, the earliest manifestations of the movement are unusual and fascinating precisely because communities of like-minded women seeking a novel way of life, pursuing similar goals and connected by various individuals who moved between them, sprang up in different places in the southern Low Countries within a relatively short time. These beguines included women who worked as caretakers and nurses, who pursued contemplative callings, either alone or in groups, or who did all of the above at various times in their life. As we shall see, the histories of some of these women demonstrate a unique willingness to experiment in a restless search for new experiences. This quest often involved significant breaks with social and family relationships, more so than would be the case in

the later stages of the beguine movement: some of these women left parents, husbands, children, repeatedly changed residence from one town to another, or even lived as vagrants. The communities they created were informal, largely nonhierarchical, and, understandably, did not survive for very long. Of the almost threehundred beguinages that existed in the southern Low Countries from the thirteenth century on, very few could reliably trace their foundation to the activities of the first beguines.

The historical sources for these early communities are scarce. Our largest body of information comes from eleven *vitae* of individual women involved with the movement between 1190 and 1250. These *vitae* were frequently written shortly after the death of these women by a male ecclesiastic in order to promote their cult, but none of the women was ever canonized.[8] Scholars sometimes refer to the histories as "beguine *vitae*," which is misleading, since most of these women were beguines only for a short while before their conversion to a traditional monastic life and ended their lives as nuns, following a rule in a monastic setting. Yet the stories contain many references to individual beguines or to beguine communities that played a formative role in the religious vocation of the saintly heroine. These women are: Mary of Oignies (d. 1213), Odilia of Liège (d. 1220), Juetta of Huy (d. 1228), Christina Mirabilis (or of Sint-Truiden, d. 1228), Ida of Nivelles (d. 1231), Ida of Louvain (d. after 1231), Margaret of Ypres (d. 1234), Lutgard of Tongeren (or Aywières, d. 1246), Juliana of Mont-Cornillon (d. 1259), Beatrice of Nazareth (d. 1268), and Ida of Gorsleeuw (d. after 1262).[9]

Some of the *vitae* illuminate beguine life more than others. Many writers of these stories characterized it as stepping stone toward monastic perfection, worthy only of a few words, and had little personal experience with beguine communities. The Premonstratensian Hugh of Floreffe, who wrote the *Life of Juetta of Huy*, and the anonymous Cistercians who compiled the *vitae* of Beatrice of Nazareth, Ida of Gorsleeuw, and Ida of Louvain, were deeply involved with individual "religious women" but appear to have known little about the early beguine communities in which the women dwelled before converting to the monastic life.[10] The Cistercian Goswin of Bossut, the presumed author of the *Life of Ida of Nivelles*, wrote from a better vantage point: he resided at the abbey of Villers in Brabant, an abbey that since the early thirteenth century had entertained relationships with prominent beguines. Yet like his fellow Cistercians he chose to emphasize the monastic career of his subject rather than Ida's brief spell as a beguine. A particular agenda often imposed its own dynamics on these *vitae*: for Hugh of Floreffe and the anonymous canon of St. Martin of Liège who wrote the life of Juliana, the story of the saints' struggles served to legitimize or defend their churches' control of the hospitals where Juetta and Juliana worked against claims made by other ecclesiastical or civil authorities. Hugh's account

of Juetta's life helped to enforce Floreffe's command of her leprosarium, while the *vita* of Juliana established Mont-Cornillon as a religious institution under the benevolent tutelage of St. Martin of Liège, and denounced as ignorant vandals the citizens of Liège who sought control of it. More importantly, the Life of Juliana was written to promote the highly successful feast of Corpus Christi that she established with the help of his fellow canons of St. Martin; naturally, the life dwelled extensively on the indifference or even hostility toward the new feast displayed by the less enlightened clergy.[11] The *Vita Odiliae* written by an anonymous canon of St. Lambert of Liège was obviously intended as an indictment of the Liégeois clergy and a patriotic lament on the fate of the diocese.[12] Laying out the principles and practices of beguine life was not a priority for these men.

James of Vitry and Thomas of Cantimpré, on the other hand, the authors of the *Lives* of Mary of Oignies, Lutgard of Tongeren, Christina Mirabilis, and Margaret of Ypres, wrote of their own, often deeply moving discussions with beguines. As itinerant preachers and confessors[13] less tied to the cloister than Cistercian monks or Premonstratensian canons, they had many more opportunities to meet with the informal groups of "religious women." Their impressions of the early beguines are thus based on a larger experience and reveal a greater sensitivity to the realities of their semireligious life, which they tended to view, moreover, as praiseworthy in its own right.

A native of Champagne, James of Vitry was a student at Paris when he heard of Mary of Oignies; after a visit to her some time before 1210, he joined the priory of regular canons at Oignies in the region of Namur to be closer to her. He developed an intense admiration for her—indeed, a religious devotion— that continued after her death in 1213. As his introduction to the *Vita Mariae Oigniacensis*, cited at the beginning of this chapter, demonstrates, James knew first hand that Mary of Oignies was but one of many *mulieres religiosae* in the diocese, and that a great variety of beguine communities populated its religious landscape. James's personal experience with the Low Country beguines was limited in the sense that he toured the dioceses of Liège and Cologne extensively but not, as far we know, the western regions of Flanders and Hainaut. He also spent many years abroad. From 1216 until 1226 he served as bishop of Acre in the Holy Land. He then briefly returned to the diocese of Liège as an auxiliary bishop but in 1229 was ordained cardinal-bishop of Tusculum and moved to Rome, where he became a member of the Roman curia. Until his death in 1240, he was kept abreast of what happened to the *mulieres religiosae* only through correspondence with friends.[14]

Thomas of Cantimpré, a generation younger than James, surpassed his master by his continuous and diversified contact with the early beguines. Born in Bellingen, south of Brussels, around 1200, he was trained at the cathedral school

of Cambrai between 1205 and 1216. Toward the end of his schooling, he heard James of Vitry preach and for the rest of his life he regarded James as his model. Like James, he became a regular canon: in 1216–17, he joined the monastery of Cantimpré near Cambrai, which maintained close relations with James's house at Oignies.[15] He worked loyally to complete James's work, though not without criticizing him when he felt let down by James's preoccupation with curial endeavors after 1229.[16] In 1232, he transferred to the Dominican order, which had just started its expansion in the Low Countries. Except for a stay at Paris between 1237 and 1242 and a journey to Trier and Cologne in 1256, Thomas lived at the Dominican convent of Louvain until his death around 1272. Throughout his career as a Dominican friar and author, and perhaps already while affiliated with the canons of Cantimpré, Thomas traversed the Low Countries from east to west to preach and hear confession, much as James had covered northern and southern France preaching the Albigensian crusade. As a native Dutch-speaker trained in French-speaking cities, Thomas was probably bilingual (which James was not) and thus able to preach in the vernacular to people on both sides of the linguistic border. His hagiographical work demonstrates his wide range of activity among the *mulieres religiosae*: in addition to the *Life of John of Cantimpré*, an esteemed abbot at the monastery of Cantimpré (written about 1223, but revised in 1224–28 and again shortly before his death), he wrote a *Supplement to the Life of Mary of Oignies*, set in Walloon Brabant and the western part of the diocese of Liège (written in 1229–32), the *Life of Christina Mirabilis*, who lived in the region of Sint-Truiden (started around 1232 and revised until 1239–40), the *Life of Margaret of Ypres* in Flanders (written in 1243), and the *Life of Lutgard of Tongeren* (started before 1248 but reworked until 1262).[17]

Teasing out bits and pieces of information from these and other sources, we can reconstruct the preinstitutional phase of the beguine movement, which largely took place in four main centers of beguine activity. A first group of beguines was located near Huy in the diocese of Liège, where around 1181 Juetta, a twenty-three-year-old widow, left her home and children to serve a community of lepers (later known as the hospital of Grands Malades) outside the town walls. For ten years, she actively ministered to the lepers, joined by women and men who followed her example. She then resigned from her duties and chose to be immured as an anchoress in a cell beside the lepers' chapel, where she lived another thirty-six years. Her biographer Hugh, a member of the Premonstratensian abbey at Floreffe (which held spiritual rights over the leprosarium), had little to say about the early community that formed around Juetta between 1181 and 1191, preoccupied as he was with delineating the spiritual growth of the individual "saint" from a married woman of the world to a recluse graced with visions. Still, among the *familiares*, as he called this irregular group, women obvi-

ously dominated, and at least three of them followed Juetta to be immured at the same church.[18]

About a decade later, around 1191, Mary, a girl of Nivelles who had been married at the age of fourteen, persuaded her husband to live in continence shortly after their wedding. They abandoned their home in Nivelles to serve lepers in nearby Willambroux for many years. She too became a recluse after leaving Willambroux around 1207 for the monastery of Augustinian canons regular of St. Nicolas at Oignies, some fifteen miles southeast of Nivelles, where she lived close to the priory's church until her death at the age of thirty-six in 1213.[19] Around 1210 her future biographer James of Vitry came to Oignies to be with her; other members of the clergy likewise sought her advice.[20] But few men other than her husband were members of the lay community that served the lepers with her at Willambroux. Several scenes of the *vita* show that lay women were her close confidants and formed an inner circle of daily companions.[21] After her move to Oignies, women followed her to live as *mulieres religiosae* in a loose association that continued after Mary's death in 1213.[22] Writing in 1229–32, Thomas of Cantimpré noted that James of Vitry, after his stay in the Holy Land, returned to Oignies to dwell "among flocks of beguines"(*inter oves beghinarum*)[23] in 1226–29, and in a will of 1239, a local priest bequeathed a small gift to "the beguines of Oignies."[24]

The towns of Nivelles and Oignies thus form the second center of early beguine life. This is confirmed by the *Life of Ida of Nivelles*, who died as a Cistercian nun at La Ramée in 1231.[25] It shows that in 1208 or 1209—shortly after Mary left Willambroux—another beguine community had formed close to the church of St. Sépulchre at Nivelles. The *Life* relates how Ida ran away from home at the age of nine because her family had decided to give her in marriage to the son of a Nivelles townsman. "Taking nothing with her but the psalter which she had just started to memorize," the *Life* notes, "she slipped out at night through the window of her father's house" and sought shelter with a group of "[seven] poor virgins who dwelled next to the church of St. Sépulchre, 'in the aid of the Lord, and secured by the protection of the God of Heaven' (Psalms 90, 1)" living without possessions and begging through the streets of Nivelles for food and clothing.[26] These beguines gave her religious instruction and supported her until 1215, when the sixteen-year-old Ida was admitted to the monastery of Cistercian nuns at Kerkom. After moving with the nuns to a new location at La Ramée, Ida gained a reputation as an ecstatic, solicited for advice by outsiders. The largest part of the *vita* is devoted to her devotions and trance experiences at La Ramée, but the author, most probably Goswin of Bossut, a Cistercian of the monastery of Villers, also interviewed some of her former beguine companions and other women of Nivelles, with whom Ida kept in touch after having taken the veil as

a Cistercian nun.[27] The beguine community at St. Sépulchre grew very fast in the decades following Ida's stay, perhaps due to the presence of a hospital, attested since 1204.[28] This must be the beguine group that Caesarius of Heisterbach had in mind in 1219–24, when he set an *exemplum* about Ida among "certain religious women of the Nivelles area," whom she had joined after leaving her father's home and kin.[29] The beguines are mentioned in local documents from 1239 onward.[30]

We have less information on the third center of beguine life in this early period, the city of Liège, and it is difficult to interpret what little there is. In his *Life of Mary of Oignies*, James of Vitry noted that Mary and her clerical admirers were horrified that Liège was sacked in May 1212 by the troops of duke Henry I of Brabant, as they feared for the many women there who had vowed themselves to virginity. John of Nivelle, a canon of St. John's church at Liège, who was visiting Mary of Oignies at that time, "was cast down in mind and grieved in particular without solace for those holy virgins [of Liège] whom he had acquired for the Lord by his preaching and example, for he feared, following the deceitful reports of certain men, that they had succumbed to the violence of the attackers, although he doubted it with fatherly concern."[31] Although James did not say so, it is clear that these "holy virgins" were not cloistered. He reassured his readers that the women had not come to harm, or more precisely, had chosen death before defilement, yet been miraculously saved: "When Liège was destroyed, they truly clung to the Lord: those who could not flee to the churches threw themselves into the river and chose to die rather than to have their chastity violated. Some jumped into sewers filled with dung and preferred to be perish in stink rather than to be robbed of their virginity. Nevertheless, the merciful Bridegroom took such care of His brides that not one of all those virgins could be found whose body had died, or whose chastity had been breached."[32]

As a major figure in the ecclesiastical milieux of Liège until he retired to the monastery of Oignies some time between 1215 and 1219, John of Nivelle's influence on early beguines in the city of Liège may have been considerable. Nevertheless the hypothesis that he founded the very first beguinage in Liège, advanced at the beginning of this century,[33] cannot be substantiated. James of Vitry called him "the light, teacher, and spiritual father of the entire diocese,"[34] celebrating his charisma and preaching powers, as did his near contemporaries Thomas of Cantimpré and Goswin of Bossut.[35] No documentary evidence exists, however, to clarify John's organizational efforts on behalf of the beguines of Liège.

In his *Historia Occidentalis*, James of Vitry mentioned John as the "companion" (*socius*) of another preacher, master John of Liroux, probably a canon at St. Denis of Liège.[36] This John attempted to secure papal support for the beguines but apparently died while crossing the Alps on his way to Rome some

time after 1216.[37] He gave spiritual advice to several *mulieres religiosae*, including Odilia, a widow who devoted herself to a secular life of chastity in Liège from 1203 until her death in 1220, and whose *vita* contains some scattered information on the first beguines of Liège. They appear to have lived alone in different parts of the city, and attended services at the churches of St. John the Evangelist, St. Denis, St. Gangulphe, and the cathedral of St. Lambert; some were anchoresses.[38] Odilia's son, also called John, who became a chaplain at St. Lambert of Liège, endowed a convent for twenty-four beguines in his house close to the church of St. Mary Magdalen in Liège shortly before his death in 1241, but is not known since how long the beguines had been living there.[39] Other women later known as beguines gathered between 1207 and 1219 in the Liégeois parish of St. Christophe, where a beguinage took shape by 1241.[40]

Meanwhile a group of women and men had started to take care of the ill at the leper house of Mont-Cornillon in an eastern suburb of Liège. They originally formed a loose association that recalls those built around Juetta of Huy and Mary of Oignies. According to her *vita*, written between 1261 and 1264, Juliana, a five-year-old orphan, was raised under the auspices of several *mulieres religiosae* and became the superior of the female community at Mont-Cornillon around 1222, promoting a strict regime modeled on a monastic lifestyle. Disciplinary problems reminiscent of those experienced by double monasteries,[41] as well as a disagreement with the head of the male community attached to the hospital, and with the citizens of Liège who funded it, led to open conflict in 1237 and to her ousting in 1247. Juliana then wandered throughout the diocese with three female companions, supported by friends in Cistercian nunneries, until her death in 1258 as a recluse in Fosses near Namur.[42]

Two women who led a beguine-like life exerted a formative influence on Juliana: Sapientia, a "spiritual sister," who took charge of her education, and Eve of St. Martin, an anchoress, who acted as her mentor and supporter in her later years. Sapientia belonged to the original women's group at Mont-Cornillon— and eventually became its prioress—but lived apart at the farm dependency at Boverie during Juliana's childhood. She taught Juliana to read Latin and exposed her to the writings of Augustine and Bernard of Clairvaux. Juliana's biographer acknowledged her as a teacher of great wisdom.[43] As an adult, Juliana often sought help from the anchoress Eve of St. Martin, an ardent supporter of Juliana's cause to promote the new feast of Corpus Christi but an independent spirit who never joined Mont-Cornillon or any other monastic community and remained enclosed at St. Martin until her death in 1266. Eve's written or dictated notes in Walloon on Juliana's life and struggles, now lost, probably served as a basis for the Latin *vita* composed by a canon at St. Martin.[44]

The fourth and final center of early beguine life lay some twenty miles

northwest of Liège, in a cluster of towns—Borgloon, Sint-Truiden, and Zoutleeuw—that lodged beguine communities. These communities are also difficult to date, in part because the *Life of Christina Mirabilis*, one of our main sources, contains so few references to datable events (or indeed to any events to which we can ascribe a tangible reality).[45] A native of Sint-Truiden, Christina grew up as the youngest of three orphaned sisters, entrusted with the care of the household herds. In 1182, she fell ill and was given up for dead but miraculously recovered, after which she left home and moved around the central area of the diocese of Liège, like a female equivalent of the male wandering preachers so common in this age; yet, according to her biographer, Thomas of Cantimpré, she was more modest and acknowledged that expounding the scriptures belonged to the ordained ministry alone.[46] She stayed for nine years with an anchoress called Jutta in one or more cells attached to the local church; she also frequented the court of the local count, Louis II of Loon (1197–1218), and visited the Benedictine nuns of St. Catherine's near Sint-Truiden, where she died in 1224.[47] Christina was not the only one who dwelled with the recluse Jutta. The young Lutgard of Tongeren spent at least two weeks with her at Borgloon before entering a monastery in 1216–17,[48] whereas Ida of Gorsleeuw, attending the chapter school in Borgloon around 1210, "paid regular visits to the recluses and beguines" (*frequentabat tam reclusas quam beguinas*) of the town until she was admitted to the Cistercian order, probably in 1213.[49] Jutta's and Christina's fame thus had attracted several female apprentices to the cells at the church, but other "religious women" lived in Borgloon as well, perhaps near the hospital of Gratem just outside the town walls, where a beguine community serving the hospital is attested in 1259.[50]

There must have been yet another beguine community in the nearby town of Zoutleeuw in the first decade of the thirteenth century. We know of it through the remarkable *vita* of Beatrice, a girl from Tienen who entered the Cistercian monastery of Florival around 1210 at the age of 10. The *Life*, compiled on the basis of interviews and a lost autobiographical memoir by Beatrice herself, reports that Beatrice's mother had started to teach her to read and possibly to write when she was five but died two years later, probably in 1207. Her father then sent her to "a group of beguines" (*beghinarum collegio*) in Zoutleeuw, so that she "would make greater progress in virtue."[51] According to the author or compiler of the *Life of Beatrice*, the beguine community at Zoutleeuw was ruled by a mistress (*magistra*), "a venerable woman to whose teaching she [Beatrice] was assigned," which may imply hierarchical structures more common to the compiler's age (ca. 1275) than to that of Beatrice's youth, but there is no reason to doubt that she lodged for about a year at the age of seven with beguines in this town to receive moral and religious instruction. Meanwhile she also went to a coeducational school in the town of Zoutleeuw to complete her training in read-

ing and writing.[52] Further evidence regarding the Zoutleeuw beguines is lacking until 1242, when they are known to have clustered in an area outside the walls called Grieken, and a formal beguinage with its own chapel was established.[53]

Indications of beguine life outside these four areas are scarce and rather uncertain before 1230. In his *Dialogue of Miracles* written in 1219–24, Caesarius of Heisterbach reported on a "religiosa femina" called Uda (or Oda), a visionary with an intense devotion for the Eucharist, who in 1220 shared a house with at least one other "religious woman" in Thorembais, a tiny village south of Louvain; together they initiated a small beguine community attested there again from 1267 until the late eighteenth century.[54] Caesarius also knew of two "holy women" in Brussels, *Halewigis* (or Hadewijch), and Ida, who must have lived before 1225–28; it is not known if they had any companions.[55] Ida, the daughter of a merchant of Louvain, rejected her father's wealth to embrace a life of poverty in her hometown around 1230, when she was eighteen years old. Like many Cistercian hagiographers of the era, her biographer's emphasis lay on her route toward the Cistercian order, which she joined a few years later, and on her experiences as a nun. Nevertheless, the earliest chapters of the *Life of Ida of Louvain*, dealing with her days in Louvain before she took a nun's veil, contain a few vignettes of her with a local beguine or joining a beguine group in prayer; this beguine community was probably established at Ten Hove, just outside the walls of Louvain.[56] A beguine community also arose in Aachen around 1230.[57] Thomas of Cantimpré's *Vita Joannis Cantimpratensis*, composed between 1224 and 1228, praised a nobleman from the region of Cambrai, Philip of Montmirail, because he enabled "up to 300 chaste women and virgins to live without a rule but in chastity and holy;" these women may have been the first beguines at Cantimpré near Cambrai, attested in 1233.[58] In his *Life of Margaret of Ypres*, he briefly referred to the beguines of Flanders. He recounted that Margaret lived piously with her mother and sisters, guided by a Dominican friar, Zeger of Lille, from 1234, when she was eighteen, until her death in 1237. During that time, her visions gained her fame throughout Flanders. Thomas noted one encounter between her and *mulieres religiosae*, "who came to her, as was their custom, and asked her to speak of Christ,"[59] but it is not clear whether these beguines formed a local community. The first archival document attesting a beguine community in Ypres dates from 1240.[60]

These life stories therefore reveal several beguine communities in the diocese of Liège that formed a network of support for many of the saintly heroines they nurtured before 1230; by that date, beguines had also formed communities outside the diocese, in the city of Cambrai, in Thorembais, perhaps in Brussels, and farther west, in Flanders. Although there is clearly no single center from which all beguine communities grew, nor a single authority supervising

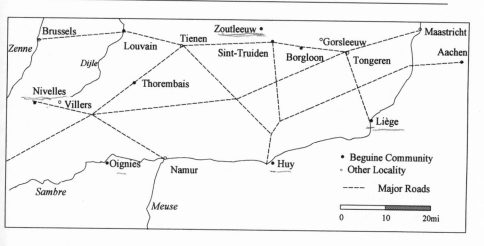

Map 3: The First Beguine Communities in Brabant-Liège (ca. 1200–ca. 1230)

them, the early beguine groups were not unconnected: beguines and others sympathetic to their cause were in touch with one another (Map 3). A network of roads, part Roman, part medieval, had long facilitated communication between the towns of the Sambre-and-Meuse valley (Oignies, Namur, Huy, Liège) and urban centers of Brabant and Loon to its north (Nivelles, Louvain, Zoutleeuw, Sint-Truiden, Borgloon, Tongeren).[61] Some of these women traveled those roads regularly. We have already noted how Mary of Oignies shuttled between Willambroux and Oignies, and how Christina Mirabilis walked from Sint-Truiden to Borgloon and other towns of the area; she visited Liège at least once.[62] Lutgard of Tongeren met the recluse Jutta of Borgloon as well as Christina Mirabilis; she was also acquainted with Mary of Oignies.[63] Juliana of Mont-Cornillon knew by reputation a beguine from Huy called Isabella, whom she invited to join her community near Liege around 1230; she also made a pilgrimage to Cologne and Tongeren, and in her later years found refuge "with some poor beguines" at Namur, where she probably helped founding a new beguinage.[64] Ida of Nivelles, Beatrice of Nazareth, and probably Ida of Gorsleeuw all joined the monastery of La Ramée and may have known one another before their conversion to the monastic life.[65] Ida of Louvain welcomed in her home an anonymous beguine from out of town who wished to celebrate the night office for Epiphany at the church of the Dominicans of Louvain.[66]

A few clerics assisted individual beguines (or beguine groups) in different towns and relayed messages between them. James of Vitry, who was most devoted to Mary of Oignies, also met Juetta of Huy, Christina Mirabilis, Lutgard

of Tongeren, and, we may assume, many of their companions.[67] As noted above, Thomas of Cantimpré knew their later communities even better. He regarded Lutgard of Tongeren as "a most special mother" for twenty-five years, and was acquainted with *mulieres religiosae* in Sint-Truiden, Liège, and Nivelles.[68] John of Nivelle left the care of religious women in Liège to join the Augustinian monastery of Oignies before 1219 but had been a liaison between *mulieres religiosae* at both places before that date, and may have continued to act in that capacity in later years.[69] John of Liroux, Odilia of Liège's supporter, also assisted Lutgard of Tongeren.[70] Mary of Oignies's brother-in-law, the cleric Guido of Nivelles (not to be confused with his near-namesake, John of Nivelle), served as a chaplain in the leper house of Willambroux while Mary and her husband lived there until around 1207, and afterward ministered to the hospital chapel at St. Sépulchre and its adjacent beguine community until his death in 1227.[71] An undated and now lost text commemorating Guido's work at Nivelles celebrated him as an inspiring preacher at Nivelles, who encouraged many young women "from the Kempen and Flanders, from the lands of the Empire as well as from France," to elect virginity and the ascetic life.[72]

The Cistercian monastery of Villers, founded by monks from Clairvaux in 1146, served as a spiritual beacon for many individual beguines in the region, especially for those of nearby Nivelles and Oignies.[73] Goswin of Bossut, the presumed author of the *Life of Ida of Nivelles*, resided at Villers, as did perhaps other anonymous authors of the *vitae*. The monks at Villers displayed a keen interest in the spirituality and visionary experiences of religious women since their correspondence with the Rhenish visionary abbess, Hildegard of Bingen, in 1175–77.[74] In the thirteenth century, abbots William (1221–37/38) and James (1276–83) of Villers regularly traveled to Nivelles and preached to beguines.[75] Gobert of Aspremont, a young nobleman contemplating a monastic career in the Cistercian order between 1231 and 1237, was encouraged to take vows at Villers by a beguine of Nivelles.[76] To thank her, Gobert (and a lay brother at Villers following his example) granted the beguines provisions in clothing and wheat to alleviate their "poverty."[77] Upon the death of an abbot, Villers would routinely request prayers from the beguines of Nivelles while starting the procedure to elect a new one.[78] Caesarius of Heisterbach's *exempla* collections contain many stories about *mulieres religiosae* of southern Brabant whom the monks of Villers held in high esteem.[79] In 1269, the bodies of three *mulieres religiosae*—Juliana of Mont-Cornillon, Helewidis, an anchoress at St. Syr in Nivelles, and *Marquina*, an anchoress at Willambroux—were solemnly transferred along with those of four saintly monks to the prestigious space behind the high altar of Villers. Two years later, the body of Mary of Grez, a beguine of Nivelles, was entombed in the same holy space with those of two other monks.[80]

The importance of these clerics and monks for the beguines' success should be weighed carefully. Their priestly function made them indispensable as administrators of the sacraments—especially the Eucharist, so central to beguine spirituality—and their willingness to associate themselves with the women certainly helped legitimize this lay movement at a time when Cathar and other heresies loomed large. Even more important, they *wrote* about beguines and cast them in a favorable light—rather cleverly, in fact, using capsule biographies to personalize what was surely a relatively diffuse and varied way of life. On the other hand, they tended to appropriate and misrepresent it in some important ways. Although they sometimes depicted their beguine protégés as superior to members of traditional religious orders, gifted with extraordinary will power and innocence, they clearly envisaged them as ascetics living under close ecclesiastical supervision,[81] or as potential nuns, bound to adopt a more cloistered monastic existence in the near future, like the Cistercian nuns. This is one of the main themes projected by the *vitae*,[82] but it is also reflected in the usage, common among these clerical defenders, of the term *religio* to denote the beguine lifestyle. The liturgy of the office for Mary of Oignies sung at Villers in the 1230s or 1240s (possibly composed by none other than Goswin of Bossut), commemorated her as the initiator of the new beguine *religio* (*novae religionis benignarum*) at nearby Nivelles.[83] As we have seen, Albéric of Troisfontaines, writing from the Liégeois point of view around 1250, emphasized Lambert le Bègue's role as the propagator of the *nova religio*, while the *Vita Odiliae* spoke of this way of life as the *novella plantatio religionis* (an allusion to Psalm 143:12 in the Gallican version).[84] This phrase soon afterward turned into a stock metaphor for beguine life in Liège.[85] In all of these cases, *religio* meant something different from "religion": it was the expression of a devotion to Christ rather than a set of beliefs, and it was closely associated with the "religious" or monastic life.[86] Beguine *religio*, in other words, was only one step away from the monastic vocation, or such, at least, was the impression left by the authors of the *vitae* and other members of the Church who supported the women. However, none of these men were official leaders of the beguines, despite the assumptions made in the *vitae* and in modern scholarship,[87] and none held any authority over them beyond that exercised by a priest over his flock. Even the involvement by the monks of Villers with the early beguines remained largely informal and inspirational. With the possible exception of the nascent communities at Thorembais and Borgloon, no beguine group of this early age appears to have answered to Villers (or to any other monastery) as its spiritual or disciplinary overseer.[88]

The data thus suggest that beguine communities sprang up in different parts of the region more or less simultaneously, without central coordination, and, most certainly, without a single point of origin or a single founder. Whatever

connections existed at this time between beguine communities or between be-
guines and monastic houses, they were personal and ad hoc. And in defiance
of the hopes and expectations of the clergymen who guided the first beguines,
their communities did not become nunneries but rather institutions that resisted
strict enclosure, the so-called beguinages.

## Formal Communities

The beguine movement changed dramatically in the second quarter of the thir-
teenth century, when beguines began to acquire property as a community and
identified themselves to the outside world as formal institutions, "beguinages."
These institutions dotted the urban landscape of the southern Low Countries
until well into the modern age. Although they were rarely created by a formal act
of foundation and in some cases left no substantive trail of archival records, their
existence through the late middle ages can be traced with more or less accuracy.[89]
     At least 298 beguinages were established in 111 towns and cities of the south-
ern Low Countries before the Revolt (Table 1). The first of these were undoubt-
edly inspired by the formal approval of the beguine life by pope Gregory IX
in 1230–33. In October 1216, James of Vitry had notified his friends in the Low
Countries that pope Honorius III had given him oral assurances that "religious
women, not only in the diocese of Liège but also in France and the Empire, were
permitted to live in the same house and to incite each other toward the good by
mutual exhortations."[90] The pope's authorization of the beguine life was never
officially registered, however, and seems to have had little effect. Some time be-
fore 1231, a papal legate offered letters of protection to beguines of Cologne, and
on 30 May 1233 pope Gregory IX formally extended his protection to the "con-
tinent virgins of Germany (*Teutonia*) who vow perpetual chastity to God" in a
bull that five days later was reissued for the beguines of Cambrai. Aachen's St.
Mathiashof, the oldest beguinage for which firm documentary evidence exists,
is first mentioned in 1230, and the foundation charters of Cantimpré at Cambrai
explicitly invoked Gregory's bull of 1233. Within a few years, beguinages were
also set up in Louvain, Ghent, Namur, and Valenciennes.[91]
     While some of the oldest beguinages were founded in the area where infor-
mal gatherings of beguines had been attested since about 1200 (Nivelles, Oignies,
Liège, Zoutleeuw, and Borgloon) or in their immediate vicinity (Aachen, Diest,
Hasselt, and Tongeren), they appeared almost simultaneously in other parts
of the southern Low Countries: before 1250, there were also beguinages in
Vilvoorde, Antwerp, Brussels, Mechelen, Bruges, Ypres, Aardenburg, Kortrijk,
Lille, Arras, Douai, Tournai, Le Quesnoy, and Mons. The beguine way of life ex-

Table 1: Court and Convent Beguinages Founded Before 1566

| | Convent Beguinages | Court Beguinages | Total |
|---|---|---|---|
| Before 1240 | 1 | 9 | 10 |
| 1241–50 | 6 | 20 | 26 |
| 1251–60 | 9 | 10 | 19 |
| 1261–70 | 16 | 11 | 27 |
| 1271–80 | 18 | 10 | 28 |
| 1281–90 | 21 | 2 | 23 |
| 1291–1300 | 16 | 3 | 19 |
| 1301–10 | 18 | 1 | 19 |
| 1311–20 | 33 | 1 | 34 |
| 1321–30 | 8 | 0 | 8 |
| 1331–40 | 14 | 2 | 16 |
| 1341–50 | 5 | 1 | 6 |
| 1351–60 | 6 | 0 | 6 |
| 1361–70 | 6 | 0 | 6 |
| 1371–80 | 3 | 1 | 4 |
| 1381–90 | 5 | 2 | 7 |
| 1391–1400 | 4 | 0 | 4 |
| 1401–10 | 0 | 0 | 0 |
| 1411–20 | 5 | 0 | 5 |
| 1421–30 | 6 | 0 | 6 |
| 1431–40 | 3 | 0 | 3 |
| 1441–50 | 2 | 0 | 2 |
| 1451–60 | 4 | 0 | 4 |
| 1461–70 | 2 | 0 | 2 |
| 1471–80 | 1 | 0 | 1 |
| 1481–90 | 1 | 1 | 2 |
| 1491–1500 | 0 | 3 | 3 |
| 1501–10 | 0 | 0 | 0 |
| 1511–20 | 1 | 0 | 1 |
| 1521–30 | 0 | 0 | 0 |
| 1531–40 | 1 | 0 | 1 |
| 1541–50 | 0 | 0 | 0 |
| 1551–60 | 5 | 0 | 5 |
| 1561–65 | 1 | 0 | 1 |
| Total | 221 | 77 | 298 |

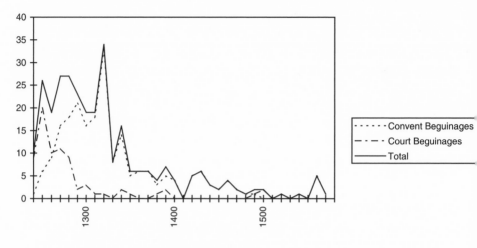

Court and Convent Beguinages Founded Before 1566

panded further in the course of the thirteenth century to all urban centers of the southern Low Countries and well beyond: beguine convents also sprang up in the Rhenish lands, around Lake Constance, in most of northern France and some parts of the south, in the northern Low Countries and northern Germany, and as far east as Bohemia.[92]

Most beguine institutions in the southern Low Countries were established between 1230 and 1320 (205 beguinages, or 68.8 percent), particularly in 1240–80 and 1310–20. New foundations continued to be made in the later Middle Ages but at a much slower rate.

The most common type of beguine institution (221 out of 298 beguinages, or 74.2 percent) was the convent (Latin *conventus*: Dutch *convent*; French *couvent*), an association of beguines living together or in close proximity to one another under the guidance of a single superior, the "mistress" (*magistra*) or prioress. In most cases, beguines who lived in a convent agreed to obey certain regulations for the duration of their stay and contributed to the common fund of the convent.[93] With a few exceptions, convents did not have access to a private chapel: beguines thus attended religious services in their parish church and were subject, in spiritual matters, to the authority of the parish priest. Some convents were located quite close to the parish church or to the churches of the mendicant orders, whose wide spaces designed for preaching provided a generous welcome to lay people.[94]

The second type of beguine institution, the "court" (Latin *curtis, curia beguinarum*; Dutch: *[begijn]hof*; French *court [de beguines]*), was less common (77

out of 298 beguinages, or 25.8 percent) but in many ways left a greater imprint on the movement in the southern Low Countries. As Table 1 made clear, the formation of courts actually preceded that of most convents: sixty out of seventy-seven courts (77.9 percent) were erected before 1280, when relatively few convents (50 out of 221, or 23 percent) had been started up. They were not formed out of pre-existing convents, as previously was thought, but were entirely new creations built specifically for the use of beguines in open spaces within the city walls or, more often, just outside the city walls.[95] Courts consisted of several dwellings for beguines arranged around a central chapel or church used by them for their religious ceremonies; they included houses for individual beguines living alone or with one or more companions and servants, each with its own garden,[96] larger residences (also called "convents") for communal living under the rule of a mistress, and numerous service buildings, like a brewery, a bakery, or even a small farm;[97] the entire complex was governed by a single superior, the grand mistress. The larger courts eventually obtained "parochial" status, which entailed the appointment of a special parish priest, sometimes assisted by one or more chaplains, to serve the beguines of the court. A few courts that did not gain parochial status and remained subservient to a higher parochial authority, nonetheless retained special chaplains to perform liturgical services in the beguine chapel. Whereas beguine convents existed in all regions of Europe where the beguine movement took hold, court beguinages, with a few exceptions, were unique to the Low Countries (figs. 2–5).[98]

Courts tended to be larger than convents, as well as more complex and more diverse. While the average number of beguines residing in convents was 14.7, most were actually smaller than that figure suggests. Over half of the convents whose population is known numbered between five and sixteen beguines (see Table 2); in the troubled years of the mid-fourteenth century,[99] convents might house as few as three or four beguines. Only the largest convents had more than twenty-five beguines: la Thieuloye, Notre Dame, and St. Anne at Arras reached a population of twenty-six, forty, and fifty in 1316–24; the convent of Aire had forty beguines in 1531; St. Syr in Nivelles, an old center of beguine life, had fifty-one beguines in 1284, and the largest convent on record, that of Le Roy in Arras, had seventy-two inhabitants in 1316–24. Beguine convents in other parts of northern Europe were of comparable size or somewhat smaller.[100]

While the population of a few court beguinages sometimes dropped as low as that of the average convent—the courts of Braine-le-Comte and Eindhoven had only a handful of beguines at the beginning of the sixteenth century, a period of decline for both institutions—the figures were usually much higher (Table 3). Among the thirty-one court beguinages whose population can be determined with any accuracy, at least ten had between thirty-five and one hundred

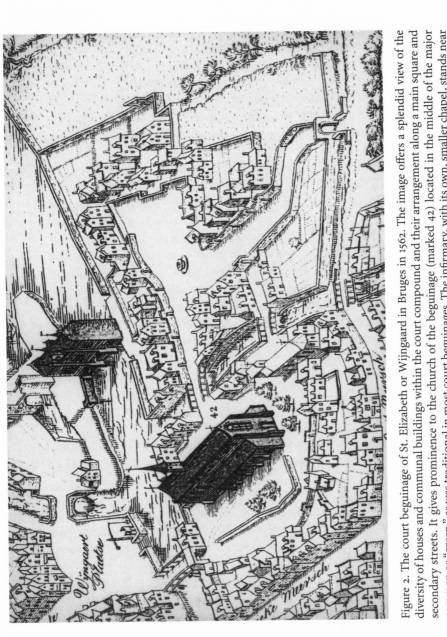

Figure 2. The court beguinage of St. Elizabeth or Wijngaard in Bruges in 1562. The image offers a splendid view of the diversity of houses and communal buildings within the court compound and their arrangement along a main square and secondary streets. It gives prominence to the church of the beguinage (marked 42) located in the middle of the major common or "green," as was traditional in most court beguinages. The infirmary, with its own, smaller chapel, stands near the western portal of the church. The main entrance of the court, at the top left, was accessed by a bridge from the "Wijn-gaert Plaetse"; another entrance is visible at the bottom right. The court's exterior walls are clearly depicted on the eastern and southern sides but are obscured on the northern and northwestern sides by houses in adjacent streets, outside the

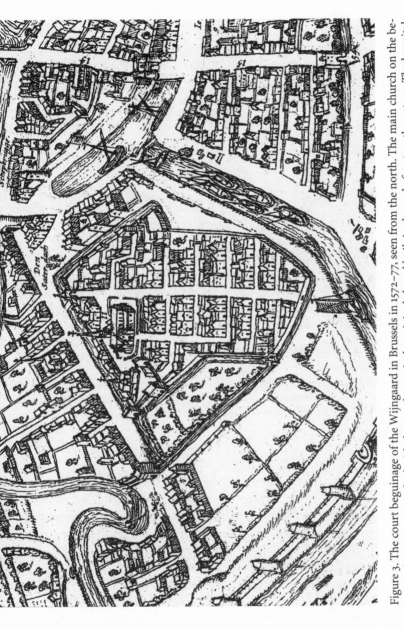

Figure 3. The court beguinage of the Wijngaard in Brussels in 1572–77, seen from the north. The main church on the beguinage's common, marked with the number 11, is the original chapel built in the early fourteenth century. The hospital, service buildings, convents and houses are arranged along streets that run in a regular pattern. The court is surrounded by a wall on all sides, and a moat on three. Just south of the beguinage is a small public square, Den Saterdach. From Georgius Bruin and Franciscus Hogenbergius, *Civitates orbis Terrarum*, vol. 1 (Cologne: Apud Godefridum Kempensem, 1577). By permission of Ghent University Library.

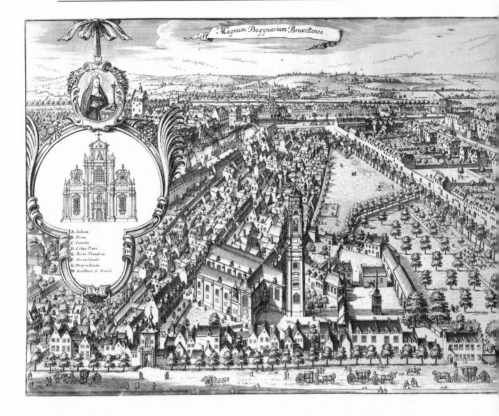

Figure 4. The court beguinage of the Wijngaard in Brussels in the early eighteenth century, seen from south. The large baroque church (also in inset), built to replace the medieval church in the seventeen century, is all that is left of the beguinage today. Jacob Harrewijn, *Magnum Begynasium Bruxellense*, Copyright IRPA-KIK Brussels.

beguines at some time before 1565 (Bergen op Zoom, Breda, Hesdin, Kortrijk, Lier, Cantimpret at Mons, Tienen, Turnhout, Valenciennes, and Zoutleeuw).[101] At least eleven others numbered between 100 and 400 beguines (St. Catherine at Antwerp, Wijngaard at Bruges, Wijngaard at Brussels, St. Catherine at Diest, the main beguinage of Dendermonde, Champfleury at Douai, Klein Begijnhof at Ghent, Herentals, Groot Begijnhof at 's-Hertogenbosch, Groot Begijnhof at Louvain, St. Catherine at Tongeren).[102] Three beguinages stood out as exceptionally large formations: Ghent's Groot Begijnhof of St. Elizabeth, with about 610–730 beguines in the late thirteenth century; St. Christophe at Liège, whose population comprised about 1,000 members in the mid-thirteenth century; and the Groot Begijnhof of St. Catherine at Mechelen, a truly massive community

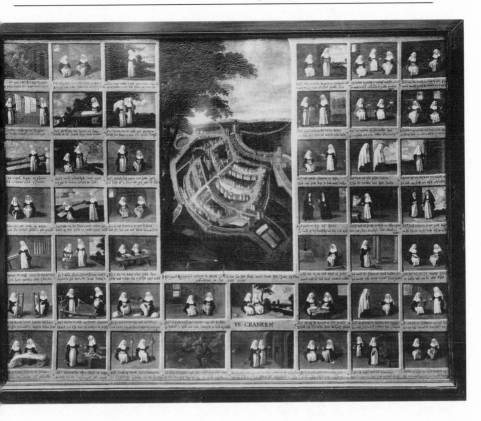

ure 5. View of the court beguinage of St. Catherine in Mechelen prior to its destruction in 1578. The ~uinage's massive size, taking up an entire suburb (the city of Mechelen itself is just barely visible in background), is evident from this crude sketch, but particular sites in the beguinage are difficult distinguish. The view is surrounded by forty-six vignettes from beguine life. Mechelen, Openbaar ntrum voor Maatschappelijk Welzijn, seventeenth century. Copyright IRPA-KIK Brussels.

of about 1,500 to 1,900 beguines in the late fifteenth and first half of the six-teenth centuries, at the height of the city's expansion. Surrounded by walls and sometimes even by moats, these courts often constituted a city within the city — a "city of beguines"(*civitas beghinarum*)[103] — and their remains still form promi-nent landmarks in many urban centers of the southern Low Countries.

Courts were much larger than the common nunnery. Penelope Johnson in-dicated that convents for women of the traditional monastic orders had on aver-age about thirty-five nuns in thirteenth-century Normandy.[104] R. R. Post came to similar conclusions in his survey of male and female religious houses in the northern Netherlands on the eve of the Reformation. He found that nunneries

Table 2: Population of Convent Beguinages

| Beguinage | Date | Number of beguines | Source |
|---|---|---|---|
| Aachen, St. Margaret | 1315 | 25 | R. Pick, "Der St. Margarethenkonvent im Beguinenwinkel zu Aachen," *Annalen des Historischen Vereins für den Niederrhein* 46(1887): 179–80 |
| Aire | 1531 | 40 | Paul Bertin, "Le Béguinage d'Aire-sur-la-Lys," *Revue du Nord* 31 (1949): 92–104, at 95 |
| Anderlecht | 1496, 1526 | 8 | Joseph Cuvelier, *Les dénombrements de foyers en Brabant (XIVe–XVIe siècle)* (Brussels: P. Imbreghts, 1912), 287. |
| Arras, Le Roy | 1316–24 | 72 | Delmaire, *Diocèse d'Arras*, vol. 1, 324 |
| Arras, St. Anne | 1316–24 | 50 | Ibid., 323 |
| Arras, Tasse Huquedieu | 1316–24 | 12 | Ibid., 324 |
| Arras, Notre Dame | 1316–24 | 40 | Ibid., 324 |
| Arras, 11,000 Vierges | 1316–24 | 20 | Ibid., 324 |
| Arras, Marguerite Amion | 1316–24 | 22 | Ibid., 324 |
| Arras, Élyas | 1316–24 | 12 | Ibid., 324 |
| Arras, de la Vigne | 1316–24 | 24 | Ibid., 324 |
| Arras, de la Thieuloye | 1316–24 | 26 | Ibid., 324 |
| Bouvignes | 1420 | 3 | Appendix I, no. 22 |
| Dinant, Lambert le Sage | 1418 | 5 | Appendix I, no. 34B |
| Douai, Bernard Pilate | b. 1282–1362 | 10 | AMD, GG 191 |
| | a. 1362 | 6 | Ibid. |
| Douai, Wetz | 1350–72 | 27 (about) | Jean-Pierre Deregnaucourt, "Les béguines de l'hôpital des Wetz de Douai de 1350 à 1372," *Revue du Nord* 82 (2000): 35–52 |
| | 1399–1490 | 18 (max.) | Georges Espinas, *La vie urbaine de Douai au Moyen-Age* (Paris: A. Picard, 1913), vol. 4, 738, no. 1530 |
| | a. 1490 | 13 (max.) | M. Brassart, *Inventaire général des chartes, titres et papiers appartenant aux hospices et au bureau de bienfaisance de la ville de Douai* (Douai: Adam d'Aubers, 1839), 260, no. 818. |

| | | | |
|---|---|---|---|
| Halen | 1526 | 2 | Cuvelier, *Les dénombrements*, cclvi |
| Huy, Montroyal | 1251 | 17 | Appendix I, no. 56 |
| Huy, Henri le Soris | 1337 | 13 | Ibid. |
| Huy, Agnès de Gauwes | 1359 | 8 | Ibid. |
| Huy, Henri le Clokier | 1363 | 6 | Ibid. |
| Huy, Juette de Tahier | 1388 | 3 | Ibid. |
| Huy, Jean Lempereur | 1463 | 5 | Ibid. |
| Liège, la Madeleine-en-Ile | 1241 | 24 | Appendix I, no. 61B |
| Liège, Chevalbay | b. 1370 | 13 | Appendix I, no. 61B |
| Mesen | 1440 | 10 | Appendix I, no. 73 |
| | 1486 | 13 | Ibid. |
| Momalle | 1341–60 | 13 (min) | Appendix I, no. 74 |
| Mons, Hion | 1323 | 5 | Walter De Keyzer, "Aspects de la vie béguinale à Mons aux XIIIe et XIVe siècles," in *Autour de la ville*, 205–26, at 221. |
| Mons, le Taye | 1333 | 12 | Ibid. |
| Mons, des Prés | 1365 | 7 | Ibid. |
| Mons, Cokelet | 1365 | 4 | Ibid. |
| Mons, Mauclercs | 1365 | 4 | Ibid. |
| Mons, Beloit | 1365 | 4 | Ibid. |
| Mons, le Piere | 1365 | 4 | Ibid. |
| Mons, Gemblues | 1365 | 3 | Ibid. |
| Mons, Havrech | 1365 | 3 | Ibid. |
| Mons, Le Chapelain | 1365 | 3 | Ibid. |
| Mons, Pesiere | 1365 | 3 | Ibid. |
| Mons, Anthones | 1365 | 3 | Ibid. |
| Nivelles, St. Syr | 1284 | 51 | Hanon de Louvet, "L'Origine," 54 |
| Oisterwijk | 1539 | 9 | Appendix I, no. 84 |
| Thorn | 1287 | 12 | Appendix I, no. 97 |
| Tournai, As Degrés | 1261–80 | 8 (min) | Appendix I, no. 103B |

Table 3: Population of Court Beguinages

| Beguinage | Date | Number of beguines | Source |
|---|---|---|---|
| Aarschot | 1526 | 28 | Cuvelier, *Les dénombrements*, 343 |
| Antwerp | 1526 | 101 (min) | Ibid., 462. |
| Bergen op Zoom | 1526 | 65 | Ibid., 473 |
| Braine-le-comte | 1512 | 4 | Appendix I, no. 23 |
| Breda | 1480 | 37 | Cuvelier, *Les dénombrements*, 472 |
| Breda | 1535 | 32 | G. C. A. Juten, *Cartularium van het begijnhof te Breda*, vol. 1 ('s-Hertogenbosch: Provinciaal Genootschap van Kunsten en Wetenschappen in Noord-Brabant, 1910), 188–89. |
| Bruges, Wijngaard | 1439–55 | 137–153 (min.) | Appendix II, no. 1 |
| Brussels, Wijngaard | 1526 | 326 | Appendix II, no. 2 |
| Diest, St. Catherine | 1526 | 193 | Cuvelier, *Les dénombrements*, 354 |
| Diest, St. Catherine | 1558 | 144 | Michel Van der Eycken, "Stadseconomie en conjunctuur te Diest (1490–1795)" (Ph.D. diss., Katholieke Universiteit Leuven, 1982), vol. 1, 108 |
| Dendermonde, Virgin Mary/St. Alexius | 1461–80 | about 223–75 | Appendix II, no. 3 |
| Douai, Champfleury | 1272 | 100 (min.) | *AMD*, FF 861, at date August 1272 |
| Edingen | 1501 | 18 (min.) | Ernest Matthieu, *Histoire de la ville d'Enghien* (Mons: Dequesne-Masquillier, 1878), 585 |
| Eindhoven | 1526 | 7 | J. Van der Hammen and Aug. Sassen, "Telling der huizen en haardsteden in de stad en meijerij van 's-Hertogenbosch, gedaan in het jaar 1526," *Handelingen van het Provinciaal Genootschap van Kunsten en Wetenschappen in Noord-Brabant* (1891–93): 221–63, at 244 |

| Location | Date | Number | Reference |
|---|---|---|---|
| Ghent, Groot begijnhof | 1284 | about 610–730 | Appendix II, no. 4 |
| Ghent, Klein Begijnhof | 1500 | 269 | Appendix II, no. 5 |
| Ghent, Poortakker | 1326 | 28 (max.) | SAG, Reeks LXXX, charters, no. 15 |
| Herentals | 1480 | 266 | Cuvelier, *Les dénombrements*, 462–63 |
| 's-Hertogenbosch, Groot Begijnhof | 1526 | 183 | Van der Hammen and Sassen, "Telling," 224–25, 227 |
| Hesdin | 1317–24 | 38 | *DB*, 158 |
| Hoogstraten | 1480 | 30 | Cuvelier, *Les dénombrements*, 469 |
| | 1553 | 27 | J. Lauwerys, *Het begijnhof van Hoogstraten* (Hoogstraten: Hasel-donckx, 1974–76), vol. 1, 45. |
| Kortrijk | 1491 | 46 | Antoon Viaene, "Het begijnhof van Kortrijk in 1491," *Biekorf* 57 (1956): 257–59 |
| | 1526 | 52 (max.) | E. Reusens, "Documents concernant le béguinage de Courtrai," *ASHEB* 14 (1877): 86–98, at 94 |
| Le Quesnoy | 1246 | 15 (min.) | *DB*, 158 |
| Liège, St. Christophe | 1253 | about 1000 | Appendix II, no. 6 |
| Lier | 1480 | 69 | Cuvelier, *Les dénombrements*, 462 |
| Louvain, Groot Begijnhof | about 1270–80 | about 200–300 | Appendix II, no. 7 |
| | 1526 | 125 | Appendix II, no. 7 |
| Mechelen, Groot Begijnhof | 1486–1550 | about 1500–1900 | Appendix II, no. 8 |
| Mons, Cantimpret | 1365 | 84 | De Keyzer, "Aspects," 221 |
| Tienen | 1526 | 39 (min.) | Cuvelier, *Les dénombrements*, 379 |
| Tongeren, St. Catherine | 1322 | ca. 230 | Appendix II, no. 9 |
| Turnhout | 1480 | 60 | Cuvelier, *Les dénombrements*, 471 |
| Valenciennes | 1484–85 | 49 (min.) | Bernadette Carpentier, "Le Béguinage Sainte-Élisabeth de Valenciennes, de sa fondation au XVIeme siècle," *Mémoires du Cercle archéologique et historique de Valenciennes* 4 (1959): 95–182, at 129 |
| Zoutleeuw | 1526 | 36 | Cuvelier, *Les dénombrements*, 366 |

of the Benedictine, Cistercian, and Dominican orders, as well as the institutions of the Sisters of the Common Life, had on average forty members, while convents of Premonstratensian nuns had twenty. The largest population he recorded was that of the Sisterhouse of Mary Magdalen of Bethany at Amsterdam, which numbered 210 sisters in 1462 and 1493.[105] The largest nunneries of the Cistercian order in the southern Low Countries had at the most sixty members in the thirteenth through fifteenth centuries.[106]

The great number of beguines also impressed chroniclers of the age. Although some of their figures are wildly off the mark, others, perhaps surprisingly, are not: Thomas of Cantimpré claimed there were 2,000 beguines in Nivelles between 1256 and 1263, which is hardly possible,[107] but when Matthew Paris spoke of "2,000 beguines in Cologne and its environs" around 1243, he may have come close to the truth.[108]

Whether living in convents or courts, beguines could thus make up a significant part of the urban community, but the exact proportion varied. A tally of beguines in St. Omer registered a total of 395 beguines living in twenty-one convents in 1322, or about 1 percent of the city's total population, estimated at 35,000 to 40,000.[109] Our data suggest that beguines formed about 1.7 percent of the population in late thirteenth-century Ghent (about 64,000 inhabitants), 3.2 percent of the population of Diest in 1526 (about 6,100), 4.4 percent of the population of Liège in the mid-thirteenth century (20,000 to 25,000?), 5.5 percent of the population of Dendermonde in 1460–80 (about 4500), 6.5 percent of the population of Mechelen in the late fifteenth and the first half of the sixteenth centuries (about 26,000), and 7.7 percent of the population of Herentals in 1480 (about 3,450).[110] The range of proportions is in itself not unusual—it has been reported for beguine populations in other parts of Europe—but it is wider in the southern Low Countries than elsewhere.[111] As we will see in the next chapters, it points to the great diversity of the movement and the social factors that supported it.

# 3. The Contemplative and the Active Life

Like many other religious movements — orthodox as well as heretical — that rose up after the eleventh century, the beguines demonstrated both a desire to withdraw from contemporary social life and a wish to be involved in it. These seemingly contradictory goals were embedded in the apostolic model that informed religious renewal and dissent in this age. The model celebrated the ideals of voluntary poverty, material asceticism, simplicity, and a more profound and introspective religiosity, all of which were favored by seclusion; yet it also emphasized the need for charity toward the weak and the sick, and advocated a greater attention to pastoral care in the world. In the male religious orders of renewal, like the Cistercians and the regular canons of Prémontre and Arrouaise, the conflict led to a fierce debate but was eventually resolved by decreasing the members' involvement with outsiders or allotting the tasks of charitable care and agricultural work to lay sisters and brothers.[1] The two tendencies, however, coexisted in the beguine movement throughout the Middle Ages.

Beguines' involvement with the world — what one might call their active apostolate — comprised three tasks: charity, manual work, and teaching. It was preceded by a conversion to a more contemplative life that, although it was not as definitive as the monastic vocation, nevertheless demanded a distinct break with social expectations.

## The Withdrawal from the World

Beguines chose to turn away from the world to devote themselves to a life of prayer, contemplation, and study in a variety of ways. Those who lived in town and were deeply involved in charitable work might retreat at night to a beguine convent that offered little privacy or tranquility. At the other end of the spectrum, some led a strictly solitary life as an anchoress, often immured in a cell close to a church. The great beguine courts occupied the middle ground: surrounded by walls on the edge of the city or even outside the walls, they formed islands of contemplation and seclusion whose inhabitants often worked in town

and to which many outsiders had access during the daytime. No beguinage ever enjoined the kind of monastic seclusion imposed for women by the traditional religious orders. The beguines' withdrawal from the world was thus more often the product of a mental construction than a physical reality, as Caesarius of Heisterbach so keenly understood,[2] but it did provide individual beguines with the support of like-minded women who wished to escape the entanglements of secular life. Beguines were particularly eager, it appears, to evade two obstacles to the spiritual life: the lure of material possessions and the obligations of marriage.[3]

*Material Simplicity*

The important social effects of the money economy in the newly urbanized southern Low Countries left their imprint on the *vitae* of the *mulieres religiosae*, which evoke a mental climate around 1200 that was increasingly sensitive to social differentiation, the pernicious influence of credit and business on social relationships, the rising divide between rich and poor, and the marginalization of the weaker elements in society, like lepers, the elderly, and the urban poor. Social change and the dangers of commerce feature in the very first pages of the *Life* of Lutgard of Tongeren. Thomas of Cantimpré explains that Lutgard came from a rather unusual family: her mother was a noble lady, but her father was a merchant and burgher of Tongeren. When Lutgard was still quite young, her father invested twenty marks in a business venture to generate a respectable dowry in anticipation of Lutgard's life in the world. Her mother was wiser and wished her to become a nun. Thwarted by Providence, her father's investment was soon lost, but her mother was able to reassure Lutgard that she could provide funding for admission to a "most distinguished monastery [*monasterium honestissimum*] if she decided to become the bride of Christ."[4] In 1194, when she was "just over twelve years of age," Lutgard joined the Benedictine monastery of St. Catherine's near Sint-Truiden; in 1216–17 she moved on to the stricter Cistercian monastery of Aywières, where she died in 1246.[5] The author of the Life, Thomas of Cantimpré, who wrote the book for the nuns of Aywières, thus presented Lutgard's vocation as a triumph of noble values and her mother's predilection for the monastic life over her father's commercial drive and materialism. For Thomas, a truly monastic retreat far away from the city was not only superior to life as a beguine, but also the appropriate answer to her father's foolishness.[6]

On various occasions, the *vitae* place the saint's distaste for material possessions squarely against the background of an expansive urban and commercial economy, driven by a spirit of usury and a voracious appetite for monetary wealth. Mary of Oignies was said to be so distressed by what she saw in the streets

of Nivelles that she mutilated the feet that had brought her there from her re-treat in Oignies, "because [at Nivelles] she dwelled in places where evil humans had provoked their Creator with so many injuries and pained him with so many disgraces."[7] Ida of Nivelles felt a pang of conscience when she learned that her father had provided her with a monastic dowry of forty pounds:

> She was disturbed in her heart because the money had been acquired, she thought, by means that were less than justifiable. When she consulted some loyal members of her extended family and friends, who had known her father's way of life very well, they tried to reassure her that it had not been gained by way of usury (upon which an anathema rested), but by legitimate commercial enterprises that her father had undertaken. There-fore, they said, she could use the money for any alms she wished to make. But she did not really believe them; a scruple preserved in her heart induced her to consult with that "One Counselor in a thousand" [Ecclus 6:6], Christ our Lord. She made a pact with him like this: "My sweetest Lord, please listen, I am worried about this money but if you wish out of your ineffable goodness to increase the grace of Your spirit in me, I shall be satisfied and no longer question whether the money was gathered by sordid means [cf. I Pet. 5:2]. Otherwise, my heart cannot find consolation for its anguish." . . . And the Lord showed her how willingly He accepted such a laudable proposal of the heart, and he multiplied His grace in her heart so much that her tiny spring grew into a great river, and from the tiny spark a greater fire was kindled.[8]

Juetta of Huy also agonized about whether a profit gained from an invest-ment was not sinful, and Mary of Oignies harbored guilty feelings because her mother had made a profit from usury and "fraudulent" trade.[9] But Ida of Louvain mounted the most direct attack against the world of commerce. Her mother did everything she could to expose her to the benefits of mass and the delights of the Eucharist, with the result that, by the age of eighteen, she viewed her merchant father's

> wealth as ill-gotten gain, and her conscience gnawed at her over it until she abstained from it as from a deadly poison. . . . Her father was really a man quite given to worldly concern and taken up with secular cares in no mean measure. When he noticed how his devoted daughter was doing all she could to get away from what he had spent (and continued to spend) his days greedily amassing, how she treated it all as dirt, as fouled with the filth of avarice, his mind lost all contact with upright intention, and he began to vomit his stirred up gall all over her. Losing all restraint, day after day he would beat with the harsh blows of his curses this girl, so innocent, so commendable, so unused to answering back. . . .
> Once when Ida's father had just stocked a number of casks of wine in his cellar and, in his eagerness for earthly gain, was displaying them for sale, his daughter sent her per-sonal servant to him to ask that she be allowed a measure of wine in advance, to be repaid later in cash. . . . She thus meant to signal her intention to buy what she could rightfully make use of without any question of sale at all, counting as her own these goods that she was free to use as she chose. Her father later overheard the domestics telling the story and he thus learned why the matter had been arranged in this way. Quite put out, he forth-

with brought the whole force of his fury to bear on his daughter. . . . But the Lord . . . took the headstrong father to task and showed his esteem for the devout daughter's patience, by means of a clear-cut and extraordinary miracle. For no natural or seasonal reason all the wines he had amassed in his storage barrels at that time turned bad; suddenly they started frothing and lost their color as well as their flavor. . . . Seeing it, her father growled aloud in a furious rage with no idea of what to do or where to turn. . . . On the other hand, when news of all this reached Ida, she completely forgot about the wrongs her father had done her, and instead felt the most affectionate compassion over his grief and betook herself to implore her all-considerate God most insistently that her father be forgiven the wrongs he had done her and that the disaster of the wine, for whose loss he was so upset, be made good. The Lord in His kindness promptly heard her and forthwith expelled the contagion from all the storage casks.[10]

One can hardly imagine a harsher indictment of retail business, even though the author never explicitly condemned it. What Ida's real thoughts on the matter were—as opposed to her hagiographer's—may ultimately elude us, but we do know that the lines between legitimate and sinful business practice were not yet firmly drawn in the early thirteenth century. As Lester K. Little and Jacques Le Goff have shown, Europe did not easily adapt itself to the more complex moral environment created by the profit economy since the eleventh century: it was only from about 1200 onward, and primarily in the second half of the thirteenth century, that theologians—mostly friars—devised sophisticated regulations and rationalizations to accommodate trade and credit and the moral questions they posed.[11] Before that time, preachers and satirists tended to depict all commercial activity, and many other typically urban trades, as inherently suspect. Avarice was the most heinous vice, moralists asserted in the eleventh and twelfth centuries, and money-lending against interest, or usury, its most egregious manifestation since it was based on appropriation of time belonging to God alone. According to Honorius Augustodunensis, who lived in the early twelfth century, all merchants, whether they engaged in banking or not, would have difficulty gaining salvation because virtually all they earned they got by fraud, lies, and a selfish desire for gain.[12] These critics of business practice appear to have been especially active in the southern Low Countries in the late twelfth and early thirteenth centuries. It is not hard to find reasons for their special interest in these lands, the main hubs of trade in northern Europe: while money-lending in other parts of Europe was a quasi-monopoly of a few specialized Italian, southern French, and Jewish businesses, it was here an important source of profit for all kinds of native merchants.[13] Fulk of Neuilly, Robert of Courson, and James of Vitry himself preached in these regions against usury between 1195 and 1215, as did John of Cantimpré, the abbot of the canons regular of Cantimpré near Cambrai in 1180–1205/10.[14]

That commercial enterprise and usury were still firmly paired in the moral-

ists's mind in the early thirteenth century is demonstrated by James of Vitry's four model sermons "to merchants and money-changers," composed between 1226 and 1240 but based at least in part on his experience as a preacher in the Low Countries and France before that time. Three out of the four sermons were built upon a biblical theme condemning usury, and more than half of the exempla in the sermons dealt with usury.[15] His outlook on the profession was shaped by what Jacques Le Goff has called the "moralizing and pessimistic" features of his preaching function: he operated on the assumption that it was better to warn against potential sin than to praise uncertain virtue. Nor do we find much trace in James's sermons of the more forward looking efforts made by theologians like his former master at Paris, Peter the Chanter, to establish the notion of a "just price" in the world of trade and credit.[16] But James admitted that trade could be a legitimate occupation if the abuses of usury were avoided, that there were good and bad merchants, and most important, that a tradesperson might earn salvation by donating to charity.

The *Lives* of the Low Country *mulieres religiosae* thus accurately reflect the views on trade and credit held by many moralists and theologians of the early thirteenth century. Sharing the theologians' suspicions of the corruptive power of money, the *Lives* prescribed charitable work as an instrument of redemption. They also make it clear, however, that the *mulieres religiosae* did such penance for the sins of others:[17] Mary of Oignies, Ida of Nivelles, Ida of Louvain, and many others described in the *vitae* rejected their parents' profession and wealth because their businesses were tainted by speculative gain. Voluntary poverty enabled them to redress the injustices created by the search for greater wealth; liberated from the social obligations of property, they could devote their life to the care of the indigent.

Their stories recall those of the many male merchants, from the orthodox Godric of Finchale to the heterodox Valdes of Lyons, who resigned their trade and lived like hermits or apostolic preachers in the latter part of the twelfth century, but they form a particular striking pendant to that of their Mediterranean contemporary, Francis of Assisi, who disassociated himself publicly from his father's wealth in 1205–6 and gave it away to those in need.[18] The similarities between the lives of the *mulieres religiosae* of the southern Low Countries and their contemporaries, the first Franciscans of Umbria and Tuscany, apparently also struck James of Vitry, who on his way to the Levant, in October 1216, sent his friends in Brabant and Liège an enthusiastic report on the goals and ideals of the Franciscans, whom he described in much the same terms as he did the beguines.[19] In several studies, the Capucin historian, Alcantara Mens even called the southern Low Countries of about 1200 "the Umbria of the North," because they "displayed all the characteristics of the kind of piety one encountered

around the same time, or even somewhat later, in Umbria," among the Friars
Minor of Francis and their female followers.[20]

Like Francis, these women turned their back on their commercial or bour-
geois milieu to embrace voluntary poverty and work among the poor and lepers.
Juetta of Huy sold all her property and distributed the profits as alms after her
conversion to beguine life, to the great distress of friends and family oversee-
ing her children's estate. Similarly, Mary of Oignies and her husband gave away
all they had to nurse the lepers of Willambroux.[21] Many of the *mulieres reli-
giosae* marked their conversion by casting off their fine clothes in favor of the
most wretched rags in a fashion closely resembling Francis. According to James
of Vitry,

Mary of Oignies, through the spirit of fear for God, conceived such a great love for
poverty, that she barely wanted to possess even the necessities of life. She thus made plans
one day to flee so that, unknown and despised among strangers, she might beg from door
to door, and naked she might follow the naked Christ.[22] She burned with such a desire
for poverty that she took with her a little bag to collect alms and a small bowl for water
or to keep food donated to her while she was begging. Even the copious tears of friends
could barely restrain her, but when this poor little woman of Christ had said her farewell
and wanted to take the road clothed in rags, with her little bag and bowl, her friends who
loved her in Christ sorrowed so much and so many tears were shed that she could not
endure it and was filled with compassion. . . . She chose to remain because . . . her absence
would have seemed intolerable to her brothers and sisters [of the religious community
at Oignies]. But afterwards she persevered in such love of poverty that at times she cut
up her tablecloth or other linen to give it away to the poor, keeping only small pieces for
herself.[23]

With his usual vigor, the author of the *Life of Ida of Louvain* described her con-
version to a life of poverty in a scene that could be drawn from Francis's life
itself:

She dashed to a recluse's nearby cell, threw off her own garb, wrapped herself in a de-
spicable piece of fabric, draped a shabby cloth over it as a mantle, and wound a filthy
rag around her head so that only her face was visible. She looked disgusting, but in that
manner she walked the busiest streets and squares of the town, especially those where
she had previously appeared in grand style and had haughtily dazzled the public with
her fashionable appearance. Now she walked the same route as a horrible spectacle, a
crazy fool.[24]

Poverty, however, was never as central, and as absolute, an ideal for be-
guines as it was for Francis and the early Franciscans, who made it the most
fundamental tenet of their religious *propositum* and rejected all individual and
collective property so that public begging of alms gradually became their normal
means of existence.[25] The early beguines did not condemn property per se, only

its misuse and excesses. Income and property gained through lawful means, for instance through manual labor, and required for the necessities of life were not to be spurned. Moreover, a life based solely on begging for alms was not possible for women. The Fourth Lateran Council of 1215 allowed public questing only if properly licensed by the Holy See or by a local bishop. Francis obtained such a license for himself and his fellow brethren, but rarely, if ever, was it granted to women.[26] Goswin of Bossut, in his *Life of Ida of Nivelles*, did mention that Ida, serving her beguine companions at St. Sépulchre "like a new Martha" [Luke 10:38], "went out in the streets and alleys of the town to beg for clothes and shoes, for bread, meat and other comestibles, both from her own relatives and from people she did not know; she would bring everything back in a bag and distribute 'as each had need' [Acts 2:45; 4:35]." She collected these gifts, however, for "those who were feeble and in need," not for herself, and the events also preceded the decree of the Lateran Council.[27] Although James of Vitry may have completed the *Life of Mary of Oignies* before learning of the new prohibition, he certainly knew that the Church disapproved of public begging by women. Ever so eager to corroborate Mary's orthodoxy, James assured his readers that she never actually did so, claiming, as we have seen, that her love for her companions made her abandon those plans. In his introductory overview of the beguine movement, he further asserted that "not one among this great multitude of holy women was found in the whole diocese of Liège who was forced either to die of starvation [during the great famine of 1195–97] or to beg publicly, even though they had already given up everything for Christ."[28] Writing around 1239, Thomas of Cantimpré declared that Christina of Sint-Truiden "used to beg from door to door every day to bear the sins of the people who fed her," and got sick whenever anything she was given to eat had been acquired illicitly; she did not beg, however, for herself.[29] In his *Life of Margaret of Ypres*, completed the following year, he made it clear that her confessor, the Dominican Zeger of Lille, tried to stop her begging for alms on behalf of lepers. On the occasions that she did beg, Thomas suggests, she acted indirectly for the Church:

She wore an ugly, humble habit and rejected new clothes — she would always say: "I am only a poor little woman, for whom old and worn clothes suffice," because she carefully kept in mind the poverty of Christ. Whenever she ran away from her mother and aunts in order to go begging, her spiritual father would command her to return and stay home with her mother. . . . When lepers stood in the middle of the road to beg and asked something from her coming along, she tearfully told them: "I would gladly give to you, if only I had something to give. Let me beg for you, however, and let us see if I can get something." Promptly the humble maid of the Lord knelt down before the passers-by and begged for an obol. It would truly have been a cold and unrightful person who would have refused such a poor little woman. Whatever she got, she gave to the lepers. From then on, her parish priest would give her an obol so as to satisfy his conscience as well as the beggars.[30]

These restrictions obviously limited the beguines' ability to support themselves through alms in the Franciscan fashion. Instead, beguines relied on manual labor for sustenance. What they earned by the work of their hands served both to feed and clothe them and to aid the poor and the sick. One cannot overemphasize the importance of the innerworldly component — to use Max Weber's terminology — of the beguines' withdrawal from the world: the detachment from material comfort and wealth made their active charity among the disadvantaged of the world possible, setting the mind free on its road to God.[31] James of Vitry stated that Mary worked with her hands until her very last days to feed not only herself and her companions, but also those in need outside her small circle; Ida of Nivelles and Ida of Louvain also worked for the benefit of the urban poor.[32]

Perhaps a more fitting parallel may be drawn, then, between the beguines and the Humiliati or "Humbled Ones" of northern Italy. The movement of the Humiliati originated in Lombardy around 1170 as a loose association of devout lay men and women. When it received papal approval in 1201, it was composed of three parts: a clerical wing of canons and canonesses; a monastic order of cloistered monks and nuns; and a lay association of mostly married men and women who lived with their families and had only limited religious obligations. As their name indicates, the Humiliati advocated a "humble" Christian lifestyle that prescribed simplicity and charity but allowed members of the third group to own personal property, to marry, and to be work professionally. They, too, condemned usury, stressed the need to "live by the work of their own hand," as James of Vitry noted in 1216, and applied what exceeded their needs to charity.[33]

Like the Humiliati, beguines did not take a vow of poverty. Except for those who were received as inmates in the infirmary and were supported by the community as indigents,[34] beguines were allowed to possess property, as did the community (convent or court) as a whole. All that was required of them was restraint: they were to live soberly ("to always love poverty and soberness, since they will lead us to all virtues," as the early sixteenth-century statutes of the beguinage of Diest advised so typically),[35] to avoid the display of wealth, and to share what was not necessary. The simplicity of their residences, furniture, tools, and clothing, characterized beguine life until the twentieth century.[36]

*Rejection of Marriage*

It was common in medieval hagiography to mark the saint's final conversion to the religious life with a reference to his or her consideration, and rejection, of marriage. That decision usually led to a conflict with the saint's parents, who had arranged the marriage or at least had sought out a possible partner. The

pressure to accept the parental choice was immense, especially for women, who rarely had a say in the selection of marriage partners.[37] The *vitae* of the *mulieres religiosae* often follow these conventions. Ida of Nivelles ran away from home when she was only nine to escape marriage. Lutgard of Tongeren was courted by several men while she was only a young girl, but refused them all; during her stay as a lodger at St. Catherine's of Sint-Truiden, before she took her monastic vows, one of them tried to rape her and force her into marriage, but she escaped miraculously. The eighteen-year-old Margaret of Ypres briefly fell in love with a man before her conversion experience, and felt "faint stirrings of passion" for another man shortly afterward, we are told.[38]

The *Lives* of Juetta of Huy, Mary of Oignies, and Odilia of Liège follow less familiar patterns. According to her hagiographer, Juetta strenuously objected to the marriage her parents had planned for her: "The girl, who wisely intuited what experience had not yet taught her, knew that the married state was a heavy yoke, as were the awful burdens of the womb, the dangers of childbirth, the education of the children; and on top of all this, the fate of husbands was so unsure, there was the care of the family and household, the constant worries about the daily work. So she rejected all husbands, imploring her father and mother by all means that they would leave her without a man."[39] She finally gave in to the demands of her family and their network of friends in the town, and married a man with whom she had three children. After five years of marriage, her husband died, and she successfully thwarted all plans for a second marriage, gaining the freedom to divest herself of her wealth and to work on behalf of lepers at Huy, against the objections of her extended family.[40] Mary of Oignies also reluctantly agreed to get married when she was fourteen years old, but convinced her husband, John, to live in chastity shortly afterward, joined to her in a "spiritual marriage" (*matrimonii spiritualis nexu*).[41] According to James of Vitry, she was not the only one to do so: in the prologue of the *Life of Mary*, he recalled to bishop Fulk of Toulouse "the many holy women you were happy to see [in the diocese of Liège], serving the Lord devoutly in matrimony, raising their sons in fear of God, guarding an honest marriage and 'an undefiled wedding bed' [Matt. 13: 18]. . . . Abstaining from licit embraces with the consent of their husbands, they led a celibate—yes, an angelic—life."[42]

Similarly, the parents of Odilia of Liège engaged her to a man when she was only seven; eight years later she was forced to marry but managed to avoid all intercourse for five years. She then gave birth to a boy, named John. Five years later, the death of her husband released her from sexual activity. Around 1203, she conceived ecstatic images of Christ's passion, followed by visions during the Eucharist of him as an infant that cured her of sinful thoughts. She henceforth devoted herself to a celibate life in the world, even though her vow was threat-

ened on more than one occasion by lascivious clergymen, her hagiographer tells us.[43] Her son, nicknamed "the abbot" since childhood, shared her love of chastity and ultimately became a priest following a promise his mother had privately made to God. He formed a beguine convent in one of his houses in the Ile près de la Madeleine of Liège, which he endowed shortly before his death.[44]

The authors of the *vitae* used strong language to describe their heroines' aversion to the married life, particularly to sex. On the eve of her marriage, Odilia's fiancé reportedly asked her whether she loved him; she replied that she would have his throat cut, if only she could.[45] Similarly, Juetta of Huy hated sex so much that she wished her husband dead.[46] The sensual feelings she and other women experienced were usually represented as demonic assaults, a common theme in the *vitae* of the *mulieres religiosae*.[47] As a corollary, Juetta of Huy's hagiographer assures us that her revulsion for the sexual act after her marriage was a "natural mental impulse." Once the demonic attempts were dispelled, the saint regained a state of innocence in which she could truly exploit the natural grace that God gave her.[48]

Most important, the *vitae* taught that chastity, as distinct from virginity, was worthy of praise. It should be coupled with charitable efforts like those of Juetta of Huy, for instance, who helped others who were troubled by sexual temptation to be true to the celibate ideal, or Mary of Oignies, who persuaded her husband to remain chaste with her.[49] Indeed, the beguines' militant advocacy of continence among married people became proverbial: in the mid-fourteenth century, Catherine of Sweden (St. Bridget's daughter), who lived in a chaste marriage, was angrily accused by her brother of turning herself into a beguine and attempting to do the same with his wife, making her an object of gossip.[50] But the point made by the *vitae* of the *mulieres religiosae* was no less certain: women like Juetta, Mary, and Odilia, who vowed themselves to a life of chastity after marriage and to works of charity, deserved just as much praise as physical virgins. Caesarius of Heisterbach included in his *Dialogue on Miracles* a discussion between a monk and a novice about the respective merits of virgins and married people. The monk explained that although in theory virgins were better, in practice this was not always true: "Indeed, among married people and widows, there are many who have more merit than many virgins because merit does not lie in physical integrity, which even heathens have and which is not a virtue in itself, but in charity." And he went on to recommend three types of chastity: the chaste life of virgins, who lived in "virginal continence" (*continentia virginalis*); that of married people who lived in "conjugal modesty" (*pudicitia coniugalis*); and that of widows, who practiced "widowed continence" (*continentia vidualis*). The thirtyfold reward bestowed in heaven on those who were married (according to the conventional ranking popularized by Jerome) could in fact be greater

than the hundredfold one reserved for physical virgins, because of their greater charity.[51] This is probably why James of Vitry wrote that Mary of Oignies, after converting her husband to a chaste marriage and choosing a life of penance among the lepers of Willambroux, was granted back "the hundredfold reward in this world."[52] These findings confirm the observations of Clarissa Atkinson and others, who have noted that from the twelfth century onwards, the ideal of "spiritual" virginity vied in importance with that of physical virginity, although theologians continued to stress that the latter held greater rewards in heaven.[53]

The condemnation of sex and marriage that looms so large in the *vitae* of the *mulieres religiosae* cannot be attributed solely to the monastic ideals of their authors. Of course, these hagiographers frequently borrowed from an ancient, largely monastic, literature denouncing the "nuisances of marriage."[54] Yet they unquestionably described real attitudes that were common among lay women in the southern Low Countries. Archival documents from beguinages sometimes testify directly to the fact that beguines indeed regarded their life as an alternative for, or rather, as an escape from, marriage. For instance, in 1242, countess Joan of Flanders ordered her officers and aldermen in the county to protect "all maidens who converted to the Lord and went off to live with beguines in their houses . . . renouncing the world and its concupiscence," against those who "put severe pressure on them, violently take them away from the beguines, or appropriate their goods."[55] Her successors reissued or confirmed the order at regular intervals until the mid-fourteenth century.[56]

Despite these measures, a group of three men and a woman abducted a young beguine of Bruges to force her into marriage in late 1344 or early 1345. The effort failed, and the abductors were tried before the aldermen of Bruges.[57] The main perpetrator was Lievin van Aerlebeke, son of James of Male, who belonged to a Bruges family but probably lived in Harelbeke, some thirty miles south of the city. Along with his brother, John, a servant, Gheerkin, and a female accomplice, Lisebette van Dudzele, Lievin entered the beguinage of the Wijngaard of Bruges and "violently carried away" (*ontvoerden ende namen met crachte*) a certain Kateline, daughter of Bouden Vedelaer, "in order to marry her against her will and despite her cries for help" (*omme huwelijc met hare te doene haers haers [sic] ondanckens ende tieghen haren wille, ende helpe roupende*). Alerted by the beguines, the bailiff of Bruges, who was the comital officer appointed to protect them, organized a posse of men that included not only his adjunct but also urban police officers to pursue the abductors, a sure sign that the matter was taken very seriously by the authorities.[58] They finally arrested Lievin and his helpers in Roeselare on the road to Harelbeke. Kateline returned safely to the beguinage after a night in a shelter at the Burg of Bruges. Her screams for help while resisting Lievin and his accomplices, explicitly mentioned in the trial's

verdict, were crucial evidence in Flemish law: they defined the crime as violent abduction rather than as elopement, which would have carried a lesser sentence. Lievin was banished from Flanders for 100 years and a day; his accomplices were each sentenced to six years of exile and a fine of 50 lb; they also lost all of their property.[59] We do not know anything about the victim, Kateline, except that her family probably belonged to the well-to-do elite of the *Vrije*, the rural district around Bruges, and that her father and brother held fiefs from the count. Laying a hand on her part of the estate was almost surely one of Lievin's motives.[60] In late 1360, another "Lievin," Lievin Banghelin junior, was exiled for having tried to rape a woman at night in the beguinage of St. Elizabeth of Ghent "to get her property."[61] In a very similar case, one hundred years later, a certain Egied de Drivere violently abducted by night Katherina vander Hulst, a widow living in the beguinage of Aalst; he was tried before the official of Brussels, and the beguines of Aalst subsequently requested a special privilege from Duke Philip the Good, granted in 1459, to protect them against "those who take by force the good women and young girls from the beguinage to ravish them and do as they wish to them," acts that, the beguines maintained, were committed "daily."[62] These were indeed not isolated cases. As Walter Prevenier, Marc Boone, and Thérèse de Hemptinne have shown, members of the most prominent families were involved in schemes to abduct or rape single women and widows with property in order to force a marriage.[63]

In addition to offering protection for those wishing to escape an arranged or forced marriage, beguine communities helped girls and women earn an income for themselves as an alternative to marriage. Patrons of the beguines often granted property or rents to a beguine community with instructions to apply part of the income to the sustenance of a specific member of the beguinage, usually a relative, on the condition that she remain a beguine; if she left the community to get married or for any other reason, she and the beguinage forfeited the income.[64] Beguines similarly supported young girls or widows in their endeavors to lead the beguine life. Of the thirty-seven wills made by beguines of St. Catherine's of Tongeren between 1264 and 1338, eighteen contained bequests to particular women on the explicit condition that they become or remain beguines; if they did not, the gift reverted to someone else or to the beguinage's infirmary.[65] The beneficiaries of such gifts were usually young girls, who would thus be enticed to join a beguine community before reaching the nuptial age. In 1471 Criste Tsflogheleere, a beguine at St. Alexis of Dendermonde, left her rights to half of a house in the beguinage to any daughter of her brother who expressed a desire to become a beguine before she was fifteen.[66] Shortly afterward, Christine Coucke, a beguine at St. Elizabeth of Kortrijk, bequeathed her house

in the beguinage to her grandchild, Jaenkin 't Kint Joos's daughter, who was then eleven years old and probably lived with her; the sole condition was that Jaenkin promise to take her vows as a beguine when she became twenty-four, possibly the minimum age for profession at St. Elizabeth's.[67]

A will made by the beguine of Tongeren, Elizabeth of Berg, at the end of the thirteenth century, even offered help to a married woman. Elizabeth herself had been married to a man called Renier. After his death between 1279 and 1290–91, she became a beguine at St. Catherine's of Tongeren. She had no children of her own, but two of her nieces, also residing in the beguinage, were recorded in her will, as was a niece of her late husband, Jutta, who was a beguine in an unknown community. Wealthy, with extensive property in the city and its environs, Elizabeth owned a house at St. Catherine's that had five rooms: she and her maid, Basilia, lived in two large rooms on the ground floor; the three small attic rooms were occupied by "poor" beguines. Elizabeth granted all of them "living rights" to their respective quarters in her will. She reserved the rights to her own room, however, for Margaret, daughter of a certain Albert of Henis, "should she be able to liberate herself from her marriage and desire to live in the beguinage in honesty and peace" (*si eam contigerit a matrimonia liberari et in beghinagio voluerit honeste et pacifice conversari*). A draft version of the same will put it somewhat differently: it stated that Margaret had resided at St. Catherine's for a while before her marriage, perhaps as a young girl, but now there was a chance that her marriage might be dissolved so that she could come back to the beguinage (*si tamen dissolva matrimonia at beghinagium redire contigerit*).[68] We do not know on what grounds Margaret sought the annulment of her marriage (for nonconsummation?), but she apparently succeeded in doing so and returned to St. Catherine's; at least, a beguine of that name (Margaretha de Henis) made her own will there in 1334.[69] These practices explain why bishop Bruno of Olmütz in 1273 accused beguines of "fleeing the constraints of marriage."[70]

It is perhaps because beguines strove for continence rather than virginity, and acknowledged what strong pressures could be brought to bear on individual beguines to get married, that some medieval rules for beguine communities showed great tolerance for beguines who strayed from the right path. The oldest statutes for St. Catherine's beguinage of Mechelen, which date from 1286–1300, stated that "the beguine who has the misfortune to become pregnant, shall be removed from the beguinage for a year as soon as her condition becomes obvious; afterwards, if she demonstrates good behavior attested by good witnesses, she will be re-accepted into the community."[71] The statutes for St. Catherine's at Tongeren of 1453 also allow the return of a fallen beguine after a year, except if her sexual partner was a cleric or married man.[72] The remarkably mild punish-

ment—recalcitrant beguines, for instance, who questioned the authority of the grand mistress were usually removed for life—made it possible for the woman to raise the child in the beguinage rather than to be forced into an unwanted marriage or lead a life of prostitution. It may have increased suspicion of the beguines' "loose" lifestyle, however, and the provision to reallow such women was dropped from later rules for the two beguinages.[73]

Some beguines chose an extreme form of retreat from the world as recluses or anchoresses. Their eremitical life was certainly not new: it had been known since the earliest days of monasticism and was a creative component of the apostolic movement of the eleventh and twelfth centuries, when, as has been seen, lay hermits were active preachers and founded new religious houses in many parts of the Low Countries.[74] The eremitical tradition changed, however, around 1200: until then, hermits usually sought sites far from human habitation, but hermitages of the later age were most often found in urban centers, where the environment provided financial support and a receptive audience for the recluse's teachings. By the thirteenth century, anchorholds flanking churches and chapels were quite common in cities and towns of the southern Low Countries.[75] The transition to the city accompanied another, important change: whereas most known hermits of the eleventh and twelfth centuries were men, the new anchorites were usually women, almost invariably immured for life in the anchorhold.[76] It is fair to surmise—though impossible to substantiate with hard data—that between 1200 and 1500 more women than men chose solitary and permanent confinement in a cell close to an urban church or chapel. Southern Low Country wills and other documents of the age record numerous gifts to anchoresses but rarely to male recluses.[77] Beguines who chose this form of life thus engaged in a religious vocation that by 1200 had become largely or even exclusively female. Their mental concentration on the Eucharist, the prominence of their physical space, so closely linked with the sacred space around the church altar, their fasting and other endurances, and the advice they handed out to visitors often gave them a social resonance in the urban community that few religious men could equal.

The formation of these anchorholds near churches was undoubtedly stimulated by the new custom of preserving consecrated hosts not in the vestry but in the church, usually in pyxes, specially designed receptacles hanging over the main altar.[78] They appeared in the southern Low Countries rather early, in the twelfth century, perhaps in response to the strong Eucharist current that governed popular religious practice in the region and gave rise to the creation of the feast of Corpus Christi in the thirteenth century. The hanging pyx and the lamp accompanying it were clearly visible markers of the Eucharist presence that could be observed at all times by the recluse from her anchorhold, which had at

least one small window with a view of the altar. Mary of Oignies sent a man to contemplate the pyx in church in order to assuage his religious doubts.[79] Ida of Louvain has a vision of the pyx greeting her in church.[80] In 1177, Margaret, an anchoress at St. John's of Liège, established a fund to maintain a lamp for the pyx in the church, a custom maintained by many beguines in later centuries.[81] Several *vitae* of the era convey how much anchoresses—and beguines—longed for the Eucharist presence and gained sustenance from observing it.[82]

Our survey of the primitive beguine communities in the Brabantine and Liège areas revealed their close interaction with anchoresses like Jutta of Borgloon, Eve of St. Martin, and Heldewidis of Willambroux, who evidently played a pivotal role in the religious education of those early beguines. Some beguines viewed the strict solitary life as the culmination of a life of penance and charitable action in the world, and were eager to retreat to a cell to pursue the contemplation of God in its most perfect form. From there, they might instruct their sisters and younger disciples, liberated from common bonds to the world. Juetta of Huy, for example, decided to enter an anchorhold when those who depended on her had died, and she "felt as if liberated from all the burdens of this life, and chose to serve the Lord under an even stricter vow; abandoning the service of Martha, she gave herself entirely to the part of Mary, which is the best, and had herself enclosed . . . in a little cell . . . that had been built next to the church." [83] Immuration for life in a cell attached to a church was unusual for beguines, however. While Juetta of Huy (and her three companions), Mary of Willambroux, Juliana of Mont-Cornillon, and perhaps Uda of Thorembais ended their life as anchoresses, others, like Mary of Oignies, preferred a looser form of the eremitical life, in which the recluse could at times leave her cell. Still, at least four beguinages were formed as "anchorages": Dendermonde (Kluis), Nivelles (Willambroux), Oudenaarde (Kluis), and the beguine convent of Ten Hamerkine in Bruges.[84] In other beguinages, a beguine might be given the opportunity to live in an anchorhold attached to the central chapel of the beguine court. Such beguine anchorholds are known in the court beguinages of Mechelen (Klein Begijnhof) in 1266, Mons (Cantimpret) in 1270, Sint-Truiden in 1293, Assenede between 1296 and 1351, Herentals in 1408, 's-Hertogenbosch (Groot Begijnhof) from 1490 until at least 1620, and Bergen op Zoom in 1563.[85] Joan d'Anthée, a beguine of Liège, had herself immured at the church of St. Catherine, next to the cell of another recluse, Agnes d'Anthée, "her friend" (*amice eius*), in 1392.[86] In other places, beguines helped to support anchoresses living outside the beguinage with rents, bequests in wills, or by personal visits; we find examples of this devotion to anchoresses in the thirteenth-century *Lives* of Juliana of Mont-Cornillon, Lutgard of Tongeren, Ida of Gorsleeuw, Ida of Louvain, and Ida of Nivelles, but also in

later *Lives*, like that of Petronilla, an anchoress at the church of St. Nicolas out-side the walls of Mechelen between 1440 and 1472, whom beguines of Mechelen visited and nursed in her final illness.[87]

## Charity

In caring for the poor, the sick, and those who were explicitly rejected from the social body, the lepers, beguines responded to a spiritual ideal as much as to a social need.[88] Charitable work of this nature had been part of the religious pro-gram of many new orders but their institutions were often located in rural areas and dispensed charity primarily to pilgrims. As the population in the southern Low Countries grew and became more urban, new institutions staffed by lay men and women emerged in the most important cities and towns: St. Omer, Cambrai, Tournai, Arras, Ypres, Liège, Bruges, Ghent, Brussels, Huy, Mons, Tongeren, and Douai, all had at least one hospital for the needy and sick by the year 1200.[89] James of Vitry, writing the *Historia Occidentalis* in 1221–23, referred to the hospi-tal movement as a force of renewal in the western Church and cited the hospitals of Tournai, Liège, and Brussels, among others, as "hospices of piety, houses of honesty, workshops of holiness, convents of the right and devout life, refuges of the poor, sustenance to the wretched, consolation to those in mourning, refec-tories for the hungry, comfort and relief for those who are ill."[90] The list of new institutions of charity grew even faster in the thirteenth century but still lagged behind the social needs of these cities. By 1250–75, excessive migration to urban centers, a growing disparity of wealth, and an intense polarization between vari-ous urban groups caused social unrest and massive layoffs in the most advanced regions of the southern Low Countries.[91]

Beguines originally provided care to men and women alike. The early groups around Juetta of Huy, the young Ida of Nivelles, Ida of Louvain, and dur-ing her stay at Willambroux, Mary of Oignies, worked for lepers and the weak for many years. Although the *Life* of Juliana of Mont-Cornillon says little about it, some of her female mentors took care of male and female lepers in Liège, as did her followers at the leper house of Mont-Cornillon. In their institutional-ized communities, however, beguines concentrated their efforts on urban and rural women who where elderly, had fallen ill, were destitute or without shelter. The court beguinages of Borgloon, Ghent (Groot Begijnhof), Lille, Mechelen, Tongeren, Valenciennes, and perhaps also of Bergues and Liège (St. Christophe) were formed by beguines working as nurses in or near a preexisting hospital.[92] In the courts of Antwerp (Sion), Assenede, Cambrai (Cantimpré), Diksmuide, 's-Hertogenbosch, Maubeuge, and Mons (Cantimpret), the infirmary was one of

the original buildings of the beguinage,[93] and in numerous others it was erected not long after the beguinage's foundation. It was in the name of the infirmary that many early beguine institutions received donations of lands and rents to be used for the care of the sick and the indigent. Convents were also founded for the explicit purpose of caring for elderly, sick, or needy women. Those of Antwerp (Klapdorp), Arras (St. Anne), Bruges (St. Aubert), Brussels (Ter Arken), Douai (Wetz), Ghent (Poortakker), Louvain (Wierinck), Mons (*de le Taye*), and Ypres (Baerdonc) were created as beguine hospitals, while many small convents were specifically intended as shelter for poor women. In the thirteenth and fourteenth centuries, the charitable function of certain convents was so obvious that some sources used the terms "beguine hospital" and "beguine convent" interchangeably.[94] These charitable endeavors remained central to many beguine institutions until the end of the Ancien Régime. They also helped to ensure their survival during the Revolutionary era, when French Republican authorities suppressed all religious institutions (including some beguinages) but allowed beguine hospitals to reopen under the auspices of the *Bureaux de Bienfaisance*.[95]

In the last decades of the thirteenth century, when the growing population of many court beguinages—and the growing number of poor beguines—placed a strain on their resources and accommodations, there was a tendency to reserve charitable care for beguines of the court and their relatives. If space was available, however, an outsider received care, especially is she was a poor beguine living alone in town, lacking the support structure of a beguinage. In 1300, two beguines of St. Elizabeth of Ghent donated their house in the beguinage to the poor of the court supported by the dole, but ordered that one bed in the house should be set apart "so that poor beguines from outside can rest there" (*ende .i. bedde den vremden armen beghinen op te rustene*).[96] Beguines also provided charitable services—either salaried or voluntary—in the city. The beguines of Anderlecht, Braine-le-Comte, Mesen, Thorn, and other institutions worked as nurses in urban hospitals, collegiate churches, and local nunneries.[97] Those of Mechelen (Groot Begijnhof) and perhaps also of Antwerp (Sion) originally took care of elderly clerics but shifted their care to women within a few years.[98] Individual beguines sometimes worked outside their own institution as caregivers for single women and/or their children. In 1297, for instance, Sandre Colemer, a lay widow of Tournai unaffiliated with any of the city's beguinages, left in her will not only bequests to the beguine court *des Prés* but also to "the beguine who [was] taking care of her."[99] Ysabiaus de Warlaing, a beguine of Douai, headed the staff of Saint Jehan des Trouvés devant St. Pierre, the city's hospice for foundlings, in 1355.[100]

Presumably, some beguines were not only experienced nurses but also received medical training, for instance in the treatment of leprosy, but such ex-

pertise has unfortunately remained undocumented.[101] Certain beguinage stat-
utes expressly forbade them to work as midwives, which means, of course, that
some actually did. Midwifery was prohibited, for example, by the statutes of
St. Catherine's of Mechelen in 1286–1300, by the fifteenth-century rules of the
beguinages of Sint-Truiden and Geraardsbergen, and by the statutes for the be-
guinage of Hoogstraten, issued in 1509.[102] The rule of 1551 for the beguines of
Dendermonde permitted them to come to the aid of a woman in childbed only if
the mother's life was in danger; the statutes of 1489 for the beguinage of Heren-
tals stipulated that a beguine could give such care only to her mother or her
brother's sister.[103]

Perhaps as an extension of their work as nurses, but surely also because their
prayers were held in high regard, beguines were often asked to assist the dying,
lay out the body, conduct wakes, and accompany the dead to their grave. It was
common for them to read the psalter during the night after the death of one of
their sister beguines. In her will of 25 April 1316, Sainte Glachons, a beguine of
Tournai, bequeathed "to the twelve beguines who will read the psalms of David
around my body on the night of my death, 12 d. par. each."[104] The oldest rule of
the Wijngaard of Bruges, which dates from the early fourteenth century, recom-
mended that when a member of a convent in the court beguinage died, "one half
of the convent will keep the wake during half of the night, the other half for the
rest of the night until dawn."[105] The oldest statutes of St. Catherine's of Mechelen
did not permit beguines to keep wakes for outsiders, except for the lord and lady
of Mechelen, or for the bishop of Liège and the priest of the beguinage.[106] The
stricter beguine rules of the fifteenth and sixteenth century eliminated beguine
involvement with funeral services outside their community entirely, but until
about 1450, they may well be regarded as "specialists of death."[107]

The beguines' concentration on saying the Aves (as evidenced in the oldest
rule for the beguines of Ghent[108]) and reciting the Psalter of the Virgin in their
daily prayer routines, which must have been well known to the public, may
have helped to popularize their funeral roles outside their own communities.
Beguines at the convent of Thorn were expected to tend to the needs of a dying
nun at the abbey of Thorn and keep a wake at her body.[109] Wills and other docu-
ments suggest that many lay people called on beguines for the same purposes.
In her will of 1297, Sandre Colemer, as mentioned, expressed her appreciation
for a beguine who helped her in her final illness.[110] More frequently, lay women
and men requested in their wills that on the night after their death groups of
beguines came to their house and stay with the body until it was buried. In 1397,
the executors of the will of Catherine Boineffant, a woman of Tournai, rewarded
"the ladies of [the beguine convent of] Haulte-Vie for keeping watch at the body
of the deceased on the night after her passing, and saying the Seven [Penitential]

Psalms and prayers for her soul" and for "watching over the body of the deceased until it was buried."[111] A woman of Douai left money in her will of 1317 "for the poor beguines who will carry her to church and will take care of her body."[112] Wealthier individuals sometimes asked to have as many as twenty beguines at their wake, as did Béatrix Fouke of Tournai in 1317; most people, however, requested smaller groups of four, six, or eight, and the fifteenth-century statutes for the beguinage of Sint-Truiden recommended that not more than twelve beguines leave for funerary services, unless a close relative of a beguine asked for more.[113] Beguines usually performed these services for women only, although exceptions were made for special male benefactors. The will of Pierre Maistardies of Tournai, written in 1349, provides an interesting example of a male testator who valued beguine funerary rituals even though his primary devotional allegiance was to the Franciscans. He chose to be buried in the church or in the convent of the Franciscans but demanded that during his wake on the eve of the funeral eight beguines, seated by his body, would read the psalter "for the relief of [his] soul."[114]

In medieval Europe, as in many other premodern societies, mourning and the laying out of the dead were predominantly female functions. Beguines played a special role in the transition from this life to the next because of their unique position: as adult virgins or chaste widows well known for their work in hospitals and for their care of lepers — the "living dead" of the medieval world[115] — and as laywomen vowed to religious pursuits, who took part in secular life during the day but withdrew to their convents or courts at night, they were liminal figures, ideally suited to mediate during those first hours after death. Significantly, the only other group to "specialize" in wakes and funeral processions in fourteenth-century Douai were the Bons-Enfants, young, virginal, boys who were preparing for the priesthood in a semi-cloistered setting.[116]

The beguine's capacity to straddle the border between life and death is nowhere more graphically illustrated than in the *vita* of Christina Mirabilis. Thomas recounts that when she "died" from an illness at a young age, she arrived in purgatory but was given a choice: she could go to heaven or return to earth and save the souls of others by continuous prayer and submission to torments that mimicked those of purgatory. Choosing the latter, she spent the rest of her life as a beguine penitent.[117] As Robert Sweetman, Barbara Newman, and Michel Lauwers have argued, Christina's Life and the *vitae* of the other *mulieres religiosae* can be read as long *exempla* concerning the doctrine of purgatory and the holy women's power to intercede on behalf of the dead. Stories of resurrection, revenants, and meetings with the dead underpin a narrative intended to demonstrate that the prayer and penitence, pain and suffering of the *mulieres religiosae* helped to redeem humankind.[118] There is no doubt that in the mind of

many people, beguine prayers for the dead were just as valuable, if not more, as masses said by priests. Some years after the accidental death of count William of Flanders in 1251, his spouse Beatrice ordered her cleric Amalricus to visit several religious houses in Brabant, her homeland, and seek masses and other services for her husband's soul. Amalricus garnered masses from monks and prayers (the Seven Penitential Psalms and the Office of the Dead) promised by beguines, and did not seem to value one more than the other.[119] James of Vitry thought so too. Even a priest cannot save a human soul from purgatory, he said in a sermon, since "the souls in purgatory fall outside his domain." Only the Suffrages of the Church, including works of penance, may incite God to deliver these souls.[120] At the same time, the beguines' mourning had special potency because it was inspired by compassion, punctuated by tears and moans, as in the final episodes of the *Life of Mary of Oignies*: contemplating the fate of sinners, herself included, Mary was said to have emitted cries of agony like a woman giving birth.[121] Sermons to beguines of Paris in 1272–73 repeatedly called for them to pray for the souls in purgatory as an act of compassion. The *Règle des Fins Amans*, probably written for beguines in northern France (Amiens?) around 1300, demanded they pray for the dead awaiting mercy, "so that God will relieve their torment and hasten their glory."[122] To assume the debts of the deceased souls was therefore the most perfect act of charity a beguine could perform.

While the beguines' charitable work fulfilled an important social function in the cities and towns of the southern Low Countries, it necessarily involved contact with the world around them. Unlike truly cloistered nuns, beguines often operated in the public arena and were thus exposed to popular scrutiny. Their care of the dead — perhaps the most publicly visible manifestation of their vocation — appears to have prompted conflicting responses. Although it surely was valued by many, it also drew ridicule. During popular festivities at Huy in 1298, groups of commoners lampooned various social groups in a carnaval parade. According to a quasi-contemporary chronicle, "several men had shaved their beard and dressed as ladies or beguines, marching through the streets two by two as if in a procession, some singing, others holding an open book in their hands, as if they were reading."[123] Beyond such popular derision of beguines one readily perceives a sense of anxiety fueled by the beguines' proximity to death, an unease that surely contributed to antibeguine discourse in this age.[124]

## Teaching

Providing instruction and guidance to young girls in a secluded, but not cloistered setting, was part of the beguines' vocation from the very beginning of the

movement. Here, too, beguines may have followed the example of anchoresses. Many anchorholds had chambers for guests, young girls, who would serve the anchoress as apprentices in return for religious and other training, primarily in reading and music (the famous Hildegard of Bingen was raised in this way).[125] The *Life of Arnulf*, a lay brother of Villers who died in 1228, mentions a boy who regularly visited a female recluse to learn the important lessons of life.[126] Beguines continued this tradition and expanded it in their own dwellings. While she was an anchoress, Juetta of Huy "raised" from childhood (*ab infantia*) at least three of the female companions mentioned in her *Life*.[127] Ida of Nivelles, Beatrice of Nazareth, Ida of Gorsleeuw, and perhaps also Juliana of Mont-Cornillon, were sent to or actively sought out the anonymous beguines of Nivelles, Zoutleeuw, Borgloon, and Liège, to receive food, lodging, and above all instruction from them. Beatrix and Juliana were assigned to the care of a prominent member of the group who would act as their mentor.[128]

Teaching remained an important goal of the more formally organized beguine communities that arose after 1230. Young children must have been a common sight in beguinages; a famous incident at Nivelles in 1241 involved a four-year-old girl who, playing in the beguinage of Saint-Syr, fell into a well but was saved from drowning by the intervention of St. Gertrude, the local patron saint.[129] Most children who dwelled in beguinages came to receive instruction at a slightly later age, and beguine teachers had obviously no problems attracting them.[130] Of the fifteen women schoolteachers registered in the city of Ghent in 1567, at least three were beguines.[131] The school at the beguinage of Valenciennes, which was first attested in 1267 and in the fifteenth century provided instruction to boys and girls, had at least one beguine teacher (Marie de Hasnon) in 1335, and two in the fifteenth century (Quintine Dassonleville and Simone Saimane in 1438, Colette and Jeanne Prevost in 1497), assisted by one male teacher. Eighteen girls were enrolled in 1497, at least six in 1498.[132] The school of the beguines of St. Catherine in Mechelen had at least two teachers in 1286–1300, and probably many more in later centuries, but precise figures are not known.[133] The beguinages of Herentals and Avesnes had special schoolhouses, attested in 1462 and 1537, which suggests large numbers of children; the school of the court at Kortrijk had twenty-four pupils in 1491, and thirty-four girls resided as pupils in the beguinage of Diest in 1526.[134] The most extensive information available comes from the main beguinage of Antwerp, where seven beguines taught school in 1526. They had fifty-seven "young girls" in their care, who lived in their teachers' houses; the largest group consisted of thirteen girls.[135] Beguine schools are rarely mentioned in other parts of Europe: we know of a beguine in Mainz who taught reading and writing in 1294, and a school existed in the beguinages of Paris and Leiden in the late fifteenth century.[136]

The level, subject, and nature of the teaching dispensed by beguines varied. Contemporary clerics who commented on beguine instruction defined it as exhortation to practice basic Christian virtues, particularly those deemed most appropriate for women. Describing the early beguine communities in a sermon to "virgins" composed between 1229 and 1240, James of Vitry said that, "led by one of them who surpasses the others in virtue and prudence, they receive instruction in good morals and in letters, and are trained in vigils, prayer, fasting and other ascetic exercises, in manual labor and poverty, in denial of the self and humility."[137] Beatrice of Nazareth's father sent her to the beguines of Zoutleeuw, her biographer says, so that "she would make greater progress in virtue."[138] Although Ida of Gorsleeuw's biographer did not expound on the teaching she received from beguines at Borgloon, his account also suggests that she sought them out because they taught moral lessons that she could not learn in the school of the local collegiate chapter. He relates that Ida was driven from an early age by such an immense desire for "knowledge" (*studium*) that her parents were forced to oblige her and arranged to bring her to school in Borgloon by horse whenever inclement weather made walking impossible. She thirsted for instruction in more than reading and writing (*literalis scholas scientia*): while in town to attend the school of St. Odulphus, she sought to "edify herself by assiduously visiting beguines and recluses," and did so to the distress of her more worldly sister.[139] An inquiry into the orthodoxy of the beguines of Ter Hooie in Ghent in 1328 noted in their defense that "they are so wise and so well mannered, that great and respected people send their daughters to live with them to be enlightened and taught good manners, so that they will learn virtue, excellence, good customs, and how to behave among all people correctly and devoutly, and that whatever their ulterior vocation might be, whether it is in religion or in marriage, they will behave better according to their state."[140]

Still, we must not assume that beguine teaching always followed those conventional lines and was a mere drilling in good and devout manners, or was even limited to elementary instruction in reading and "manual work, reading, and writing," as L. Van de Meerendonk characterized beguine teaching in the main court of 's-Hertogenbosch.[141] It could include not only instruction in a foreign language but also in music, Latin and, at least in a few cases, Bible study, contemporary spirituality, and possibly even theology. In several court beguinages, a *schola* or special music school existed to train young girls (and a select group of older beguines) in reading elementary Latin and in chant for choir service, while some beguinages in the Flemish- or Dutch-speaking parts of the Low Countries offered instruction in French.[142] After spending seven years with the beguines at St. Sépulchre, Ida of Nivelles had some familiarity with Latin when she entered a Cistercian monastery at age sixteen but did not know it well.[143] Mary of Oignies

could recite the Latin psalter and write a letter, though probably only in the vernacular.[144] Beatrice and Ida of Gorsleeuw, as we have seen, attended a school run by male clerics while frequenting the beguines of Zoutleeuw and Borgloon, apparently because the clerics' school offered a more formal curriculum, while their beguine instructors may have tutored them in music and on certain topics in contemporary spirituality ignored by the clerics, or simply shared that knowledge informally.

In the thirteenth and early fourteenth centuries, some beguines were certainly highly educated and determined to share their knowledge with others. According to the Franciscan theologian and polemicist, Guibert of Tournai, writing shortly before the council held at Lyons in 1274, beguines employed Bible translations and commentaries in the vernacular for religious instruction; around 1300 a beguine of Rheims possessed a verse translation of the Bible into French (now preserved at the Municipal Library of Rheims) that could be used for teaching purposes.[145] Juliana of Mont-Cornillion's mentor, the beguine Sapientia, taught her reading in the vernacular but also introduced her to the study of Latin and the works of St. Augustine and St. Bernard, particularly the latter's Sermons on the Song of Songs.[146] Upon the foundation of the beguine court at Champfleury in Douai, in December 1245, the beguines even secured a commitment by the collegiate chapter of St. Amé of Douai to appoint a "competent cleric to give instruction at the beguinage to women — and not members of the other sex — in the learned disciplines," a clear attempt to bring beguine teaching up to par with that of schools that trained boys for an ecclesiastical career.[147] Unfortunately, we have no way of assessing in any comprehensive manner what books were most commonly read by beguines or used in their teaching. Since beguinages of the southern Low Countries did not have collective libraries in the Middle Ages, no library catalogues detailing their possessions have survived. Books were transmitted to individual beguines, or sometimes to convents, by gift, purchase, or will, and they were lent out to others so that informal reading groups formed, but these activities rarely left a trace in the records.[148] Still, the work of the most famous beguine writers, Hadewijch and Marguerite Porete, displays the breadth of their "learned" knowledge, at least in part based on books, as well as the desire to instruct others in their circle.

It is evident, anyway, that some beguines were esteemed as teachers for more than their formal instruction in letters or proper behavior, and that girls and women sought their guidance on a wide range of moral and ethical issues. Their stay with anchoresses and beguines took the form of an apprenticeship based on personal example and an intense, close relationship between teacher and student. It therefore held great potential for creating strong bonds between mistress and disciple, a potential applauded by sympathizers but mistrusted by

others. According to Beatrice of Nazareth's biographer, "she grew increasingly fond of the individual members of the devout group [of beguines at Zoutleeuw], especially of the esteemed woman to whose teaching she was assigned. She attested herself that she never gave her own parents as much love as she then gave these women; she, in turn, was loved no less by them."[149] Any reader of these life stories will be struck by the fact that many of these women chose the company of beguines after one or both of their parents had died. Leaving aside Juetta of Huy and Mary of Oignies (who converted to a beguine life after having been married at the ages of thirteen and fourteen, respectively), four *mulieres religiosae* (Beatrice of Nazareth, Ida of Nivelles, Juliana of Mont-Cornillon, Christina Mirabilis) turned to beguines as adolescents after losing one or both parents. Clearly, beguines (and recluses) formed an alternative family. These girls and young women established extremely close relationships with their main mentor and other members of the beguine community.[150]

The emphasis on teaching in its broadest sense may explain why *magistra*, or "mistress," became the title commonly given to the superior in beguine institutions. In its most general application, *magister/magistra* simply meant "leader" or "superviser." The use of the term in religious communities, however — whether monastic, clerical, or lay, heretical or orthodox — implied something more. In classical Latin, a *magister* could also be a teacher and educator. The term was revived in the mid-twelfth century to designate the cleric who had completed a full program of study in a *studium generale*; it became the title of choice for the graduate who had received the license to teach and was admitted to a university's faculty in the following century. Before that time, however, it could be applied more loosely to any reputable teacher of doctrine, or to clerics renowned for their preaching skills and their ability to enlighten people and clergy with their sermons.[151] In traditional monasticism, the term was certainly not unknown, but rarely used for the superior of a monastic community, who was generally called *abbas* (father) or *prior*; the female equivalents were *abbatissa* and *priorissa*. The title *magister/magistra* was usually reserved for the monk or regular canon responsible for the novices' instruction, the *magister noviciorum*, occasionally for the superior of lay brothers or sisters, or for the female superior of sisters that answered to male houses.[152] Among the Waldensians of Lombardy and parts of Germany around 1200, the *magister/magistra* was the male or female entitled to preach and instruct.[153] Gervase of Tilbury, in his brief note on the heretical *publicani* of Rheims, also called their female leader *magistra* because, as the story revealed, she was their teacher.[154] Beguines may have adopted the term after its use in anchorholds, where it is attested from the thirteenth century but may well be much older. In his *Bonum Universale de Apibus*, Thomas of Cantimpré told an *exemplum* about a pious girl who begged her father to buy

her a psalter, but was sent instead "to a *magistra* who taught the psalms to the daughters of rich people," so that she would know the psalter by heart; with the financial help of wealthy ladies in the parish, the girl eventually bought a psalter and "rented" a cell next to the church, undoubtedly as a member of a multiple *reclusorium* headed by an anchoress-teacher.[155] In the northern Netherlands and Germany, where hospital care took up an even larger part of beguine life, the superior was often known as "Martha" (*maerte* in Dutch), to emphasize her role in humble service and as a caretaker;[156] in contrast, the term *magistra* continued to be applied exclusively to the head of a beguine community in the southern Low Countries until the twentieth century.

## Manual Work

Contemporary observers stressed from the very beginning that beguines did not live from alms or actively beg but earned their keep "by the work of their own hands," again following an established apostolic ideal.[157] Manual work also played an important social and spiritual role, as it brought beguines together in collective work sessions, during which the psalter and other religious texts and prayers were recited or discussed; this practice, attested since the beginnings of the movement, was maintained until the twentieth century.[158] Beguine work included service in hospitals and leper houses, and the nursing of individuals in private homes, both for charitable reasons and in order to earn a small income. Some beguines, especially those living in court beguinages on the edge of the city, did farm work in nearby fields, herded animals, raised poultry, or grew vegetables for the urban market.[159] Still others worked in an unspecified capacity in the city, perhaps as maids.[160]

The bulk of the evidence, however, suggests that most beguine workers of the large court beguinages—and of some convents—were laborers in the textile industry. Urban decrees regarding beguine work and rules governing the internal life in beguine courts contain many more clauses related to the production, treatment, and trade of cloth than to any other professional activity. They show that beguines were primarily, but not exclusively, involved in the preparatory and finishing stages of cloth production traditionally dominated by women.[161] Beguines hackled, combed and spun wool, napped or otherwise finished the woven woolen cloth, prepared it for dyeing, or cut and prepared flax for the production of linens.[162] Court beguinages, with their spacious meadows and gardens close to waterways, were convenient locations for washing and bleaching woolens and linens.[163] Beguines also worked as tailors and perhaps as embroiderers.[164]

Beguines originally also earned a livelihood by weaving, an ancient female task, which, as the central phase in the manufacturing of cloth, had become an overwhelmingly male occupation in the urban economies of the southern Low Countries around 1200. Female weavers who worked professionally were extremely rare after that date. Yet, there is conclusive evidence that beguines wove woolen cloth for sale in Aalst, Bergues, Bruges, Diest, and Mechelen during the thirteenth and early fourteenth centuries, although many restrictions on the sale of their products applied.[165] In later centuries, they concentrated on manufacturing and trading linen cloth: beguines are attested as linen weavers and traders of linen in Mons during the fourteenth century, in Maastricht (St. Andrew) and Herentals in the fifteenth century, and in Tongeren and Antwerp in the early sixteenth century. In 1483, the beguines of Herentals produced 37.6 percent of all linen manufactured in the city.[166] In many other cities, beguines wove cloth in their beguinages, but perhaps only for their own use, or for distribution to the poor.[167] Of course, not all beguines active in the textile industry were actual laborers. For instance, in her will of 1304, Margritain, a beguine *des Prés* of Tournai, made a bequest to forty beguine spinsters in her employ;[168] she probably was a draper (Dutch: *drapierder* or *drapierster*, French: *drapier* or *drapière*) rather than a weaver, that is, an entrepreneur who hired other (beguine) workers, supplied her employees with raw materials and traded the finished product on the local market. A beguine of Tongeren kept sheep in a pasture outside the city and traded in wool in 1309.[169] A *beghine de le draperie* of Douai is cited in 1286–87; two beguines, sisters, sold cloth wholesale on the Douai market in 1304, and one of them was still renting half a booth in the cloth hall in 1325.[170] Around that time, a few beguines traded cloth locally and interregionaly in Bruges, Ghent, and Arras. They, too, were most likely entrepreneurs or merchants who did not engage in manual labor.[171] It is difficult to believe, however, that many beguines earned their living solely from commerce. As we have seen, beguine spirituality and practices were often at odds with the world of trade and highly suspicious of it; some statutes for court and convent beguinages in the fifteenth and sixteenth centuries explicitly prohibited beguines from commercial business.[172]

The beguines' engagement in the textile industry was far more extensive than that of religious women in traditional nunneries—who sometimes worked as embroiderers of silk, woolen cloth, and linen, especially for liturgical vestments, and as manufacturers of tapestries, often for religious usage[173]—and bears a striking similarity to the professional activities of the Humiliati in the cities of northern Italy. Many "lay" members of this order were active in the production of cloth and fustian (a cotton cloth), the men as weavers, the women *Humiliate* mainly as spinsters, though some of the women also appear to have woven woolen cloth. In this movement, too, some of the cloth workers eventu-

ally abandoned manual labor per se and became entrepreneurs and merchants of cloth.[174]

## Saints and Workers

The range of saints whom beguine communities invoked as patrons mirrored the variety of their vocation. Many court beguinages and a few beguine convents or hospitals placed themselves under the patronage of a particular saint, whose cult was actively promoted by the members of the community. In a few cases, the selection of a patron must have depended on local devotions, the availability of relics, or the preferences of important donors. Others, however, were clearly chosen because they reflected beguine conceptions of the active and contemplative life.

Table 4 lists the saints invoked by seventy-eight communities in which such collective patronage can be clearly established. The Virgin Mary was the most popular of all, selected by at least twenty-one beguinages. Her prominence may in part derive from her wide popularity in contemporary lay religiosity and among such religious orders as the Cistercians, Dominicans, and Franciscans, which all influenced beguine spirituality. But the Virgin also spoke to beguines in a way that directly addressed their own condition: chaste but not without having been married, virginal but also a mother, Mary encapsulated many of the contradictions that characterized beguine life. It is not surprising, then, to find her invoked as a major patron of beguine communities. That such patronage was not a mere bow to common practice but powerfully engaged beguine devotion is suggested by the numerous beguine confraternities (or "guilds," prayer associations formed within certain beguinages) in her honor;[175] or the works of art celebrating her motherhood that beguinages commissioned in this age, like the images of the Virgin and Child from the beguinages of St. Truiden, the Wijngaard of Bruges, and St. Catherine's at Diest, which date from the late thirteenth through mid-fourteenth centuries, or the late medieval Pietàs traced to Low Country beguinages.[176]

Beguine devotion to St. Catherine and St. Elizabeth emphasized different facets of their life as religious women. Catherine of Alexandria, the legendary early Christian virgin who shunned the advances of the pagan emperor Maxentius and chose martyrdom for her faith, was not only known for her constancy under torture—the spiked wheel that failed to break her became her symbol (the Catherine wheel)—but also for her learning: she was said to have vanquished fifty pagan philosophers in debate.[177] This was undoubtedly why beguines adopted her as a patron. While they were certainly not the only lay people

Table 4: Main Patron Saints of Beguinages

|  | Number of Beguinages |
|---|---|
| Virgin Mary | 21 |
| Catherine | 15 |
| Elizabeth | 13 |
| Mary Magdalen | 8 |
| Agnes | 4 |
| Margaret | 3 |
| Aubert | 2 |
| Barbara | 2 |
| Nicholas | 2 |
| John the Baptist | 2 |
| Christine | 1 |
| Holy Spirit | 1 |
| 11,000 Virgins | 1 |
| Anne | 1 |
| Calixtus | 1 |
| Thomas | 1 |
| Total | 78 |

Source: Appendix I.

of the Low Countries who venerated her, they vigorously promoted the cult of this virginal teacher of wisdom during the thirteenth and fourteenth centuries. Perhaps as many as fifteen beguinages invoked her as a patron, and many others paid service to her in different ways, as did individual beguines.[178]

St. Elizabeth of Hungary or Thuringia, a chaste widow known for her charitable care of the sick and lepers, became the patron of thirteen other beguinages. Married to the Landgraf of Thuringia in 1221 at the age of fourteen, Elizabeth had three children by him before he died in 1227. She subsequently renounced the world to devote herself to the poor and the sick until her death in 1231. Pope Gregory IX canonized her in 1235 in a bull celebrating her as an emblem of Christian charity who shared the life of those she served.[179] Her cult spread immediately and rapidly throughout the Low Countries, perhaps under the influence of bishop John II of Liège, who participated in the canonization procedure; her life gained further notoriety in these lands after the marriage of Beatrice of Brabant to her son Henry II of Thuringia in 1239.[180] Beguines and other lay people involved in hospital work were among the first to formally honor her for her sustenance of the poor and the sick. Their devotion to Elizabeth is manifest as early as 1239 in Valenciennes and Lille, where hospitals dedicated to her soon evolved into beguinages.[181] Some of the oldest and largest beguinages of Flan-

ders chose her as their patron in the 1240s. She, too, was the object of a personal cult among beguines.[182]

Among the other female patron saints commonly chosen, Mary Magdalen deserves special mention. Early Christianity knew her as the repentant prostitute of the New Testament, but at least since the thirteenth century, she was revered as a preacher who had converted Gaul. Beguines appear to have honored her, like Catherine, for her intellectual and evangelic work. In addition to the five beguinages that recognized her as a patron, there are signs of her cult in St. Christophe of Liège, where the hospital of Tirebourse was dedicated to her, at Ter Hooie in Ghent, Hoogstraten, and in the beguinages of Diest and Sint-Truiden.[183]

Most of these patrons were thus women — either widows or virgins (Barbara, Agnes, Margaret) — but a few male saints also gained a certain popularity among beguines. Two of them, St. Aubert (*Aubertus*) and St. Alexis, may be regarded as typical beguine saints because their cult was little known outside beguine circles and other charitable institutions. Aubert, a bishop of Cambrai and Arras (d. 668–69), is sometimes regarded as a patron saint of merchants and was especially venerated for his charity (as legend would have it, he was aided in his almsgiving by a donkey that peddled bread and collected money to be used for his charitable work). The translation of his relics to Cambrai's cathedral in the late ninth century gave his cult a modest boost and placed his feastday (13 December) firmly on the calendar of the dioceses of Cambrai and its neighbors. There is little evidence of a popular cult to Aubert in these lands, however, until the foundation of the beguinages that took his name in Bruges (St. Obrecht) and Ghent (St. Obrecht or Poortakker) around 1269–78. His cult among beguines must have been inspired by their own work for the destitute in what they perceived as a harsh commercial environment, and more particularly by their efforts to convert the income of work and trade to sustain the poor.[184]

The story of St. Alexis, originally written in Greek in the fifth century, became well known in the West after its adaptation into the French vernacular. Alexis reputedly left his rich father's home in Rome to travel as a beggar, rejecting both the mercantile world in which his father thrived and the wealthy woman he was to marry. According to the eleventh-century versions of the Life in French and Latin, Alexis eventually returned home but for many years lived as a humble servant, unrecognized, taking care of the poor and infirm, and repeatedly harassed by other servants. It was a performance of his legend by a jongleur that inspired the merchant Valdes of Lyon, the founder of the Waldensian movement, to sell his business and property, turn away from the world, and endorse absolute poverty shortly before 1176.[185] Beguines would have known the legend either in its French form or in a Middle Dutch version attested in writing in the

late thirteenth century, but probably spread long before that date.[186] Only one beguinage (at Dendermonde) formally adopted Alexis as its patron, but in many others, beguines honored him privately or collectively. Their devotion to Alexis is attested as early as 1273 in the Wijngaard of Bruges, but was also known at St. Elizabeth's of Ghent around 1300.[187] The legend of this rich young man forsaking worldly goods and marriage for a life of service in the world obviously exerted a special appeal on beguines — as it had to Christina of Markyate one hundred years earlier[188] — and explored themes dear to them: repudiation of commercial gain, conflict with and defiance of parental expectations, liberation by chastity, and active charity among the disadvantaged.

The importance of these forms of patronage cannot be underestimated. Not only did they situate beguine communities firmly within the boundaries of orthodoxy, they often presented individual beguines with examples of lay women and men from the past whose life stories strongly engaged their imagination because these saints had pursued similar objectives as they did: to live simply and chastely among the people, to work in order to support those who could not, and to instruct younger women. The choice of these particular saints suggests that they consciously reflected on the purposes of their vocation, and clearly distinguished it from the traditional forms of religious life for women. Their own vocation was sufficiently open-ended, however, to allow for a variety of talents to be exploited within the community.

# 4. The Social Composition of
# Beguine Communities

## Social and Economic Status

The oldest studies of medieval German beguines believed they came primarily from the lower artisan or servant strata, a conviction that relied more on late nineteenth- and early twentieth-century sociological theory than on empirical research.[1] In his authoritative *Religiöse Bewegungen* of 1935, Herbert Grundmann rejected that view categorically and argued that the beguines' ideal of voluntary poverty was fundamentally religious and could have been meaningful only to members of the privileged classes. He substantiated his proposition with references to *vitae* of early beguines who belonged to the upper strata, and to thirteenth-century statutes of beguine houses in Strasbourg that admitted only women with property.[2] Alcantara Mens and, more ambivalently, Ernest McDonnell, agreed with Grundmann.[3] These studies can be said to have been based on a limited range of archival sources. Joseph Asen and Dayton Phillips, the first historians to conduct more extensive research in the archival records left by beguine communities, came to conflicting conclusions: in his research on the Cologne beguines before 1450, Asen noted the large number of beguines from patrician families in Cologne before 1330; Phillips thought that "the predominance of the lower classes among the members of the beguine houses [of Strasbourg] was overwhelming."[4] More recent work on the beguines of Germany, Basel, and Holland has suggested that beguine recruitment changed over time: at first aristocratic beguines of noble (or ministerial) and patrician origins dominated, but they were gradually replaced by beguines of the lower social groups, so that by 1400, beguines of the middling and even popular strata were more numerous.[5] Our data on the beguines of the southern Low Countries tend to confirm the latter findings but indicate that a substantial number of beguines of the lower classes were always part of the movement; it is also manifest that important differences existed between various institutions.

According to James of Vitry, the first beguines came from wealthy and noble families. In his second *Sermon to Virgins* he said that he knew "many who

despised the riches of their parents and rejected the husbands of great nobility who presented themselves to them, to live in great and cheerful poverty, having nothing besides what they could earn through spinning or the work of their own hands, satisfied with vile clothes and a mean meal."[6] Rhetoric aside, James's information concurs with the *vitae* of the *mulieres religiosae*. Juliana of Mont-Cornillon's father, for instance, was a man "of famous lineage and wealthy in goods," indicating a well-to-do noble heritage.[7] Although the authors of the other *vitae* often maintained that their heroines were born of middling origins following a hagiographic topos that dates from the early middle ages,[8] these women clearly belonged to the rural nobility or the upper strata of the free urban population. Ida of Gorsleeuw, whom her hagiographer characterized as born in "a family of middling condition" (*mediocri prosapia*), came from a venerable lineage at the top of Loon's nobility: Ida's uncle, Geoffrey, was a direct vassal of the count of Loon and regarded as a powerful, illustrious figure in the region. He gave his name to the seignory of Leeuw, which soon was known as *Godefredi Lewis* or Gorsleeuw.[9] Juetta of Huy's family was of ministerial rank, and her father served the prince-bishop of Liège as his financial officer in the city of Huy.[10] The parents of Beatrice of Nazareth, Ida of Louvain, Ida of Nivelles, and probably also Odilia of Liège and Mary of Oignies, were prominent and wealthy burgers; Lutgard of Tongeren's father was a merchant of Tongeren involved in trade with England, her mother a member of the rural nobility; a man of "prominent lineage" vied for her hand, and a young knight attempted to abduct and force her to marry him.[11]

Whether these aristocratic women were representative of the early beguine movement as a whole may be doubted, however. After all, the hagiographers, including James of Vitry,[12] were mostly interested in beguines who went on to join Cistercian or Benedictine monasteries, which recruited predominantly if not exclusively among the aristocracy and urban patriciate.[13] We have no reason to believe the beguines who lived with the heroines of the *vitae* came from equally distinguished backgrounds. On the contrary, there is evidence that some were of distinctly lesser rank, like the companions who play a secondary role in the *vitae* and are identified as "servants" or "maids:" a woman called Clementia, for instance, who served Mary of Oignies at Willambroux and followed her to Oignies, where she became a "devout virgin," or the anonymous woman who accompanied Juetta of Huy as her "servant" throughout the various stages of her life as a beguine and anchoress.[14] Other beguines who routinely performed the more menial tasks in the early communities undoubtedly also came from the lower social strata. It seems possible, therefore, that beguine communities were from the very beginning composed of women of diverse social origins.

We know a great deal more about the composition of the formal beguine

communities that arose from the 1230s onward. The social and economic diversity of the members at this time is clear. To be sure, noble women still joined these communities, but they were not numerous. Sophia Berthout, daughter of lord Walter of Mechelen — one of the barons of Brabant — and widow of Henry V, lord of Breda, was closely associated with the main beguinage of St. Catherine in Mechelen from 1275 until her death in 1299–1300. She donated her residence and other property on the edge of the beguinage for the use of the beguines' infirmary, gave the beguinage its first statutes, and may have resided in the beguinage in the last years of her life, but it is not known if she actually became a member of the community.[15] Emmain, a daughter of John of Béthune and niece of Mathilda of Béthune, count Guy of Flanders's wife, was a beguine in 1259–64.[16] At the end of the thirteenth century, two daughters of Razo VII of Gavere, lord of Liedekerke and Breda, were beguines, possibly at St. Catherine's in Breda.[17] Aleidis and Sara of Aishove, two of the first mistresses of the beguinage of Ter Hooie in Ghent, were noble, as was, perhaps, Isabelle de Flesquières, one of the first grand mistresses of Cantimpré at Cambrai.[18] The two beguine sisters, Ida and Oda de Lude, who founded the beguinage of St. Catherine of Tongeren in 1243 through the gift of their house, probably belonged to the noble family of Lauw, while two daughters of the knight Arnold of Betho took their vows as beguines at St. Catherine's in or shortly before March 1273. Several beguines of Tongeren held fiefs in the thirteenth and early fourteenth century, which at that time strongly suggests a noble heritage.[19] In the same period, noble ladies also appear among the beguines at the Wijngaard in Bruges, a beguinage founded by the countesses Joan and Margaret of Flanders and closely associated with the Flemish comital family. Margaret, daughter of lord Henry of Praat, entered the beguinage in 1279, and Margaret of Kleve, widow of Henry of Flanders, the son of count Guy, resided there in 1340. Between 1439 and 1454, a period for which our documentation is particularly abundant, at least four residents of the Wijngaard were noble: Kateline Adorne, Kateline van der Delft, Aechte van der Heede, and Kateline van Themseke.[20] Catherina of Cuijk, an illegitimate daughter of Lord Wenemar of Hoogstraten, was one of the founders of the beguinage of Hoogstraten in 1380–82, and in 1543 the noble Mary van der Gracht was a beguine of St. Elizabeth at Ghent.[21] Yet, except for the Wijngaard of Bruges, whose population always tended to be rather aristocratic and patrician, there appear to have been very few beguinages who had noble residents in the fifteenth and sixteenth centuries.

Women of the urban elite, however, found their way to beguinages in far greater numbers. The beguinages of St. Elizabeth and Ter Hooie in Ghent housed members of the SerBraems, Bruusch, uten Hove, uten Meram, and uter Volrestrate families, to mention only a few of the oldest lineages of Ghent.[22] Patri-

cian and other prominent lineages are also well represented in the beguinages of other cities: we find beguines of the Lams, Dops, and Bonins in the Wijngaard of Bruges,[23] of the Egloys and uten Steenweghes in the Wijngaard of Brussels,[24] of the Nose and Kiekeninne in Sion at Antwerp,[25] of the Roelants and Scoerbroets in Ten Hove at Louvain,[26] of the Saint-Albins and Boinebrokes in the beguinage des Wetz at Douai;[27] and the list could go on to include other distinguished families in the beguinages of these and other cities.[28]

Some of the beguines who could not claim such exalted ancestors nevertheless belonged to well-to-do segments of urban and rural society, as their gifts to the beguinage and their wills testify. For instance, Lijsbette Langherox, widow of Segher Langherox, who joined the beguinage of Ter Hooie in Ghent, in 1311, owned a house in the Neder Kwaadham—one of the more prosperous parts of the city—as well as a dyer's workshop and two small houses or apartments in the nearby Zand, and about 21 bunder (about 70 acres) of land in the seigniory of Rode, a substantial estate.[29] Maghine Bêcheron, a beguine of Liège, left in her will of 1265 (supplemented by a codicil in 1266) 10 bonniers (about 33 acres) of land in various rural locations as well as a house in the city and about 2 lbs. par. of annual rents.[30] Felissia, daughter of Riboud Minkes of Vlissegem, a beguine in the Wijngaard of Bruges, sold 12 measures (about 13 acres) of land in Vlissegem to the Benedictine abbey of St. Andries near Bruges in 1258—a smaller, but not insignificant piece of land.[31]

Other beguines had enough cash to lend money to others: at least nine beguines of Ypres were active on the local credit market between 1275 and 1291, and ten beguines of Douai bought life rents from the city of Bruges in the late thirteenth century. After the death of Helewidis de Angulo (a beguine of Tongeren who made her will on 20 October 1291), the executors of the will listed nine people who owed her money for a total of more than 30 lb.[32] Although these beguines were not professional money lenders—their clients were often relatives, other beguines, or clergymen—their transactions were not always small: the median credit amount extended by the beguines of Ypres, about 20 lb. art., was only slightly below the median loan amount recorded in 1275–91 (24 lb. 10 s. art.).[33] A few transactions made elsewhere involved significantly higher sums: two beguines of Arras—a well known center of banking—lent 200 lb. to the city of Calais in 1300–1301 at 10 percent interest, just below the going rates of 12 to 24 percent (par courtoisie);[34] Betteken van Loe, a beguine of Ghent, lent the sum of 480 lb. to a certain Clais de Wilde in the 1340s.[35] These loans certainly approached the magnitude of those made by professional bankers but may have been exceptional.

Alongside these prosperous or even wealthy beguines lived others of more modest background who, as we have seen, supported themselves as teachers,

nurses, textile workers, or small business owners. A description of the beguinage of Ter Hooie in Ghent from 1328 makes a clear distinction between the wealthy beguines who lived off rents and those who worked for a living: "Some women [at Ter Hooie] are rich and have rents, but most own little more than their clothes, the personal belongings they store in coffers, and their beds. Yet they are a burden to no one, working with their hands, supporting themselves, napping wool and finishing cloth."[36] The beguines' own labor could yield an adequate income, especially if it were supplemented by rents or other revenues from whatever property they might own. These were beguines like Clarisse le Candilliere ("the candlemaker") and Jaque de Lens, of Douai, who wrote their wills in 1354 and 1356. Clarisse, who probably resided at the convent beguinage of Wetz, left about 3 lb. par. to celebrate a funeral mass and a month's mind in the church of the Dominicans of Douai, to whom she also bequeathed her bed and linens; she donated 5 s. par. to the porter of the Dominicans and to the Franciscans of Douai for vigils, as well as 10 s. for the priest, chaplain, and cleric of the parish, 10 s. for two local hospitals, 2 s. for each beguine who would carry her body to the church and cemetery, and 3 s. for the beguines at Wetz. Three cousins received one gold florin each; one man and four women were given pieces of clothing and simple household items, and a young girl, the daughter of a certain Cateline des Claves, received her book of *Hours*. Jaque de Lens, the head of the beguine convent of Fressaing at Douai, a convent dedicated to the care of elderly and sick women, left 9 s. to her parish clergy, 10 s. to her own convent, 2 s. each to the beguinages of Wetz and Champfleury, 1 s. to the beguine convent *des Pilates*, and 5 s. to the hospital *des Chartriers*, all at Douai. She also bequeathed a few pieces of clothing, linens, furniture, and five golden écus to individuals, including her confessor, probably a Franciscan. She chose to be buried in the Franciscan convent, where she founded six trentels to be celebrated within the year after her death. In all, the value of these two estates — furniture, clothing, and household objects included — may be estimated at about 15 lb. par. each, or about four months of wages of a journeyman mason. Hardly a fortune, but perhaps enough for a beguine to live in relative comfort as long as she was able to work.[37]

There are strong indications, however, that many beguines only barely eked out a living and needed charitable help in times of economic contraction, during an illness, or when they grew older and could no longer work. Clarisse le Candilliere made her will at a time when she had fallen ill and the prospects of recovery were grim: in her will she explicitly favored a female companion, Maroie, so that she would "take care of her through her illness."[38] Apparently, she had found shelter in the beguinage of Wetz, where she received room and board. Such provisions for poor and elderly beguines were made in all of the court beguinages and many of the convents.

The number of genuinely poor beguines, as opposed to those who embraced the apostolic ideal of *paupertas* or voluntary detachment from material goods and concerns, seems to have risen rapidly after the formation of beguine institutions in the 1230s and 1240s. The change affected the ways in which the beguines' poverty was described and perceived. At the foundation of the beguinage of the Briel at Ypres in 1240, for instance, countess Joan of Flanders referred to the community as one of "poor beguines" (*pauper[es] mulier[es] que beghine vocantur*).[39] Similar expressions were used for many other beguine institutions throughout the years 1230–60. They referred not only to the inmates of the infirmary,[40] but also and perhaps even primarily to their caregivers and other members of the beguine community who embraced a humble life of service and detachment from material goods while being quite well to do.[41] After 1260, however, "poor" was increasingly used in another sense, to refer to beguines who were truly destitute; the religious or apostolic usage of the epithet, although still well known, became less common. The shift did not occur because the apostolic ideals were abandoned but rather because beguines who were truly indigent began to be considered deserving of special care.[42] Donors (outsiders as well as beguines) made gifts of property, rents, or simple alms not only to the community as a whole or to the sick and elderly beguines in the infirmary, but also specifically to the impoverished members of the beguine community, the economic poor. Thus Margaret, widow of William Cassart, donated in June 1258 one bonnier of land to the infirmary of the Wijngaard in Brussels on the condition that the income it generated be used to support thirty of the poorest beguines.[43] Baldwin, parish priest of Scheldewindeke, made arrangements in 1270 for the distribution at his funeral of alms to "the poor beguines [of Ter Hooie in Ghent] who do not reside at the infirmary."[44] Maroie de Fierin, a beguine of Champfleury at Douai, made in her will of March 1273 a special donation to support the work of her companion Clarissa (*Clarisse se compagnesse*), who had built a house in the beguinage; Maroie left two beds and 10 lb. par. "to help poor beguines."[45] The wealthy Elizabeth uten Hove, mistress of Ter Hooie in Ghent, donated before November 1280 an annuity of 15 lb. par. to the Holy Spirit Table of St. John in Ghent for poor relief in St. John's parish and in the beguinage, where the grand mistress should distribute ten pairs of shoes "to the poor beguines who need them the most."[46] A beguine of St. Catherine at Tongeren implicitly acknowledged the gap between wealthy and poor members of her beguinage in her will of 1290–91 when she bequeathed one mark "to be divided equally between all beguines of her court beguinage, be they rich or poor" (*tam divites quam pauperes*).[47] In contrast, Odile a le Take, widow of Henri a le Take of Tournai, left in her will 3 s. par. "to each convent of the beguines of [the court beguinage of] Prés and in downtown Tournai," but then went on to note that those 3 s. par.

should be given to "the six poorest beguines of each convent."[48] The rule of 1262 for the beguines of the convent du Sac in the court beguinage of St. Elizabeth at Valenciennes required them to leave what they could to the poorest members of their convent.[49] The statutes for the beguinage of Herentals in 1489 ordered every beguine to leave a will and make a bequest to the poor of the court.[50] A similar requirement may have existed in other beguinages, since bequests for "the poor beguines" of their community were common in beguine wills of the late thirteenth and fourteenth centuries.[51]

Beginning in the 1260s, beguines realized that the number of indigent members of their communities had risen to the point where it required structural solutions. One answer was to establish in each beguinage a special fund or dole, called the "Table of the Holy Spirit" (*Heilige Geesttafel* in Dutch, *Table du Saint Esprit* in French), the "Coffer" (*Kiste* in Dutch) or "guild" (*gilde* in Dutch, *Charité* in French)[52] to assist those in need who could not be supported by the infirmary. The beguine dole is first mentioned at St. Catherine in Mechelen (1269),[53] the Wijngaard of Brussels (10 March 1273),[54] St. Elizabeth of Valenciennes (July 1273),[55] St. Elizabeth of Ghent (December 1278)[56] and existed in one form or another in many court beguinages shortly afterward.[57] The beguines of St. Elizabeth at Ghent briefly explained its origin and function to count Guy in a poignant request for help:

On the advice of men in religion and other wise men we have established a Table of the Holy Spirit in our court to support the poor of our court, of which there are well 300 or so, and there are some who, before the Table was started, had had only bread for nine years; the wealthy beguines give alms to the Table, with which we support the beguines who have nothing and cannot earn anything because of old age. When they are ill, they are provided for in the infirmary; when they are healthy, they live on alms that are put in a coffer in the church.[58]

The Table of the Holy Spirit coordinated the distribution of rye, bread, fish, oil, cloth, and shoes to impoverished beguines, provided them with an additional income, and, in the larger beguinages, gave them shelter in houses or convents owned by the foundation. Funding for the institution came from outside donors as well as from the wealthier beguines of the community.[59] As the 1526 census of hearth in Brabant explained with regard to the court beguinage of Zoutleeuw, "The beguinage consist of three members: the beguine community itself, the beguine hospital, and the Coffer; all three jointly contribute to give alms to the needy in the beguinage, if one finds that they are very poor and that each of them would not be able to support herself."[60]

A second solution was to create special convents within the court beguinage for beguines in need. We have already mentioned the house for poor beguines

built by the beguine Clarisse at the beguinage of Champfleury of Douai in March 1273.[61] In 1338, Marie Dops, a wealthy beguine of the Wijngaard in Bruges, established a convent within the court "for the poorest beguines of the Wijngaard" (*pauperrimas beghinas de Vinea*).[62] Other such foundations followed in the late fourteenth and fifteenth centuries.[63]

The third, most radical, measure to deal with the growing ranks of impoverished beguines was the foundation of new beguinages designed and funded to provide specifically for indigent women. The first such institutions were founded in Bruges (St. Aubert, before 1269), Antwerp (Klapdorp, before 1274), Boekhoute (1271), Ypres (Baerdonc, 1273), Louvain (Wierinck or St. Barbara, before 1278) and Ghent (St. Aubert or Poortakker, 1278).[64] Hugh Moer, the founder of the beguinage of Boekhoute, wished it to benefit "poor beguines, to whom especially this place is given — not to rich or noble beguines" (*beghine pauperes quibus specialiter locus predictus datus est nec divitibus sive nobilibus*).[65] Significantly, most of the new foundations in these years were in Flanders, which had been hit hard by the rupture of trade relations with England in 1270–74, a rupture that had a particularly catastrophic impact on the textile industry.[66]

The new foundations were intended to support poor beguines as well as to relieve the pressure they exerted on the resources of the existing beguinages. The foundation history of Poortakker illustrates the increased demand for sustenance and shelter for beguines in Ghent, and the bitter choices that the mistresses of beguine communities had to make under these circumstances. By May 1264, the mistresses of St. Elizabeth and Ter Hooie in Ghent had conceived a plan to erect a subsidiary of both institutions at Poortakker, an area in a western suburb of Ghent known for its textile frames.[67] When the plan failed (for reasons that are not clear), the infirmaries of St. Elizabeth and Ter Hooie were stressed to their limits. In principle, they were reserved for beguines of the two communities who fell ill or were otherwise in need, but women who lived as beguines outside the two beguinages could be admitted if space was available and with the permission of the beguinages' mistresses. In the first days of May 1269, Dominican friars who advised Countess Margaret on beguine matters in Ghent told her that henceforth the beguines of St. Elizabeth had agreed to admit "beguines from other convents in Ghent" to their infirmary in times of need, and had her write an ordinance to that effect for the beguinage of St. Elizabeth. The grand mistress and other beguines of St. Elizabeth then complained to the countess "that they had never agreed on this and that the order had caused many disagreements among them." Countess Margaret revoked the ordinance on 20 May 1269, rebuking the Dominicans for their deception and confirming the rights of the beguines of St. Elizabeth to limit the use of the infirmary to their own community unless the grand mistress and all the other mistresses decided otherwise.[68]

The hospital for poor beguines at Poortakker was finally built in 1278; in June of that year countess Margaret ordered her officers in Ghent to lend their assistance and protection to the new beguine convent, intended "for the great multitude of beguines of our city of Ghent, residing outside the court beguinages of St. Elizabeth and Ter Hooie in Ghent, who cannot be provided for and maintained together with the sickly beguines in the infirmaries of those communities, in a manner fitting the demands and requirements of their illnesses and needs." [69]

The new institutions like Poortakker did not suffice to alleviate the needs of poor beguines. Not only were they small—Poortakker had space for only twenty-eight beguines—but elderly women from the wealthier families that had founded and sponsored them sometimes secured a place in them as prebendaries, thus limiting the resources available for the care of the truly destitute. [70] The economic crisis in Flanders around 1300, the great famine of 1316, and the successive waves of plague that struck the Low Countries beginning in 1348, engendered new foundations for destitute beguines. [71] In Antwerp, two beguines who lived outside the court of Sion converted their houses into convents for "poor beguines" by will in 1293 and 1296; other institutions of this kind were erected in Antwerp in the following decades but are only sparsely documented. [72] Various citizens of Bruges established at least seven convents for poor beguines between about 1302 and 1374. Townspeople called them "almshouses" (alemoesene huzen), houses of "begging" or "encumbered" beguines (beghine mendicantes, becommerde beghinen), terms that describe the social position of their residents well but are somewhat misleading since these beguines most certainly did not engage in public begging. [73] Many of the beguine convents that were founded in Douai, Huy, Liège, Mons, and St. Omer in the late thirteenth and early fourteenth centuries provided for indigent beguines. [74]

By about 1400, some court beguinages and convents not only demanded that incoming beguines either possess rents or the ability to earn a living, but prohibited new members from receiving support from the "table of the Holy Spirit" or Kiste during their first three years at the beguinage. [75] A few courts began to exact entrance fees, a custom quite common in monasteries. [76] The beguinage of Geraardsbergen required a payment of 12 s. par. for "virgins" (young women) and 24 s. par. for widows, according to the rule of 1414. [77] The statutes introduced at the beguinage of Kortrijk in 1450 prescribed an entrance fee of 3 lb. par., and another 6 s. par. for membership in a convent in the beguinage; beguines would subsequently pay 8 s. par. annually for maintenance of the houses and convents in the beguinage. [78] In the beguinage of Dendermonde, new beguines paid an average fee of 6 s. par. between 1460 and 1480. [79] These were rather modest sums that would have barred only the poorest women from entering.

Three Flemish court beguinages, however, were more selective in the fif-

teenth and sixteenth centuries. The beguinage of St. Elizabeth at Lille demanded 12 lb. par. for prebendaries in its infirmary after 1401.[80] The same payment was expected from any new beguine in the beguinage of Oudenaarde in 1522.[81] The Wijngaard at Bruges was probably the most exclusive of all beguinages in the Low Countries: of the 213 beguines who lived there from 1439 until 1454, at least 173 (81.2 percent) owned a house, land, rents, or left a substantial estate, while only sixteen (7.5 percent) may be called poor.[82] The beguinage prided itself on its special status as a "princely" foundation created by the countesses of Flanders, its continued protection by the rulers of Flanders and Burgundy, and the high standing of its inhabitants. According to the fifteenth-century rule of beguinage, "a certain countess" had even granted the beguines an exception to the general command to wear sober and simple dress: their habits sported a silk ribbon on their sleeves "as worn by queens, countesses, and princesses."[83] These were exceptional cases, however; most courts and convents continued to provide for beguines of the lower strata until the late eighteenth century.

The social and economic diversity of the beguine population was reflected in the structure of court beguinages, which offered beguines a range of living options compatible with their status and material wealth: beguines of patrician or upper class heritage who could afford it bought a house and lived alone or with a few chosen companions, while others had to content themselves with a room in one of the beguinage's convents. Originally, individual beguines financed and owned the newly built houses. In the 1270s, when the oldest courts took on definitive borders, internal regulations began to underscore the principle—perhaps acknowledged from the start—that beguines "owned" their houses for a lifetime only: after their death or departure from the beguinage, the houses became the property of the beguinage or its central institution, the infirmary. Once the space in the beguinage given over to private residences was filled, newly professed beguines were given the chance to "buy" existing houses as they became available.[84] Beguines who could not raise the money to buy a house for their own resided in convents, in the infirmary, or rented a room in a house.

Only wealthy women had the resources to acquire rights to the more comfortable residences. In June 1277, a house in the beguinage of St. Elizabeth at Ghent was sold to five sisters of the van Bassevelde family, who lived there together, for 50 lb. par.[85] The oldest statutes of the main beguinage of Mechelen (1286–1300) urged beguines who owned more than 100 lb. par. to construct or buy their own houses, or at least cover half of the costs of a house.[86] It took Joye Franque, beguine of St. Elizabeth of Lille, twenty-two years to save enough money to buy a private residence in the beguinage valued in 1391 at 76 *francs* (125 lb. par.).[87] In the fifteenth century, houses in the beguinage of the Wijngaard of Bruges sold for 10 to 360 lb. par., the majority of which in the 60 to 200 lb. range.[88]

It is difficult, but not impossible, to find evidence for the social and economic status of beguine populations that is statistically meaningful. One method, adopted by historians of German beguine communities, involves the systematic comparison of beguines' surnames found in archival records and names of families of patrician, artisan, or other factions in the city council, the main representative body in German cities.[89] Applying this procedure to the political and social situation in cities of the Low Countries, we can best compare beguine names with those of aldermen's families, the families and lineages that dominated the city government. Of the thirty-two beguines of St. Elizabeth at Ghent whose surnames can be gleaned from various sources between 1234 and 1350, thirteen (or 41 percent) bore names of elite families; at Ter Hooie of Ghent before 1350, six (or 40 percent) of the fifteen beguines known by name belonged to those families.[90] The proportions remained relatively constant over time: between 1385 and 1453, fifty-two (55 percent) of ninety-four known beguines of St. Elizabeth, and eighteen (or 47 percent) of thirty-eight beguines of Ter Hooie can be associated with aldermen's families.[91] In Douai between 1250 and 1350, about one third of the eighty-three beguines identified may have been related to elite families.[92]

Does this mean that one third to half or more of the beguines came from urban upper class families? Not at all. In each case, the list of beguines identified by surname in archival sources comprises only a small fraction of the total beguine population in these courts, which as we have seen, ran into several hundreds. Moreover, nearly all of the names were gathered from contracts, deeds, wills, and other documents dealing with property, or other transactions with the beguine community in which only the beguines' superiors are mentioned by name. In other words, the names collected do not in the least constitute a random sample but represent solely the propertied members of these communities and their superiors—who may have been elected to their positions precisely because of their family connections with urban elites.[93] Under these circumstances, what is significant is rather that a relatively large number of propertied beguines do *not* seem to have belonged to aldermen's families and therefore came either from middle or lower class milieus with no access to political power in the cities, or from the countryside.[94]

Two other types of sources provide an overview of the economic status of beguines. The first consists of obituary books or registers of anniversaries and other commemorative ceremonies founded by members of the community and by outsiders. The oldest that has survived concerns the beguinage of Sion at Antwerp. Sion's obituary book was probably started in the later decades of the thirteenth century (drawing on records kept since the beginning of the beguinage in the 1240s)[95] and was kept up until the third quarter of the fourteenth century. Because none of the entries by thirteenth- or fourteenth-century hands carry a

date and few names can be dated with confidence on the basis of other sources, it is difficult to say when exactly the manuscript fell out of use. The last entry that can be dated with any accuracy is the anniversary for the beguine Marie van der Elst, who is last mentioned in a will of 1362.[96] After a hiatus of about one century, when the community presumably used another, now lost obituary book, several hands of the late fifteenth, sixteenth, and seventeenth centuries added notes on new anniversary foundations, but they did so irregularly and were by no means comprehensive. In sum, the manuscript contains a complete record of anniversary services established in the beguinage from its foundation in the 1240s until about 1362. Although we do not know the minimum payment required for anniversary services in the beguinage, we can safely assume that the costs were not negligible, and that individuals — beguines or outsiders — who founded anniversaries were at least moderately prosperous. The beguinage of Sion was a rather large community, whose population at this time probably hovered around 100 beguines.[97] In a population of this size, the theoretical number of deaths between 1245 and 1362 may be estimated at 455.[98] Yet, only 179 women whose names were entered by scribes between 1245 and 1362 can possibly be identified as beguines. Thus, only about 39 percent of the beguines who lived (and died) at Sion between the foundation of the beguinage and about 1362 were able to afford even a simple anniversary service.

An even smaller proportion of the beguine population of Poortakker (or St. Aubert) beguinage in Ghent founded an anniversary. The obituary book of Poortakker was started around 1335 by a scribe who incorporated in his or her work records of anniversaries established since 1299;[99] four other scribes entered new foundations until about 1402.[100] Those who wished to found an anniversary at Poortakker had a wide range of options: services could be bought for as little as 12 s. 5 d. par., but a truly solemn anniversary could cost 20 lb. 5 s. par.; the standard service of mass with vigils and commendations was available for 16 lb. par., a very substantial sum. As mentioned, Poortakker was a small community whose number of residents was capped at twenty-eight in 1326.[101] Of the 112 beguines who presumably died at Poortakker between 1299 and 1402, only thirty beguines (or 26.7 percent) of the beguinage population acquired anniversary services.

The proportion of beguines at Breda's St. Catherine beguinage who had the financial means to found an anniversary in their church was only slightly higher than at Poortakker. In 1535, when the beguinage was moved to a new site, a list of all beguines residing at St. Catherine mentions thirty-two names;[102] only nine of these (or 28 percent) are found in the obituary book for that period. Again, the costs of an anniversary (14 to 16 Rijks guilders, or 28 to 32 lb. par., on average) must have been beyond the means of most beguines.[103]

Table 5: Number of Beguines Qualified as Poor in Tax Census Records of Brabant, 1496–1526

|  |  | Total Number of Beguines | Number of Poor Beguines | Percentage of Poor Beguines |
| --- | --- | --- | --- | --- |
| Aarschot | 1526 | 28 | 14 | 50 |
| Brussel, Wijngaard | 1526 | 329 | 108 | 32.8 |
| Diest, St. Catherine | 1526 | 193 | 22 | 11 |
| Lier | 1496 | ca. 69 | 28 | ca. 40.6 |
| Louvain, Groot Begijnhof | 1526 | 125 | 69 | 55.2 |
| Tienen | 1526 | 39 (min.) | 33 | ? |

Source: Cuvelier, *Les dénombrements*, 240–47, 287, 317, 343, 354, 379, 503. The population figure for the beguinage of Lier is derived from the census of 1480; see Table 3.

Finally, the Brabantine census records of hearths of the late fifteenth and early sixteenth centuries give us a sense of the number of beguines who were regarded as poor and thus exempt from taxation (Table 5). Tax assessors did not always investigate the economic status of beguines with care, and their criteria for exemption may have varied from place to place. In most cases, individuals who received sustenance from the local doles or earned an income below a certain level were declared "poor."[104] When the Vrijheid of Hoogstraten demanded that the local beguinage contribute in a general tax levied in 1553, the beguines argued that "only three or four" were able to pay; all others were "poor," earning a modest living from spinning.[105] In the beguinage of Diest, the assessors of the hearth survey of 1526 apparently considered all beguines as taxable except those regularly supported by doles, which may account for the relatively low number of poor beguines registered in the census (11 percent). In the other beguinages, the assessors may have broadened the definition to include beguines who occasionally received support from the dole. The number of beguines identified as "poor" in the Wijngaard in Brussels (108, or 32.8 percent) in 1526 seems to be based on actual dole figures, for we know that in the previous century between fifty-five and one hundred beguines received aid in foodstuffs and clothing from the beguinage's dole.[106] The relatively large number of poor beguines may have been the result of the particularly severe problems experienced by the cloth industry in these cities in the late fifteenth and early sixteenth centuries.[107]

Beguine communities, especially the court beguinages that housed rich and poor beguines alike, thus formed a microcosm of the total female population in the cities of the Low Countries. They were composed of women who came from all social milieus and whose economic status diverged widely. While noble

and patrician women were certainly among their leaders in the first decades and continued to join the movement in later years, the majority of beguines undoubtedly belonged to the middle and lower working classes from town and countryside. The increasing number of beguines who needed help strained the resources of the existing beguinages in the third quarter of the thirteenth century, prompting the foundation of special institutions to care for them. Yet in most communities, a large proportion of the beguines continued to need aid. We may assume that between the late thirteenth and sixteenth centuries, about one quarter to less than half of the beguine population was moderately well to do (a small fraction of the beguines might even be called wealthy), while more than half to three quarters of the beguines, relying solely on manual labor, lived on the brink of poverty and found themselves in a vulnerable position whenever their income was threatened by crises in trade relations, industrial layoffs, and, perhaps more important, by illness and old age.

Obviously, the wide disparity in social background and income level among beguines living in the same community must have created internal tensions that should not be underestimated. Despite the mechanisms of solidarity that tied them to the socially disadvantaged in the beguinage, wealthier beguines often carefully maintained the marks of their status: a private house in the beguinage, membership in an "exclusive" confraternity, dress of higher quality cloth or discretely embellished. The legend of Matteken, a beguine who resided at St. Elizabeth of Ghent in the second half of the fifteenth century, may be indicative of the strains on social life in the beguinage caused by these contrasts. Matteken, it was said, was so poor that most beguines shunned her. Isolated, bitterly resenting her exclusion from social gatherings, she prayed assiduously to a sculpture of Christ on the Cross in the church of the beguinage. Finally, Christ received her prayers and divulged to her a secret that would enhance her stature within the community: He told her that the Virgin Mary had miraculously repaired the grand mistress's dress with red thread. When Matteken informed the grand mistress of the miracle, the latter was astonished by her insight and bestowed on her the greatest reward possible: she invited Matteken to her table. The happy beguine returned to pray for the crucifix in church and died there during the night, kneeling in prayer.[108]

## Patrons of the Beguinages

The establishment of a spacious court beguinage required great expenses that could be borne only by a wealthy benefactor; although convents were generally much smaller institutions, they, too, depended on an initial endowment, if only

Table 6: Patrons of Beguinages

| | Princes, Nobility | | | Other Laity | | | Clergy | |
|---|---|---|---|---|---|---|---|---|
| | Male | Female | Couple | Male | Female | Couple | Male | Female |
| Courts | 7 | 12 | — | 0 | 2 | 2 | 5 | 0 |
| Convents | 4 | 2 | 1 | 24 | 27 | 2 | 10 | 2 |
| Total | 11 | 14 | 1 | 24 | 29 | 4 | 15 | 2 |

of a house or other property to provide lodging to beguines. Because so few documents have been preserved that reveal the foundation history of these institutions, we know only a few of the people who helped establish them. For about one third of all beguinages or twenty-eight courts and seventy-two convents, we can identify a main "material founder" or patron who was primarily responsible for the initial donation of land and the construction of the beguinage, or who supplied it with substantial means of sustenance (Table 6).[109]

Given the size of most courts, it is not surprising that they were founded most often by the rulers of these lands and members of the highest aristocracy: the countesses Joan and Margaret of Flanders and Hainaut, who played a major role in the foundation of the beguinages in Ghent (St. Elizabeth), Bruges (Wijngaard), Lille, Douai (Champfleury), Kortrijk, Valenciennes, Mons (Cantimpret), Ypres (Briel), and perhaps also the courts of Cambrai (Cantimpré) and Ter Hooie and Poortakker in Ghent;[110] the counts of Loon, founders of the courts at Borgloon and Maaseik;[111] and the lords of Beaumont, Breda, Diest, Edingen, and Hoogstraten, who made important contributions to the court beguinages in their cities.[112] Powerful church officials like William, abbot of Sint-Truiden, and Walter of Marvis, bishop of Tournai, were responsible for the foundation of courts at Sint-Truiden and Tournai. Priests were instrumental in the foundation of at least three courts: Gerungus of Brecht in Antwerp (Sion), master Reinerus of Breeteyck in Brussels (Wijngaard), and a certain Arnold in Herentals. Yet it is difficult to pinpoint their exact role, and there are strong indications that they worked in concert with family members, not in the least with women who joined the community and became prominent leaders. At least two (and possibly many more) female relatives of Gerungus's were beguines at Sion; his mother was the first grand mistress, and by the late sixteenth century beguines commemorated her as Sion's (spiritual?) "founder." Reinerus of Breeteyck is mentioned in connection with four sisters from Gooik who jointly established one of the first convents of the beguinage of the Wijngaard; these beguines, too, were credited in later centuries with the foundation of the beguinage.[113] A few small courts owed

their beginnings to private citizens: the beguinages of Aalst and Zoutleeuw, con-
structed on land donated by two couples; the Grand Béguinage of Namur, which
started in three houses given by a widow, Ava; and the court of Bergen op Zoom,
created with funds left by Agatha Backer, also a widow.[114]

Some convents owed their foundation to members of the nobility. King
Louis IX and an unnamed queen of France reputedly founded or greatly en-
dowed the important beguine *convent le Roi* at Arras and the *convent le Roine* at
Nivelles, respectively; the lord and lady of Heinsberg and a certain John, lord
of Cuijk and Grave, endowed convents at Heinsberg and Grave; Fastré Coke-
let, a knight, founded the convent of Cokelet in Mons, and Hellin, lord of Aul-
noy, established the beguine convent in his town.[115] Clerics were involved in
the creation of convents at Anderlecht, Boekhoute, Cambrai, Liège, Momalle,
Mons, Namur, and Oisterwijk; like the clerics who founded court beguinages,
their plans were usually made in consultation with lay women, possibly rela-
tives.[116] The majority of the convents, however (fifty-three out of seventy-two),
were founded by nonnoble citizens and, as Walter De Keyzer has pointed out,
by wealthy lay people from the countryside.[117]

The foundation history of beguinages therefore followed a pattern famil-
iar to scholars of monastic and religious history: princes and other members
of the landed nobility were patrons of the oldest and largest institutions, fol-
lowed shortly afterward by members of the nonnoble urban and rural elite, who
tended to endow somewhat smaller and less expensive houses.[118] Whatever the
investor's social rank and the size of his or her endowment, his or her goals were
fundamentally the same: to reap the spiritual benefits of an act of piety, to gain
prestige in the community, and to provide for family members.

Patrons were rewarded by prayers and other services, or shared in the good
works of the beguines. The founders of the beguinage of Aalst candidly but
simply declared that their gift of land was made "so that the beguines of Aalst
may . . . establish their court on it and serve the Lord and pray for us."[119] Other
patrons were more specific: Peter of Taviers, chaplain at the cathedral of St. Lam-
bert in Liège, left in his will of 1291 funds to buy a house for twelve beguines in the
parish of St. Christophe or St. Adalbert (well-known beguine neighborhoods),
and requested that they say daily the vigils of the Office of the Dead and the
Seven Penitential Psalms for the salvation of his soul.[120] Bernard Pilate, a patri-
cian of Douai, founded a beguine convent or hospital in the city before 1282 "for
ten poor women, beguines, of good name, grace, and reputation, free from any
scandal," whom he installed in two houses in the rue d'Infroy, equipped with ten
beds, linens, furniture, and kitchen utensils as well as an annual revenue of ten
marks; he also appointed the first superior, a certain Jehanne d'Aniche. The be-
guines promised, in return for his gift, "to pray for the souls of the said Bernard,

his father and mother, and those who had done him well." On his deathbed, Bernard added another request: the beguines were "to say daily, before the statue of the Virgin Mary in the hospital, five Paternosters and five Hail Marys, and every Saturday fifteen Paternosters and fifteen Hail Marys; they should also light a wax candle in front of the statue for a half hour on those Saturdays as well as on the five vigils of the Virgin, Christmas, Easter, Pentecost, and all the feasts of the twelve Apostles." [121]

The very simplicity of these services appealed perhaps not only to the middling classes who could not afford greater foundations (and were related to the beguines that lived in these communities), but also to lay people who were dissatisfied with the magnificent and elaborate ceremonies conducted in collegiate chapters and traditional monasteries. It is impossible to say just how widespread that sentiment was among the laity in the thirteenth century, when most beguinages were founded. Monastic reformers of the twelfth century, like the Cistercians and regular canons, had revised and reduced their liturgies, as did the Mendicants of the early thirteenth century, but they did so to make them more meaningful for the monks, canons, or friars who participated in them, or to use their time more efficiently, not because patrons demanded it. As a matter of fact, popular demand for more solemn liturgical anniversaries and other special services grew significantly in the following centuries.[122] Some of the larger court beguinages with chapels and churches that could offer such services did not escape this trend. Yet, beguine prayers were fundamentally different: construed from texts that ordinary people were taught and presumed to understand, like the Pater, the Ave, and the penitential psalms, they were more personal and intimate, and, as the last wishes of these patrons suggest, were regularly performed outside a formal liturgical context. Moreover, since beguines were commonly known as funerary specialists and intercessors on behalf of the dead,[123] their prayers were seen as particularly effective: while the established orders offered ever more grand services, these women brought to their task a sincerity of purpose and expression that was recognizable to all.

One may assume that the foundation of a beguinage generated prestige and acclaim to the donor, given the precedent set by the countesses of Flanders and Hainaut in the years 1234–45. From the beginning, patricians followed their example: Gervais de le Vile, for instance, established the beguinage of Wetz at Douai in or before 1239. In common speech, people of the southern Low Countries usually referred to beguine convents (and to hospitals and other charitable institutions) by the name of the founder rather than by that of the patron saint or its location. Founders also exercised certain rights over the community. They appointed the first superior of the house, as Bernard Pilate did at Douai, or issued a rule or other regulations of internal order, as did verKateline Pelegans, citizen

of Bruges, and Hugh uten Riede, chaplain of Our Lady of Bruges, when they endowed a convent in Bruges for poor beguines in 1338.[124] They could also reserve one or more places in the convent for their own family members.[125]

The foundation history of these beguinages diverges from traditional patterns of monastic history in one respect, namely the high number of female patrons: forty-five (45 percent) of these beguinages were founded by women. Along with the countesses of Flanders and the queen of France, already mentioned, patrons included noble ladies like Jutta, widow of William of Montjoie, who established a convent in her city of Sittard, and prominent nuns or canonesses, such as Isabelle de Houpelines, canoness of Sainte-Waudru in Mons, or abbess Guda of Rennenberg, who started a convent near her abbey of Thorn.[126] But the large majority of the female patrons were single lay women, often widows, who owned city property that they converted into a convent, or who left instructions to do so upon their death. The proportion of female patrons is much higher than has been observed for houses of monks and nuns. Penelope Johnson found that slightly more than a third of the nunneries that she examined in eleventh- and twelfth-century northern France were created by women; she noted that less than 10 percent of male houses in the area were founded by women. Sally Thompson's study of nunneries in England in the same period concluded that women were the driving force behind about 20 percent of the foundations.[127]

The relatively secure rights exerted by married women and widows to certain kinds of property, including houses, in most parts of the southern Low Countries, gave them the freedom to endow a religious foundation of their choice; noble women, who were more likely to favor traditional nunneries, did not always have that power.[128] There were also strong links that tied female lay patrons to beguines. As we have seen, beguines' social services were usually reserved for women. Their function as funerary intercessors, especially for women, also played a role. Women outnumbered men among the lay people who acquired anniversary celebrations at beguinages. Of the thirty anniversary foundations registered in St. Elizabeth of Ghent between 1262 and 1543, twenty-one were made by women, two by couples, and seven by men.[129] The obituary book of Poortakker, covering foundations made between 1299 and about 1402, lists forty anniversaries by women (excluding beguines), seventeen by couples, and twenty-three by men.[130] At the beguinage of Breda, 119 women and seventy men had their names registered for anniversary services in the obituary book for the years 1500–1626.[131]

These data suggest a certain degree of intimacy between female patrons and beguine life. Whether they only wished to support the charitable work of beguines, joined the beguinage to take part in it, or provided for their loved ones

by founding a beguine convent or court, they left their mark on the urban community in a way that preserved their memory for generations, if not centuries.

## The Success of a Formula

By all accounts the beguine movement was a popular success. Some two hundred beguinages were created before 1320, providing housing and support for a total number of beguines that can be estimated at several thousands. Why did so many women choose this way of life?

Historians have so far advanced two possible explanations: the abrupt refusal of several religious orders around 1200 to accommodate female members, and the growing number of women unable to find suitable marriage partners in a medieval world characterized by a "women's surplus." At the very beginning of our inquiry, we have seen that sources from the thirteenth and fourteenth centuries suggested likewise: James of Vitry and the episcopal deputies who inspected the beguinage of St. Elizabeth of Ghent in 1328 spoke of beguines as women who could neither gain entrance in a monastery nor find a husband.[132] The authors of these texts may have regarded beguine life as an honorable pursuit, but nevertheless saw it as a necessity, a substitute for the more traditional options open to women of standing: marriage or the cloister.

There is certainly truth to the contention that several religious orders were reluctant to accept women at the turn of the twelfth and thirteenth centuries. As we observed, religious orders of reform initially welcomed female members but eventually closed their doors to them. The Premonstratensians officially stopped admitting nuns in 1198.[133] The order of Arrouaise limited their number in 1197, and ruled in 1233 that women could be admitted only by special permission of the order's general chapter meeting; finally, in 1258, it refused to accept new female entrants.[134] The policy of the third great reform order, the Cistercians, was less clear-cut. During the twelfth century, several houses for religious women were founded that observed Cistercian customs and dress, although they were not formally incorporated into the order. Between 1190 and 1213 the order adopted new procedures to regulate the association of these houses with the male branch of the order, and strengthened the control of male abbots over the Cistercian nunneries. It apparently led to many new conversions, for the number of houses that were founded at this time under the umbrella of the Cistercian order was impressive: according to Bruce Venarde, there were over one hundred Cistercian nunneries in England and France by 1215.[135] In the southern Low Countries alone, more than a dozen houses of Cistercian nuns existed by that time, and ten more were founded by 1228. This was the "multiplication" of houses "like stars

in the sky" that James of Vitry celebrated as divine intervention in his second *Sermon to Virgins* and in the *Historia Occidentalis*—although he admitted that the decision by the Premonstratensians to exclude women might have helped.[136] Soon afterward, in 1220, and again in 1228, the general chapter of the Cistercians prohibited new incorporations of nunneries, now thought to be an excessive burden and distraction for the male branch of the order. All of these measures, historians have argued, were clearly intended to limit the number of nuns and consequently prompted women aspiring to the religious life to seek an alternative, the beguinage.[137]

In practice, however, the measures taken by these orders presented many loopholes. As John B. Freed, Carol Neel, and Pauline Hagemeijer have demonstrated, Premonstratensians and Cistercians continued to accept new female recruits—despite the official regulations—in many parts of Europe until at least the end of the thirteenth century.[138] Of the forty-nine Cistercian nunneries founded within the borders of present-day Belgium, twenty one were incorporated in the Cistercian order after 1228.[139] Moreover, while these orders permanently or temporarily refused women, there were others that seem to have been eager to recruit them. Several new religious orders comparable to Cîteaux, Prémontré, and Arrouaise began to establish houses in the southern Low Countries during the early and mid-thirteenth century: the sisters of Mary Magdalen (or *Wittevrouwen*) in 1235 and the nuns of St. Victor in 1240,[140] the Poor Clares and the sisters of St. Dominic (the two female branches of the main mendicant orders) in 1255 and 1262.[141]

Be that as it may, the policies of these orders may have had little impact on the growth of the beguine movement because very few beguines could realistically hope to become a nun in any of these houses—or to join the traditional Benedictines or secular canonesses. Virtually all of these orders accepted only noble ladies and women of patrician families; commoners did not have a place there, except as lay sisters.[142] It is true that the foundation stories of the Cistercian monasteries of Notre-Dame-des-Prés near Douai (established before 1218) and Fontenelles (founded around 1212) described the first members of the community as "beguines," but these texts were written much later, at the end of the thirteenth and fourteenth centuries, and used an anachronistic terminology; as far as we can tell, the foundations involved women from elite families.[143] James of Vitry and other authors of the *vitae* mentioned several beguines who became Cistercians but all of them belonged to that same, small, upper crust. Apart from the *vitae*, there is not much evidence of beguines converting to the monastic life. Avezoete van der Ameede, a woman from a prominent patrician family of Ghent, was a beguine at Ter Hooie when she founded the convent of the Clares at Gentbrugge, which she joined in 1286.[144] Hele and Marote Haze, two sisters

from Douai who lived as beguines at St. Elizabeth of Lille in the 1280s, joined the Dominican sisters of l'Abiette near Lille before 1293; they were wealthy and probably noble.[145] Of the 213 beguines who lived in the beguinage of the Wijngaard in Bruges — surely the most elitist of all beguinages in the Low Countries — from 1439 until 1454, only three left to become nuns at Augustinian houses of Ghent influenced by the *Devotio Moderna* movement.[146]

Women of means who had the choice may have preferred the more loosely controlled life as a beguine to the more disciplined existence of a nun. Beguines advocated a moderate form of monastic retreat and frequently interacted with their environment; nuns were increasingly subjected to strict enclosure. Beguines exercised a profession and were actively engaged in charity; nuns were devoted to the contemplative life. Despite the similarities that existed in the thirteenth century between beguine and Cistercian spirituality — as attested by the *vitae* and other sources[147] — these were not the same vocations. It is not surprising, therefore, that only few women made the transition from one to the other.

The second reason suggested for the beguines' large numbers — the difficulty for women to find marriage partners — is also valid only for that same, small, aristocratic segment of the beguine population. There is now a general agreement among scholars that the position of women in the nobility suffered from the social changes of the central middle ages, in particular the rise of inheritance systems that privileged the oldest male heir and forced many younger sons to postpone or forego marriage.[148] James of Vitry and the visitors to the beguinage of Ghent probably had personal acquaintances of theirs in mind when they referred to noble ladies who could not conclude a suitable marriage. Lutgard of Tongeren's mother, a noble woman who had married a burgher of Tongeren, may have been regarded the victim of the sort of *mésalliance* many noble families tried to avoid. Ida of Gorsleeuw belonged to an impoverished branch of a prominent noble family; as one of at least three daughters, her chances of marriage may have been slim.[149]

It is difficult to see, however, how much of an impact, if any, these conditions had on nonnoble families of the countryside and on urban populations. As we have explained above, the biased sex-ratios in cities of the southern Low Countries were the result of different migration patterns and cannot be considered a sign of a "shortage" of men on the "marriage market." To argue that those "surplus" single women necessarily sought to be married is not only to misinterpret the mechanisms that led to the biased sex ratio, but also to repeat an ancient and stubborn misconception. Women moved to the city for work, not to find a husband. Beguines, in particular, often *fled* marriage and actively helped others to avoid it.[150]

These explanations for the popular success of the beguine movement thus

are inadequate or, at best, incomplete. I suggest that a more fundamental rea-
son for the movement's wide appeal lies in the dual nature of the beguine life
and, more particularly, in their unique and flexible combination of an active
life among urban citizens and a contemplative life within a secure setting. Al-
though their vocation was a religious one, it did not burden them with the lasting
obligations that nuns or monks assumed. In order to realize this goal, beguines
adopted—by necessity rather than by design, perhaps—two innovative strate-
gies that proved to be highly effective: first, they accepted the principle of per-
sonal property, usually shunned by traditional monastic orders; second, a large
number of beguines joined beguine courts, which offered just enough of a quasi-
monastic enclosure to protect them from *scandalum*, yet allowed them access
to the urban labor market and ultimately served as a powerful magnet for new
recruits.

*The Economics of the Active Life*

Beguines formed religious communities but did not observe a vow of strict indi-
vidual poverty. On the contrary, it was generally expected that they either pos-
sessed sufficient rents or practiced a craft to earn their own income. This was as
crucial for the individual beguine as it was for the survival of the institution as
a whole, because beguinages had relatively few endowed possessions. Even the
Wijngaard of Bruges and St. Elizabeth of Ghent, two of the oldest and wealthiest
of all courts, did not own large landholdings: when tax collectors for the count
of Flanders assessed the wealth of more than ninety religious and charitable in-
stitutions in the county around 1294, they ranked these two beguinages in the
bottom third.[151] Whatever income or real estate beguines acquired collectively
through purchases or, more often, from gifts, was used for charitable care and
maintenance of its church, chapel, and other communal buildings. Under these
circumstances, it was imperative that beguines earn their own keep and were
allowed to hold private property.

By adopting this regime, beguinages overcame a problem that had vexed
all female monastic communities before them. Since nuns were generally clois-
tered and economically unproductive, their institutions relied heavily on reve-
nues from rural estates cultivated by lay brothers, tenants, and hired laborers.
Yet they also had cumbrous expenses, notably for hiring priests to say masses, to
hear confessions, and to lead other services. Given these limitations, nunneries
were forced to adopt a cap on admissions, but often found themselves in dire
straits regardless. As Penelope Johnson has proven, most nunneries experienced
severe financial problems by the late twelfth and early thirteenth century.[152]

Naturally, beguinages could only be viable in an urban environment, which presented a much wider range of professional opportunities for single women than could be found in the country. Only there could women hope to gain the economic independence that, in turn, granted them the freedom to pursue a religious lifestyle. With few exceptions, beguinages were thus located in cities: two courts and eleven convents were founded in places that must be called rural; all of these beguinages were small, and most are attested for a short while only.[153] Beguinages were absent in Luxemburg, the one part of the southern Low Countries that remained largely untouched by urbanization until the early modern age.

## The Appeal of Court Beguinages

Religious objectives and economic need cooperated to create the court beguinages, those highly original complexes for which no obvious precedent can be found.[154] Financed in part by wealthy benefactors like the countesses of Flanders and other rulers, the foundation of court beguinages responded to the demands and needs of the Church and of urban authorities, but served beguine goals well.

The initial impetus to gather beguines in enclosed quarters seems to have come from Dominican friars. The Dominicans reached the Low Countries in 1224, establishing their convents in Lille, Ghent, Louvain, Liège, Bruges, Valenciennes, and Arras before 1235.[155] Shortly afterward, they participated in the creation of courts in Ghent (St. Elizabeth), Bruges (Wijngaard), Douai (Champfleury), Lille (St. Elizabeth), Aalst, Tongeren, Aarschot, Herentals, and possibly in Valenciennes, Antwerp, Zoutleeuw, and Ypres.[156] As confessors and religious advisers to Joan and Margaret of Flanders and Hainaut, they unquestionably had a hand in the countesses' continuous support and protection of beguines, and often supervised beguine orthodoxy in their lands in the thirteenth century. The Cistercians of Villers and St. Bernard on the Scheldt fulfilled a similar role in Brabant, as did canon Renerus of Tongeren in the diocese of Liège.[157]

Although a certain degree of seclusion surely answered to the beguines' own desire for tranquillity, the foundation charters of these courts usually stress other motives that seem to have driven the friars and other clergymen: they reveal the nagging doubts on their part that a righteous life was possible at all for single women exposed to the spectacles of the city, and their intention to keep beguines off the street. Beguines needed to be placed in a compound surrounded by a barrier (*in una loco sub una clausura*).[158] Master Theobald, parish priest of Tongeren, and the Dominicans who assisted him, claimed to protect beguines from temptation in a charter granting the erection of the beguinage of Tongeren as a separate parish in 1245:

Since devout maidens commonly called beguines chose and acquired houses for them in our parish of Tongeren, outside the gate known as the "hospital gate," in order to pursue more peacefully the contemplation of the divine and to be further removed from the disorder and clamor of lay people, we wish to grant them that just peace. Therefore, so as not to allow the opportunity or reason for them to run about and err, which might result from attending parish churches in the city, especially because they live so far away from these churches that they must pass market squares and streets and even by inns, and because on high feasts they find themselves submerged by crowds of the populace in the main church of Tongeren, where they might eagerly observe these people while being dangerously exposed to them, we acquiesce to their request and at the instigation and desire of our reverend father Robert, by the grace of God bishop of Liège, of the venerable father J[ohn], by the same grace formerly bishop of Bosnia and now master general of the Dominican order and papal penitentiary, as well as of the dean of the cathedral of Liège, and of master Marcoald, archdeacon and provost of Tongeren, and on the advice of religious men, friars preachers, and other prudent men, we have granted to all beguines who are now residing outside that gate or who will do so in the future, that they shall forever be exempt from the parish and the parish churches of the city, that they may attend the chapel of the said hospital, dedicated in honor of St. James the apostle, which is close to them, that the chaplain of St. James be their priest, to hear their confession, administer the Eucharist and ecclesiastical sacraments to them, and give the dead among them an ecclesiastical burial in the cemetery of the hospital, and does for them everything else that is known to pertain to the pastoral or parochial care and attention.[159]

The sight of such—literally—"disorderly" religious women wandering the streets shocked contemporary sensibilities.[160] The parish priest of Herentals similarly argued in 1270 that the local beguine court must have its own church "because I believe it is a dangerous thing that they attend with such great numbers the parish church every day, crossing the city and mixing with lay people."[161] In a letter of protection for the beguinage of St. Elizabeth of Lille in 1299, King Philip IV of France confirmed the customs of the court "so that the beguines of our city of Lille no longer have reason to wander, and that the odor of their name will be more widely spread by preserving a praiseworthy life."[162]

It seems reasonable to assume that Dominicans and other clergymen were at least in part motivated by the desire to check and preserve orthodoxy among beguines. This obviously would be easier to do if they were brought together in one place to be monitored by their own priest and a Dominican confessor—the usual arrangement in court beguinages. As a matter of fact, heresy appeared to pose an acute challenge in the second quarter of the thirteenth century. Robert le Bougre, a Dominican inquisitor, persecuted heretics in Champagne, Cambrai, and Flanders between 1233 and 1239. In Douai and Lille alone, he had about thirty people executed, among whom many single men and women. According to Hadewijch, he "killed a beguine for her righteous love."[163] Around 1245, William Cornelius, a priest of Antwerp, taught among other things that it was permitted to steal from the rich to give to the poor and that radical, voluntary

poverty terminated all sins—beliefs for which he was condemned after his death. His teachings, possibly the earliest evidence for the so-called Heresy of the Free Spirit, later associated with beguines, were sufficiently well known to be listed in a manuscript of the Parisian theologian Robert de Sorbon (d. 1274) as "heresies for which certain people were condemned in Antwerp."[164] It is impossible to say how many of those rounded up by Robert le Bougre were beguines, whether the Antwerp heresies were spread by beguines, or even if they had anything to do with William Cornelius. It can hardly be a coincidence, however, that Dominicans helped erect court beguinages in Douai, Lille, and Antwerp, precisely at a time when heresy loomed large in those same cities.

Economic concerns explain why city magistrates—notoriously reluctant to release urban property to religious institutions[165]—often facilitated the foundation of such courts. St. Elizabeth of Ghent, for instance, originally located on comital land close to the Bijloke abbey, was moved to an area ceded by the city in 1242. This land was no great loss to the city, but suited the foundation project because it was surrounded by ditches on all sides.[166] As the names of court beguinages (Champfleury, Cantimpré, Campus, Des Prés, Ter Hooie, Wijngaard)[167] suggest, they were often established on fields, meadows, marshes, or other rural lands outside the city walls that were previously used as commons but had little economic value in the thirteenth century.

Moreover, court beguinages not only offered charitable care and other social services to urban residents, but were a reservoir for relatively cheap labor. The changes in the manufacturing of cloth in the larger centers of the textile industry during the twelfth century—namely, the introduction of the heavy loom—had increased not only the productivity of weavers but also the demand for spinsters and other female laborers to supply the raw materials, prepare the wool, and finish the cloth.[168] Most of these women were found in the countryside, but beguines provided those services as well, and originally did so at a lower cost than urban workers. Only in 1295, for instance, after a strike by beguines at the Wijngaard of Brussels, did the drapers' guild of Brussels agree to pay them the same wage as [female] laborers in the city.[169] In the new centers of textile production that sprang up in the late middle ages, such as Hoogstraten in the fourteenth and Bergen-op-Zoom in the fifteenth century, court beguinages were created shortly after the cloth industry developed. As G. Juten has shown, the city magistrate of Bergen-op-Zoom tried for years to obtain funding for the foundation of a beguine court, and to gain ecclesiastical approval of it. When the local collegiate chapter finally consented to the creation of the court, in 1490, it did so "not only for the augmentation of divine worship and the honor of God and to the advantage of the church, but also for the expansion, considerable utility, and the well being of the city."[170]

Whether they were intended to do so or not, court beguinages attracted

women from rural areas who could find work there in a safe and supportive environment. Early modern source materials show that 45 to 95 percent of the beguines in court beguinages came from the countryside.[171] Bernard Delmaire has observed that half of the beguines he identified at Douai between 1250 and 1350 were known by surnames derived from a toponym — significantly more than the 37 percent of ordinary citizens of Douai with such names.[172] Beguines from rural areas are also frequently mentioned in the obituary book of the beguinage of Sion at Antwerp, but it is difficult to say how many of them were recent immigrants. In Mons, Walter De Keyzer found that fourteen of the twenty-three convents whose patron he could identify were founded by families from the surrounding countryside.[173] A young woman from the village of Leulingen spun wool as a beguine at Arras in 1305; two of her sisters were also beguines, one at Arras, the other at Saint-Omer.[174] The naive countrygirl who came to the city and ended up as a beguine, ridiculed in the fourteenth-century *Truwanten*, a comic farce from Brabant, may have been something of a type.[175]

The greater opportunities for women to work in the margins of the urban textile industries, unfettered by guild regulations that applied to tasks monopolized by males, probably also explains why beguine communities became so much larger than those of their male counterparts, the so-called "beghards." In the first decades of the movement, at least a few men shared the semireligious life of the earliest beguines. In July 1246, a beguine of Douai left a bed to the *couvent des beghins* of her town, the oldest reference to a formal beghard community in the Low Countries;[176] shortly afterward, in 1252, the beghards (*beghini*) also had a convent in Bruges.[177] About a dozen beghard convents were set up in the various provinces of the southern Low Countries before the Clementine Decrees against beguines and beghards were issued, in 1317, after which many of them joined the Franciscan Third Order.[178] From their very beginnings, these convents, whose members worked as wool weavers (and less often as linen weavers), were controlled by weavers' guilds, who attempted to prevent competition with guild workers and put caps on the beghards' cloth production. These restrictions necessarily also limited the number of residents in beghard convents: the Antwerp convent, for instance, had only seven beghards in 1455.[179]

P. J. P. Goldberg and Sharon Farmer have recently suggested that female immigrants to late medieval cities tended to seek each other's company and to settle close to one another.[180] We may imagine beguinages as institutional supports for such clusters of migrant women, offering companionship, mutual assistance, medical aid, and instruction, as well as relief in hard times. Even within the same community, smaller groups of women tended to bind together along kin lines or because they came from the same village. Two, three, or even five sisters might share a house in a court beguinage or join a convent together.[181] We find, in the

beguinage, aunts with their nieces,[182] mothers with daughters,[183] a grandmother with granddaughter.[184] Clusters of beguines from the same village are attested at St. Catherine's of Tongeren, where a survey of buildings listed forty-two houses and convents within the beguinage in 1322 named after the place or origin of the beguine who financed its construction: a house of Mal, of Berg, of Henis, of Lauw, of Kolmont, and many other villages from the environs of Tongeren are mentioned. Since beguines of Tongeren customarily allotted rooms of their houses and convents to relatives or friends in their wills, it is highly likely that the residents came from the same towns; a woman who lived in the convent *de Lude* in 1317 indeed originated from the village of Lauw.[185] Beguines also formed lasting relationships in their community. Wills and other personal documents frequently mention a companion (*socia, compagnesse*),[186] with whom they might buy a house in the beguinage[187] and even wish to share a grave.[188]

The courts created in the first half of the thirteenth century received a great afflux of new beguines around 1250 and were soon found to be too small. In Tongeren, for instance, "an ever growing numerous multitude of beguines" had settled in the court by 1264, and the site became "so congested that there was no more space to construct houses and the necessary service buildings for the beguines," whereupon the city agreed to cede another piece of common land adjacent to the beguinage "of very little use for common pasture."[189] The courts of St. Elizabeth in Ghent, St. Catherine in Diest, and St. Elizabeth in Lille also expanded at that time, but signs of overcrowding were manifested again in 1270–80.[190] Many of the newer recruits were beguines who needed assistance and for whom special institutions were established: a dole, special convents within the court, or convents in the city that functioned as small hospitals for the poor and were funded by supportive citizens. Of course, not all beguines who joined these courts harbored the same religious vocation, which may explain why reports of disciplinary problems within the beguinages multiplied around 1300.

Economic incentives therefore spurred the growth of these *curtes* and had a significant impact on the beguine movement as a whole. To acknowledge that beguines, because of their particular way of life, formed an integral part of urban economies and could not have gained such a popular success in any other environment, should not in the least devalue their religious ambitions, nor does it require us to conclude that beguinages were only refuges for poor women. On the contrary, as we will see, it is because their religious and intellectual ambitions were so important that beguines were eventually accused of heresy, and that measures were taken to check their expansion and even to suppress them.

# 5. Conflict and Coexistence

In the summer of 1273, most probably on the feast of the Transfiguration cele-
brated on August 6, the Dominican Giles of Orleans preached a sermon in the
church of the beguines of Paris on the parable of the unjust steward, taken from
Luke 16. Giles was a popular preacher, who spoke to the beguines at least four
times in that same liturgical year. In this sermon, he wished to remind them that
penance, the beguines' particular vocation, required constant vigilance. Giles
explained that the rich man in the Gospel of the day symbolized Christ, who
through his Passion had constituted a treasure from which priests of the Church
drew indulgences. But the benefits of that treasure were made available to all of
us, he said: the steward of the Gospel stood for each Christian (cleric and lay-
man alike) endowed with the duty to manage and protect his or her estate. We
should do that as best we could, because accounts were rendered, not only in
this world—each time one takes confession—but also in the next world, at the
Last Judgment. Only constant penance can help you, beguines, prepare for that
moment, Giles went on. Not only may it deliver you from the pains of Purgatory,
but it also grants us the power to resist evil.[1]

Giles proceded to illustrate his lesson with a story, an *exemplum*, that
showed how the bad behavior of certain beguines discredited the whole be-
guinage and all who chose that lifestyle. Once, he explained, he spoke of beguine
life to a noble lady, and she surprised him with her reply: she said that she would
never become a beguine because they behaved badly. He then tried to convince
her that there were bad apples among the best—was there not a Judas among
Christ's disciples? Surely that could not be a reason to condemn "a righteous
religious lifestyle" (*bona religio*)! But she rebutted:

I am not surprised when a nun lapses into sin and comes to bad shame. . . . Say, I have
four or five daughters. I am unable to marry them off according to their status as well as
mine, and am obliged to hand them in marriage to cobblers, if marriage is what I want.
But considering that it might be shameful for me in the eyes of the world, but not to
God, I place them in a convent in a way that does not invoke God, nor His Mother, nor
His saints, upon their entry: I shall pay the abbey one hundred or two hundred pounds,
so that my child does not think of God, and neither do I or the abbess or prioress. God

is not invoked here, nor is He when she [my daughter] enters the convent. So where is the surprise if there is a mishap after entering a nunnery for the wrong reason? When a beguine enters a beguinage, however, she does that by her own free will, so that by her own free will she is a beguine. And therefore, since of her own free will she joined other holy and wise women, if she misbehaves and causes a great scandal, I think she should be stoned and marked with a hot iron.[2]

Giles's sermon could easily be dismissed as a routine call for discipline in the beguine community. But Giles was not the only one to talk of misbehaving beguines in Paris. In fact, these stories began to circulate shortly after King Louis had established a court beguinage in Paris, headed by a Flemish *magistra*, Agnes of Orchies, in or before 1264.[3]

The fiercest critic of the beguines in Paris was the professional poet and part-time student Rutebeuf, who vilified them with evident pleasure in several pieces, written between 1264 and 1270. In *Les Ordres de Paris* and the *Chanson des Ordres* the beguines constituted only one among many targets, but in his *Dit des Beguines* his charges were specific:

Whatever a beguine says, listen only to what is good. All that happens in her life is religious. Her speech is prophesy; if she laughs, it is good companionship; if she cries, its out of devotion; if she sleeps, she is ravished; if she has a dream, it is a vision; and if she lies, don't think of it.

If a beguine marries, that is her vocation, because her vows or profession are not for life. Last year she wept, now she prays, next year she'll take a husband. Now she is Martha, then she is Mary; now she is chaste, then she gets a husband. But remember: say only good things of her, because the King would not tolerate otherwise.[4]

This little satirical piece neatly summarizes the various reproaches made against beguines in the thirteenth century. There was, first of all, the open-ended nature of beguine life, a religious vocation without permanent vows, which allowed the beguine to cross with relative ease the boundary between the secular and the religious life, the divide between the lay and the ecclesiastical world. Beguines also alternated between the contemplative and the active life, combining the part of Mary with that of Martha.[5] The informality of this "religious" life was particularly disturbing to outsiders because it was reversible: one could be a beguine for a while and then return to the world. To Rutebeuf and many others, the beguine was by definition two-faced, untrustworthy, a liar or trickster. But she was also an unbearable ecstatic, always ready to prophesy. Everything that happened to her was given a religious meaning, all aspects of her life were signs, all things were repackaged and recoded to be broadcasted to the world as "religious experience."

Rutebeuf's attack was repeated in various forms by many others, not only

in Paris but also in the Low Countries and Germany. Soon these verbal assaults turned into a more concerted effort to arrest the spread of the movement, and to monitor beguines more tightly than before. Jean-Claude Schmitt and Robert Lerner[6] have argued that German beguines and their male counterparts, the beghards, were singled out for criticism because of their radical conceptions of voluntary poverty and their vagrancy—which in Germany frequently included public begging—their overly pious ways, and their close association with the Mendicant friars. All of these features, they suggested, contributed to a matrix of suspicion that enveloped beguines and beghards in the thirteenth century and eventually led to accusations of heresy. Beginning with the condemnation of Marguerite Porète in 1310, beguines were routinely accused of belonging to the so-called Sect of the Free Spirit, which allegedly held antinomian beliefs. Following the condemnation of the heresy of the Free Spirit by the Council of Vienne in 1311–12, papal decrees instructed bishops to take action against suspect beguines, to verify their behavior and to convict them of heresy if they were found guilty. These measures gradually led to the suppression of beguine communities in the German lands in the course of the fourteenth and fifteenth centuries; those that survived usually accepted an approved rule, like that of the Third Order of St. Francis. Jean-Claude Schmitt further claimed that antibeguinal polemics in Germany moved around 1400 from heresy toward the issue of able-bodied mendicancy, when the more pressing economic concerns came to the fore and the debate shifted from the doctrinal domain to the area of public order. Robert Lerner, in his authoritative discussion of the Heresy of the Free Spirit, pointed to the growing divide between orthodox medieval spirituality on the one hand, and certain forms of late medieval mysticism expressing supreme confidence in spiritual union with the divine, on the other. Tensions that had arisen over this divide were aggravated, according to Lerner, by the general crisis of fourteenth-century Europe and the dislocations it provoked in German society.

Without disputing the general contours of this analysis, I would like to redirect attention to the accusations leveled against beguines in thirteenth-century northern Europe. The history of the movement in the Low Countries and northern France shows that semireligious women were suspect from the very beginning, before they were associated with the Mendicants, and before they expressed the sophisticated but obscure and suspect confidence in the soul's unmediated union with God, that proved to be Marguerite Porète's undoing, and that of other beguines and beghards who shared her fate in the first decades of the fourteenth century. Even in the Low Countries, where beguines did not beg but earned an income by their own labor, where they did not generally roam about uncontrolled but tended to reside in relatively stable communities, suspicion developed from the very first days of the movement. Part of the explanation might well

be that the rhetoric formed against one type of beguine—the vagrant, begging, and unruly woman, associated with beghards and other preachers of dubious alloy—was transposed onto the very different kind of beguine—stable, working, and obedient to the Church—that predominated in the southern Low Countries. Indeed, this is the argument that was made on behalf of the latter beguines in the early fourteenth century and ultimately saved them from suppression.

Yet, when we review the charges made against beguines in the century before the Council of Vienne, it becomes evident that they betray a more fundamental anxiety in dominant Church milieus (but not in all) over the ambivalent nature of beguine life and most importantly about beguine claims for an active, female, apostolate. The debate that ensued occupied some of the best minds in the Church.

## The Debate

In a sense, the discussion surrounding the beguines may be understood as a problem of classification, as Rutebeuf pointed out. Language and etymology feature prominently in the discourse. Opponents of the beguines called them all kinds of wicked names, as James of Vitry reported in the *Life of Mary of Oignies* without further clarification, but he returned to the issue in his second *Sermon to Virgins* of 1229–40:

If a young maiden wishes to preserve her virginity and her parents offer her a wealthy suitor in marriage, she despises and rejects him. . . . But secular prelates and other malicious men try to destroy her and convince her to give up her sacred purpose; they say: "Look, she wishes to be a *beguina*" (because that is what they call them in Flanders and Brabant), or *papelarda* (that is what they call them in France), or *humiliata* (their name in Lombardy), or *bizoke* (their name in Italy), or *coquennunne* (as they are called in Germany). It is with such nicknames and insults that they intended to dissuade them from pursuing a life of purity.[7]

*Beguina*, and its equivalents in the other languages recorded by James, evidently served as an insult. But what did it really mean? The etymology of the word has been the subject of a long debate. Of the three hypotheses often cited in the scholarly literature, we can safely discard two. Misled by the accusations of heresy that were made against beguines, historians have long believed *beguina* was related to the Latin *Albigensis*, an adjective or noun referring to the southern French town of Albi, the noted center of the Cathar heresy.[8] In this hypothesis, *beguina* or *beguinus* meant "heretic," a powerful invective if there ever was one. The *Continuationes* of the *Annales Colonienses Maximi*, written around 1220, used the

masculine form (*Beggini*) in notes for the years 1209–13 with reference to the Cathars of southern France and to adherents of Amalricus of Bène.[9] But writing in the same region of Cologne in 1219–24, Caesarius of Heisterbach treated the word rather as a relatively innocuous nickname. He related how the monk Walter of Utrecht once traveled to a Cistercian nunnery in the hope of securing the prayers of a *femina religiosa* but had to stop overnight in Brabant, where he found lodgings with an "honest matron." When she heard where he was headed, the woman asked him: "What do you want from those 'beguines' (*begginas*)? If you wish, I will show you a good woman, who can obtain from God all she wants!"[10] Philologists now also doubt that *beguina*, with an occlusive -g-, could derive from *Albigensis*.[11]

A second hypothesis relates the term to the French word *beges*, from the Latin *badius*, an attribute usually applied to wool and meaning "undyed," of a grayish-brown color.[12] The term would then refer to the humble raiment worn by beguines in sign of their penitent status.[13] Why it would have been a term of derision remains unexplained, however, while again the etymology does not appear to bear the most recent philological scrutiny.[14]

In 1970 the Flemish philologist Maurits Gysseling suggested a third etymology. He argued that *beguina* is derived from the Indo-European root *begg-* and means someone who speaks indistinctly, mumbles, as when reciting prayers. The word is related to the old-French *béguer*, to stammer (modern French: *bégayer*), which was, as we will recall, the nickname given in the thirteenth century to Lambert, the Liégeois priest who died in 1177. The term is also closely related, both in meaning and construction, to the French *papelard* (another term of derision used for beguines in France, as mentioned by James of Vitry), which in turn is derived from the Middle Dutch *popelen*, or to mumble, especially to mumble prayers. It is akin to the English *lollard*, derived from the Middle Dutch *lollaert* or beghard (the Dutch *lollen* means to mumble prayers or to sing quietly).[15]

All of these terms, *beguina*, *papelard*, and *lollaert*, originally stood for a person involved in private prayer, so private in fact that his or her speech cannot be understood. Its pejorative connotations were clear from the start: the individual claimed to be devout, but was she really praying? She gave the impression of chanting devoutly, but we have only her word for it, because we do not actually recognize the sounds; hence the notion that she may be a hypocrite. But yet more importantly the term also served to relegate the person to another, inferior realm with which "reasoned" communication seemed impossible: the beguine would not or could not communicate clearly. We are reminded of the classic definition of the foreigner given by de Saussure: a person who lacks the power of our speech, who is "dumb."[16] To call someone a beguine or *papelard* or *lollard*

was more than to question her sincerety: she spoke another language that defied comprehension.

That beguines aroused ridicule from the very beginning, as James claimed, is confirmed by many of his contemporaries who reported on the new movement, albeit often with less sympathy. Walter of Coincy, a Benedictine monk from northern France, who is best known for his popular collection of miraculous stories of the Virgin Mary, *Les Miracles de la Sainte Vierge*, composed a *Life of Saint Léocade* between 1222 and 1227, in which he inserted a long diatribe against those who misled the laity into false devotions. He called these dangerous individuals *papelart* and *papelarde, beguin, begart*, and their way of life, *papelardie* and *beguinage*.[17] All were hypocrites, Walter said. "When I saw them coming, I was ready to sink to my knees; that is how clever mimics they are of the Magdalen," the prostitute of the New Testament who became the quintessential penitent of the high Middle Ages.[18] Walter commented that they assumed the role of stern penitents who refused to laugh and claimed to live ascetically, but in reality lusted after copious meals and the pleasures of the flesh.

To some extent, Walter's charges formed a staple in anticlerical literature of the later middle ages. From the twelfth century on, members of the clergy, regular or secular, male or female, often appeared in fiction as lascivious characters engaged in sexual acrobatics whenever given the slightest opportunity.[19] Walter may have been the first to depict beguines and beghards in that role, but he certainly was not the last. In Netherlandish satires of the fourteenth century, the emergence of a beguine on the scene would be sure to arouse catcalls and snickers. Two of the oldest *farces* in Middle Dutch were set in the beguinage of Brussels, where beguines gave themselves over to savage couplings with visitors, once literally bringing the roof down when their bed crashes through the attic floor.[20] Nor were these stories and innuendoes entirely unfounded: the informal kind of enclosure to which beguines were subjected, and their relative freedom to leave the beguinage or receive visitors in their home — at least in the thirteenth century — not only fostered suspicion but in a very real sense also increased the chances that beguines might violate their temporary vow of chastity; sexual relations between beguines and outsiders (often, in fact, clerics) can be well documented for the fifteenth century, but must have been just as numerous, if not more so, in the thirteenth.[21]

When leveled by ecclesiastics, however, the accusation of hypocrisy and false devotion served a more specific agenda: to denounce new forms of monastic or religious life, or simply to discredit a competing force within the Church. The scriptural basis for such charges lay in Apocalyptic thought: Christ's prophesy on the destruction of the Temple and his warnings against false prophets in Mark 13:22 ("For there will rise up false Christs and false prophets, and they

shall shew signs and wonders to seduce — if it were possible — even the elect"); or 2 Timothy 3:1-5 ("In the last days shall come dangerous times. Men shall be . . . traitors . . . and lovers of pleasures more than of God, having an appearance indeed of godliness, but denying the power thereof"); and finally Revelation 6:3-8, whose Pale Horse was understood to symbolize the Devil's persecution of the Church initiated by "false brethren disguised under the habit of sanctity," as the *Glossa Ordinaria* explained. By the thirteenth century, such invectives as pseudo-prophet and pseudo-apostle often spiced internal ecclesiastical bickering, but its more sophisticated usage in the hands of a master could still inflict serious damage, as William of Saint-Amour demonstrated against the Mendicant friars at the University of Paris. Between 1250 and 1259 his antifraternal writings based on scriptural exegesis formed a goldmine for later polemicists, and many of his most vibrant caricatures of the Mendicants found their way into vernacular literature.[22]

Some members of the Church welcomed the plurality of religious vocations as a sign of diversity, and even included lay people into the equation. According to James of Vitry, "We should regard as 'regulars' not only those who renounce the world and convert to the religious life but also the faithful of Christ serving the Lord under the rule of the Gospel and ordained under the one highest and supreme abbot, God."[23] Others were not so sure, and accepted at best that various forms of religious life contributed to purify the faith of real Christians, forcing them, as it were, to make a choice between good and bad. In the end, the more exclusionary forces in the Church dominated the Lateran Council of 1215, which forbade the foundation of new religious orders.

It is within this context that we must reinterpret criticism of beguines and Walter of Coincy's discourse in particular. Walter, a Benedictine, refused to accept the beguines and beghards as candidates for a new religious order. Not only did he object to their unsettled life and to their "bigotry," or religious hypocrisy, but argued that their moral turpitude must invalidate whatever message they intended to spread. Their speech was treacherous, their examples invalid. Look at their own name, he wrote: they claimed that the word *beguin* comes from *benignitas* ("goodness" or "generosity") but he knew better: it was derived from the word *begun* or dung.[24]

Having exposed the beguines' attempt to legitimize their way of life by the invocation of fake etymology, Walter added that their use of language revealed an even greater perversion. In the most curious passage of his attack on beguines and beghards, he said: "They join *hic* with *hic* without discrimination, like grammar does; but Nature condemns such coupling. . . . Nature rejoices, it seems to me, when *hic* couples with *haec*: but *hic* and *hic* is a lost cause, and bewilders Nature. She beats her fists and wrings her hands."[25] As John Boswell and

Jan Ziolkowski have noted, Walter joined the ranks of twelfth- and thirteenth-century theologians who maintained that the linguistic arts led to errors, and the grammar of Latin needed correction by the superior grammar of Nature. Grammar might have geared subjects to seek couplings of the same gender, but Nature had no use for homosexual relationships.[26]

As far as we can tell, Walter was the only thirteenth-century writer to suggest that beguines and beghards practiced gay love.[27] His charge betrays once again his debt to the rhetoric of clerical and antiheretical disputes, in which the accusation of sodomy was sure to acquire resonance. Nevertheless, his insistence that the beguines' and beghards' naive fascination with language went hand in hand with vicious, unnatural acts, suggests that in his view one of their major errors was indeed to have appropriated the tools of learned language without proper training and supervision.

The theme of beguines' intrusion upon the terrain of clerics was taken up again by Guibert of Tournai, a Franciscan master of theology at Paris. Shortly before the Council of Lyons, in 1274, he composed his *Collectio de Scandalis Ecclesiae*, a treatise on ecclesiastical reform that analyzed moral problems at each social station in Christendom, from high to low, from the Pope down to the meanest laborer. At the very end of this *revue des états*, he listed a new estate, that of the beguines. In the first part of the *Collectio*, devoted to the clergy, Guibert had mentioned their existence briefly, indicating that he was uncertain whether to classify them as religious or secular, since they seemed to pertain to both categories. He finally relegated them to the laity, examining their case after that of the peasants, weavers, sailors, and domestic servants, who received a few gentle words of advice taken from routine sermon literature on the subject. The beguines, however, warranted special concern:

There are in our lands women called beguines, and some of them are famous for their subtleties and enjoy speculating about novelties. They have interpreted the mysteries of Scripture and translated them in the common vernacular, although the best experts in Scripture can hardly comprehend them. They read these texts in common, without due respect, boldly, in their little convents and in their workshops, or even in public places. I have myself seen and read and held in my hands a Bible in French, whose exemplar is available to everyone at Parisian writing-shops so that heretical and erroneous, dubious, or stupid interpretations might be copied.

Guibert predicted that such books would lead more and more people astray and recommended they be destroyed so that "the speech of things divine be no longer stained by common, vulgar utterance" (*ne sermo divinus a dictione vulgari vilescat*).[28]

What emerges from these attacks on beguines and and beghards, I believe,

is a new awareness among clerics that the unique powers and privileges of the priestly office and of the clergy in general—just barely won, by around 1200— must be safeguarded against new claims. The polemics were so heated, the language so fierce, I suggest, not so much because clerics viewed beguines and other lay folks with apostolic aspirations as competitors—although that was certainly one element—but because the ecclesiastical milieu was itself divided on this issue. If beguines were viewed as challenging a clerical monopoly, they did so with the support of a small group of clerics who favored an apostolate of the laity. The most influential of these was Peter the Chanter (d. 1197), the main theologian at Paris in the last decades of the twelfth century, and the probable teacher of James of Vitry, John of Liroux, John of Nivelle, and others who were among the first supporters of the beguines in the southern Low Countries.

As Philippe Buc has shown, Peter the Chanter's Bible commentaries made an explicit case for greater lay participation in promoting the Christian faith.[29] His argument in favor of lay preaching was not entirely new: it owed a great deal to Gregory the Great's notion that preaching is a charitable duty, *opus elemosinarum*, and to the patristic doctrine of the "priesthood of the faithful," which maintained that all followers of Christ were participants in His royal priesthood.[30] Yet, it ran counter to prevalent canon law: Gratian's *Decretum* (c. 1140) forbade "a woman, however learned and holy she might be, to teach in a meeting of men," and said that "a lay person shall not teach in the presence of clerics."[31] This was usually interpreted broadly to exclude "all public preaching (that is, in a church) by a lay person or a woman," as in Thomas of Chobham's *Summa de arte predicandi*.[32] A bishop could grant the license to preach only to priests or, in exceptional cases, to laymen whose sanctity and special mission God had sanctioned by the performance of miracles.

Peter the Chanter argued that canon law forbidding such preaching by lay people had no basis in the gospel. For, what had happened to St. Paul himself?

Where did Paul get his preaching certificate? He started to preach right after his conversion. That convinces me, that each Christian can preach if he sees his brother in error. Not in the church, unless the local bishop or the local priest has granted him permission. But otherwise it is enough to be guided by the Holy Spirit, even if one is not licensed by a human or by any ecclesiastical authority. It has been said that no one should preach without being ordered to do so by man. But should I not give alms to a poor person even if I am not commissioned to do so by the Church? Preaching is very similar: it is a work of charity, and thus the Gospel itself was preached to many without any commission.[33]

Peter's argument was twofold: on the one hand, the gospel itself showed that the preaching mission should be shared by all who have the faith and should not rest solely upon the shoulders of the ordained clergy, to whom he still reserved the

office of formal *predicatio* in church; on the other hand, preaching encompassed more than spreading the word of God: it could be done by gentle admonition or *exhortatio* and was an act of charity, an act for which no one should require prior permission.[34]

Peter's teaching left room for a broad interpretation of *exhortatio*, which he considered the duty of every good Christian. His thesis did not find a consensus within the Church, but it did guide a small circle of influential students. Pope Innocent III, who had briefly studied at Paris with Peter, was surely following his master's teachings when he wrote to the bishop of Metz in 1199 that the laity's desire to translate Scripture was wrong, but understandable. He repeated that lay people were not permitted to preach or interpret Scripture, but he commended them for their "zeal to exhort" (*studium exhortandi*).[35] James of Vitry honored Peter as his teacher in the *Historia Occidentalis* and followed his advice by supporting the work of Mary of Oignies and other beguines.[36] Thanks to James, Pope Honorius III reportedly sanctioned the beguines' *exhortatio* in 1216, as we have seen.[37] Other supporters of the beguines such as John of Liroux, John of Nivelle, and perhaps also Guido of Nivelles, gained their degrees in Paris around the same time and may have studied with Peter as well. Master Renerus of Tongeren, whom the bishop of Liège appointed as "protector of the beguinages in the region of Tongeren" before 1243,[38] and master Reinerus of Breeteyck, who helped found the beguinage of the Wijngaard in Brussels in or before 1247, probably studied at Paris after Peter's death but undoubtedly were familiar with his teaching, if only through James of Vitry and Thomas of Cantimpré.

Between 1260 and 1274, while Giles of Orléans, Rutebeuf, Guibert of Tournai, and many others, launched their attacks on beguines, at least three Parisian masters—Thomas Aquinas, Henry of Ghent, and Eustace of Arras—debated whether women could be allowed to preach in public. All three argued against the proposition on the familiar grounds that women had always been prohibited from speaking in public on religious subjects; that female preachers by their very appearance would constitute a distraction to a male audience; that women lacked the training, the natural ability for wisdom, the reliability to be trusted in such a responsible position; and finally, that women by their nature were subordinate to the male sex and therefore could not hold a position of authority over them.[39] As Thomas Aquinas wrote, even though some women may have been graced by God with the talent and wisdom to exhort others, they should do so in private, within the household.[40]

These theologians did admit, on the other hand, that two powerful precedents existed in the history of Christianity in favor of a female apostolate: the first was Mary Magdalen, who according to the *Golden Legend* had helped to convert southern France to Christianity; the second was St. Catherine of Alexandria, the

early Christian saint, who was said to have conducted learned disputes with fifty pagan philosophers.[41] Aquinas and Henry of Ghent dismissed those examples as exceptional cases particular to the Church of the early days, when, as Henry put it, paraphrasing Matt. 9:37, "harvests were large, and laborers few." [42] But Eustace of Arras thought otherwise. He spoke with understanding of those who "zealously believe — to the praise and glory of all women saints — that holy women such as Mary Magdalen and the blessed Catherine merit celestical crowns, because even if they were not sent by man (as by a prelate having that power), yet they preached both by instigation of the Holy Spirit and sent by the Holy Spirit: the sign of this being that they converted many important people to the faith in Christ." [43] Eustace maintained that such women derived their "authority" to preach directly from the Holy Spirit, as was proven by the positive results of their preaching. He did believe that only a select few women (*electae et priviligiatae*) would be granted such grace — and he excluded married women from that group — but he admitted that there was nothing in their nature that made it impossible. He therefore breached the categorical refusal of traditional Christian theologians to accept women as preachers because of their sex.

James of Vitry had advanced the same argument in his *Life of Mary of Oignies*, which recounted the ways in which Mary, "the King's daughter," displayed the seven gifts of the Holy Spirit, including the gifts of knowledge, understanding, and wisdom. Thomas of Cantimpré explained that Christina Mirabilis was granted the gift of prophecy and spoke with an persuasive power that nobody could resist. Although she did not have training in Latin, she supposedly understood it well and could even explain Scripture, but he added that she did so reluctantly, respectful as she was of the clergy.[44] Mary Magdalen and St. Catherine were two of the most popular saints among beguines.[45] As Michel Lauwers has shown, the authors of the *vitae* of *mulieres religiosae* tended to depict Mary Magdalen as the prototype of the penitent, humble and obedient, but it is not at all certain that beguines venerated her for the same reason.[46] In the church of the beguinage of St. Truiden, a thirteenth-century fresco near the high altar presents a remarkable image of Mary Magdalen in a prominent position — above the altar on the southern side of the choir, juxtaposed with the Coronation of the Virgin on the north side. The Magdalen stands erect, holding the True Face of Christ in front of her: she is a *Christophora*, who brings Christ to those wishing to be liberated by the eucharist at the altar (fig. 6).[47] Hadewijch cited her fourth in her List of the Perfect, after the Virgin Mary, John the Baptist, and John the Evangelist, and celebrated her unselfish love of the Lord in her *Visions*; Marguerite Porète honored her too in her *Mirror of Simple Souls*.[48]

The Parisian theologians who discussed the right of women to preach were certainly aware of beguines' claims in this regard. Eustace of Arras and Henry of

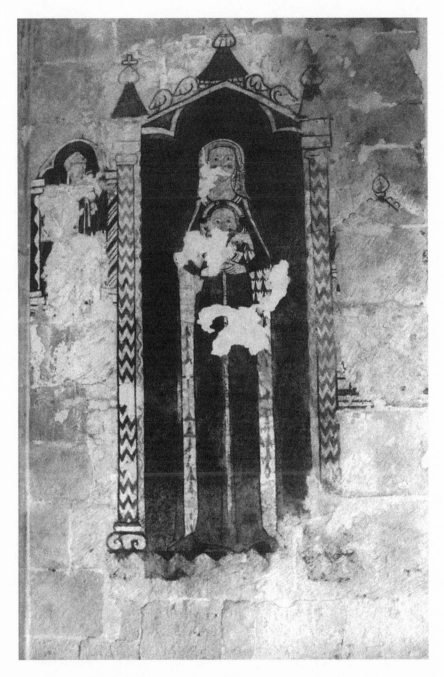

Figure 6. St. Mary Magdalen as *Christophora*? Wall painting in the main church of the beguinage of St. Agnes in Sint-Truiden, about 1300. Photograph by the author.

Ghent came from cities with large numbers of beguines — Henry of Ghent's own sister was a beguine at the main beguinage of Tournai.[49] But they could have seen them at work in Paris as well. Peter of Limoges, the ardent collector of sermon materials in Paris around 1273–74, took down several fragments of what appear to be sermons to the beguines by the grand mistress, Agnes of Orchies. We know that she spoke on the themes of love, Christian faith, tribulation, and on the feast of the dedication of the beguine church.[50] Although Agnes probably did not preach in church and, as far as we know, did not formally interpret Scripture, she evidently was well educated and trained in the art of public speaking.

There were other ways in which beguines could "preach." Reporting on the stigmata of Elizabeth of Spalbeek, a beguine who lived with her mother and sisters in a village outside Hasselt in 1267–77, Philip of Clairvaux assured his readers that her wounds were real. To those who doubted that a woman could be the bearer of such marks and objected to Elizabeth's habit of displaying them to visitors, he said:

In the male sex, namely in the person of St. Francis, God has revealed himself already. Now both sexes may perceive on Christ's cross what should be honored, venerated, adored, imitated, and loved, not only by the testimony of Scriptures but also by living examples of the human condition, so that no human, whom that Child of the Immaculate Virgin redeemed, can prevaricate, being illiterate and simple, and say: "I cannot understand such profound mysteries, because I am not lettered," or "because this is a closed book for me." Now this illiterate man or woman can read in the members and the body of this girl, as a vivid and unmistakable Veronica, a living image and an animated history of redemption, as though he or she were reading parchments or documents . . . . Truly every human must gain strength of faith, a desire for charity, and eagerness in devotion, when convinced by arguments that have come alive and stand bodily before our eyes.[51]

For defenders of beguines, their teaching formed a welcome addition to that of the ordained clergy, and might be accomplished by different means — in Elizabeth's case by ritualized showings of her stigmata in a kind of pantomime mimicking Christ's passion. Hadewijch, too, taught in unorthodox ways: some of her poetry was apparently intended to be sung, and the pervasiveness of the theme of dance in beguine culture suggests these songs were accompanied by dancing on the part of teacher and students of her circle.[52] One is reminded here of Rutebeuf's sarcastic comment that everything in a beguine's life was religion, and that her whole life became a religious performance. For beguine opponents, however, the office of preaching was sacrosanct and should be strictly regulated: it required special training, knowledge of Latin in particular, and that unique sanction of the Word vested in the Church by apostolic tradition.

The controversy was also fueled by the nature of beguine teaching. The "vernacular theology" (to use Bernard McGinn's term) of beguine mystics

tended to locate authority within God's grace rather than in professional, learned knowledge,[53] and it often did so aggressively. The *Compilatio singularis exemplorum*,[54] probably the work of a Dominican active in northern France about 1270–97, contains a dialogue between a Parisian master of theology and a beguine that illustrates this tendency of beguine thought. The learned master first reproached the beguine for her irreverent and presumptuous attitude. The beguine responded:

> You talk, we act.
> You learn, we seize.
> You inspect, we choose.
> You chew, we swallow.
> You bargain, we buy.
> You glow, we take fire.
> You assume, we know.
> You ask, we take.
> You search, we find.
> You love, we languish.
> You languish, we die.
> You sow, we reap.
> You work, we rest.
> You grow thin, we grow fat.
> You ring, we sing.
> You sing, we dance.
> You dance, we jump.
> You blossom, we bear fruit.
> You taste, we savor.[55]

This extraordinary text juxtaposes two genders and two types of knowledge: one male and learned, the other female and intuitive. The beguine makes full use of paradox, a favorite didactic tool of mystics, to demonstrate her superiority over the learned master. The quick succession of opposing and puzzling sign-images fulfills an important, almost ritual function:[56] the elementary opposition between the pronouns "you" and "we" supports a scheme of metonymic transformation; strenghtened by a few surprising reversals ("You ring, we sing, you *sing*, we dance"), this playful game of wits mocks the master's received wisdom and implies that the beguine possesses deeper insight, greater truth, and acts on a higher plane. Whatever the "you" does, the "we" does better. The dialogue resembles the debates between man and woman in French literature of the thirteenth and fourteenth centuries recently studied by Helen Solterer, debates in

which the master's carefully constructed house of cards crumbles by the force of a woman's analysis.[57] But the dispute of course confirms the master's initial complaint: the beguine is arrogant and presumptious, mocking established concepts and predicates as though she possessed secret knowledge that transcends human language.

Two manuscripts of the *Compilatio* left the story open-ended, for who could tell if indeed beguines did not have access to realms of knowledge elusive to those masters at Paris?[58] The oldest version, however, attested around 1300, granted the master another line to beat the beguine at her own game. Switching to French from his original Latin, he asserts: *Vous aputés, nous desputons* ("You debauch yourself, we dispute"), a pun on the French *pute*, or prostitute.[59] It was a warning of things to come. Before long, the confrontation between master and beguine was no longer play.

## The Inquiries

There is little evidence that Church authorities in the southern Low Countries took any systematic action against beguines before the condemnation and execution of Marguerite Porète in 1310 and the subsequent decrees of the Council of Vienne.[60] There were, of course, problems of discipline in the ever growing beguine communities at the end of the thirteenth century. On 12 August 1283, bishop John of Liège took steps to reorganize the administration of the beguinage of St. Christophe in his city. While he recognized that most beguines led a life that was to be commended, there were some among them, he said, who had fallen in disrepute. He appointed a committee of four beguines, "mature, with a proven record of good manners and life" to investigate the behavior of their sister beguines and report all irregularities to the parish priest. Those who were found guilty of grave offenses would be expelled.[61] Roughly ten years later, count Guy of Flanders ordered his bailiff in Ghent to watch out for "people who wear the habit of beguines but are unworthy of it because of suspect conversations, carnal lapses, or other crimes." The bailiff should intervene whenever he was alerted to such persons by the guardian of the Franciscan convent, the beguines' confessors, or the beguine mistresses, and force unruly beguines to discard their habit.[62]

At some point between 1296 and 1306, bishop Guy of Cambrai condemned Marguerite Porète's book, *The Mirror of Simple Souls*, and had it burned at Valenciennes in her presence. Marguerite probably resided in that city; we do not know if she belonged to the local beguinage of St. Elizabeth. Bishop Guy apparently warned her against spreading the ideas expressed in the *Mirror*, but

Marguerite continued to defend her book, several copies of which must already have been in circulation. She submitted it to the Franciscan John of Quaregnon, the Cistercian Franco of Villers, and master Geoffrey of Fontaines, who all approved it. Nevertheless, toward the end of 1308 she and a male follower, Guiard de Cressonessart, were arrested and brought before the inquisitor of Paris. After a long trial at which the book was again condemned as heretical, Marguerite was executed on 1 May 1310.[63]

The Council of Vienne (1311–12) formally denounced a set of heretical beliefs spread by "an abominable sect of wicked men called beghards and faithless women commonly called beguines in the kingdom of Germany."[64] It also devoted a special decree, *Cum de Quibusdam Mulieribus*, to the question of beguine life. The decree defined beguines as women who assumed religious dress but did not take vows of obedience or renounced private property and lived without observing an approved rule. Some of them, it said, "discussed and preached about the Trinity and divine essence and expressed opinions contrary to the Catholic faith as if driven by a particular insanity," and led others into various errors. The council prohibited their mode of life "under any form," but added that "of course, we do not intend in any way to forbid faithful women, whether they promise chastity or not, from living uprightly in their hospices (*hospitiis*), wishing to lead a life of penance and serving the Lord."[65] The council's decrees were published in 1317 and were followed by a new bull, *Ratio Recta*, issued by Pope John XXII on 13 August 1318. John admonished bishops to continue their efforts to detect heretical beliefs among beguines but repeated that those who did not express controversial ideas on the Trinity, the divine esssence, or the sacraments of the Church would be allowed to pursue their lives as before; this did not mean, he added, that the Holy See approved of the beguines as a religious order.[66]

While bishops in the Rhineland began to investigate and harass beguines in their dioceses shortly after the publication of the council's decrees, the authorities in the southern Low Countries were slower to react, perhaps because they were uncertain whether the council's decrees applied to the stable beguine communities in their lands. Here and there agents of the bishops attempted unsuccesfully to ban beguine life. The Wijngaard of Brussels received a letter of protection from Pope John XXII issued on 21 May 1319, while the beguines of Vilvoorde, who were excommunicated for refusing to break up their community, were reconciled on 25 November 1319.[67] Beguines "who misbehaved" (*inhonestam vitam ducunt*) were expelled from St. Christophe in Liège in the first months of 1320.[68] But it was only after John issued new instructions to examine beguine orthodoxy at the end of 1320 and 1321 that bishops in the dioceses of Thérouanne, Arras, Cambrai, Tournai, and Liège conducted a full inquiry. The beguinage of St. Elizabeth of Valenciennes (the memory of Marguerite Porète's

activities in the city being still vivid) was among the first to be visited by the investigators and was cleared of all charges on 4 August 1323.[69] Bishop Adolph of Liège confirmed the beguines of all court beguinages in his diocese on 24 October 1324.[70] In most dioceses, however, the investigation was not completed until late in 1328.[71]

Despite the late start, the inquiries seriously threatened the continuation of beguine life in the southern Low Countries. At first, beguines received the formidable help of count Robert of Flanders. Since his ancestors had founded several court beguinages in the county, Robert assumed responsibility of their defense. On 12 June 1319, he appointed his councillor Henry Braem, "trained in canon and civil law," to protect the beguines of St. Elizabeth in Ghent from all accusations. Henry was to expell all beguines who caused scandal and to supervise a "reform" of the beguinage.[72] He was probably also the author of a petition addressed by count Robert to Pope John XXII in 1319–22 to vouch for the beguines' orthodoxy. The petition assured the Pope that they attended mass daily, earned their own living by the work of their hands, obeyed all prelates of the Church, listened attentively to sermons on feast days, and gave young girls a proper education. Robert's death in September 1322, however, aborted these efforts, and it is unclear whether the petition was actually sent.[73]

During most of this uncertain period, beguinages were evidently in a state of disarray. From 1319 until 1328 members of these communities went to great lengths not to identify themselves as "beguines:" they were "religious women whom one used to call beguines,"[74] "good women who serve God and used to be called beguines" (*les boines femes qui servent Dieu que on soloit jadis appieler beghines*),[75] or simply "good women" (*boines femmes*),[76] and their community "a court formerly occupied by beguines" (*curtis olim beghinarum*).[77] They also cast off their gray-brown habits and dressed in ordinary, secular clothes.[78] Beguines at St. Elizabeth of Ghent were forced to compile a list of all property acquired by the beguinage since the Second Council of Lyons in 1274 (which had suppressed all religious orders created after 1215)[79] — clearly a first step toward the confiscation of these goods by the Church.[80] In 1323 Dominican and Franciscan friars devised a plan — never carried out — to dissolve the beguinage of the Wijngaard of Bruges and enlist the beguines in their respective Third Orders (or their orders of Tertiaries), as was commonly done in the northern Netherlands and Germany at that time.[81]

Beguines found themselves in a particularly weak position for several reasons. The economic crisis that struck Flanders and other parts of the Low Countries in the early fourteenth century lowered wages and reduced the workforce in the textile industry. Unable to support the excessive numbers of impoverished beguines, several beguinages must have had severe financial problems. The lack

of institutional links between the various communities also hindered a coordi-
nated defense. The grand mistresses of the beguinages of St. Elizabeth of Ghent
and the Wijngaard in Bruges did meet in 1326 in West-Eeklo, about midway be-
tween the two cities, to discuss the situation and share a copy of John XXII's bull,
*Cum de Mulieribus*, of 1321, but no common strategy emerged from that session.[82]
Lobbying in favor of the beguines thus became the task of their Dominican and
Franciscan confessors, and of the priests of the beguinages.[83]

## The Aftermath

In 1328 the episcopal inquiries ended with the full exoneration of beguines who
resided in court beguinages. There were new rounds of inquests in the 1330s,
now conducted on behalf of the counts of Flanders, and some courts did not
recover property, alienated in the years after the Clementine decrees, until the
mid-fourteenth century; suspicion of beguines lingered for much longer.[84] These
investigations left their mark on the beguine movement. They affected the ability
of single women to pursue the beguine life outside an established court or con-
vent. Such solitary beguines, rarely documented after 1320, had not been un-
common in the thirteenth century.[85] Some of them were probably financially
independent and unwilling to submit to the kind of discipline expected from
beguines living in convents or courts. Elizabeth of Spalbeek, for instance, who
may have been noble, lived as a beguine with her mother and sisters in rural
Spalbeek in the third quarter of the thirteenth century.[86] Marguerite Porète and
Hadewijch, the two most prominent beguine writers of the medieval Low Coun-
tries, may have spent a large part of their life as solitary beguines in the late
thirteenth century. Marguerite observed in *The Mirror of Simple Souls* that "be-
guines say that I err, priests, clerics and Friars Preachers, Augustinians, Carmel-
ites, and Friars Minor, because I wrote about the being of the one purified by
Love."[87] The documents of her trial do not associate her with any beguine com-
munity but simply identify her as Marguerite Porète of Hainaut.[88] If she once
was a member of a beguinage, she probably severed all ties to it before she was
arrested in 1308. In the case of Hadewijch of Brabant we have even fewer hard
biographical data to work with. She is not documented in archival records and
offers little information about herself in her work. The date of her activity as a
writer is also uncertain. On the basis of her *List of the Perfect*, it is possible to
suggest that she wrote in the third quarter of the thirteenth century, but other
dates have been advanced.[89] Her *Letters* show that she moved at least once from
one beguine group to another, and also that she made plans to form a new group
of like-minded beguines. Her experience of opposition and rejection was strik-

ingly similar to Marguerite's, for she, too, warned her loyal followers that "false brethren who pose as friends of our belief . . . sow confusion and try to break up our circle, and especially attempt to keep you away from me." [90]

However uncertain our information about the two women, it does indicate that both did not fare well in a structured setting, supervised by clerics and friars. As mystics, their concept of beguine life may also have been at variance with the regulations that governed life in institutionalized communities. [91] Yet regardless of their personal traits, their experiences reflected a wider trend. As early as 1246 bishop Robert of Liège ordered beguines of his diocese to live in communities governed by a beguine rule and a "mistress," if only to silence their detractors. [92] By the time the decrees of the Council of Vienne were implemented, life in such a community became the norm. Significantly, the few solitary beguines who appear in sources after 1328 were mentioned in a context of crime: in Bruges, for instance, an unnamed beguine was fined for rioting in 1341, the beguine Lisbette received a fine as a troublemaker in 1375, and Beele, "the beguine" was said to keep a brothel in 1392. [93]

Beguine convents outside the great courts also suffered from the Vienne decrees. Unable to mount a succesful defense against the incriminations, many of the smaller and poorer convents were shut down. By 1350, more than fifty beguine convents previously attested were closed—or, at least, dropped from the records; another thirty-five ceased to exist before the end of the fourteenth century. At the end of our period, around 1565, only a few dozen were still maintained as beguine convents. [94]

The religious climate within the court beguinages was further affected by the introduction of new statutes intended to prevent "scandalous" behavior. Fourteenth- and fifteenth-century rules regulated more strictly than before the circumstances under which beguines could leave the court, limited contact with men, and prescribed minutely their dress and outward behavior: when moving about town, the beguine was to preserve a humble demeanor, keeping her head veiled and eyes averted. [95] The greater restrictions placed on travel undoubtedly contracted the beguines' social and intellectual horizon: whereas thirteenth-century wills by beguines in the courts of Sint-Truiden and Tongeren frequently contain legacies to other beguinages and individual beguines living as far away as Aachen, Brussels, Mechelen, or Nivelles, those of later centuries rarely show such contacts. [96] It is difficult to imagine in this later age beguines engaged in the trade and transport of relics between Cologne, Spalbeek, and St. Truiden, like the enigmatic Ermentrudis, a friend of Elizabeth of Spalbeek, mentioned in 1270–71. [97] In the late fifteenth and early sixteenth century, priests and other clerical advisers inspired by the *Devotio Moderna* movement carried out reforms in several court beguinages to promote the more contemplative aspects of be-

guine life at the expense of other activities and restricted contact between the beguine and the outside world even more.[98] The prevalent image of the beguine in this later age was no longer controversial or defiant, but rather that of a naïve, somewhat foolish but inoffensive *kwezel*.[99] The terms used to designate beguines in this period are again instructive: from the mid-fifteenth century on, *beghinkin* is the name of choice, a *diminutivum charitatis* that expresses the beguine's simplicity and perceived innocence.[100]

Yet within the walls of the court beguinage there was still room for a diversity of lifestyles. In 's-Hertogenbosch and elsewhere, new anchorholds were established.[101] In Cantimpret at Mons around 1351, and in St. Elizabeth at Ghent between 1428 and 1437, a few beguines resolved to lead a stricter form of common life than did other beguines and formed a special community within the larger court.[102] And even though no beguine of the later age left a body of written work as original and extraordinary as that of Hadewijch or Marguerite Porète, some were still able to explore its complexities. In a list of seventy manuscripts in Dutch donated to the beguinage of Ter Hooie in Ghent in the late fifteenth century—most of which belong to that vaste, unexceptional, but still barely known body of devotional texts enjoyed by the laity in the fourteenth and fifteenth centuries—one title stands out: "A book on how a soul will keep itself stripped from sin onto God" (*Item eenen bouc hoe haar een siele naect sal hauden an Gode*). This must have been a Flemish (or Dutch) translation of none other than Marguerite Porète's *Mirror of Simple Souls*, which starts with the words *Ame de Dieu touchee, et denuee de peché*.[103]

# 6. Conclusion

The mid-sixteenth century was a turbulent time for the southern Low Countries. Political and religious dissent led to numerous conflicts between the Spanish crown and its subjects from the 1520s on; excessive taxation and economic setbacks further aggravated the tensions, which finally escalated in the iconoclast movement of 1566 and the subsequent revolt.

In 1559, in an atmosphere of rising anxiety, Lievin vander Muelene, a priest of St. Lievens Esse, some fifteen miles south of Ghent, drew up his last will and testament. It contained a long opening statement, in which Lievin contemplated the fate of his country and the Catholic Church, besieged by economic woes and the temptations of Protestantism. The preamble was an insightful social commentary, made even more relevant by Lievin's references to his own life story:

I am considering the long period of hardship, and how all rents have become extraordinarily high and all goods on earth most horribly expensive, and everything today even increases in price because of the great wars and various heavy burdens and taxes that multiply every year, causing enormous expense, burden, and sorrow for the townspeople, who from day to day find it even more difficult to sustain themselves honorably and to raise their children properly. I am also concerned by the strange and very dangerous days for all people of good will who love the works of the Holy Church, and especially for the many young, simple hearts now growing up, who have had so little instruction, so little proof, so little help, to lead a pure, clean, religious life, because, although they might be well enough disposed to do so, they are continuously waylaid by poisonous, perverting minds who sow their noxious seeds in all corners of the world to the detriment of divine service and denigration of the clergy. People of good will therefore loose confidence and become desperate, as they did not and will not receive the kind of natural affection or favors that encourage them to teach or have taught their children any Church customs, which previously drew the young to the clergy or to service of the Holy Church.[1]

Instead, Lievin wrote, people leave their children uneducated, sending them off to be trained in a craft or business, or to herd animals, or to live as vagrants destined for a life of crime, or to work as servants in all kinds of households — often of ungodly or perverse people[2] — where the children learn only blasphemy, crime, derision of the Church and the saints.

Turning to his own course of life, Lievin praised the Lord for the help that

he received at a critical age from a beguine at St. Elizabeth's of Ghent, Maijke (or *Maijkin*) Bennins:

When I became twenty years old, and also later, I was myself most tormented by those perverted minds; but, like good parents naturally love their children and diligently work day and night to raise them well towards a proper and honorable existence, a good and devout little beguine (*een goet devot beghijntkin*) of St. Elizabeth of Ghent, called Maijke Bennins, labored and worked hard in God's spirit, praying and shedding many tears so that the Almighty Lord should call me and lead me to a life of virtue and eventually have me ordained a priest, which is what the benevolent Lord decided—honor and benediction be His in eternity. And like good parents chastise their children if they misbehave, she also chastised me through God's love with sharp words and virtuous lectures, often punishing my misdeeds in writing or speech, correcting me and leading me toward virtue throughout her life. That is why I dare to say and write that she was my spiritual mother, for she was the cause and most important reason for my well-being.[3]

Lievin finally stated the main purpose of his will: to set up a foundation in the beguinage of St. Elizabeth of Ghent, in Maijke's honor, to support up to five young girls of his extended family (or others of poor families) while they went to school with beguines at St. Elizabeth, and up to four boys who attended the school of the Brothers of the Common Life or "any other good Latin school in the city." The girls enrolled at St. Elizabeth's were to be trained in "virtue and good manners, and in reading, writing, or sewing" (*inden wech van duechden ende in goede manieren, tsij om te leeren lesene, scrivene, of naeijene*) and to be supported for two or three years, unless they decided to become beguines. He further made arrangements for the distribution of alms in Maijke's convent at St. Elizabeth's; an annual service on the feast of *Nomen Jesu* (15 January), with a requiem mass and commendations for himself, his parents, and Maijke, with a distribution of bread to forty people; an anniversary service for Maijke, with vigils, commendation, high mass at the altar of the Blessed Virgin, and a requiem mass, on the Tuesday after St. Mark; and an anniversary service with vigils, commendations, and high mass on Tuesday before Pentecost for another beguine, Gheertruyt vander Linden, his "great friend" (*grote vriendinne*), who also encouraged him to become a priest; at the latter service, breads should be given to fifteen beguines of her convent at St. Elizabeth.[4]

More than three centuries before Lievin wrote his will, James of Vitry, Thomas of Cantimpré, and others had paid tribute to *their* "spiritual mothers," Mary of Oignies, Lutgard of Tongeren, and other members of the first beguine generation. James and Thomas honored them as beacons of true faith in a world degenerated by the pursuit of material wealth, and as pillars of the Church and its sacraments against the threats of heresy. Although they did not write hagiographical accounts of their encounters with beguines, such clerics as John of

Liroux, John of Nivelle, Guido of Nivelles, as well as the clerical founders of certain beguinages, appear to have shared with James and Thomas a belief in the special virtues of beguines. A variety of incidental sources allude to the ties that clergymen, especially the Mendicants, developed with individual beguines in the fourteenth and fifteenth centuries.[5] Throughout the central and late Middle Ages, the beguines' concentration on the mysteries of Christ's humanity, their devotion to the Eucharist, their commitment to good works — not to mention their visions of miraculous hosts and the fires of purgatory — confirmed points of doctrine that were often disputed.[6]

Lievin vander Muelene relied on Maijke's moral fortitude to aspire to the priesthood in an age in which the Church experienced even greater challenges. He was not the last to turn to beguines as sources of inspiration and support in the Early Modern period. Pelgrim Pullen, a priest at the beguinage of Roermond in the late sixteenth century, left us copious notes of a conversation he had in 1587 with Claesinne van Nieuwlant, a beguine and recluse at Ter Hooie in Ghent, on her mystic ecstasies, outwardly manifested (or induced) by fasting and levitations.[7] Joseph Geldolph van Rijckel, abbot of St. Gertrude of Louvain, the "visitor" of the two court beguinages in Louvain and the first historian of the beguine movement in the Low Countries, published in 1631 numerous vignettes taken from the lives of contemporary beguines, based on written notes and interviews with their companions; these were amplified and updated by an anonymous cleric in a massive tome of beguine portraits, *Het Leven Van de seer Edele Doorluchtighste en H. Begga hertoginne van Brabant*, which served as a treasure throve for all clerics writing for and preaching to women in the southern, "Spanish" and "Austrian" Netherlands of the Counter Reformation.[8] Thus, from the early thirteenth century to the eighteenth (and, as some might suggest, well into the twentieth century), clergymen troubled by the Church's frailty repeatedly sought the company of such devout beguines to bolster their own confidence, forming close relationships in which their own alleged deficiencies were offset by the women's special holiness. As John Coakley has argued in his study of late medieval friars and their female subjects, such men admired in religious women that what they, their office, and their gender, were perceived to be lacking: true religious poverty, integrity, spontaneity, charisma, a clear presence of the divine, so poignantly absent, many thought, from the institutional Church.[9]

Yet, if the picture of beguine spirituality that emerges from these testimonials is one of rock solid orthodoxy, it is not hard, as we have seen, to find along with it a wholly different view that found fault with beguines for the very same reasons they were exalted: their informality, irregularity, lack of solemn vows, mystical experiences, in other words, their "strangeness."

The contrast between these views reminds us of a wider debate that engaged

western Christianity from the eleventh century on, a debate that concerned the role of the laity and of women in the Church. As our survey of religious reform and dissent in the southern Low Countries before the rise of the beguines has shown, lay women and men made frequent attempts to be more actively involved in religious life and the reform of the *societas christiana*. They were a driving force in various movements to correct the failings of ecclesiastical institutions and personnel, to dispose of excessive wealth and aid the powerless, and to promote a better knowledge of Scripture and other guiding Christian texts. Heretics such as the Cathars as well as orthodox women and men such as the parishioners that Lambert le Bègue supported, formed small circles that read and discussed Scripture; some of these lay men and women also desired to express their religious ideas and ideals by word and deed. In the large, independent-minded urban centers of the Low Countries, the craving for this kind of religious emancipation was certainly great. Beguines may thus be said to have realized what many eleventh- and twelfth-century lay people in this region had aspired to achieve.

They were not the only ones on the European scene to fulfill these long-standing ambitions. In early thirteenth-century Italy, ascetic movements of lay men and women like the *humiliati* and the various "orders of penitence" pursued a vocation very similar to that of the beguines; shortly afterward, the *beatae* of Catalonia, Castille, and Aragon espoused the same interest in an informal religious life outside the convent. As Kaspar Elm has emphasized, the *via media* or *status tertius*, or "middle way of life" between laity and clergy, became a pan-European phenomenon in the thirteenth century: it included not only these semireligious living in the world but also anchoresses, recluses, and the groups of men and women devoted to the care of poor and sick in urban hospitals.[10] What exactly the role, rights, and duties of the *status tertius* would be in the *societas Christiana* of the late middle ages remained undetermined. While Pope Innocent III and his successors supported and firmly anchored some of the semireligious within the Church, they were not willing to grant them the right to teach and to preach, thus maintaining a fundamental distinction between clergy and laity.

The extent to which beguines held "heretical" beliefs is difficult to determine. Although certain aspects of beguine mysticism, such as the perceived antinomianism of Marguerite Porète's writings, were controversial, and the hope for mystical union may have led some beguines to ignore clerical authority, there is little hard evidence that doctrine inconsistent with official dogma enjoyed widespread acclaim among beguines. At the most one can discern certain "pre-Protestant" ideals in beguine practices: an interest in vernacular readings of Scripture, lay preaching, and even material simplicity. With few exceptions,

their evident faith in the cult of saints, fasting, pilgrimage, and their respect for the sacramental power of the priesthood, placed them within the boundaries of contemporary orthodoxy.[11]

Two other facets of beguine life deserve our attention. First, we must consider the ways in which social factors helped shape their history. Despite the cloud of suspicion that persistently weighed upon their activities, beguinages attracted numerous women; it is quite possible that in the thirteenth-century Low Countries, life in a beguinage constituted the most popular of all religious vocations.[12] This success was closely tied to the social and economic needs of the cities in which they lived. As this study has argued, many beguine communities were initially supported and tolerated because cities in the southern Low Countries wished to attract a cheap, flexible labor force for the lower-wage-scale occupations in the textile industries as well as for charitable tasks and other social services, all of which were deemed suitable for women.[13] By the late thirteenth century, however, the urban economies of the Low Countries experienced severe crises that disturbed the labor market. The opportunities for women to work independently or in "high-labor-status" positions, diminished even further in the late fifteenth and early sixteenth century. Yet one may suspect that the accusations of heresy that were leveled against beguines around 1300 were generated by a more profound, lingering anxiety about their claims to a chaste life as single women outside the cloister and their intellectual ambitions as preachers and teachers. Beguinages and beguines, survived, however, by accepting more rigid rules of enclosure, and by adopting a posture of restraint and submission. Even so, their numbers dwindled in the course of the fourteenth and fifteenth centuries, not to regain their previous heights until the Counter Reformation.[14]

Second, there is no need to idealize beguine life. Important social and economic disparities created divisions within the communities and were the source of internal friction, confirming Miri Rubin's apt reminder that gender can rarely be the sole basis of group identity.[15] As we have seen, the consequences of decentralized government and weak formal ties between the beguinages were made adamantly clear in the early fourteenth century, when beguines were unable to mount a joint defense against the accusations of heresy.[16] Informality and lack of overarching structures also affected the beguines' sense of their own history. As early as the 1240s, erroneous stories about the foundation of the movement began to circulate in Liège, where beguines, as we know, started to honor the memory of the priest Lambert le Bègue. By the late Middle Ages, the first beguine house was attributed to a "learned doctor," who supposedly founded an institution for one hundred beguines in Prague, and gave their residents the name "*beghinae*," taking the first two letters of the names of the Queen of Bohemia and her two daughters: Beatrix, Ghiselbundis, and Nazarena.[17] In a few beguinages,

a cult arose to St. Begga, the seventh-century abbess of Andenne, who was said to have established the first beguinage in the area of Nivelles.[18] Scattered over more than one hundred cities and towns of the southern Low Countries, in communities great and small, beguines lacked the means to reflect collectively on their past and common destiny. Few, if any beguines, appear to have read the *vitae* of the pioneer beguines,[19] or to have reflected in writing on their common past. Unlike Christine de Pizan, they never wrote a history of their own "cities of ladies."

Yet in the end, their significance was expressed and felt differently. As the only movement in medieval monastic history that was created by women and for women — and not affiliated with, or supervised by, a male order — beguines bear many of the characteristics historians, anthropologists, and scholars of comparative religion have associated with religious communities dominated by women: a lack of overarching governmental structures, a low level of internal hierarchy, a tendency toward the sacralization of routine work, the use of dance and ecstasy in worship, and an emphasis on the continuity between female existence before and after entrance into the community.[20] Beguines never formed a centralized religious order or adopted a single rule. Although beguinages had internal systems of ranking, all functions within the community, including that of grand mistress, were held for a specific time only and rotated among senior members. Like the female Shakers of North America,[21] beguines combined manual work with sacred readings; indeed, work itself had religious significance. Like the Shakers, beguines were known to engage in dance and ecstatic behavior.[22] The tasks they performed were quite similar to those traditionally carried out by women in the household; some beguines even joined a beguinage with their children.[23] It is then, I suggest, by creating and sustaining for seven centuries this unique and supportive environment for single women of all ages, ranks, and intellectual ambitions, that beguines made their most important contribution to religious and social life.

# Abbreviations

| | |
|---|---|
| *AAMBM* | Mechelen, Aartsbisschoppelijk Archief, Begijnhof Mechelen. |
| *AA.SS.* | *Acta Sanctorum.* |
| *ADN* | Lille, Archives départementales du Nord. |
| *AEL* | Liège, Archives de l'État. |
| *AGN* | *Algemene Geschiedenis der Nederlanden.* |
| *AMD* | Douai, Archives municipales. |
| *AOCMWB* | Bruges, Archief van het OCMW. |
| *AOCMWBR* | Brussels, Archief van het OCMW/Archives du CPAS. |
| *ARA* | Brussels, Algemeen Rijksarchief/Archives générales du Royaume. |
| *ARA, AOOL* | Brussels, Algemeen Rijksarchief, Archief van de Commissie van Openbare Onderstand der stad Leuven. |
| *ARA, KAB* | Brussels, Algemeen Rijksarchief, Kerkelijk Archief van Brabant/ Archives générales du Royaume, Archives ecclésiastiques du Brabant. |
| *ASHEB* | *Analectes pour servir à l'histoire ecclésiastique de Belgique.* |
| *BAB* | Bruges, Bischoppelijk Archief. |
| *BC* | Béthune, *Cartulaire.* |
| *BCRH* | *Bulletin de la Commission royale d'Histoire/Handelingen van de Koninklijke Commissie voor Geschiedenis.* |
| *BG* | *Bijdragen tot de Geschiedenis.* |
| *BGSD* | Bruges, Groot-Seminarie, Ter Duinen. |
| *BHF* | Bynum, *Holy Feast and Holy Fast.* |
| *BHL* | *Bibliotheca Hagiographica Latina.* |
| *BMPM* | Baldwin, *Masters, Princes, and Merchants.* |
| *BTFG* | *Belgisch Tijdschrift voor Filologie en Geschiedenis/Revue belge de Philologie et d'Histoire.* |
| *CDIN* | Fredericq, *Corpus.* |
| *CR* | Constable, *The Reformation of the Twelfth Century.* |
| *DB* | Delmaire, "Les béguines dans le Nord de la France." |
| *GC*, I, II | Gysseling, *Corpus*, I, II. |

| | |
|---|---|
| *GRB* | Grundmann, *Religiöse Bewegungen im Mittelalter.* |
| *HEB* | De Moreau, *Histoire de l'Église en Belgique.* |
| *HKOM* | *Handelingen van de Koninklijke Kring voor Oudheidkunde, Letteren en Kunst van Mechelen.* |
| *HSEB* | *Handelingen van het Genootschap voor Geschiedenis gesticht onder de benaming "Société d'Émulation de Bruges."* |
| *KB* | Brussels, Koninklijke Bibliotheek Albert I/Bibliothèque royale Albert Ier. |
| *KB, M* | Brussels, Koninklijke Bibliotheek Albert I, Verzameling Merghelynck/Bibliothèque royale Albert Ier., Collection Merghelynck. |
| *LS* | Lauwers and Simons, *Béguins et Béguines à Tournai.* |
| *LUB* | Louvain, Universiteitsbibliotheek, Archief, Collectie Philippen. |
| *MBB* | McDonnell, *The Beguines and Beghards in Medieval Culture.* |
| *MC* | Mansi, *Sacrorum Conciliorum . . . Collectio.* |
| *MCF* | Majérus, *Ces femmes qu'on dit béguines.* |
| *MF* | Miraeus and Foppens, *Opera Diplomatica.* |
| *MGH, SS* | *Monumenta Germaniae Historica, Scriptores.* |
| *MKA* | Mens, "De kleine armen van Christus." |
| *MOB* | Mens, *Oorsprong en Betekenis van de Nederlandse Begijnen- en Begardenbeweging.* |
| *OGE* | *Ons Geestelijk Erf.* |
| *PB* | Philippen, *De Begijnhoven.* |
| *PL* | Migne, *Patrologiae Latinae Cursus Completus.* |
| *RAB* | Bruges, Rijksarchief. |
| *RAG* | Ghent, Rijksarchief. |
| *RAG, SG* | Ghent, Rijksarchief, Charters van de Graven van Vlaanderen, Collectie de Saint-Genois. |
| *RAH* | Hasselt, Rijksarchief. |
| *RHC* | Roisin, *L'Hagiographie cistercienne.* |
| *RHE* | *Revue d'Histoire Ecclésiastique.* |
| *SAB* | Bruges, Stadsarchief. |
| *SAB, B* | Bruges, Stadsarchief, Reeks 438, Bogarden. |
| *SAG* | Ghent, Stadsarchief. |
| *SAG, B* | Ghent, Stadsarchief, Reeks LXXVIII, Charters Béthune. |
| *SAM* | Mechelen, Stadsarchief. |
| *SAT* | Tongeren, Stadsarchief. |
| *VB* | *Vita Beatricis*, ed. Reypens; reprinted in DeGanck, *The Life of Beatrice of Nazareth*. References are to the reprint. |

| VC | Thomas of Cantimpré, *Vita beatae Christinae Mirabilis.* |
| VE | Philip of Clairvaux, *Vita Elizabeth.* |
| VH, I, II, III | Verachtert, et al., *Voorsale des Hemels*, parts I, II, III |
| VIL | *Vita B. Idae Lewensis.* |
| VILO | *Vita Idae Lovaniensis.* |
| VIN | *Vita B. Idae de Nivellis.* |
| VJ | Hugh of Floreffe, *Vita B. Juettae reclusae.* |
| VJC | *Vita sanctae Julianae virginis.* |
| VL | Thomas of Cantimpré, *Vita Lutgardis.* |
| VM | James of Vitry, *Vita Mariae Oigniacensis.* |
| VMS | Thomas of Cantimpré, *Vita Mariae Oigniacensis. Supplementum.* |
| VMY | Thomas of Cantimpré, *Vita Margaretae de Ypris.* |
| VO | *Vita B. Odiliae.* |

# Notes

## Preface

1. Joseph Greven, "Der Ursprung des Beginenwesens," *Historisches Jahrbuch* 35 (1914): 26–58, 291–318, at 46–47.

2. Joseph Greven, *Die Anfänge der Beginen: Ein Beitrag zur Geschichte der Volksfrömmigkeit und des Ordenswesens im Hochmittelalter* (Münster i. Westfalen: Aschendorffsche Verlagsbuchhandlung, 1912).

3. *SAG, B*, no. 106, ed. *BC*, 73–74, no. 106.

4. Karl Bücher, *Die Frauenfrage im Mittelalter*, 2nd ed. (Tubingen: H. Laupp, 1910). For a review of those studies, see *MBB*, 81–85.

5. Berlin, 1935, 2nd ed. (Darmstadt: Wissenschaftliche Buchgesellschaft, 1961). For insightful comments on Grundmann's understanding of "movements," see John Van Engen, "The Christian Middle Ages as an Historical Problem," *American Historical Review* 91 (1986): 519–52, at 522–24. See also Kaspar Elm, "Die Stellung der Frau in Ordenswesen, Semireligiosentum und Häresie zur Zeit der heiligen Elisabeth," in *Sankt Elisabeth. Fürstin, Dienerin, Heilige* (Sigmaringen: Jan Thorbecke Verlag, 1981), 7–28; Robert E. Lerner, "Introduction," in Herbert Grundmann, *Religious Movements in the Middle Ages*, trans. Steven Rowan (Notre Dame: University of Notre Dame Press, 1995), ix–xxv, and Martina Wehrli-Johns, "Vorraussetzungen und Perspektiven mittelalterlicher Laienfrömmigkeit seit Innocenz III. Eine auseinandersetzung mit Herbert Grundmanns 'Religiöse Bewegungen'," *Mitteilungen des Instituts für österreichische Geschichtsforschung* 104 (1996): 286–309.

6. Robert I. Moore, *The Formation of a Persecuting Society: Power and Deviance in Western Europe, 950–1250* (Oxford: Basil Blackwell, 1987).

7. Giles Constable, *The Reformation of the Twelfth Century* (Cambridge: Cambridge University Press, 1996); idem, *Three Studies in Medieval Religious and Social Thought* (Cambridge: Cambridge University Press, 1995).

8. Caroline Walker Bynum, *Holy Feast and Holy Fast: The Religious Significance of Food to Medieval Women* (Berkeley and Los Angeles: University of California Press, 1987); idem, *Fragmentation and Redemption: Essays on Gender and the Human Body in Medieval Religion* (New York: Zone Books, 1992); André Vauchez, *La sainteté en Occident aux derniers siècles du moyen âge. D'après les procès de canonisation et les documents hagiographiques* (Rome: École française de Rome, 1981); Anne L. Clark, *Elisabeth of Schönau: A Twelfth-Century Visionary* (Philadelphia: University of Pennsylvania Press, 1992); Barbara Newman, *From Virile Woman to WomanChrist: Studies in Medieval Religion and Literature* (Philadelphia: University of Pennsylvania Press, 1995). See also the important

work of art historian Jeffrey F. Hamburger, *The Rothschild Canticles: Art and Mysticism in Flanders and the Rhineland circa 1300* (New Haven: Yale University Press, 1990); idem, *The Visual and the Visionary: Art and Female Spirituality in Late Medieval Germany* (New York: Zone Books, 1998).

9. See, among many other works, Daniel Bornstein, "Women and Religion in Late Medieval Italy: History and Historiography," in Daniel Bornstein and Roberto Rusconi, eds., *Women and Religion in Medieval and Renaissance Italy* (Chicago: University of Chicago Press, 1996), 1–27; Roberta Gilchrist, *Gender and Material Culture: The Archeology of Religious Culture* (London: Routledge, 1994), and idem, *Contemplation and Action: The Other Monasticism* (London: Leicester University Press, 1995).

10. I will devote relatively little space to beguine mysticism and spirituality, subjects that have been covered most recently by Bernard McGinn, *The Flowering of Mysticism: Men and Women in the New Mysticism (1200–1350)* (New York: The Crossroad, 1998); Bernard McGinn, ed., *Meister Eckhart and the Beguine Mystics: Hadewijch of Brabant, Mechtild of Magdeburg, and Marguerite Porete* (New York: Continuum, 1994); and by my colleague Amy Hollywood, *The Soul as Virgin Wife: Mechtild of Magdeburg, Marguerite Porete, and Meister Eckhart* (Notre Dame: University of Notre Dame Press, 1995). Other recent works that illuminate beguine spirituality through the study of art objects are Joanna E. Ziegler, *Sculpture of Compassion: The Pietà and the Beguines in the Southern Low Countries, c. 1300–c. 1600* (Brussels and Rome: Institut historique belge de Rome, 1992), and Paul Vandenbroeck, ed., *Hooglied. De beeldwereld van religieuze vrouwen in de Zuidelijke Nederlanden, vanaf de 13de eeuw* (Brussels: Paleis voor Schone Kunsten; Ghent: Snoeck-Ducaju & Zoon, 1994). I encountered Juliette Dor, Lesley Johnson, and Jocelyn Wogan-Browne, eds., *New Trends in Female Spirituality: The Holy Women of Liège and Their Impact* (Turnhout: Brepols, 1999), which also offers a wide ranging examination of beguine spirituality, too late to fully integrate it into this book.

11. The present work does not claim to offer a complete history of the medieval beguines. L. J. M. Philippen, *De Begijnhoven. Oorsprong, Geschiedenis, Inrichting* (Antwerp: Veritas, 1918), and Ernest McDonnell, *The Beguines and Beghards in Medieval Culture: With Special Emphasis on the Belgian Scene* (New Brunswick, N.J.: Rutgers University Press, 1954), while difficult to use and outdated in many respects, remain useful sources of information.

12. Since the political boundaries of this region varied greatly in the Middle Ages, I have adopted the borders of the dioceses that covered the area throughout the period— borders that, happily, remained unchanged until the late sixteenth century. These dioceses were, from west to east: Thérouanne, Arras, Tournai, Cambrai, and Liège. I have also included a small section of northern Flanders subject to jurisdiction of the bishop of Utrecht but culturally and politically part of the Flemish county.

13. See, for example, Jos. van Tichelen, "Het Groot Begijnhof en de Geuzen te Brussel," *Eigen Schoon en de Brabander* 15 (1933): 257–69.

## Chapter 1. Women, Work, and Religion in the Southern Low Countries

1. The count of Flanders was in fact a vassal of both the French king and the German king-emperor: while holding the largest part of Flanders, known as "Crown Flanders," from the former, he swore allegiance to the latter for a smaller part of his county, east of

the Scheldt River, known as "Imperial Flanders." See David Nicholas, *Medieval Flanders* (London: Longman, 1992), 44, 49–55. The small city-state of Tournai fell under the direct command of the French king.

2. The best introduction to the history of the Low Countries up to and including the Dutch Revolt is *AGN*, vols. 1–6; Geoffrey Parker, *The Dutch Revolt* (London: Allen Lane, 1977; revised edition, London: Penguin Books, 1985; references hereafter are to the latter), offers a convenient summary in English; for the Burgundian era, see especially Walter Prevenier and Willem Pieter Blockmans, *The Burgundian Netherlands* (Cambridge: Cambridge University Press, 1986); Wim Blockmans and Walter Prevenier, *The Promised Lands: The Low Countries Under Burgundian Rule, 1369–1530* (Philadelphia: University of Pennsylvania Press, 1999); and Walter Prevenier, ed., *Prinsen en poorters: Beelden van de laatmiddeleeuwse samenleving in de Bourgondische Nederlanden, 1384–1530* (Antwerp: Fonds Mercator, 1998), published in French as *Le Prince et le Peuple: Images de la société du temps des ducs de Bourgogne, 1384–1530* (Antwerp: Fonds Mercator, 1998); subsequent references will be to the latter version.

3. Philippe Godding, *Le droit privé dans les Pays-Bas méridionaux du 12e au 18e siècle* (Brussels: Palais des Académies, 1987, revised ed. 1991). As Robert Jacob, *Les époux, le seigneur et la cité: Coutume et pratique matrimoniales des bourgeois et paysans de France du Nord au Moyen Age* (Brussels: Publications des Facultés Universitaires Saint-Louis, 1990) and Martha Howell, *The Marriage Exchange: Property, Social Place, and Gender in Cities of the Low Countries, 1300–1550* (Chicago: University of Chicago Press, 1998) have made clear, inheritance systems and testamentary practice also varied significantly over time within a single region.

4. Wim Blockmans, "De vorming van een politieke unie (veertiende-zestiende eeuw)," in J. C. H. Blom and E. Lamberts, eds., *Geschiedenis van de Nederlanden* (Rijswijk, The Netherlands: Nijgh & Van Ditmar, 1993), 45–117, at 68.

5. See, among many others, Prevenier and Blockmans, *The Burgundian Netherlands*, 12, 46, 252–80.

6. Just how self-contained and homogenous these lands were has been the subject of a long debate, initiated by Henri Pirenne, *Histoire de Belgique* (Brussels: H. Lamertin, 1st ed., 1900–1930; 5th ed., 1929–32); see Walter Simons, "The Annales and Medieval Studies in the Low Countries," in Miri Rubin, ed., *The Work of Jacques Le Goff and the Challenges of Medieval History* (Woodbridge, Suffolk: Boydell Press, 1997), 99–122, at 99–108; and Antoon de Baets, "Belgian Historiography," in D. R. Woolf, ed., *A Global Encyclopedia of Historical Writing*, vol. 1 (New York: Garland, 1998), 83–85.

7. The bilingual composition of these lands in the Middle Ages is sometimes neglected by scholars outside the southern Low Countries, who tend to view them as "French," "German," or "Dutch." On the origins of ethnic heterogenity in the region, see Maurits Gysseling, "Germanisering en taalgrens," in *AGN*, vol. 2, 100–15, and Nicholas, *Medieval Flanders*, 2–13.

8. Arnoud-Jan Bijsterveld, *Laverend tussen Kerk en wereld: De pastoors in Noord-Brabant 1400–1570* (Amsterdam: VU Uitgeverij, 1993), 87; it is true that the object of the complaint, priest Tielens, made things more difficult by "mixing Latin with his Dutch" (*sijn Brabanssche spraick mit Lattijn [is] ondermynget*). For other examples of such problems, see Nicholas, *Medieval Flanders*, 89–90, 347. I am not, of course, denying the significance of cultural differences within the same language area.

9. Prevenier and Blockmans, *The Burgundian Netherlands*, 260–61; Elisabeth

Dhanens, *Van Eyck: The Ghent Altarpiece* (New York: Viking Press, 1973), and idem, *Rogier van der Weyden. Revisie van de documenten* (Brussel: Paleis der Academiën, 1995), with on p. 108 excerpts from accounting documents featuring Rogier as "guardian" of the infirmary and dole in the main beguinage of Brussels in 1455-57.

10. Wim Blockmans et al., "Tussen crisis en welvaart: sociale veranderingen 1300–1500," in *AGN*, vol. 2, 42-86, at 51-56; Prevenier and Blockmans, *The Burgundian Netherlands*, 43. Foreign observers frequently noted the ability of citizens of the southern Low Countries to express themselves in foreign languages; see, for instance, Lodovico Guicciardini, *Descrittione di tutti i Paesi Bassi, altrimenti detti Germania Inferiore* (Antwerp: Silvius, 1567), 27-28.

11. Jan Gessler, ed., *Het Brugsche Livre des Mestiers en zijn navolgingen. Vier aloude conversatieboekjes om Fransch te leeren* (Bruges and New York: Publications of the Institute of French Studies, 1931).

12. Marianne Danneel, *Weduwen en wezen in het laat-middeleeuwse Gent* (Louvain and Apeldoorn: Garant, 1995), 31-32. See also David Nicholas, *The Domestic Life of a Medieval City: Women, Children, and the Family in Fourteenth-Century Ghent* (Lincoln: University of Nebraska Press, 1985), 127-28.

13. A point made differently by Walter Prevenier, "Court and City Culture in the Low Countries from 1100 to 1530," in Erik Kooper, ed., *Medieval Dutch Literature in Its European Context* (Cambridge: Cambridge University Press, 1994), 11-29.

14. Blockmans et al., "Tussen crisis en welvaart," 44-45; Blockmans, "De vorming," 85. Paul M. M. Klep, "Population Estimates of Belgium, by Province (1375-1831)," in *Historiens et Populations: Liber Amicorum Étienne Hélin* (Louvain-la-Neuve: Academia, 1991), 483-507, using a different method of calculation, suggests slightly different ratios.

15. Paul M. Hohenberg and Lynn Hollen Lees, *The Making of Urban Europe 1000–1950* (Cambridge, Mass.: Harvard University Press, 1985), 50-59, 83-85; David Herlihy and Christiane Klapisch-Zuber, *Tuscans and Their Families: A Study of the Florentine Catasto of 1427* (New Haven: Yale University Press, 1985), 54; and Peter Stabel, *Dwarfs Among Giants: The Flemish Urban Network in the Late Middle Ages* (Louvain and Apeldoorn: Garant, 1997), 72-79.

16. Blockmans, "De vorming," 101; Blockmans et al., "Tussen crisis en welvaart," 51; Stabel, *Dwarfs*, 67-69; Walter Simons, *Stad en apostolaat: De vestiging van de bedelorden in het graafschap Vlaanderen (ca. 1225-ca. 1350)* (Brussels: Paleis der Academiën, 1987), 88-100; Raymond Van Uytven, ed., *Leuven "De beste stad van Brabant,"* vol. 1 (Louvain: Stadsbestuur van Leuven, 1980), 113; Pierre De Spiegeler, *Les hôpitaux et l'assistance à Liège (Xe-XVe siècles): Aspects institutionnels et sociaux* (Paris: Les Belles Lettres, 1987), 55. Research on the important networks made up of smaller towns has just started, see, for instance, Peter Stabel, *De kleine stad in Vlaanderen: Bevolkingsdynamiek en economische functies van de kleine en secundaire stedelijke centra in het Gentse kwartier (14de-16de eeuw)* (Brussels: Paleis der Academiën, 1995).

17. Herman Van der Wee, "Industrial Dynamics and the Process of Urbanization and De-Urbanization in the Low Countries from the Late Middle Ages to the Eighteenth Century," in Herman Van der Wee, ed., *The Rise and Decline of Urban Industries in Italy and the Low Countries (Late Middle Ages-Early Modern Times)* (Louvain: Leuven University Press, 1988), 307-81, at 323-42. Many recent studies emphasize the resilience and multifunctionality of the major urban centers throughout this period, see for instance Marc Boone and Martha Howell, "Becoming Early Modern in the Late Medieval Low

Countries: Ghent and Douai From the Fourteenth to the Sixteenth Century," *Urban History* 23 (1996): 300–324.

18. Herman Pleij, "With a View to Reality: The Rise of Bourgeois-Ideals in the Late Middle Ages," in Maurits Smeyers and Bert Cardon, eds., *Flanders in a European Perspective: Manuscript Illumination Around 1400 in Flanders and Abroad* (Louvain: Peeters, 1995), 3–24, at 13; see also, among his many other works, *De sneeuwpoppen van 1511. Literatuur en stadscultuur tussen middeleeuwen en moderne tijd* (Amsterdam: Meulenhoff; Louvain: Kritak, 1988) and "Urban Elites in Search of a Culture: The Brussels Snow Festival of 1511," *New Literary History* 21 (1990): 629–47.

19. Paul Vandenbroeck, *Jheronimus Bosch: Tussen volksleven en stadscultuur* (Berchem: Epo, 1987).

20. Prevenier, "Court and City Culture," argues for a "common ground" between urban and rural elite culture in the thirteenth through fifteenth centuries. It may have found its earliest expression, I would argue, in the disdain for the (rural) "vilain" in the thirteenth-century *fabliaux*, many of which originated or were set in the francophone cities of Flanders and Artois. On their social context, see Roger Berger, *Littérature et société arrageoises au XIIIe siècle: Les chansons et dits artésiens* (Arras: Commission Départementales des Monuments Historiques du Pas-de-Calais, 1981).

21. Henri Pirenne, "L'instruction des marchands au moyen âge," *Annales d'Histoire économique et sociale* 1 (1929): 13–28.

22. Hilde De Ridder-Symoens, "La sécularisation de l'enseignement aux anciens Pays-Bas au Moyen Age et à la Renaissance," in Jean-Marie Duvosquel and Eric Thoen, eds., *Peasants and Townsmen in Medieval Europe: Studia in honorem Adriaan Verhulst* (Ghent: Snoeck-Ducaju, 1995), 721–38; idem, "Education and Literacy in the Burgundian-Habsburg Netherlands," *Canadian Journal of Netherlandic Studies/Revue Canadienne d'Études néerlandaises* 15 (1995): 6–21. Stabel, *Dwarfs*, 207–8.

23. Guicciardini, *Descrittione*, 27; Parker, *Dutch Revolt*, 21; De Ridder-Symoens, "Education and Literacy," 6, 16.

24. Nicholas, *Domestic Life*, 127–30; De Ridder-Symoens, "Education and Literacy," 8–9.

25. Placide F. Lefèvre, *L'organisation ecclésiastique de la ville de Bruxelles au moyen âge* (Louvain: Bibliothèque de l'Université; Brussels: Éditions Universitaires, 1942), 218–21; De Ridder-Symoens, "Education and Literacy," 10.

26. Guido Marnef, *Antwerp in the Age of Reformation: Underground Protestantism in a Commercial Metropolis, 1550–1577* (Baltimore: Johns Hopkins University Press, 1996), 35; Henry de Groote, "De zestiende-eeuwse Antwerpse schoolmeesters," *BG* 50 (1967): 179–318, at 188; Jozef Scheerder, "Schoolmeesters en schoolmeesteressen te Gent tijdens het wonderjaar (1566–1567)," *Handelingen der Maatschappij voor Geschiedenis en Oudheidkunde te Gent*, n.s. 35 (1981): 114–28. The figures for Lyon and Venice are taken from Natalie Zemon Davis, "City Women and Religious Change," in idem, *Society and Culture in Early Modern France* (Stanford, Calif.: Stanford University Press, 1975), 73, and Peter Burke, *The Historical Anthropology of Early Modern Italy: Essays on Perception and Communication* (Cambridge: Cambridge University Press, 1987), 160–61. Paul F. Grendler, *Schooling in Renaissance Italy: Literacy and Learning, 1300–1600* (Baltimore: Johns Hopkins University Press, 1989), 90–3 found slightly higher numbers of female teachers in fifteenth- and sixteenth-century Verona.

27. Myriam Greilsammer, *L'envers du tableau: Marriage et maternité en Flandre*

*médiévale* (Paris: Armand Colin, 1990), 14, citing Pedro Cornejo's account of the Dutch Revolt, published in 1578.

28. See Martha C. Howell, *Women, Production, and Patriarchy in Late Medieval Cities* (Chicago: University of Chicago Press, 1986), and idem, *The Marriage Exchange*; Greilsammer, *L'envers*; Eric Bousmar, "Du marché aux *bordiaulx*. Hommes, femmes et rapports de sexe (*gender*) dans les villes des Pays-Bas au bas moyen âge. État de nos connaissances et perspectives de recherche," in Myriam Carlier et al., eds., *Hart en marge in de laat-middeleeuwse stedelijke maatschappij* (Louvain and Apeldoorn: Garant, 1997), 51–70.

29. Still seminal is John Hajnal, "European Marriage Patterns in Perspective," in D. V. Glass and D. E. C. Eversley, eds., *Population in History: Essays in Historical Demography* (London: Edward Arnold, 1965), 101–43. For important comments that address the contrast between northern and southern Europe, see R. M. Smith, "Geographical Diversity in the Resort to Marriage in Late Medieval Europe: Work, Reputation, and Unmarried Females in the Household Formation Systems of Northern and Southern Europe," in P. J. P. Goldberg, ed., *Women in Medieval English Society c. 1200–1500*, 2nd ed. (Stroud: Sutton, 1997), 16–59; P. J. P. Goldberg, *Women, Work, and Life Cycle in a Medieval Economy: Women in York and Yorkshire, c. 1300–1520* (Oxford: Clarendon Press, 1992); and, on the Low Countries, Nicholas, *Domestic Life*, 1–12; Howell, *Women*, 9–19; Ellen Kittell, "Testaments of Two Cities: A Comparative Analysis of the Wills of Medieval Genoa and Douai," *European Review of History/Revue Européenne d'Histoire* 5 (1998): 47–82, at 47–48.

30. Herlihy and Klapisch-Zuber, *Tuscans*, 202–11; Francesco Bengno, "The Southern Italian Family in the Early Modern Period: A Discussion of Co-Residential Patterns," *Continuity and Change* 4 (1989): 165–94.

31. Prevenier, *Prince*, 188–89.

32. Howell, *Women*, 17–19, 43–44; David Herlihy, *Medieval Households* (Cambridge, Mass.: Harvard University Press, 1985), 98–111 (using largely anecdotal evidence, however). For the breakdown of the majestic stone residences of the Ghent elite into smaller units around 1200, see Anne Duhameeuw, "De hoge middeleeuwen," in Beatrix Bailleul and Anne Duhameeuw, eds., *Een stad in opbouw: Gent voor 1540* (Tielt: Lannoo, 1989), 79–133, at 129–30, and Nicholas, *Domestic Life*, 177, 192. Stabel, *De kleine stad*, 54–83, and idem, *Dwarfs*, 115–27, again remind us of the important fluctuations over time.

33. Henri Pirenne, "Les dénombrements de la population d'Ypres au XVe siècle (1412–1506). Contribution à la statistique sociale du moyen âge," *Vierteljahrschrift für Sozial- und Wirtschaftsgeschichte* 1 (1903): 1–32, at 16 (note 1); Van Uytven, ed., *Leuven*, vol. 1, 119; Joseph Verbeemen, "Louvain en 1755: Sa situation démographique et économique," *Tablettes de Brabant* 4 (1960): 247–74, at 252; idem, "Antwerpen in 1755: een demografische en sociaal-economische studie," *BG* 40 (1957): 27–63, at 31; idem, "De werking van economische factoren op de stedelijke demografie der XVIIe en der XVIIIe eeuw in de Zuidelijke Nederlanden," *BTFG* 34 (1956): 680–700 and 1021–55, at 682; idem, "Bruxelles en 1755. Sa situation démographique, sociale et économique," *BG* 45 (1962): 203–33 and 46 (1963): 65–133 (especially 1962: 205–9); Chris Vandenbroeke, "Prospektus van het historisch-demografisch onderzoek in Vlaanderen," *HSEB* 113 (1976): 1–85, at 30–31; for Europe in general, Roger Mols, *Introduction à la démographie historique des villes d'Europe du XIVe au XVIIIe siècle* (Gembloux: Duculot, 1954–56), vol. 2, 183–89, 218–22, 532.

34. For reviews of medieval data, see Esther Koch, "The positie van vrouwen op de huwelijksmarkt," *Tijdschrift voor sociale geschiedenis* 13 (1987): 150–72; Hajnal, "European Population," 117; and for Flanders, Stabel, *Giants*, 126, who notes the relatively high percentage of (single) women as "heads of households."

35. Karl Bücher, *Die Frauenfrage im Mittelalter*, 2nd ed. (Tubingen: H. Laupp, 1910). Peter Biller, "Applying Number to Men and Women in the Thirteenth and Early Fourteenth Centuries: An Enquiry into the Origins of the Idea of 'Sex-Ratio,' " in Rubin, *The Work of Jacques Le Goff*, 27–52, at 46 (with an acknowledgment to Lyndal Roper) and Kittell, "Testaments," 80–81, point out that the original phrasing of the issue as a *Frauenfrage* embodied a fundamentally misogynist attitude that identified a majority of women as a "problem." As will be made clear below, I argue that during the preindustrial age in cities of the Low Countries (and elsewhere in northern Europe), the larger proportion of women was in fact "normal."

36. Hohenberg and Lees, *Making*, 85–97.

37. Mols, *Introduction*, vol. 2, 374–75 (see also, however, p. 532). Examining migration to Paris between about 1242 and 1282, Sharon Farmer, "Down and Out and Female in Thirteenth-Century Paris," *American Historical Review* 103 (1998): 345–72, at 351–53, found a slightly greater incidence of males than females; although the result should warn us to be more careful in our generalizations, the sample of forty-eight individuals featured in stories of miraculous healings at the tomb of St. Louis may not be entirely representative of actual migration patterns.

38. I have discussed the mechanism driving the unequal migration patterns of men and women more extensively in my "The Beguine Movement in the Southern Low Countries: A Reassessment," *Bulletin de l'Institut historique belge de Rome/Bulletin van het Belgisch Historisch instituut te Rome* 59 (1989): 63–105, at 71–72, and "Een zeker bestaan: de zuidnederlandse begijnen en de *Frauenfrage*," *Tijdschrift voor sociale geschiedenis* 17 (1991): 125–46, at 131–33.

39. Pirenne," Les dénombrements," 18. Howell, *Women*, 84, noted that 80 percent of the total servant population of Leiden in 1581 was female.

40. See for instance Boone and Howell, "Becoming Early Modern," 305–16.

41. In addition to the works mentioned in note 32, see Christiane Klapisch-Zuber, *Women, Family, and Ritual in Renaissance Italy* (Chicago: University of Chicago Press, 1985) and *La maison et le nom: Stratégies et rituels dans l'Italie de la Renaissance* (Paris: Éditions de l'École des Hautes Études en Sciences Sociales, 1990). Samuel K. Cohn, *Women in the Streets: Essays on Sex and Power in Renaissance Italy* (Baltimore: Johns Hopkins University Press, 1996), reminds us, among other things, that Tuscany is not Italy.

42. Goldberg, *Women, Work, and Life Cycle*, 335–45, whose characterization of women's work assumes a concept of gender that is older than the post-plague period on which he concentrates. For the earlier period, see Rodney Hilton, "Lords, Burgesses and Hucksters," *Past and Present* 97 (1982): 3–15.

43. Herlihy and Klapisch-Zuber, *Tuscans*, 131–58, discuss the data on sex-ratios in fifteenth-century Tuscany (expressed as the number of men per one hundred women); Goldberg, *Women, Work, and Life Cycle*, 42–45. On migration and service work, see also Cohn, *Women in the Streets*, 163–65, and on the contrast with northern Europe, see Smith, "Geographical Diversity."

44. Jan Van Gerven, "Vrouwen, arbeid en sociale positie. Een voorlopig onderzoek naar de economische rol en maatschappelijke positie van vrouwen in de Brabantse steden

in de late middeleeuwen," *BTFG* 73 (1995): 947–66; Peter Stabel. "Women at the Market: Gender and Retail in the Towns of Late Medieval Flanders," in Wim Blockmans, Marc Boone, and Thérèse de Hemptinne, eds., *Secretum Scriptorum: Liber Alumnorum Walter Prevenier* (Louvain and Apeldoorn: Garant, 1999), 259–76. See also David Herlihy, *Opera Muliebria: Women and Work in Medieval Europe* (New York: McGraw-Hill, 1990), 75–153, 171–84; Greilsammer, *L'envers*, 25–43; Nicholas, *Domestic Life*, 70–106; Pleij, *Sneeuwpoppen*, 259–87.

45. *Pero Tafur, Travels and Adventures 1435–1439*, trans. Malcolm Letts (New York: Harper & Brothers, 1926), 200; Guicciardini, *Descrittioni*, 31; Parker, *Dutch Revolt*, 20; Greilsammer, *L'envers*, 7.

46. Claire Billen, "Le marché urbain: un espace de liberté pour les femmes rurales?" in Éliane Gubin and Jean-Pierre Nandrin, eds., *La ville et les femmes en Belgique: histoire et sociologie* (Brussels: Facultés universitaires Saint-Louis, 1993), 41–56.

47. Danneel, *Weduwen en wezen*, 371. See also Guy De Poerck, *La draperie médiévale en Flandre et en Artois* (Bruges: De Tempel, 1951), vol. 1, 27–68; Alain Derville, *Saint-Omer des origines au début du XIVe siècle* (Lille: Presses Universitaires de Lille, 1995), 203–4.

48. Pirenne, "Les dénombrements," 31 (see Wim Blockmans and Walter Prevenier, "Armoede in de Nederlanden van de 14e tot het midden van de 16e eeuw: bronnen en problemen," *Tijdschrift voor Geschiedenis* 88 [1975]: 501–38, at 512). For similar findings in other parts of northern Europe, see Annette Winter, "Studien zur sozialen Situation der Frauen in der Stadt Trier nach der Steurliste von 1364. Die Unterschicht," *Kurtrierische Jahrbuch* (1975): 20–45; Ernst Schubert, "Soziale Randgruppen und Bevölkerungsentwicklung im Mittelalter," *Saeculum* 39 (1988): 294–339; Judith M. Bennett, "History That Stands Still: Women's Work in the European Past," *Feminist Studies* 14 (1988): 269–81, as well as the essays by Judith M. Bennett and Amy Froide, "A Singular Past," and Maryanne Kowaleski, "Singlewomen in Medieval and Early Modern Europe: The Demographic Perspective," in Judith M. Bennett and Amy M. Froide, eds., *Singlewomen in the European Past, 1250–1800* (Philadelphia: University of Pennsylvania Press, 1999), 1–37 and 38–81.

49. Howell, *Women*; Nicholas, *Domestic Life*, 98–103. Other studies explored how these changes in turn were reflected in or affected by legal change, see for instance Jacob, *Les époux*; Greilsammer, *L'envers*, 17–24; Howell, *The Marriage Exchange*.

50. On gender and the fabliaux, see the excellent but brief remarks, with references, in Alcuin Blamires et al., eds., *Woman Defamed and Woman Defended: An Anthology of Medieval Texts* (Oxford: Clarendon Press, 1992), 5–6, 130, 177.

51. Peter Arnade, *Realms of Ritual: Burgundian Ceremony and Civic Life in Late Medieval Ghent* (Ithaca: Cornell University Press, 1996), 47–51. Nicholas, *Domestic Life*, 60, interprets the evidence differently.

52. Pleij, *Sneeuwpoppen*, 178–79, 284 (with a brief discussion of another, mysterious custom, the *vrouwkensavond*).

53. A point also made for late medieval England by Barbara Hanawalt in her recent collection of essays *"Of Good and Ill Repute": Gender and Social Control in Medieval England* (New York: Oxford University Press, 1998), xi–xiii, 81–84.

54. Arnade, *Realms*, 25–27.

55. J. H. Jacobs, ed., *Jan de Weert's Nieuwe Doctrinael of Spieghel van Sonden* (The Hague: Martinus Nijhoff, 1915), v. 887–97. On such topoi, see Paul Vandenbroeck, *Beeld*

*van de andere, vertoog over het zelf: Over wilden en narren, boeren en bedelaars,* exhib. cat. (Antwerp: Koninklijk Museum voor Schone Kunsten, 1987).

56. On the Latin original of this popular work, see Alfred Schmitt, *Matheus von Boulogne: "Lamentationes Matheoluli" (Kommentierte und kritische Edition der beiden ersten Bücher)* (Bonn: Rheinische Friedrich-Wilhelms-Universität, 1974), 5–21.

57. Pleij, *Sneeuwpoppen,* 155–58; Van Gerven, "Vrouwen," 951.

58. See the incisive discussion of these Church fathers by Marcia Colish, "Cosmetic Theology: The Transformation of a Stoic Theme," *Assays* 1 (1981): 3–14, and R. Howard Bloch, *Medieval Misogyny and the Invention of Western Romantic Love* (Chicago: University of Chicago Press, 1991), especially 39–63. The so-called "Poème moral," a didactic tract in Walloon verse written by a cleric in the Liège area around 1200, contains a typical warning against women's excessive concern for beauty and ornamentation: Alphonse Bayot, ed., *Le poème moral: Traité de vie Chrétienne écrit dans la région wallonne* (Liège: H. Vaillant-Carmanne, 1929), 33–34, 38–40, v. 433–53 and 497–520.

59. Georges Espinas, *La vie urbaine de Douai au Moyen Age* (Paris: A. Picard et fils, 1913), vol. 2, 633–34. See Ellen Kittell, "Flemish Female Misdeeds: A Speculation," in Karen Glente and Lise Winther-Jensen, eds., *Female Power in the Middle Ages: Proceedings from the 2. St. Gertrud Symposium, Copenhagen, August 1986* (Copenhagen: C. A. Reitzel, 1989), 105–28; Nicholas, *Domestic Life,* 61; Greilsammer, *L'envers,* 37–39; and, for England, Hanawalt, *'Of Good and Ill Repute',* 83–84.

60. Howell, *Women,* 87–88, 161–62; Greilsammer, *L'envers,* 27, 38, 43. It could be argued that, whereas urban and rural women held no place in political space and discourse, female authority was relatively well established in feudal law and feudal institutions. Subjects of the southern Low Countries found themselves at regular intervals ruled by female princesses, some of whom reigned for many decades, as did the sisters Joan and Margaret (1205–44 and 1244–78) in Flanders and Hainaut, to name only the most famous example; see now Karen S. Nicholas, "Countesses as Rulers in Flanders," in Theodore Evergates, ed., *Aristocratic Women in Medieval France* (Philadelphia: University of Pennsylvania Press, 1999), 111–37, and more generally, Godding, *Le droit privé,* 77–78, 324–50, and Bousmar, "Du marché," 68. Yet these women, operating in a male dominated environment, encountered stark hostility from their subjects, who either attributed stereotypical female defects to them or criticized them for being harsh and unladylike. See for instance Herman of Tournai's comments on regent Clementia of Flanders (1096–1100) in his *Liber de restauratione monasterii Sancti Martini Tornacensis,* ed. Georg Waitz, in *MGH, SS,* vol. 14, 274–327, at 282; the fourteenth-century *Le Livre de Baudoyn, conte de Flandre suivi de fragments du roman de Trasignyes,* ed. C. P. Serrure and A. Voisin (Brussels: Berthot et Périchon, 1836), 14–20, and 143, on Joan and Margaret, and Pleij, *Sneeuwpoppen,* 283, 291–94, on Margaret of Austria, regent of the Low Countries in 1518–30.

61. Although most medievalists agree that religious dissent was more widespread in densely urbanized regions, they explain the phenomenon in different ways. Some emphasize the function of cities as centers of communication and cultural change, and as attraction poles for social groups that are marginalized, as did Cinzio Violante," Hérésies urbaines et hérésies rurales en Italie du 11e au 13e siècle," in Jacques Le Goff, ed., *Hérésies et sociétiés dans l'Europe pré-industrielle 11e-18e siècles* (Paris: Mouton, 1968), 171–98; or Bronislaw Geremek, "Hérésies médiévales et déracinement social," in Henri Dubois, Jean-Claude Hocquet, and André Vauchez, eds., *Horizons marins, itineraires spirituels (Ve–XVIIIe siècles): Études* (Paris: Publications de la Sorbonne, 1987), vol. 1, 55–65. Others

acknowledge more broadly social tension as a catalyst for religious debate, see Malcolm Lambert, *Medieval Heresy: Popular Movements from the Gregorian Reform to the Reformation*, 2nd ed. (Oxford: Blackwell, 1992), 7. Jeffrey Burton Russell, *Dissent and Order in the Middle Ages: The Search for Legitimate Authority* (New York: Twayne, 1992), 28, argues that the new cities fostered heresy by their support for "textual communities," a reference to Brian Stock, *The Implications of Literacy: Written Language and Models of Interpretation in the Eleventh and Twelfth Centuries* (Princeton: Princeton University Press, 1983), at 92–150. See also R. I. Moore, "Literacy and the Making of Heresy," in Peter Biller and Anne Hudson, eds., *Heresy and Literacy, 1000–1530* (Cambridge: Cambridge University Press, 1994), 19–37, Peter Biller, "Heresy and Literacy: Earlier History of the Theme," in the same volume, 1–18.

62. Ludo Milis, "Beroering omtrent bisdomssplitsingen in Vlaanderen in de jaren 1112–1113," in *Pascua Mediaevalia: Studies voor Prof. Dr. J. M. De Smet* (Louvain: Universitaire Pers Leuven, 1983), 5–14; idem, "De Kerk tussen de gregoriaanse hervorming en Avignon," in *AGN*, vol. 3, 166–211, at 166–68; *HEB*, vol. 3, 24–28 and *HEB, Tome Complémentaire*, maps.

63. *HEB*, vol. 3, 41–70; Milis, "De Kerk," 167–76.

64. *PL*, vol. 185 bis, cols. 1911–14.

65. Tadeusz Manteuffel, *Naissance d'une hérésie: les adeptes de la pauvreté volontaire au moyen âge* (Paris: Mouton, 1970), 8. *CR*, 148–50, 155–56.

66. Ludo Milis, *L'ordre des chanoines réguliers d'Arrouaise* (Bruges: De Tempel, 1969), vol. 1, 93–158; idem, "Ermites et chanoines réguliers au XIIe siècle," *Cahiers de Civilisation Médiévale* 22 (1979): 39–80; Charles Dereine, "Les origines de Prémontré," *RHE* 42 (1947): 352–78; *CR*, 60–65; *GRB*, 40–50. For Affligem, an important eremitical settlement that adopted a more traditional Benedictine custom, see now Frans J. Van Droogenbroeck, "Paltsgraaf Herman II (+1085) en de stichting van de abdij van Affligem (28 juni 1062)," *Jaarboek voor middeleeuwse geschiedenis* 2 (1999): 38–95.

67. "De Kerk," 179–80.

68. Egied I. Strubbe, "La paix dans le Nord de la France," in *Recueils de la Société Jean Bodin*, vol. 14 (Brussels: Librairie Encyclopédique, 1961), 489–501; on the connections between the Peace of God movement and ecclesiastical reform, see also R. I. Moore, "Postscript: The Peace of God and the Social Revolution," in Thomas Head and Richard Landes, eds., *The Peace of God: Social Violence and Religious Response in France Around the Year 1000* (Ithaca, N.Y.: Cornell University Press, 1992), 308–26; on opposition by certain bishops, see the nuanced assessment by David C. Van Meter, "The Peace of Amiens-Corbie and Gerard of Cambrai's Oration on the Three Functional Orders: The Date, the Context, and the Rhetoric," *BTFG* 74 (1996): 633–57. On the first bishops of reform (and the support they received from the Flemish counts), see Walter Simons, "Jean de Warneton et la réforme grégorienne," *Mémoires de la Société d'Histoire de Comines-Warneton et de la Région* 17 (1987): 35–54.

69. R. I. Moore, "Heresy, Repression, and Social Change in the Age of Gregorian reform," in Scott L. Waugh and Peter D. Diehl, eds., *Christendom and Its Discontents: Exclusion, Persecution, and Rebellion, 1000–1500* (Cambridge: Cambridge University Press, 1996), 19–46; idem, "Literacy," 19–37.

70. It is true that many sources on eleventh and twelfth-century heretical groups as a matter of course depict their protagonists as "illiterate" or as "laymen," to be contrasted with learned, orthodox clerics, even though some of the "heretics" may actually

have been ordained into the clergy; see Herbert Grundmann, "Litteratus-illiteratus. Der Wandel einer Bildungsnorm vom Altertum zum Mittelalter," *Archiv für Kulturgeschichte* 40 (1958): 1–65; Biller, "Heresy and literacy," 3–9; and, for the fluidity of these terms in orthodox terminology of the twelfth century, *CR*, 9–10. In this case, and in those that will be discussed below, several indicators converge to denote most of the "heretics" as lay people.

71. *Acta Synodi Attrebatensis*, in *PL*, vol. 142, col. 1269–1312; *CDIN*, vol. 1, 1–5, nos. 1–2; Lambert, *Medieval Heresy*, 22–25; Michael Frassetto, "Reaction and Reform: Reception of Heresy in Arras and Aquitaine in the Early Eleventh Century," *Catholic Historical Review* 83 (1997): 385–400. Moore, "Literacy," 26 suggest that because these people wished to "prepare their food with their own hands" (*de laboribus manuum suarum victum parare*), they were wealthy enough to have domestic servants, whose help they were foreswearing. I believe rather that they wished to "earn a common income gained by their own labor," as was customary among adherents of the *Vita apostolica* in keeping with Tobias, 2:19; no servants were involved (the term *parare*, literally "to turn to joint use," enhances this reading). Besides, Moore notes that the accused were apparently "unfree" since they endured torture.

72. *PL*, vol. 142, col. 1289–96. For its themes, see Henri Platelle, "La cathédrale et le diocèse. Un aspect religieux du rapport ville-campagne. L'exemple de Cambrai," in Jean-Marie Duvosquel and Alain Dierkens, eds., *Villes et campagnes au moyen âge: Mélanges Georges Despy* (Liège: Éditions du Perron, 1991), 625–41, at 627–29, and Frassetto, "Reaction and Reform," 393–400.

73. *Chronicon S. Andreae Castri Cameracesii*, ed. L. C. Bethmann, in *MGH, SS*, vol. 7 (Hanover, 1846), 540; also in *PL*, vol. 149, col. 269–70. See also Erik Van Mingroot, "Ramihrdus de Schere, alias Ramihrd d'Esquerchin (+1077)," in *Pascua Medievalia*, 75–92. For Pope Gregory VII's reprimand of bishop Gerard (who later maintained that he did not know lay investiture was no longer acceptable), see *Gregorii VII. Registrum*, ed. E. Caspar in *MGH, Epistolae selectae*, vol. 2 (Berlin: Weidmann, 1920), 328–29 and 331–34. I believe Stock, *The Implications of Literacy*, 232, was right to call Ramihrd a "layman" (against the majority opinion) since the *Chronicon S. Andreae*, 540, our main source, identifies him simply as *hominem quendam nomine Ramihrdum*.

74. The literature on Tanchelm is extensive, although the primary sources best informed of his activity are few: a letter of 1112–14 by the clergy of Utrecht preserved in the *Codex Udalrici*, ed. Philipp Jaffé, in *Monumenta Bambergensia* (Berlin, 1869, repr. Aalen: Scientia Verlag, 1964), 296–300, and a few contemporary chronicles, see *CDIN*, vol. 1, 15–18, 22–29, nos. 11, 14–22; vol. 2, 3–6, nos. 4–7. See also, somewhat later, *Vita Norberti [A]*, ed. R. Wilmans, *Vita Norberti archiepiscopi Magdeburgensis*, in *MGH, SS*, vol. 12 (Hannover: Hahn, 1856), 663–703, at 690–91; E. M. Buytaert and C. J. Mews, eds., *Petri Abaelardi Opera Theologica*, vol. 3 (Turnhout: Brepols, 1987), 439; *Sigeberti Gemblacensis Chronica Continuatio Praemonstratensis*, ed. L. Bethmann, in *MGH, SS*, vol. 6 (Hannover: Hahn, 1844), 447–56, at 449. The best modern discussions are Jozef-Maria De Smet, "De monnik Tanchelm en de Utrechtse bisschopszetel in 1112–1114," in *Scrinium Lovaniense: Mélanges historiques-Historische opstellen Étienne van Cauwenbergh* (Gembloux: J. Duculot, 1961), 207–34 (with whom I partly disagree, however) and Milis, "Beroering," 7–14. Tanchelm's lay status was also posited by *GRB*, 35.

75. Our understanding of Catharism in northwestern Europe, though still far from perfect, has greatly increased in recent years. There are good, short overviews in Lambert,

*Medieval Heresy*, 55–61 and R. I. Moore, *The Origins of European Dissent*, 2nd ed. (Oxford: Basil Blackwell, 1985), 168–240 (more cautious, less convinced of the connections between the various Cathar groups). Among the newer work, Gerhard Rottenwöhrer, *Der Katharismus* (Bad Honnef: Bock & Herchen, 1982–93); Malcolm Lambert, *The Cathars* (Oxford: Blackwell, 1998), and Peter Biller, "Northern Cathars and Higher learning," in Peter Biller and Barrie Dobson, eds., *The Medieval Church: Universities, Heresy, and the Religious Life. Essays in Honour of Gordon Leff* (Woodbridge, Suffolk: Boydell Press and the Ecclesiastical History Society, 1999), 25–53, are useful, although they sometimes neglect the evidence on Catharism in the Low Countries.

76. For all primary sources regarding Catharism in twelfth-century Liège, see Marc Suttor, "Le *Triumphus Sancti Lamberti de castro Bullonio* et le catharisme à Liège au milieu du XIIe siècle," *Le Moyen Age* 91 (1985): 227–64 (an important article, overlooked by the recent surveys mentioned in the previous note).

77. *PL*, vol. 179, col. 937–38; *CDIN*, vol. 1, 31–33, no. 30. The group described here may have been connected to the one mentioned briefly (in the year 1135) in *Annales Rodenses*, ed. P. C. Boeren and G. W. A. Panhuysen (Assen: Van Gorcum, 1968), 78. Georges Despy's objection that these and other sources do not prove Cathar presence in Liège was convincingly refuted by Suttor, "Le *Triumphus*," 238–50, and idem, "La lettre de *l'Ecclesia Leodiensis* au pape L.: attitude de Rome et de l'archidiocèse de Cologne face au catharisme au milieu du XIIe siècle," in *Rome et les églises nationales, VIIe–XIIIe siècles* (Aix-en-Provence: Publications de l'Université de Provence, 1991), 75–113, with references to the Despy essays. For the distinction between *auditores* and *credentes*, see Arno Borst, *Die Katharen* (Stuttgart: Hiersemann Verlag, 1953), 192, note 8, and Daniela Müller, *Frauen vor der Inquisition: Lebensform, Glaubenszeugnis und Aburteilung der deutschen und französischen Katharerinnen* (Mainz: Philipp von Zabern, 1996), 36. For the case of a possibly Catharist priest at Neder-Over-Heembeek near Brussels around 1167, see *CDIN*, vol. 1, 34–35, no. 33.

78. Everwin of Steinfeld, *Epistola ad S. Bernardum*, in *PL*, vol. 182, col. 676–80, quotation at 679; see col. 678 for the heretics' apostolic ideals. See also *GRB*, 18–20; Moore, *The Origins of European Dissent*, 168–75; Lambert, *The Cathars*, 20–23, 31–42.

79. Lieven Van Acker, ed., *Hildegardis Bingensis Epistolarium* (Turnhout: Brepols, 1991–93), vol. 1, 34–47, 49–52, nos. XV and XVR; Eckbertus of Schönau, *Sermones contra Catharos*, ed. *PL*, vol. 195, col. 11–102; Moore, *The Origins of European Dissent*, 176–82; Lambert, *The Cathars*, 29–23, 43–44.

80. Borst, *Die Katharer*, 95. See also Müller, *Frauen*, 38–42.

81. *Sermones*, col. 18, 31. Elsewhere Eckbert mentioned that Cathars was the name used for them "in the [German] vernacular" (*hi sunt quos vulgo Catharos vocant, Sermones*, col. 13–14), which misled several scholars to believe that the Latin *catharus* in twelfth-century sources was derived from the German vernacular *Ketzer* (Dutch, *Ketter*), a generic word for heretic. Lambert, *The Cathars*, 43–44, accepts yet another etymology that seems unwarranted to me.

82. *Sermones*, in *PL*, 195, col. 13 ("hos nostra Germania, Catharos; Flandria Piphles; Gallia Texerant[s] ab usu texendi, appellat"). The meaning of *Piphles* (see also note 86) is not known; it could be a misrepresentation of a French (Walloon) or Dutch (Flemish) word that has not been preserved. The term "Flandria" probably covers the entire southern Low Countries rather than the county of that name alone. On heretics as weavers (and vice versa), see note 94.

83. *Chronica Regia Coloniensis*, ed. Georg Waitz, in *MGH, SS. Rerum Germanicarum in usum scholarum* vol. 14 (Hanover: Hahn, 1880), 114. Again I have understood "de Flandrie partibus" to mean "from the southern Low Countries."

84. Moore, *The Origins of European Dissent*, 176, 181–82.

85. Borst, *Die Katharer*, 247; Moore, *The Origins of European Dissent*, 305, note 33, leans toward accepting a connection with the ancient, dualist Paulicians.

86. *MC*, vol. 21, 843; *CDIN*, vol. 1, 35–36, no. 34.

87. *CDIN*, vol. 1, 37–39, nos. 37–38; *GRB*, 55–57.

88. William of Newburgh, *Historia Rerum Anglicarum*, in *Chronicles of the Reigns of Stephen, Henry II., and Richard I.*, ed. Richard Howlett, vol. 1 (London: Rolls Series, 1884), 131–34, at 133, called these *publicani* "uncivilized and rustic persons of Teutonic birth and speech"; see the insightful essay by Peter Biller, "William of Newburgh and the Cathar Mission to England," in Diana Wood, ed., *Life and Thought in the Northern Church c. 1100–c. 1700. Essays in Honour of Claire Cross* (Woodbridge, Suffolk: Boydell Press and the Ecclesiastical History Society, 1999), 11–30. As did most scholars who examined the text, Biller assumes the Cathars came from "Germany." Gilbert Foliot in two letters to bishop Roger of Worcester referred to them as "weavers" (*textores*): Adrian Morey and Christopher Brooke, eds., *The Letters and Charters of Gilbert Foliot* (Cambridge: Cambridge University Press, 1967), 207–10, nos. 157–58. Taken together, these references point to "Teutonic" or Dutch-speaking Flemings or Brabanders rather than to merchants from the Cologne area. There was of course frequent contact between Flanders and England in this age, and groups of Flemish craftsmen and other skilled workers were known to migrate to Britain, see Nicholas, *Medieval Flanders* 107–8, 225, and the literature cited in Lauran Toorians, "Flemish Settlements in Twelfth-Century Scotland," *BTFG* 74 (1996): 659–93.

89. *CDIN*, vol. 1, 45, 47–50, 63–65, nos. 46, 48–52, 64, and vol. 2, 36–37, no. 17.

90. Robert Godding, "Une oeuvre inédite de Thomas de Cantimpré. La "Vita Ioannis Cantipratensis," *RHE* 76 (1981): 241–316, at 260, 264. See also idem, "Vie apostolique et société urbaine à l'aube du XIIIe siècle. Une oeuvre inédite de Thomas de Cantimpré," *Nouvelle Revue Théologique* 104 (1982): 692–721.

91. Godding, "Une oeuvre inédite," 265. On this type of eucharistic miracle, see Miri Rubin, *Corpus Christi: The Eucharist in Late Medieval Culture* (Cambridge: Cambridge University Press, 1991), 108–29, especially 113.

92. Bernard Delmaire, "Un sermon arrageois inédit sur les "bougres" du Nord de la France (vers 1200)," *Heresis* 17 (1991): 1–15. Lambert, *The Cathars*, 90. On the possible doctrinal differences between all of these Cathar groups, see Moore, *The Origins of European Dissent*, 184–86.

93. *PL*, vol. 142, col. 1271.

94. *Chronicon S. Andreae*, 540. The link between heresy and textile work has been explored but not satisfactorily answered in *GRB*, 29–34.

95. *MOB*, 339–46; Charles Dereine, *Les Chanoines réguliers au diocèse de Liège avant Saint Norbert* (Brussels: Palais des Académies, 1952), especially 237–40, and idem, "Les origines de Prémontré," 372; Milis, "De Kerk," 185–86; Pauline Hagemeijer, "Samen maar wel apart. Vrouwen en dubbelkloosters in de Noordelijke Nederlanden, 1100–1400," in *Jaarboek voor vrouwengeschiedenis* (Nijmegen: Sun, 1984), 111–30; Carol Neel, "The Origins of the Beguines," *Signs* 14 (1989): 321–421. On the initial success of syneisactism in northern Europe, see *GRB*, 46–50, and Berenice M. Kerr, *Religious Life for Women, c. 1100–*

*c. 1350: Fontevraud in England* (Oxford: Oxford University Press, 1999), 15–45. For new opportunities for women in older monastic movements, see Urban Küsters, *Der verschlossene Garten: Volkssprachliche Hohelied-Auslegung und monastischen Lebensform im 12. Jahrhundert* (Düsseldorf: Droste Verlag, 1985).

96. Dereine, *Les Chanoines réguliers*, 165 and 204–5; Milis, *L'ordre*, vol. 1, 506–8.

97. See Micheline de Fontette, *Les religieuses à l'âge classique du droit canon. Recherches sur les structures juridiques des branches féminines des ordres* (Paris: J. Vrin, 1967), 13–19; Milis, *L'ordre*, vol. 1, 506–15; Hagemeijer, "Samen," 122–23. Distinctions between nuns and lay sisters in these communities are often difficult to make.

98. Not wholly surprisingly, that book has not been preserved; the author mentions these figures in the preface of the surviving, first book: G. Constable and B. Smith, eds., *Libellus de diversis ordinibus et professionibus qui sunt in aecclesia* (Oxford: Clarendon Press, 1972), 4, and the introduction, xix–xx.

99. Paul Bonenfant, "Hôpitaux et bienfaisance publique dans les anciens Pays-Bas des origines à la fin du XVIIIe siècle," *Annales de la société belge d'histoire des hôpitaux* 3 (1965): 3–44, at 13–21; Griet Maréchal, *De sociale en politieke gebondenheid van het Brugse hospitaalwezen in de middeleeuwen* (Kortrijk–Heule: Standen en Landen, 1978); De Spiegeler, *Les hôpitaux*, 57–69, 147–55, and (more generally for northern Europe) François-Olivier Touati, "Les groupes de laïcs dans les hôpitaux et les léproseries au moyen âge," in *Les mouvances laïques des ordres religieux. Actes du Troisième Colloque International du C.E.R.C.O.R.* (Saint-Étienne: Publications del'Université de Saint-Étienne, 1996), 137–62.

100. Dereine, *Les Chanoines réguliers*, 123–30; Herman of Tournai, *Liber de restauratione monasterii Sancti Martini Tornacensis*, ed. Georg Waitz, in *MGH, SS*, vol. XIV (Hanover: Hahn, 1883), 274–327, at 307. Nuns left St. Martin soon afterward.

101. *Chronicon S. Andreae*, 540; Jaffé, *Monumenta Bambergensia*, 297 (with the explicit statement that Tanchelm used his sexual powers over women).

102. *PL*, 182, col. 679 (emphasis mine); Van Acker, *Hildegardis*, vol. 1, 42; Müller, *Frauen*, 36, 42–43.

103. Borst, *Die Katharer*, 208–11; Eleanor McLaughlin, "Les femmes et l'hérésie médiévale," *Concilium* 111 (1976): 73–90; Malcolm Barber, "Women and Catharism," *Reading Medieval Studies* 3 (1977): 45–62; Richard Abels and Ellen Harrison, "The Participation of Women in Languedocian Catharism," *Mediaeval Studies* 41 (1979): 215–51; *BHF*, 16–20; Anne Brenon, *Les femmes cathares* (Paris: Perrin, 1992). Carol Lansing, *Power and Purity: Cathar Heresy in Medieval Italy* (New York: Oxford University Press, 1998), 106–20; Lambert, *The Cathars*, 148–51.

104. Borst, *Die Katharer*, 145–46, 181; Lambert, *The Cathars*, 150–51. Peter Biller, "The Common Woman in the Western Church in the Thirteenth and Early Fourteenth Centuries," in W. J. Sheils and Diana Wood, eds., *Women in the Church* (Oxford: Basil Blackwell, 1990), 127–57, at 148–52, rightly emphasized that Catharist rethoric in the thirteenth century must have struck women as misogynist, and noted that traces of the belief that women could only enter heaven as men can be found in Cathar doctrine relatively early. Müller, *Frauen*, 250–70 offers an intriguing and nuanced analysis of Cathar doctrine regarding women, but does not deny that the growing institutionalization of the Cathar church limited the role of women in it.

105. McLaughlin, "Les femmes," 80.

106. See Borst, *Die Katharer*, 182; Abels and Harrison, "The Participation of

Women," 217-19, and references to the Cathars' apostolic model by Everwin of Steinfeld and Eckbert of Schönau (*PL*, vol. 182, cols. 679-80; vol. 195, col. 14); see also Müller, *Frauen*, 263-65. For the spiritual ideal of gender equality in religious movements of the twelfth century, based on the apostolic example and St. Paul's injunction that "There is neither male nor female", (Gal. 3:28), see *CR*, 66-69.

107. Dyan Elliott, *Spiritual Marriage: Sexual Abstinence in Medieval Wedlock* (Princeton: Princeton University Press, 1993), 141 (cf. 129), and, for the medical theory, Joan Cadden, *Meanings of Sex Difference in the Middle Ages: Medicine, Science, and Culture* (Cambridge: Cambridge University Press, 1993), 38, 97-99, 150-62. For the discussion around 1200, see John W. Baldwin, *The Language of Sex: Five Voices from Northern France around 1200* (Chicago: University of Chicago Press, 1994), 134-37, 194, 217, 233.

108. Elizabeth Makowski, *Canon Law and Cloistered Women*: Periculoso *and Its Commentators 1298-1545* (Washington, D. C.: Catholic University of America Press, 1997).

109. *Sancti Bernardi sermones super Cantica Canticorum*, no. 65, ed. Jean Leclercq, Charles H. Talbot, and Henri-Marie Rochais, in *Sancti Bernardi Opera*, vol. 2 (Rome: Editiones Cistercienses, 1958), 172-88.

110. Milis, *L'ordre*, vol. 1, 515-57. See also Chapter 2.

111. *Chronica Regia Coloniensis*, 114. The chronicler's attitude differs from that of Caesarius of Heisterbach, writing well after the facts (in 1219-24), who claimed that the young woman was overwhelmed by the seductive powers of the group leader: *Caesarii Heisterbacensis . . . Dialogus Miraculorum*, ed. Joseph Strange (Cologne: H. Lempertz, 1851), vol. 1, 298-99 (reprinted in *CDIN*, vol. 1, 43-44, no. 43). Examples of such slurs are in Jaffé, *Monumenta Bambergensis*, 297, and *Vita Norberti*, in *MGH, SS*, vol. 12, 690-91. On the Cathars' serenity at the pyre, see Bernard Hamilton, "The Cathars and Christian Perfection," in Biller and Dobson, eds., *The Medieval Church*, 5-23, at 23.

112. As did Hildegard of Bingen (note 79).

113. Radulf of Coggeshall, *Chronicon Anglicanum*, ed. Joseph Stevenson (London: Rolls Series, 1875), 121-25 (also in *CDIN*, vol. 1, 61-62, no. 62).

114. *GRB*, 179; Peter the Chanter, *Verbum Abbreviatum*, ed. *PL*, vol. 205, col. 230 (short version) and 545 (long version, which locates the events in *Flandria*); for dates and text tradition, see *BMPM*, vol. 1, 15, 321, and vol. 2, 246-65; Peter returned briefly to the issue in his *Summa de sacramentis et animae consiliis*, ed. Jean-Albert Dugauquier (Louvain: Éditions Nauwelaerts; Lille: Librairie Giard, 1954-67), vol. 3, 2a, 376, c. 319. Since Peter discussed the case with reference to ordeals, he probably alluded to the trials of 1182-83 in Arras, Ypres, and elsewhere in Flanders, at which the use of the ordeal is attested by other sources (cf. *CDIN*, vol. 1, 47-48, no. 48).

115. See notes 85-92.

116. The sources on Lambert's life have been reviewed most recently by Jean Goossens, *De kwestie Lambertus "li Beges" (+1177)* (Brussels: Paleis der Academiën, 1984).

117. Émile Schoolmeesters, "Lambert-le-Bègue et l'origine des Béguines," *Leodium* 11 (1912): 126-32. St. Christophe is first mentioned as a chapel in 1159 and became a parish church some time before 1183: Greven, *Die Anfänge*, 183. On Lambert's tenure as a priest there, see also Prosper Poswick, "Lambert-le-Bègue et l'origine des béguinages," *Bulletin de la Société d'art et d'histoire du diocèse de Liège* 32 (1946): 59-73.

118. Greven, *Die Anfänge*, 168; Goossens, *De kwestie*, 42-43.

119. Goossens, *De kwestie*, 52. On the basis of Dereine, *Les Chanoines réguliers*,161-69, we may conclude that the Neufmoustier canons embraced the more conservative *ordo*

*antiquus* branch of the canons regular in the second half of the twelfth century and were in close contact with the secular canons of St. Paul of Liège, Lambert's former superiors; in 1196, the prior of Neufmoustier was deposed for simony.

120. Glasgow, University Library, MS. Hunter 454 (V.6.4), fol. 1r–16v (*Antigraphum*), and 17r–24v (Letters), and Paris, Bibliothèque nationale, MS lat. 6785, fol. 47v–82r (*Antigraphum*), both from c. 1200, ed. A. Fayen, "L'Antigraphum Petri' et les lettres concernant Lambert le Bègue conservées dans le manuscrit de Glasgow," *BRCH*, 5th s., 9 (1899): 255–356 (the letters are also in *CDIN*, vol. 2, 9–32, nos. 11–14). While *MBB*, 75, 389, and many others accepted Lambert as the author of the *Antigraphum*, Goossens, *De kwestie*, 13–42, 74–5 attributed it to an unknown priest called Peter, who wrote around 1153. In Walter Simons, review of Jean Goossens, *De kwestie Lambertus "li Beges" (+1177)*, *Cahiers de Civilisation Médiévale* 31 (1988): 274–75, I questioned Goossens's argumentation, and Michel Lauwers, *La mémoire des ancêtres, le souci des morts. Morts, rites et société au moyen âge (diocèse de Liège, XIe–XIIIe siècles)* (Paris: Beauchesne, 1996), 241, note 42, also formulated doubts about it, but since there is indeed no positive proof for Lambert's authorship, I leave the question open.

121. Lambert le Bègue, Letter to Calixtus III, ed. Fayen, "L' 'Antigraphum Petri,' " 343–56, quotes from 349 and 344.

122. As did *MBB*, 71–77 (suggesting, without any basis, that Liège was in the thralls of a "Puritan ethic"), and Moore, *The Origins of European Dissent*, 192. Lauwers, *La mémoire*, 242 and 246, calls Lambert a "radical Gregorian."

123. Fayen, "L' 'Antigraphum Petri,' " 346. For clerical involvement with magic, see Richard Kieckhefer, *Magic in the Middle Ages* (Cambridge: Cambridge University Press, 1989), 151–75.

124. Fayen, "L' 'Antigraphum Petri,' " 338. For Lambert's references to Christ's example, see notes 121 and 132.

125. See *Sancti Aureli Augustini Hipponiensis episcopi Epistulae*, no. 29, ed. Al. Goldbacher, *S. Aureli Augustini Operum Sectio II, Pars I. Corpus Scriptorum Ecclesiasticorum Latinorum*, vol. 34 (Vienna: Tempsky, 1895), 120. Lauwers, *La mémoire*, 245, places Lambert's preaching in the context of his criticism of contemporary practices to reconcile the relationship between the living and the dead, and notes parallels with the *Antigraphum Petri*, ed. Fayen, "L' 'Antigraphum Petri,' " 315–17.

126. See note 63. *VO*, written in 1241–47, contains a stern indictment of the mores and practices of the higher clergy (including the bishops) in the diocese during the twelfth century.

127. Lambert, *Heresy*, 58.

128. Fayen, "L' 'Antigraphum Petri,' " 351.

129. This is also close to the view defended in the *Antigraphum*, see Goossens, *De kwestie*, 109–18; Lauwers, *La mémoire*, 246; idem, "*Praedicatio-Exhortatio*: L'Église, la réforme et les laïcs (XIe–XIIIe siècles)," in Rosa Maria Dessi and Michel Lauwers, eds., *La parole du prédicateur Ve–XVe siècles* (Nice: Centre d'Études médiévales, 1997), 187–232, at 202–3, emphasizes the distinction made by Lambert in his defense between the priest's role as a preacher and the laity's task to "exhort," entirely according to prevalent orthodox views of the late twelfth century. As explained below, I believe Lambert's rhetoric went further and raised serious doubts about clerical privileges; his teaching thus differs from that of many twelfth-century theologians of reform who firmly maintained the hierarchical superiority of the ordained clergy despite their proposals for a more active lay

apostolate, see Michel Grandjean, *Laïcs dans l'Église: Regards de Pierre Damien, Anselme de Cantorbéry, Yves de Chartres* (Paris: Beauchesne, 1994), 101–5, 276–85, 345–65.

130. As *CR*, 21, has noted, Lambert's reply was also intended to "associate himself with the structure and values of the church as a whole."

131. Although the Church never issued a formal prohibition of such translations, local bishops did take measures against them after the rise of popular heresy in the twelfth century, see Eligius Dekkers, "L'Église devant la Bible en langue vernaculaire," in Willem Lourdeaux and Daniël Verhelst, eds., *The Bible and Medieval Culture* (Louvain: Leuven University Press, 1979), 1–15 and André Vauchez, "La Bible et les confréries et les mouvements de dévotion," in Pierre Riché and Guy Lobrichon, eds., *Le Moyen Age et la Bible* (Paris: Beauchesne, 1984), 581–95, at 591–92.

132. *Epistola VI*, ed. Fayen, "L' 'Antigraphum Petri,' " 351–53 (reprinted in *CDIN*, vol. 2, 26–32, no. 14). This text has been frequently misinterpreted in the scholarly literature. The English translation in R. I. Moore, *The Birth of Popular Heresy* (New York: St. Martin's Press, 1975), 109, was based on a corrupt text (see the end of this note), and has a few important errors; it implies for instance that Lambert's followers described in this section of the letter were women, "who had realized the life and passion of the Blessed Virgin, Mother of Christ" and that Lambert translated the Acts of the Apostles for them. *MOB*, 415–16, *MBB*, 388–90, offer other misinterpretations that have found their way into textbooks. The Latin text of the most controversial section is as follows: "Unde et ego bonis eorum studiis cooperans, virginibus vitam et passionem beate virginis et Christi martyris Agnetis, omnibus vero generaliter Actus Apostolorum rithmicis concrepantes modulis, ad linguam sibi notiorem a Latina transfuderam, multis loco congruo insertis exhortationibus, ut videlicet haberent quo diebus festis, mundo in rebus pessimis exultante, a venenato ipsius melle sese revocare potuissent. Et hoc est, quod preter scripti sui accusationes queritur iste, me Scripturas sacras indignis aperuisse. [ . . .] Est preterea apud eos liber psalmorum cum omnibus glosulis suis et auctoritatibus eas roborantibus, in vulgarem linguam a quodam magistro flandrensi translatus. Quare de eo non queritur? Quare hunc non incusat? Propterea forsitan 'quia nemo propheta acceptus est in patria sua.' [Luke 4:24] Ille vero magister de patria ejus non fuit" (emended from Fayen, "L' 'Antigraphum Petri,' " 352–53, which has *matris Agnetis* for *martyris Agnetis*; the correction was first made in Greven, *Die Anfänge*, 177–78; cf. *GRB*, 452).

133. The translation mentioned by Lambert may have been a vernacular commentary of the Psalms produced by several Walloon masters between 1163 and the 1190s, which circulated widely; at least part of it was written for Lauretta of Alsace, a Benedictine nun and daughter of the Flemish count Thierry, and could thus be conceived as authored by "a Flemish master." See most recently, Elizabeth den Hartog, "Het maecenaat van Filips van de Elzas en zijn opvolgers. Over de oorsprong van het Ingeborgpsalter en de verbreiding van de 'Muldenstil'," *Handelingen der Maatschappij voor Geschiedenis en Oudheidkunde te Gent*, N.S., 48 (1994): 1–101, at 4–16. For bilingual psalters used by nuns, see Michel Zink, *La prédication en langue romane avant 1300* (Paris: Honoré Champion, 1976).

134. Guy De Poerck and Rika Van Deyck, "La Bible et l'activité traductrice dans les pays romans avant 1300," in Jürgen Beyer, ed., *La Literature didactique, allégorique et satirique* (Gründriss der romanischen Literaturen des Mittelalters, Hans Robert Jauss gen. ed., part VI), vol. 1 (Heidelberg: Carl Winter-Universitätsverlag, 1968), 21–57, at 25–31.

135. As Judith Oliver, *Gothic Manuscript Illumination in the Diocese of Liège (c. 1250–c. 1330)* (Louvain: Peeters, 1988), vol. 1, 112, pointed out.

136. *GRB*, 453; *MOB*, 157, 194, 414–16 (cf. *MKA* [1963], 353–54); and Oliver, *Gothic*, vol. 1, 112, note 37, wrongly assumed that Lambert's (female) followers used such a Psalms translation, or even that Lambert "owned a vernacular psalter" (Oliver, *Gothic*, 108). They apparently misinterpreted the Latin text *"Est preterea apud eos liber psalmorum"* (Fayen, "L' 'Antigraphum Petri,'" 353; the text is quoted above, note 132) and understood *eos* to mean "my followers;" grammatically, however, it must refer to the preceding *iste*, that is, Lambert's opponents. My understanding of the text agrees with that of Moore, *The Birth of Popular Heresy*, 109, and Goossens, *De kwestie*, 63, n. 88. That a number of thirteenth-century psalters originating from Liège are copies of an archetype written by Lambert, or that he wrote some of the Walloon poems found in them, as Paul Meyer, "Le Psautier de Lambert le Bègue," *Romania* 29 (1900): 528–45," and Keith V. Sinclair, "Les manuscrits du psautier de Lambert le Bègue," *Romania* 86 (1965): 22–47, have suggested, is merely speculation inspired by a misunderstanding of the source cited above. For religious vernacular poetry from the Liège area around 1200 that cannot be attributed to Lambert, see Bayot, *Le poème moral*.

137. Rubin, *Corpus Christi*, 83–108.

138. See the sources on Tanchelm (note 101), or the hostile acccounts of the (orthodox) preacher Robert d'Arbrissel, who had a large following of women (Kerr, *Religious Life*, 6–7, 38–39; Bruce L. Venarde, *Women's Monasticism and Medieval Society: Nunneries in France and England, 890–1215* [Ithaca: Cornell University Press, 1997, 57–61]).

139. See Chapter 2.

140. Manteuffel, *Naissance d'une hérésie*, 7–56; Vauchez, "La Bible," 583.

141. They, too, could be called "textual communities," as conceptualized by Stock, *The Implications of Literacy*, 90–92, but the Liège community around Lambert displayed a higher degree of literacy than the groups Stock had in mind, since its members interacted with actual texts and their vernacular translation to a greater extent than did the examples Stock discussed.

142. De Poerck and Van Deyck, "La Bible," 31–37, surveys the translation work among the Waldensians and the northern Italian Humiliati; see most recently, Alexander Patschovsky, "The Literacy of Waldensians from Valdes to c. 1400," in Biller and Hudson, eds., *Heresy and Literacy*, 112–36, with further references, and Kaelber, *Schools of Asceticism*, 140–42. On the Waldensians, see now Gabriel Audisio, *The Waldensian Dissent: Persecution and Survival c. 1170–c. 1570* (Cambridge: Cambridge University Press, 1999).

143. Lambert, *Heresy*, 63–64, 80, 92; Moore, *The Formation of a Persecuting Society*, 34, 66, 92–93.

144. *Epistola VI*, ed. Fayen, "L' 'Antigraphum Petri,'" 353.

145. Stéphane Bormans et al., eds., *Cartulaire de l'Église Saint-Lambert de Liège*, vol. 1 (Brussels: Commission Royale d'Histoire, 1893), 134; *CDIN*, vol. 1, 63, no. 63. The decree is often understood as evidence of Waldensian activity in the region, but that is not at all certain.

146. B. Hauréau, "Un concile et un hérétique inconnus," *Journal des Savants* (August 1889): 505–7, and M. M. Davy, *Les sermons universitaires parisiens de 1230–1231: Contribution à l'histoire de la prédication médiévale* (Paris: J. Vrin, 1931), 97, 127–28; *MC*, vol. 23, 241 and *CDIN*, vol. 1, 81, no. 82. Charles H. Haskins, "Robert le Bougre and the Beginnings of the Inquisition in Northern France," *American Historical Review* 7 (1902): 437–57, 631–52, at 442, 444, noted that Echard was described as a follower of "the Poor of Lyons," that is, the Waldensians, but this may have been only because the transla-

tion of scriptures was then viewed as a typically Waldensian practice. Michel Lauwers, "Paroles de femmes, sainteté féminine. L'Église du XIIIe siècle face aux béguines," in Gaston Braive and Jean-Marie Cauchies, eds., *La critique historique à l'épreuve: Liber disciplinorum Jacques Paquet* (Brussels: Facultés universitaires Saint-Louis, 1989), 99–115, at 104, claims that partial translations of the Bible in Flemish (*in theutonicum*) circulated by 1231 among beguines of Brabant and Flanders, due to a hasty interpretation of a source (Cebus Cornelus De Bruin, *Middelnederlandse vertalingen van het Nieuwe Testament* [Groningen and Batavia: J. B. Wolters, 1934], vol. 1, 9–12) that was itself rather speculative. The assumption is not unreasonable, however.

147. *VO*, 283–84; *VL*, 192, 200.

148. See Chapter 3; Appendix I, no. 94 (see also nos. 29, 45, and 55 for other evidence of the cult of St. Agnes in beguinages). On the Latin and oldest French version of the Life of St. Agnes (dating from the thirteenth century), see Alexander Joseph Denomy, ed., *The Old French Lives of Saint Agnes and Other Vernacular Versions of the Middle Ages* (Cambridge, Mass.: Harvard University Press, 1938).

149. See note 120.

150. *VO*, 206–9. On the whole, the author of this *vita*, a canon of St. Lambert of Liège, knew little about Lambert. His source seems limited to an incomplete oral tradition, see Goossens, *De kwestie*, 69. Joseph Greven, "Der Ursprung," at 296–98, pointed out that in the description of Lambert, the *vita* borrowed heavily from Gregory the Great's *Dialogues*.

151. Giles of Orval, *Gesta episcoporum Leodiensium*, ed. Johan Heller, in *MGH, SS*, vol. 25, 1–129 (quotation from p. 110). See Greven, *Die Anfänge*, 188, and, for Giles's dependence on *VO*, Goossens, *De kwestie*, 70–74. It is very unlikely that the historical Lambert was "a stammerer," but see Chapter 5.

152. Albéric of Troisfontaines, *Chronicon*, ed. P. Scheffer-Boichorst, in *MGH, SS*, vol. 23, 855: "Magister Lambertus Leodiensis de Sancto Christoforo obiit [anno 1177], nove religionis que fervet in Leodio et circa partes illas ferventissimus predicator. Iste Antigraphum scripsit et tabulam que Lamberti intitulatur edidit, sed multos libros et maxime vitas sanctorum et Actus Apostolorum de Latino vertit in Romanum" (see Goossens, *De kwestie*, 22, 74–75). Here, Albéric may have been indebted to another section in *VO*, not connected with Lambert, in which Odilia's lifestyle is described as *novella plantatio religionis* (*VO*, 219). The term *religio* probably alludes to the beguine life rather than to "religion" (as translated by *MBB*, 73: "a fervent preacher of the new religion"); see Chapter 2.

153. London, British Library, Add. Ms. 21114, fol. 7v: *Ge sui ichis Lambers, nel tenez pas a fable, ki fundai sain Cristophle, ki enscri ceste table*; the caption reads *Sires Lambers*, and the heading *Cil prudom fist prumiers l'ordne de beginage, les epistles sain Poul mist en nostre lengage*. For the date of the manuscript and further references, see Oliver, *Gothic*, vol. 1, 109–12 (I disagree with Oliver's transcription of the caption and banderole) and 2, 262–64. The term *beginage* is used here in the sense of "the beguine way of life," and does not denote a beguine "house," "convent," or "court," as Godefroid Kurth, "L'origine liégeoise des béguines," *Bulletins de l'Académie royale de Belgique, Classe des Lettres*, 5th ser., 2 (1912): 437–62, at 458, argued. *MOB*, 412, wrongly suggested that the term was used no later than about 1250, which he regarded as a *terminus ad quem* of the drawing, but its Latin equivalent (and presumably therefore also its vernacular form) is in fact attested in Liège as late as 1266 (*AEL*, Chartriers des Dominicains, no. 20, ed. Michel

Lauwers, "Testaments inédits du chartrier des Dominicains de Liège," *BCRH* 154 [1988], 180). The erroneous assertion that Lambert also translated St. Paul's letters was surely prompted by the local legend, recounted in *VO*, 208, that during Lambert's stay in prison Paul provided him with writing implements.

154. This "*Lambertum*-table" to compute the date of Easter derives its name from the verse "Lambertum talem qui nobis ingerit artem ad paradisiaci perducat lumina regni magnus celorum factor" inscribed in the table; it does not refer to Lambert "le Bègue," but to St. Lambert, the patron saint of Liège (d. ca. 700), see Oliver, *Gothic*, vol. 1, 32–34. For the etymology of "beguine," see Chapter 5.

155. Goossens, *De kwestie*, 8–10, 78–84; Oliver, *Gothic*, vol. 1, 109–12.

## Chapter 2. The Formation of Beguinages

1. *VM*, 547. James wrote the *Life of Mary* in 1215, but this scene refers to bishop Fulk of Toulouse's visits to the diocese of Liège in 1211–2 and 1213, shortly before Mary's death, see Rita Lejeune, "L'évêque de Toulouse Folquet de Marseille et la principauté de Liège," in *Mélanges Félix Rousseau: Études sur l'histoire du pays mosan au moyen âge* (Brussels: La Renaissance du Livre, 1958), 433–38. Elsewhere in the *Vita* he noted that "during the three years of great famine that struck France and a large part of the Empire . . . , not one of the great multitude of holy women in the diocese of Liège died of hunger or was forced to beg in public" (*VM*, 548), which would date the spread of the movement even further back, to the great famine of 1195–97 (for the date of that famine and its effect in the Low Countries, see Hans Van Werveke, *De middeleeuwse hongersnood* [Brussels: Paleis der Academiën, 1967], 7–8, 11–12, 16).

2. *Libri VIII Miraculorum*, ed. Alfons Hilka, *Die Wundergeschichten des Caesarius von Heisterbach* (Bonn: Peter Hanstein Verlagsbuchhandlung, 1933–37), vol. 3, 26–27; on the date of this work, see Jaap van Moolenbroek, *Mirakels historisch: De exempels van Caesarius van Heisterbach over Nederland en Nederlanders* (Hilversum: Verloren, 1999), 327–28. As Greven, "Der Ursprung," 51–52, noted, the passage is in part indebted to James of Vitry's *Life of Mary* (cf. *VM*, 547). Humbert of Romans, writing his *De modo prompte cudendi sermones* around 1270, said that "there are good women who with the grace of God imitate good things and by the fear of the Lord have adopted a salutary spirit and live a most holy life in the midst of a perverse community; they are called beguines" (Marguerin de la Bigne, *Maxima Bibliotheca Veterum Patrum* [Lyons: Apud Annisonios, 1677], vol. 25, 483).

3. *Fratris Thomae, vulgo dicti de Eccleston Tractatus De Adventu Fratrum Minorum in Angliam*, ed. A. G. Little (Manchester: Manchester University Press, 1951), 98–99. It is not quite certain that Robert used the term "beguines" for these women, but when Eccleston wrote his *Tractatus* in 1258–59 (ibid., xxii), the name *beguina* was well known in England.

4. *PB*, 31–32, 39–40, and *MOB*, 315–17, list most of the sources of the early thirteenth-century Low Countries that used these terms for women who led an ascetic lifestyle but were not nuns.

5. *VM*, 548.

6. Although *beguina* was surely one of the nicknames or insults to which James of Vitry alluded in his *Life of Mary*, written in 1215 and quoted in the previous note, he

chose not to mention the name there (compare Preface, note 1). Its earliest explicit use for the *mulieres religiosae* is in Caesarius of Heisterbach, *Dialogus Miraculorum* (lb. II, c. 20, ed. Strange, vol. 1, 89), completed in 1224; for the date, see van Moolenbroek, *Mirakels*, 324–27; see also Chapter 5.

7. I explicitly reject the traditional division of beguine history in four stages, first sketched out by the Flemish historian L. J. M. Philippen in 1919 (*PB*, 40–126) and popularized in the English-speaking world by Ernest McDonnell (*MBB*, 5–7), who added a few details not found in the original. In the first stage, Philippen proposed, beguines lived alone, either with their parents or in their own houses, as *beguinae singulariter in saeculo manentes* ("beguines who lived by themselves in the world"). Beguines entered the second stage of their development when they became *congregationes beghinarum disciplinatarum* ("communities of beguines subject to a rule") under the leadership of a priest (see *PB*, 58–68 for this fundamental aspect of Philippen's view). He dated this development to the years around 1200, but thought it was possible that Lambert le Bègue had presided over such a community in Liège before his death in 1177. After 1216, beguines were grouped in larger communities physically and topographically separated from their lay environment. Philippen called them *beguinae clausae* ("cloistered or enclosed beguines") and affirmed that this third stage was the final one for most beguines in Wallonia. In Dutch-speaking areas, Philippen concluded, beguinages reached a fourth stage, when episcopal authorities recognized them as "beguine parishes," communities directed by a priest with full parochial rights and duties. Philippen's typology and chronology are thoroughly misleading. His use of Latin terms for the "four stages" wrongly created the impression that his classification reflected distinctions made by contemporaries and was sanctioned by the Church. In fact, Philippen pulled the first two terms — *beguinae singulariter in saeculo manentes* and *congregationes beghinarum disciplinatarum* — from a single document of 1266 that has no bearing on the early history of the movement (Bishop Henry of Liège's appointment of Renier of Tongeren as visitor and supervisor of beguine communities in the diocese, dated 1 August 1266, ed. Edmond Reusens, "Un document très important, établissant l'origine liégeoise de l'institut des béguines," *AHEB* 20 [1886]: 125–28), and the term *beguinae clausae* from two documents, of 26 March 1246 (ed. P. J. Goetschalckx, "Oudste stukken uit het Archief der Kapelanen in de Kerk van O. L. V. te Antwerpen," *BG* 14 [1923]: 280–96, at 291–92, no. 20) and 25 April 1246 (ed. J. Van den Nieuwenhuizen, *Oorkondenboek van het Sint-Elizabethhospitaal te Antwerpen (1226–1355)* [Brussels: Palais des Académies/Paleis des Academiën, 1976], 44–48, no. 29) regarding the main beguinage of Antwerp, written by clerics who rather prematurely conceived of the nascent beguine community there as a monastic enclosure, see the sources cited in Appendix I, no. 7A. A third source for the term was a bull by Urban IV for the *magistre et conventui domus beginarum inclusarum* of Vilvoorde, issued in 1262, ed. Ernst Hallmann, *Die Geschichte des Ursprungs des belgischen Beghinen* (Berlin: G. Reimer, 1843), 77, but Philippen misinterpreted pope Urban's use of *incluse* ("anchoresses," "recluses") to denote beguines, see two examples from the same year in Urban's letters to the Liégeois beguines (*MF*, vol. 1, 429–30 [7 and 11 July 1262]) and the comments on Urban's terminology in *MOB*, 358–60 and *MKA* (1963): 372–76.

8. Mary of Oignies came the closest to official canonization: the translation of her relics ca. 1226–28 may have received papal approval (see *VM*, 542–43), and liturgical services were conducted for her at Villers by about 1250, see Daniel Misonne, "Office liturgique neumé de la bienheureuse Marie d'Oignies à l'abbaye de Villers au XIIIe siècle,"

in *Album J. Balon* (Namur: Les anciens établissements Godenne, 1968), 171–89. For the elevation of Lutgard of Tongeren's relics in 1612, see Jean-Baptiste Lefèvre, "Sainte Lutgarde d'Aywières en son temps (1182–1246)," *Collectanea Cisterciensia* 58 (1996): 277–335, at 325–29. The literature on these *vitae* is vaste. Besides *PB, GRB, MOB, MBB, BHF*, Greven, *Die Anfänge*, and *RHC* (still the best work on the *vitae* written by Cistercians), the most important studies are: Brenda Bolton, "*Mulieres Sanctae*," in Susan Mosher Stuard, ed., *Women in Medieval Society* (Philadelphia: University of Pennsylvania Press, 1976), 141–58; idem, "*Vitae Matrum*: A Further Aspect of the Frauenfrage," in Derek Baker, ed., *Medieval Women, Studies in Church History*, vol. 10 (Oxford: Basil Blackwell, 1978), 253–73; Ursula Peters, *Religiose Erfahrung als literarisches Faktum: Zur Vorgeschichte und Genese frauenmystischer Texte des 13. und 14. Jahrhunderts* (Tübingen: Max Niemeyer, 1988); Michel Lauwers, "Expérience béguinale et récit hagiographique," *Journal des Savants* (1989): 61–103; idem, " 'Noli me tangere': Marie Madeleine, Marie d'Oignies et les pénitentes du XIIIe siècle," *Mélanges de l'École Française de Rome. Moyen Age* 104 (1992): 209–68; idem, "Parole de femmes"; and Barbara Newman, "Possessed by the Spirit: Devout Women, Demoniacs, and the Apostolic Life in the Thirteenth Century," *Speculum* 73 (1998): 733–70. References to studies of a particular *vita* will be found later.

9. For editions and textual tradition, see *BHL*, nos. 5516–17 (Mary), 6276 (Odilia), 4620 (Juetta), 1746–47 (Christina), 4146–47 (Ida of Nivelles), 4145 (Ida of Louvain), 4950 (Lutgard), 4521 (Juliana), 5319 (Margaret), 1062 (Beatrice), and 4144 (Ida of Gorsleeuw). I have omitted from this list two *vitae* often discussed in the literature on the beguines, namely those of Elizabeth of Spalbeek (d. after 1278, *BHL* 2484), because her short life did not span the pre-institutional period of the beguine movement, and of Alice of Schaarbeek (d. 1250, *BHL* 264), because she spent almost her entire life in a Cistercian monastery and does not appear to have been in touch with beguines.

10. Some authors were quite far removed from the events they related and did not even know the subject of the *vita* personally; see for instance A. Goetstouwers, "Het 'vita' der zalige Ida van Leuven. Chronologische aantekeningen," *BG*, 3rd ser., 5 (1953): 197–201. Of course, they conducted interviews and used written notes, but on the whole I suspect they gathered rather little information on the beguine communities the women had frequented.

11. See for these issues Isabelle Cochelin, "Sainteté laïque: l'exemple de Juette de Huy (1158–1228)," *Le Moyen Age* 95 (1989): 397–417; De Spiegeler, *Les hôpitaux*, 114–16; Rubin, *Corpus Christi*, 173–76, and Charles M. A. Caspers, *De eucharistische vroomheid en het feest van sacramentsdag in de Nederlanden tijdens de late middeleeuwen* (Louvain: Peeters, 1992), 42–44.

12. Joseph Daris, "Examen critique de la Vie d'Odile et de Jean, son fils," *Bulletin de l'Institut archéologique liégeois* 11 (1872): 153–88; Godefroid Kurth, "L'archidiacre Hervard," *BCRH* 72 (1903): 121–80.

13. Alexander Murray, "Confession as a Historical Source in the Thirteenth Century," in R. H. C. Davis, and J. M. Wallace-Hadrill, eds., *The Writing of History in the Middle Ages* (Oxford: Clarendon Press, 1981), 275–322, at 286–305, argued that Thomas's experience as a Dominican confessor sharpened his empathy for the personal lives of the laity, as expressed in his later *Bonum Universale de Apibus*; Iris Geyer, *Maria von Oignies: Eine hochmittelalterliche Mystikerin zwischen Ketzerei und Rechtgläubigkeit* (Frankfurt am Main: Peter Lang, 1992), 46–49, also thought that James's association with Mary of Oignies and his biography of her were defined by his role as her confessor. Henri Pla-

telle, ed., *Thomas de Cantimpré. Les exemples du "Livre des Abeilles." Une vision médiévale* (Turnhout: Brepols, 1997), 5–56, summarizing many years of research on Thomas, attributed his interest more broadly to his pastoral work. The influence of confessional practice on the devotional treatises of such preachers is also discussed in several essays of *Faire croire: Modalités de la diffusion et de la réception des messages religieux du XIIe au XVe siècles* (Rome: École française de Rome, 1981).

14. James's official activity in the Low Countries is documented in Ursmer Berlière, "Les évêques auxiliaires de Liège," *Revue Bénédictine* 29 (1912): 60–81; see also *VMS*, 578–79, and R. B. C. Huygens, ed., *Lettres de Jacques de Vitry (1160/1170–1240) évêque de Saint-Jean d'Acre. Edition critique* (Leiden: E.J. Brill, 1960), 71–97, 123–153. For his biography, see *Jacques de Vitry, "Histoire Occidentale." Historia Occidentalis (Tableau de l'Occident au XIIIe siècle)*, trans. Gaston Duchet-Suchaux, intro. Jean Longère (Paris: Cerf, 1997), 7–16; Walter Simons, "Jacques de Vitry," in Deborah Sinnreich-Levi and Ian S. Laurie, eds., *Literature of the French and Occitan Middle Ages: Eleventh to Fifteenth Centuries* (Detroit: Bruccoli, Clark, & Layman, 1999), 157–62, and Monica Sandor, "The Popular Preaching of Jacques de Vitry" (Ph.D. diss., University of Toronto, 1993; a revised version of the thesis is being prepared for publication). His relative lack of contact with the Low Countries after 1216 may explain why James, in his overview of the religious condition of the West known as the *Historia Occidentalis* (of 1221–23/25), had little more to say about the beguines than he had already recorded in his *Life of Mary* (see John Frederick Hinnebusch, O.P., ed., *The Historia Occidentalis of Jacques de Vitry. A Critical Edition* [Fribourg: The University Press, 1972], 206–7, and 16–20 for the date of composition; in *Jacques de Vitry, "Histoire Occidentale,"* 32–37, Jean Longère suggested that James continued to revise this work until 1225).

15. The canons of Oignies asked Thomas to write a supplement to the *Life of Mary*: *VMS*, 572 (*BHL* 5517).

16. *VMS*, 579–81.

17. The best biographical notices on Thomas currently available are Platelle, *Thomas de Cantimpré*, 11–17 and C. M. Stutvoet-Joanknecht, Der Byenboeck. *De Middelnederlandse vertalingen van Bonum universale de apibus van Thomas van Cantimpré en hun achtergrond* (Amsterdam: VU Uitgeverij, 1990), part 1, 7–31. The date for *VMY* given here (1243, rather than 1240) is based on Stutvoet-Joanknecht's analysis; the date for *VC*, different from that usually cited (about 1232), is my own suggestion, based on a reference in the *vita* to abbot Thomas of Sint-Truiden, who was abbot from 1239 until 1248 (P. Pieyns-Rigo, "Abbaye de Saint-Trond," in *Monasticon belge. Tome VI: Province de Limbourg* [Liège: Centre nationale de recherches d'histoire religieuse, 1976], 46); since James of Vitry was still alive when Thomas finished the book, the *terminus ad quem* is 1240. Thomas's *vitae* of Christina and Margaret of Ypres were not based on a personal acquaintance with them.

18. *VJ*, especially 152–54, 166. *MOB*, 384–402 provided a groundbreaking analysis of the *vita*, largely ignored by *MBB* (cf. *MKA* [1962]: 286–89), and other works on the beguines until Cochelin, "Sainteté laïque;" see now also Jennifer Carpenter, "Juette of Huy, Recluse and Mother (1158–1228): Children and Mothering in the Saintly Life," in Jennifer Carpenter and Sally-Beth MacLean, eds., *Power of the Weak: Studies on Medieval Women* (Urbana: University of Illinois Press, 1995), 57–93; Anneke B. Mulder-Bakker, "Ivetta of Huy: Mater et Magistra," in idem, ed., *Sanctity and Motherhood: Essays on Holy Mothers in the Middle Ages* (New York: Garland, 1995), 225–58; Jo Ann McNamara, trans., *The Life*

*of Yvette of Huy* by Hugh of Floreffe (Toronto: Peregrina, 1999). On the Grands Malades, which in Juetta's days was probably only a small shelter for lepers with few provisions for care, see André Joris, *La ville de Huy au Moyen Age* (Paris: Les Belles Lettres, 1959), 388–89. For an example of an early beguine at Huy who lived under the parental roof around 1190–1200, see the *Vita Abundi*, ed. A. M. Frenken, "De Vita van Abundus van Hoei," *Cîteaux* 10 (1959): 5–33, at 13.

19. *VM*, 553, 555, 563, and *VMS*, 576 (and *MOB*, 259). For the history of Oignies, founded at the end of the twelfth century, see Édouard Poncelet, *Chartes du prieuré d'Oignies de l'Ordre de Saint-Augustin*, vol. 1 (Namur: Ad. Wesmael–Charlier, 1912), i–lxvii and *MBB*, 8–19. Mary of Oignies, as she became known, is probably the most famous of all early beguines and has received the attention of many scholars. For the most important studies, see André Vauchez, "Prosélytisme et action antihérétique en milieu féminin au XIIIe siècle: la *Vie de Marie d'Oignies* (+1213) par Jacques de Vitry," *Problèmes d'Histoire du Christianisme* 17 (1987): 59–110; Geyer, *Maria von Oignies*; Michel Lauwers, "Entre béguinisme et mysticisme: La Vie de Marie d'Oignies (+1213) de Jacques de Vitry ou la définition d'une sainteté féminine," *OGE* 66 (1992): 46–70; Margot H. King et al., trans., *The Life of Marie d'Oignies by Jacques de Vitry* 3rd ed. (Saskatoon: Peregrina, 1993).

20. *VMS*, 573; Geyer, *Maria von Oignies*, 25–26; Simons, "Jacques de Vitry." *MOB*, 223 dates James's arrival at Oignies "about 1207," and Jean Longère, *Jacques de Vitry. "Histoire Occidentale*," about 1208, or shortly after Mary settled there, but both dates seem too early. The other churchmen consulting her were Thomas of Cantimpré and John of Nivelle, see later in this chapter.

21. *VM*, 559; 565. Mary returned to these *familiares* for a visit at least once after her move to Oignies (*VM*, 562). Data on the beguine community at Willambroux are gathered in Appendix I, no. 81.

22. These companions—some of whom were relatives of the canons, like the prior's mother—are briefly mentioned in *VM*, 555, *VMS*, 576.

23. *VMS*, 580.

24. C. Roland, "Les seigneurs et comtes de Rochefort," *Annales de la Société Archéologique de Nivelles* 20 (1893): 63–144, 329–411, at 354, note 2 (24 July 1239), and Appendix I, no. 83.

25. The *Life* was first edited rather poorly by Chrysostomus Henriquez in his *Quinque Prudentes Virgines* (Antwerp: Apud Ioannem Cnobbaert, 1630), 199–297 (=*VIN*); the Bollandists edited passages he had omitted in *Catalogus codicum hagiographicorum Bibliothecae Regiae Bruxellensis*, vol. 2 (Brussels: Polleunis, Ceuterick et Desmet, 1889), 222–26, and two chapters of the *vita* were critically reedited as an appendix to Leonce Reypens, *Vita Beatricis* (Antwerp: Ruusbroec–Genootschap, 1962), 218–220. Martinus Cawley, ed. and trans., *Lives of Ida of Nivelles, Lutgard, and Alice the Leper* (Lafayette, Oregon: Guadalupe Translations, 1987), gathered those disparate materials and added a fine English translation in a limited edition; see also *RHC*, 54–59. Albert d'Haenens, "Femmes excédentaires et vocation religieuse dans l'ancien diocèse de Liège lors de l'essor urbain (fin du XIIe–début du XIIIe siècle): Le cas d'Ide de Nivelles (1200–1231)," in Hervé Hasquin, ed., *Hommages à la Wallonie: Mélanges d'histoire, de littérature et de philologie wallonnes offerts à Maurice A. Arnould et Pierre Ruelle* (Brussels: Université Libre de Bruxelles, 1981), 217–35, is a good analysis of the social realities behind Ida's route to the monastery.

26. *VIN*, 201–3 (quotes from 201). For the chronology of these events, see *VIN*, 209–

10, *RHC*, 54, and Roger De Ganck, "Chronological data in the lives of Ida of Nivelles and Beatrice of Nazareth, *OGE* 57 (1983): 14–29, correcting *MBB*, 63, 66, who dated Ida's entry into the Cistercian order in 1211.

27. See for instance *VIN*, 243 and 253; *VIN*, 202, cites as a witness "Mary, a recluse of *Heylonbineth*, who used to be among them [=the beguines]." This anchoress Mary of Willambroux (Henriquez's transcription is incorrect: *KB*, MS. 8609-20, fol. 148r has *Heylenbroec*), was probably a companion of Heldewidis, who lived as an anchoress at Willambroux before 1207 (*VM*, 565), or her successor at the anchorhold (I disagree with the identification proposed by *MOB*, 392, note 208). For the history of Kerkom and La Ramée, see Émile Brouette, "Abbaye de la Ramée, à Jauchellete," in *Monasticon belge. Tome IV. Province de Brabant*, vol. 2 (Liège: Centre nationale de recherches d'histoire religieuse, 1968), 469–90.

28. Jean-Luc Delattre, "La fondation des hôpitaux de Saint-Nicolas et du Saint-Sépulchre à Nivelles au XIIe siècle," in *Hommage au Professeur Paul Bonenfant (1899–1965)* (Brussels: Université Libre de Bruxelles, 1965), 595–99.

29. Caesarius of Heisterbach, *Dialogus Miraculorum*, ed. Strange, vol. 1, 251; the "virgo quaedam de Nivella nata, domum patri et parentes amore Christi deserens," with whom Caesarius begins the story, must be Ida of Nivelles, despite the doubts of *MOB*, 367, note 121, who thought it was odd that this particular anecdote is not in her *vita*. Stories circulated independently about such women, however, and no one *vita* claimed to contain all of them.

30. See Appendix I, no. 81.

31. *VM*, 560. Liège was sacked by Henry I of Brabant on May 3–7, 1212.

32. *VM*, 548 (cf. King, *The Life of Marie*, 38–39).

33. As was argued by Greven, *Die Anfänge*, 84–88; Jozef van Mierlo, "Lambert li Beges in verband met den oorsprong der begijnenbeweging," *Verslagen en Mededeelingen van de Koninklijke Vlaamsche Academie voor Taal- en Letterkunde* (1926): 621–55, and by many others since then; see more recently Christine Renardy, *Les maîtres universitaires du diocèse de Liège: Répertoire biographique 1140–1350* (Paris: Les Belles Lettres, 1981), 361–64; De Spiegeler, *Les hôpitaux*, 113. *MBB*, 40–45, lists documents regarding pastoral care in the city of Liège and its vicinity, in which John's name appears, but does not offer concrete evidence for the assertion that he "discharged pastoral duties among the *mulieres sanctae*" (p. 41); on the whole McDonnell was misled by the dual assumption, made by many scholars at that time, that John, like Mary of Oignies, was a native of Nivelles in Brabant and thus had known the Nivelles beguines from his youth (in fact John's name, *de Nivello*, refers to the hamlet of Nivelle on the Meuse river, close to Liège) and that the hospital of St. Christophe of Liège, attested since 1183 and with which John was in touch around 1199, was run by beguines (it was not: see Appendix I, no. 61A).

34. *VM*, 560; cf. his assessment of John as a preacher in the *Historia Occidentalis*, ed. Hinnebusch, *Historia Occidentalis*, 102–3.

35. Respectively in Thomas of Cantimpré's *Bonum Universale de Apibus*, ed. Georgius Colvenerius (Douai: B. Belleri, 1627), Lb. II, ch. xxxi, nos. 3–5 (my references to this edition, which has several systems of pagination, will list book [Lb.], chapter [ch.], and paragraph number) and the *Vita Arnulphi Conversi*, ed. D. Papebroeck in *AA.SS.*, Jun., vol. 7, 573; cf. Goswin's *Vita Abundi*, ed. Frenken, "De Vita," 27.

36. "Magister Iohannes de Lirot et socius eius, magister Iohannes de Nivella" in Hinnebusch, ed., *The Historia Occidentalis*, 103. The wording suggests John of Liroux was

John of Nivelle's senior and mentor rather than the other way around, as is generally held. Like John of Nivelle, John of Liroux has been wrongly identified as a native of Brabant because of his Latin surname *de Lirot*, which was assumed to refer to the city of Lier in Brabant (Greven, *Die Anfänge*, 87; *PB*, 77, 79; *MOB*, 257, note 13, corrected in *MKA* [1962], 325–26, note 157); since Latin forms of his surname are unknown in contemporary sources referring to Lier (usually known as *Lira*), and John's activity was centered in the French-speaking parts of the diocese of Liège rather than in Dutch-speaking parts of the diocese of Cambrai, where Lier was located, it makes more sense to assume John came from Liroux, close to Gembloux (see Renardy, *Les maîtres*, 355–57).

37. *VL*, 197. Greven, *Die Anfänge*, 133–34, believed that this happened "around 1216," a date now generally accepted (cf. *MBB*, 47; Hinnebusch, *Historia Occidentalis*, 285), but founded on the belief that John's failure to reach Rome necessitated James of Vitry's request for papal approval of the beguines, which occurred in the summer of 1216. However, John was still in the Liège area in the spring of 1216, perhaps even in 1217 (Guido Hendrix, *Thomas van Cantimprés Vita Lutgardis. Nederlandse vertaling van de tweede versie naar handschrift Brussel, Koninklijke Bibliotheek Albert I, 8609–8620* [Louvain: Bibliotheek van de Faculteit Godgeleerdheid, 1997], x). In fact, Thomas of Cantimpré, our only source for this event, does not say that John tried to gain approval for the beguines, but only that he traveled to Rome to defend *mulieres religiosae* against those who harassed them, which he could well have done after James's talks at Rome. Renardy, *Les maîtres*, 356–57, lists a charter of 1220 for Mont-Cornillon as the last document in which John was mentioned, but its textual tradition is uncertain: it is a fifteenth-century copy of a late thirteenth-century *vidimus*, and cites the witness as Johannes *de Nigro*, not *de Liro*.

38. *VO*, 215, 218–19, 222, 226. The chronology of Odilia's life is difficult to determine; her "conversion" to the ascetic life appears to have occurred seven years after the birth of her son, John, which took place in 1196, when she was twenty years old (correct the editor's note, *VO*, 211). The *vita* does not mention a beguinage in the parish of St. Christophe.

39. Appendix I, no. 61B.

40. This is the famous beguinage of St. Christophe whose foundation has long been (erroneously) attributed to Lambert le Bègue, see Chapter 1, and Appendix I, no. 61A.

41. For instance Juliana's surprise inspections of the female dormitory to ward off possible trysts with members of the male community, *VJC*, 456.

42. *VJC*, 443–73. A more detailed account of her life and her campaign to establish the feast of Corpus Christi may be found in *MBB*, 299–319, and Rubin, *Corpus Christi*, 164–76, with further references. There is an excellent translation of her Life into English by Barbara Newman, *The Life of Juliana of Mont Cornillon* (Toronto: Peregrina, 1989). The conflict over Juliana's rule at Mont-Cornillon illustrates the broader contest between urban government and Church for control of urban hospitals in the thirteenth century (De Spiegeler, *Les hôpitaux*, 106–32; Griet Maréchal, "Armen- en ziekenzorg in de Zuidelijke Nederlanden," in *AGN*, vol. 2, 268–80; and especially Pierre De Spiegeler, "La Léproserie de Cornillon et la cité de Liège (XIIe-XIVe siècle)," *Annales de la Société d'histoire des hôpitaux/Annalen van de Belgische Vereiniging voor Hospitaalgeschiedenis* 18 [1980]: 5–16).

43. *VJC*, 443–444.

44. *VJC*, 443, 458, 475. On Eve's authorship of the notes, "approved by John of Lausanne, canon of St. Martin of Liège," (*VJC*, 443), see Joseph Demarteau, *Le première*

*auteur wallonne: la bienheureuse Ève de Saint-Martin* (Liège: Demarteau, 1896), 7–16; C. Lambot, "Éve de Saint-Martin et les premiers historiens liégeois de la Fête-Dieu," in *Studia Eucharistica DCCI anni a condito festo sanctissimi corporis Christi 1246–1946* (Antwerp and Bussum: De Nederlandsche Boekhandel, 1946), 10–35, particularly 11–12.

45. I am not suggesting, of course, that a *vita* is worthy of our attention only for the "hard" historical information it might contain. The *Life of Christina* is a wonderful source for the religious climate around 1200 and compelling reading for historians and anthropologists interested, for instance, in explorations of otherworldly experiences in thirteenth-century Europe. *BHF*, 120–23, 193, 203, 211, 234, 273–74; Robert Sweetman, "Christine of Saint-Trond's Preaching Apostolate: Thomas of Cantimpré's Hagiographical Method Revisited," *Vox Benedictina* 9 (1992): 67–97; and most recently Newman, "Possessed by the Spirit," 763–68, have begun to explore this fascinating story, which, as Newman noted (ibid., 768, note 138), was among the most popular of Thomas's saint's lives. A translation in Middle-Dutch was made for a nun at Nonnemielen before about 1280–90: *CG*, II, vol. 6, xii–xiii. Margot King, trans., *The Life of Christina of Saint-Trond by Thomas of Cantimpré* (Saskatoon: Peregrina, 1986) is a translation into English with fine explanatory notes.

46. *VC*, 657.

47. She was in Borgloon on September 1187, around 1203, and again in 1218: *VC*, 656–659, cf. Antoon Steenwegen, "De gelukz. Ida de Lewis of Ida van Gorsleeuw," *OGE*, 57 (1983): 105–33; 209–47, 305–22, at 126.

48. *VL*, 194. Guido Hendrix, "Primitive versions of Thomas of Cantimpré's *Vita Lutgardis*," *Cîteaux* 29 (1978): 153–206, reviewed the complex textual tradition of the *Life of Lutgard*; a new edition by Hendrix is in preparation. For the date of Lutgard's entry into the monastic life (previously situated around 1206 rather than 1216–7), see Hendrix, *Thomas van Cantimprés Vita Lutgardis*, x. The literature on Lutgard is too voluminous to discuss here: see the bibliography in Hendrix, *Thomas van Cantimprés Vita Lutgardis*, xx–xxi.

49. *VIL*, 110 (the life, written around 1270, uses the term *beguinas* rather anachronistically). As Steenwegen, "De gelukz. Ida," 106–19, has shown, Ida derived her name from her family's lordship at Gorsleeuw (today in the village of Gors-Opleeuw, a few miles east of Borgloon), and not of Zoutleeuw (French: Léau), a town to the west of Sint-Truiden (the older literature often erroneously associated her with the beguines of Zoutleeuw: *RHC*, 62, note 1, and *MOB*, 235, note 45, corrected in *MKA* [1962]: 301–3). *MBB*, 383 and 386 suggested Ida went to a beguine school at Zoutleeuw (in the same sense: *MCF*, vol. 1, 42); but Steenwegen, "De gelukz. Ida," 120–33, demonstrated convincingly that Ida's school was that of the canons of St. Odulphus in Borgloon.

50. Steenwegen, "De gelukz. Ida," 127–29 assumed the beguines mentioned in *VIL*, 194 lived at Gratem, but this is not certain. For the 1259 documents, see Appendix I, no. 21.

51. *VB*, 24 (for the wording, see the note below). Roger De Ganck, *The Life of Beatrice of Nazareth 1200–1268* (Kalamazoo: Cistercian Publications, 1991), offers a good English translation and discusses the tricky question of the *Vita*'s authorship and the chronology of Beatrice's life; for additional literature, see Roger De Ganck, *Beatrice of Nazareth in Her Context* (Kalamazoo: Cistercian Publications, 1991). Beatrice later moved to the new Cistercian monastery of Nazareth (near Lier), which gave her the surname by which she is known in the scholarly literature; on that monastery, see K. Breugelmans and F. Vanhoof, "Abbaye de Nazareth à Lierre, puis à Brecht," in *Monasticon belge.*

*Tome VIII: Province d'Anvers*, vol. 1 (Liège: Centre nationale de recherches d'histoire religieuse, 1992), 101–26, at 104, 108–11.

52. This, at least, is my interpretation of a short passage in the *Life* where the arrangement is explained: "ut liberius ad virtutis provectum conscenderet, in oppido cui Lewis vocabulum est illam devoto beghinarum collegio sociavit, et tam magistre, mulieri religiose scilicet et devote, quam ceteris consororibus sub eius regimine domino famulantibus, bonis informandam moribus, erudiendam exemplis et virtutibus adornandam, hanc pius pater attentius commendavit. Quibus virgo domini . . . miro dilectionis affectu . . . precipue venerabilem illam, cuius magisterio delegata fuerat, instructicem, mox cordi suo cepit imprimere. Per idem quoque tempus a patre magistris liberalium artium est commissa disciplinis scolaribus, quibus iam a matre . . . iniciata fuerat, expeditius informanda. Ubi cum inter multitudinem scolarium cogeretur toto die devotissima Christi discipula residere . . . sed et quantum potuit ab illis corpore pariter et animo sequestrata, facie quoque aversa, soli lectionis studio quam a magistro memorie commendandem acceperat intendebat. . . . Attendant inquam electam hanc Dei virginem per totum et eo amplius anni circulum inter scolares quam plurimos ita solitariam accubasse" (*VB*, 24, 26). Her teacher in this co-educational school of Zoutleeuw thus appears to have been a man. The term *liberales artes* suggests its program was quite advanced and included Latin instruction. *MOB*, 332–23, notes 23–24, and *MBB*, 386, misrepresent the evidence for higher forms of teaching by these early beguine communities; *MKA* (1962): 297, stays closer to the *vita* in this respect. The term *beghinarum collegio* is used in a loose way ("association of beguines"), and not to denote a formal beguine institution; in the latter sense, it appears for the first time in a charter of 1240 regarding the beguinage at Valenciennes (*ADN*, 40 H 556, no. 1343A [28 May 1240]).

53. See Appendix I, no. 111.

54. Caesarius of Heisterbach, *Dialogus Miraculorum*, ed. Strange, 188, 191 (cf. *MOB*, 365–66); see also Appendix I, no. 96.

55. *Libri VIII Miraculorum*, ed. Hilka, *Die Wundergeschichten*, vol. 3, 25–27. We cannot identify *Halewigis* with the famous author Hadewijch "of Brabant" since the name was extremely common among beguines and recluses.

56. *VILO*, 165–68, 172. The chronology of the *Life* is uncertain: *RHC*, 67–70 and others have placed her birth around 1210 and conversion to the monastic life in 1233; *MKA*, 306–08, dates her birth to 1220/30 and conversion to 1250/60; Goetstouwers, "Het 'vita,' " assumes (on the slenderest of evidence) that she was born around 1200 and died before 1261. According to *VILO*, 172, the beguines of Louvain had their own church when Ida visited them, which puts that event around or even after 1232, when the church of the beguinage of Ten Hove was formally erected (see Appendix I, no. 64A); elsewhere the *Life* (*VILO*, 184) records that Ida's long residence as a nun at Rozendaal occurred while the Cistercian nuns took communion by drinking from the chalice, a custom abolished in 1261. I therefore suggest (with caution) that Ida met and socialized with the beguines of Louvain around 1232 and entered the Cistercian order at Rozendaal around 1240 (on Rozendaal, founded ca. 1227–28, see F. Vanhoof, "Abbaye de Rozendaal à Wavre-Sainte-Catherine," in *Monasticon belge. Tome VII: Province d'Anvers*, vol. 1, 127–64). There exists a very good English translation of the *Life* in a limited edition: Martinus Cawley, trans., *Ida of Louvain: Medieval Cistercian Nun* (Lafayette: Guadalupe Translations, 1990).

57. Appendix I, no. 1A.

58. Godding, "Une oeuvre inédite," 285; some thirty years later, in his *Bonum uni-*

*versale de Apibus*, Thomas wrote that Philip had supported "5,000 beguines," ed. Colvenerius, Lb. II, ch. xxxviii, no. 2). Philip was probably a member of the noble Montmirail family (see also Godding, "Une oeuvre inédite," 284–85, 290), but we know nothing about him. See also Appendix I, no. 28A.

59. *VMY*, 118. Margaret also received visitors from remote parts of Flanders (ibid., 112–13).

60. Appendix I, no. 108A.

61. These routes were in part responsible for the precocious urban growth in this part of the southern Low Countries, see André Joris, "Les villes de la Meuse et leur commerce au Moyen Age," in idem, *Villes: Affaires-Mentalités. Autour du pays mosan* (Brussels: De Boeck, 1993), 195–213.

62. *VC*, 652. According to Thomas of Cantimpré, Christina approached the parish priest of St. Christophe to receive communion from him, suggesting that Christina knew of the nascent beguine community of St. Christophe, firmly attested in 1241 but probably older (see Appendix I, no. 61A). The visit cannot be precisely dated, however, and it is possible that Thomas, completing the *vita* in 1239–40, added the reference to St. Christophe at that time because he knew of beguines there; for the date of *VC*, see also note 17.

63. *VL*, 196–98.

64. *VJC*, 458, 468, and Appendix I, no. 78B.

65. *VILO*, 109–10, 113 (cf. *RHC*, 60, note 2).

66. *VILO*, 112. The event must have taken place after 1228–30 (foundation date of the Dominican convent at Louvain, see Simons, *Stad en apostolaat*, 99) and 1232 (the probable foundation date of the beguinage and church of Ten Hove at Louvain, Appendix I, no. 64A).

67. *VM*, 548 (for Juetta: cf. *MOB*, 389); *VC*, 650; *VL*, 196–98; Huygens, *Lettres*, 79–97; Ursmer Berlière, "Jacques de Vitry, ses relations avec les abbayes d'Aywières et de Doorezeele," *Revue bénédictine* 27 (1908): 185–93.

68. Platelle, *Thomas de Cantimpré*, 15–17; Sweetman, "Christine of Saint-Trond's Preaching Apostolate," 67–69. The quote is from *VL*, 202.

69. See for instance Goswin of Bossut's *Vita Sancti Arnulfi*, ed. P. Papebroeck, in *AA.SS.*, Jun., vol. 7, 573.

70. *VL*, 195, 197–98.

71. James of Vitry mentioned Guido a few times in his *Life of Mary of Oignies* (*VM*, 560, 565, 568), but not in his *Historia Occidentalis*; Thomas of Cantimpré did not include him in his Supplement to Mary's life, written in 1229–32, but in his later *Bonum Universale de Apibus* he affirmed that he had met Guido (Lb. II, ch. xxx, nos. 30–31); see also *Vita Arnulfi*, in *AA.SS.*, Jun., vol. 7, 572. Archival documents attesting Guido's activities in Nivelles from 1211 until his death in 1227 are reviewed in R. Hanon de Louvet, "L'Origine nivelloise de l'Institution béguinale 'La Royauté,' fondation béguinale d'une Reine de France Marie de Brabant et la légende de la béguine de Nivelles," *Annales de la Société archéologique et folklorique de Nivelles et du Brabant wallon* 17 (1952): 5–77, at 19–23, and Pascal Majérus, "Fondateur ou formateur? Maître Guidon et l'établissement des béguines de Nivelles," *Revue d'histoire religieuse du Brabant wallon* 12 (1998): 51–73, at 54–58.

72. "Pluribus e terris ad eum venere doceri/ Denique Teutonici, Campania, Flandria, Franci/ Virgineas acies illi misere docendas/Tanta puellarum confluxit copia, qua-

rum/Vix numera credi posset, si posset haberi/ . . . Hinc iam virginitas longe lateque per orbem/Nobiliter florens coenobia tanta subornat," ed. Ioseph Geldolph a Ryckel, *Vita S. Beggae* (Louvain: Typis Corn. Coenestenii, 1631), 293–94, as *Planctus virginum super morte patris sui* from the "Nivelles archives;" reprinted in Greven, *Die Anfänge*, 85. Like *PB*, 64, Hanon de Louvet, "L'origine nivelloise," 22, and Majérus, "Fondateur," 68, I have translated *Campania* as the Kempen, the region straddling northeastern Brabant and northern Loon, rather than Champagne, as Ryckel, Greven, and others did. It is not possible to identify the author or date of the document, which is now lost; Ryckel's edition also appears incomplete. There is no evidence that it was "composed by the local beguines" (Hanon, "L'Origine," 21; *MBB*, 46; *MKA* [1962], 327). Two allusions to bees in the epitaph suggest very strongly that it was inspired by Thomas of Cantimpré's *Bonum Universale de Apibus*, which would date it after 1256–63. Greven, *Die Anfänge*, 86, note 1, rejected, somewhat defensively, the possibility of a seventeenth-century forgery, arguing that the verses were medieval because they resembled certain memorial hymns or epitaphs inserted in the *Chronica Villariensis monasterii* (ed. Georg Waitz, in *MGH, SS.*, vol. 25 [Hanover: Hahn, 1880], 195–209, at 199, 204, 205), and the *Gesta Sanctorum Villariensium* (ed., in part, ibid., 220–35, at 229, 232). Was Guido's hymn composed at Villers? It is certainly noteworthy that the Villers chronicles of the late thirteenth and early fourteenth century also draw on Thomas's *Bonum Universale* (cf. *RHC*, 27) and that the hymn acknowledges Guido's preaching of virginity and the formation of *coenobia* of virgins ("nunneries," like those affiliated with Villers?) but does not mention beguines. See also note 73.

73. *VM*, 553–54, notes Mary of Oignies's contacts with Villers (see also note 83), and for James of Vitry's relations with the abbey, see Huygens, *Lettres*, 43, 133–34. More generally, see Simone Roisin, "L'efflorescence cistercienne et le courant féminin de piété au XIIIe siècle," *RHE* 39 (1943): 342–78, at 363–73. *MBB*, 320–40, does not adequately discern changes over time and draws from late, misinformed sources. The influence of Villers and other Cistercian monasteries on the beguines is exaggerated, in my view, by Georgette Epiney-Burgard, "Les béguines et l'ordre cistercien aux Pays-Bas du sud (XIIIe siècle)," in *Les mouvances laïques des ordres religieux*, 261–77.

74. Édouard de Moreau, *L'abbaye de Villers-en-Brabant aux XIIe et XIIIe siècles. Étude d'histoire religieuse et économique* (Brussels: Albert Dewit, 1909), 105–9; *MBB*, 281–91; Van Acker, *Hildegardis Bingensis Epistolarium*, vol. 2, 269–71, no. CIXR (see also 235–36).

75. *Chronica Villariensis Monasterii*, 200; *Continuatio secunda*, ed. Georg Waitz, in *MGH, SS.*, vol. 25, 209–19, at 211–12.

76. *Vita Goberti Asperimontis*, ed. P. Dolmans, in *AA.SS.*, *Aug.*, vol. 4, 370–95, at 384–85; cf. *Gesta Sanctorum Villariensium*, 227; *RHC*, 39; Frenken, "De Vita van Abundus van Hoei," 8 (and 15, for a similar story about Juetta of Huy).

77. *Vita Goberti Asperimontis*, 390; *Gesta Sanctorum Villariensium*, 234 (cf. *MBB*, 324–25; *RHC*, 128).

78. *Gesta Sanctorum Villariensium*, 235.

79. *Dialogus Miraculorum*, ed. Strange, vol. 1, 88–89; *Libri VIII Miraculorum*, ed. Hilka, *Die Wundergeschichte*, vol. 3, 22–27; *RHC*, 174.

80. H. Schuermans, "Les reliques de la B. Julienne de Cornillon à l'abbaye de Villers," *Annales de la Société archéologique de l'arrondissement de Nivelles* 7 (1903): 1–68; Josef Van Mierlo, "Uit de geschiedenis onzer middeleeuwsche letterkunde: Hadewijch,"

*Dietsche Warande en Belfort* 21 (1921): 480–96, 622–35 (at 631); De Moreau, *L'abbaye*, lxix; *MOB*, 237 and 392; Brouette, "Abbaye de Villers," 355. For Juliana's earlier contacts with Villers, see also Appendix I, no. 78B. Roisin, "L'efflorescence," 376, and *MOB*, 112, note 31, 392, note 208, and *MKA* (1962): 293, formulated several hypotheses about the identity of the two anchoresses buried at Villers that I do not find plausible. The anchoress of St. Syr in Nivelles must have been rather famous, since she received a gift in the will of a beguine of Dinant, written on 27 February 1261 and preserved at *AEL*, Dominicains, charter no. 13.

81. As eloquently argued in Lauwers, "Expérience," and "Parole de femmes."

82. Although the theme might take different forms. For instance, the Cistercian who wrote the *vita* of Ida of Louvain explained that her entrance into the Cistercian order was necessary because excessive devotion to her by people of Louvain opened the door to vanity; only in a monastic setting could Ida hope to maintain Christ as her sole objective (*VILO*, 171–72).

83. Misonne, "Office," 179, 181–89; see also G.-M. Dreves's edition of the hymns to Mary in *Analecta hymnica medii aevi*, vol. 12 (Leipzig: Fues, 1892), 178–79. For the use of *benigna* for *beguina*, see Chapter 5.

84. See Chapter 1, note 152.

85. See the charter by count Arnold for the beguinage of Maaseik in July 1266 (A. Polus, "Vijf charters betrekkelijk Sint Agnetenklooster te Maeseyck," *Publications de la Société historique et archéologique dans le duché de Limbourg* 12 [1875]: 458–79, at 459, no. 2) or bishop Henry of Liège's appointment of master Renerus as visitor of beguinages in his diocese, on 1 August 1266 (Reussens, "Un document," 125–26), and *VILO*, 169 (for Louvain).

86. On the use of these terms, see *CR*, 7, 297; Vauchez, "La Bible," and Peter Biller, "Words and the Medieval Notion of 'Religion,' " *Journal of Ecclesiastical History* 36 (1985): 351–69.

87. Greven, *Die Anfänge*, 84–96; *MBB*, 40–65; *MKA* (1962): 324–29; Hanon, "L'Origine," 20–23. Majérus, "Fondateur," 72–73, reaches the more nuanced conclusion that Guido of Nivelles aided but did not organize or direct the first beguine communities of Nivelles.

88. Much of Villers's legal say over the beguines of Thorembais may have been that of a landlord, see Édouard De Moreau and J.-B. Goetstouwers, ed., "Le polyptique de l'abbaye de Villers," *ASHEB* 32 (1906): 367–466, at 434; concrete proof that Villers also ruled on admissions to the beguinage exists only for the fifteenth century (Gérard Van Haeperen, "Le béguinage de Thorembais-les-Béguines," *Le Folklore Brabançon* 237–38 [1983]: 95–119, at 99–100). Beginning about 1180 Villers held the right to appoint the priest at the chapel of Gratem near Borgloon; the abbey was also the beguinage's *provisor*, presumably since its foundation, as a charter of 1497 suggests (G. V. Lux and M. Bussels, "De opgravingen in en om de kapel van het gasthuis te Borgloon," *Het Oude Land van Loon* 24 (1969): 163–225, at 166; Laurentius Robyns, *Diplomata Lossensia* [Liège: F. Alexander Barchon, 1717], 26–27). Villers's abbot also had a say in the appointment of priests at Louvain's beguinage of Ten Hove since 1232 (Louvain, Stadsarchief, charters, no. 4623); for all of these beguinages, and a few that were "supervised" by Villers in later years, see Appendix I, nos. 21, 49, 64A, 78B, and 96.

89. See Appendix I: Repertory of Beguine Institutions.

90. Huygens, *Lettres*, 74, no. 1. James sought the Pope's permission in order to pro-

tect the beguines from their detractors. Canon 13 of the Fourth Lateran Council of 1215, prohibiting new religious orders (Norman Tanner, ed., *Decrees of the Ecumenical Councils*, vol. 1 [London: Sheed & Ward; Washington, D.C.: Georgetown University Press, 1990], 242) may also have prompted his intervention, as *MBB*, 155 and others have suggested, but it is not clear whether Honorius exempted the beguines from it.

91. *MBB*, 159-60. See Appendix I, no. 28A.

92. The literature is far too large to be cited here: for the most recent studies, see Kaspar Elm et al. "Beg(h)inen," in *Lexikon des Mittelalters*, vol. 1 (München and Zürich: Artemis, 1980), cols. 1799-1803; Robert E. Lerner, "Beguines and Beghards," in *Dictionary of the Middle Ages*, ed. Joseph R. Strayer, vol. 2 (New York: Charles Scribner's Sons, 1983), 157-62; Florence Koorn, *Begijnenhoven in Holland en Zeeland gedurende de middeleeuwen* (Assen: Van Gorcum, 1981); Jean-Claude Schmitt, *Mort d'une hérésie: L'Église et les clercs face aux béguines et aux béghards du Rhin supérieur du XIVe au XVe siècle* (Paris: Mouton, 1978); Andreas Wilts, *Beginen im Bodenseeraum* (Sigmaringen: Thorbecke, 1994).

93. See for instance the significant clause in a Tournai will of 1304 that bequeathed monetary gifts to those convents outside the main beguinage "where there is a common life" (*as autres couvens en le vile la u il a commun*, Paris, Bibliothèque nationale, Nouvelles Acquisitions Latines, MS. 2592, no. 118 [June 1304]). For the main beguinage and other convents at Tournai around 1304, see Appendix I, nos. 103A and 103B.

94. Beguine convents located in the vicinity of the convents of the Franciscan, Dominican, Carmelite, Augustinian, and Saccite orders were numerous in Bruges and Tournai (Simons, *Stad en apostolaat*, 219; *LS*, 15-23), Huy, and perhaps also in Antwerp, Ghent, and Liège (Appendix I, nos. 7C, 40D, 56, and 61B). The convents of the beguines of Aire and Boekhoute were located right next to a parish church (Appendix I, no. 20; Bertin, "Le Béguinage," 92-93). In other parts of northern Europe, beguines also frequently resided close to mendicant convents of parish churches, see Dayton Phillips, *Beguines in Medieval Strasburg: A Study of the Social Aspect of Beguine Life* (Stanford: Stanford University Press, 1941), 45-141; Pierre Desportes, *Reims et les Rémois aux XIIIe et XIVe siècles* (Paris: A. & J. Picard, 1979), 328-29; Martina Wehrli-Johns, *Geschichte des Zürcher Predigerkonvents (1230-1524): Mendikantentum zwischen Kirche, Adel, und Stadt* (Zürich: H. Rohr, 1980), 104-32.

95. Of the fifty court beguinages whose location with regard to the town walls can be determined at the date of foundation, eight (16 percent) were within the walls, and forty-two (84 percent) were outside (references are listed in Appendix I).

96. See for instance the description of the beguinage of St. Elizabeth in Ghent in a memorandum submitted to the bishop of Tournai in 1328: "The court of St. Elizabeth is surrounded on all sides with canals and walls; in its center there is a church with a cemetery and an infirmary . . . for the weak and ill of the beguinage. . . . Many houses have been built as residences for these women, separated from one another by a ditch or a hedge, and each of them has its own garden." (*SAG*, *B*, no. 106, ed. *BC*, 74, no. 106). There exists an almost identical description in Middle Dutch for the beguinage of Ter Hooie in Ghent; it was probably written on the same occasion (Ghent, Begijnhof Ter Hooie, charters, no. 52C).

97. Farms, usually attached to the infirmary, are attested at several court beguinages, for example at Bruges, see Dirk Desmet, "Het begijnhof 'De Wijngaerd' te Brugge. Onderzoek naar het dagelijks leven rond het midden van de vijftiende eeuw" (master's thesis, Katholieke Universiteit Leuven, 1979), 60-76.

98. One of the most famous exceptions is the beguinage of Paris, founded by King Louis IX in or before 1264 and modeled after the Flemish example, see Louis le Grand, "Les béguines de Paris," *Mémoires de la Société d'histoire de Paris er de l'Ile-de-France* 20 (1893): 295–357. According to a description of the court beguinage of St. Elizabeth in Ghent in 1328, King Louis formed the plan to establish beguines at Paris during a visit to St. Elizabeth (*SAG, B*, no. 106, ed. *BC*, 73–76, no. 106). Louis indeed visited Ghent in November 1255 (Charles A. Duvivier, *La querelle des d'Avesnes et des Dampierre jusqu'à la mort de Jean d'Avesnes (1257)* [Brussels: Librairie européenne C. Muquardt, 1894], vol. 2, 397–400, no. CCXXXIII). The first grand mistress of the beguinage of Paris, Agnès d'Orchies, was Flemish (see Nicole Bériou, "La prédication au béguinage de Paris pendant l'année liturgique 1272–1273," *Recherches augustiniennes* 13 [1978]: 105–229, at 193–4). For court beguinages in the northern Low Countries, all located in the western provinces of Holland and Zeeland, see Koorn, *Begijnhoven*.

99. See Chapter 5.

100. Günter Peters, "Norddeutsches Beginen- und Begardenwesen im Mittelalter," *Niedersächsische Jahrbuch für Landesgeschichte* 41 (1969–70): 50–118, at 72–73, counted on average thirteen beguines per convent; Brigitte Degler-Spengler, "Die Beginen in Basel," *Basler Zeitschrift für Geschichte und Altertumskunde* 69 (1969): 5–83; 70 (1970): 29–118, at [1969] 40–41, thought twelve was the mean in Basel around 1400; Phillips, *Beguines in Medieval Strasburg*, 226–27, suggested an average of ten beguines in fourteenth-century Strasbourg; seven seems to have been the average in Cologne in the thirteenth through fifteenth centuries, and three to four in Mainz in the fourteenth century (see Schmitt, *Mort d'une hérésie*, 39–40). It is difficult to compare these figures with those cited in Wilts, *Beginen im Bodenseeraum*, 42–43, where all kinds of female houses are lumped together as "beguines."

101. The beguinage of Bergen-op-Zoom, founded in 1497, had fifty-three houses by 1526; it probably belongs in this category, although we do not have reliable population figures (cf. Cuvelier, *Les dénombrements*, 473). Other courts that may have approached this size are those of Louvain (Klein Begijnhof, see Appendix II, no. 7), Cambrai (Cantimpré), Hasselt (see Simons, "Een zeker bestaan," 145), Lille, and Ypres (Briel).

102. A few other court beguinages whose population before 1565 is not known were probably about as large. The beguinage of Sint-Truiden, for instance, had seventy-one houses in 1576 and about 150 beguines in 1643 (Simons, "Een zeker bestaan," 144–45). In the thirteenth and fourteenth century, the Wijngaard at Brussels and Ten Hove at Louvain may have been even larger than the figures in Table 3 suggest (see Appendix II, nos. 2 and 7).

103. The expression is used for the beguinage of Dendermonde in 1288 (Jan Broeckaert, *Cartularium van het begijnhof van Dendermonde* [Dendermonde: August De Schepper-Philips, 1902], 2–4, no. II).

104. Penelope D. Johnson, *Equal in Monastic Profession: Religious Women in Medieval France* (Chicago: University of Chicago Press, 1991), 173–74. The data collected by Wilts, *Beginen im Bodenseeraum*, 277–78, for nunneries in the Lake Constance region, diverge widely but suggest a slightly lower average. For the number of monks in twelfth-century monasteries, see *CR*, 87–92.

105. R. R. Post, "De roeping tot het kloosterleven in de 16e eeuw," *Mededelingen der Koninklijke Academie van Wetenschappen, Afdeling Letterkunde, n.s.* 13, no. 3 (1950): 31–76; Craig Harline, "Actives and Contemplatives: The Female religious of the Low Countries

Before and After Trent," *The Catholic Historical Review* 81 (1995): 541–67; and Esther M. F. Koch, *De kloosterpoort als sluitpost? Adellijke vrouwen langs Maas en Rijn tussen huwelijk en convent, 1200–1600* (Amsterdam: Vrije Universiteit, 1994), 95–96.

106. Simons, *Stad en apostolaat*, 155–56; Daniel Verhelst and Eduard Van Ermen, "De cisterciënzerinnen in het hertogdom Brabant," in M. Sabbe, M. Lamberigts, and F. Gistelinck, eds., *Bernardus en de Cisterciënzerfamilie in België 1090–1990* (Louvain: Bibliotheek van de Faculteit der Godgeleerdheid, 1990), 271–93, at 288.

107. Thomas of Cantimpré, *Bonum Universale de Apibus*, ed. Colvenerius, Lb. II, ch. liv, no. 10. There cannot have been more than 5,000 people in the entire town of Nivelles at that time. See Blockmans et al., "Tussen crisis en welvaart," 48.

108. *Matthaei Parisiensis, monachi sancti Albani, Chronica Majora*, ed. Henry Richards Luard (London: Her Majesty's Stationery Office, 1872–84), vol. 4, 278. Elsewhere in the chronicle, summarizing the most important developments between 1200 and 1250, Matthew mentions "one thousand or more beguines in the city of Cologne alone" (ibid., vol. 5, 194). In the mid-fourteenth century (a moment of crisis in the history of the movement), there were at least 1,170 beguines in the city of Cologne alone (Schmitt, *Mort d'une hérésie*, 40), and there existed many beguine convents in smaller towns in the area. See Gerhard Rehm, "Beginen am Niederrhein," in *"Zahlreich wie die Sterne des Himmels": Beginen am Niederrhein zwischen Mythos und Wirklichkeit* (Bergisch-Gladbach: Thomas Morus-Akademie Bensberg, 1992), 57–84.

109. Derville, *Saint-Omer*, 243 and 273; Derville, "L'urbanisation," 295.

110. For the population figures of these cities, see Chapter 1. The total population figure of Herentals in 1480 is based on Cuvelier, *Les dénombrements*, 462–63.

111. Schmitt, *Mort d'une hérésie*, 39–40 noted proportions of 0.36 percent in Mainz, 2 to 3 percent in Strasbourg, 3.34 percent in Cologne, and 3.5 percent in Basel.

*Chapter 3. The Contemplative and the Active Life*

1. *CR*, 168–295; Constable, *Three Studies*, 44–92. Premonstratensian canons continued the care of souls in most of the Empire (including the larger part of the Low Countries) but generally not in France and England (*CR*, 233); the practices of Arrouaisian canons also varied (Milis, *L'ordre*, vol. 1, 207–11).

2. See Chapter 2.

3. This analysis conforms with the view expressed in Peter Dinzelbacher, "Rollenverweigerung, religiöser Aufbruch und mystisches Erleben mittelalterlicher Frauen," in idem, *Mittelalterliche Frauenmystik* (Paderborn: Ferdinand Schöningh, 1993), 27–77, at 38–46, who regarded rejection of material wealth and marriage as the fundamental *Rollenverweigerung* demonstrated by the religious "women's movement" of the middle ages (perhaps inspired by *GRB*, 190–95); I would add, however, that although beguines rejected certain social roles, they accepted and assumed others, such as sustenance of the weak, and teaching.

4. *VL*, 189–90.

5. *VL*, 196 (on the date of Lutgard's transition to Aywières, see now Hendrix, *Thomas van Cantimprés Vita*, x–xi). Both nunneries were almost exclusively aristocratic; Lutgard's status at St. Catherine's in her initial years is uncertain. Judging by Thomas's

description, she enjoyed a great deal of freedom to travel outside the monastery, and thus may have first entered it as an oblate or boarder and taken her vows a few years later. Around 1200, canon law demanded that women who took vows be at least twelve years old but customs differed greatly between unaffiliated houses. See Jacques Hourlier, *L' âge classique (1140–1378)*. *Les religieux, Histoire du Droit et des Institutions de L'Église en Occident*, X (Toulouse: Cujas, 1974), 182; Koch, *De kloosterpoort*, 109–110. As discussed below, the fact that Lutgard barely escaped rape as a young girl may have been a factor in her decision to pursue a monastic vocation.

6. Thomas's sympathy for certain noble figures and clear suspicion of burghers is also evident in his *Life* of John of Cantimpré and the *Bonum Universale de Apibus* (cf. Lb. II, ch. XXXVIII, no. 2; see, however, his criticism of noble violence, discussed by Henri Platelle, "Vengeance privée et réconciliation dans l'oeuvre de Thomas de Cantimpré," *Tijdschrift voor Rechtsgeschiedenis/Revue d'histoire du droit* 52 [1974]: 269–81). On hagiographers' belief in the conjunction between noble birth and a disposition for saintly perfection, see Vauchez, *La sainteté*, 204–5.

7. *VM*, 562.

8. *VIN*, 211.

9. Juetta felt remorse for having invested money in a business on behalf of her children when she was widowed: *VJ*, 150–52 (Cf. Cochelin, "Sainteté laïque," 406–7). For Mary, see Thomas of Cantimpré, *Bonum Universale de Apibus*, Lb. II, ch. liv, no. 18.

10. *VILO*, 159–60. On miracles of food service in this *Life* and other stories of the *mulieres religiosae*, see *BHF*, 119–25, 233–34.

11. Lester K. Little, *Religious Poverty and the Profit Economy in Medieval Europe* (Ithaca: Cornell University Press, 1978), 29–41, 136–96; Jacques Le Goff, *Your Money or Your Life: Economy and Religion in the Middle Ages*, trans. Patricia Ranum (New York: Zone Books, 1988). See also *BMPM*, vol. 1, 261–311; and, for the relationship between theory and practice, Carlos Wyffels, "L'usure en Flandre au XIIIe siécle," *BTFG* 59 (1991): 853–71, with further references.

12. Honorius Augustodunensis, *Elucidarium*, II, 18, cited by Little, *Religious Poverty*, 38.

13. Italian and southern French individuals and firms started to dominate the money market in Flanders (where Jews were almost entirely absent) and other areas of the southern Low Countries only at the end of the thirteenth century. See Nicholas, *Medieval Flanders*, 170. For the measures against usury taken by count Baldwin of Flanders and Hainaut in 1199, see Walter Prevenier, "Een economische maatregel van de Vlaamse graaf in 1199: het verbod der leningen tegen interest," *Tijdschrift voor Geschiedenis* 78 (1965): 389–401. Nicole Bériou, "Usure crédit, restitutions: un dossier inattendu dans les manuscrits de Robert de Sorbon," in Philippe Contamine, Thierry Dutour, Bertrand Schnerb, eds., *Commerce, Finances et Société (XIe–XVIe siècles): Recueil de travaux d'Histoire médiévale offert à M. le Professeur Henri Dubois* (Paris: Presses de l'Université de Paris-Sorbonne, 1993), 135–55, published the remarkable record of an episcopal inquiry against two usurers (a married couple) of Cambrai between 1238 and 1258.

14. See Alberto Forni, "La 'nouvelle prédication' des disciples de Foulques de Neuilly: intentions, techniques et réactions," in *Faire croire*, 19–37; *BMPM*, vol. 1, 296–311 and vol. 2, 12–13, 204–11; Godding, "Une oeuvre inédite," 295–99 and idem, "Vie apostolique et société urbaine," 700–1; Henri Platelle, "Conversion spectaculaires et language

symbolique (Cambrai XIIe s.): De la polyvalence des symboles," *Bulletin philologique et historique* (1980) [1983]: 27–38. Usury is also an important subject in an anonymous collection of sermons preached in Arras around 1200, see Delmaire, "Un sermon," 1–15.

15. *Sermones ad status*, nos. 56–59, see Johannes-Baptist Schneyer, *Repertorium des lateinischen Sermones des Mittelalters für die Zeit von 1150–1350*, vol. 3 (Münster i. Westfalen: Aschendorffsche Verlagsbuchhandlung, 1971), nos. 421–24. The *exempla* are in Thomas Frederick Crane, *The Exempla or Illustrative Stories from the Sermones Vulgares of Jacques de Vitry* (London: Folk-Lore Society, 1890), nos. CLIX–CLXXIX (see also the introduction, xl–xlvi); *BMPM*, vol. 1, 302.

16. Le Goff, *Your Money*, 38; *BMPM*, vol. 1, 265–69; Little, *Religious Poverty*, 175–83.

17. *BHF*, 24–25 and 316–17 noted that women's *vitae* were less often marked by rejection of personal wealth than were those of men.

18. The literature on St. Francis and the Franciscans is abundant. On Francis's conversion and his views on poverty and charitable care, see especially Kajetan Esser, "Die Armutsauffassung des hl. Franziskus," in David Flood, ed., *Poverty in the Middle Ages* (Werl i. Westfalen: Dietrich-Coelde-Verlag, 1975), 60–70; Manteuffel, *Naissance d'une hérésie*, 57–67. For Godric of Finchale (d. 1170), see Little, *Religious Poverty*, 214–15; for Valdes, see Chapter 1. These ideas are of course indebted to the ideals of poverty expressed by many reform movements of the twelfth century, see *CR*, 146–47.

19. Huygens, *Lettres*, 71–78, no. I, at 75–76.

20. *MOB*, vii (those characteristics were: bridal mysticism, devotion to Christ, apostolic poverty, and the zeal for conversion). Mens developed these thoughts in *MKA* (1963–65) and *L'Ombrie italienne et l'Ombrie brabançonne: deux courants religieux parallèles d'inspiration commune*, Études franciscaines, XVII, Supplément annuel (Paris and Blois: Librairie Mariale et Franciscaine, 1967). See also Greven, *Die Anfänge*, xiii–xv, 99–101.

21. *VJ*, 147–50; *VM*, 550–51, 557.

22. The expression *nudum Christum nudum/nuda sequi* was commonly used to describe the goals of religious poverty movements since the eleventh century (its origins are actually much older). See *MOB*, 17, 20, 71; Giles Constable, " 'Nudus nudum Christum sequi' and Parallel Formulas in the Twelfth Century: A Supplementary Dossier," in F. Forester Church and Timothy George, eds., *Continuity and Discontinuity in Church History: Essays Presented to George Hunston Williams on the Occasion of his 65th Birthday* (Leiden: E. J. Brill, 1979), 83–91.

23. *VM*, 557 (translation adapted from King et al., *The Life of Marie d'Oignies*, 76–77). Thomas of Cantimpré described Christina Mirabilis's appearance and charity in similar terms: *VC*, 651–52, 655; see also his words on Margaret, cited in note 30.

24. *VILO*, 163; see *MKA* (1962), 310 (Goetstouwers, "Het 'vita,'" 199, erroneously placed these events at an anchorhold in Walem). Although the author of Ida's *vita* may have known any of the three Lives of Francis written in the thirteenth century, he does not appear to have consciously drawn on Francis's image in his portrait of Ida. As a matter of fact, none of the *vitae* of *mulieres religiosae* bear a demonstrable Franciscan influence.

25. In addition to the works cited in note 18, see Malcolm D. Lambert, *Franciscan Poverty: The Doctrine of Absolute Poverty of Christ and the Apostles in the Franciscan Order, 1210–1323* (London: S. P. C. K., 1961). It is true that Francis also prescribed manual labor for all brethren (*Regula Bullata*, V–VI; *Regula Non Bullata*, VI–VIII; *Testamentum*, l. 19–20, ed. Caietanus Esser, *Opuscula Sancti Patris Francisci Assisiensis* [Grottaferrata:

Collegium S. Bonaventurae Ad Claras Aquas, 1978], 231–32, 253–58, 311), but he did not regard it as a regular means of income.

26. *Decrees of the Ecumenical Councils*, vol. 1, 263. Begging by monks and other religious men was less than universally condoned, however, see *CR*, 147–48. For the controversy surrounding the male Mendicant orders, see Michel-Marie Dufeil, *Guillaume de Saint-Amour et la polémique universitaire Parisienne 1250–1259* (Paris: A. et J. Picard, 1972), and Penn R. Szittya, *The Antifraternal Tradition in Medieval Literature* (Princeton: Princeton University Press, 1986).

27. *VIN*, 203. Thomas of Cantimpré admitted that Christina Mirabilis begged publicly, but this, too, appears to have occurred before 1215 (*VC*, 653).

28. *VM*, 548; see p. 168n.1.

29. *VC*, 654.

30. *VMY*, 117.

31. This point has been forcifully made by Caroline Walker Bynum, "The Mysticism and Asceticism of Medieval Women: Some Comments on the Typologies of Max Weber and Ernst Troeltsch," in idem, *Fragmentation and Redemption: Essays on Gender and the Human Body in Medieval Religion* (New York: Zone Books, 1992), 53–78, at 68–72 (with references to Weber's work). See also the development of the concept of poverty of the will in beguine mysticism, as discussed in Bernard McGinn, "Introduction," in *Meister Eckhart*, 1–14, at 13.

32. *VM*, 555; Caesarius of Heisterbach, *Dialogus Miraculorum*, ed. Strange, vol. 1, 251; *VL*, 161.

33. Huygens, *Lettres*, 73; see also his *Historia Occidentalis*, ed. Hinnebusch, 144–46. About forty years later, Humbert of Romans made similar observations in his *Sermones* for Humiliati, see now Frances Andrews, *The Early Humiliati* (Cambridge: Cambridge University Press, 1999), 125, 150–52, 252.

34. In most cases, beguines who enjoyed room and board in a beguine infirmary ceded all their immovables to the institution.

35. "Aermoede ende soberheyt wilt altijt beminnen, want die leyden ons tot allen duechden," ed. L. J. M. Philippen, "Het Begijnhof van Sint-Catharina 'ten Velde,' te Diest," *BG* 3 (1904): 501–18, and 4 (1905): 327–339, 423–33, 532–36, at 337.

36. See the two catalogues of exhibitions of beguine architecture and art: *Werken en kerken: 750 jaar begijnhofleven te Gent* (Ghent: Stad Gent, 1984) and Vandenbroeck, *Hooglied*. Their parsimony also became proverbial, see A. Decock, "Spreekwoorden en zegswijzen over de vrouwen, de liefde en het huwelijk," *Volkskunde* 19 (1907–8), 16–22, at 19; Jean Haust, *Dictionnaire liégeois* (Liège: H. Vaillant-Carmanne, 1933), s.v. "bèguène."

37. *BHF*, 222–27, with references to further sources.

38. *VIN*, 201; *VL*, 197; *VMY*, 108–10.

39. *VJ*, 147. As Carpenter, "Juette," points out, this section of the *vita* owes much to the anti-marriage rhetoric of the Church fathers, for instance Jerome's Letter to Eustochium. See also Mulder-Bakker, "Ivetta," 234.

40. *VJ*, 147–49.

41. *VM*, 550.

42. *VM*, 547–48. See also Elliott, *Spiritual Marriage*, 4, 10, 200–205, 239, 247–54.

43. *VO*, 210–224. See Newman, "Possessed by the Spirit," 743–44, for other cases of devout women whose "demonic possession" ended with a vision of Christ. Odilia's

visions of consecutive scenes from Christ's passion recall Elizabeth of Spalbeek's re-enactment of them while in a trance (see Walter Simons, "Reading a Saint's Body: Rapture and Bodily Movement in the *Vitae* of Thirteenth-Century Beguines," in Sarah Kay and Miri Ribin, eds., *Framing Medieval Bodies* [Manchester: Manchester University Press, 1994], 10–23).

44. See Appendix I, no. 61B, where the data regarding his foundation of a beguine convent are also discussed.

45. *VO*, 211.

46. *VJ*, 147.

47. *VO*, 215, 222–23. For references to demonic possession and sexual temptation in the *vitae*, see Newman, "Possessed by the Spirit," especially 740–49 (this essay, unfortunately, does not include a discussion of the *vita Odiliae*). Other aspects of Odilia's visions are treated in Hollywood, *The Soul as Virgin Wife*, 18–21.

48. *RHC*, 103–4, who also notes that the "natural" gifts of the soul are celebrated in particular by Beatrix of Nazareth. See *VB*, 149, 151, and DeGanck, *Beatrice of Nazareth*, 151–61.

49. *VJ*, 157–65; *VM*, 549–50.

50. *AA.SS*, March, vol. 3, 505, cited by Elliott, *Spiritual Marriage*, 270.

51. *Dialogus Miraculorum*, ed. Strange, vol. 2, 148. Jerome's ranking, based on Mark 4:1–9; Matt. 13:1–9; Luke 8:4–8, was found in his influential treatise *Against Jovinian*; on its possible sources, see Elliott, *Spiritual Marriage*, 44, note 113.

52. James's formulation poses problems of interpretation, however: "You [God], truly gave her back the hundredfold reward [of virginity] *in this world* (*Tu vero centuplum reddidisti ei* in hoc seculo: *VM*, 550, my emphasis). That James intended to suggest that her physical virginity was restored (or had never truly been lost?) seems highly unlikely. If this means simply that God granted her the hundredfold reward because of her charity, why did James specify that He did so *in this world*? Did he wish to indicate that God's rewards were revealed to Mary before her death? See Elliott, *Spiritual Marriage*, 139, note 168, for the Bollandists' and other interpretations of the passage.

53. Clarissa Atkinson, "Precious Balsam in a Fragile Glass: The Ideology of Virginity in the Later Middle Ages," *Journal of Family History* 8 (1983): 131–43. See also Newman, *From Virile Woman*, 30–31; Carpenter, "Juette of Huy," 66–67; Mulder-Bakker, "Ivetta," 230–33, and Elliott, *Spiritual Marriage*, 266–74.

54. Newman, *From Virile Woman*, 32–34.

55. *AOCMWB*, Begijnhof, K 1, fol. 1r, ed. *MF*, vol. 3, 592 (5 April 1242). See Appendix I, no. 25A.

56. *AOCMWB*, Begijnhof, charters, nos. 3 (23 November 1245), 104 (29 April 1327), 244 (6 September 1350) and K1, fol. 2r (10 July 1265), ed. H. Hoornaert and C. Callewaert, "Les plus anciens documents des archives du Béguinage de Bruges," *HSEB* 54 (1904): 253–300, at 289–90, no. 23, and T. De Limburg-Stirum, *Cartulaire de Louis de Male, comte de Flandre, de 1348 à 1358* (Bruges: Louis de Plancke, 1898–1901), vol. 1, 358–61, no. CCCXCIII.

57. At the request of the beguinage, two officers of the count's court at the Burg in Bruges issued a summary report of the case and of the verdict, to which the bailiff and *burgemeester* of Bruges appended their seal. This document of 10 May 1345 is in a private collection but was edited by Jozef De Smet, "Een aanslag tegen het Brugse begijnhof. De ontvoering van Katelijne Vedelaers 1345," *Biekorf* 72 (1971): 33–38.

58. The Bruges city accounts of 1345–46 list payments to "Janne van Arsebrouck ende Bouden van Zedelghem, die waren ysent achter .i. kind dat ontvoerd was uten Wijngaerde, bi burghemeesters, over hare coste ytaxseert 3 lb. 12 s." (*SAB*, Reeks 216, rekeningen 1345–46, fol. 128v.; this note presumably pertains to the same case, although the payment was made several months later).

59. The sentences were mandatory for the crime following an ordinance of 1278, see L. Gilliodts-van Severen, *Coutumes de la Ville de Bruges*, vol. 1 (Brussels, F. Gobbaerts, 1874), 228–32, no. VI.

60. De Smet, "Een aanslag," 35–36. Although she was called a "child" (*kind*) in the entry of the city accounts of 1345–46, cited in note 58, she was not necessarily a young girl. The report by court officers at the Burg of 10 May 1345 referred to her as a *joncvrauwe*, a term usually reserved for adult beguines, especially of the middle and upper classes. For use of the term *kind* to denote a beguine, see below, n. 148.

61. Nicholas, *The Domestic Life*, 63.

62. Cyriel Vleeschouwers and Monique Van Melkebeek, *Liber sentenciarium van de officialiteit van Brussel 1448–1459*, vol. 2 (Brussels: Ministerie van Justitie, 1983), 538–39, no. 795 (16 May 1455); Aalst, Stadsarchief, Begijnhof St. Catharina, no. 74, fol. 6v–7v, ed. E. Soens, *Cartularium en renteboek van het Begijnhof Ste Katharina op den Zavel te Aalst* (Aalst: Spitaels-Schuermans, 1912), 42–46 (26 January 1459).

63. See for instance Marc Boone, Thérèse de Hemptinne, and Walter Prevenier, "Fictie en historische realiteit. Colijn van Rijsseles 'De Spiegel der Minnen', ook een spiegel van sociale spanningen in de Nederlanden der late Middeleeuwen?" *Jaarboek van de Koninklijke soevereine Hoofdkamer van Retorica "de Fonteine" te Gent* 34 (1984): 9–33.

64. See Chapter 5.

65. *SAT*, Begijnhof, charters, 1st and 2nd series. Such clauses are also common in the wills of beguines of Liège. See for instance *AEL*, Dominicains, Charters, no. 16 (February 1263); an example for Dinant in 1302 is mentioned by D. Brouwers, "Analectes dinantais. Deuxième série," *Annales de la Société archéologique de Namur* 38 (1927): 245–81, at 254.

66. Bovijn, "Sint-Alexiusbegijnhof," 12–13. The practice was not limited to the Middle Ages: in an interview conducted in 1990, Madeleine Claeys, a beguine at St. Elizabeth of Ghent (Sint-Amandsberg), recalled that she was only fifteen when she joined her aunt at the beguinage in 1916; when the latter died, in 1918, Madeleine took her beguine vows and inherited her aunt's house (A.P. "De mooie uren van zuster begijntje," *Nieuw Genteneerke* 5 [1990], no. 6, 1–4, at 3).

67. Cecile Pauwelyn, "De gegoede burgerij van Kortrijk in de 15e eeuw (1433–1496)," in *Studiën betreffende de sociale structuren te Brugge, Kortrijk en Gent in de 14e en 15e eeuw*, vol. 1 (Heule: U.G.A., 1971), 155–213, at 191. The beguinage's statutes of 1526 demanded that novices be at least twenty years old; the minimum age at profession was then presumably twenty-two (P. Van Rossum, "Documents concernant le béguinage de Courtrai," *ASHEB* 14 [1877]: 86–98, at 88).

68. *SAT*, Begijnhof, Charters, 1st series, nos. 11 and 12 (2–30 April 1290 or 1–21 April 1291; the draft version is undated). For information regarding her husband and property, see also ibid., no. 6 (4 April 1279).

69. *SAT*, Begijnhof, Charters, 1st series, no. 61. A brief clause in a will by Hadewigis van Neynsel, who lived in the main court beguinage of 's-Hertogenbosch in the late fourteenth century, may allude to a similar situation: she left a room of her house in the court to Katherine, wife of Johannes Berwout, adding that the latter would have no say over

it (*ita quod Johannes eius maritus in hiis nullam habeat potestatem*), 's-Hertogenbosch, Stadsarchief, Archief Godshuizen, Groot Begijnhof, Charters, no. 86 (30 September 1390). One wonders if Ysabel l'*Escapée* (see Appendix I, no. 28B), who founded a beguine convent at Cambrai around 1300, had also "escaped" from marriage.

70. *Relatio de statu ecclesiae in regno Alemanniae*, ed. J. Schwalm, in *MGH, Legum Sectio IV*, vol. 3 (Hanover: Hahn, 1906), 589–94, at 593.

71. *AAMBM*, no. 12, A, fol. 3r-v, ed. F. De Ridder, "De Oudste Statuten van het Mechelsche Begijnhof," *HKOM* 39 (1934): 18–29, at 23; the rule further stipulates that the beguine, once returned, must remain inside the compound for six months.

72. Charles M. T. Thijs, *Histoire du Béguinage de Ste Cathérine à Tongres* (Tongeren: M. Collée, 1881), 453.

73. The oldest preserved statutes of the main beguinage at 's-Hertogenbosch, which date from the late fourteenth to the early fifteenth century, explicitly banned for life a beguine who gave birth to a child ('s-Hertogenbosch, Stadsarchief, Aanwinsten, no. 8040c). On the changes in beguine statutes and the generally stricter rules of the later middle ages, see Chapter 5.

74. See Chapter 1. *MOB*, 354–62 was the first to examine the influence of the eremitical tradition on beguine life. I do not agree with his contention, however, that the latter was only an extension of the former.

75. The revival of the ancient eremitical tradition in the central and late middle ages has been studied extensively for England (see especially Ann K. Warren, *Anchorites and Their Patrons in Medieval England* [Berkeley and Los Angeles: University of California Press, 1985] and Roberta Gilchrist, *Contemplation and Action: The Other Monasticism* [London: Leicester University Press, 1995], 157–208), but recently attention has turned to the continent and has stressed urban support for anchoresses: Paulette L'Hermite-Leclercq, "Le reclus dans la ville au bas moyen âge," *Journal des Savants* (July–December 1988): 219–62; idem, "Reclus et recluses dans la mouvance des ordres religieux," in *Les mouvances laïques*, 201–18; Anneke Mulder-Bakker, "Lame Margaret of Magdeburg: The Social Function of a Medieval Recluse," *Journal of Medieval History* 22 (1996): 155–69; Giovanna Casagrande, "Il fenomeno della reclusione volontaria nei secoli del basso medioevo," *Benedictina* 35 (1988): 475–507. Among the older studies, Louis Gougaud, *Ermites et reclus* (Ligugé: L'abbaye de Ligugé, 1928) and Otmar Doerr, *Das Institut der Inclusen in Süddeutschland* (Münster i. Westfalen: Aschendorffschen Verlagsbuchhandlung, 1934), are still useful. For the Liège diocese, see also Edmond van Wintershoven, "Recluseries et ermitages dans l'ancien diocèse de Liège, *Bulletin de la Société littéraire du Limbourg* 23 (1906): 96–158.

76. Doerr, *Das Institut*, 31; Warren, *Anchorites*, 19–28, 37–41; L'Hermite-Leclercq, "Reclus et recluses," 211; *MBB*, 324–36.

77. Examples for Douai: *AMD*, FF 861, at date January 1261 (ed. Monique Mestayer, "Testaments douaisiens antérieurs à 1270," *Nos Patois du Nord* 7 [1962]: 64–77, at 69–73, no. 11), and FF 862, at dates August 1328, 26 November, 1328, 18 January, 1329, and 13 August, 1339. For Ghent, in 1334–1417: Julius Vuylsteke, *Comptes de la ville et des baillis de Gand, 1280–1336*, vol. 2 (Ghent: F. Meyer-Van Loo, 1900), 975; Julius Vuylsteke, *De rekeningen der stad Gent. Tijdvak van Philips van Artevelde, 1376–1389* (Ghent: Ad. Hoste, 1893), 17–18,; *SAG*, B, no. 159, ed. *BC*, 107–12, no. 159; Ghent, Begijnhof Ter Hooie, Cartularium 1423, fol. 43r–44r (20 April 1417). For Liège, in 1245–46 and 1265: *ADN*, 40 H 556, no. 1346 (which includes references to recluses in Huy, Ans, and Walcourt), and *AEL*,

Dominicains, Charters, no. 19, ed. Michel Lauwers, "Testaments inédits du chartrier des Dominicains de Liège (1245–1300)," *BCRH* 154 (1988): 159–97, at 174–79, no. 10. Mechelen had at least five anchoresses in the fourteenth century, when it was still a relatively small city (*SAM*, Archief OCMW, no. 5162: 2 April 1347). There were seven anchorholds in Louvain and its suburbs in 1502 (*ARA, AOOL*, charters, 1st series, no. 2792 [inventary no. 1760]; compare *Joannis Molani . . . Historiae Lovaniensium Libri XIV*, ed. P. F. X. De Ram [Brussels: M. Hayez, 1861], vol. 1, 346–48); see also *VILO*, 171–74.

78. Stephanus Axters, *Geschiedenis van de vroomheid in de Nederlanden* (Antwerp: De Sikkel, 1950–60), vol. 1, 302–23; Rubin, *Corpus Christi*, 43–48; E. Maffei, *La réservation eucharistique jusqu' à la Renaissance* (Brussels: Vromant, 1942), 35–44.

79. *VMS*, 174.

80. *VILO*, 172.

81. Edmond Martène and Ursin Durand, *Veterum scriptorum et monumentorum historicorum, dogmaticorum, moralium, amplissima collectio*, vol. 1 (Paris: Montalant, 1724), col. 904.

82. For the eucharistic devotion among beguines, see *BHF* and Rubin, *Corpus Christi*, 164–81.

83. *VJ*, 153. See Carpenter, "Juette," 70, and Constable, *Three Studies*, 107.

84. Appendix I, nos. 9, 31B, 81, 87B, and 25C.

85. F. De Ridder, "De oorsprong van Mechelens begijnhof en van de parochies in de volkswijk der stad tijdens de XIIIe–XIVe eeuw," *HKOM* 35 (1930): 56–84, at 68; Léopold Devillers, "Cartulaire du béguinage de Cantimpret, à Mons," *Annales du Cercle archéologique de Mons* 6 (1865–66): 197–352, at 239–41 and 248, nos. XVIII and XXIII; *RAH*, Begijnhof Sint-Truiden, charters, no. 9; Appendix I, no. 9 (the location of the anchorhold *inside* the beguinage of Assenede is not certain, however); Floris Prims, "Het chartarium van de O.L.V. priorij van Korsendonk van af de stichting 1395 tot rond 1415," *BCRH* 113 (1948): 146–223, at 186–90, nos. 41–42; Ludovicus H. Chr. Schutjes, *Geschiedenis van het bisdom 's Hertogenbosch* (Sint-Michielsgestel: n.p., 1870–76), vol. 4, 365–67; G. C. A. Juten, "Het begijnhof te Bergen op Zoom," *Taxandria* 37 (1930): 57–66 and 38 (1931): 12–29, 57–64, at 15–16.

86. Marguerite Gastout, *Suppliques et Lettres d'Urbain VI (1378–1389) et de Boniface IX (cinq premières années: 1389–1394)* (Brussels and Rome: Institut Historique belge de Rome, 1976), 514–16, no. 632.

87. *Anecdota ex codicibus hagiographicis Iohannis Gielemans canonici regularis in Rubea Valle prope Bruxellas* (Brussels: Société des Bollandistes, 1895), 420–35.

88. The fundamentally charitable goals of the beguine movement have been emphasized by Otto Nübel, *Mittelalterliche Beginen- und Sozialsiedlungen in den Niederlanden. Ein Beitrag zur Vorgeschichte der Fuggerei* (Tübingen: Mohr, 1970).

89. Bonenfant, "Hôpitaux," 13–21; Michel Rouche, ed., *Histoire de Douai* (Dunkirk: Éditions des Beffrois, 1985), 68–70; Maréchal, "Armen- en ziekenzorg," 269–73; De Spiegeler, *Les hôpitaux*, 57–58. On monastic ideals and the realities of charitable work in this age, see *CR*, 148–50, 235–39; Ludo Milis, *Angelic Monks and Earthly Men: Monasticism and its Meaning to Medieval Society* (Woodbridge, Suffolk: Boydell Press, 1992), 55–57; Milis, *L'ordre*, vol. 1, 211–16; Thompson, *Women Religious*, 52–53.

90. *The Historia Occidentalis*, 150–51. The section comes at the end of James's survey of renewal in the regular or monastic world; the terminology used for hospitals as well as the prominence he accorded to the rule of St. Augustine in their government

(ibid., 147), suggests that James thought of the hospital movement as a branch of the monastic. For further comments, see Anne-Marie Bonenfant-Feytmans, "Les organisations hospitalières vues par Jacques de Vitry (1225)," *Annales de la Société d'histoire des hôpitaux/Annalen van de Belgische Vereniging voor Hospitaalgeschiedenis* 18 (1980): 17–45; Touati, "Les groupes de laïcs," 145; and Miri Rubin, *Charity and Community in Medieval Cambridge* (Cambridge: Cambridge University Press, 1987), 153–81.

91. Maréchal, "Armen- en ziekenzorg," 268. In England, a similar process occurred slightly later, see Rubin, *Charity and Community*, 33–53.

92. Appendix I, nos. 15, 21, 40A, 61A, 63, 72A–72B, 101A–101B, and 105. Bonenfant, "Hôpitaux et bienfaisance," 19, may have been right to assume that the beguines of Borgloon (Gratem) served pilgrims rather than the poor or sick.

93. Appendix I, nos. 7B, 9, 28A, 33, 51A, 71, 75A, and 107.

94. *DB*, 126 and Delmaire, *La diocèse d'Arras*, vol. 1, 318–19. For the institutions that were founded with the particular goal of providing for poor beguines, see Chapter 4.

95. *PB*, 159–66; Marianne Trooskens, "Begijnen in de moderne en hedendaagse tijden," in idem, ed., *Begijnen en Begijnhoven* (Brussels: Algemeen Rijksarchief, 1994), 27–111, at 42–52.

96. *SAG, B*, no. 70, ed. *BC*, 51, no. 70 (and *GC*, I, vol. 4, 2793, no. 1886 [4 July 1300]). Poor beguines who were not members of St. Elizabeth were excluded from such care in 1269 unless certain conditions were met, see p. 98.

97. Appendix I, nos. 6, 7B, 7C, 8, 23, 25B, 25C, 26B, 35C, 40C, 61B, 64C, 73, 75B, 97, and 108B. The beguine hospital of St. Calixte at Namur is a rather special case, see Appendix I, no. 78B.

98. Appendix I, nos. 72A and 72B. On 11 March 1248, bishop Guy of Cambrai transferred the property of a "confraternity" of priests in Antwerp to the beguinage of Antwerp, ed. Goetschalckx, "Oudste stukken," 286, no. 12.

99. Étienne de Béthune-Sully, *Testaments tournaisiens et comptes d'exécutions testamentaires, XIIIe–XIVe siècles* (n.p., [1970]), 15–17.

100. Espinas, *Vie urbaine*, vol. 4, 362–63, no. 1216 and *AMD*, FF 862, at date 17 November 1359 (Ysabiaus's will).

101. I do not know any medical manuscript from this period that can be traced with certainty to a beguine community but, as will be explained below, beguine manuscripts rarely bear marks identifying them as such.

102. *AAMBM*, no. 12, A, fol 3r, ed. De Ridder, "De Oudste Statuten," 25; *PB*, 310; W. L. Braekman, "De 'statuten van levene' van het begijnhof te Geraardsbergen (1414)," *Het Land van Aalst* 22 (1970): 37–47, at 46; Rachel Lambrechts, "Het begijnhof van Hoogstraten (1380–1600)," *HOK: Jaarboek van Koninklijke Hoogstratens Oudheidkundige Kring* (1959): 3–205, at 163.

103. Broeckaert, *Cartularium*, 201–7, no. CIV, at 202; J. R. Verellen, "De oudste, breed-uitgewerkte begijnenregel. De statuten van het begijnhof van Herentals 1461–1489," *BG* 32 (1949): 198–225, at 213.

104. "[A] .xii. begines qui liront le sautier de David entour men cors, le nuit de men trespas, cescune .xij. par." (A. de la Grange, "Choix de testaments tournaisiens antérieurs au XVIe siècle," *Annales de la Société historique et archéologique de Tournai*, n.s. 2 [1897]: 1–365, at 42, no. 53).

105. Bruges, Monasterium De Wijngaard, no. 1, fol. 11r, ed. Rodolphe Hoornaert, "La plus ancienne Règle du Béguinage de Bruges," *HSEB* 72 (1930): 1–79, at 62. See also

the contemporary description of life at St. Elizabeth's in Ghent, *SAG, B*, no. 106, ed. *BC*, 75, no. 106. An example at the beguinage of Tongeren in 1413 is in Thijs, *Histoire*, 353.

106. *AAMBM*, no. 12, A, fol 3v, ed. De Ridder, "De Oudste Statuten," 24.

107. "Spécialistes de la mort," in the words of Jean-Pierre Deregnaucourt, "Le dernier voyage: l'ambulation funèbre à Douai aux 14e et 15e siècles," in *Actes du Colloque La Sociabilité Urbaine en Europe du Nord-Ouest du XIVe au XVIIIe siècle* (Douai: Imprimerie Lefebvre-Lévêque, 1983), 81–88, at 81.

108. *SAG, B*, no. 106, ed. *BC*, 75, no. 106.

109. Josef Habets, *De archieven van het kapittel der hoogadellijke Rijksabdij Thorn*, vol 1 (The Hague: Algemeene Landsdrukkerij, 1889), 62–63, no. 70 [24 August 1287].

110. Beguines routinely administered this care to others in their community, see for instance the Bruges rule cited in note 105, and for St. Elizabeth of Ghent, *SAG, B*, no. 159, ed. *BC*, 107–12, no. 159, at 109. The Tournai will of 1297, mentioned in note 99, indicates that they could do so for ordinary citizens as well. For the *mulieres religiosae*'s assistance to the dying, see *VM*, 558; *VC*, 655; for that of Cistercian nuns, *VL*, 199, *VIN*, 279–80.

111. De la Grange, "Choix," 10. There are numerous other examples of the practice in the Low Countries. Schmitt, *Mort d'une hérésie*, 44–48, argues that it was the main social function of the beguines of the upper Rhine, noting that those of Strasbourg "semblaient presque exclusivement vouées à de telles fonctions funéraires" (ibid., 46).

112. "[A] povres beghines qui le porteront au moustier et qui seront ensonniées de sen corps, a cascune .ii. s." (*AMD*, FF 862, at date July 1317, will of Maroie Blokele; the woman was probably not herself a beguine). Similar bequests may be found in the will of Maroie Maillarde of Douai (*AMD*, FF 862, at date 17 April 1344) and the execution of the will of Maigne Wallequine of Tournai in 1445 (de la Grange, "Choix," 15, note 1).

113. De la Grange, "Choix," 43–44, no. 59 (17 September 1317), 184, no. 622 (27 June 1420); *AMD*, FF 862, at date 20 April 1338 (will of Maroie li Taffars); *PB*, 310 (the translation in H. Nimal, *Les béguinages* [Nivelles: Imprimerie Lanneau et Despret, 1908], 66, followed by Lauwers, *La mémoire*, 433–34, is incorrect).

114. De la Grange, "Choix," 69, no. 156.

115. Moore, *The Formation of a Persecuting Society*, 58–60.

116. See for instance *AMD*, FF 862, at date 6 March 1362 (will of Alixandre de l'Atre). On the Bons Enfants, see Léon Halkin, "La maison des Bons-Enfants de Liège," *Bulletin de l'Institut archéologique liégeois* 64 (1940): 5–54, and Pierre Desportes, "L'enseignement à Reims aux XIIIe et XIVe siècles," in *Enseignement et vie intellectuelle (IXe–XVIe siècle). Actes du 95e Congrès national des sociétés savantes, Reims, 1970. Section de philologie et d'histoire jusqu'à 1610*, vol. 1 (Paris: Bibliothèque nationale, 1975), 107–22, at 109–10 (neither examined the funerary role of the Bons Enfants, however). The convent of the Bons Enfants of Douai is attested from 1261 (*AMD*, FF 861, at date January 1261, will of Engherrans Brunamons). From the late fourteenth century to the sixteenth century, Cellites and Black Sisters also performed these functions, see for instance Dominique Vantouroux, "Les funérailles des chanoines de Saint-Omer (1426–1598)," *Revue du Nord* 65 (1983): 360–68, at 362.

117. *VC*, 652; *VM*, 549. For an original attempt to reconstruct the "real" events, see Newman, "Possessed by the Spirit," 766–67.

118. See Sweetman, "Christine of Saint-Trond's Preaching Apostolate;" Newman, *From Virile Woman*, 108–36; and Lauwers, *La mémoire*, 439–56. See also *BHF*, 120–21, 127–37, 234–35, who laid the groundwork for this interpretation.

119. *RAG, SG*, no. 400 (ca. 1270–80). See Appendix II, no. 2.

120. *Sermones de tempore: Dominica in Albis*, cited by Lauwers, *La mémoire*, 455.

121. *VM*, 560, 569. On vicarious suffering, especially that of women, see *BHF*, 275–76.

122. Bériou, "La prédication au béguinage de Paris," 124, 129, 140, 195 note 307; Karl Christ, "*La règle des Fins Amans*: Eine Beginenregel aus dem Ende des XIII. Jahrhunderts," in B. Schädel and W. Mulertt, eds., *Philologische Studien aus dem romanisch-germanischen Kulturkreise: Karl Voretzsch zum 60. Geburtstage und zum Gedenken an seine erste akademische Berufung vor 35 Jahren dargebracht* (Halle: Max Niemeyer, 1927), 173–213, at 201. See also Newman, *From Virile Woman*, 111–12.

123. Sylvain Balau, *Chroniques liégeoises*, vol. 1 (Brussels: P. Imbreghts, 1915), 47–48.

124. As Schmitt, *Mort d'une hérésie*, 46, has suggested with regard to beguine polemics in fourteenth- and fifteenth-century Rhineland. Criticism of beguines in the southern Low Countries is discussed in Chapter 5.

125. Warren, *Anchorites*, 31–35; Doerr, *Das Institut*, 56–57; Axters, *Geschiedenis*, vol. 1, 299–300.

126. *Vita B. Arnulfi Monachi*, in *AA.SS.*, Jun., vol. 7, 572.

127. *VJ*, 157, 159, 161.

128. See pp. 42–43.

129. R. Hanon de Louvet, *Contribution à l'Histoire de la Ville de Nivelles* (Gembloux: Duculot, 1948), 125–47.

130. The statutes of the beguinage of Breda in 1516 considered it common practice, but stipulated that beguines who took in children as boarders must ask permission from the grand mistress (Juten, *Cartularium*, vol. 1, 161–62). For a juridical conflict over a girl boarded out to a beguine in 1398, see Prosper De Pelsmaeker, *Registres aux sentences des échevins d'Ypres* (Brussels: J. Goemare, 1914), 153–54, no. 305). On beguine teaching in the early modern era, see *PB*, 276–80, and Maurits De Vroede, *Religieuses et béguines enseignantes dans les Pays-Bas méridionaux et la Principauté de Liège aux XVIIe–XVIIIe siècles* (Louvain: Leuven University Press, 1996).

131. Scheerder, "Schoolmeesters en schoolmeesteressen," 120.

132. The 1498 figure concerns the number of girls enrolled with one beguine teacher only; the male teacher's class for boys (who probably did not reside at the beguinage) covered "reading, writing, spelling, and good morals," according to the fifteenth-century oath of office (see Carpentier, "Le Béguinage," 146–48).

133. *AAMBM*, no. 12, A, fol. 1v–2r, 4v, ed. De Ridder, "De Oudste Statuten," 22, 26. An account of the destruction of the beguinage in 1578 noted that in addition to "about 1200" beguines, some 200 to 300 other inhabitants of the beguinage were forced to leave; an undetermined number among those were probably students (F. De Ridder, "Mechelen's Groot Begijnhof binnen de stad. (Het ontstaan)," *HKOM* 40 [1935]: 15–43, at 16; and idem, "De Conventen van het Oud-Begijnhof te Mechelen," *HKOM* 42 [1937]: 23–83, at 23).

134. M.-Th. Vriens, "Het oud begijnhof van Herentals (ca. 1260–1508)," Master's thesis, Katholieke Universiteit Leuven, 1968, 159 (for the year 1462); Jean Mossay, *Histoire de la ville d'Avesnes* (Avesnes-sur-Helpe: Éditions de l'Observateur, 1956), 58; Viaene, "Het begijnhof van Kortrijk," 258; Cuvelier, *Dénombrements*, 354 (on Diest).

135. Antwerp, Stadsarchief, PK 2551, fol. 103v: "Een schoelmeestersse int beghynhof met zesse jonge kinderen meyskens in hueren cost. . . . Een ander mit negen kinderen in

hueren cost. . . . Een ander mit zeven. . . . Een mit xiii. . . . Een mit vijfne. . . . Een mit zeven. . . . Een mit thienen." (from the tax survey in the beguinage). Naturally, smaller beguinages had fewer pupils: a beguine teacher in Lille had only two in 1342–43 (*ADN*, B 7758, no. 157184).

136. Eva Gertrud Neumann, *Rheinisches Beginen- und Begardenwesen. Ein Mainzer Beitrag zur religiosen Bewegung am Rhein* (Meisenheim am Glam: A. Hain, 1960), 95; Le Grand, "Les béguines," 333; Koorn, *Begijnhoven*, 98.

137. *Sermo LVII, ad virgines et juvenculas* (or *Sermo II ad virgines*), ed. Greven, "Der Ursprung," 43–49 (quotation on 47).

138. See Chapter 2.

139. *VIL*, 109–110; cf. *MKA* (1962): 302.

140. Ghent, Begijnhof Ter Hooie, charters, no. 52C, Middle Dutch version. A similar report, in Latin, on the beguines of St. Elizabeth in Ghent (probably the only report actually submitted to the bishop's investigators), has the following, slightly abridged description of their teaching: "Their manners were so well ordered and their expertise in domestic affairs so great, that great and respectable people often entrusted to them their daughters for their education, in the hope that, whatever would be the vocation that called them afterwards, whether it was religion or marriage, their daughters would be found superior to others" (*SAG, B*, no. 106, ed. *BC*, 75, no. 106).

141. Van de Meerendonk, *Tussen reformatie en contrareformatie*, 30.

142. These *scholae* were for beguines (and aspiring beguines) only and did not accept outsiders. They are attested from the thirteenth century: in Bruges (Wijngaard) in 1281 (*AOCMWB*, Begijnhof, charters, no. 28 [11 October 1281]), in Herentals before 1287 (Vriens, "Het oud begijnhof," 172); in Tongeren after 1291 (*SAT*, Begijnhof, charters, 1st series, no. 15); in Antwerp (St. Catherine) in 1293 (Floris Prims, *Kerkelijk Antwerpen in het laatste kwart der XIIIde eeuw* [Antwerp: Boekhandel der Bijdragen, 1928], 303 [3 September 1293]; see also the many references to *scolieren* by the oldest hands, of the late thirteenth century, in Sion's obituary book, *LUB*, XV, no. 1). These *scholae* of chant are sometimes difficult to distinguish in the sources from the beguine schools that offered a more general program (*MBB*, 272–73, erred in this respect, as I did in my *Stad en apostolaat*, 220–21, note 279, where I regarded the oldest references to *scholae* in the beguinages of Bruges and Ypres as evidence of schools). "Walsche" schools, or schools with instruction in French, are attested in the beguinages of Ghent (St. Elizabeth) and 's-Hertogenbosch in 1531 and ca. 1570, respectively (*SAG, B*, no. 295, ed. *BC*, 193–94, no. 295, and Van de Meerendonk, *Tussen reformatie en contrareformatie*, 30).

143. Her grasp of Latin seems to have been based on rote memorization of the Latin psalter (mentioned in her escape from the parental home) and was elementary (see *VIN*, 207). Unlike Beatrice or Ida of Gorsleeuw, who also lived at La Ramée, Ida of Nivelles was not trained as a scribe in the Cistercian convent. Her Latin "literacy" may therefore have resembled that of Ida of Louvain, who could never read more than her psalter (*VILO*, 183); according to Thomas of Cantimpré, Lutgard of Tongeren never understood a word of Latin (*VL*, 199).

144. *VM*, 553, 566, 570.

145. Gilbert of Tournai, *Collectio de Scandalis Ecclesiae*, ed. A. Stroick, "Collectio de Scandalis Ecclesiae. Nova editio," *Archivum Franciscanum Historicum* 24 (1931): 33–62, at 61–62 (see also Chapter 5). Rheims, Bibliothèque municipale, MS 52 (with inscription of ownership on fol. 174v). The beguine, Ysabelle, was the daughter of a certain Aubri le

Clerc of Rheims; she may be identified with a certain *Ysabeles, la maitresse de l'escolle*, mentioned in a tax survey of 1318–28 (Desportes, "L'enseignement à Reims," 118–19; cf. Desportes, *Reims et les Rémois*, 207).

146. See Chapter 2.

147. "Ad hec inter cetera provisum est quod in loco predicto [=the beguinage of Champfleury] per iamdictos decanum et capitulum annis singulis clericus ad hoc ydoneus prefigatur qui mulieres et non sexus alterius in litteralibus instruat disciplinis" (*ADN*, 30 H 17, no. 250). The term *litterales disciplinae* clearly denotes "advanced schooling," and not simply instruction in reading and writing. The medieval archives of St. Amé and of the beguinage of Champfleury (*ADN*, 1 G and 30 H 16–18), do not allow us to determine whether or not such training actually took place.

148. For instance, in an undated will (probably of the fourteenth century), Yde tSrademakers, beguine of the Wijngaard at Brussels, left her manuscript of *Den Dissipel ende de Sierheit* to two other beguines of the court, with the request that they held it for any "poor children" (probably beguines supported by the dole) "and others who wished to read it" (*Item Den dissipel ende de Sierheit, dat begaric dat joff. Helien ende joff. Nax die houden selen ten armen kinderen behoef ende den anderen die in lesen willen*: AOCMWBR, B 1452). See also *LS*, 32–35. A few lists of books owned by convents are known for the late fifteenth and sixteenh centuries, but they are rarely as detailed as that of the northern Netherlandish beguinage of Haarlem, examined in B. A. M. Vaske, "Het Boekenlijstje van de Haarlemse begijnen," *OGE* 67 (1993): 131–46. See also Chapter 5, and, for more on literacy and the use of books among beguines, my "Geletterdheid en boekengebruik bij de vroegste begijnen," *Handelingen der Koninklijke Zuid-Nederlandse Maatschappij voor Taal- en Letterkunde en Geschiedenis* 53 (1999): 167–80.

149. *VB*, 24, 26 (Beatrice's testimony, to which the compiler of the *vita* referred, may have been part of the lost autobiographical notes she left at her death).

150. *VB*, 24, 26; *VIN*, 204; *VJC*, 441–46; *VC*, 652.

151. Albéric of Troisfontaines called Lambert le Bègue a *magister* because of his fame as a preacher, see Renardy, *Les maîtres universitaires*, 143; see also Christine Renardy, *Le monde des maîtres universitaires du diocèse de Liège 1140–1350. Recherches sur sa composition et ses activités* (Paris: Société d'Édition "Les Belles Lettres," 1979), 79–90.

152. For *magistra* as the title of leader of female *conversae* associated with Premonstratensian monasteries, see Hugues Lamy, *L'abbaye de Tongerloo depuis sa fondation jusqu'en 1263* (Louvain: Bureau du Recueil, 1914), 101–2.

153. Lambert, *Medieval Heresy*, 72.

154. See Chapter 1.

155. Thomas of Cantimpré, *Bonum Universale de Apibus*, ed. Colvenerius, Lb. I, ch. xxxiii, nos. 1–3. On the use of *magistra* in anchorholds with several residents, see Doerr, *Das Institut*, 35–36, 57 and *MOB*, 333–34.

156. Schmitt, *Mort d'une hérésie*, 101–4; Robert E. Lerner, *The Heresy of the Free Spirit in the Later Middle Ages* (Berkeley and Los Angeles: University of California Press, 1972), 139–40; and for its symbolic meaning, Constable, *Three Studies*, 109. I have found only two texts that show beguines from the southern Low Countries knew this conception of the superior's role: in 1270, Laurette, one of the seven convent mistresses of the Wijngaard beguinage of Bruges, was called *dienstwijf* ("maid") of the beguinage (*AOCMWB*, Begijnhof, K1, fol. 34r) and in 1425 Amelberghe Dootstekers, grand mistress of St. Elizabeth at Ghent, called herself *dienigghe van den haermen beghinen van*

*sente Lysbette in Ghent* ("servant of the poor beguines of St. Elizabeth of Ghent": *SAG, B*, no. 207, *CB*, 146, no. 207); the grand mistress traditionally supervised the care of the poor in the beguinage.

157. *VM*, 547, 548, 555; James of Vitry, *Sermo II ad Virgines*, ed. Greven, "Der Ursprung," 47. Ida of Louvain spun to aid the poor (*VILO*, 161–63). See also Chapter 2.

158. *VM*, 553; Ghent, Begijnhof Ter Hooie, charters, no. 52C; *SAG, B*, no. 106, ed. *BC*, 74–75, no. 106.

159. *ADN*, 40 H 552, no. 1334, ed. Carpentier, "Le béguinage," 176 (Valenciennes, 1262); *SAT*, Begijnhof, charters, 1st series, no. 30 (Tongeren, 1302); *PB*, 313 (Sint-Truiden, fifteenth century); Bovijn, "Sint-Alexiusbegijnhof," 36–38 (Dendermonde, 1460–80). Some beguines traded rather than grew the foodstuffs. Maroie li Cresoniere, a grand mistress of Champfleury at Douai who died before 1313, leased watercress beds in Esquerchin to outsiders; her name suggests that she ran a business selling the crops (*AMD*, FF 661, September 1270, ed. Espinas, *Vie urbaine*, vol. 3, 409–10, no. 543; *ADN*, 30 H 18, no. 284 [8 December 1313]).

160. The statutes for Lier in 1401 stipulated that "no one will serve outside the court or nurse someone or will stay with someone, unless by permission of the mistresses," ed. *PB*, 341; the bilingual (Dutch and French) rule of St. Omer's "Grand Couvent" before 1428 required beguines—"workers and others"—who went into town during the day to return before the evening bell; the Dutch version of this rule suggested beguines went to town "to work" (*omme te werkene*: Saint-Omer, Archives municipales, B 239, no. 13, fol. 2r and 7v, cited in *DB*, 149, note 104; see also the appendix to the French version, added in 1428, ed. Paul Fredericq, "À propos du Règlement des Béguines de Saint-Omer (1428)," *Bulletins de l'Académie royale des Sciences, des Lettres et des Beaux-Arts de Belgique* 67 [1897]: 121–29, at 128). In the latter case, these beguines may have been textile workers rather than servants.

161. For the gendered division of work in the textile industries of the medieval Low Countries see Howell, *Women, Production, and Patriarchy*; De Poerck, *La draperie*, vol. 1, 27–149; Nicholas, *The Domestic Life*, 100–2; Derville, *Saint-Omer*, 203–4. Much still needs to be done, however, to clarify the shifts that took place during the twelfth and thirteenth centuries.

162. Spinning: *AAMBM*, no. 12, A, fol 5r, ed. De Ridder, "De Oudste Statuten," 26–27 (Mechelen, Groot Begijnhof, 1286–1300; these statutes also mention hackling, cutting and preparation of cloth for dyeing); Vriens, "Het begijnhof," 158 (Herentals, fifteenth century). Napping (Dutch: *noppen*): *SAG, B*, no. 106, ed. *BC*, 74, no. 106, and Ghent, Begijnhof Ter Hooie, charters, no. 52C (Ghent, St. Elizabeth and Ter Hooie, 1328); Braekman, "De 'statuten van levene'," 45 (Geraardsbergen, 1414); *PB*, 312 (Sint-Truiden, fifteenth century). Hackling of wool, napping, and cutting of cloth (Dutch: *scroeden*): F. Favresse, "Actes intéressant la ville de Bruxelles (1154–2 décembre 1302)," *BCRH* 103 (1938): 355–512, at 492–97, no. 46 (Brussels, 1296); Henry Joosen, "Recueil de documents relatifs à l'histoire de l'industrie drapière de Malines (des origines à 1384)," *BCRH* 99 (1935): 365–572, at 507, no. 55 (Mechelen, 1331); 's-Hertogenbosch, Stadsarchief, Aanwinsten, 8046c (main beguinage of 's-Hertogenbosch, fourteenth to fifteenth centuries). Hackling, napping cloth and cutting flax: *RAH*, Begijnhof Sint-Truiden, no. 9, fol. 161r (Tongeren, fifteenth century). Sewing, spinning, combing, carding in the production of linens and woolens: J. P. W. A. Smit, "Het Begijnhof van Oisterwijk," *Bossche Bijdragen* 3 (1919–20): 40–55, at 47 (Oisterwijk, 1539).

163. Bleaching: Verellen, "De oudste," 212–13 (Herentals, 1489). Bleaching of linen: Broeckaert, *Cartularium*, 59, no. LIX (Dendermonde, 1452); De Ridder, "De conventen," 39 (Mechelen, 1564).

164. The saintly beguine Clarissa Leynaerts, who died around 1460, was twelve when her parents boarded her out to a mistress at the beguinage of Mechelen, where she learned "to read the psalter and to sew woolen clothes" (ed. *Anecdota . . . Iohannis Gielemans*, 436; see *PB*, 312, for another reference to tailoring [Sint-Truiden, fifteenth century]); beguines of Diest embroidered vestments for the lord and lady of Diest in 1320–21 (F. J. E. Raymaekers, *Het kerkelijk en liefdadig Diest* [Louvain: Karel Peeters, 1870], 460), but it is not known if they did so professionally.

165. The evidence is strongest for Bruges, 1252 (*SAB, B*, 1st series, no. II, ed. L. Gilliodts-van Severen, *Inventaire diplomatique des archives de l'ancienne École Bogarde à Bruges* [Bruges: Louis de Plancke, 1899–1900], vol. 2, 2, no. II); Diest, 1279 (Raymaekers, *Kerkelijk en liefdadig Diest*, 436; see also the statutes of 1361, ed. Philippen, "Het Begijnhof van Sint-Catharina," 330); Mechelen, 1286–1300 (*AAMBM*, no. 12, A, fol 5r, ed. De Ridder, "De Oudste Statuten," 26). Charters issued by the counts of Flanders for the beguinages of Bergues (1310–11) and Aalst (1321) also suggest beguines wove woolen cloth (*ADN*, B 1508, no. 4764, ed. Georges Espinas and Henri Pirenne, eds., *Recueil de documents relatifs à l'histoire de l'industrie drapière en Flandre: 1re partie* [Brussels: Commission Royale d'Histoire, 1906–20], vol. 1, 307–8, no. 125; and Aalst, Stadsarchief, Begijnhof St. Catharina, no. 74, fol. 6r, ed. Soens, *Cartularium*, 40–41, no. V).

166. Étienne Sabbe, *De Belgische vlasnijverheid*, vol. 1 (Bruges: De Tempel, 1943), 94 (Mons, 1369–70, 1377–78); M. A. van der Eerden-Vonk, ed., *Raadsverdragen van Maastricht 1367–1428* (The Hague: Instituut voor Nederlandse Geschiedenis, 1992), 419, no. 1297 (admission of the beguines to the *kortspoeldersambacht*, or linen weavers guild, in 1426); J. R. Verellen, "Oorkonden van het begijnhof van Herentals," *BG* 33 (1950): 54–63, 167–91, 246–55 and 34 (1951): 122–31, 177–87, at (1951): 185–87, no. 50 (9 July 1483: the beguines produced 23,433 ells; the total output of the town was 39,480 ells); Antwerp, Stadsarchief, GA 4201, fol. 28 r (licensing of a beguine as linen weaver, 28 January 1516).

167. Woolen and linen cloths produced in the main beguinage of Dendermonde in 1460–80, for instance, appear to have been intended for the use of beguines within the community alone, see Bovijn, "Sint-Alexiusbegijnhof," 73–74. Beguines of Tongeren were prohibited from selling (linen) cloth in town in 1505 (Thijs, *Histoire*, 440, no. XI). Maria of Lille, a beguine of Herentals, spun and wove linen for the poor in the mid-fifteenth century: *Anecdota ex codicibus . . . Gielemans*, 419.

168. Paris, Bibliothèque nationale, Nouvelles Acquisitions Latines, MS 2592, no. 118. In 1269, a beguine of St. Christophe of Liège left 12 d. in her will to "girls who work with me," (*AEL*, Dominicains, charters, no. 27, 16 November 1269).

169. *SAT*, Begijnhof, Charters, 1st series, no. 36.

170. Georges Espinas, *Les origines du capitalisme. Sire Jehan Boinebroke, patricien et drapier douaisien (?–1286 environ)* (Lille: L. Raoust, 1933), 35 (the context suggests that she was an entrepreneur of a certain stature); Hauwildis and Pierone de Hornaing, beguines of Douai (see Appendix I, "Discarded," for the identification), are mentioned in a list of 268 wholesale traders of cloth at the hall of Douai in 1304 (Catherine Dhérent, "L'assise sur le commerce des draps à Douai en 1304," *Revue du Nord* 65 [1983]: 369–97, at 390; because the list is incomplete, it is impossible to tell if they were the only beguines

active that year as drapers on the Douai market). For Pierone's activities in 1325, see Espinas and Pirenne, *Recueil*, vol. 2, 220, 222, no. 338. In October 1276 countess Margaret ordered beguines of Champfleury who were "public and well known merchants" to pay taxes like ordinary citizens of Douai (*ADN*, 30 H 17, no. 264, ed. Georges Espinas, *Les finances de la commune de Douai des origines au XVe siècle* [Paris: A. Picard et fils, 1902], 447, no. 54).

171. Godelieve van Hertsberghe, a beguine of Bruges, acquired membership in the Hanse of London in 1285, which suggests she had business dealings with England, perhaps as a draper (Carlos Wyffels and Jozef De Smet, eds., *De rekeningen van de stad Brugge (1280–1319). Eerste deel (1280–1302)* [Brussels: Palais des Académies/Paleis der Academiën, 1965–71], vol. 1, 103); Adelise Scheppers, beguine of Bruges, sold cloth *up die nieuwe halle* in 1308 (*SAB*, Reeks 216, rekeningen 1308–09, vol. 1, fol. 26r; she is identified as a beguine, ibid., rekeningen 1307–08, vol. 1, fol. 31v); Margriete van Eke, a beguine of Ghent, sent cloth to Antwerp to be sold there in 1306 (*RAG*, Charters der Graven van Vlaanderen, Chronologisch gerangschikt supplement, no. 454, ed. Espinas and Pirenne, *Recueil*, vol. 2, no. 414); Ysabel Aurrie, beguine of Arras, sold *tiretaines* to the countess of Artois for 32 lb. in 1315 (*DB*, 139).

172. J. De Busco, "Oorkonden betrekkelijk het Beggijnhof in 'sHertogenbosch," *Dietsche Warande* 6 (1864): 142–55, at 152; Smit, "Het Begijnhof," 47.

173. See for instance Victoria Joan Moessner, "The Medieval Embroideries of Convent Wienhausen," in Meredith Parsons Lillich, ed., *Studies in Cistercian Art and Architecture*, vol. 3 (Kalamazoo: Cistercian Publications, 1987), 161–77.

174. Lorenzo Paolini, "Le Umiliate al lavoro," in Maria Giuseppina Muzzarelli et al., eds., *Donne e lavoro nell'Italia medievale* (Turin: Rosenberg & Sellier, 1991), 141–79.

175. Such a guild was established at Wijngaard in Bruges before 1336 (*AOCMWB*, Begijnhof, Charters, no. 153), and at the beguinage of Dendermonde in 1450 (Aimé Stroobants et al., *700 jaar begijnhof 1288–1988*. Dendermonde [n.p., 1988], 39). For evidence of a cult of the Virgin in beguinages not dedicated to her, see for instance *SAT*, Begijnhof, Charters, 1st series, nos. 6 and 37 (Tongeren, 1279, 1310); *RAG*, Sint-Baafsabdij, Charters, at date 8 March 1360 (Poortakker at Ghent); Wilmet, "Histoire," 64–65 (beguinage Hors Postil at Namur, fourteenth century); de la Grange, "Choix," 283, no. 995 (beguinage des Prés, Tournai, 1459); and especially Appendix I, nos. 7A and 45. The main altar of the church in the beguinage of St. Catherine at Diest was dedicated to the Virgin, and the beguinage was placed under the dual patronage of Catherine and the Virgin Mary in 1572 (Raymaekers, *Het kerkelijk en liefdadig Diest*, 448–49, 469).

176. See for the Bruges Madonna, Bonneure and Verstraete, *Het prinselijk begijnhof*, 45, 119–20; for the Sint-Truiden Madonna, *In beeld geprezen*, 160–61; and for the Diest sculpture, Raymaekers, *Het kerkelijk en liefdadig Diest*, 448–49, 466; the first two are still preserved locally; the Diest Madonna is now at the Metropolitan Museum of Art in New York. Beguine Pietàs have been examined by Ziegler, *Sculpture of Compassion*, especially at 117–52. There is of course documentary evidence for many more works of art representing the Virgin Mary in beguine communities; see for example De Cuyper, "Het begijnhof van Kortrijk," 16, 27, 40 (Kortrijk, 1353, 1445, 1450–51); Verellen, "Oorkonden," 187 (Herentals, 1341); de la Grange, "Choix," 106, 218, 227, 326, etc., nos. 316, 770, 798, 1143 (Tournai, 1386, 1434, 1438, 1484).

177. See for instance David L. d'Avray, "Katharine of Alexandria and Mass Com-

munication in Germany: Woman as Intellectual," in Nicole Bériou and David L. d'Avray, eds., *Modern Questions About Medieval Sermons: Essays on Marriage, Death, History and Sanctity* (Spoleto: Centro Italiano di Studi sull'alto medioevo, 1994), 401–8.

178. For evidence of her cult in communities not formally dedicated to her, see, among many others, de la Grange, "Choix," 227, no. 798 (Tournai, 1438); Lauwerys, *Het begijnhof van Hoogstraten*, vol. 3, 135–39 (Hoogstraten, fifteenth century); KB, MS IV, 210, fol. 5v (Wijngaard of Bruges, c. 1500); and Appendix I, no. 64A. Judith H. Oliver, "Medieval Alphabet Soup: Reconstruction of a Mosan Psalter-Hours in Philadelphia and Oxford and the Cult of St. Catherine," *Gesta* 24 (1985): 129–40, discusses several fragments of a thirteenth-century psalter with illustrations of the life of St. Catherine, possibly made for beguines in the diocese of Liège (see also Oliver, *Gothic Manuscript Illumination*, vol. 1, 113–4). L. J. M. Philippen, "Het oudste Zegel en de vroegste Geschiedenis der Begijnen van Antwerpen," *BG* 26 (1935): 81–106, suggested that the beguines' devotion to Catherine was due to the "relations that once existed between Catharism and the beguine movement." Wielding Ockham's razor, I think we do not need to assume such a bizarre connection to explain beguine interest in St. Catherine.

179. Vauchez, *La sainteté*, 433–35; BHF, 135–36. Contrary to what has often been asserted Elizabeth was not venerated as a Tertiary of the Franciscan order in the medieval Low Countries.

180. De Spiegeler, *Les hôpitaux*, 73, note 93; Marguerite Gastout, *Béatrix de Brabant. Landgravinne de Thuringe, Reine des Romains, Comtesse de Flandre, Dame de Courtrai (1225?–1288)* (Louvain: Bibliothèque de l'Université, 1943), 14–30.

181. See Appendix I, nos. 63, 105 (cf. no. 15). Elizabeth was the patron of other hospitals in Liège and Antwerp that did not become beguinages (De Spiegeler, *Les hôpitaux*, 71–73; Van den Nieuwenhuizen, *Oorkondenboek*, x).

182. See for instance Ghent, Begijnhof Ter Hooie, Charters, no. 185 (Ter Hooie Ghent, 1418); de la Grange, "Choix," 227, no. 798 (Tournai, 1438); RAH, Begijnhof Sint-Truiden, Charters, no. 451 (Sint-Truiden, 1562).

183. MCF, vol. 2, 515; Ghent, Begijnhof Ter Hooie, Charters, nos. 118 and 155 (1363, 1387); Lambrechts, "Het begijnhof van Hoogstraten," 97; Appendix I, no. 32A. For the role of Catherine and Mary Magdalen in beguine spirituality, see also Chapter 5.

184. See Appendix I, nos. 25B and 40C. A statue of St. Aubert dating from the third quarter of the thirteenth century and now preserved in a private collection, probably originated from the Poortakker beguinage, see *Werken en Kerken*, 232, no. 371. For general data on the cult, see Charles Lefèbvre, "Auberto," in *Bibliotheca Sanctorum*, vol. 2 (Rome: Instituto Giovanni XXIII, 1962), cols. 581–82.

185. Lambert, *Medieval Heresy*, 62–63. On the Alexis legend in the middle ages and its sources (the Latin and vernacular versions, for instance, drew heavily on the life of John Kalybita), see C. E. Stebbins, "Les origines de la légende de Saint Alexis," BTFG 51 (1973): 497–507; Baudouin de Gaiffier, "*Intactam sponsam relinquens*. À propos de la vie de S. Alexis," *Analecta Bollandiana* 65 (1947): 157–95; and, for Alexis as a "paradigm of chaste marriage," Elliott, *Spiritual Marriage*, 7, 208; *Werken van barmhartigheid. 650 jaar Alexianen in de Zuidelijke Nederlanden*, exhibit. catal. (Louvain: Stedelijk Museum Vander Kelen-Mertens, 1985), 186–218.

186. GC, II, vol. 1, 526–28, no. 35, an edition of the oldest extant version in Dutch, found in KB, MS IV, 775, from southwestern Flanders.

187. A chantry in honor of St. Alexis was founded in the beguinage of the Wijngaard

on 25 January 1273 (*AOCMWB*, Begijnhof, K 1, fol 5r-v). For his cult at St. Elizabeth's of Ghent, see *RAG*, Sint-Elisabethbegijnhof Gent, Charters, at date 21 january 1304; there are numerous other sources for the cult in this community afterward. On his cult at the main beguinage of Dendermonde, named after him, see Appendix I, no. 31A.

188. C. H. Talbot, ed., *The Life of Christina of Markyate: A Twelfth-Century Recluse* (Oxford: Oxford University Press, 1959), 26–27. The influence of the *Life of St. Alexis* on lay religiosity in the Low Countries is older, however.

*Chapter 4. The Social Composition of Beguine Communities*

1. The literature is reviewed in Greven, *Die Anfänge*, 1–26; *PB*, 10–11; *MBB*, 81–85.

2. *GRB*, 181–98, and for the Strasbourg statutes, 344–51, where Grundmann, in my opinion, stretched the evidence to support his thesis — an unusual lapse in this great book.

3. *MKA* (1963): 390–98; *MBB*, 81–100.

4. Asen, *Beginen in Köln*, vol. 1, 92–93. See also Frederick M. Stein, "The Religious women of Cologne" (Ph.D. diss., Yale University, 1977), 281; Phillips, *Beguines in Medieval Strasburg*, 27.

5. Neumann, *Rheinisches Beginen- und Begardenwesen*, 105–11 (although hesitant to break with Grundmann's views); Peters, "Norddeutsches Beginen- und Begardenwesen," 82–85; Degler-Spengler, "Die Beginen in Basel," 64–65; Schmitt, *Mort*, 42–43 (brief survey of research on Rhenish cities); Koorn, *Begijnhoven*, 100–106; Hans-Joachim Behr, "Der Convent der Blaue Beginen in Lüneburg," *Lüneburger Blätter* 11–12 (1961): 181–93, observed the opposite trend in a small convent at Lüneburg between the late thirteenth and fifteenth centuries: the early community was made up of destitute young women and widows, slowly displaced by daughters of wealthy urban families. Ute Weinmann, *Mittelalterliche Frauenbewegungen: Ihre Beziehungen zur Orthodoxie und Häresie* (Pfaffenweiler: Centaurus-Verlagsgesellschaft, 1990), 185–202, reviews German data but comes to conclusions that I do not always share.

6. *Sermo II ad virgines*, ed. Greven, "Der Ursprung," 47 (see also *VM*, 547, cited in Chapter 2, note 1). Thomas of Cantimpré's *Bonum Universale*, ed. Colvenerius, Lb. II, ch. xxix, no. 39, was almost certainly inspired by these words.

7. *VJC*, 444.

8. Constable, *Three Studies*, 436, 352, 359; *GRB*, 188–98. The author of the *Vita Odiliae* wrote that she was born from parents, "whose secular status was not the lowest" (*VO*, 210).

9. *VIL*, 109: the author explicitly situated her family below that of the most powerful nobility but above its poorer members (cf. *VL*, 110, where the family is called *nobilis*) who were preoccuppied with procuring the necessities of life. See Steenwegen, "De gelukz. Ida," 116–19.

10. *VJ*, 146–47, and Joris, *La ville de Huy*, 359, 421–22. Mulder-Bakker, "Ivetta," 225, called her family "patrician," thus locating it rightly at the top of the urban community but obscuring its links to the rural aristocracy.

11. *VB*, 11; *VILO*, 158–59; *VIN*, 199, 210; *VM*, 550; *VO*, 210; *VL*, 189–92; Geyer, *Maria*, 15; D'Haenens, "Femmes excédentaires," 220.

12. James's second *Sermon to Virgins*, cited above, implied that along with the wealthy and noble women whom he singled out for special praise, there were others, pre-

sumably of lesser status, who joined the beguines. His characterization of the former corresponds to his description of the early Cistercian nuns in the *Historia Occidentalis*, 117.

13. *MKA* (1963): 384–90; Koch, *De kloosterpoort*, 62–70.

14. *VM*, 553, 562, 569; *VJ*, 163.

15. *SAM*, Archief OCMW, no. 9436, fol. 3r-v (15 June 1275 and August 1276); De Ridder, "De oorsprong," 60–76 (uncritical, to be used with caution); De Ridder, "De Oudste Statuten," 18–19; P. C. Boeren, *De heren van Breda en Schoten, ca. 1100–1281* (Leiden: Sijthoff, 1965), 229.

16. She received a bequest in her aunt's will (*ADN*, B 446, no. 1202, ed. Édouard Hautcoeur, *Cartulaire de l'abbaye de Flines (1200–1630)* [Lille: L. Quarré, 1873–74], vol. 1, 124–29, no. CXXIV, and *RAG*, *SG*, no. 112 [execution of the will ca. 1264]). We do not know, however, to which community she belonged.

17. Ernest Warlop, *The Flemish Nobility before 1300* (Kortrijk: G. Desmet-Huysman, 1976), part 2, vol. 1, 807, 815 (the evidence is uncertain).

18. With Elizabeth uten Hove, Aelidis issued a charter on 25 June 1270; Sara acted as a substitute for the Grand Mistress in November 1282 (Ghent, Begijnhof Ter Hooie, charters, nos. 10, ed. A. Cassiman, "Stichting van het klooster van de Rijke Claren te Gentbrugge," *Franciscana* 8 [1953]: 1–29, at 16, note 16; Ghent, Begijnhof Ter Hooie, cartularium, fol. 147v). On Isabelle, see *DB*, 137.

19. *SAT*, Begijnhof, Charters 1st series, nos. 1 (for their family ties, see also no. 14; cf. Appendix 1, no. 101A), 4–5 (will of Meghtild *dicta Mella*), 22 (Margaret of Offelken, 25 July 1295), 23 (Catherine of Sint-Jan, 30 May 1298), 31 (Elizabeth, Aleidis, and Catherine of Schalkhoven); 47 (Gertrude of Schalkhoven, 19 March 1317), 49 (Catherine Spormekere, 29 April 1317). At this time, relatively few burghers or other nonnobles of Loon possessed fiefs.

20. *AOCMWB*, Begijnhof, charters, no. 26 (ed. *GC*, I, vol. 1, 458, no. 281, December 1279), and 165 (11 February 1340). Countess Margaret's chambermaid (*Cameraria*), Elizabeth of Bruges, donated her house at the beguinage's entrance way to the Wijngaard in July 1251, but, as far as we know, she did not belong to the community (*AOCMWB*, Begijnhof, charters, no. 4, ed. Hoornaert and Callewaert, "Les plus anciens," 290–91, no. 24). For the noble beguines of Bruges in the fifteenth century, see Desmet, "Het begijnhof," 151, 168, 171–72, 227.

21. See Appendix I, no. 54; *SAG*, B, nos. 304 and 313, ed. *BC*, 200–202, no. 304 and (in part), 207, no. 313 (8 August 1543, 11 January 1559).

22. *RAG*, Sint-Elisabethbegijnhof, Charters, at dates 1 October 1273, 2–8 October 1300 (ed. *GC.*, I, vol. 4, 2811–12, no. 1905), 21 January 1305, and 16 December 1309; *RAG*, Sint-Niklaaskerk, charter at date 30 September 1313; *RAG*, Bisdom, E 373, fol. 13r–14r (1437); *SAG*, B, no. 33, ed. *GC*, I, vol. 1, 383–84, no. 214 (ca. 1273–77), no. 85 (30 November 1309), no. 93 (14 April 1315); Ghent, Begijnhof Ter Hooie, Charters, nos. 10 (25 June 1270, see note 18) and 28 (31 January 1297); Ghent, Begijnhof Ter Hooie, cartularium, fol. 94v–96r (1 October 1320), 138v–139r (2 August 1291).

23. *AOCMWB*, Begijnhof, Charters, nos. 30 (17 December 1283), 41 (16 January 1294), 105 (1327), 162 (12 May 1338); *BAB*, Begijnhof, Charters, at date 22 January 1337; cf. Desmet, "Het begijnhof," 6, 85, 156–57; Valentin Vermeersch, *Grafmonumenten te Brugge voor 1578* (Bruges: De Raaklijn, 1976), vol. 2, 34, 35, 37, 60, 92, 102, 122, nos. 19, 20, 23, 29, 48, 49, 88, 105, 130.

24. Placide Lefèvre, Philippe Godding, and Françoise Godding-Ganshof, eds.,

*Chartes du chapitre de Sainte-Gudule à Bruxelles 1047–1300* (Louvain-la-Neuve: Collège Érasme; and Brussels: Éditions Nauwelaerts, 1993), 221–22, no. 287 (2 February 1290) and K. Ruelens, "Jan van Ruysbroek en Blommardinne," in J. Vercouillie, ed., *Werken van zuster Hadewijch*, vol. 3 (Ghent: C. Annoot-Braeckman, 1905), xxi–xcvi, at lxxxii (November 1275 and 21 November 1296).

25. *LUB*, XV, no. 1, fol. 28r, 29r (ca. 1300); cf. Prims, *Kerkelijk Antwerpen in het laatste kwart der XIIIde eeuw*, 200.

26. F. Van Molle, "De koperen grafplaat van Machtelt Roelants (+1396) uit de Begijnhofkerk te Leuven," *Arca Lovaniensis* 2 (1973): 157–65; J. Crab, L. Van Buyten, and P. V. Maes, *Kerk van het Groot-Begijnhof* (Louvain: n.p., 1966), 217–19, 227 and *ARA, AOOL*, charters, 1st series, nos. 1439 (1382), 2049–50 (1422), 2944 (1533).

27. Espinas, *Vie urbaine*, vol.3, 552–53, no. 755 (10–30 April 1289) and vol. 4, 78–79, no. 945 (1–25 March 1312).

28. Joris, *La ville de Huy*, 354; F. H. M. Roebroeks, "Van Aldenhof tot Sint-Catharina Bongart, bijdrage tot de geschiedenis van een Maastrichts begijnhof," in *Munsters in de Maasgouw: Archeologie en Kerkgeschiedenis in Limburg* (Maastricht: Limburgs Geschieden Oudheidkundig Genootschap, 1986), 158–73, at 169; Jan De Cuyper, "Het begijnhof van Kortrijk," *De Leiegouw* 15 (1973): 5–48, at 25, 26, 30.

29. Ghent, Begijnhof Ter Hooie, charters, no. 40 (9 December 1307). Dyeries were among the most valuable pieces of industrial real estate, see Nicholas, *Methamorphosis*, 106–7.

30. *AEL*, Dominicains, Charters, nos. 19, 20 (ed. Lauwers, "Testaments," 174–81, nos. 10–11). Such examples could be easily multiplied: see for instance Brouwers, "Analectes Dinantais," 254 (Dinant, 1302); *LS*, 37 (thirteenth-century Tournai).

31. *RAB*, Oorkonden met Blauwe Nummers, nos. 3940, 7422, 7425 (March–July 1258); the land was probably Felissia's share in her parental estate.

32. *SAT*, Begijnhof, Charters, 1st. series, no. 15; the debtors were other beguines, clergymen, and their relatives.

33. Carlos Wyffels, *Analyses de reconnaissances de dettes passées devant les échevins d'Ypres (1249–1291)* (Brussels: Palais des Académies/Paleis der Academiën, 1991), 140–41, 192, 254, 324, 342, 370, 394, 422, 488, nos. 1525, 2124, 2808, 3591, 3810, 4116, 4403, 4744, 5504 (in at least three of the nine cases recorded, the debtor was explictly identified as the beguine's relative; the average for the Yprois transactions is based on a random sample of 100 transactions in the period); Wyffels and De Smet, *De Rekeningen . . . Eerste Deel*, vol. 1, 182, 253, 314, 378 (for the identification of Marie le Cordière as a beguine, see Espinas, *Vie urbaine*, vol. 3, 634, no. 849, and for Agnes d'Escaudain, *DB*, 148, note 96), 640, 978. Other examples of beguines lending money for small amounts are: Espinas, *Vie urbaine*, vol. 3, 80, no. 119 (Douai, 1250); *ADN*, 16 G 16, no. 162 (Lille, 1272).

34. Pierre Bougard and Carlos Wyffels, *Les finances de Calais au XIIIe siècle. Textes de 1255 à 1302 publiés et étudiés* (Brussels: Crédit communal de Belgique, 1966), 152, no. 1550 (see also 47–48 and 231, no. 1356).

35. *SAG*, Reeks 301, no. 1, fol. 19r (undated, probably before 1343–44).

36. "*[Z]ome* [beguines] rike ende zijn gherent, ghemeenlicken nochtan harem lettel meer hebbende dan hare cledere, kisten, forstiere ende bedden. Nochtan niemene ne zijn zi last, maer werkende met den anden, noppende wullen of wiedende lakene win zi haere broed." (Ghent, Begijnhof Ter Hooie, charters, no. 52C; a contemporary report on life at St. Elizabeth of Ghent, in Latin, is more succinct: *SAG, B*, no. 106, ed. *BC*, 74, no. 106).

37. *AMD*, FF 862, at dates 30 November 1354 and 19 June 1359. The absence of any references to real estate in Clarisse's will supports, in my view, the hypothesis that she resided at Wetz, where beguines usually received room and board in exchange for such property. It is certain that she died as a beguine of Wetz in 1357 (Deregnaucourt, "Les béguines," 48). For the identification of Jaque as a superior of the convent of Fressaing, see Espinas, *Vie urbaine*, vol. 4, no. 1216 (26 February 1355).

38. *AMD*, FF 861, at date 30 November 1354.

39. Appendix I, no. 108A.

40. As in a donation "for the benefit of the poor women called beguines in the hospital of St. Elizabeth near Lille" in March 1245 (*ADN*, B 444, no. 825). See also Appendix I, nos. 35B, 105, and 107.

41. See for instance Appendix I, nos. 35A, 61A, 61B, 74, and 101A (these "poor beguines" are required to pay an annuity); many other examples of the usage exist.

42. On the notion of the "deserving poor" in the moral theory and practice of almsgiving, and its spread in the thirteenth and fourteenth century, see Rubin, *Charity and Community*, 68–74, 253–56.

43. *AOCMWBR*, H 270/1.

44. Ghent, Begijnhof Ter Hooie, charters, no. 10, ed. Cassiman, "De stichting," 16, note 16.

45. *AMD*, FF 861, at date.

46. Ghent, Begijnhof Ter Hooie, Cartularium 1423, fol. 58r–59r (November 1280).

47. *SAT*, Begijnhof, Charters, 1st series, no. 11 (2–30 April 1290 or 1–21 April 1291).

48. Mons, Archives de l'État, Collection L. Verriest, no. 3 (21 July 1290), a twentieth-century copy of an original document, now lost. On the convents in the city of Tournai, see Appendix I, no. 103B.

49. *ADN*, 40 H 552, no. 1334 (May 1262), ed. Carpentier, "Le Béguinage," 176–77.

50. Verellen, "De oudste," 219 (bequests to the beguinage's church, which is 'very poor," and to the Holy Spirit Table; on the latter, see below).

51. In St. Catherine's of Tongeren, beguines routinely left money or property in their wills for "the poor of our court" (*pauperibus curie nostre* in the will of Meghtild Mella, *SAT*, Begijnhof, Charters, 1st series, no. 5 [March 1273]); such clauses appear in most wills made by beguines at St. Catherine in this age.

52. These terms followed local, civic usage: *Heilige Geesttafels* or *Tables du Saint-Esprit* were known as communal charitable institutions in many towns of the Low Countries; *charité* was the name used for them in Walloon Flanders and parts of Hainaut. The name *Gilde*, used by the beguines at St. Agnes in St. Truiden (*RAH*, Begijnhof Sint-Truiden, no. 4, fol 5r [1 September 1388] and charters, no. 61 [10 May 1358]) was probably inspired by that of the parochial Table of St. Truiden, the *Gilde* of St. Eucharius. Only the term *kiste* is truly peculiar to beguine usage.

53. J. Withof, "De 'Tafels van den Heiligen Geest' te Mechelen," *HKOM* 32 (1927): 85–134, at 103.

54. *ARA*, *KAB*, no. 13402/4. For the Kiste at the Wijngaard of Brussels, see *MBB*, 147–48.

55. *ADN*, 40 H 558, no. 1365 (*la carité des povres beghines de Sainte Ysabiel*).

56. *RAG*, Sint-Elizabethbegijnhof Gent, charters, at date, ed. *BC*, 31–32, no. 38 (after the fifteenth-century cartulary of the Heilige Geesttafel, *SAG*, Reeks LXXIII, uncatalogued, fol. 17r–v; this charter is the oldest document in the cartulary).

57. The Aumone of the beguinage of St. Christophe in Liège presents a special case. Mentioned for the first time in 1251 (*AEL*, Dominicains, charters, no. 7), the dole for poor beguines of the parish of St. Christophe was originally the only institution that united the various beguine houses and convents in the parish, until a common leadership was appointed in 1283.

58. "Aions fait et ordené en nostre court par consel de gens de religion et dautres preudommes une table de Saint Esperit pour soustenir les povres de le court, dont il i en a bien .ccc. u la entour, et tels en i a ke dedens .ix. ans ne eürent sauf de pain, anchois ke cheste table fu commenchié; à quoi les riches beghines donnent leur amosnes, et en sous-tient on chaus ki nient ne ont et ki nient ne puent waingnier de le vielleche, et quant il sont malade gisent il en lenfermerie, et quant il sont haitiet vivent il des amosnes, lesqueles on met en une huge" (*RAG*, Sint-Elisabethbegijnhof Gent, charters, at date 30 April 1284). The document is a final, undated draft preserved in the archives of the beguinage; since the request pertained to the acquisition of land by the Table that was approved by count Guy on 30 April 1284 (ibid., at date; ed. *BC*, 39, no. 49), it probably dates from the first months of 1284. It is the work of a trained scribe who did not use the formal writing style found in most charters of the age (another request to the count probably by the same hand, is in *SAG*, B, no. 50 [before 10 October 1284]). Incidentally, if the request was writ-ten by a beguine of St. Elizabeth—as I believe it was—it proves that she knew French, the language of the Flemish comital family, and wrote it well.

59. Some early examples of these gifts are in the will of Catherine *de Serkingen*, be-guine of St. Agnes in Sint-Truiden (*RAH*, Begijnhof Sint-Truiden, charters, no. 13 [Octo-ber 1284]), and in a set of wills by beguines and a lay donor of Tongeren (*SAT*, Begijnhof Tongeren, charters, 1st series, nos. 11, 13, 15, 16, 18 [April 1290/91–22 December 1293]).

60. Cuvelier, *Les dénombrements*, 366.

61. See note 45.

62. *AOCMWB*, Begijnhof, no. 162 (12 May 1338). This was probably not the first convent for poor beguines founded within the Wijngaard of Bruges, for a will of 1305 contains a bequest of 20 s. *pauperibus conventibus in Vinea* (*BGSD*, Charters, no. 1464 (transfix), ed. F. Van de Putte, *Cronica et cartularium monasterii de Dunis* [Bruges: Société d'Émulation de Bruges, 1864–67], 687–88, no. DCXII).

63. One example among many: the Stickersconvent for poor beguines in the court of St. Alexis at Dendermonde, established in 1448 (Broeckaert, *Cartularium*, 56–58, no. LVIII).

64. Appendix I, no. 7B, 20, 25B, 40C, 64C, 108B. Ter Arken of Brussels (1263) appears to have been intended for ailing rather than for poor beguines (Appendix I, no. 26B).

65. *SAG*, B, no. 26, ed. *BC*, 23–24, no. 26 (see Appendix I, no. 20).

66. Nicholas, *Medieval Flanders*, 176–79.

67. Appendix I, no. 40C.

68. *RAG*, Bisdom, E 374, fol. 10r. (a scalding letter to the Dominicans of Ghent; a copy of the letter was probably sent to the beguines of St. Elizabeth, who copied it in their cartulary in 1404). The next day, interestingly, Countess Margaret wrote to the beguines and ordered them to adhere strictly to the "ordinances and statutes that were issued in your court during the reign of our sister Joan" (*SAG*, B, no. 22, ed. *BC*, 17, no. 22). She probably refered to the foundation charters for the beguinage, discussed in Appendix I, no. 40A, and not to the rule of the beguinage, as *BC*, 17–22, no. 23, thought.

69. *SAG*, Reeks LXXX, charters, no. 1, ed. E. Luykx-Foncke, "Sint-Aubertus-

Gesticht op Poortakker," *Bijdragen tot de geschiedenis en oudheidkunde* [1943]: 77–96, at 83–84.

70. Women of the Van Vaernewijck, de Vriendt, uten Hove, and van de Pitte families were found among the beguines of Poortakker in the fourteenth century: *SAG*, Reeks LXXX, no. 123.

71. Nicholas, *Medieval Flanders*, 206–7; 265–73; Maréchal, "Armen- en ziekenzorg," 273–79; Blockmans et al., "Tussen crisis en welvaart," 56–59, 81–83; Van Uytven, ed., *Leuven*, vol. 1, 125.

72. Appendix I, no. 7C.

73. Appendix I, no. 25 C.

74. We know little of the foundation history of these convents. References to the most important texts are gathered in Appendix I, nos. 35C, 56, 61B, 75B, and 92. For a rare, well-documented example in Mons, see Walter De Keyzer, "L'hôpital Le Taye, une infirmerie pour béguines à Mons à la fin du XIIIe siècle," in *Album Carlos Wyffels* (Brussels: Algemeen Rijksarchief/Archives générales du Royaume, 1987), 131–37.

75. Statutes for Lier of 1401 (*PB*, 340); for Sion at Antwerp from the fourteenth to fifteenth centuries (ibid., 336), for Herentals of 1489 (Verellen, "De oudste," 208). The beguinage of Breda admitted only women who could prove an annual income of 1 *sester* rye, a rather modest requirement (*PB*, 168).

76. In his tract *Ad Beguttas*, written in 1380–84, Geert Grote objected to the practice of selling "prebends" in beguine convents, see Geert Groote, *De Simonia ad Beguttas. De Middelnederlandsche tekst opnieuw uitgegeven met inleiding en aanteekeningen*, ed. W. de Vreese (The Hague: Martinus Nijhoff, 1940); A. G. Weijler, "Geert Grote en begijnen in de begintijd van de Moderne Devotie," *OGE* 69 (1995): 114–32.

77. Braekman, "De 'statuten van levene,'" 44. The earliest example of this type of requirement is in the statutes of 1307 for the convent at Heinsberg, which required the modest payment of 4 s. brab.; 3 s. were expected in 1322 (Heinz Hermann Deussen, "Ein Beginenhof im mittelalterlichen Heinsberg," *Heimatkalender des Selfkantkreises Geilenkirchen-Heinsberg* 13 [1963]: 55–61).

78. Alphonse-Marie Coulon, *Histoire du Béguinage de Sainte-Élisabeth à Courtrai d'après les documents authentiques* (Kortrijk: Jules Vermaut, 1891), 10–12; De Cuyper, "Het begijnhof," 22, misrepresented this text (see also Van Rossum, "Documents," 92).

79. Bovijn, "Sint-Alexiusbegijnhof," 11; the statutes of 1551 prescribed an entry fee of 6 gr. for virgins, 2 s. 6 gr. for widows, and 5 s. gr. for others (Broeckaert, *Cartularium*, 195–207, no. CIV).

80. Denis du Péage, *Documents*, 83–88.

81. According to statutes issued on 24 October 1522 (partly based on an older, lost, set of regulations of 1368): Van Lerberghe and Ronsse, *Audenaerdsche Mengelingen*, vol. 5, 246–49.

82. We have no information about twenty-four beguines (11.3 percent). These figures, based on the data in Desmet, "Het Begijnhof," 148–243, do not lend themselves well to statistical operations because the properties and incomes of beguines are diverse and hard to convert into money values.

83. Bruges, Monasterium De Wijngaard, Archives, "Regel" (uncatalogued), fol. 3v.

84. Legislation on the matter was issued by countess Margaret of Flanders for the beguinage of Champfleury at Douai on 5 February 1256 (*AMD*, GG 190); the principle was accepted in the beguinage of Aalst in January 1266 (Aalst, Stadsarchief, begijnhof St.

Catharina, no. 74, fol. 1r–v, ed. Soens, *Cartularium*, 18–20) and at the Wijngaard of Brussels on 17 May 1271 (*MF*, vol. 2, 1006–7). On 27 August 1274, countess Margaret confirmed a similar ruling for the beguinage of the Wijngaard in Bruges, insisting that it had been the understanding of the first beguines who constructed houses in the beguinage (*AOCMWB*, K1, fol. 6v, ed. De Limburg-Stirum, *Cartulaire*, vol. 1, 359–60, no. CCCXCIII). Margaret issued a comparable ordinance for the beguinage of Lille on 20 april 1278 (*ADN*, B 1528, no. 2005, ed. Denis du Péage, *Documents*, 26). The system is attested for the beguinage of St. Catherine at Mechelen in 1278 (*AAMBM*, charters, at date 3 June 1278). As early as 1265, a beguine of Liège gave orders to the prior of the Dominican convent to sell her house, *outside* the beguinage of St. Christophe, "for the life of one or more persons" (*AEL*, Dominicains, charters, no. 19, ed. Lauwers, "Testaments," 175); such arrangements with mendicant friars were common in fourteenth-century Strasbourg (Phillips, *Beguines*, 35–44) but rare in the southern Low Countries.

85. RAG, Sint-Elisabethbegijnhof, Charters, at date, ed. *BC*, 29, no. 35.

86. *AAMBM*, no. 12, A, 3r, ed. De Ridder," De Oudste Statuten," 24. The injunction was directed to "widows," who were presumed to possess the necessary funds.

87. Denis du Péage, *Documents*, 73–74. In a remarkable study of living rights in the beguinage of St. Elizabeth at Ghent in the early modern era, Peter Welvaert found that beguines who bought a private residence did so after spending an average of nineteen years in a convent; the mean price of a house was then the equivalent of five times the annual wage of a journeyman mason (Peter Welvaert, "1617–1797: 180 jaar wonen in het Sint-Elizabethbegijnhof te Gent," *BG* 63 [1980]: 219–66, at 230, 244–5). On the whole, house prices within the beguinage did not differ very much from those of houses in the city. There has not been much comparative work, however, on the price of urban houses and the proportion of citizens in late medieval Flanders who owned their own residence (see Nicholas, *Metamorphosis*, 104–7; Howell, *The Marriage Exchange*, 63–64). Marc Boone, Machteld Dumon, and Birgit Reusens, *Immobiliënmarkt, fiskaliteit en sociale ongelijkheid te Gent, 1483–1503* (Kortrijk: U. G. A., 1980), 60–73 also registered a wide range of prices in Ghent between 1483 and 1493; they calculated that a skilled laborer would need to save for about twenty-five years, and an unskilled laborer for fifty years, to buy a house of average value.

88. Calculations based on the data in Desmet, "Het begijnhof," 148–243, covering the years 1439–1467.

89. Phillips, *Beguines*, 24–27; Schmitt, *Mort*, 42–44 (with references to sources on 219–20).

90. These data are based on SAG, B; RAG, Sint-Elizabethbegijnhof, Charters, and Ghent, Begijnhof Ter Hooie, Charters. The names of aldermen's families can be found in Blockmans, *Stadspatriciaat*, 455–65; Vuylsteke, *Comptes . . . Register*, s.v. "schepenen;" Napoleon De Pauw and Julius Vuylsteke, *De rekeningen der stad Gent. Tijdvak van Jacob van Artevelde 1336–1349* (Ghent: A. Hoste, 1874–85); and P. C. Van der Meersch, *Memorieboek der stad Gent* (Ghent: C. Annoot-Braeckman, 1852–61).

91. Marc Boone, *Gent en de Bourgondische hertogen ca. 1384–ca. 1453. Een sociaal-politieke studie van een staatsvormingsproces* (Brussels: Paleis der Academiën, 1990), 148–49, 155–56.

92. Delmaire, *Le diocèse*, vol. 1, 330–32.

93. This is why, in my opinion, studies of German beguine communities that have adopted this method for the social ranking of beguines are flawed.

94. For the rural origins of beguines, see p. 116; as noted above, the number of noble beguines was very small.

95. A note in the manuscript by Johannes Fratericus, a notary who examined the document in 1568, dates the book to "around 1266" (*LUB*, XV, no. 1, fol. 4v); Prims, "Kerkelijk Antwerpen," suggests the obituary book was started "before 1273," but the argumentation is weak.

96. *LUB*, XV, no. 1, fol. 34r. For the date, see W.A. Olyslager, *750 jaar Antwerpse begijnen* (Antwerpen: Pelckmans, 1990), 62–63. Floris Prims, *Geschiedenis van Antwerpen* (Antwerp: Standaard Boekhandel, 1926–49), vol. 4, part 2, 131 and 145, wrongly maintained that the manuscript was not used after 1322.

97. Its population was at least 101 beguines in the early sixteenth century, see Table 3. It may have been smaller in the first decades of its existence, but the court reached its greatest expansion fairly soon: the main church was under construction in 1252, and by 1316 the court was served by a priest and three chaplains, a number that suggests a very large beguine population (Olyslager, *750 Jaar*, 52).

98. At an annual date rate of 38.9 per 1000, see Appendix II, nos. 1 and 6.

99. *SAG*, Reeks LXXX, no. 123, fol. 21v. In October 1282, Catherine Bruusch, a beguine at St. Elizabeth, founded an anniversary at Poortakker with distribution of wine and fish or meat in the infirmary and an annual rent to her maid, Margaret of Ypres, who probably retired at Poortakker (*SAG*, Reeks LXXX, Charters, no. 5); Catherine died on 24 September 1299 (*RAG*, Sint-Elizabethbegijnhof, charter at date October 1300, ed. *GC*, I, vol. 4, 2811–12, no. 1905).

100. *SAG*, Reeks LXXX, no. 123, fol 15r: foundation by Peter Mortiers, whose death in 1402 is mentioned in the entry.

101. See Table 3.

102. See Table 3.

103. The obituary book has been edited by Frans Gooskens, *Het jaargetijdenregister van het begijnhof te Breda (1353) ca. 1500–1626* (Breda: Gemeentelijke Archiefdienst, 1992). It covers the period 1500–1626, with some additional notes pertaining to the years 1353 and 1429–1499.

104. Blockmans and Prevenier, "Armoede in de Nederlanden," 511–12, 515–19, defined those exempt as "fiscal poor."

105. Lauwerys, *Het begijnhof*, vol. 1, 108–10. The total number of beguines is not known.

106. Claire Dickstein-Bernard, "Pauperisme et secours aux pauvres à Bruxelles au XVe siècle," *BTFG* 55 (1977): 390–415, at 398.

107. Van Uytven, ed., *Leuven*, vol. 1, 208–14; Dickstein-Bernard, "Pauperisme," 394–96.

108. The legend was first recorded in the early seventeenth century by Ryckel, *Vita S. Beggae*, 319–22, but obviously dates from an older era. Among the possessions of the current beguinage of St. Amandsberg of Ghent is a large crucifix of about 1330–40 that, as legend has it, spoke to Matteken, see *Werken en Kerken*, 23, 137–39, nos. 17–18.

109. To designate a founder of any religious or charitable institution is naturally a simplification of a complex process that involved many individuals. It is made especially difficult for beguinages because so-called "foundation charters," which often supply important information for the early history of monastic houses, are rarely available, and there are also few obituary books or other liturgical documents that might enlighten us

about the remembrance of the founder within the community; in any case, the memory of the original founder was sometimes eclipsed by that of a later, powerful benefactor (see, for instance, Appendix I, no. 39, 72A). The names of beguine convents help to some extent but are difficult to interpret: they were usually derived from the founder's name or surname, but sometimes they might refer to a prominent member or superior of the convent, the patron saint, or even the location (see Appendix I, nos. 8, 25C, 61B, and 78A, and De Keyzer, "Aspects,"211).

110. Appendix I, nos. 25A, 28A, 35A, 40A, 40B, 40C, 58, 63, 75A, 105, and 108A. One may suspect that countess Margaret also had a hand in founding the beguinages of Aardenburg, Binche, Le Quesnoy, Veurne, and IJzendijke (ibid., nos. 3, 19, 60, 86, 106, 109), and the convent of St. Aubert at Bruges (ibid., 25B). The participation of the dukes of Brabant in the foundation of several beguinages (for example those of Aarschot and Ten Hove at Louvain, Appendix I, nos. 4, 64A) is possible but hard to prove.

111. Appendix 1, nos. 21, 65. It is possible that they also supported the foundation of beguinages in Bilzen and Hasselt (ibid., nos. 18, 45).

112. Appendix 1, nos. 13, 24, 32A, 37, 54. Sophia Berthout, widow of Henry V of Breda and daughter of the lord of Mechelen, was an important benefactor of the main beguinage at Mechelen in the thirteenth century (ibid., no. 72A).

113. Appendix I, nos. 7A, 26A, 50, 94, and 103A. In addition to Gerungus of Brecht's mother, Christine, Sion's obituary book also cites a niece, Lysbette van Brecht (*LUB*, XV, no. 1, fol. 36r), his maid, Geile (ibid., 28r), and fifteen other individuals from Brecht, at least two of whom can be identified as beguines (ibid., fol. 7r, 34v). It is clear that the distinction between spiritual and material founder is difficult to make here, as it is in the foundation of the beguinage of the Wijngaard in Brussels.

114. Appendix I, nos. 2, 14, 78A, 111 (the community of Zoutleeuw seems to have existed before the donation by Arnold and Christine of Schiven).

115. Appendix I, nos. 8, 11, 81; De Keyzer, "Aspects," 212. "Lord Lanvin le Blaiier," founder of the convent that bore his name in Douai (Appendix 1, no. 35C), may have been noble.

116. Appendix 1, nos. 6, 20, 28B, 61B, 74, and 75B (see also De Keyzer, "Aspects," 212), 78B, and 84.

117. Appendix I, nos. 7C, 8, 10, 22, 25C, 26B, 34B, 35B, 35C, 56, 61B, 75B (De Keyzer, "Aspects," 212), 78C, 92, and 108B.

118. See for example Thompson, *Women Religious*, 162–74.

119. Appendix I, no. 2.

120. Bormans and Schoolmeesters, *Cartulaire . . . Saint-Lambert*, vol. 1, 477–83 (19 May 1291).

121. "Pria et requit ledit Bernard en son lict mortel as dittes femmes que tous les jours que elles audit hospital seront demourans que pour l'ame de li elles vaussissent dire pardevant la Vierge Marie cincq Patrenostre et cincq Ave Maria et tous les samedis de l'an quinze Patrenostre et quinze Ave Maria pardevant ledit Vierge audit hospital, avecq une chandelle de cire qui soit allumée tous les samedis, les cinqs nuits Nostre Dame, Noel, Pasque, Pentecouste et tous jours des douze Apostles au depense dudit hospital par l'espace d'ung demy heur" (*AMD*, GG 191). The *cinq nuits Nostre Dame* are probably the four traditional feasts of the Virgin (Purification, Annunciation, Assumption, and Nativity) and the Feast of the Immaculate Conception, which may have been celebrated in Douai as early as the thirteenth century.

122. *CR*, 198–208; Simons, *Stad en apostolaat*, 171–85. On the growing demand for liturgical services in the later middle ages, see Jacques Chiffoleau, *La comptabilité de l'au-delà. Les hommes, la mort et la religion dans la région d'Avignon à la fin du moyen âge (vers 1320–vers 1480)* (Rome: École française de Rome, 1980).

123. See p. 80.

124. *AOCMWB*, Dis Onze-Lieve-Vrouw Brugge, charters, no. 14, ed. Marechal, "Konventen van arme begijnen," 263–64.

125. See for example the foundation of a convent in the beguinage of St Christophe of Liège by Ida of Wotrenges, who reserved three places in the convent for her nieces (*AEL*, Dominicains, charters, no. 40 [15 February 1285]). Such arrangements were very common.

126. Appendix I, no. 95, 97, and De Keyzer, "Aspects," 212.

127. Johnson, *Equal in Monastic Profession*, 34–35; Thompson, *Women Religious*, 217–31.

128. Generalization on this subject, however, is frought with problems. See Howell, *The Marriage Exchange*, for Douai, and Danneel, *Weduwen en wezen*, for practices in Ghent.

129. Since no obituary book of the beguinage has been preserved, the calculation was made on the basis of charter records only (*SAG, B; RAG*, Sint-Elisabethbegijnhof, charters). Five anniversaries founded by beguines have not been included.

130. *SAG*, Reeks LXXX, no. 123.

131. Gooskens, *Het jaargetijdenregister*, 104.

132. Preface, p. xi.

133. Erens, "Les soeurs dans l'ordre de Prémontré," 8; Thompson, *Women Religious*, 134–39.

134. Milis, *L'ordre*, 515–17.

135. Venarde, *Women's Monasticism*, 160. See now also Constance Hoffman Berman, *The Cistercian Evolution: The Invention of a Religious Order in Twelfth-Century Europe* (Philadelphia: University of Pennsylvania Press, 2000), 39–45, 120–24.

136. See the Introduction, and James of Vitry, *The Historia Occidentalis*, 117. The precise dates of these foundations are not always known. The documentation is discussed ibid., 262–68, with further references; see also *Bernardus en de Cisterciënzerfamilie*, 447–52; M.-E. Montulet-Henneau, *Les Cisterciennes du pays mosan. Moniales et vie contemplative à l'époque moderne* (Brussels and Rome: Institut historique belge de Rome/Belgisch Historisch Instituut te Rome, 1990), 179–91.

137. Greven, *Die Anfange*, 139–58; *MBB*, 101–19.

138. John B. Freed, "Urban Development and the 'Cura Monialium' in Thirteenth-Century Germany," *Viator* 3 (1972): 311–27; Neel, "The Origins," 331; Hagemeijer, "Samen maar wel apart," 127–28.

139. *Bernardus en de Cisterciënzerfamilie*, 447–52.

140. They were originally based at Prémy, a convent founded by nuns formerly attached to Cantimpré near Cambrai, see M. P. Coenegracht, "Ontstaan van de Brabantse witte vrouwen en hun overgang naar de orde van St. Victor," *OGE* 34 (1960): 53–90; Milis, "De Kerk," 204.

141. Walter Simons, *Bedelordekloosters in het graafschap Vlaanderen. Chronologie en topografie van de bedelordenverpreiding in het graafschap Vlaanderen vóór 1350* (Bruges: Stichting Jan Cobbaut; Sint-Pietersabdij Steenbrugge, 1987), 126–27.

142. *MKA* (1963): 384–90; Koch, *De kloosterpoort*, 62–70. For the exclusive background of the Franciscan and Dominican sisters, see Simons, *Stad en apostolaat*, 215–17. For the traditional orders, see Ursmer Berlière, *Le recrutement dans les monastères bénédictins aux XIIIe et XIVe siècles* (Brussels: Académie royale de Belgique, 1923), 14–26; Ziegler, "Secular Canonesses," 126–28. We know unfortunately little about lay sisters in these orders.

143. Bernard Delmaire, "Deux récits versifiés de la fondation de l'abbaye des Prés à Douai," *Revue du Nord* 61 (1979): 331–51; *MOB*, 370–73; *MBB*, 109–10; Walter Simons, "Neuvireuil (Novirella), Michaël van (de)," in *Nationaal Biografisch Woordenboek*, vol. 12 (Brussels: Paleis der Academiën, 1987), cols. 563–67.

144. *RAG*, Rijke Klaren Gentbrugge, Charters, at date 29 September 1285 and 13 October 1285; Simons, *Bedelordekloosters*, 130–33.

145. *ADN*, 130 H 114, nos. 503, 512 (May 1268), 130 H 21, nos. 146 (February 1281), 147 (May 1283); 130 H 16, no. 112 (November 1293); 16 G 16, no. 162 (January 1272); *ARA*, Rekenkamers/Chambres des Comptes, Rolrekeningen/Comptes en Rouleaux, no. 266 (1296).

146. Desmet, "Het begijnhof," 133, 158, 206. As far as we can tell, the social composition of nunneries in the circle of the Devotio Moderna was comparable to that of beguines, see Gerhard Rehm, *Die Schwestern vom Gemeinsamen Leben im nordwestlichen Deutschland. Untersuchungen zur geschichte der Devotio Moderna und des weiblichen Religiosentums* (Berlin: Duncker & Humblot, 1985), 219–24; A. G. Weiler, "De intrede van rijke weduwen en arme meisjes in de leefgemeenschappen van de Moderne Devotie," *OGE* 59 (1985): 403–19.

147. Roisin, "L'efflorescence"; Epiney-Burgard, "Les béguines," 270–76.

148. Herlihy, *Medieval Households*, 92–111; Georges Duby, *The Knight, The Lady, and the Priest: The Making of Modern Marriage in Medieval France* (Chicago: University of Chicago Press, 1983), 264–78. See also Thomas N. Bisson, "Nobility and Family in Medieval France: A Review Essay," *French Historical Studies* 16 (1990): 597–613.

149. Steenwegen, "De gelukz. Ida," 117–18. It should be noted that one of her sisters entered a Cistercian nunnery: the family was therefore not impoverished to the extent that it could not raise the required *dos* for one of the girls.

150. See pp. 72–73.

151. Walter Prevenier, "De verhouding van de Clerus tot de locale en regionale Overheid in het graafschap Vlaanderen in de Late Middeleeuwen," in *Bronnen voor de religieuze geschiedenis van België. Middeleeuwen en Moderne Tijden* (Louvain: Bureau van de Revue d'Histoire Ecclésiastique, 1968), 9–46, at 42.

152. Johnson, *Equal in Monastic Profession*, 219–26.

153. Courts at Overijse and Thuin, convents of Aulnoy, Dudzele, Henis, Hocht, Malèves, Marck, Masnuy, Momalle, Noirhat, Sin-le-Noble, Thorembais (see Appendix I, nos. 11, 36, 49, 53, 68–70, 74, 82, 89, 93, 96, and 98). One finds occasionally two or three women living together as beguines in other rural areas, but they did not form convents. For instance, beguines (single, or in groups of two, possibly three) are attested in Oostkerke (*BGSD*, Charters, no. 1037 [January 1269]), Zaamslag (*RAG*, Abdij Boudelo, no. 10, fol. 13r–14r [4 March 1276]), Horion and Wotrenges (*AEL*, Dominicains, charters, no. 18 [30 March–4 April 1265], as well as Lummen (Polydore Daniëls, "Begijnen te Lummen," *'t Daghet in het Oosten* 2 [1887]: 66–69 [11 April 1279]).

154. Ziegler, "Secular canonesses," 127–28 raised the interesting possibility that

courts were modeled on the arrangements of houses and churches used by secular canonesses.

155. Simons, *Stad en apostolaat*, 98–100.

156. Ibid., 218–19; idem, "The Beguine Movement," 87–89; *Het Begijnhof van Aarschot*, 138, no. IV; Soens, *Cartularium*, 17–18; Verellen, "Oorkonden," (1950): 55–57; Carpentier, "Le Béguinage,"115–18; *PB*, 93–94.

157. *PB*, 93–96; *MBB*, 165–86, 201–2; Jean Paquay, "Regesta de Renier écolâtre de Tongres, vicaire-générale de Henri de Gueldre," *Bulletin de l'Institut archéologique liégeois* 35 (1905): 1–74; Olyslager, *750 Jaar*, 183–84; Simons, "The Beguine Movement," 88–89; Appendix I, nos. 21 and 49.

158. For instance in the foundation act of the beguinage of St. Truiden (*RAH*, Begijnhof, charters, no. 1, ed. François Straven, *Notice historique sur le béguinage dit de Sainte-Agnes à Saint-Trond* (Sint-Truiden: Typographie E. Schoofs-Herman, 1876), 103–7, no. 1, but the idea is expressed in a charter for Champfleury at Douai in December 1245: "ut ibi religiose mulieres que beghine vocantur infra certum ambitum deberent conversari" (*ADN*, 30 H 17).

159. *SAT*, Begijnhof, Charters, 2nd series, at date, ed. Jean Paquay, "Regesta de Marcuald de Modène, Archidiacre de Hesbaye, prévôt de Tongres, 1237–1274," *Bulletins de la Société scientifique et littéraire du Limbourg* 23 (1905): 201–82, at 250–53, no. VI. Paquay wrongly identified "master J." as the dean of the cathedral of Liège (Jean de Rumigny), mentioned right after him. He is John of Wildeshausen, also known as *Johannes Teutonicus*, bishop of Bosnia in 1234–37, master general of the Dominican order and papal penitentiary in 1241–52: Daniël Antoine Mortier, *Histoire des maîtres généraux de l'ordre des frères Prêcheurs*, vol. 1 (Paris: A. Picard et fils, 1903), 287–413. Many other charters related to the foundation of beguinages contain these ideas. One recalls James of Vitry's alarm that virgins intent on a life of chastity were exposed to pernicious secular influence, and his insistence that Mary of Oignies was "disgusted" by what she saw in the streets of Nivelles; see Chapter 2.

160. Compare the problems of Italian Tertiaries and other lay religious, who attempted to resist strict enclosure in the fourteenth and fifteenth centuries, after the issue of Boniface VIII's decretal *Periculoso* of 1298: Katherine Gill, "*Scandala*: Controversies concerning *clausura* and women's religious communities in late medieval Italy," in *Christendom and Its Discontents*, 177–203.

161. Verellen, "Oorkonden" (1950), 57–58, no. 4.

162. *ADN*, B 1528, no. 4211, ed. Denis du Péage, *Documents*, 31.

163. "Ene beghine die meester Robbeert doedde om haren gherechte minne" (Hadewijch, *Visioenen*, ed. and intro. Frank Willaert; trans. Imme Dros [Amsterdam: Prometheus/Bert Bakker, 1996], 160).

164. "Hec sunt hereses que fuerunt dampnate contra quosdam de Antuerpia" (Paris, Bibliothèque nationale, MS lat. 15954, fol. 263v; the manuscript largely consists of sermons preached in Paris in 1261–74). *CDIN*, vol. 1, 118–21, nos. 124–26. On the sources regarding William, and the possible date of his preaching, see Prims, "Kerkelijk Antwerpen," 219–23 (to be used with caution).

165. The expansion of Church property usually resulted in a loss of tax revenue for the city and posed a threat to communal jurisdiction (Richard Koerperich, *Les Lois sur la Mainmorte dans les Pays-Bas Catholiques. Étude sur l'édit du 15 septembre 1753, ses précédents et son exécution* [Louvain: P. Smeetsers, 1922], 23–30); even though beguinages

were not, strictly speaking, ecclesiastical institutions, they posed a clear risk of being converted at a later date into monastic enclaves. When the city magistrate of Tournai agreed to the foundation of a beguine court on urban land, in May 1241, it stipulated that it "could not be used to establish an abbey or house of a religious order without the permission of the city of Tournai;" edited, after a document now lost, by A. Hocquet, "Le Béguinage. Son véritable fondateur," *Annales de la Société historique et archéologique de Tournai* 7 (1902): 75–80, at 78–79.

166. Appendix I, no. 40A.

167. The name of the beguinages of the Wijngaard (*Vinea*, or vineyard) in Bruges, Brussels, and Oudenaarde has usually been explained as a reference to the Vineyard of the Song of Songs, 2:15 (and Innocent III's image of the *Vinea Domini* in his famous letter of 1213, see *MBB*, 414). In fact, the name is derived from a toponym (*waine* is low-lying, marshy land) that preceded the foundation of the beguinages. See J. Noterdaeme, "Wainebrugge," *Biekorf* 54 (1953): 62–66 and Ryckaert, *Brugge*, 71.

168. Walter Endrei, *L'évolution des techniques du filage et du tissage du Moyen Age à la révolution industrielle* (Paris and The Hague: Mouton, 1968), 14–47. It is estimated that up to twenty spinsters were needed to provide the materials used by one weaver. On their precarious position, see Dominique Cardon, "Arachné ligotée: la fileuse du moyen âge face au drapier," *Médiévales* 30 (1996): 13–22, and idem, *La Draperie au Moyen Age: Essor d'une grande industrie européenne* (Paris: CNRS, 1999), 221–67.

169. Favresse, "Actes," 492–97, no. 46; Guillaume Des Marez, *L'organisation du travail à Bruxelles au XVe siècle* (Brussels: Hayez, 1904), 253–54.

170. Levelt, *Het begijnhof*, 123; Juten, "Het begijnhof te Bergen op Zoom," 57–65.

171. Simons, "The Beguine Movement," 73–74; idem, "Een zeker bestaan," 138–40. The highest proportion of country women is found in court beguinages located in small centers dominated by the textile industry like Hoogstraten, where only two of the eighty-two beguines living at the court in 1619 were city-born (Lambrechts, "Het begijnhof," 58–59). By the mid-nineteenth century, even in large cities as Ghent about 90 percent of the beguines came from the country (D'Huys, "De Gentse begijnhoven," 35–40).

172. Delmaire, *Le diocèse*, vol. 1, 332.

173. De Keyzer, "Aspects," 211–12.

174. Delmaire, *Le diocèse*, vol. 1, 332, note 162.

175. Robert E. Lerner, "Vagabonds and Little Women: The Medieval Netherlandish Dramatic Fragment *De Truwanten*," *Modern Philology* 65 (1968): 301–6; Herman Brinkman and Janny Schenkel, eds., *Het handschrift-Van Hulthem. Hs. Brussel, Koninklijke Bibliotheek van België, 15.589–623* (Hilversum: Verloren, 1999), vol. 2, 1189–92, no. 210.

176. *ADN*, 1 G 91, no. 212; Simons, "Begijnen en begarden in het middeleeuwse Douai," 184.

177. *Beghini apud Brugas commorantes*, in *SAB*, B, 1st series, no. XX, ed. Gilliodts-van Severen, *Inventaire . . . l'École bogarde*, vol. 2, 1–2, no. I (16 March 1252). They were called *begard[i]* later that year: *SAB*, B, 1st series, no. II, ed. Ibid., vol. 2, 2, no. II (22 December 1252).

178. These convents still await further investigation. Along with those of Douai and Bruges, the oldest appear to be those of Diest (1257: Raymaekers, *Kerkelijk en liefdadig Diest*, 298–307), Sint-Truiden (1270: Aerts, "Begijnen en begarden," 247–8), and Nivelles (1272: Hanon de Louvet, "L'origine," 59, no. 4). See also Jozef Van Mierlo, "Het begardisme: Een synthetische studie," *Verslagen en Mededeelingen van de Koninklijke*

*Vlaamsche Academie voor Taal-en Letterkunde* (1930): 277–305. While beghard convents in the eastern provinces embraced the Rule of Franciscan Tertiaries to demonstrate their orthodoxy from 1319 on, the Flemish beghards did not do so until the late fourteenth century, see Simons, *Bedelordekloosters*, 153–55, 166–70. For the beghard movement as a whole, see Walter Simons, "Beghards," in *Encyclopedia of Monasticism*, ed. William M. Johnston (Chicago: Fitzroy Dearborn, 2000), vol. 1, 120–21.

179. Jacques Le Leu, "De Begarden te Antwerpen, 1296–1474," *Franciscana* 34 (1979): 135–57, at 135–36.

180. Goldberg, *Women, Work, and Life Cycle*, 300–301; Farmer, "Down and Out," 366.

181. Numerous examples at St. Catherine's of Tongeren in 1298–1308 (*SAT*, Begijnhof, Charters, 1st series, nos. 9, 13, 17, 23, 31, 35); St. Agnes in Sint-Truiden in 1276–1328 (*RAH*, Begijnhof Sint-Truiden, Charters, nos. 10, 18, 22, 47); the Wijngaard in Bruges in 1256 and 1381 (*AOCMWB*, Begijnhof, charters, no. 7; *BAB*, C 419, charter at date 6 February 1381); St. Elizabeth in Ghent (*RAG*, Sint-Elisabethbegijnhof, Charters, at date June 1277); Ten Hove at Louvain in 1286 (*LUB*, XVII, no. 7): the convent of Harnes in Douai in 1349 (*AMD*, FF 862, at date 28 November 1349) and many other beguinages.

182. At St. Elizabeth Ghent in 1279 (*SAG*, B, no. 28, ed. *BC*, 25, no. 28); 's-Hertogenbosch in 1296 (H. P. H. Camps, ed., *Oorkondenboek van Noord-Brabant tot 1312. I. De meierij van 's-Hertogenbosch (met de heerlijkheid Gemert)* [The Hague: Martinus Nijhoff, 1979], vol. 2, 655–56, no. 540; see also vol. 1, 437–38 and 441–42, nos. 347 and 351); Dinant in 1302 (Brouwers, "Analectes," 254).

183. At Aardenburg in 1307 (Lucien Ceyssens, "Eenige oorkonden over het Begijnhof van Aardenburg," *HSEB* 78 [1935]: 59–102, at 62–63, no. I); Sint-Truiden in 1385 (*SAH*, Begijnhof Sint-Truiden, Charters, no. 71); St. Elizabeth of Ghent in 1427, 1431, 1434, 1439 (*RAG*, Bisdom, E 373, fol. 5r–6r, 11r–12r, 16v–17r, 25v–26r).

184. At the beguinage des Prés of Tournai in 1492 (de la Grange, "Choix," 337, no. 1183).

185. *SAT*, Begijnhof, no. 68a (the total number of houses was forty-six); Thijs, *Histoire*, 430–32; Henri Baillien, "Het Begijnhof van Tongeren, zijn aanleg, plaatsnamen, gebouwen en bewoonsters," *Het Oude Land van Loon* 25 (1970): 55–100, at 58, 73–100; *SAT*, Begijnhof, Charters, 1st series, no. 48 (26 March 1317). In nineteenth-century Ghent, beguines also tended to originate from a specific set of villages (D'Huys, "De Gentse begijnhoven," 36–39).

186. A sample of many documents: *AMD*, FF 861, at dates December 1266, March 1273; *AMD*, FF 862, at date February 1308; *AEL*, Dominicains, no. 27 (12 November 1269). Farmer, "Down and Out," 364–67, cites examples of such relationships among beguines of Paris in the thirteenth century.

187. For example, in St. Elizabeth's of Ghent in 1428, 1434, 1443, and 1443 (*RAG*, Bisdom, E 373, fol. 8r–9v, 15v–16v, 30r–v, 31r–v); in the beguinage of Hoogstraten in 1566 (Lambrechts, "Het begijnhof," 140).

188. In the beguinage of Hoogstraten, 1422–79 (ibid., 133, 136).

189. *SAT*, Begijnhof, Charters, 2nd series, at date 1264, ed. Paquay, "Regesta de Marcuald," 268–70.

190. *SAG*, B, no. 30, ed. *BC*, 26–27, no. 30 (October 1274); Philippen, "Het Begijnhof van Sint-Catharina," 511–12, no. II (11 March 1272) and Raymaekers, *Het kerkelijk en*

*liefdadig Diest*, 430–31, note 1 (21 March 1272); *ADN*, B 1528, no. 1974, ed. Denis du Péage, *Documents*, 23–24 (25 July 1277).

## Chapter 5. Conflict and Coexistence

1. Paris, Bibliothèque nationale, MS lat. 16482, fol. 162v–163r (with additions on 21r–22r, 77r–v, 166v–168r, 253v–254r). See Bériou, "La prédication au béguinage de Paris," 159–60.

2. " 'Non est mirum si una monacha uel nona cadat in peccatum et uadat ad malum pudorem.' 'Sancta Maria,' dixi ego, 'quid dicitis uos?' . . . Et illa: 'Domine, ostendo uobis qui dicere uolo. Ego habeo .iiii.or uel v filias. Non potero maritare eas secundum quod status meus et earum requirit, sed oportebit me eas maritare ad sutores (chauetiers) si uolo eas maritare. Et cogitans quod hoc esset michi pudor secundum mundum, licet non secundum Deum, pono eas in religione ita quod nec Deus, nec mater sua, nec sancti eius inuocabuntur ad introitum. Sed dabo abbacie centum libras uel ducentas, ita quod nec puer habet Deum pre oculis, nec ego, nec abbatissa, nec priorissa. Nec Deus est ibi inuocatus, nec est ad introitum. Quid igitur mirum si malus sit euentus ex quo malus est introitus? Sed quando una begina uadit ad begginagium, uadit ibi de propria uoluntate, et est beggina de propria uoluntate. Et ideo, ex quo de sua propria uoluntate uadit inter alias sanctas et probas mulieres, deberet lapidari et flatrir quando facit rem inhonestam et facit magnum scandalum.' " (Paris, Bibliothèque nationale, MS lat. 16482, fol. 167v).

3. See Chapter 2. Upon completing the book, I read Renate Blumenfeld-Kosinski, "Satirical Views of the Beguines in Northern French Literature," in *New Trends*, 237–49, which discusses some of the same sources, drawing similar but slightly divergent conclusions from them.

4. Edmond Faral and Julia Bastin, eds., *Oeuvres complètes de Rutebeuf* (Paris: A. et J. Picard, 1959–60), vol. 1, 334–35; see also 318–33 for *Les Ordres de Paris* and the *Chanson des Ordres*.

5. See Constable, *Three Studies*, 109.

6. Schmitt, *Mort d'une hérésie*; Lerner, *The Heresy of the Free Spirit*. There are important differences of opinion between the two scholars that cannot be discussed at length here; see for instance Lerner's review of Schmitt's book in *Speculum* 54 (1979): 842–45. See also I. Wormgoor, "De vervolging van de Vrijen van Geest, de begijnen en begarden," *Nederlands Archief voor Kerkgeschiedenis* 65 (1985): 107–30; Kate P. Crawford Galea, "Unhappy Choices: Factors that Contributed to the Decline and Condemnation of the Beguines," *Vox Benedictina* 10 (1993): 57–73; and Anke Passenier, " 'Women on the Loose': Stereotypes of Women in the Story of the Medieval Beguines," in *Female Stereotypes in Religious Traditions*, ed. Ria Kloppenborg and Wouter J. Hanegraaff, Studies in the History of Religions, LXVI (Leyden: E. J. Brill, 1995), 61–88.

7. Quando autem puella virginitatem suam custodire proposuit et parentes offerunt ei maritum cum diviciis, conculcet et respuat . . . . [P]relati scilicet seculares et alii maliciosi homines, volunt eam interficere et a bono proposito retrahere dicentes: "Hec vult esse Beguina"—sic enim nominantur in Flandria et Brabancia—, vel Papelarda—sic enim appellantur in Francia—, vel Humiliata—sicut dicitur in Lombardia—, vel Bizoke—secundum quod dicitur in Ytalia—, vel Coquennunne—ut dicitur in Theo-

tonia—; et ita deridendo eas et quasi infamando nituntur eas retrahere a sancto proposito" (ed. Greven, "Der Ursprung," 44); see also *PB*, 24.

8. Josef van Mierlo, "Ophelderingen bij de vroegste geschiedenis van het woord begijn," *Verslagen en Mededeelingen der Koninklijke Vlaamse Academie voor Taal- en Letterkunde* (1931): 983–1006.

9. *Annales Colonienses Maximi*, ed. Karolus Pertz, in *MGH, SS.*, vol. 17 (Hannover: Hahn, 1861), 824–27. Amalricus's followers were called *papelardos* in the Annals of the Cistercian abbey of Mailros (see *GRB*, 356–58). On the southern French "Béguins," who have little to do with the beguines of the southern Low Countries, see Robert E. Lerner, "Beguins," in *Dictionary of the Middle Ages*, ed. Joseph R. Strayer, vol. 2 (New York: Charles Scribner's Sons, 1983), 162–63, and Geneviève Brunel-Lobrichon, "Existe-t-il un Christianisme méridional? L'exemple de Douceline: le béguinage provençal," *Heresis* 11 (1988): 41–51.

10. *Dialogus Miraculorum*, ed. Strange, vol. 1, 59–60. The context makes clear that these *begginas* were early Cistercian nuns.

11. Maurits Gysseling, "De herkomst van het woord begijn," *Heemkundig Nieuws* 13 (1985): 9–12, at 12; see also Pierre Bougard and Maurits Gysseling, *L'impôt royal en Artois (1295–1302). Rôles du 100e et du 50e présentés et publiés avec une table anthroponymique* (Brussels: Commission royale d'Histoire, 1970), 173.

12. *MOB*, 418–26.

13. Their habit is clearly shown in an illumination from the mid-fourteenth century representing abbot Gilles le Muisit admonishing beguines of Tournai (*KB*, MS IV 119, fol. 84r; *LS*, 24, plate).

14. Gysseling, "De herkomst," 12.

15. Ibid., 10–11. For the earliest uses of *lollaert* (ca. 1309) and its meaning, see Dietrich Kurze, "Die festländischen Lollarden," *Archiv für Kulturgeschichte* 47 (1965): 48–76; Lerner, *The Heresy*, 40–41; Simons, *Bedelordekloosters*, 157. The name later crossed the channel and was applied to the first heretical movement on English soil, the Lollards.

16. Ferdinand de Saussure, *Cours de linguistique générale*, ed. Charles Bally et al. (Paris: Payot, 1968), 262.

17. Gautier de Coincy, *De sainte Léocade*, ed. Eva Vilamo-Pentti (Helsinki: Société de Littérature Finnoise, 1950), 168–84. See *GRB*, 378–84.

18. Ibid., 309, vv. 1190–93.

19. Jean-Charles Payen, "La satire anticléricale dans les oeuvres françaises de 1250 à 1300," in *1274-Année charnière. Mutations et continuités* (Paris: C. N. R. S., 1977), 261–80.

20. *Van Eenre Baghinen ene Goede Boerde*, and *Dits vanden Tanden*, ed. Brinkman and Schenkel, *Het handschrift-Van Hulthem*, vol. 2, 625–27 and 864; see also, for a beguine's stereotypical hypocrisy, Bouden vander Lore's *Achte Persone Wenschen*, ibid., vol. 1, 250–54.

21. See, for example, Louis Maes, *Vijf eeuwen stedelijk strafrecht. Bijdrage tot de rechts- en cultuurgeschiedenis der Nederlanden* (Antwerp: De Sikkel; The Hague: Martinus Nijhoff, 1947), 220, 585–86, 596 (Mechelen, 1458, 1462); *ADN*, B 32, fol. 146v (Lille, 1469); Vleeschouwers and Van Melkebeek, *Liber sentenciarum*, vol. 1, 387, no. 523 (Vilvoorde, 1453) and vol. 2, 822–23, 833, nos. 1330–31, 1351 (Wijngaard Brussels, 1458). The particular types of sources that revealed these violations of vows of chastity in the fifteenth century, that is, registers kept by episcopal judges (officials) or urban courts, did not exist in the thirteenth.

22. Szittya, *The Antifraternal Tradition*, 6–7, 31–61; Dufeil, *Guillaume*.

23. *Historia Occidentalis*, 165; *CR*, 7, 11.

24. "Beguin, ce dient, sunt benigne,//Beguin, ce dient, sunt si digne//. . . Beguin ce dient, se derive//Et vient a *benignitate*://Ha! Ha! larron, quel barat, hé!//G'i sai autre dirivoison,//. . . Beguin certes ne sont pas douz,//Ja soit ce qu'aient simples vouz,//Ainz sunt poignant plus de fregum.//Beguin se vienent de begun "(Gautier de Coincy, *De Sainte Léocade*, 183–84, vv. 1521–31); Lerner, *The Heresy*, 39.

25. "La gramaire *hic* a *hic* acouple,//Mais Nature maudit la couple.//. . . Nature rit, si com moi samble,//Quant *hic* et *hec* joignent ensamble.//Mais *hic* et *hic* chose est perdue,//Nature en est tout esperdue,//Ses poinz debat et tort ses mains" (Gautier de Coincy, *De sainte Léocade*, 172, vv. 1233–43).

26. John Boswell, *Christianity, Social Tolerance, and Homosexuality: Gay People in Western Europe from the Beginning of the Christian Era to the Fourteenth Century* (Chicago: University of Chicago Press, 1980), 259; Jan Ziolkowski, *Alan of Lille's Grammar of Sex: The Meaning of Grammar to a Twelfth-Century Intellectual* (Cambridge: The Medieval Academy of America, 1985).

27. Walter wrote before the formation of beguinages, where beguines often lived as couples and formed long-term relationships. Although some beguines appear to have engaged in lesbian sex and were punished for it, it did not become a stock accusation used against them. For a case of a young beguine of Mechelen condemned for lesbian acts in 1450, see Maes, *Vijf eeuwen*, 567, no. 103.

28. Stroick, *Collectio*, 62; see also 58, for Guibert's remarks on the uncertain status of the beguines. The reference to beguines reading the Bible in their workshops alludes to their customary discussions of sermons and texts during their work. Gilbert's suspicion of those talks anticipated the satirical works of later centuries that scrutinize women's conversation during spinning, such as the French *Evangile des Quenouilles*, and the Flemish *Evangelien vanden spinrocke*, see Dirk Callewaert, *Die evangelien vanden spinrocke. Een verboden volksboek "zo waar als evangelie" (ca. 1510)* (Kapellen, Belgium: DNP/Pelckmans, 1992). *GRB*, 334–40 incorrectly attributed the *Collectio* to Simon of Tournai; for a discussion of authorship and sources, see Autbertus Stroick, "Verfasser und Quellen der Collectio de Scandalis Ecclesiae (Reformschrift des Fr. Gilbert von Tournay, O.F.M., zum II. Konzil von Lyon, 1274)," *Archivum Franciscanum Historicum* 23 (1930): 3–41, 273–99, 433–66.

29. Philippe Buc, "*Vox clamantis in deserto?* Pierre le Chantre et la prédication laïque," *Revue Mabillon* 65 (1993): 5–47. Peter's thoughts on the matter were inspired by the Church's measures against Waldensian preaching.

30. Buc, "*Vox clamantis*," 13, 20–21. See also Rolf Zerfass, *Der Streit um die Laienpredigt. Ein pastoralgeschichtliche Untersuchung zum Verständnis des Predigtamtes und zu seiner Entwicklung im 12. und 13. Jahrhundert* (Freiburg: Herder, 1974).

31. *Decretum*, Ia pars, dist. XXIII, c. xxix, ed. Aemilius Friedberg, *Corpus Juris Canonici* (Leipzig: B. Tauchnitz, 1879–82), vol. 1, col. 86.

32. Thomas of Chobham, *Summa de Arte Praedicandi*, ed. Franco Morenzoni (Turnhout: Brepols, 1988), 57; Lauwers, "*Praedicatio-Exhortatio*," 205–07.

33. Peter the Chanter, Commentary on Romans 10:13–16, ed. Buc, "*Vox clamantis*," 37.

34. Ibid., 37.

35. O. Hageneder, W. Maleczek, and A. A. Strnad, *Die Register Innocenz' III*, vol. 2

(Graz, Cologne, and Vienna: Österreichischen Kulturinstituts in Rom, 1979), 271–75, no. 132.

36. *Historia Occidentalis*, 94.

37. See Chapter 2.

38. Paquay, "Regesta de Renier," 1–9.

39. Alcuin Blamires, "Women and Preaching in Medieval Orthodoxy, Heresy, and Saints' Lives," *Viator* 26 (1995): 135–52. Not surprisingly, this discussion was of interest to Church authorities wishing to refute Lollard claims in favor of women preaching in late fourteenth-century England; see Alcuin Blamires and C. W. Marx, "Women Not to Preach: A Disputation in British Library MS Harley 31," *The Journal of Medieval Latin* 2 (1993): 34–63, and Margaret Aston, "Lollard Women Priests?" *Journal of Ecclesiastical History* 31 (1980): 441–61. See also Francine Cardman, "The Medieval Question of Women and Orders," *The Thomist* 42 (1978): 582–99; John Hilary Martin, "The Injustice of Not Ordaining Women: A Problem for Medieval Theologians," *Theological Studies* 48 (1987): 303–16; and Alcuin Blamires, *The Case for Women in Medieval Culture* (Oxford: Clarendon Press, 1997), 188–98.

40. Cardman, "The Medieval Question," 586–87.

41. Blamires, "Women and Preaching," 139–47, with further references.

42. Blamires and Marx, "Woman Not to Preach," 54, 62.

43. Eustace of Arras, *Quodlibeta*, II, q. 5, ed. Jean Leclercq, "Le magistère du prédicateur au XIIIe siècle," *Archives d'histoire doctrinale et littéraire du Moyen Age* 21 (1946): 105–47, at 120; Leclercq dates the work to 1263–66. I have followed the translation by Blamires, "Women and Preaching," 148.

44. *VC*, 655, 657. See Sweetman, "Christine," 72–73.

45. See Chapter 3.

46. Lauwers, "*Noli me tangere.*" See also Oliver, *Gothic Manuscript Illumination*, vol. 2, 414 (Illumination in a Book of Hours attributed to beguines of Huy, c. 1300–10, now at Baltimore, Walters Art Gallery MS 37, fol. 100v). On the changing nature of the Magdalen's image, see most recently Katherine Ludwig Jansen, *The Making of the Magdalen: Preaching and Popular Devotion in the Later Middle Ages* (Princeton: Princeton University Press, 2000).

47. Anne Bergmans, "Een mystieke bruid anno 1300: *La douce Madeleine?*" in *Hooglied*, 264–70, citing fifteenth-century Italian examples of this theme. *In beeld geprezen. Miniaturen uit Maaslandse devotieboeken 1250–1350*, Exhibition Catalog (Louvain: Peeters, 1989), 155–57, discusses other interpretations of the image: as an early image of the Vera Icon, or a symbolic representation of *Sapientia*. For a depiction of the Magdalen in the church of the main beguinage of Louvain, see Anne Bergmans et al., "De Sint-Jan-de-Doperkerk van het groot begijnhof in Leuven," *Monumenten en Landschappen* 4, no. 4 (1985): 6–27.

48. Hadewijch, *Visioenen*, 150; Marguerite Porète, *Le Mirouer des Simples Ames/ Margaretae Porete, Speculum Simplicium Animarum*, ed. Romana Guarnieri and Paul Verdeyen (Turnhout: Brepols, 1986), 350–60. See also Frank Willaert, "Hadewijch en Maria Magdalena," in Elly Cockx-Indestege and Frans Hendrickx, eds., *Miscellanea Neerlandica. Opstellen voor Dr. Jan Deschamps ter gelegenheid van zijn zeventigste verjaardag* (Louvain: Peeters, 1987), 57–69; Hollywood, *The Soul as Virgin Wife*, 111–12; Newman, *From Virile Woman*, 174–78.

49. Napoleon De Pauw, "Dernières découvertes concernant le Docteur solennel

Henri de Gand, fils de Jean le Tailleur (Formator ou De Sceppere)," *BCRH* 4th s., 16 (1889): 27–138, at 116–19, no. 7.

50. Bériou, "La prédication au béguinage," 193–94, and 200–201.

51. *VE*, 362–78, at 373. See Walter Simons and Joanna E. Ziegler, "Phenomenal Religion in the Thirteenth Century and Its Image: Elisabeth of Spalbeek and the Passion Cult," in W. J. Sheils and Diana Wood eds., *Women in the Church* (Oxford: Basil Blackwell, 1990), 117–26, and Simons, "Reading a Saint's Body," 10–13. For the use of the female body to teach the mysteries of the Passion, see Caroline Bynum, "The Female Body and Religious Practice in the Later Middle Ages," in idem, *Fragmentation and Redemption*, 181–238.

52. Louis Peter Grijp, "De zingende Hadewijch. Op zoek naar de melodiën van haar Strofische Gedichten," in Frank Willaert, ed., *Een zoet akkoord. Middeleeuwse lyriek in de Lage Landen* (Amsterdam: Prometheus, 1992), 72–92.

53. McGinn, *The Flowering of Mysticism*, 19–21.

54. See J.-Th. Welter, *L'exemplum dans la littérature religieuse et didactique du Moyen Age* (Paris and Toulouse: Occitania, 1927), 236–44, and Alfons Hilka, "Neue Beiträge zur Erzählungsliteratur des Mittelalters (die Compilatio Singularis Exemplorum der Hs. Tours 468, ergänzt durch eine Schwesterhandschrift Bern 679)," *Jahresbericht der Schlesischen Gesellschaft für vaterländische Cultur* 90 (1913): 1–24, at 3.

55. *Vous dites et nous faisons.//Vous aprenés et nous aprenons.//Vous lisés et nous eslisons.//Vous machiés et nous engloucissons.//Vous marcheandés et nous acatons.//Vous enluminés et nous embrasons.//Vous quidés et nous savons.//Vous demandés et nous prenons.//Vous querés et nous trouvons.//Vous amés et nous languissons. //Vous languissiés et nous mourons. //Vous semés et nous messonnons.//Vous labourés et nous reposons. //Vous agraillissiés, nous engroissons.//Vous sonnés et nous cantons.//Vous cantés et nous espringons.//Vous florissiés, nous fructefions.//Vous goustés, nous assavorons.* (Bern, Burgerbibliothek, MS 679, fol. 14v–15r, c. 1300). Alfons Hilka, "Altfranzösische Mystik und Beginentum," *Zeitschrift für romanische Philologie* 47 (1927): 121–70, at 160, offers a slightly different version of the text based on Tours, Bibliothèque municipale, 468, which dates from the fifteenth century.

56. On such processional effects of metaphor and metonym, see James W. Fernandez, "The Mission of Metaphor in Expressive Culture," *Current Anthropology* 15 (1974): 199–45. On paradoxes in mystical writing, see, among many works, Michael A. Sells, *Mystical Languages of Unsaying* (Chicago: University of Chicago Press, 1994).

57. Helen Solterer, *The Master and Minerva. Disputing Women in French Medieval Culture* (Berkeley and Los Angeles: University of California Press, 1995). The conversation between the master and beguine also contains elements of the fourteenth-century *Schwester Katrei* texts; for the latter, see Lerner, *The Heresy*, 213–21; Newman, *From Virile Woman*, 172–81. For master Robert of Sorbon's statement that beguines would receive a milder sentence at the Last Judgment than many learned men, see *GRB*, 322–23.

58. Tours, Bibliothèque municipale, 468 (fifteenth century), and Upsala, University Library, MS C 523 (fourteenth century), see Hilka, "Altfranzösische Mystik," 160.

59. Bern, Burgerbibliothek, MS 679, fol. 15r.

60. In 1304 a beguine of Metz living in Flanders was arrested and tortured in Paris for treason. She apparently had gained access to the royal court because of her prophetic gifts but fell out of favor during the Franco-Flemish conflict of 1297–1305 (*MBB*, 523; Lerner, *The Heresy*, 70). It was not the first time that the French royal family consulted

a beguine visionary from the Low Countries: in 1276–78, after the sudden death of the dauphin, the French crown sought the advice of Elizabeth of Spalbeek. See Simons and Ziegler, "Phenomenal Religion," 117; Remco Sleiderink, "Elisabeth van Spalbeek en de dood van de Franse kroonprins," *Madoc* 11 (1997): 42–53.

61. Van Wintershoven, "Notes et documents," 68–70, no. I. The text of this document is corrupt; it can be restored in part on the basis of the charter issued by bishop Hugh in 1296, edited in M. D. D. Brouwers, "Documents relatifs à l'administration du béguinage Saint-Christophe à Liège," *ASHEB* 32 (1906): 266–76, at 270–72, no. II.

62. Ghent, Begijnhof Ter Hooie, Charters, no. 24.

63. The sources for the trial were most recently examined by Paul Verdeyen, "Le procès d'Inquisition contre Marguerite Porète et Guiard de Cressonessart (1309–10)," *RHE* 81 (1986): 47–94. On the exact nature of the charge and grounds for conviction, see also Kent Emery, Jr., "Foreword: Margaret Porette and Her Book," and Edmund Colledge, "Introductory Interpretative Essay," in Margaret Porette, *The Mirror of Simple Souls*, trans. Edmund Colledge, J. C. Marler, and Judith Grant (Notre Dame: University of Notre Dame Press, 1999), vii–xxxii, xxxv–lxxxvii.

64. Tanner, *Decrees*, 383, c. 28, *Ad Nostrum*. For the context and antecedents of the decree, see Lerner, *The Heresy*, 78–84. As Jacqueline Tarrant, "The Clementine Decrees on the Beguines: Conciliar and Papal Versions," *Archivum Historiae Pontificae* 12 (1974): 300–308 explained, the exact nature of the council's condemnation of beguines is obscured by the fact that the decrees were significantly revised before their promulgation as part of the Clementine constitutions on 1 November 1317. For later interpretations of the decrees concerning the beguines, see Elizabeth Makowski, "*Mulieres Religiosae*, Strictly Speaking: Some Fourteenth-Century Canonical Opinions," *The Catholic Historical Review* 85 (1999): 1–14.

65. Tanner, *Decrees*, 374. Lerner, *The Heresy*, 47–49, 94–95; Schmitt, *Mort d'une hérésie*, 70–72; *MBB*, 521–29. See also Alexander Patschovsky, "Strassburger Beginenverfolgungen im 14. Jahrhundert," *Deutsches Archiv* 30 (1974): 56–198.

66. *CDIN*, vol. 2, 72–74, no. 44 (edition based on *KB*, MS 2670–82, fol. 228r-v).

67. *CDIN*, vol. 2, 78–80, nos. 47–48; I disagree with the interpretation of the first bull in *MBB*, 539.

68. Brouwers, "Documents," 274–76 (28 June 1320).

69. *ADN*, 40 H 552, no. 1336. For the pope's instructions that prompted these inspections, see *MBB*, 540–41.

70. *SAT*, Begijnhof, Charters, 2nd series, at date, ed. Straven, *Notice*, 111–14.

71. *MBB*, 541–46. The bishops' actions in Flanders were probably slowed down by the general disarray in large parts of the county during the peasants' revolt of 1323–28.

72. *SAG, B*, no. 94, ed. *BC*, 67, no. 94.

73. A draft of the petition has been preserved in Ghent, Begijnhof Ter Hooie, Charters, no. 43. Defenders of the beguines used the text to compose a report on the beguines' behavior submitted to episcopal investigators on 14 May 1328 (*SAG, B*, no. 106, ed. *BC*, 73–77, no. 106; Ghent, Begijnhof Ter Hooie, Charters, no. 52C).

74. *SAG, B*, no. 94, ed. *BC*, 67, no. 94.

75. Ghent, Begijnhof Ter Hooie, Charters, no. 48 (24 November 1321).

76. *SAG, B*, no. 96, ed. *BC*, 68, no. 96 (29 February 1320, St. Elizabeth Ghent).

77. Bonenfant, "Une fondation," 103, note 1 (Wijngaard of Brussels, 1324–28). Bonenfant (and others) wrongly assumed that the beguinage was closed at that time.

78. *SAG*, Reeks LXXVII, Charters, no. 94 (dorsal note).

79. Tanner, *Decrees*, 326–27 (c. 23, *Religionum Diversitatem*).

80. *BC*, 42–43, no. 56.

81. Bruges, Stadsbibliotheek, MS 599 (8), 38–40. On the transition of beguines to the Third Orders in the Netherlands, Germany, and Switzerland, see Koorn, *Begijnhoven*, 16–24 and Wilts, *Beginen*, 196–203.

82. *RAG*, Sint-Elisabethbegijnhof, Charters, at date 8 February 1329.

83. See for example Raymaekers, *Kerkelijk en liefdadig Diest*, 461 (Diest, 1320–21).

84. *ADN*, B 1562, fol. 89r, B 1565, fol. 63v; *SAH*, Begijnhof Sint-Truiden, Charters, no. 54 (8 October 1344).

85. See for instance the will of Bartholomew, priest of Dudzele, written in January 1269: Bruges, Groot Seminarie, Ter Duinen, Charters, no. 1037.

86. Elizabeth was related to William of Ryckel, abbot of Sint-Truiden, who was certainly noble (*VE*, 373).

87. Marguerite Porète, *Le Mirouer*, 344.

88. Verdeyen, "Le procès," 60.

89. Guido Hendrix, "Hadewijch benaderd vanuit de tekst over de 28e volmaakte," *Leuvense Bijdragen* 67 (1978): 129–45. Wybren Scheepsma, "Hadewijch und die Limburgse sermoenen. Überlegungen zu Datierung, Identität und Authentizität," in Walter Haug and Wolfram Schneider-Lastin, eds., *Deutsche Mystik im abendländischen Zusammenhang. Neuerschlossene Texte, neue methodische Ansätze, neue theoretische Konzepte. Kolloquium Kloster Fischingen 1998* (Tübingen: Universität Tübingen, in press) has reopened the discussion, arguing that Hadewijch wrote around 1300. I am very grateful to Dr. Scheepsma for sharing his important essay with me.

90. Hadewijch, *Letter V*, 15, in Paul Mommaerts, ed., *De brieven van Hadewijch* (Averbode: Altiora; Kampen: Kok, 1990), 40.

91. Richard Kieckhefer, "Convention and Conversion: Patterns in Late Medieval Spirituality," *Church History* 67 (1998): 32–51, has suggested that some late medieval mystics turned to inward contemplation in part as a reaction against the "devotional churchliness" of their contemporaries; this does seem to be the case for Marguerite Porète and, to a lesser degree, for Hadewijch.

92. Jan Paquay, "Het eerste statuut der begijnhoven," *Verzamelde Opstellen* 11 (1935): 13–204, at 190.

93. Marechal, "Konventen," 257.

94. See Appendix I.

95. For a brief survey of these rules, see Ziegler, *Sculpture of Compassion*, 96–106.

96. See for example the wills of Katerina van Zerkingen, beguine at St. Agnes of Sint-Truiden, of October 1284 (*RAH*, Begijnhof Sint-Truiden, Charters, no. 13), or those of Helewidis de Angulo and Menta de Blole, of St. Catherine's at Tongeren, of 20 October 1291 and 6 May 1306, respectively (*SAT*, Begijnhof Tongeren, Charters, 1st Series, nos. 15, 33).

97. Philippe George, "À Saint-Trond, un import-export de reliques des Onze Mille Vierges au XIIIe siècle," *Bulletin de la Société royale Le Vieux-Liège* 252–53 (1991): 209–28. Elizabeth of Spalbeek was herself in touch with a recluse of Lille (*VE*, 376).

98. See Michel Van der Eycken, "Nicolaas van Essche en de hervorming van het Diestse Begijnhof," *Arca Lovaniensis* 5 (1976): 277–97; Olyslager, *750 jaar*, 193–98. On the trend toward greater "claustration" of religious women influenced by the Modern Devout

in the late fourteenth and fifteenth centuries, see Weiler, "Geert Grote en begijnen," 131–32 and Florence Koorn, "Hollandse nuchterheid? De houding van de Moderne Devoten tegenover vrouwenmystiek en ascese," *OGE* 66 (1992): 97–114.

99. The term is virtually untranslatable: the English "bigot" comes close, but does not convey its sense of artlessness.

100. See for instance the accounts of the beguinage of Kortrijk for 1444, 1450–51 (De Cuyper, "Het Begijnhof," 27, 40).

101. See Chapter 4.

102. Devillers, "Cartulaire du béguinage de Cantimpret," 279–82, 286–88, 298–300, nos. 46–47, 49, 54; *RAG*, Bisdom, E 373, fol. 8r-v.

103. Ghent, Begijnhof Ter Hooie, Collectie Winnepennick, uncatalogued. The list was edited most recently in Albert Derolez, ed., *Corpus Catalogorum Belgii*, vol. 3 (Brussels: Paleis der Academiën, 1999), 28–31 (see page 28, item [5]). Compare Marguerite Porète, *Le Mirouer des Simples Ames*, 10. On the problems of assessing book ownership by beguines, see my "Geletterdheid en boekengebruik," 170–74.

## Chapter 6. Conclusion

1. *SAG, B*, no. 315, ed. *BC*, 208–23, no. 315, at 208.

2. The reference is clearly to Protestants, ibid., 209.

3. Ibid., 209.

4. Lievin's foundation contained a great number of other clauses that I leave aside for simplicity's sake. Maijke Bennin's convent was that of Ter Leijen; Gheertruyt vander Linden lived at the convent of Beertelins. Lievin probably died shortly after the registration of this will in 1559.

5. See for instance the writings of the Dominican Henry of Calster, confessor of Petrissa, beguine of St. Catherine's of Mechelen around 1300 (Stephanus Axters, "De zalige Hendrik van Leuven, O. P.," *OGE* 21 [1947]: 225–56); Nicolas van Essche (*not* a Mendicant), in touch with the beguine mystic Mary of Hout at Oisterwijk in the 1530s and 1540s (J. M. Willeumier-Schalij, ed., *De brieven uit 'Der Rechte Wech' van de Oisterwijkse begijn en mystica Maria van Hout (+ Keulen, 1547)* [Louvain: Peeters, 1993], 5–7, 64, and Kirsten M. Christensen, "Maria van Hout and her Carthusian Editor," *OGE* 72 [1998]: 105–21); the Franciscan Frans Vervoort (+1550), active among beguines of Mechelen and perhaps also Brussels (*Jan van Ruusbroec 1293–1381*, Exhibition catalogue [Brussels: Koninklijke Bibliotheek Albert I, 1981], 306–8). Archival documents contain oblique references to such relationships, see for instance the accounts of the friars who sold indulgences in the diocese of Liège in 1443–46 (Paul Fredericq, *Les comptes des indulgences dans les Pays-Bas. Deuxième série. Les comptes des indulgences papales émises au profit de la cathédrale de Saint-Lambert, à Liège (1443–1446)* (Brussels: Hayez, 1903–4), 10–11, 25–28, 40–42). For James, Thomas, and other clerical supporters of beguines and beguinages, see Chapters 2, 4, and 5.

6. See *BHF*, 263–67, and Bynum, *Fragmentation and Redemption*, 151–238. Even the beguines' radical, but not unorthodox, interpretation of the Magdalen as a female preacher may have received the support of certain clerics aware of the gnostic understandings of the figure (for the latter, see Newman, *From Virile Woman*, 172–81).

7. Léonce Reypens, "Markante mystiek in het Gentsch begijnhof. Claesinne van

Nieuwlant (±1550-1611)," *OGE* 12 (1939): 291-360; idem, "Pelgrim Pullen (1550-1608). Een heilig mystiek leider en zijn onuitgegeven geschriften," *OGE* 3 (1929): 22-44, 125-43, 245-77. See also Ryckel, *Vita S. Beggae*, 475-88; Hadewich Cailliau, *"Soo geluckigh als een beggijn."* *Het begijnhof Onze-Lieve-Vrouw-Ter-Hooie 1584-1792* (Ghent: Maatschappij voor geschiedenis en oudheidkunde, 1995), 157-58.

8. *Het Leven Van de seer Edele Doorluchtighste en H. Begga hertoginne van Brabant, Stichtersse der Beggynnen . . . door eenen onbekenden Dienaer Godts* (Antwerp: By de Weduwe van Petrus Jacobs, 1712).

9. John Coakley, "Friars as Confidants of Holy Women in Medieval Dominican Hagiography," in Renate Blumenfeld-Kosinski and Timea Szell, eds., *Images of Sainthood in Medieval Europe* (Ithaca and London: Cornell University Press, 1991), 222-46; idem, "Gender and the Authority of Friars: The Significance of Holy Women for Thirteenth-Century Franciscans and Dominicans," *Church History* 60 (1991): 445-60. See also Newman, *From Virile Woman*, 211-12.

10. Kaspar Elm, "*Vita regularis sine regula.* Bedeutung, Rechtsstellung und Selbstverständnis des mittelalterlichen und frühneuzeitlichen Semireligiosentums," in Frantisek Smahel and Elisabeth Müller-Luckner, eds., *Häresie und vorzeitige Reformation im Spätmittelalter* (Munich: R. Oldenbourg Verlag, 1998), 239-73, and idem, "Die Stellung der Frau," 16-17. See also Giles Gérard Meersseman, *Dossier de l'ordre de Pénitence au XIIIe siècle* (Fribourg: Éditions universitaires, 1961); Anna Benvenuti Papi, "Donne religiose nella Firenze del due-trecento; appunti per una ricerca in corso," in *Le mouvement confraternal au moyen âge: France, Italie, Suisse* (Rome: École française de Rome, 1987), 41-82; and the essays collected in *Women and Religion in Medieval and Renaissance Italy*; for an explicit comparison of the Italian penitential movement and the beguines, see now also Wherli-Johns, "Voraussetzungen," 299-308.

11. Assuming, of course, that "orthodoxy" can easily be defined throughout the thirteenth and sixteenth centuries. It must be said that in the sixteenth century, only very few beguines were accused of Lutheran, Calvinist, or Anabaptist convictions. The only examples that I found are: at St. Catherine's of Antwerp in 1530 and 1580-81 (case of a "heretical priest," and one Calvinist beguine, respectively: Olyslager, *750 Jaar*, 55, 101); at Bergen-op-Zoom in 1525 (priest of the beguinage, and at least one beguine, convicted of Lutheran sympathies: Levelt, *Het Begijnhof*, 20-24, 113-22); at the main beguinage of 's-Hertogenbosch in 1526 (two beguines convicted of Lutheran faith: C. R. Hermans, *Verzameling van Kronyken, Charters en Oorkonden betrekkelijk de stad en meijerij van 's-Hertogenbosch*, vol. 1 ['s-Hertogenbosch,: P. Stokvis, 1848], 96-98).

12. See Chapter 2. Generally, the "active" religious life for women may have been more widespread in parts of northern Europe than we previously believed, see Harline, "Actives and Contemplatives."

13. Beguine courts, which played a large role in attracting such laborers (see Chapter 5), closely resemble in this respect the housing complexes erected for rural women in the mill towns of nineteenth-century New England, discussed by Thomas Dublin, *Women at Work: The Transformation of Work and Community in Lowell, Massachusetts, 1826-1860* (New York: Columbia University Press, 1979).

14. My preliminary research suggests that the new expansion of beguine population in the seventeenth century should not be attributed only to Counter Reformation preaching to women, but may also be explained by the relative prosperity of the urban economy in the period, and the deterioration of economic prospects for rural women.

See Simons, "Een zeker bestaan." On the notion of high labor-status, see Howell, *Women, Production, and Patriarchy*, 21-26.

15. Miri Rubin, "Small Groups: Identity and Solidarity in the Late Middle Ages," in Jennifer Kermode, ed., *Enterprise and Individuals in Fifteenth-Century England* (Stroud: Alan Sutton Press, 1991), 132-50.

16. See Chapter 4.

17. C. Lecoutere, "Eene legende over den oorsprong der begijnen," *Verslagen en Mededeelingen der Koninklijke Vlaamsche Academie* (1907): 96-134.

18. *PB*, 1-20.

19. As far as I know, not a single manuscript of those *vitae* can be traced to a beguine community or individual beguine.

20. Bynum, *Fragmentation and Redemption*, 27-51; Susan Starr Sered, *Priestess, Mother, Sacred Sister: Religions Dominated by Women* (New York: Oxford University Press, 1994), especially 243-56; Ross Shepard Kraemer, *Her Share of the Blessings. Women's Religions Among Pagans, Jews, and Christians in the Greco-Roman World* (New York: Oxford University Press, 1992).

21. Sered, *Priestess, Mother, Sacred Sister*, 151-52; Marjorie Procter Smith, *Women in Shaker Community and Worship: A Feminist Analysis of the Uses of Religious Symbolism* (Lewiston, N.Y.: Edwin Mellen Press, 1985).

22. Simons, "Reading a Saint's Body," 10-23, with further references.

23. For examples of beguines living with their children (and grandchildren), see Chapter 4.

# Bibliography

PRIMARY SOURCES

UNPRINTED

Note: Only the most important manuscript documents have been included.

*Aalst, Stadsarchief*
Begijnhof St. Katharina. No. 74: Cartulary.

*Antwerp, Stadsarchief*
GA 4201: Privileges of linen weavers guild, fifteenth–sixteenth centuries.
PK 2551: Surveys of hearths, 1436–1526.

*Bern, Burgerbibliothek*
MS 679: *Compilatio Singularis Exemplorum*, c. 1300.

*Bruges, Archief van het OCMW*
Begijnhof. D, I, 9: Accounts of the Guild of the Blessed Virgin, 1454–67. Diversen, "Reken-
    ingen Scholieren:" 1450–57, 1458–59, 1461–62. H, 2: Statutes of the beguinage, 1441.
    K, 1: Cartulary, 1241–1368. K, 2: Cartulary, 1281–1520. Charters.
Dis Onze-Lieve-Vrouwekerk Brugge. Charters.

*Bruges, Bisschoppelijk Archief*
C 419: Begijnhof Brugge, Charters.
F2: Aardenburg, Parish and Beguinage.

*Bruges, Groot-Seminarie*
Abdij Ter Duinen, Charters.

*Bruges, Monasterium De Wijngaard*
Archief van het Begijnhof. No. 1: Rule, ca. 1310. No. 7: Regulations, fifteenth–seventeenth
    centuries. Charters.

*Bruges, Rijksarchief*
Découvertes, no. 112: Cartulary of the beguinage of St. Aubertus, fifteenth century.
Onze-Lieve-Vrouwekerk Brugge. Archief; Charters.
Oorkonden met Blauwe Nummers.

*Bruges, Stadsarchief*
Reeks 99: "Politieke oorkonden," Charters, 1st Series.
Reeks 216: City accounts.
Reeks 438: Bogardenschool, Charters, 1st and 2nd Series.

*Bruges, Stadsbibliotheek*
MS 599 (8): W. H. James Weale, *Notes détachées. Bruges et Franc de Bruges: Frères Prêcheurs* (modern copy of lost *Liber Notabilium* of the Dominican convent of Bruges, end of the fourteenth century).

*Brussels, Algemeen Rijksarchief/Archives Générales du Royaume*
Archief Sint-Goedele/Archives de Sainte-Gudule.
Archief van het Bestuur van Openbare Onderstand van Leuven.
Kerkelijke Archieven van Brabant/Archives ecclésiastiques du Brabant.
Oorkonden van Vlaanderen/Chartes de Flandres.
Rekenkamers, Rolrekeningen/Chambres des Comptes, Comptes en rouleaux.

*Brussels, Archief van het OCMW/Archives du CPAS*
Serie/Série B: "Bienfaisance."
Serie/Série H: "Hospices."

*Brussels, Koninklijke Bibliotheek Albert I/Bibliothèque royale Albert I*
MS 7440: *Chronycke van S. Winoci, 651–1646.*
MS II. 4881, vol. 5: nineteenth-century copies of archival records concerning religious and charitable institutions of Ypres.
MS IV. 119: Gilles le Muisit, Works, ca. 1350.
MS IV. 210: Processional, beguinage Wijngaard Bruges, ca. 1500.
Verzameling/Collection Merghelynck.

*Douai, Archives Municipales*
FF 657–74: Contracts, 1224–1350.
FF 861–62: Wills, 1228–1366.
GG 190–91: Charters of charitable institutions.

*Ghent, Augustijnenklooster*
Klooster Brugge, Charters.

*Ghent, Begijnhof Ter Hooie*
Charters.
Cartularium 1423.
Archief Van der Haeghen.
Collectie Winnepennick.

*Ghent, Maria-Middelareskliniek*
Archief Bijlokeabdij en -hospitaal, Charters.

*Ghent, Rijksarchief*
Abdij Boudelo, nos. 8–10: Cartularies.
Abdij Doornzele.
Abdij Zwijveke.
Bisdom Gent. E 373: Register of sales of houses in the beguinage of St. Elizabeth of Ghent, 1425–45. E 374: Cartulary of the beguinage of St. Elizabeth of Ghent. Sint-Baafsabdij Gent, Charters.
Charters van de Graven van Vlaanderen. Collectie de St. Genois. Collectie Gaillard. Chronologisch Gerangschikt Supplement.
Familie De Ghellinck.
Rijke Klaren Gentbrugge, Charters.
Sint-Elisabethbegijnhof Gent, Charters.
Sint-Niklaaskerk, Charters.
Sint-Pietersabdij Gent, Charters.
"II. Varia," no. 506: chancery register of the counts of Flanders, 1348–58.

*Ghent, Stadsarchief*
Reeks 94: City charters.
Reeks 301: Registers of the "Schepenen van de Keure."
Reeks 330: Registers of the "Schepenen van Gedele."
Reeks LXXVIII: Beguinage of St. Elizabeth, Charters Béthune; Cartulary of Holy Ghost Table.
Reeks LXXIX: Beguinage of Ter Hooie.
Reeks LXXX: Beguinage Poortakker. No. 123: Obituary book. Charters.

*Hasselt, Rijksarchief*
Begijnhof Bilzen, Charters.
Begijnhof Gratem, Borgloon.
Begijnhof Maaseik.
Begijnhof Sint-Truiden, Charters; Registers.
Nonnemielen.

*'s-Hertogenbosch, Stadsarchief*
Aanwinsten.
Collectie Sassen.
Godshuizen, Groot-Begijnhof, Charters.
Tafels van de Heilige Geest, Charters.

*Kortrijk, Rijksarchief*
Collection d'Ennetières, Charters.
Kapittel Harelbeke, F 108 (1413).

*Liège, Archives de l'État*
Abbaye de Saint-Laurent, G III: Cartulary.
Béguinage de Saint-Christophe.
Dominicains de Liège, Charters.

*Liège, Bibliothèque de l'Université*
MS 27: Cartulary of the abbey of Sint-Truiden, fourteenth century.

*Lille, Archives Départementales du Nord*
B 225–1560: Charters of the counts of Flanders.
B 1562–64: Cartularies of the counts of Flanders, fourteenth century.
B 1565: Chancery register of the counts of Flanders, 1363–66.
B 4063, 4316: "Rolrekeningen" of the counts of Flanders.
B 7758: Accounts of the beguinage of St. Elizabeth, Lille, 1337–38, 1342–43.
1 G: Chapter of St. Amé, Douai.
16 G: Chapter of St. Pierre, Lille.
30 H: Abbey of Notre-Dame-des-Prés, Douai.
31 H: Abbey of Flines.
37 H: Abbey of Notre-Dame, Cantimpré.
40 H: Abbey of St. Jean-Baptiste, Valenciennes.
130 H: Convent of Dominican nuns of l'Abbiette, Lille.
161 H: Beguinage of Cantimpré, Cambrai.
Archives hospitalières de Lille. I: Hôpital Comtesse, Lille.

*Lille, Bibliothèque municipale*
MS. 274: Cartulary of St. Pierre of Lille, ca. 1300.

*London, British Library*
Add. MS 21114: Psalter from Liège, about 1255–65.

*Louvain, Dominikanenklooster*
Kloosterarchieven.
Provinciaal Archief.

*Louvain, Stadsarchief*
Nos. 4623 and 4623bis: Charters of the beguinage of Ten Hove.

*Louvain, Universiteitsbibliotheek*
Archief: Collectie Philippen.
XV: Beguinage of Sion, Antwerp, no. 1: Obituary book of the beguinage, thirteenth-sixteenth centuries.
XVI: Beguinage of St. Catherine, Diest.
XVII: Beguinage of Ten Hove, Louvain.

*Mechelen, Aartsbisschoppelijk Archief*
Begijnhof Mechelen

*Mechelen, Stadsarchief*
Archief OCMW. No. 9442: Profession register of the beguinage of St. Catherine of Mechelen, 1486–1551. Charters.

*Mons, Archives de l'État*
Collection L. Verriest

*Namur, Archives de l'État*
Archives Ecclésiastiques
Commune de Dinant. No. 27: Registre aux cens et rentes de l'hôpital des béguines. No. 30: Registre aux contestations.

*Paris, Bibliothèque nationale*
Manuscrits Latins. No. 6785, fol. 47v–82r: *Antigraphum Petri*, ca. 1200. No. 15954: Sermons, 1261–74. No. 16482: *Distinctiones* and Sermons, ca. 1261–64, 1272–73.
Nouvelles Acquisitions Françaises. Nos. 3549, 10058, 23652: Wills from Tournai, thirteenth–fourteenth centuries.
Nouvelles Acquisitions Latines. Nos. 2230, 2306, 2309, 2592: Wills from Tournai, thirteenth–fourteenth centuries.

*Ronse, Rijksarchief*
Onze-Lieve-Vrouwhospitaal Geraardsbergen, Charters.

*Sint-Truiden, Minderbroedersklooster*
Provincial Archives of the Franciscan Order, Kloosterarchieven.

*Tongeren, Stadsarchief*
Begijnhof. No. 68: Register of rents in the beguinage, 1322–1464. Charters, 1st and 2nd Series.
Sint-Jacobsgasthuis, Charters.

*Tournai, Archives de la Cathédrale*
Cartulaire D: Cartulary of the cathedral of Notre Dame of Tournai, thirteenth century.
XVII, A, no. 12: "Livre Rouge" of the abbey of St. Médard, thirteenth century.

*Tournai, Archives de l'État*
Cartulaires, no. 68: Cartulary of the Bishop of Tournai, thirteenth-fourteenth centuries.

PRINTED

The following lists of printed primary and secondary sources cited in this work are selective. Sources cited only once (and given a full bibliographical reference at that time in note) are not included.

*Acta Sanctorum . . . Editio novissima* (Paris: Palmé, 1863–).
*Acta Synodi Attrebatensis.* Edited in *PL*, vol. 142, cols. 1269–1312.
Albéric of Troisfontaines. *Chronicon.* Edited by P. Scheffer-Boichorst. In *MGH, SS*, vol. 23, 674–950.

*Anecdota ex codicibus hagiographicis Iohannis Gielemans canonici regularis in Rubea Valle prope Bruxellas.* Edited by the Bollandists. Brussels: Société des Bollandistes; Société Belge de Librairie, 1895.

*Annales Colonienses Maximi.* Edited by Karolus Pertz. In *MGH, SS*, vol. 17, 729–847.

Baix, François. *La Chambre apostolique et les "Libri Annatarum" de Martin V (1417–1431).* Brussels: Palais des Académies; Rome: Academia Belgica, 1947.

Balau, Sylvain. *Chroniques liégeoises.* Brussels: P. Imbreghts, 1915.

Bayot, Alphonse. *Le poème moral. Traité de vie Chrétienne écrit dans la région wallonne.* Liège: H. Vaillant-Carmanne, 1929.

Bernard of Clairvaux. *Sancti Bernardi Opera.* Edited by Jean Leclercq, Charles H. Talbot, and Henri-Marie Rochais. Rome: Editiones Cistercienses, 1957–77.

Béthune, Jean. *Cartulaire du Béguinage de Sainte-Élisabeth à Gand.* Bruges: Aimé de Zuttere, 1883.

Bormans, Stéphane. *Cartulaire de l'Église Saint-Lambert de Liège*, vol. 1. Brussels: Commission Royale d'Histoire, 1893.

Braekman, W. L. "De 'statuten van levene' van het begijnhof te Geraardsbergen (1414)." *Het Land van Aalst* 22 (1970): 37–47.

Brassart, M. *Inventaire général des chartes, titres et papiers appartenant aux hospices et au bureau de bienfaisance de la ville de Douai.* Douai: Adam d'Aubers, 1839.

Brinkman, Herman, and Janny Schenkel. *Het handschrift-Van Hulthem. Hs. Brussel, Koninklijke Bibliotheek van België, 15.589–623.* Hilversum: Verloren, 1999.

Broeckaert, Jan. *Cartularium van het begijnhof van Dendermonde.* Dendermonde: August De Schepper-Philips, 1902.

Brouwers, M. D. D. "Documents relatifs à l'administration du béguinage Saint-Christophe à Liège." *ASHEB* 32 (1906): 266–76.

Bussels, M. "De stichtingsoorkonde van het Maaseiker begijnhof." *Het Oude Land van Loon* 10 (1955): 73–78.

Caesarius of Heisterbach. *Dialogus Miraculorum.* Edited by Joseph Strange. Cologne: H. Lempertz, 1851.

———. *Libri VIII Miraculorum.* Edited by Alfons Hilka, *Die Wundergeschichten des Caesarius von Heisterbach.* Vols. 1 and 3. Bonn: Peter Hanstein, 1933–37.

Camps, H. P. H. *Oorkondeboek van Noord-Brabant tot 1312. I. De Meijerij van 's-Hertogenbosch (met de heerlijkheid Gemert).* The Hague: Martinus Nijhoff, 1979.

*Catalogus codicum hagiographicorum Bibliothecae Regiae Bruxellensis.* Brussels: Société des Bollandistes, 1889.

Ceyssens, Lucien. "Eenige oorkonden over het Begijnhof van Aardenburg." *HSEB* 78 (1935): 59–102.

Christ, Karl. "*La règle des Fins Amans:* Eine Beginenregel aus dem Ende des XIII. Jahrhunderts." In *Philologische Studien aus dem romanisch-germanischen Kulturkreise: Karl Voretzsch zum 60. Geburtstage und zum Gedenken an seine erste akademische Berufung vor 35 Jahren dargebracht,* 173–213. Edited by B. Schädel and W. Mulertt. Halle: Max Niemeyer, 1927.

*Chronica Villariensis monasterii.* Edited by Georg Waitz. In *MGH, SS*, vol. 25, 195–209.

*Chronica Villariensis monasterii. Continuatio secunda.* Edited by Georg Waitz. In *MGH, SS*, vol. 25, 209–19.

*Chronicon S. Andreae Castri Cameracesii.* Edited by L. C. Bethmann. In *MGH, SS*, vol. 7, 526–50.

Crane, Thomas Frederick. *The Exempla or Illustrative Stories from the Sermones Vulgares of Jacques de Vitry.* London, The Folk-Lore Society, 1890.

Cuvelier, Joseph. *Cartulaire de l'abbaye du Val-Benoît.* Brussels: Kiessling & P. Imbreghts, 1906.

———. *Les dénombrements de foyers en Brabant (XIVe–XVIe siècle).* Brussels: P. Imbreghts, 1912.

De Busco, J. "Oorkonden betrekkelijk het Beggijnhof in 'sHertogenbosch." *Dietsche Warande* 6 (1864): 142–55.

*Decrees of the Ecumenical Councils.* Edited and Translated by Norman Tanner. Vol. 1. London: Sheed & Ward; Washington, D.C.: Georgetown University Press, 1990.

De la Grange, A. "Choix de testaments tournaisiens antérieurs au XVIe siècle." *Annales de la Société historique et archéologique de Tournai* n.s. 2 (1897): 1–365.

De Limburg-Stirum, T. *Cartulaire de Louis de Male, comte de Flandre, de 1348 à 1358.* Bruges: Louis de Plancke, 1898–1901.

Denis du Péage, Paul. *Documents sur le Béguinage de Lille 1245–1841.* Lille: S. I. L. I. C. Impr., 1942.

Deregnaucourt, Jean-Pierre. "Le testament d'une douaisienne en 1355." *Linguistique Picarde* 20, 3 (1980): 39–43.

De Ridder, C. B. "Documents concernant les béguines de Malines et d'Aerschot." *ASHEB* 12 (1875): 22–32.

———. "Pouillé du diocèse de Liège (1558)." *ASHEB* 1 (1864): 234–98, 446–74; 2 (1865): 137–61, 365–93, 447–54; 3 (1866): 167–86, 397–414.

De Ridder, F. "Het archief der kerk van Aarschot. Begijnhof van Aarschot." *Hagelands Gedenkschriften* 6 (1912): 19–72.

———. "De Oudste Statuten van het Mechelsche Begijnhof." *HKOM* 39 (1934): 18–29.

Devillers, Léopold. "Cartulaire du béguinage de Cantimpret, à Mons." *Annales du Cercle archéologique de Mons* 6 (1865–66): 197–352.

Diegerick, I. L. A. *Inventaire analytique et chronologique des chartes et documents appartenant aux Archives de la ville d'Ypres.* Vol. 7. Bruges, Vandecasteele-Werbrouck, 1868.

Eckbert of Schönau. *Sermones contra Catharos.* Edited in *PL*, vol. 195, cols. 11–102.

Espinas, Georges, and Henri Pirenne. *Recueil de documents relatifs à l'histoire de l'industrie drapière en Flandre: 1re partie.* Brussels: Commission Royale d'Histoire, 1906–20.

Evers, J. J. "Onbekende of onuitgegeven Oorkonden aangaande het begijnhof van Aarschot, 1251–1341." *BG* 29 (1938): 134–54.

Everwin of Steinfeld. *Epistola ad S. Bernardum.* Edited in *PL*, vol. 182, cols. 676–80.

Favresse, F. "Actes intéressant la ville de Bruxelles (1154–2 décembre 1302)." *BCRH* 103 (1938): 355–512.

Fayen, A. "L' 'Antigraphum Petri' et les lettres concernant Lambert le Bègue conservées dans le manuscrit de Glasgow." *BCRH*, 5th s., 9 (1899): 255–356.

Feys, E., and A. Nelis. *Les cartulaires de la prévôté de Saint-Martin à Ypres, précédés d'une esquisse historique sur la prévôté.* Bruges, 1880–83.

Fredericq, Paul. "À propos du Règlement des Béguines de Saint-Omer (1428)." *Bulletins de l'Académie royale des Sciences, des Lettres et des Beaux-Arts de Belgique* 67 (1897): 121–29.

Fredericq, Paul, et al. *Corpus documentorum Inquisitionis haereticae pravitatis Neerlandicae.* Ghent: J. Vuylsteke; The Hague: Martinus Nijhoff, 1889–1906.

Gastout, Marguerite. *Suppliques et Lettres d'Urbain VI (1378–1389) et de Boniface IX (cinq*

*premières années: 1389–1394*). *Textes et Analyses*. Brussels and Rome: Institut historique belge de Rome, 1976.

Gautier de Coincy. *De sainte Léocade*. Edited by Eva Vilamo-Pentti. Helsinki: Société de Littérature Finnoise, 1950.

*Gesta Episcoporum Cameracensium*. Edited by L. Bethmann. In *MGH, SS*, vol. 7, 393–525.

*Gesta Sanctorum Villariensium*. Edited by G. Waitz. In *MGH, SS*, vol. 25, 220–35.

Gilbert of Tournai. *Collectio de Scandalis Ecclesiae*. Edited by Autbertus Stroick, "*Collectio de Scandalis Ecclesiae*. Nova editio.*" Archivum Franciscanum Historicum* 24 (1931): 33–62.

Giles of Orval. *Gesta episcoporum Leodiensium*. Edited by Johan Heller. In *MGH, SS*, vol. 25, 1–129.

Gilliodts-van Severen, L. *Inventaire diplomatique des archives de l'ancienne École Bogarde à Bruges*. Bruges: Louis de Plancke, 1899–1900.

Goetschalckx, P. J. "Oudste stukken uit het Archief der Kapelanen in de Kerk van O. L. V. te Antwerpen." *BG* 14 (1923): 280–96.

Gooskens, Frans. *Het jaargetijdenregister van het begijnhof te Breda (1353) ca. 1500–1626*. Breda: Gemeentelijke Archiefdienst, 1992.

Goswin of Bossut. *Vita Abundi*. Edited by A.M. Frenken. "De Vita van Abundus van Hoei." *Cîteaux* 10 (1959): 5–33.

———. *Vita Arnulphi Conversi*. Edited by D. Papebroeck. In *AA.SS.*, Jun., vol. 7, 556–79.

Guicciardini, Lodovico. *Descrittione di tutti i Paesi Bassi, altrimenti detti Germania Inferiore*. Antwerp: Silvius, 1567.

Gysseling, Maurits, and Willy Pijnenburg. *Corpus van Middelnederlandse teksten (tot en met het jaar 1300)*. I: *Ambtelijke bescheiden*. II: *Literaire handschriften*. The Hague: Martinus Nijhoff, 1977–87.

Habets, Jozef. *De archieven van het kapittel der hoogadellijke Rijksabdij Thorn*, vol. 1. The Hague: Algemeene Landsdrukkerij, 1889.

Hadewijch. *Brieven*. Edited by Paul Mommaerts. *De brieven van Hadewijch*. Averbode: Altiora; Kampen: Kok, 1990.

———. *Visioenen*. Edited by Frank Willaert; Translated by Imme Dros. Amsterdam: Prometheus and Bert Bakker, 1996.

Hansay, A. "Documents des XIIe et XIIIe siècles concernant l'Alleu de Hex et l'Hôpital de Looz." *Verzamelde Opstellen* 11 (1935): 331–50.

Hautcoeur, Édouard. *Cartulaire de l'abbaye de Flines (1200–1630)*. Lille: L. Quarré, 1873–74.

Hautcoeur, Édouard. *Cartulaire de l'église collégiale de Saint-Pierre-de Lille*. Lille: L. Quarré, 1894.

Henriquez Chrysostomus. *Quinque Prudentes Virgines*. Antwerp: Apud Joannem Cnobbaert, 1630.

Herman of Tournai. *Liber de restauratione monasterii Sancti Martini Tornacensis*. Edited by Georg Waitz. In *MGH, SS*, vol. 14, 274–327.

Hildegard of Bingen. *Hildegardis Bingensis Epistolarium*. Edited by Lieven Van Acker. Turnhout: Brepols, 1991–93.

Hoornaert, H. and C. Callewaert."Les plus anciens documents des archives du Béguinage de Bruges." *HSEB* 54 (1904): 253–300.

Hoornaert, Rodolphe. "La plus ancienne Règle du Béguinage de Bruges." *HSEB* 72 (1930): 1–79.

Hugh of Floreffe. *Vita B. Juettae reclusae*. Edited by G. Henschen. In *AA.SS.*, Jan., vol. 2, 145–69.

*Ida of Louvain: Medieval Cistercian Nun*. Translated by Martinus Cawley. Lafayette: Guadalupe Translations, 1990.

Jaffé, Philipp. *Monumenta Bambergensia*. Berlin, 1869, repr. Aalen: Scientia Verlag, 1964.

James of Vitry. *The Historia Occidentalis of Jacques de Vitry. A Critical Edition*. Edited by John Frederick Hinnebusch, O.P. Fribourg: The University Press, 1972.

―――. *Lettres de Jacques de Vitry (1160/1170–1240) évêque de Saint-Jean d'Acre*. Edited by R. B. C. Huygens. Leiden: E. J. Brill, 1960.

―――. *Jacques de Vitry, "Histoire Occidentale." Historia Occidentalis (Tableau de l'Occident au XIIIe siècle)*. Translated by Gaston Duchet-Suchaux; Introduction by Jean Longère. Paris: Cerf, 1997.

―――. *Vita Mariae Oigniacensis*. Edited by D. Papebroeck. In *AA.SS.*, Jun., vol. 5, 542–72.

Joris, André. "Documents relatifs à l'histoire économique et sociale de Huy au moyen âge." *BCRH* 124 (1959): 213–65.

Juten, G.C.A. *Cartularium van het begijnhof te Breda*. 's-Hertogenbosch: Provinciaal Genootschap van Kunsten en Wetenschappen in Noord-Brabant, 1910.

Langlois, E. *Les registres de Nicolas IV*. Paris: Écoles françaises d'Athènes et de Rome, 1887–93.

Lauwers, Michel. "Testaments inédits du chartrier des Dominicains de Liège (1245–1300)." *BCRH* 154 (1988): 159–97.

Leboucq, Simon. *Histoire ecclésiastique de la ville et du comté de Valentienne*. Edited by Arthur Dinaux. Valenciennes: A. Prignet, 1840.

Lefèvre, Placide. "Testaments bruxellois du XIIIe siècle." *BG* 19 (1928): 360–70, 417–45.

Lefèvre, Placide, Philippe Godding, and Françoise Godding-Ganshof. *Chartes du chapitre de Sainte-Gudule à Bruxelles 1047–1300*. Louvain-la-Neuve: Collège Érasme; Brussels: Éditions Nauwelaerts, 1993.

Lemaire, Emmanuel. *Archives anciennes de la ville de St-Quentin*. Saint-Quentin: Ch. Poette, 1888.

*Libellus de diversis ordinibus et professionibus qui sunt in aecclesia*. Edited by Giles Constable and B. Smith. Oxford: Clarendon Press, 1972.

*The Life of Juliana of Mont Cornillon*. Translated by Barbara Newman. Toronto: Peregrina, 1989.

*The Life of Margaret of Ypres by Thomas of Cantimpré*. Translated by Margot H. King. 2nd. ed., Toronto: Peregrina, 1995.

*The Life of Marie d'Oignies by Jacques de Vitry*. Translated by Margot H. King. 3d ed.: Toronto: Peregrina, 1993.

*Lives of Ida of Nivelles, Lutgard, and Alice the Leper*. Translated by Martinus Cawley. Lafayette, Oregon: Guadalupe Translations, 1987.

Longnon, Auguste. *Pouillés de la Province de Reims*. Paris: C. Klincksieck, 1908.

Mansi, Giovanni Domenico. *Sacrorum conciliorum nova et amplissima collectio*. 2nd. ed. Paris and Leipzig: H. Welter, 1901–04.

Marguerite Porète. *Le Mirouer des Simples Ames/Margaretae Porete, Speculum Simplicium Animarum*. Edited by Romana Guarnieri and Paul Verdeyen. Turnhout: Brepols, 1986.

Matthew Paris. *Matthaei Parisiensis, monachi sancti Albani, Chronica Majora*. Edited by Henry Richards Luard. London: Her Majesty's Stationery Office, 1872–84.

Mestayer, Monique. "Testaments douaisiens antérieurs à 1270." *Nos Patois du Nord* 7 (1962): 64–77.

Migne, Jean-Paul. *Patrologiae cursus completus. Series Latina*. Paris: Migne, 1844–64.

Miraeus, Aubertus. *Opera Diplomatica et Historica*. Edited by Johannes Franciscus Foppens. Louvain: Typis Aegidii Denique, 1723–48.

Molanus, Joannes. *Historiae Lovaniensium Libri XIV*. Edited by P. F. X. De Ram. Brussels: M. Hayez, 1861.

*Monumenta Germaniae Historica. Scriptores*. Hannover: A. Hahn et al., 1826–1980.

Moolenbroek, Jaap van. *Mirakels historisch. De exempels van Caesarius van Heisterbach over Nederland en Nederlanders*. Hilversum: Verloren, 1999.

Paquay, Jean [Jan]. "Het eerste statuut der begijnhoven." *Verzamelde Opstellen* 11 (1935): 185–204.

———. *Pouillé de l'ancien diocèse de Liège en 1497*. Tongeren: Collée, 1908.

———. "Regesta de Marcuald de Modène, Archidiacre de Hesbaye, prévôt de Tongres, 1237–1274." *Bulletins de la Société scientifique et littéraire du Limbourg* 23 (1905): 201–82.

———. "Regesta de Renier écolâtre de Tongres, vicaire-générale de Henri de Gueldre." *Bulletin de l'Institut archéologique liégeois* 35 (1905): 1–74.

Peter, J. "Documents sur le béguinage d'Avesnes." *Mémoires de la Société Archéologique et Historique de l'Arrondissement d'Avesnes* 13 (1930): 206–7.

Philip of Clairvaux. *Vita Elizabeth sanctimonialis in Erkenrode*. In *Catalogus codicum hagiographicorum Bibliothecae Regiae Bruxellensis*, vol. 1, 362–78.

Philippen, L. J. M. "Een vijftal Oorkonden betreffende de Antwerpsche Begijnen." *BG* 22 (1931): 29–47.

Piot, Charles. *Cartulaire de l'abbaye de Saint-Trond*. Brussels: Commission royale d'Histoire, 1870–74.

Pirenne, Henri. *Le Livre de l'abbé Guillaume de Ryckel (1249–1272). Polyptique et comptes de l'abbaye de Saint-Trond au milieu du XIIIe siècle*. Ghent: H. Engelcke, 1896.

Polus, A. "Vijf charters betrekkelijk Sint Agnetenklooster te Maeseyck." *Publications de la Société historique et archéologique dans le duché de Limbourg* 12 (1875): 458–79.

Poncelet, Édouard. *Chartes du prieuré d'Oignies de l'Ordre de Saint-Augustin*. Namur: Ad. Wesmael-Charlier, 1912.

Radulf of Coggeshall. *Chronicon Anglicanum*. Edited by Joseph Stevenson. In *Rerum Brittanicarum Medii Aevi Scriptores*. London: Rolls Series, 1875, 1–208.

Reusens, Edmond. "Un document très important, établissant l'origine liégeoise de l'institut des béguines." *AHEB* 20 (1886): 125–28.

———. "Documents concernant le béguinage de Courtrai." *ASHEB* 14 (1877): 86–98.

———. "Pouillé du diocèse de Cambrai. Les doyennés de Grammont, de Hal, de Bruxelles, d'Alost, de Pamele-Audenarde et d'Anvers en 1567." *ASHEB* 28 (1900): 257–351.

Robyns, Laurentius. *Diplomata Lossensia*. Liège: F. Alexander Barchon, 1717.

Rutebeuf. *Oeuvres complètes de Rutebeuf*. Edited by Edmond Faral and Julia Bastin. Paris: A. et J. Picard, 1959–60.

Schoolmeesters, Émile. "L'archidiaconé de Campine en 1400." *ASHEB* 32 (1906): 289–344.

Soens, E. *Cartularium en renteboek van het Begijnhof Ste Katharina op den Zavel te Aalst*. Aalst: Spitaels-Schuermans, 1912.

Stutvoet-Joanknecht. Der Byen Boeck. *De middelnederlandse vertalingen van* Bonum universale de Apibus *van Thomas van Cantimpré en hun achtergrond*. Amsterdam: VU Uitgeverij, 1990.

Tailliar, Eugène François Joseph. *Recueil d'actes des XIIe et XIIIe siècles en langue romane wallonne du Nord de la France*. Douai: A. d'Aubers, 1849.

*Thomas de Cantimpré. Les exemples du "Livre des Abeilles". Une vision médiévale*. Translated by Henri Platelle. Turnhout: Brepols, 1997.

Thomas of Cantimpré. *Bonum Universale de Apibus*. Edited by Georgius Colvenerius. Douai: B. Belleri, 1627.

———. *Vita beatae Christinae Mirabilis Trudonopoli in Hesbania*. Edited by J. Pinius. In *AA.SS.*, Jul., vol. 5, 637–60.

———. *Vita Ioannis Cantipratensis*. Edited by Robert Godding. "Une oeuvre inédite de Thomas de Cantimpré. La "Vita Ioannis Cantipratensis."" *RHE* 76 (1981): 241–316.

———. *Vita Lutgardis*. Edited by G. Henschen. In *AA.SS.*, Jun., vol. 4, 187–210; additions in *Catalogus codicum hagiographicorum*, vol. 2, 220.

———. *Vita Margarete de Ypris*. Edited in Meersseman, "Les Frères Prêcheurs," 106–30.

———. *Vita Mariae Oigniacensis. Supplementum*. Edited by Arnold Raysse. In *AA.SS*, Jun., vol. 5, 572–81.

Thomas of Chobham. *Summa de Arte Praedicandi*. Edited by Franco Morenzoni. Turnhout: Brepols, 1988.

Tihon, Camille, "Le testament d'une béguine d'Oignies en 1275." *Namurcum* 14 (1937): 40–44.

Van den Nieuwenhuizen, J. *Oorkondenboek van het Sint-Elizabethhospitaal te Antwerpen (1226–1355)*. Brussels: Palais des Académies/Paleis der Academiën, 1976.

Van de Putte, F. *Cronica et cartularium monasterii de Dunis*. Bruges: Société d'Émulation de Bruges, 1864–67.

Van der Eerden-Vonk, M. A. *Raadsverdragen van Maastricht 1367–1428*. The Hague: Instituut voor Nederlandse Geschiedenis, 1992.

Van Lerberghe, Lodewijk, and Jozef Ronsse. *Audenaerdsche Mengelingen*. Oudenaarde: F. Van Peteghem-Ronsse, 1845–54.

Van Lokeren, Auguste. *Chartes et documents de l'abbaye de Saint-Pierre au Mont-Blandin à Gand depuis sa fondation jusqu'à sa suppression, avec une introduction historique*. Ghent: H. Hoste, 1868–71.

Vannérus, Jules. "Documents sur les Bogards de Malines (1284–1558)." *BCRH* 80 (1911): 215–86.

Van Rossum, P. "Documents concernant le béguinage de Courtrai." *ASHEB* 14 (1877): 86–98.

Van Wintershoven, Edmond. "Notes et documents concernant l'ancien béguinage de Saint-Christophe à Liège." *ASHEB* 23 (1892): 61–115.

Verellen, J. R. "De oudste, breed-uitgewerkte begijnenregel. De statuten van het begijnhof van Herentals 1461–1489." *BG* 32 (1949): 198–225.

———. "Oorkonden van het begijnhof van Herentals." *BG* 33 (1950): 54–63, 167–91, 246–55; 34 (1951): 122–31, 177–87.

*Vita Beatricis*. Edited by Leonce Reypens. Antwerp: Ruusbroec-Genootschap, 1962. Reprinted in Roger De Ganck. *The Life of Beatrice of Nazareth 1200–1268*. Kalamazoo: Cistercian Publications, 1991.

*Vita B. Idae Lewensis*. Edited by Remigius de Buck. In *AA.SS.*, Oct., vol. 13, 100–135.

*Vita B. Idae de Nivellis*. Edited by Chrysostomos Henriquez, *Quinque Prudentes Virgines*, 199–297; omissions edited in *Catalogus codicum hagiographicorum Bibliothecae Regiae Bruxellensis*, vol. 2, 222–26.

*Vita B. Odiliae*. Edited in *Analecta Bollandiana* 13 (1894): 197–287.

*Vita Goberti Asperimontis*. Edited by P. Dolmans. In *AA.SS.*, Aug., vol. 4, 370–95.

*Vita Idae Lovaniensis*. Edited by D. Papebroeck. In *AA.SS.*, Apr., vol. 2, 156–89.

*Vita Norberti archiepiscopi Magdeburgensis*. Edited by R. Wilmans. In *MGH, SS*, vol. 12, 663–703.

*Vita sanctae Julianae virginis*. Edited by G. Henschen and D. Papebroeck. In *AA.SS.*, Apr., vol. 1, 435–75.

Vleeschouwers, Cyriel. *De oorkonden van de Sint-Baafsabdij te Gent (819–1321)*. Brussels: Koninklijke Commissie voor Geschiedenis, 1990–91.

Vleeschouwers, Cyriel, and Monique Van Melkebeek. *Liber sentenciarum van de officialiteit van Brussel 1448–1459*. Brussel: Ministerie van Justitie, 1982–83.

Voisin, C. J. "Testament d'Arnould de Maldeghem, chanoine de Tournai." *HSEB* 10 (1849): 345–86.

Vuylsteke, Julius. *Comptes de la ville et des baillis de Gand, 1280–1336*. Ghent: F. Meyer-Van Loo, 1900–1908.

———. *De rekeningen der stad Gent. Tijdvak van Philips van Artevelde, 1376–1389*. Ghent: Ad. Hoste, 1893.

Walter of Thérouanne. *Vita Iohannis episcopi Tervanensis*. Edited by O. Holder-Egger. In *MGH, SS*, vol. 15, part 2, 1136–50.

Warichez, Joseph. "État bénéficial de la Flandre et du Tournaisis au temps de Philippe le Bon (1455)." *ASHEB* 35 (1909): 433–73; 36 (1910): 1–38, 151–68, 245–304, 430–57; 37 (1911): 91–124, 161–221, 413–69; 38 (1912): 5–47.

Wyffels, Carlos, and Jozef De Smet. *De rekeningen van de stad Brugge (1280–1319). Eerste deel (1280–1302)*. Brussels: Palais des Académies/Paleis der Academiën, 1965–71.

Willeumier-Schalij, J. M. *De brieven uit 'Der Rechte Wech' van de Oisterwijkse begijn en mystica Maria van Hout (+Keulen, 1547)*. Louvain: Peeters, 1993.

SECONDARY SOURCES

*Algemene Geschiedenis der Nederlanden*. Haarlem: Fibula-Van Dishoeck, 1977–83.

Andrews, Frances. *The Early Humiliati*. Cambridge: Cambridge University Press, 1999.

Arnade, Peter. *Realms of Ritual: Burgundian Ceremony and Civic Life in Late Medieval Ghent*. Ithaca: Cornell University Press, 1996.

Asen, Johannes. "Die Beginen in Köln." *Annalen des Historischen Vereins für den Niederrhein* 111 (1927–28): 81–180; 112 (1927–28): 71–148; 113 (1927–8): 13–19.

*Autour de la ville en Hainaut. Mélanges d'archéologie et d'histoire urbaines offerts à Jean Dugnoille et à René Sansen*. Ath: Cercle Royal d'histoire et d'archéologie d'Ath et de la région et musées athois, 1986.

Axters, Stephanus. *Geschiedenis van de vroomheid in de Nederlanden*. Antwerp: De Sikkel, 1950–60.

Baillien, Henri. "Het Begijnhof van Tongeren, zijn aanleg, plaatsnamen, gebouwen en bewoonsters." *Het Oude Land van Loon* 25 (1970): 55–100.

Baldwin, John W. *The Language of Sex. Five Voices from Northern France around 1200.* Chicago: The University of Chicago Press, 1994.

———. *Masters, Princes and Merchants. The Social Views of Peter the Chanter and His Circle.* Princeton: Princeton University Press, 1970.

*Begijnen en Begijnhoven.* Edited by Marianne Trooskens. Brussels: Algemeen Rijksarchief, 1994.

*Het Begijnhof van Aarschot.* Aarschot: Aarschotse Kring voor Heemkunde, 1976.

Berger, Roger. *Litérature et société arrageoises au XIIIe siècle: Les chansons et dits artésiens.* Arras: Commission Départementale des Monuments Historiques du Pas-de-Calais, 1981.

Bergmans, Ann, and Chris De Maegd. "De Sint-Jan-de-Doperkerk van het Groot begijnhof in Leuven." *M & L: Monumenten en Landschappen:* 4 (1985): 6–27.

Bériou, Nicole. "La prédication au béguinage de Paris pendant l'année liturgique 1272–1273." *Recherches augustiniennes* 13 (1978): 105–229.

Berlière, Ursmer. "Les évêques auxiliaires de Liège." *Revue Bénédictine* 29 (1912): 60–81.

*Bernardus en de Cisterciënzerfamilie in België 1090–1990.* Edited by M. Sabbe, M. Lamberigts, and F. Gistelinck. Louvain: Bibliotheek van de Faculteit godgeleerdheid, 1990.

Bertin, Paul. "Le Béguinage d'Aire-sur-la-Lys." *Revue du Nord* 31 (1949): 92–104.

Bets, P. V. *Histoire de la ville et des institutions de Tirlemont.* Louvain: n.p., 1861.

*Bibliotheca Hagiographica Latina antiquae et mediae aetatis.* Brussels: Société des Bollandistes, 1898–1901.

Bijsterveld, Arnoud-Jan. *Laverend tussen Kerk en wereld: De pastoors in Noord-Brabant 1400–1570.* Amsterdam: VU Uitgeverij, 1993.

Billen, Claire. "Le marché urbain: un espace de liberté pour les femmes rurales?" In *La ville et les femmes en Belgique: histoire et sociologie.* Edited by Éliane Gubin and Jean-Pierre Nandrin, 41–56. Brussels: Facultés universitaires Saint-Louis, 1993.

Biller, Peter. "Heresy and Literacy: Earlier History of the Theme." In *Heresy and Literacy, 1000–1530,* 1–18.

Blamires, Alcuin. *The Case for Women in Medieval Culture.* Oxford: Clarendon Press, 1997.

———. "Women and Preaching in Medieval Orthodoxy, Heresy, and Saints' Lives." *Viator* 26 (1995): 135–52.

Blamires, Alcuin, and C. W. Marx. "Women Not to Preach: A Disputation in British Library MS Harley 31." *Journal of Medieval Latin* 2 (1993): 34–63.

Blockmans, Frans. *Het Gentsche Stadspatriciaat tot omstreeks 1302.* Antwerp: De Sikkel, 1938.

Blockmans, Wim. "De vorming van een politieke unie (veertiende–zestiende eeuw)." In *Geschiedenis van de Nederlanden,* 45–117.

Blockmans, Wim, et al. "Tussen crisis en welvaart: sociale veranderingen 1300–1500." In *AGN,* vol. 2, 42–86.

Blockmans, Wim, and Walter Prevenier. "Armoede in de Nederlanden van de 14e tot het midden van de de 16e eeuw: bronnen en problemen." *Tijdschrift voor Geschiedenis* 88 (1975): 501–38.

Bolton, Brenda. "*Mulieres Sanctae.*" In *Women in Medieval Society.* Edited by Susan Mosher Stuard, 141–58. Philadelphia: University of Pennsylvania Press, 1976.

———. "*Vitae Matrum:* A further aspect of the Frauenfrage." In *Medieval Women,* 253–73.

Bonenfant, Paul. "Hôpitaux et bienfaisance publique dans les anciens Pays-Bas des origines à la fin du XVIIIe siècle." *Annales de la société belge d'histoire des hôpitaux* 3 (1965): 3–44.

———. "Une fondation patricienne pour béguines à Bruxelles au XIIIe siècle. In *Mélanges Georges Smets*, 91–104. Brussels: Librairie Encyclopédique, 1952.

Bonneure, Fernand, and Lieven Verstraete. *Het prinselijk begijnhof De Wijngaard in Brugge. Geschiedenis van de site en van de bewoners.* Tielt, Belgium: Lannoo, 1992.

Boone, Marc. *Gent en de Bourgondische hertogen ca. 1384–ca. 1453. Een sociaal-politieke studie van een staatsvormingsproces.* Brussels: Paleis der Academiën, 1990.

Boone, Marc, and Martha Howell. "Becoming Early Modern in the Late Medieval Low Countries: Ghent and Douai from the Fourteenth to the Sixteenth Century." *Urban History* 23 (1996): 300–324.

Bornstein, Daniel. "Women and Religion in Late Medieval Italy: History and Historiography." In *Women and Religion in Medieval and Renaissance Italy*, 1–27.

Borst, Arno. *Die Katharen.* Stuttgart: Hiersemann Verlag, 1953.

Bousmar, Éric. "Du marché aux *bordiaulx*. Hommes, femmes et rapports de sexe (*gender*) dans les villes des Pays-Bas au bas moyen âge. État de nos connaissances et perspectives de recherche." In *Hart en marge*, 51–70.

Bovyn, M. "Sint-Alexiusbegijnhof te Dendermonde." *Oudheidkundige Kring van het land van Dendermonde. Gedenkschriften* 3rd s. 9 (1959–60): 1–267.

Brassart, M. *Notes historiques sur les hôpitaux et établissements de charité de la ville de Douai.* Douai: Adam d'Aubers, 1842.

Brouwers, D. "Analectes dinantais. Deuxième série." *Annales de la Société archéologique d Namur* 38 (1927): 245–81.

Buc, Pierre. "*Vox clamantis in deserto?* Pierre le Chantre et la prédication laïque." *Revue Mabillon* 65 (1993): 5–47.

Bücher, Karl. *Die Frauenfrage im Mittelalter.* 2nd. ed. Tübingen: H. Laupp, 1910.

Bynum, Caroline Walker. *Fragmentation and Redemption: Essays on Gender and the Human Body in Medieval Religion.* New York: Zone Books, 1992.

———. *Holy Feast and Holy Fast: The Religious Significance of Food to Medieval Women.* Berkeley: University of California Press, 1987.

Cailliau, Hadewich. "*Soo geluckigh als een beggijn.*" *Het begijnhof Onze-Lieve-Vrouw-Ter-Hooie 1584–1792.* Ghent: Maatschappij voor geschiedenis en oudheidkunde te Gent, 1995.

Cambier, Albert. "Het begijnhof te Ronse." *Annalen van de Geschied- en Oudheidkundige Kring van Ronse en het tenement van Inde* 11 (1962): 41–45, 47–52, 56–88; 12 (1963): 78–80; 13 (1964): 130–78; 14 (1965): 59–67, 119–27; 15 (1966): 153–83; 16 (1967): 57–70.

Cardman, Francine. "The Medieval Question of Women and Orders." *The Thomist* 42 (1978): 582–99.

Carpenter, Jennifer. "Juette of Huy, Recluse and Mother (1158–1228): Children and Mothering in the Saintly Life." In *Power of the Weak: Studies on Medieval Women.* Edited by Jennifer Carpenter and Sally-Beth MacLean, 57–93. Urbana and Chicago: University of Illinois Press, 1995.

Carpentier, Bernadette. "Le Béguinage Sainte-Élisabeth de Valenciennes, de sa fondation au XVIeme siècle." *Mémoires du Cercle archéologique et historique de Valenciennes* 4 (1959): 95–182.

*Christendom and Its Discontents: Exclusion, Persecution, and Rebellion, 1000–1500.* Edited by Scott L. Waugh and Peter D. Diehl. Cambridge: Cambridge University Press, 1996.

Clark, Anne L. *Elisabeth of Schönau: A Twelfth-Century Visionary.* Philadelphia: University of Pennsylvania Press, 1992.

Coakley, John. "Friars as Confidants of Holy Women in Medieval Dominican Hagiography." In *Images of Sainthood in Medieval Europe.* Edited by Renate Blumenfeld-Kosinski and Timea Szell, 222–46. Ithaca, N.Y.: Cornell University Press, 1991.

———. "Gender and the Authority of Friars: The Significance of Holy Women for Thirteenth-Century Franciscans and Dominicans." *Church History* 60 (1991): 445–60.

Cochelin, Isabelle. "Sainteté laïque: l'exemple de Juette de Huy (1158–1228)." *Le Moyen Age* 95 (1989): 397–417.

Cohn, Samuel K. *Women in the Streets: Essays on Sex and Power in Renaissance Italy.* Baltimore: Johns Hopkins University Press, 1996.

Coldeweij, J. A. *De heren van Kuyc 1096–1400.* Tilburg: Stichting Zuidelijk Historisch Contact, 1981.

Constable, Giles. "The Diversity of Religious Life and Acceptance of Social Pluralism in the Twelfth Century." In *History, Society and the Churches: Essays in Honour of Owen Chadwick.* Edited by Derek Beales and Geoffrey Best, 29–47. Cambridge: Cambridge University Press, 1985.

———. *The Reformation of the Twelfth Century.* Cambridge, Cambridge University Press, 1996.

———. *Three Studies in Medieval Religious and Social Thought.* Cambridge: Cambridge University Press, 1995.

Coppens, J. A. *Nieuwe beschrijving van het bisdom van 's Hertogenbosch.* vol. 3, part 2. 's-Hertogenbosch: J. F. Demelinne, 1843.

Coulon, Alphonse-Marie. *Histoire du Béguinage de Sainte-Élisabeth à Courtrai d'après les documents authentiques.* Kortrijk: Jules Vermaut, 1891.

Danneel, Marianne. *Weduwen en wezen in het laat-middeleeuwse Gent.* Louvain: Garant, 1995.

Daris, Joseph. "Examen critique de la Vie d'Odile et de Jean, son fils." *Bulletin de l'Institut archéologique liégeois* 11 (1872): 153–88.

———. *Histoire du diocèse et de la principauté de Liège pendant le XIIIe et le XIVe siècle.* Liège: Louis Demarteau, 1891.

———. *Notices historiques sur les églises du diocèse de Liège.* Vol. 12. Liège: Louis Demarteau, 1885.

Davis, Natalie Zemon. *Society and Culture in Early Modern France.* Stanford, Calif.: Stanford University Press, 1975.

De Cuyper, Jan. "Het begijnhof van Kortrijk." *De Leiegouw* 15 (1973): 5–48.

———. "De oudste volledige rekening van het Kortrijkse Begijnhof 1393." In *Album Albert Schouteet,* 37–47. Bruges: Westvlaams Verbond van Kringen voor Heemkunde, 1973.

De Fontette, Micheline. *Les religieuses à l'âge classique du droit canon. Recherches sur les structures juridiques des branches féminines des ordres.* Paris: J. Vrin, 1967.

De Ganck, Roger. *Beatrice of Nazareth in Her Context.* Kalamazoo: Cistercian Publications, 1991.

Degler-Spengler, Brigitte. "Die Beginen in Basel." *Basler Zeitschrift für Geschichte und Altertumskunde* 69 (1969): 5–83; 70 (1970): 29–118.

De Keyzer, Walter. "Aspects de la vie béguinale à Mons aux XIIIe et XIVe siècles." In *Autour de la ville*, 205–26.

———. "L'hôpital Le Taye, une infirmerie pour béguines à Mons à la fin du XIIIe siècle." In *Album Carlos Wyffels*, 131–37. Brussels: Algemeen Rijksarchief/Archives générales du Royaume, 1987.

Delmaire, Bernard. "Les béguines dans le Nord de la France au premier siècle de leur histoire (vers 1230–vers 1350)." In *Les religieuses en France au XIIIe siècle*. Edited by Michel Parisse, 121–62. Nancy: Presses Universitaires, 1985.

———. *Le diocèse d'Arras de 1093 au milieu du XIVe siècle: Recherches sur la vie religieuse dans le Nord de la France au Moyen Age*. Arras: Commission départementale d'Histoire et d'Archéologie du Pas-de-Calais, 1994.

———. "Un sermon arrageois inédit sur les 'Bougres' du Nord de la France (vers 1200)." *Heresis* 17 (1991): 1–15.

De Moreau, Édouard. *Histoire de l'Église en Belgique*. 2nd ed. Brussels: L'Édition Universelle, 1945–52.

De Poerck, Guy. *La draperie médiévale en Flandre et en Artois*. Bruges: De Tempel, 1951.

De Poerck, Guy, and Rika Van Deyck. "La Bible et l'activité traductrice dans les pays romans avant 1300." In *La Literature didactique, allégorique et satirique*. Edited by Jürgen Beyer. *Gründriss der romanischen Literaturen des Mittelalters*, part VI, vol. 1, 21–57. Heidelberg: Carl Winter-Universitätsverlag, 1968.

De Potter, Frans. *Gent van den oudsten tijd to heden: Geschiedkundige beschrijving der stad*. Ghent: n.p., 1883–1901.

Deregnaucourt, Jean-Pierre. "Les béguines de l'hôpital des Wetz de Douai de 1350 à 1372." *Revue du Nord* 82 (2000): 35–52.

Dereine, Charles. *Les Chanoines réguliers au diocèse de Liège avant Saint Norbert*. Brussels: Palais des Académies, 1952.

De Ridder, F. "De Conventen van het Oud-Begijnhof te Mechelen." *HKOM* 42 (1937): 23–83.

———. "Mechelen's Groot Begijnhof binnen de stad. (Het ontstaan)." *HKOM* 40 (1935): 15–43.

———. "De oorsprong van Mechelens begijnhof en van de parochies in de volkswijk der stad tijdens de XIIIe–XIVe eeuw." *HKOM* 35 (1930): 56–84.

De Ridder-Symoens, Hilde. "Education and Literacy in the Burgundian-Habsburg Netherlands." *Canadian Journal of Netherlandic Studies/Revue Canadienne d'Études néerlandaises* 15 (1995): 6–21.

———. "La sécularisation de l'enseignement aux anciens Pays-Bas au Moyen Age et à la Renaissance." In *Peasants and Townsmen in Medieval Europe. Studia in honorem Adriaan Verhulst*. Edited by Jean-Marie Duvosquel and Eric Thoen, 721–38. Ghent: Snoeck-Ducaju, 1995.

Derville, Alain. "Le nombre d'habitants des villes d'Artois et de la Flandre Wallonne (1300–1450)." *Revue du Nord* 65 (1983): 277–299.

———. *Saint-Omer des origines au début du XIVe siècle*. Lille: Presses Universitaires de Lille, 1995.

Des Marez, Guillaume. "Le droit privé à Ypres au XIIIe siècle." *Bulletin de la Commission*

*royale pour la publication des anciennes Lois et Ordonnances de Belgique* 12 (1927): 210–460.

Desmet, Dirk. "Het begijnhof 'De Wijngaerd' te Brugge. Onderzoek naar het dagelijks leven rond het midden van de vijftiende eeuw." Master's thesis, Katholieke Universiteit Leuven, 1979.

De Smet, Jozef. "Een aanslag tegen het Brugse begijnhof. De ontvoering van Katelijne Vedelaers 1345." *Biekorf* 72 (1971): 33–38.

De Spiegeler, Pierre. *Les hôpitaux et l'assistance à Liège (Xe–XVe siècles): Apects institutionnels et sociaux.* Paris: Les Belles Lettres, 1987.

Desportes, Pierre. "L'enseignement à Reims aux XIIIe et XIVe siècles." In *Enseignement et vie intellectuelle (IXe–XVIe siècle). Actes du 95e Congrès national des sociétés savantes, Reims, 1970. Section de philologie et d'histoire jusqu'à 1610.* Vol. 1, 107–122. Paris: Bibliothèque nationale, 1975.

———. *Reims et les Rémois aux XIIIe et XIVe siècles.* Paris: A. & J. Picard, 1979.

Deussen, Heinz Hermann. "Ein Beginenhof im mittelalterlichen Heinsberg." *Heimatkalender des Selfkantkreises Geilenkirchen-Heinsberg* 13 (1963): 55–61.

Dhérent, Catherine. "L'assise sur le commerce des draps à Douai en 1304." *Revue du Nord* 65 (1983): 369–97.

D'Huys, Bert. "De Gentse begijnhoven in cultuurhistorisch perspectief." In *Werken en Kerken. 750 jaar begijnhofleven te Gent.* Exhibition catalogue, 13–48. Ghent: Stad Gent, 1984.

*Dictionary of the Middle Ages.* Edited by Joseph R. Strayer. New York: Charles Scribner's Sons, 1982–89.

Dinzelbacher, Peter. *Mittelalterliche Frauenmystik.* Paderborn: Ferdinand Schöningh, 1993.

Doerr, Otmar. *Das Institut der Inclusen in Süddeutschland.* Münster in Westfalen: Aschendorffschen Verlagsbuchhandlung, 1934.

Dufeil, Michel-Marie. *Guillaume de Saint-Amour et la polémique universitaire parisienne 1250–1259.* Paris: A. et J. Picard, 1972.

Elliott, Dyan. *Spiritual Marriage: Sexual Abstinence in Medieval Wedlock.* Princeton: Princeton University Press, 1993.

Elm, Kaspar. "Die Stellung der Frau in Ordenswesen, Semireligiosentum und Häresie zur Zeit der heiligen Elisabeth." In *Sankt Elisabeth. Fürstin, Dienerin, Heilige,* 7–28. Sigmaringen: Jan Thorbecke Verlag, 1981.

Epiney-Burgard, Georgette. "Les béguines et l'ordre cistercien aux Pays-Bas du sud (XIIIe siècle)." In *Les mouvances laïques des ordres religieux,* 261–77.

Erens, A. "Les soeurs dans l'ordre de Prémontré." *Analecta Praemonstratensia* 5 (1929): 5–29.

Espinas, Georges. *La vie urbaine de Douai au Moyen Age.* Paris: A. Picard et fils, 1913.

*Faire croire: Modalités de la diffusion et de la réception des messages religieux du XIIe au XVe siècle.* Rome: École française de Rome, 1981.

Farmer, Sharon. "Down and Out and Female in Thirteenth-Century Paris." *American Historical Review* 103 (1998): 345–72.

Freed, John B. "Urban Development and the 'Cura Monialium' in Thirteenth-Century Germany." *Viator* 3 (1972): 311–27.

Galloway, Penelope. " 'Discreet and Devout Maidens': Women's Involvement in Beguine

Communities in Northern France, 1200–1500." In *Medieval Women in Their Communities*. Edited by Diane Watt, 92–115. Toronto: University of Toronto Press, 1997.

Gastout, Marguerite. *Béatrix de Brabant. Landgravinne de Thuringe, Reine des Romains, Comtesse de Flandre, Dame de Courtrai (1225?–1288)*. Louvain: Bibliothèque de l'Université, 1943.

Geirnaert, Noël. "Het 'convent ten Hamerkine' te Brugge (14de–15de eeuw)." *Biekorf* 82 (1982): 220–24.

*De geschiedenis van Mechelen: Van heerlijkheid tot stadsgewest*. Edited by Raymond Van Uytven. Tielt: Lannoo, 1991.

*Geschiedenis van de Nederlanden*. Edited by J. C. H. Blom and E. Lamberts. Rijswijk, The Netherlands: Nijgh & Van Ditmar: 1993.

Geyer, Iris. *Maria von Oignies: Eine hochmittelalterliche Mystikerin zwischen Ketzerei und Rechtgläubigkeit*. Frankfurt am Main: Peter Lang, 1992.

Gilchrist, Roberta. *Contemplation and Action: The Other Monasticism* London: Leicester University Press, 1995.

———. *Gender and Material Culture: The Archeology of Religious Culture*. London: Routledge, 1994.

Gill, Katherine. "*Scandala*: Controversies Concerning *Clausura* and Women's Religious Communities in Late Medieval Italy." In *Christendom and Its Discontents*, 177–203.

Godding, Philippe. *Le droit foncier à Bruxelles au moyen âge*. Brussels: Institut de Sociologie Solvay, 1960.

———. *Le droit privé dans les Pays-Bas méridionaux du 12e au 18e siècle*. Brussels: Palais des Académies, 1987. Revised ed. 1991.

Godding, Robert. "Vie apostolique et société urbaine à l'aube du XIIIe siècle. Une oeuvre inédite de Thomas de Cantimpré." *Nouvelle Revue Théologique* 104 (1982): 692–721.

Goetstouwers, A. "Het 'vita' der zalige Ida van Leuven. Chronologische aantekeningen." *BG*, 3rd ser., 5 (1953): 197–201.

Goldberg, P. J. P. *Women, Work, and Life Cycle in a Medieval Economy: Women in York and Yorkshire c. 1300–1520*. Oxford: Clarendon Press, 1992.

Goossens, Jean. *De kwestie Lambertus 'li Beges' (+1177)*. Brussels: Paleis der Academiën, 1984.

Greilsammer, Myriam. *L'envers du tableau: Marriage et maternité en Flandre médiévale*. Paris: Armand Colin, 1990.

Greven, Joseph. *Die Anfänge der Beginen: Ein Beitrag zur Geschichte der Volksfrömmigkeit und des Ordenswesens im Hochmittelalter*. Münster in Westfalen: Aschendorffsche Verlagsbuchhandlung, 1912.

———. "Der Ursprung des Beginenwesens." *Historisches Jahrbuch* 35 (1914): 26–58, 291–318.

*Grote lijnen: Syntheses over Middelnederlandse letterkunde*. Edited by Frits Van Oostrom et al. Amsterdam: Prometheus, 1995.

Grundmann, Herbert. *Religiöse Bewegungen im Mittelalter. Untersuchungen über die geschichtlichen Zusammenhänge zwischen der Ketzerei, den Bettelorden und der religiösen Frauenbewegung im 12. und 13. Jahrhundert und über die geschichtlichen Grundlagen der deutschen Mystik*. 2nd. ed. Darmstadt: Wissenschaftliche Buchgesellschaft, 1961.

Gysseling, Maurits. "De herkomst van het woord begijn." *Heemkundig Nieuws* 13 (1985): 9–12.

Hagemeijer, Pauline. "Samen maar wel apart. Vrouwen en dubbelkloosters in de Noordelijke Nederlanden, 1100–1400." In *Jaarboek voor vrouwengeschiedenis*, 111–30. Nijmegen: Sun, 1984.

Hajnal, John. "European Marriage Patterns in Perspective." In *Population in History: Essays in Historical Demography.* Edited by D. V. Glass and D. E. C. Eversley, 101–43. London: Edward Arnold, 1965.

Halkin, Léon. "La Maison des Bons-Enfants de Liège." *Bulletin de l'Institut archéologique liégeois* 64 (1940): 5–54.

Hallmann, Ernst. *Die Geschichte des Ursprungs der belgischen Beghinen.* Berlin: G. Reimer, 1843.

Hanawalt, Barbara. *"Of Good and Ill Repute": Gender and Social Control in Medieval England.* New York: Oxford University Press, 1998.

Hanon de Louvet, R. *Contribution à l'histoire de la ville de Nivelles. Première série.* Gembloux: Duculot, 1948.

———. "L'Origine nivelloise de l'Institution béguinale 'La Royauté', fondation béguinale d'une Reine de France Marie de Brabant et la légende de la béguine de Nivelles." *Annales de la Société archéologique et folklorique de Nivelles et du Brabant wallon* 17 (1952): 5–77.

Harline, Craig. "Actives and Contemplatives: The Female Religious of the Low Countries Before and After Trent." *Catholic Historical Review* 81 (1995): 541–67.

*Hart en marge in de laat-middeleeuwse stedelijke maatschappij/Core and Periphery in Late Medieval Urban Society/Coeur et marge dans la société urbaine au bas moyen âge.* Edited by Myriam Carlier et al., Louvain and Apeldoorn: Garant, 1997.

Hendrix, Guido. "Hadewijch benaderd vanuit de tekst over de 28e volmaakte." *Leuvense Bijdragen* 67 (1978): 129–45.

———. "Primitive versions of Thomas of Cantimpré's *Vita Lutgardis.*" *Cîteaux* 29 (1978): 153–206.

Henne, Alexandre, and Alphonse Wauters. *Histoire de la Ville de Bruxelles.* 2nd ed. by Mina Martens. Brussels: Éditions "Culture et Civilisation," 1968–69.

*Heresy and Literacy, 1000–1530.* Edited by Peter Biller and Anne Hudson. Cambridge: Cambridge University Press, 1994.

Herlihy, David. *Opera Muliebria: Women and Work in Medieval Europe.* New York: McGraw-Hill, 1990.

Herlihy, David, and Christiane Klapisch-Zuber. *Tuscans and Their Families: A Study of the Florentine Catasto of 1427.* New Haven and London: Yale University Press, 1985.

*Hidden Springs: Cistercian Monastic Women.* Edited by John A. Nichols and Lillian Thomas Shank. *Medieval Religious Women.* Part 3. Kalamazoo: Cistercian Publications, 1995.

Hilka, Alfons. "Altfranzösische Mystik und Beginentum." *Zeitschrift für romanische Philologie* 47 (1927): 121–70.

*A History of Women in the West.* Edited by Christiane Klapisch-Zuber. vol. 2. Cambridge, Mass.: Harvard University Press, 1992.

Hocquet, A. "Le Béguinage. Son véritable fondateur." *Annales de la Société historique et archéologique de Tournai* 7 (1902): 75–80.

Hohenberg, Paul M., and Lynn Hollen Lees. *The Making of Urban Europe 1000–1950.* Cambridge, Mass.: Harvard University Press, 1985.

Hollywood, Amy. *The Soul as Virgin Wife: Mechtild of Magdeburg, Marguerite Porete, and Meister Eckhart*. Notre Dame: University of Notre Dame Press, 1995.

*Hooglied. De beeldwereld van religieuze vrouwen in de Zuidelijke Nederlanden, vanaf de 13de eeuw*. Edited by Paul Vandenbroeck. Brussels: Paleis voor Schone Kunsten; Ghent: Snoeck-Ducaju & Zoon, 1994.

Howell, Martha. "Fixing Movables: Gifts by Testament in Late Medieval Douai." *Past and Present* 150 (February 1996): 3–45.

———. *The Marriage Exchange: Property, Social Place, and Gender in Cities of the Low Countries, 1300–1550*. Chicago: University of Chicago Press, 1998.

———. *Women, Production, and Patriarchy in Late Medieval Cities*. Chicago: University of Chicago Press, 1986.

*In beeld geprezen. Miniaturen uit Maaslandse devotieboeken 1250–1350*. Exhibition Catalogue. Louvain: Peeters, 1989.

Jacob, Robert. *Les époux, le seigneur et la cité: Coutume et pratique matrimoniales des bourgeois et paysans de France du Nord au Moyen Age*. Brussels: Publications des Facultés Universitaires Saint-Louis, 1990.

Johnson, Penelope D. *Equal in Monastic Profession: Religious Women in Medieval France*. Chicago: University of Chicago Press, 1991.

Joris, André. *La ville de Huy au Moyen Age*. Paris: Les Belles Lettres, 1959.

Juten, G. C. A. "Het begijnhof te Bergen op Zoom." *Taxandria* 37 (1930): 57–66; 38 (1931): 12–19, 57–64.

Kervyn de Lettenhove, H. "Béatrix de Courtrai." *Bulletins de l'Académie royale de Belgique* 22 (1855), 1: 382–400.

Klapisch-Zuber, Christiane. *La maison et le nom: Stratégies et rituels dans l'Italie de la Renaissance*. Paris: Éditions de l'École des Hautes Études en Sciences Sociales, 1990.

———. *Women, Family, and Ritual in Renaissance Italy*. Chicago: University of Chicago Press, 1985.

Koch, Esther M. F. *De kloosterpoort als sluitpost? Adellijke vrouwen langs Maas en Rijn tussen huwelijk en convent, 1200–1600*. Leeuwarden: Eisma, 1994.

Koorn, Florence. *Begijnenhoven in Holland en Zeeland gedurende de middeleeuwen*. Assen: Van Gorcum, 1981.

———. "Hollandse nuchterheid? De houding van de Moderne Devoten tegenover vrouwenmystiek en ascese." *OGE* 66 (1992): 97–114.

Kurth, Godefroid. "L'archidiacre Hervard." *BCRH* 72 (1903): 121–80.

———. "L'origine liégeoise des béguines." *Bulletins de l'Académie royale de Belgique, Classe des Lettres*, 5th s., 2 (1912): 437–62.

Lambert, Malcolm. *The Cathars*. Oxford: Blackwell, 1998.

———. *Medieval Heresy: Popular Movements from the Gregorian Reform to the Reformation*. 2nd. ed. Oxford: Blackwell, 1992.

Lambrechts, Juliaan. *Het oud begijnhof of beknopte geschiedenis van het begijnhof van Hasselt*. Hasselt: M. Ceysens, 1886.

Lambrechts, Rachel. "Het begijnhof van Hoogstraten (1380–1600)." *HOK: Jaarboek van Koninklijke Hoogstratens Oudheidkundige Kring* (1959): 3–205.

Lauwers, Michel. "Entre béguinisme et mysticisme: La Vie de Marie d'Oignies (+1213) de Jacques de Vitry ou la définition d'une sainteté féminine." *OGE* 66 (1992): 46–70.

———. "Expérience béguinale et récit hagiographique." *Journal des Savants* (1989): 61–103.

——. *La mémoire des ancêtres, le souci des morts. Morts, rites et société au moyen âge (diocèse de Liège, XIe–XIIIe siècles)*. Paris: Beauchesne, 1996.

——. " 'Noli me tangere': Marie Madeleine, Marie d'Oignies et les pénitentes du XIIIe siècle." *Mélanges de l'École Française de Rome. Moyen Age* 104 (1992): 209–68.

——. "Paroles de femmes, sainteté féminine. L'Église du XIIIe siècle face aux béguines." In *La critique historique à l'épreuve: Liber disciplinorum Jacques Paquet.* Edited by Gaston Braive and Jean-Marie Cauchies, 99–115. Brussels: Facultés universitaires Saint-Louis, 1989.

——. *"Praedicatio-Exhortatio*: L'Église, la réforme et les laïcs (XIe–XIIIe siècles)." In *La parole*, 187–232.

Lauwers, Michel, and Walter Simons. *Béguins et Béguines à Tournai au Bas Moyen Age. Les communautés béguinales à Tournai du XIIIe au XVe siècle*. Tournai: Archives de la Cathédrale; Louvain-la-Neuve: Université Catholique de Louvain, 1988.

Lauwerys, J. *Het begijnhof van Hoogstraten*. Hoogstraten: Haseldonckx, 1974–76.

Leclercq, Jean. "Le magistère du prédicateur au XIIIe siècle." *Archives d'histoire doctrinale et littéraire du Moyen Age* 21 (1946): 105–47.

Lefèvre, Placide F. *L'organisation ecclésiastique de la ville de Bruxelles au moyen âge*. Louvain: Bibliothèque de l'Université; Brussels: Éditions Universitaires, 1942.

Le Goff, Jacques. *Your Money or Your Life: Economy and Religion in the Middle Ages*. Translated by Patricia Ranum. New York: Zone Books, 1988.

Le Grand, Louis. "Les béguines de Paris." *Mémoires de la Société d'histoire de Paris et de l'Ile-de-France* 20 (1893): 295–357.

Lerner, Robert E. "Beguines and Beghards." In *Dictionary of the Middle Ages*. vol. 2, 157–62.

——. *The Heresy of the Free Spirit in the Later Middle Ages*. Berkeley: University of California Press, 1972.

——. "Introduction." In Herbert Grundmann, *Religious Movements in the Middle Ages*. Translated by Steven Rowan, ix–xxv. Notre Dame: University of Notre Dame Press, 1995.

*Leuven 'De beste stad van Brabant'*. vol. 1. Edited by Raymond Van Uytven. Louvain: Stadsbestuur van Leuven, 1980.

Levelt, H. *Het begijnhof buiten Bergen op Zoom*. Bergen op Zoom: Hertogs & Timmermans, 1924.

L'Hermite-Leclercq, Paulette. "Reclus et recluses dans la mouvance des ordres religieux." In *Les mouvances laïques*, 201–18.

Luykx, Theo. *Johanna van Constantinopel, Gravin van Vlaanderen en Henegouwen. Haar leven (1199/1200–1244). Haar regering (1205–1244)*. Antwerp: Standaard Boekhandel, 1946.

Lux, G. V., and M. Bussels. "De opgravingen in en om de kapel van het gasthuis te Borgloon." *Het Oude Land van Loon* 24 (1969): 163–225.

Maes, Louis Th. *Vijf eeuwen stedelijk strafrecht. Bijdrage tot de rechts- en cultuurgeschiedenis der Nederlanden*. Antwerp: De Sikkel; The Hague: Martinus Nijhoff, 1947.

Majérus, Pascal. *Ces femmes qu'on dit béguines . . . Guide des béguinages de Belgique. Bibliographie et sources d'archives*. Brussels: Archives générales du Royaume, 1997.

Manteuffel, Tadeusz. *Naissance d'une hérésie: les adeptes de la pauvreté volontaire au moyen âge*. Paris and The Hague: Mouton, 1970.

Maréchal, Griet. "Armen- en ziekenzorg in de Zuidelijke Nederlanden." In *AGN*, vol 2, 268–80.

Marechal, J. "Konventen van arme begijnen in Brugge 1302–1374." In *Album Antoon Viaene*, 257–64. Bruges, 1970.

Martens, Mina. "Hedwige Blomart face au mystique Jean Van Ruysbroec. Leurs milieux familiaux à l'épreuve des assertions de Pomérius, visant la Bloemardinne (1250–XVe siècle)." *Cahiers Bruxellois* 31 (1990): 1–107.

Martin, J. "Les béguinages en Brabant wallon." *Wavriensia* 22 (1973): 83–84.

McDonnell, Ernest. *The Beguines and Beghards in Medieval Culture: With Special Emphasis on the Belgian Scene.* New Brunswick: Rutgers University Press, 1954.

McGinn, Bernard. *The Flowering of Mysticism: Men and Women in the New Mysticism (1200–1350).* New York: The Crossroad, 1998.

McLaughlin, Eleanor. "Les femmes et l'hérésie médiévale." *Concilium* 111 (1976): 73–90.

*The Medieval Church: Universities, Heresy, and the Religious Life. Essays in Honour of Gordon Leff.* Edited by Peter Biller and Barrie Dobson. Woodbridge, Suffolk: Boydell Press and the Ecclesiastical History Society, 1999.

*Medieval Dutch Literature in Its European Context.* Edited by Erik Kooper. Cambridge: Cambridge University Press, 1994.

*Medieval Women, Studies in Church History,* vol. 10. Edited by Derek Baker. Oxford: Basil Blackwell, 1978.

Meersseman, Giles G. "Les Frères Prêcheurs et le mouvement dévot en Flandre au XIIIe siècle." *Archivum Fratrum Praedicatorum* 18 (1949): 69–130.

*Meister Eckhart and the Beguine Mystics: Hadewijch of Brabant, Mechtild of Magdeburg, and Marguerite Porete.* Edited by Bernard McGinn. New York: Continuum, 1994.

Mens, Alcantara. "De 'Kleine Armen van Christus' in de Brabants-Luikse gewesten (einde 12e, begin 13e eeuw)." *OGE* 36 (1962): 282–331; 37 (1963): 129–69, 353–401; 38 (1964): 113–44; 39 (1965): 225–71.

———. *Oorsprong en Betekenis van de Nederlandse Begijnen- en Begardenbeweging. Vergelijkende studie: XIIde–XIIIde eeuw.* Antwerp: Standaard Boekhandel, 1947.

Milis, Ludo. *Angelic Monks and Earthly Men: Monasticism and its Meaning to Medieval Society.* Woodbridge, Suffolk: Boydell Press, 1992.

———. "Beroering omtrent bisdomssplitsingen in Vlaanderen in de jaren 1112–1113." In *Pascua Mediaevalia,* 5–14.

———. "Ermites et chanoines réguliers au XIIe siècle." *Cahiers de Civilisation Médiévale* 22 (1979): 39–80.

———. "De Kerk tussen de Gregoriaanse hervorming en Avignon." In *AGN*, vol. 3, 166–211.

———. *L'ordre des chanoines réguliers d'Arrouaise.* Bruges: De Tempel, 1969.

Misonne, Daniel. "Office liturgique neumé de la bienheureuse Marie d'Oignies à l'abbaye de Villers au XIIIe siècle." In *Album J. Balon,* 171–89. Namur: Les anciens établissements Godenne, 1968.

Mols, Roger. *Introduction à la démographie historique des villes d'Europe du XIVe au XVIIIe siècle.* Gembloux: Duculot, 1954–56.

*Monasticon belge. Tome IV. Province de Brabant,* vol. 2. Liège: Centre nationale de recherches d'histoire religieuse, 1968.

*Monasticon belge. Tome VI: Province de Limbourg.* Liège: Centre nationale de recherches d'histoire religieuse, 1976.

*Monasticon belge. Tome VIII: Province d'Anvers*, vol. 1. Liège: Centre nationale de recherches d'histoire religieuse, 1992.

Moore, R. I. *The Birth of Popular Heresy*. New York: St. Martin's Press, 1975.

———. *The Formation of a Persecuting Society: Power and Deviance in Western Europe, 950–1250*. Oxford: Basil Blackwell, 1987.

———. "Heresy, Repression, and Social Change in the Age of Gregorian Reform." In *Christendom and Its Discontents*, 19–46.

———. "Literacy and the Making of Heresy." In *Heresy and Literacy, 1000–1530*, 19–37.

———. *The Origins of European Dissent*. 2nd ed. Oxford: Basil Blackwell, 1985.

———. "Postscript: the Peace of God and the Social Revolution." In *The Peace of God: Social Violence and Religious Response in France Around the Year 1000*. Edited by Thomas Head and Richard Landes, 308–26. Ithaca: Cornell University Press, 1992.

*Les mouvances laïques des ordres religieux. Actes du Troisième Colloque International du C. E. R. C. O. R.* Saint-Étienne: Publications de l'Université de Saint-Étienne, 1996.

Mulder-Bakker, Anneke B. "Ivetta of Huy: Mater et Magistra." In *Sanctity and Motherhood: Essays on Holy Mothers in the Middle Ages*. Edited by Anneke B. Mulder-Bakker, 225–58. New York: Garland, 1995.

Müller, Daniela. *Frauen vor der Inquisition: Lebensform, Glaubenszeugnis und Aburteilung der deutschen und französischen Katharerinnen*. Mainz: Philipp von Zabern, 1996.

Neel, Carol. "The Origins of the Beguines." *Signs* 14 (1989): 321–41.

Neumann, Eva Gertrud. *Rheinisches Beginen- und Begardenwesen. Ein Mainzer Beitrag zur religiösen Bewegung am Rhein*. Meisenheim am Glam: Anton Hain, 1960.

Newman, Barbara. *From Virile Woman to WomanChrist: Studies in Medieval Religion and Literature*. Philadelphia: University of Pennsylvania Press, 1995.

———. "Possessed by the Spirit: Devout Women, Demoniacs, and the Apostolic Life in the Thirteenth Century." *Speculum* 73 (1998): 733–70.

*New Trends in Female Spirituality: The Holy Women of Liège and Their Impact*. Edited by Juliette Dor, Lesley Johnson, and Jocelyn Wogan-Browne. Turnhout: Brepols, 1999.

Nicholas, David. *The Domestic Life of a Medieval City: Women, Children, and the Family in Fourteenth-Century Ghent*. Lincoln, Nebraska: University of Nebraska Press, 1985.

———. *Medieval Flanders*. London: Longman, 1992.

———. *The Metamorphosis of a Medieval City: Ghent in the Age of the Arteveldes, 1302–1390*. Leyden: E. J. Brill, 1987.

———. *Town and Countryside: Social, Economic, and Political Tensions in Fourteenth-Century Flanders*. Bruges: De Tempel, 1971.

Nimal, H. *Les béguinages*. Nivelles: Imprimerie Lanneau et Despret, 1908.

Oliver, Judith H. *Gothic Manuscript Illumination in the Diocese of Liège (c. 1250–c. 1330)*. Louvain: Peeters, 1988.

Olyslager, W.A. *Het groot begijnhof van Leuven*. Louvain: Groot Begijnhof, 1973.

———. *750 jaar Antwerpse begijnen*. Antwerpen: Pelckmans, 1990.

Parker, Geoffrey. *The Dutch Revolt*. London: Allen Lane, 1977. Revised edition. London: Penguin Books, 1985.

*La parole du prédicateur Ve–XVe siècles*. Edited by Rosa Maria Dessì and Michel Lauwers. Nice: Centre d'Études Médiévales, 1997.

*Pascua Mediaevalia: Studies voor Prof. Dr. J. M. De Smet*. Louvain: Universitaire Pers Leuven, 1983.

Persoons, Ernest. "De bewoners van de kloosters Betlehem te Herent en Ten Troon te Grobbendonk." *Arca Lovaniensis* 5 (1976): 221–40.

Peters, Günter. "Norddeutsches Beginen- und Begardenwesen im Mittelalter." *Niedersächsische Jahrbuch für Landesgeschichte* 41 (1969–70): 50–118.

Peters, Ursula. *Religiose Erfahrung als literarisches Faktum: Zur Vorgeschichte und Genese frauenmystischer Texte des 13. und 14. Jahrhunderts.* Tübingen: Max Niemeyer, 1988.

Philippen, L. J. M. "Het Begijnhof van Sint-Catharina 'ten Velde,' te Diest." *BG* 3 (1904): 501–18, and 4 (1905): 327–39, 423–33, 532–36.

———. *De Begijnhoven. Oorsprong, Geschiedenis, Inrichting.* Antwerp: Veritas, 1918.

———. "Het oudste Zegel en de vroegste Geschiedenis der Begijnen van Antwerpen." *BG* 26 (1935): 81–106.

Phillips, Dayton. *Beguines in Medieval Strasburg: A Study of the Social Aspect of Beguine Life.* Stanford, Calif.: Stanford University Press, 1941.

Pick, P. "Der St. Margarethenkonvent im Beguinenwinkel zu Aachen." *Annalen des Historischen Vereins für den Niederrhein* 46 (1887): 179–81.

Pirenne, Henri. "Les dénombrements de la population d'Ypres au XVe siècle (1412–1506). Contribution à la statistique sociale du moyen âge." *Vierteljahrschrift für Sozial- und Wirtschaftsgeschichte* 1 (1903): 1–32.

Pleij, Herman. *De sneeuwpoppen van 1511. Literatuur en stadscultuur tussen middeleeuwen en moderne tijd.* Amsterdam: Meulenhoff; Louvain: Kritak, 1988.

———. "The Rise of Urban Literature in the Low Countries." In *Medieval Dutch Literature,* 62–77.

———. "Urban Elites in Search of a Culture: The Brussels Snow Festival of 1511." *New Literary History* 21 (1990): 629–47.

Poswick, Prosper. "Lambert-le-Bègue et l'origine des béguinages." *Bulletin de la Société d'art et d'histoire du diocèse de Liège* 32 (1946): 59–73.

Prevenier, Walter and Willem Pieter Blockmans. *The Burgundian Netherlands.* Cambridge: Cambridge University Press, 1986.

———. *The Promised Lands: The Low Countries Under Burgundian Rule, 1369–1530.* Philadelphia: University of Pennsylvania Press, 1999.

Prims, Floris. *Geschiedenis van Antwerpen.* Antwerp: Standaard Boekhandel, 1926–49.

———. *Kerkelijk Antwerpen in het laatste kwart der XIIIde eeuw.* Antwerp: Boekhandel der Bijdragen, 1928.

*Le Prince et le Peuple: Images de la société du temps des ducs de Bourgogne 1384–1530.* Edited by Walter Prevenier. Antwerp: Fonds Mercator, 1998.

Quix, Christian. "Das ehemalige Beghinen Wesen in der Stadt Aachen." *Aus Aachens Vorzeit* 5 (1892): 2–6.

Quix, Christian. "St. Stephanshof." *Aus Aachens Vorzeit* 5 (1892): 33–45.

Raymaekers, F. J. E. *Het kerkelijk en liefdadig Diest.* Louvain: Karel Peeters, 1870.

Rehm, Gerhard. "Beginen am Niederrhein." In *"Zahlreich wie die Sterne des Himmels": Beginen am Niederrhein zwischen Mythos und Wirklichkeit,* 57–84. Bergisch-Gladbach: Thomas Morus-Akademie Bensberg, 1992.

———. *Die Schwestern vom Gemeinsamen Leben im nordwestlichen Deutschland. Untersuchungen zur Geschichte der Devotio Moderna und des weiblichen Religiosentums.* Berlin: Duncker & Humblot, 1985.

Renardy, Christine. *Le monde des maîtres universitaires du diocèse de Liège 1140–1350. Recherches sur sa composition et ses activités.* Paris: Les Belles Lettres, 1979.

———. *Les maîtres universitaires du diocèse de Liège: Répertoire biographique 1140–1350*. Paris: Les Belles Lettres, 1981.

Reypens, Léonce. "Markante mystiek in het Gentsch begijnhof. Claesinne van Nieuwlant (± 1550–1611)." *OGE* 12 (1939): 291–360.

———. "Pelgrim Pullen (1550–1608). Een heilig mystiek leider en zijn onuitgegeven geschriften." *OGE* 3 (1929): 22–44, 125–43, 245–77.

Roebroeks, F. H. M. "Van Aldenhof tot Sint-Catharina Bongart, bijdrage tot de geschiedenis van een Maastrichts begijnhof." In *Munsters in de Maasgouw: Archeologie en Kerkgeschiedenis in Limburg*, 158–73. Maastricht: Limburgs Geschied- en Oudheidkundig Genootschap, 1986.

Roisin, Simone. "L'efflorescence cistercienne et le courant féminin de piété au XIIIe siècle." *RHE* 39 (1943): 342–78.

———. *L'Hagiographie cistercienne dans le diocèse de Liège au XIIIe siècle*. Louvain: Bibliothèque de l'Université; Brussels: Éditions Universitaires, 1947.

Roland, C. "Les seigneurs et comtes de Rochefort." *Annales de la Société Archéologique de Nivelles* 20 (1893): 63–144, 329–411.

Rubin, Miri. *Charity and Community in Medieval Cambridge*. Cambridge: Cambridge University Press, 1987.

———. *Corpus Christi: The Eucharist in Late Medieval Culture*. Cambridge: Cambridge University Press, 1991.

Ruelens, K. "Jan van Ruysbroek en Blommardinne." In *Werken van zuster Hadewijch*. Edited by J. Vercouillie. vol. 3, xxi–xcvi. Ghent: C. Annoot-Braeckman, 1905.

Ryckaert, Marc. *Brugge*. Brussel: Gemeentekrediet, 1991.

Ryckel, Ioseph Geldolph a. *Vita S. Beggae*. Louvain: Typis Corn. Coenestenii, 1631.

Sandor, Monica. "The Popular Preaching of Jacques de Vitry." Ph.D. diss., University of Toronto, 1993.

Scheerder, Jozef. "Schoolmeesters en schoolmeesteressen te Gent tijdens het wonderjaar (1566–1567)." *Handelingen der Maatschappij voor Geschiedenis en Oudheidkunde te Gent*, n. s. 35 (1981): 114–28.

Schmitt, Jean-Claude. *Mort d'une hérésie: L'Église et les clercs face aux béguines et aux béghards du Rhin supérieur du XIVe au XVe siècle*. Paris: Mouton, 1978.

Schneyer Johannes-Baptist. *Repertorium des lateinischen Sermones des Mittelalters für die Zeit von 1150–1350*. vol. 3. Münster in Westfalen: Aschendorffsche Verlagsbuchhandlung, 1971.

Schoengen, Michael. *Monasticon Batavum*. Amsterdam: Noord-Hollandsche Uitgevers Maatschappij, 1941–2.

Schoolmeesters, Émile. "Lambert-le-Bègue et l'origine des Béguines." *Leodium* 11 (1912): 126–32.

———. "Tableau des archidiacres de Liège pendant le XIIIe siècle." *Leodium* 2 (1903): 3–6.

Schutjes, Ludovicus H. C. *Geschiedenis van het bisdom 's Hertogenbosch*. Sint-Michielsgestel: n.p., 1870–76.

Sered, Susan Starr. *Priestess, Mother, Sacred Sister: Religions Dominated by Women*. New York: Oxford University Press, 1994.

Simons, Walter. "The Annales and Medieval Studies in the Low Countries." In *The Work of Jacques Le Goff*, 99–122.

———. *Bedelordekloosters in het graafschap Vlaanderen. Chronologie en topografie van*

*de bedelordenverpreiding in het graafschap Vlaanderen vóór 1350.* Bruges: Stichting Jan Cobbaut, 1987.

————. "Begijnen en begarden in het middeleeuwse Douai." *Jaarboek De Franse Neder-landen/Annuaire Les Pays-Bas Français* 17 (1992): 180–97.

————. The Beguine Movement in the Southern Low Countries: A Reassessment." *Bulletin de l'Institut historique belge de Rome/Bulletin van het Belgisch Historisch Instituut te Rome* 59 (1989): 63–105.

————. "Geletterdheid en boekengebruik bij de vroegste begijnen." *Handelingen der koninklijke Zuidnederlandse Maatschappij voor Taal- en Letterkunde en Geschiedenis* 53 (1999): 167–80.

————. "Jacques de Vitry." In *Literature of the French and Occitan Middle Ages: Eleventh to Fifteenth Centuries.* Edited by Deborah M. Sinnreich-Levi and Ian S. Laurie, 157–62. Farmington Hills, Mich.: The Gale Group, 1999.

————. "Jean de Warneton et la réforme grégorienne." *Mémoires de la Société d'Histoire de Comines-Warneton et de la Région* 17 (1987): 35–54.

————. "Reading a Saint's Body: Rapture and Bodily Movement in the *Vitae* of Thirteenth-Century Beguines." In *Framing Medieval Bodies.* Edited by Sarah Key and Miri Rubin, 10–23. Manchester: Manchester University Press, 1994.

————. *Stad en apostolaat: De vestiging van de bedelorden in het graafschap Vlaanderen (ca. 1225–ca. 1350).* Brussels: Paleis der Academiën, 1987.

————. "Een zeker bestaan. De zuidnederlandse begijnen en de *Frauenfrage*." *Tijdschrift voor sociale geschiedenis* 17 (1991): 125–46.

Simons, Walter, Guido Jan Bral, Jan Caudron, and J. Bockstaele. *Het Pand: Acht eeuwen geschiedenis van het oud dominicanenklooster te Gent.* Tielt: Lannoo, 1991.

Simons, Walter, and Joanna E. Ziegler. "Phenomenal Religion in the Thirteenth Century and its Image: Elisabeth of Spalbeek and the Passion Cult." In *Women in the Church,* 117–26.

Sivré, J. B. "Geschiedkundige Schets van het oud begijnhof te Roermond." *Publications de la Société historique et archéologique dans le duché de Limbourg* 11 (1874): 163–219.

Solterer, Helen. *The Master and Minerva. Disputing Women in French Medieval Culture.* Berkeley: University of California Press, 1995.

Smit, J. P. W. A. "Het Begijnhof van Oisterwijk." *Bossche Bijdragen* 3 (1919–20): 40–55.

Stabel, Peter. *Dwarfs Among Giants: The Flemish Urban Network in the Late Middle Ages.* Louvain and Apeldoorn: Garant, 1997.

————. *De kleine stad in Vlaanderen: Bevolkingsdynamiek en economische functies van de kleine en secundaire stedelijke centra in het Gentse kwartier (14de–16de eeuw).* Brussels: Paleis der Academiën, 1995.

Steenwegen, Antoon. "De gelukz. Ida de Lewis of Ida van Gorsleeuw." *OGE,* 57 (1983): 105–33; 209–47, 305–22.

Stein, Frederick M. "The Religious Women of Cologne." Ph.D. diss., Yale University, 1977.

Stock, Brian. *The Implications of Literacy: Written Language and Models of Interpretation in the Eleventh and Twelfth Centuries.* Princeton: Princeton University Press, 1983.

Straven, François. *Notice historique sur le béguinage dit de Sainte-Agnes à Saint-Trond.* Sint-Truiden: Typographie E. Schoofs-Herman, 1876.

Stroick, Autbertus. "Verfasser und Quellen der Collectio de Scandalis Ecclesiae (Reformschrift des Fr. Gilbert von Tournay, O.F.M., zum II. Konzil von Lyon, 1274)." *Archivum Franciscanum Historicum* 23 (1930): 3–41, 273–99, 433–66.

Stroobants, Aimé, et al., *700 jaar begijnhof 1288–1988*. Dendermonde, n.p., 1988.

Struyf, A. "De bevolking van het Klein Begijnhof te Leuven gedurende de XVIIde en XVIIIde eeuw." *Mededelingen van de Geschied- en Oudheidkundige Kring voor Leuven en Omgeving* 5 (1965): 149–68.

Suttor, Marc. "Le *Triumphus Sancti Lamberti de castro Bullonio* et le catharisme à Liège au milieu du XIIe siècle." *Le Moyen Age* 91 (1985): 227–64.

Sweetman, Robert. "Christine of Saint-Trond's Preaching Apostolate: Thomas of Cantimpré's Hagiographical Method Revisited." *Vox Benedictina* 9 (1992): 67–97.

Szittya, Penn R. *The Antifraternal Tradition in Medieval Literature*. Princeton: Princeton University Press, 1986.

Tarlier, J., and A. Wauters. *Géographie et histoire des communes belges. Province de Brabant, Canton de Jodogne*. Brussels: A. N. Lebègue, 1872.

———. *Géographie et histoire des communes belges. Province de Brabant, Canton de Nivelles*. Brussels: A.N. Lebègue, 1860.

Thompson, Sally. "The Problem of the Cistercian Nuns in the Twelfth and Early Thirteenth Century." In *Medieval Women*, 227–52.

Thijs, Charles M. T. *Histoire du Béguinage de Ste Cathérine à Tongres*. Tongeren: M. Collée, 1881.

Timmermans, Marian. " 'Tussen Kerk en wereld.' Het Grote Begijnhof te 's-Hertogenbosch ±1274–±1629." Bachelor's thesis, Katholieke Universiteit Nijmegen, 1987.

Touati, François-Olivier. "Les groupes de laïcs dans les hôpitaux et les léproseries au moyen âge." In *Les mouvances laïques*, 137–62.

Trooskens, Marianne. "Begijnen in de moderne en hedendaagse tijden." In *Begijnen en Begijnhoven*, 27–111.

Van den Haute, C. "L'hôpital Sainte-Calixte à Jambes." *Annales de la société archéologique de Namur* 26 (1905): 189–204.

Van de Meerendonk, L., O. Praem. *Tussen reformatie en contrareformatie. Geest en levenswijze van de clerus in stad en meijerij van 's-Hertogenbosch en zijn verhouding tot de samenleving tussen ± 1520 en ± 1570*. Tilburg: Stichting Zuidelijk Historisch Contact, 1967.

Van der Donkt, Raf. "Het Sion te Oudenaarde." *Handelingen van de Geschied- en Oudheidkundige kring van Oudenaarde* 32 (1995): 151–82.

Van der Eycken, Michel. "Nicolaas van Essche en de hervorming van het Diestse Begijnhof." *Arca Lovaniensis* 5 (1976): 277–97.

Van Even, Edward. *Louvain dans le passé & dans le présent*. Louvain: Auguste Fonteyn, 1895.

Van Gerven, Jan. "Vrouwen, arbeid en sociale positie. Een voorlopig onderzoek naar de economische rol en maatschappelijke positie van vrouwen in de Brabantse steden in de late middeleeuwen." *BTFG* 73 (1995): 947–66.

Van Haeperen, Gérard. "Le béguinage de Thorembais-les-Béguines." *Le Folklore Brabançon* 237–38 (1983): 95–119.

Van Mierlo, Jozef. "Het begardisme: Een synthetische studie." *Verslagen en Mededeelingen van de Koninklijke Vlaamsche Academie voor Taal- en Letterkunde* (1930): 277–305.

Van Mingroot, Erik. "Ramihrdus de Schere, alias Ramihrd d'Esquerchin (+1077)." In *Pascua Medievalia*, 75–92.

Vauchez, André. "Prosélytisme et action antihérétique en milieu féminin au XIIIe siècle:

la *Vie de Marie d'Oignies* (+1213) par Jacques de Vitry." *Problèmes d'Histoire du Christianisme* 17 (1987): 59–110.

————. *La sainteté en Occident aux derniers siècles du moyen âge. D'après les procès de canonisation et les documents hagiographiques.* Rome: Écoles française de Rome, 1981.

Venarde, Bruce L. *Women's Monasticism and Medieval Society: Nunneries in France and England, 890–1215.* Ithaca: Cornell University Press, 1997.

Verachtert, Frans, et al. *Voorsale des Hemels ofte Het begijnhof in de XVII Provinciën.* Retie: Kempische Boekhandel, 1973. Parts I, II, III.

Verdeyen, Paul. "Le procès d'inquisition contre Marguerite Porete et Guiard de Cressonessart." *RHE* 81 (1986): 47–94.

Verhelst, Daniël, and Eduard Van Ermen. "De cisterciënzerinnen in het hertogdom Brabant." In *Bernardus en de Cisterciënzerfamilie,* 271–93.

Vermuyten, F. *Onze Vlaamse Begijnhoven.* Antwerp: Zuid-Nederlandse Uitgeverij, 1973.

Viaene, Antoon. "Het begijnhof van Kortrijk in 1491." *Biekorf* 57 (1956): 257–59.

————. "Een 'covent van ghewillighe aermen' in Brugge, 1348." *Biekorf* 75 (1974): 407–10.

Vleeschouwers, Cyriel. "Het beheer van het O. L. Vrouw-hospitaal te Gent en de stichting van de Cisterciënserinnenabdijen O. L. Vrouw-ten-Bos (1215) en Bijloke (1228) door uten Hove's." *Annalen van de Belgische Vereniging voor Hospitaalgeschiedenis* 9 (1971): 11–34.

Vriens, M.-Th. "Het oud begijnhof van Herentals (ca. 1260–1508)." Master's thesis, Katholieke Universiteit Leuven, 1968.

Walters, J. *Geschiedenis der Zusters der Bijloke te Gent.* Ghent, n.p., 1929–30.

Warren, Ann K. *Anchorites and Their Patrons in Medieval England.* Berkeley: University of California Press, 1985.

*Wat is wijsheid? Lekenethiek in de Middelnederlandse letterkunde.* Edited by Joris Reynaert. Amsterdam: Prometheus, 1994.

Wehrli-Johns, Martina. "Vorraussetzungen und Perspektiven mittelalterlicher Laienfrömmigkeit seit Innocenz III. Eine auseinandersetzung mit Herbert Grundmanns 'Religiöse Bewegungen.'" *Mitteilungen des Instituts für österreichische Geschichtsforschung* 104 (1996): 286–309.

Weiler, A. G. "Geert Grote en begijnen in de begintijd van de Moderne Devotie." *OGE* 69 (1995): 114–32.

————. "De intrede van rijke weduwen en arme meisjes in de leefgemeenschappen van de Moderne Devotie." *OGE* 59 (1985): 403–19.

Welter, J.-Th. *L'exemplum dans la littérature religieuse et didactique du Moyen Age.* Paris and Toulouse: Occitania, 1927.

Welvaert, Peter. "1617–1797: 180 jaar wonen in het Sint-Elizabethbegijnhof te Gent." *BG* 63 (1980): 219–66.

*Werken en kerken: 750 jaar begijnhofleven te Gent.* Ghent: Stad Gent, 1984.

Wilmet, Charles. "Histoire des béguinages de Namur." *Annales de la Société archéologique de Namur* 6 (1859–60): 43–90.

Wilts, Andreas. *Beginen im Bodenseeraum.* Sigmaringen: Thorbecke, 1994.

Wolters, Mathias J. *Notice historique sur la ville de Maeseyck.* Ghent: Imprimerie F. et E. Gyselynck, 1855.

*Women and Religion in Medieval and Renaissance Italy.* Edited by Daniel Bornstein and Roberto Rusconi. Chicago: The University of Chicago Press, 1996.

*Women in the Church.* Edited by W. J. Sheils and Diana Wood. Oxford: Basil Blackwell, 1990.

*The Work of Jacques Le Goff and the Challenges of Medieval History.* Edited by Miri Rubin. Woodbridge, Suffolk: Boydell Press, 1997.

Wormgoor, I. "De vervolging van de Vrijen van Geest, de begijnen en begarden." *Nederlands Archief voor Kerkgeschiedenis* 65 (1985): 107–30.

Ziegler, Joanna E. *Sculpture of Compassion: The Pietà and the Beguines in the Southern Low Countries c. 1300–c. 1600.* Brussels and Rome: Institut historique belge de Rome, 1992.

———. "Secular Canonesses as Antecedent of the Beguines in the Low Countries: An Introduction to Some Older Views." *Studies in Medieval and Renaissance History* 23 (1992): 117–35.

# Appendix I: Repertory of Beguine Communities

The foundation date and location of female religious communities during the Middle Ages are notoriously difficult to chart. Neglected by historians of medieval monasticism until the mid-twentieth century, many houses of female religious orders are still poorly known, while their archival collections have often suffered irreparable losses. Yet the lack of information is not only the result of neglect. Certain features of houses for women pose a formidable challenge to the cataloging principles developed for the male orders: the houses were often founded in obscure circumstances, changed name, or were moved from one site to another more frequently than was the case for the men's houses, or were not affiliated with an "order" for many centuries.

For the historian of beguine communities in the Low Countries, the challenges may even be greater, since none of the beguine institutions belonged to a religious order, some lasted only a few decades, and quite a few owned little or no property likely to generate a substantial archive.

The following checklist of beguine houses is therefore provisional, and more research is bound to augment it. If it errs, it is on the side of caution: future discoveries notwithstanding, I doubt that many of the houses cited here will need to be deleted from the list. I have made a particular effort to eliminate all communities of Franciscan or Dominican Tertiaries, Cellites, or Sisters of the Common Life, even if medieval sources occasionally called them houses of "beguines." In some cases it is difficult to distinguish between a beguinage and an "almshouse" for women — especially for smaller institutions of the fifteenth and sixteenth centuries. Whenever there is any doubt, I have eliminated the reference. If a community started out as a beguine convent but evolved into an almshouse, I have so indicated, and have regarded the transition as the end of the beguine community. I have also deleted all mention of beguines living individually or in their family households, about whom the reader will find more above, page 135. I have disregarded references to *begijnen, beguines, beguinae, mulieres religiosae*, and similar terms attested only in a single primary source, unless there is good reason to believe that the source refered to a "convent" or "court" beguinage, that is to a group of beguines conceived as an institution. For instance, I have retained on the list communities at Gistel, Masnuy, Noirhat, and

Map A: Beguinages in the Southern Low Countries, 1200–1565

**Beguine Convents:**
× 1 convent
■ 2 to 10 convents
■ more than 10 convents

**Beguine Courts:**
○ 1 court
◉ more than 1 court

0    25    50 mi

Torhout, although each is mentioned only in a single primary source; in each case, however, the community is cited along with established and better known beguine institutions by an individual who was well informed about beguine life in his or her region (see nos. 41, 70, 82, and 102). References to "beguines" that did not meet this requirement were discarded. I discuss some of them, cited in secondary sources, in a separate section at the end ("Discarded"). Medieval sources sometimes (but not often) refer to a beguine convent that was part of a larger "court" beguinage as if it were an independent community. Needless to say, I have eliminated all such references from the list (see for instance, for the beguines *du Sac* within the beguinage of Valenciennes, the note to no. 105).

In the central area of beguine expansion, that is, in the Dutch- and French-speaking parts of what is now Belgium, where beguines formed an integral part of cultural life and their institutions could possess scattered properties in town and countryside, many place names refer to beguines, even though no beguine community actually resided in them. The town of Begijnendijk, so named because the beguinage of Aarschot owned lands in the area, is a good example (cf. *Het begijnhof van Aarschot*, 203). In some cases, parts of towns or villages, or streets and houses, were called *begijnhof* or *béguinage* for centuries, even though no beguine ever lived there, either because the property was once owned by a beguine community or women erroneously associated with beguines lived there. I have systematically eliminated them as well; the section on "Discards" discusses only a few such places, namely, those that have been prominently, but wrongly, identified as beguinages in the scholarly literature.

Despite the uncertainties and informalities that characterized beguine life in so many ways, the following list offers a comprehensive survey of its institutions in the southern Low Countries between about 1200 and 1565. Insofar as possible I have added a note on the history of these communities after 1565. The list also contains data on the patron saints of the beguinages. Although some beguinages were explicitly dedicated to a particular saint and were commonly known by that patron's name, the matter is not so clear for many others. I have tried to indicate in each case whether primary sources before 1565 record a patrocinium.

Seventeen beguinages survived until the twentieth century, but only a handful of beguines remain today.

## Abbreviations

a.: after or in this year.
b.: before or in this year.

beg.: beguinage.

c.: century, centuries.

ch.: chapel, church.

cl.: closed.

conv.: convent.

e.m.: *extra muros*, or outside the (town) walls.

f.: foundation, founded.

i.m.: *intra muros*, or within the (town) walls.

inf.: infirmary, hospital.

misc.: miscellaneous, that is, several independent convents (+number of convents).

| No. | Town, name of beguinage and/or patron saint | Type | Beginning | End |
|---|---|---|---|---|
| 1A | Aachen, St. Mathias | court | 1230 | 1640 |
| 1B | Aachen, St. Stephen | court | 1261 | 19th. c. |
| 1C | Aachen, Misc.(4) | convents | b. 1315–1455 | a. 1391–1455 |
| 2 | Aalst, St. Catherine | court | 1261 | 1953 |
| 3 | Aardenburg, St. Catherine | court | 1249 | 1487–99 |
| 4 | Aarschot, Virgin Mary | court | b. 1251 | 1856 |
| 5 | Aire-sur-la-Lys | convent | b. 1292 | 1793 |
| 6 | Anderlecht | convent | 1252 | 1798 |
| 7A | Antwerp, Sion (Virgin Mary; St. Catherine) | court | b. 1246 | 1986 |
| 7B | Antwerp, Klapdorp (St. Mary Magdalen) | convent | b. 1274 | 1545 |
| 7C | Antwerp, Misc. (3 to 5) | convents | b. 1274–1343 | 14th–15th c. |
| 8 | Arras, Misc. (10) | convents | b. 1246–1324 | a. 1320–1547 |
| 9 | Assenede, "Maddijch" | court | b. 1251 | b. 1457 |
| 10 | Ath | convent | 1416 | 1464 |
| 11 | Aulnoy | convent | b. 1248 | 1796 |
| 12 | Avesnes, St. Mary Magdalen | court | b. 1292 | a. 1748 |
| 13 | Beaumont, St. John and Virgin Mary | court | 1281 | 1796 |
| 14 | Bergen op Zoom | court | 1497 | 1583 |
| 15 | Bergues, St. Elizabeth | court | b. 1259 | a. 1310–11 |
| 16 | Béthune | convent | b. 1299 | a. 1370 |
| 17 | Biervliet, Rosendale | convent | b. 1293 | 1377? |
| 18 | Bilzen, Virgin Mary | court | b. 1256 | 1849 |
| 19 | Binche, Cantimpret (St. Elizabeth) | court | b. 1248 | 1620 |
| 20 | Boekhoute | convent | 1271 | 14th c? |
| 21 | Borgloon, St. Mary Magdalen | court | b. 1259 | a. 1813 |
| 22 | Bouvinges, Robinoit | convent | 1420 | a. 1606 |

| 23 | Braine-le-Comte, St. Elizabeth | court | b. 1304 | 1528 |
|---|---|---|---|---|
| 24 | Breda, St. Catherine | court | b. 1267 | 1990 |
| 25A | Bruges, Wijngaard (St. Elizabeth) | court | 1242 | 1927 |
| 25B | Bruges, St. Aubert (*Obrecht*) | convent | b. 1269 | 1609 |
| 25C | Bruges, Misc. (8) | convents | 1302–74 | a. 1335–1471 |
| 26A | Brussels, Wijngaard (Virgin Mary) | court | b. 1247 | 1844 |
| 26B | Brussels, Ter Arken (Virgin Mary) | convent | b. 1263 | 1311–86 |
| 26C | Brussels, Meerbeek/Blomart (Trinity?) | convent | b. 1272 | b. 1371 |
| 27 | Calais, Misc. (2) | convents | b. 1335 | a. 1335 |
| 28A | Cambrai, Cantimpré | court | b. 1233 | 1796 |
| 28B | Cambrai, Misc. (3) | convents | b. 1301–1354 | a. 1528/29 |
| 29 | Damme, St. Agnes | court? | b. 1259 | 1474 |
| 30 | Deinze, St. Margaret | court? | b. 1273 | 1381 |
| 31A | Dendermonde, Virgin Mary/ St. Alexis | court | b. 1288 | 1975 |
| 31B | Dendermonde, Kluis | convent | 1288 | b. 1663/64 |
| 32A | Diest, St. Catherine | court | 1245 | 1928 |
| 32B | Diest, Klein Begijnhof | convent | b. 1251 | 15th c. |
| 33 | Diksmuide, St. Catherine | court | b. 1273 | 1914 |
| 34A | Dinant, St. John and Mary Magdalen | court | b. 1261 | 1455 |
| 34B | Dinant, Misc. (6–7) | convents | 1302–1473 | 14th–15th c. |
| 35A | Douai, Champfleury (St. Elizabeth) | court | b. 1245 | 1477 |
| 35B | Douai, Wetz (Holy Spirit) | convent | 1245 | 1752 |
| 35C | Douai, Misc. (15) | convents | 1265–1355 | 14th–15th c. |
| 36 | Dudzele | convent | b. 1269 | 14th c.? |
| 37 | Edingen, Virgin Mary/St. Mary Magdalen | court | b. 1292 | 1847 |
| 38 | Eindhoven | court | b. 1490 | 1567 |
| 39 | Geraardsbergen, St. Margaret | court | 1247 | 1843–46 |
| 40A | Ghent, Groot Begijnhof (St. Elizabeth) | court | 1234 | extant |
| 40B | Ghent, Klein Begijnhof, or Ter Hooie (Virgin Mary) | court | 1262 | extant |
| 40C | Ghent, Poortakker (St. Aubert, *Obrecht*) | court | 1278 | 1863 |
| 40D | Ghent, Misc. (2–3) | convents | b. 1269 | a. 1269–1422 |
| 41 | Gistel | convent | b. 1276 | a. 1276 |
| 42 | Grave | convent | b. 1394 | a. 1639 |
| 43 | Grez-Doiceau, "du Péry" | court | b. 1496 | a. 1530 |
| 44 | Halen | convent | b. 1483 | 1526–46 |
| 45 | Hasselt, Virgin Mary/St. Agnes/ St. Catherine | court | b. 1245 | 1886 |
| 46 | Heinsberg | convent | 1307 | a. 1360 |

| 47 | Helmond | convent | b. 1426 | 1447–96 |
|----|---------|---------|---------|---------|
| 48 | Hénin-Liétard | convent | b. 1282 | 1693 |
| 49 | Henis | convent | b. 1296 | a. 1296 |
| 50 | Herentals, St. Catherine | court | b. 1266 | extant |
| 51A | 's-Hertogenbosch, Groot Begijnhof (Virgin Mary) | court | b. 1274 | 1675 |
| 51B | 's-Hertogenbosch, Klein Begijnhof | convent | b. 1349 | a. 1591 |
| 52 | Hesdin | court | b. 1248 | a. 1345 |
| 53 | Hocht | convent | b. 1267 | a. 1267 |
| 54 | Hoogstraten, Virgin Mary | court | b. 1380 | 1972 |
| 55 | Hulst, St. Agnes | court | b. 1295 | 1458 |
| 56 | Huy, Misc. (19) | convents | 1251–1563 | 14th–18th c. |
| 57 | Jodogne, St. Nicholas | court | b. 1382 | a. 1572/73 |
| 58 | Kortrijk, St. Elizabeth | court | 1242 | extant |
| 59 | Lens | convent | b. 1273 | a. 1299 |
| 60 | Le Quesnoy | court | b. 1246 | 1462 |
| 61A | Liège, St. Christophe | court | b. 1241 | 1855–65 |
| 61B | Liège, Misc. (30) | convents | b. 1241–1468 | a. 1272–19th c. |
| 62 | Lier, St. Margaret | court | b. 1259 | a. 1970 |
| 63 | Lille, St. Elizabeth | court | 1244–45 | 1855 |
| 64A | Louvain, Groot Begijnhof, or Ten Hove | court | 1232/34 | 1988 |
| 64B | Louvain, Klein Begijnhof (St. Catherine) | court | b. 1269 | 1855 |
| 64C | Louvain, Wierinck (St. Barbara) | convent | b. 1278 | b. 1372 |
| 65 | Maaseik, St. Agnes or St. Barbara | court | b. 1265 | a. 1505? |
| 66A | Maastricht, St. Catherine | court | b. 1251 | 1502 |
| 66B | Maastricht, St. Andrew | convent | 1264 | a. 1426 |
| 67 | Maldegem | convent | b. 1343 | 1413–1528 |
| 68 | Malèves | convent | b. 1267 | a. 1336 |
| 69 | Marck | convent | b. 1302 | a. 1320 |
| 70 | Masnuy | convent | b. 1273 | a. 1273 |
| 71 | Maubeuge | court | b. 1267 | 1679 |
| 72A | Mechelen, Groot Begijnhof (Virgin Mary and St. Catherine) | court | b. 1245 | 1993 |
| 72B | Mechelen, Klein Begijnhof (St. Mary Magdalen) | court | 1259 | 1798 |
| 73 | Mesen | convent | b. 1300? | 1553 |
| 74 | Momalle | convent | b. 1256 | 19th c. |
| 75A | Mons, Cantimpret (Virgin Mary?) | court | 1245 | 1900 |
| 75B | Mons, Misc. (37) | convents | 1280–1365 | 14th–15th c. |
| 76 | Mont-Saint-Éloi | convent | b. 1312 | a. 1312 |
| 77 | Morlanwelz | convent | b. 1372 | a. 1779 |
| 78A | Namur, Grand Béguinage | court | 1235 | 1688 |
| 78B | Namur, St. Symphorien (St. Calixtus) | convent | 1248 | 1581 |
| 78C | Namur, Misc. (3) | convents | b. 1269–1420 | 15th c.–1569 |

| 79 | Nieuwpoort (St. John?) | court | b. 1314 | b. 1914 |
|---|---|---|---|---|
| 80 | Ninove | court | b. 1333 | 1475 |
| 81 | Nivelles, Misc.(6) | convents | b. 1239–1426 | a. 1292–b. 1862 |
| 82 | Noirhat | convent | b. 1267 | a. 1267 |
| 83 | Oignies | court | b. 1239 | a. 1352 |
| 84 | Oisterwijk (Betlehem) | convent | 1539 | 1725 |
| 85 | Oostburg | court | b. 1269 | a. 1550/51 |
| 86 | Orchies | court | b. 1273 | 1538 |
| 87A | Oudenaarde, Sion (Virgin Mary) | court | b. 1272 | b. 15th c.? |
| 87B | Oudenaarde, Kluis (or Wijngaard?) | court | b. 1272 | 1960 |
| 87C | Oudenaarde, Pamele | convent | b. 1277 | 1456–1547 |
| 88 | Oud-Heusden | court | b. 1390 | late 16th c. |
| 89 | Overijse, Mariëndal (Virgin Mary) | court | b. 1267 | b. 18th c. |
| 90 | Roermond, St. Catherine | court | 1279 | 1797 |
| 91 | Ronse | convent | b. 1394–1419 | 1591–1602 |
| 92 | Saint-Omer, Misc. (21) | convents | b. 1307–17 | b. 1327–16th c. |
| 93 | Sin | convent | b. 1309 | a. 1587 |
| 94 | Sint-Truiden, St. Agnes | court | b. 1258 | 1860 |
| 95 | Sittard | convent | 1276 | 1677 |
| 96 | Thorembais-les-Béguines | convent | b. 1267 | 1825 |
| 97 | Thorn | convent | 1287 | 1797 |
| 98 | Thuin, St. Elizabeth | court | b. 1497 | a. 1558 |
| 99 | Tielt, Virgin Mary | court | b. 1342 | 1492/4 |
| 100 | Tienen, Virgin Mary (?) | court | 1250 | 1857 |
| 101A | Tongeren, St. Catherine | court | 1243 | 1856 |
| 101B | Tongeren, St. James | convent | 1257 | 1276 |
| 102 | Torhout | convent | b. 1276 | a. 1276 |
| 103A | Tournai, Des Prés, or La Madeleine (St. Elizabeth) | court | 1241 | a. 1820 |
| 103B | Tournai, As Degrés | convent | b. 1251 | a. 1496 |
| 104 | Turnhout | court | b. 1340 | a. 1994 |
| 105 | Valenciennes, St. Elizabeth | court | 1239 | 1796 |
| 106 | Veurne | court | b. 1273 | 1506–11/2 |
| 107 | Vilvoorde, Consolation of Virgin Mary | court | 1239 | 1840 |
| 108A | Ypres, Briel (St. Christine) | court | 1240 | 1842 |
| 108B | Ypres, Baerdonc (St. Thomas) | convent | 1271–73 | 1383 |
| 108C | Ypres, Misc. (2) | convents | b. 1316–23 | 1416? |
| 109 | IJzendijke | court | b. 1276 | 1404? |
| 110 | Zichem | convent | late 14th c.? | 1468 |
| 111 | Zoutleeuw | court | 1207–45 | a. 1822 |

Sources and Comments

1A. First mentioned in 1230 in will of Reinerus, canon of St. Adalbert of Aachen, who bequeathed annual rents to several religious institutions in his city, including the "devout women, commonly known as beguines, . . . as long as their association lasts" (Erich Meuthen, ed., *Aachener Urkunden 1101–1250* [Bonn: Peter Hanstein-Verlag, 1972], 545–47, no. 255); phrasing suggests beg. had just been formed. It moved e.m. and was granted its own priest and cemetery on 26 February 1262 (Lacomblet, *Urkundenbuch*, vol. 2, 288, no. 512). Usually called "the new beguinage" (*nova curia*); ch. dedicated to St. Matthias (De Ridder, "Pouillé" [1864]: 464; Quix, "St. Mathiashof," 18–19). In 1470, part of beg. converted into a conv. of Franciscan Tertiaries (Marienthal), which completely absorbed beg. in 1640 (ibid., 24).

1B. After move to "new beguinage" in 1262 (see no. 1A), one of the original sites i.m. became known as the "old beguinage" (*antiqua curia*: ibid., 18: De Ridder, "Pouillé," [1864]: 464), where beguines resided around ch. dedicated to St. Stephen until nineteenth c. (Christian Quix, "St. Stephanshof," *Aus Aachens Vorzeit* 5 [1892]: 33–45; H. Schnock, "Der Beguinenconvent 'Stefanshof,'" *Aus Aachens Vorzeit* 3 [1890]: 49–54).

1C. The charter of 1262, mentioned in no. 1A, indicated that many beguines not attached to the main community lived "in various parishes" of the city (Lacomblet, *Urkundenbuch*, vol. 2, 288, no. 512). Later, conv. of St. Margaret's (for 25 beguines) attested in the Pontstrasse (years 1315, 1332, and 1391: Pick, "St. Margarethenkonvent," 179–81); conv. in the *Bendelstrasse* (1391: ibid., 179, note 1); conv. in the *Jacobstrasse* and conv. *under den Linden* (1455: Christian Quix, "Das ehemalige Beghinen Wesen in der Stadt Aachen," *Aus Aachens Vorzeit* 5 [1892]: 2–6, at 5).

2. F. charter by Walter and Gertrudis of Aalst, granting "beguines of Aalst" land and a house to "establish their court, serving God and praying for us," dated 28 May 1261 (Aalst, Stadsarchief, Begijnhof St. Katharina, no. 74, fol. 1r, ed. Soens, *Cartularium*, 17–18). Ch.'s dedication to St. Catherine noted in charters of January 1266 and 8 November 1266 (same cartulary, fol. 1v–2r, ed. Soens, *Cartularium*, 18–20 and 22–23). Beg. cl. in 1953 (*MCF*, vol. 1, 157).

3. First mentioned in charter of countess Margaret of Flanders, regarding appointment of beg.'s chaplain, 16 November 1249 (*RAG*, Sint-Baafsabdij Gent, Charters, no. 301, ed. Vleeschouwers, *Oorkonden*, vol. 2, 333, no. 308). Thirteenth-c. sources refer to community as "beguines living together in Aardenburg" (as in *BGSD*, Charters, no. 1037, January 1269); later, beguines were also called "blue beguines" (*blauwe beghinen*: Ghent, Augustijnenklooster, Klooster Brugge, Charter no. 1, 27 February 1315; see also nos. 8, 9, 10, of 1361–62); patron

saint, St. Catherine, first mentioned in 1334 (*BAB*, F2, charter of 10 March 1452, ed. Devliegher, "Het oudste reglement," 211–13; cf. charter of 31 March 1336, ed. Ceyssens, "Eenige oorkonden," 64, no. II). Beg. cl. between 1487 (ibid., 87–88, no. xv) and 1499, when property was handed over to Franciscan Tertiaries of Ghent (H. Q. Janssen and J. H. Van Dale, eds., *Bijdragen tot de oudheidkunde en geschiedenis inzonderheid van Zeeuwsch-Vlaanderen*, vol. 1 [Middelburg: J. C. & W. Altorffer, 1856], 323–26).

4. Beg. i.m., first attested in gift of land, 19 January 1251 (F. De Ridder, "Het archief der kerk van Aarschot. Begijnhof van Aarschot," *Hagelands Gedenkschriften* 6 [1912]: 19–72, at 19, no. 1); on 12 November 1251, papal legate Hugh of St. Cher issued a letter of indulgence to support construction of beguines' ch. and houses (ed. [using originals lost in 1914] J. J. Evers, "Onbekende of onuitgegeven Oorkonden aangaande het begijnhof van Aarschot, 1251–1341," *BG* 29 [1938]: 134–54, at 136–37, no. 1, reprinted in *Het Begijnhof van Aarschot*, 134, no. I). Dedication of ch. to Virgin Mary attested in indulgence letter of 16 October 1324 (Evers, "Onbekende," 148–150, no. 10). Patronage of St. Joseph (suggested in *MCF*, vol. 1, 139), unlikely for the medieval period; not attested before 1611–37 (*Het Begijnhof van Aarschot*, 66, 321). Last beguine died in 1856 (ibid., 56).

5. Conv. established in parish of St. Peter i.m. before 1292 (*DB*, 15). More in Bertin, "Le Béguinage," 92–104.

6. F. charter by William, dean of the collegiate ch. of Anderlecht (Suzanne Nys, "Le chapitre de Saint-Pierre d'Anderlecht des origines à la fin du XIIIe siècle," *Cahiers Bruxellois* 9 [1964]: 189–291, at 247), granting land to the "humble convent of beguines of Anderlecht," in June 1252 (*MF*, vol 2, 998). See also Marcel Jacobs, "Het begijnhof van Anderlecht," *Gemeentekrediet van België. Driemaandelijks Tijdschrift* 130 (1979): 285–94.

7A. The following, generally accepted, discussions of beg.'s origins and/or its founder are valuable but must be used with caution: *PB*, 113–14; L. J. M. Philippen, "Een vijftal Oorkonden betreffende de Antwerpsche Begijnen," *BG* 22 (1931): 29–47; Prims, *Kerkelijk Antwerpen*, 60–62, 198–200; Olyslager, *750 Jaar*, 43–45, 49, 54–56. A gift of land by John of Zanthoven on 26 March 1246 "in support of the chaplain who will perpetually serve the beguines of Antwerp living in an enclosure" (*clausis beghinis*, ed. Goetschalckx, "Oudste stukken," 291–92, no. 20) contains oldest reference to the court; grant of 20 s. to the "enclosed beguines" (*begghinis clausis*) of Antwerp, by lord Geoffrey IV of Breda in will of 25 April 1246 (ed. Van den Nieuwenhuizen, *Oorkonden*, 44–48, no. 29), and gift by canon John of Oorderen to "the beguines' court near Antwerp" (*curie beghinarum juxta Antwerpiam*), to be split between "the infirmary of the court" (*ad opus infirmarie eiusdem curie*) and "the chantry there" (*ad opus capellanie*

*ibidem*, 20 November 1246, ed. Goetschalckx, "Oudste stukken," 285, no. 10), confirm type of beg. A certain Gerungus, priest of Brecht, mentioned in John's charter as the beguines' *provisor*, was probably their first priest (*LUB*, XV, no. 1, fol. 20r: "Non. [jun.] Heden eest jaerghetide tser Gerungs dies persoens van Brecht ende dies cureits was van den hove;" his mother Christine ruled Sion as first grand mistress for twenty-two years (ibid., fol. 4r: "anniversarii Cristine de Brechte beghine, que fuit superior magistra dicte curtis et prima, annis xxii"; fol. 33v: "xix [kal. nov.] Heden est jareghetide ver Kerstinen ser Gerunchs moder," and "xvi [kal. nov.] Heden est jareghetide Kerstinen van Brecht der beghine;" a late sixteenth-c. scribe, possibly Joannes Lumnius, priest of the beguinage from 1562 until 1602, added a note identifying her as "begginagii fundatrix." Name of beg. clearly stated in charter of 22 September 1247 (*in curte . . . que Syon appellatur*, ed. Goetschalckx, "Oudste stukken," 286, no. 11); original dedication of ch. was to the Virgin Mary (Camille Tihon, *Lettres de Grégoire XI (1371–1378)*, vol. 3 [Brussels and Rome: Institut historique belge de Rome, 1964], 380–81, no. 3757; for other indications of devotion to Mary in thirteenth c., see Philippen, "Het oudste zegel," 81–89). Around 1471, the obituary book noted that St. Catherine "is the patron of the church, together with St. John the Evangelist" (*LUB*, XV, 1, fol. 43r). Devotion to St. Catherine is attested as early as 1329, however (Philippen, "Het oudste zegel," 87). Beg. located e.m. close to original Dominican conv. (f. in 1243: Simons, *Stad*, 100), until 1542 (Edmond Geudens, "L'ancien béguinage d'Anvers: Essai de topographie," *Bulletin de l'Académie royale d'Archéologie de Belgique* [1906]: 235–50); after 1545, new beg. of Sion built i.m. in Rodestraat (Olyslager, *750 Jaar*, 81–84). Last beguine died in 1986 (*MCF*, vol. 1, 177).

7B. In will of 21 March 1274, master Peter Conradi of Antwerp left 5 s. to "the new infirmary of beguines" (Goetschalckx, "Oudste stukken," 292–95, no. 21), called "the infirmary of the beguinage on the Driesch" in March 1282 (P. J. Goetschalckx, *Oorkondenboek der Witheerenabdij van St. -Michiels te Antwerpen* [Ekeren: Hoeydonck, 1909], vol. 1, 294), and "the infirmary of the beguinage in Klapdorp" on 5 October 1294 (Philippen, "Een vijftal Oorkonden," 143). According to statutes of 1325, it was intended for beguines who were ill and so poor that they risked losing their clothes and bed unless they were helped. For location, close to second Dominican conv. on *Dries*, see Geudens, "L'ancien béguinage," 247–50, and Philippen, "Een vijftal Oorkonden," 131; for patron, Olyslager, *750 Jaar*, 72–73, 75. Sold to Sion in 1545 (ibid., 75–76).

7C. Peter Conradi's will of 21 March 1274 (see no. 7B), lists in addition to bequests to beguines of Sion and Klapdorp, a gift to "poor beguines living in the city of Antwerp" (Goetschalckx, "Oudste stukken," 292–95, no. 21). A house for such beguines was located "to the east of the cemetery of Our Lady" according to note in obituary book of Sion by late thirteenth-c. hand (*LUB*, XV, 1, fol. 41r;

on fol. 41v, an early fourteenth-c. note refered to the house as the "almshouse near the cemetery." — Another conv. appears in will of beguine Scientia of *Nortbevelant*, who donated half of her house in the Vlamingstraat to poor beguines in residence there on 30 May 1293 (Prims, *Kerkelijk Antwerpen*, 302-3). — On 9 May 1296, a beguine, Elizabeth, "Alena's daughter," bequeathed her home close to Dominican conv. for the use poor beguines, who may have formed yet a third conv. (Philippen, "Een vijftal Oorkonden, 143-45); one of these three houses may be conv. of *Wolffaertsdycke* acquired by Sion in 1315, as Philippen, "Een vijftal Oorkonden," 132, suggested. — In 1343, the German merchant Henry Suderman, who f. several houses for Cellites and Tertiaries in Antwerp and Bruges, established a conv. for twelve women between the *Cortstrate* and *Oude Vest*, dedicated to the Virgin Mary and called a beguine conv. in 1357; its statutes of 1345 resemble beguine rules. It evolved into an almshouse by fifteenth c. (Prims, *Geschiedenis van Antwerpen*, vol. 4, part 2, 205-8, and vol. 6, part 3, 249).

    8. Despite the massive loss of documents during World War I, the following data on the ten or more beguinages that existed in Arras-Cité (the bishop's city) and in Arras-Ville, appear solid (see *DB*, 151-52; Delmaire, *Diocèse d'Arras*, vol. 1, 319-25). Conv. of *Baudimont* or *Notre-Dame*, in the *cité*, endowed with chantry under bishop Adso (1231-46) and second chantry in third quarter of thirteenth c., suggesting a large community; cl. in 1547 (see also Berger, *Littérature et société arrageoises*, 309). — Inf. dedicated to St. Anne, mentioned in 1320 and located in parish of St. Nicaise, where a *rue des béguines* is attested in 1311 (ibid., 26 [map] and 31, note 49). — Conv. *le Roy* in Arras *ville* e.m. in vicinity of the four mendicant orders; attested since 1260 and attributed to the generosity of Louis IX; extant in 1342. — Conv. of *dame Tasse Huquedieu*, parish of the Holy Cross, cited in 1314; probably f. by Tasse Loucharde, widow of Lambert Huquedieu (died 1293/94), before her own death in 1299; mentioned until fifteenth c. — Conv. of Our Lady, outside St. Nicholas' gate, also close to several mendicant convents, attested in 1314, 1320, and possibly in 1382. — Survey of 1316-24 (ed. C. Le Gentil, *Le vieil Arras* [Arras: n.p., 1877], 342-47) also mentions a "house of the 11,000 Virgins" for twenty women, which survived into the fifteenth c.; conv. "of Marguerite Amion" for twenty-two women; conv. for twelve women in the *rue Maître Adam*; conv. *de la Vigne* for twenty-four women; and conv. *de le Tiuloye* for twenty-six women close to the Franciscans; *de le Tiuloye* was probably cl. when countess Mathilda established a conv. for Dominican nuns on the same site in 1324.

    9. Beg. outside Assenede did not originate shortly before 1334, as long reported (Frans De Potter and Jan Broeckaert, *Geschiedenis van de gemeenten der Provincie Oost-Vlaanderen, Arrondissement Eekloo*, vol. 1 [Ghent: C. Annoot-Braeckman, 1870], 169 and *PB*, 445) but before 1251, when it had an inf. (*RAG*,

Abdij Doornzele, Charters at 1 March and July 1251). Received alms from Flemish count in 1296–1351 (*ADN*, B 4063, no. 5439ter and B 4316, no. 20758; *ARA*, Rekenkamers, Rolrekeningen, nos. 266, 270, 271, 272, and 282; alms also benefited anchoress living with beguines). Had its own chaplain in 1318 (*RAG*, Abdij Boudelo, 9, fol. 141r); was cl. before 1457, when site "deserted by people of devotion," became property of Augustinian nunnery of Our Lady of Nazareth; site then known as "beguinage de Maddijch emprès nostre ville de Assenede" (*ARA*, Oorkonden van Vlaanderen, 1ste r., no. 2580, ed. De Potter and Broeckaert," *Geschiedenis*, 167–68).

10. In 1416 Maillet Boudant converted his house near *Pont de Moulin* into a conv. for poor beguines (Philippe Brasseur, *Origines omnium Hannoniae coenobiorum* [Mons, Ph. Waudraeus, 1650], 428); ch. existed by 1422 (Léopold Devillers, "Ath," *Annales du Cercle archéologique de Mons* 8 [1869]: 121–23). Beguines became Augustinian nuns in 1464 (Brasseur, *Origines*, 428; *MCF*, vol. 1, 191–92).

11. Conv. cited in wills of 17 December 1248 (Emmanuel Lemaire, ed., *Archives anciennes de la ville de St - Quentin* [Saint-Quentin: Ch. Poette, 1888], vol. 1, 48–51, no. 47); 27 June 1251 (*ADN*, 30 H 14, no. 180), 27 March 1259 (*ADN*, B 446, no. 1202. ed. Hautcoeur, *Cartulaire. . . Flines*, vol. 1, 124–29, no. CXXIV), and November 1273 (*ADN*, B 445, no. 1811, ed. Hautcoeur, *Cartulaire . . . Flines*, vol. 1, 194–206, no. CLXXXII). Hellin, lord of Aulnoy, was regarded as founder of beg. (Étienne de Béthune-Sully, "Aulnoy," *Bulletin de la Société d'Études de la province de Cambrai* 43 [1955]: 1–62, at 12–13).

12. A "common fund of the beguines of Avesnes" appears in will of 27 January 1292 (*DB*, 152–53; see also Mossay, *Histoire*, 57–58); beg. i.m. still existed in 1457 but was then abandoned until 1534, when Louise d'Albret, lady of Avesnes, endowed it with funds to house "five virgins or widows, known as beguines" (J. Peter, "Documents sur le béguinage d'Avesnes," *Mémoires de la Société Archéologique et Historique de l'Arrondissement d'Avesnes* 13 [1930]: 206–7). Ch. and beg. were dedicated to Mary Magdalen (Mossay, *Histoire*, 58; Peter, "Documents," 209). Beguinage still existed in 1748 (ibid., 210–11).

13. Chaplain of newly founded hospital of Beaumont attested as cleric in charge of beguines' ch. in January 1281; beguines received gift from lord Baldwin of Beaumont in April 1282. Beg. e.m., outside Binche gate, had eleven houses for twenty-two women in 1610 (Bernier, "Histoire de la ville de Beaumont," 275–77, 333–34; Ernest Matthieu, ed., "Le besoigné ou description de la ville et comté de Baumont rédigé en 1609–1610," *Annales du Cercle archéologique de Mons* 16 [1880]: 1–249, at 153). Main altar of ch. dedicated to St. John the Evangelist and Mary, according to pouillés of 1497 and 1558 (Jean Paquay, *Pouillé de l'ancien diocèse de Liège en 1497* [Tongeren: Collée, 1908], 124; De Ridder, "Pouillé," [1865]: 390). Cl. in 1796 (*MCF*, vol. 1, 203).

14. Although there is some evidence of beguines in Bergen op Zoom for the years 1428, 1439, and 1446), city magistrate did not launch an effort to construct a beg. until 1484 (Levelt, *Het begijnhof*, 13–15, 26–27), funded in large part by Aeghten Backer, a widow who died in 1489 (Juten, "Het begijnhof," 63–64). Construction of beg. started in 1497, when last portions of grounds were acquired (ibid., 58–66). Protestant magistrate ordered its sale in 1580; cl. by 1583 (ibid., 57–58).

15. Beg. often confused in local historiography with hospital of St. Elizabeth, f. by countess Margaret of Flanders in 1248 (M. Bonvarlet, "Chronique de l'abbaye des Dames de St. Victor dite du Nouveau Cloître, à Bergues," *Mémoires de la Société dunkerquoise* [1857–8], 260–63) and transformed into Victorine nunnery of *Nieuwklooster* or *Nouveau Cloître* in 1252–53 (*KB*, MS 7440, fol. 51r–53r). In fact, some of the original hospital sisters may at that point have opted not to join the Victorines and to form beg., first attested in will of countess Mathilda of Béthune, of 27 March 1259 (*ADN*, B 446, no. 1202, ed. Hautcoeur, *Cartulaire . . . Flines*, vol. 1, 124–29, no. CXXIV, and *RAG, SG*, no. 112, execution of will about 1264). Last mentioned in privilege issued between 19 April 1310 and 10 April 1311 by count Robert of Flanders to the "large community of good women . . . gathered in the court of the beguinage of our city of Bergues, which court has since long been under the protection and guardianship of our ancestors" (*ADN*, B 1508, no. 4764, ed. Espinas and Pirenne, *Recueil . . . industrie drapière*, vol. 1, 307–8, no. 125). An early dorsal note calls the document "a copy of the charter which the count has issued to the women of the institution that used to be the beguinage of Bergues," but this does not necessarily mean that the beg. disappeared shortly after the charter was issued, as *DB*, 153 assumed; the note was probably written between 1319 and 1328, when many beguine institutions attempted to shed the label "beguine" and "beguinage," see Chapter 5. There is, however, no firm evidence for its existence after 1311.

16. First mentioned in will of count Guy of Flanders (also lord of Béthune) on 15 April 1299 (*ADN*, B 449, no. 4181); it appears in attached codicil to that will, of 4 May 1304, and in will of beguine born in Béthune but residing in Douai, of February 1308 (*AMD*, FF 862, at date). Located e.m., it is last mentioned in 1370 (*DB*, 153, with additional data in Ed. Cornet, *Histoire de Béthune*, vol. 2 [Béthune: Imprimerie A. David, 1892], 413–14).

17. Mentioned in wills of master Nicholas of Biervliet, Sr. (June 1293), of his son Nicholas, Jr. (10 July 1300; ed. Van de Putte, *Cronica et cartularium monasterii de Dunis*, 649–53, no. DXCII, and 671–75, no. DCIV), and in will of James, priest of Kaprijke (23 January 1297: ed. Achiel De Vos and Luc Stockman, "Het testament van heer Jacob, medepastoor van Kaprijke (1297–1298)," *Appeltjes van het Meetjesland* 40 [1989]: 27–42, at 35). It may have perished in the flood of 1377.

18. Beg.'s chaplain and cemetery were authorized by bishop of Liège on 24 October 1256 (*RAH*, Begijnhof Bilzen, no. 2, ed. Jean Paquay, "La charte d'érection du béguinage de Bilsen," *Leodium* 1 [1902]: 45–48). In 1472, Franciscan Tertiaries took over the beg. but they abandoned it in 1475; later history of site unclear until 1676, when beg. received new statutes modeled on those of beg. of Tongeren (Jan Paquay, *Bilzen voorheen* [2nd ed. Bilzen: De Bilzenaar, 1977], 129– 44). Special devotion to the Virgin Mary evident in early centuries, translated in seventeenth c. into a dedication to the Seven Sorrows of the Virgin (ibid., 128, and 247, for a reference to *capella beate Marie de beghinagio* in 1447–45; see also Paquay, *Pouillé*, 66, note 1). Last beguine died in 1849 (ibid., 150–51).

19. Beg. received a bequest in will of Marga of Lens on 17 December 1248 (Lemaire, *Archives anciennes*, vol. 1, 48–51, no. 47). It appears under name of "Cantimpret" in financial records of count of Hainaut's receiver at Binche for 1265 (Léopold Devillers, *Cartulaire des rentes et cens dus au comte de Hainaut, 1265–1282* [Mons: Société des Bibliophiles belges, 1873–5], vol. 1, 91, no. 23). It had an inf. by November 1273 (*ADN*, B 445, no. 1811, ed. Hautcoeur, *Cartulaire . . . Flines*, vol. 1, 194–206, no. CLXXXII) and its own parish priest by 1292 (Théophile Lejeune, *Histoire de la ville de Binche* [Binche: V. Winance-Nachtergaele, 1884], 507). Patron was St. Elizabeth (ibid., 507; see also Longnon, *Pouillés*, 314). Damaged by fire in 1554, it was acquired by Franciscans in 1598 and became conv. of Franciscan Tertiaries in 1620 (Lejeune, *Histoire*, 508; *MCF*, vol. 1, 209).

20. Beg. founded for poor beguines in February 1271 by Hugh Moer, priest of Groede, in orchard (*pomerium*) of his residence east of parish ch. of Boekhoute; if beguinage was abandoned, Hugh indicated, property was to revert to poor beguines in infirmaries of St. Elizabeth and Ter Hooie of Ghent (*SAG*, B, no. 26, ed. *BC*, 23–24, no. 26; see below, nos. 40A and 40B).

21. First beguines of Borgloon may have gathered around recluse Jutta, about 1210, as suggested by *VC* and *VL* (see Chapter 2). Earliest archival evidence (establishment of beguine court independent from parish in January 1259: Joseph Daris, *Notices historiques sur les églises du diocèse de Liège*, vol. 12 [Liège: L. Demarteau, 1885], 165–67; see also A. Hansay, "Documents des XIIe et XIIIe siècles concernant l'Alleu de Hex et l'Hôpital de Looz," *Verzamelde Opstellen* 11 [1935]: 331–50), suggests location close to ch. of Gratem e.m., and its hospital, f. by or donated to order of St. John between 1130 and 1150, and acquired by abbey of Villers in or shortly before 1175; ch. was burial site of counts of Loon in second half of twelfth c. (Lux and Bussels, "Opgravingen," 166). Villers exercised spiritual oversight of beg. in late Middle Ages, perhaps since thirteenth c., see charter of 1497 partially edited in Robyns, *Diplomata*, 26–27, which names "counts of Loon" as founders. Ch. was dedicated to St. Mary Magdalen (Lux and Bussels, "Opgravingen," 210; *RAH*, Begijnhof Gratem, nos. 2–8; Robyns, *Diplomata*, 26–

27; see however Paquay, *Pouillé*, 68). Beg. cl. in 1797, but five beguines remained until at least 1813 (Lux and Bussels, "Opgravingen," 167).

22. Small conv. for three beguines f. by Colard Robinoit in will of 18 October 1420 (ed. J. Borgnet, *Cartulaire de la commune de Bouvignes*, vol. 1 [Namur: n.p., 1862], 72–89); last mentioned in 1606 (*MCF*, vol. 1, 211–12).

23. F. by countess Margaret of Flanders in 1250 (as indicated in Joseph Croquet, "Notice historique sur l'église paroissiale et sur les institutions religieuses de Braine-le-Comte," *Annales du Cercle archéologique d'Enghien* 3 [1887]: 296–508, at 433), seems unlikely, since beg. is not mentioned in Margaret's will. Attested first in 1304; beguines regularly received support from counts of Hainaut in fourteenth–fifteenth c., in part for their work at local hospital of St. Nicholas. Reduced to four beguines in 1512, beg. was cl. in 1528; Franciscan Tertiaries replaced beguines as nurses in hospital (ibid., 434–36). Ch. dedicated to St. Elizabeth (ibid., 436; Longnon, *Pouillés*, 307).

24. Established on land first held from Henry, lord of Breda, who ceded full ownership of it on 2 March 1267, authorizing construction of ch. with cemetery (Juten, *Cartularium*, 1, no. 1). Originally e.m., beg. was included in new fortifications of 1350 (ibid., vii). Original patron was St. Catherine (ibid., 5–6, no. 4). Last beguine died in 1990.

25A. Since the only extant copy of countess Joan's general order to bailiffs and aldermen of Flanders to protect "all maidens who converted to the Lord and went off to live with beguines in their houses," of 5 April 1242, is found in a cartulary of this beg. (*AOCMWB*, Begijnhof, K1, fol. 1r; ed. in *MF*, vol. 3, 592), the latter probably existed at that date. Another charter issued by countess Joan on 22 July 1243 promises to compensate ch. of Our Lady in Bruges for loss of income due to erection of "the chapel of the beguines located in the Vineyard" (*RAB*, Onze-Lieve-Vrouwekerk, no. 12, fol. 48v), on the countess's property e.m.; it was incorporated into second urban fortifications of 1297–1300 (Ryckaert, *Brugge*, 71). Erected as an independent parish in January–23 July 1245 thanks to financial support of Joan and her successor Margaret, who arranged for transfer of old chantry at count's ch. in *Burg* to the beguines' ch. (Bruges, Monasterium De Wijngaard, Charters, nos. 11, 12, 12bis; *BAB*, C 419, two charters at date "May 1245," ed. Hoornaert and Callewaert, "Les plus anciens documents," 283–89, nos. 18–22; in this edition, no. 18 was incorrectly dated to 24 July 1244, the f. date often cited in the literature; the correct date is 23 July 1245). Main altar of beguines' ch. dedicated to St. Lieven, patron of old comital chantry, but St. Elizabeth honored as beg.'s patron (Desmet, *Het begijnhof*, 113–15, 122). Converted into nunnery in 1927 (Bonneure and Verstraete, *Het prinselijk begijnhof*, 49–56).

25B. "Hospital of poor beguines outside the Vineyard," in the Langestraat, first mentioned in will of May 1269 (*BGSD*, Charters, no. 1031, ed. Van de Putte,

*Cronica et cartularium*, 608, no. DLV; see also no. 1048, April 1270), formally placed under countess Margaret's protection by 10 April 1272 (her successors Guy, Louis I, and Louis II confirmed her privilege in 1278, 1327, 1357: *RAB*, Découvertes, no. 112, fol. 1r–3r, and *RAG*, II Varia, no. 506, fol. 112v, ed. De Limburg-Stirum, *Cartulaire*, vol. 1, 595–96, no. DCXXXVII). Patron was St. Aubert or *Obrecht* (will of 28 May 1285, *BGSD*, charter no. 1332, ed. Van de Putte, *Cronica et cartularium*, 656–57, no. DXCIV; see also *RAB*, Blauwe Nummers, nos. 4151 [1292]; 5944 [1319], etc.). In 1609, the beg., abandoned save by a few beguines, was acquired by the Carthusian order (Ryckaert, *Brugge*, 205).

25C. In the fourteenth c., at least eight beguine convents unaffiliated with the Vineyard or St. Aubert must have existed in Bruges. *Ten Vanekine* in the *Waalse straat* close to the Franciscan conv., probably f. by the *van den Vanekine* family before 1302, described as "an almshouse for poor beguines" in 1335 (Marechal, "Konventen," 259).—The *Zuudwerve* conv., named after Cateline van Zuudwerve, a beguine who acquired a house east in the *Ganzestraat* on 4 April 1315 and later established a conv. there, first attested on 12 September 1374 (*SAB*, B, II, nos. 14 and 259; Gilliodts-van Severen, *Inventaire École Bogarde*, vol. 2, 197 and 320, nos. 14 and 259). It was then supervised by begards of Bruges, who became Franciscan Tertiaries between 19 November 1374 and 28 July 1376; Zuudwerve may have joined that order too, possibly by a merger with the Tertiaries of St. Barbara in the same *Ganzestraat* (Simons, *Bedelordekloosters*, 161–62 and 169–70).—The *Rooms* or *Rams* conv. (named after the *de Ram* family?) in the *Katelijnestraat*, described as an "almshouse," with its own "mistress" on 10 June 1330, subsequently destroyed by fire but resuscitated on 20 January 1338 as a "convent for poor beguines" (*AOCMWB*, Dis Onze-Lieve-Vrouwekerk, Charters, nos. 8 and 14, ed. Marechal, "Konventen," 261–64, nos. I–II). In 1471 the conv. was turned into an almshouse of the parish of Our Lady (Hilde De Bruyne, *De Godshuizen in Brugge* [Roeselare: Gemeentekrediet and Roularta Books, 1994], 22–23; see also Simons, *Bedelordekloosters*, 163–65).—The *Groote Hertsberghe* conv., founded on 14 October 1335 by Griele and Marzoete van Herdsberghe, also in *Katelijnestraat*, intended for "poor women who observe the customs of beguines and live under guidance, but are known to be poor" and maintained by the Begards of Bruges until at least 1445 (Marechal, "Konventen," 258; see also *RAB*, Onze-Lieve-Vrouwekerk, Charters, no. 552, of 24 July 1444); it later became an almshouse.—The conv. of "poor women, known as the convent *van Ricelle*" along the Nieuwe Gentweg, mentioned in a document of 23 March 1348 (Bruges, Zwartzustersklooster, charter at date, ed. Antoon Viaene, "Een 'covent van gewillighe aermen' in Brugge, 1348," *Biekorf* 75 [1974]: 407–10, at 409–10), probably founded by *van Rissele* family, and merged with the Black Sisters after 1360 (Catharina D'Hooghe, *De huizen van het Zuidproosse te Brugge van ca. 1400*

*tot 1920* [Brussels: n.p., 1997], 404). — The conv. of *Daverlo* on the Nieuwe Gent-weg, known through documents of 27 February 1346 and 27 March 1356, but an almshouse for widows in the early fifteenth c. (Catharine D'Hooghe, "De Zwart-zusters te Brugge: Ontstaan en situering van 1356 tot 1580," *HSEB* 124 [1987], 35–46). — The conv. *ten Hamerkine*, f. by "poor people" gathering around an anchoress later known as "sister Catherine," who died on 14 November 1368. Located close to Jerusalem ch., it was last mentioned in 1455, to be superseded by an almshouse between 1470 and 1483 (Geirnaert, "Het 'convent ten Hamer-kine' te Brugge," 220–224). — The *sCalkers* conv. for "encumbered beguines" (*becommerde beghinen*) in the Goezeputstraat, probably established by the *de Calkere* family, mentioned in a document of 1374 (Marechal, "Konventen," 259). Perhaps these beguines joined the Franciscan Tertiaries who f. a conv. in the Goezeputstraat attested in 1391 (Simons, *Bedelordekloosters*, 181–82; Ryckaert, *Brugge*, 190–91).

26A. A privilege by pope Innocent IV of 21 March 1247, allowing "the mis-stress and sisters, beguines of the Vineyard of Mary in Brussels" to attend ser-vices in their ch. with closed doors in time of interdict, suggests these beguines were well organized by that date (*AOCMWBR*, B 1452, ad date, copy of ca. 1500). Documents from April 1248 mention their inf. as well as *provisor*, master Rein-erus of Breeteyck (*AOCMWBR*, H 268, 270), regarded as founder of the beg. in "statutes" of 1271 (*ARA*, *KAB*, no. 13402, Charter no. 2, ed. *MF*, vol. 2, 1006–7). Beg. headed by master Reinerus obtained parish status in April 1252 (Lefèvre, Godding, and Godding-Ganshof, *Chartes*, 104–7, nos. 81–82), and received fur-ther papal privileges on 10 July 1253 (*MF*, vol. 2, 998, see also Martens, "Chartes," 7, no. 2, both with the incorrect date "1254") and 1254–55 (*MBB*, 179). Reinerus set up one of first convents in beg. for Beatrice, Heilewida, Ada, and Catherine, daughters of Michael de Hond of Gooik, and their niece Catherine, before March 1257 (*MF*, vol. 4, 720, with a wrong date, "1250," accepted in *MBB*, 177; see cor-rection in Martens, *Chartes*, 7, no. 3). Brussels's second fortification of 1357–59 enclosed beg., see map in Philippe Godding, *Le droit foncier à Bruxelles au moyen âge* (Brussels: Institut de Sociology Solvay, 1960). Ch. was cl. in 1797, but be-guines continued to live on site until 1844 (*MCF*, vol. 1, 242).

26B. First mentioned in May 1263 (*AOCMWBR*, H 1065, fol. 133r: *ad opus debilium de Archa*), the conv. (or inf.) of Ter Arken, close to the "arch" over the Koperbeek within Brussels' oldest fortifications, was intended for sickly be-guines (Michelle Tasiaux, "L'hospice Terarken, à Bruxelles des origines à 1386," *Annales de la Société royale d'archéologie de Bruxelles* 57 [1980]: 3–37, at 24–25). F. may be due to beguine Margaret of Hoeilaart, but by the mid-fourteenth c. governance was firmly in the hands of prominent Clutinc family. It evolved into an almshouse for 16 elderly women between 1311 and 1386 (ibid., 18–26). Ch.

was dedicated to the Virgin Mary (*domus beate Marie de Archa*, on 16 July 1264: Lefèvre, Godding, and Godding-Ganshof, *Chartes*, 124, no. 110).

26C. Conv. started by beguine Heilewid van Meerbeek in her home southeast of St. Gudula's ch. in 1272; her property was acquired in 1305 by Heilwig Blomart or Bloemardinne, who expanded it until 1316; it then consisted of two houses occupied by single or widowed women, some of whom were called beguines. After Heilwig Blomart's death in 1335, the conv. was gradually transformed into almshouse of the Holy Trinity for "twelve poor women," officially approved on 8 September 1371 (documents first discussed in Ruelens, "Jan van Ruysbroek en Blommardinne," lxxvii–xcvi; superb new analysis in Martens, "Hedwige Blomart").

27. Two convents mentioned in a single document of 1335, identified by their parish location only: *les beghines Nostre Dame* and *les beghines Saint Nicolai* (*DB*, 153).

28A. Gregory IX's reissue, on 4 June 1233, of the bull *Gloriam virginalem* for the "continent virgins . . . of the city and diocese of Cambrai" was probably addressed to beguines of Cambrai gathered near monastery of Cantimpré in suburban parish of St. Sauveur; Ryckel found the only known copy of the bull in beg.'s archives in the early seventeenth c. (ed. Ryckel, *Vita S. Beggae*, 626–27). Beguines may have been living there for a while, since Thomas of Cantimpré, in his *Vita Ioannis Cantipratensis* of 1224–28, wrote of a certain Philip of Montmirail who established *continentes vel virgines, absque regulari ordinis norma caste ac sancte uiuere* in or around Cambrai (see Chapter 2). Yet their inf. is not mentioned until January 1236, when bishop Geoffrey of Cambrai, with a reference to pope Gregory's bull, authorized its construction for "the great multitude of women, who live together in small houses." The bishop granted his protection to the inf. and the houses "within the beguines' enclosure" between 30 March 1236 and end 1236–early 1237 (Ryckel, *Vita S. Beggae*, 627–29).

28B. Three beguine convents existed in Cambrai outside enclosure at Cantimpré until 1528–29, at least (*DB*, 154–55). A *couvent Saint Georges* was apparently founded by Thierry, chaplain of St. Sauveur and Isabel l'Escapée in a house close to parish ch. of St. George, before February 1301. — A conv. *de Lille* in the *rue des Asnes* in same parish received a bequest in will of Margaret of Lille (perhaps a relative of the founder or foundress), in 1319. — Conv. *Saint Vaast* in parish of St. Vaast appears in 1354 and 1357.

29. Beg. received gift from three sisters, possibly beguines, in July 1259 (*AOCMWB*, Begijnhof, charters, no. 7). Countess Margaret of Flanders, later commemorated as founder of the beg., endowed it in her will of November 1273 (*ADN*, B 445, no. 1811, ed. Hautcoeur, *Cartulaire Flines*, 194–206, no. CLXXXII). St. Agnes appears as patron in letter of indulgence for beguines' ch. issued on

5 December 1466 (J. Opdedrinck, "Het oude Begijnhof van Damme en de Cistercienser vrouwenabdij van Bethlehem, uit Schouwen," *HSEB* 64 [1914]: 28–56, at 30). In 1474, beg. was converted into a nunnery according to the rule of St. Augustine, which lasted until 1573 (ibid., 35).

30. Will of Arnold of Maldegem, canon of Tournai, on 23 January 1276 (Tournai, Archives de la Cathedrale, cartulaire D, fol. 21v–22v, ed. C. J. Voisin, "Testament d'Arnould de Maldeghem, chanoine de Tournai," *HSEB* 10 (1849): 345–86, at 362), is oldest reference to beg., located e.m. close to Lys River. Ch. dedicated to St. Margaret existed by 1310 (*VH*, I, 127). Beg. destroyed by fire in 1381; grounds were acquired by Sisters of the Common Life in 1423–24 (*MCF*, vol. 1, 271).

31A. Contrary to local historiographical tradition (e.g. *MCF*, vol. 2, 725), there is no evidence of beguines in Dendermonde before 1288. Beg. is not listed among many religious houses favored by Mathilda of Béthune, lady of Dendermonde, in her will of 27 March 1259 (see no. 15), or by countess Margaret in November 1273 (see no. 29). A certain Immesota, *begina*, daughter of Folkardus Mommaerts (a prominent local family), who donated land to hospital of St. Blasius in Dendermonde in September 1272, has been mistakenly identified as a beguine of Dendermonde (as in Broeckaert, *Cartularium*, 1–2, no. I; *PB*, 105; Stroobant, *700 jaar begijnhof*, 8–9; *MCF*, vol. 2, 725). In fact, Immesota probably resided at beg. of St. Elizabeth in Ghent (see no. 40A, and, for identification of beguines in Immesota's charter: *RAG*, Sint-Elisabethbegijnhof, Charters, at dates March 1252 and June 1261; *SAG*, B, no. 16, ed. *BC*, 12–13, no. 16). A "beguine community" (*beginarum civitatis*) of Dendermonde did exist on 7 April 1288, when local collegiate chapter allowed beg. to move from St. Giles parish to that of Our Lady, to erect a ch. there and to have its own priest (Broeckaert, *Cartularium*, 2–4, no. II); a cemetery was authorized on 2 August 1295 (ibid., 8–9, no. VI). Original patron was the Virgin Mary, as demonstrated by beg.'s seal in the fourteenth c. (ibid., 26–27, no. XXI) and pouillés from fourteenth through sixteenth c. (Longnon, *Pouillés*, 351, and Edmond Reusens, "Pouillé du diocèse de Cambrai. Les doyennés de Grammont, de Hal, de Bruxelles, d'Alost, de Pamele-Audenarde et d'Anvers en 1567," *ASHEB* 28 (1900): 257–351, at 292). Although there is evidence for cult of St. Alexis since 1477 (Stroobants, *700 jaar begijnhof*, 39), the saint came to real prominence only in seventeenth c., and only in nineteenth c. did beg. bear his name (ibid., 38–46). Last beguine of Dendermonde died in 1975 (ibid., 25).

31B. When the beg. of Dendermonde moved to new site (see no. 31B), a few women remained at old location near ch. of St. Giles and were called "beguines of the old beguinage" (*beghinis antique curtis*, as opposed to the *beghinis nove curtis* in a will of 3 June 1303: *RAG*, Abdij Zwijveke, Charters, no. 83,

ed. A. De Vlaminck, *Cartulaire de l'Abbaye de Zwyveke-lez-Termonde* [Dender-monde: Cercle Archéologique de Termonde, 1869], 86–90, no. LXXXIII); in 1454, 1504, and 1593, they were called "recluses," and "anchoresses" (*clusenaressen*) in a document of 1454, now lost but edited by A. De Vlaminck, *De stad en heer-lijkheid van Dendermonde. Geschiedkundige opzoekingen* [Dendermonde: n.p, 1864–70], vol. 4, 281; see also Broeckaert, *Cartularium*, 160–64, no. LXXXV). Site was incorporated into conv. of Maricol sisters in 1663–64 (Stroobants, *700 jaar begijnhof*, 9).

32A. On 5 March 1245, Innocent IV issued a letter of protection to the "mistress and sisters, beguines of the town of Diest" (*ARA, KAB*, no. 13700, charter no. 1, ed. Raymaekers, *Kerkelijk Diest*, 422, note 1), and on 26 July 1246 he allowed them to attend services in their ch. behind closed doors in case of interdict, which suggests they then had formed an organized community (*LUB*, XVI, no. 29, ed. Raymaekers, *Kerkelijk Diest*, 423, note 2). For location "on the meadow" (*loco dicto Campo*), south of the city, see charter of 11 March 1251 (ibid., 425, note 1). Possibly because beg. was too small, beguines sought to move it to a nearby field in Webbekom as early as 7 September 1247; this involved an exchange of land between abbey of St. Truiden (owner of property) and lord of Diest, annexation of new site to city, and erection of beg. into separate parish on June 1255 (ibid., 423–29, 456; Philippen, "Het Begijnhof van Sint-Catharina," 505–11; *PB*, 109–12; *MBB*, 185–86). Lords of Diest claimed credit for f. of beg. as their own in January 1255 (*MF*, vol, 1, 768), although they may have had little to do with the initial settlement. Ch. of first beg. was dedicated to St. Catherine; when lord Arnold of Diest authorized beguines to construct houses and ch. on new site, he demanded that new ch. be dedicated to Mary Magdalen (*ARA, KAB*, no. 13700, charter no. 2, ed. Raymaekers, *Kerkelijk Diest*, 425–6, note 2: date is 1–11 April 1254 rather than 21–30 April 1253). Later documents show that patron of beguine ch. and beg. remained St. Catherine (ibid., 426–27, note 1; *MF*, vol 1, 768; etc.). Beg. cl. in 1928 (*MCF*, vol. 1, 281).

32B. On 11 March 1251, Arnold, lord of Diest, ordered all beguines of Diest, whether they lived in beg. at *Campus* or elsewhere, to submit to the authority of the beguine "master" appointed by bishop of Liège to supervise *Campus*, at the risk of losing the right to wear "religious gown" (*LUB*, XVI, no. 1, ed. Ray-maekers, *Kerkelijk Diest*, 425, note 1). Some beguines evidently refused to join St. Catherine's. Document of 1378 mentions "small beguinage" (*cleyn begynhof*: Philippen, "Het Begijnhof," 506), attested until fifteenth c. (F. Loix, "Heeft er ooit te Diest een klein begijnhof bestaan?" *Meer Schoonheid* 30 [1983]: 8–11).

33. Margherite Godscalc, beguine of Diksmuide, made several gifts to nuns of St. Clare of Ypres and "infirmary of the beguines of Diksmuide" on 29 Sep-tember 1273 (ed. Hugolinus Lippens, "L'abbaye des Clarisses d'Ypres aux XIIIe

et XIVe siècles. Notes et documents relatifs à son histoire économique," *Revue d'Histoire franciscaine* 7 [1930]: 297–330, at 317–18, no. LXIII). Beg. had its own chapel (Camille Tihon, *Lettres de Grégoire XI (1371–1378)*, vol. 1 [Brussels: Palais des Académies; Rome: Academia Belgica, 1958], 554, no. 1336, 12 December 1371). Its patron was most probably St. Catherine (F. Vermuyten, *Onze Vlaamse Begijnhoven* [Antwerp: Zuid-Nederlandse Uitgeverij, 1973], 60) rather than St. Godeliva (*MCF*, vol. 1, 300). It was destroyed in 1914 (*VH*, I, 322–23).

34A. Although a beguine of Leffe (a western suburb of Dinant) appears in a deed of 1242 (Brouwers, "Analectes," 247), we have no evidence of a beg. there until 1261, when "60 beguines" of Dinant received a bequest in will of beguine Joan of Marcinelles (*AEL*, Dominicains, charters, no. 13 [27 February 1261]). In 1302, the beguine Heilhewis Soutre cited the "poor beguines of Dinant" along with "[those] of Leffe" or "outside Dinant" (Brouwers, "Analectes," 254–62). The latter beguines had several dwellings close to the ch. of St. George in Leffe, including an inf. known as the *petit hospital* to distinguish it from the urban hospital of St. John; its chapel was dedicated to St. John the Baptist and Mary Magdalen (ibid., 260 and Josianne Gaier-Lhoest, *L'Évolution topographique de la ville de Dinant au Moyen Age* [Brussels: Crédit Communal, 1964], 63 [years 1378, 1421, 1431]). In 1455 Carmelite nuns acquired the site; a few, elderly beguines lived close to new nunnery but beguinage ceased to exist (*MCF*, vol. 1, 294).

34B. In will of 1302, mentioned in no. 34A, Heilhewis Soutre left her house across St. Andrew gate to beguines who lived with her. This may have been the start of the "convent of Arras" attested close to that gate on 29 July 1312 (*couvent con dist d'Arras*: Brouwers, "Analectes," 263–64); it still existed in the fifteenth c. (ibid., 248; *MCF*, vol. 1, 295–96, believes the conv. founded by Heilhewis was distinct from that of Arras). — In 1344 the abbot of Brogne established a conv. for beguines *en Ree*, east of the ch. of Our Lady, headed by his cousin Marie delle Porte; the conv. may not have survived destruction of city in 1466 (Brouwers, "Analectes," 248). — Two convents are known by the name of their founder only: a conv. *de Hastières*, in 1322 (possibly abandoned: Gaier-Lhoest, *L'Évolution topographique*, 64), and a conv. of *Wautier de Coraine*, in 1458 (Brouwers, "Analectes," 248). — A conv. for five virgins established by the alderman, Lambert le Sage, in 1418, became a house of Grey Sisters between before 1489 (Jerome Goyens, "Chapitres de Soeurs Grises hospitalières en Flandres 1483–1528," *Archivum Franciscanum Historicum* 14 [1921]: 199–208, at 203; *MCF*. vol. 1, 298). — Accounts of Notre Dame at Dinant for 1473 mention another beguine conv. of "St. Medard" (ibid., 300).

35A. In codicil to her will drafted on 4 December 1244, on the eve of her death, countess Joan of Flanders left an annual income of 100 s. Fl. for the "residence of the beguines of Douai" on land she had bought at "Champfleury" in

parish of St. Albin e.m. (*ADN*, B 444, no. 808, ed. Giles Gérard Meersseman, "Jeanne de Constantinople et les Frères Prêcheurs," *Archivum Fratrum Praedicatorum* 19 (1949): 122–68, at 168, no. XI). In March 1245 countess Margaret confirmed and augmented the donation (*ADN*, 30 H 17, no. 248; charter also mentions a "mistress" leading beg.). Having secured independent parochial status for the beg. in December 1245 (*ADN*, 1 G 91, no. 211; *AMD*, GG 190, reverse of uncataloged scroll), Margaret recounted f. history of beg. in a solemn charter issued later that month (*ADN*, 30 H 17, no. 250). In July 1246, beg. was called a *cort* (*ADN*, 1 G 91, no. 212); St. Elizabeth was its patron from the start (*ADN*, 1 G 91, no. 211 [December 1245] and no. 213 [June 1248]; *AMD*, FF 861, will of Maroie le Paien of January 1249; *ADN*, 30 H 17, no. 252 [4–30 April 1249]). It was razed in 1477; the remaining beguines joined conv. of Wetz (Brassart, *Notes*, 108–9; see no. 35B, and Simons, "Begijnen en begarden").

35B. In or before 1239, Gervais de le Vile, a prominent citizen of Douai, founded an inf. within the northern gate of Wetz (charter of December 1239, ed. Tailliar, *Recueil*, 105–6, no. 44, confirmed 20–30 April 1242 or 1–11 April 1243, ed. Espinas, *Vie urbaine*, vol. 3, 47; map in Simons, "Begijnen en begarden," 182). Before October 1245, however, he specified that new inf. should serve "poor women commonly known as beguines" (ed. Espinas, *Vie urbaine*, vol. 3, 53–54, no. 73); conv. consisted of two adjacent houses, one of which he and his wife Maroie had used as their home. After his death, his wife Maroie placed conv. and inf. under city governance (31 March 1247–18 April 1248, ed. ibid., 67–68, no. 93). On 29 September 1247, the collegiate chapter of St. Peter of Douai authorized contruction of ch. dedicated to the Holy Spirit (Brassart, *Notes*, 304–7; Brassart, *Inventaire général*, 255 [April 1252 or 1–19 April 1253]; Espinas, *Vie urbaine*, vol. 3, 443, no. 590 [1273]; although a cult to the 11,000 virgins is well established in the fourteenth century, I do not believe, as does Deregnaucourt, "Les béguines," 37, that the hospital chapel was originally dedicated to them). Beg. became part of the urban "hôpital général" in 1752 (*DB*, 155).

35C. In general and for locations, see Simons, "Begijnen en begarden," 182. Conv. f. by Agnes *de Corbie* for "poor beguines, respectable and elderly women" in her house in the *rue dou Puc Fillori* before 27 May 1265 (Espinas, *Vie urbaine*, vol. 3, 362–63, no. 486) cited in numerous wills of Douai citizens from February 1270 on (*AMD*, FF 861, at date, will of Adam de Mausni). — Conv. f. by Philippe *le Toilier* in or before 1276, in his house i.m. near the gate of Canteleu, as recorded in a charter of 1312 (Espinas, *Vie urbaine*, vol. 4, 82–83, no. 950). Conv. is mentioned occasionally in wills starting with that of Aelis d'Aubrecichourt in February 1296 (*AMD*, FF 861, at date). — Conv. due to Bernard *Pilate* in same neighborhood, attested first in November 1282 (will of Marote, daughter of Willaume le Caucheteur, *AMD*, FF 861, at date). — Conv. "of the *Croket*, which is behind

the cemetery of the [parish] church of St. James" outside the walls in the new suburb of Neuvile and listed in will of Aelis d'Aubrecichourt of February 1296 (*AMD*, FF 861, at date); it included two houses known as *.ii. couvens dou Croket* by May 1327 (*AMD*, FF 862, at date). — A conv. named after its founder, *signeur Lanvin le Blaiier*, attested from 28 October 1311 on (*ADN*, 1 G 198, no. 1089; with situation in *rue a le fontaine Noie Kat*, not yet identified). — A conv. *de le Huge*, established in will of Gerart de le Huge in or before December 1305 (*ADN*, 51 H 13, no. 73), cited in several documents from March 1328 on (*AMD*, FF 862, will of Jehan Brehaut). — Convents f. by Marie *de Harnes* and Jeanne *de Deuwioel* before December 1314 (will of Berghe and Katheline li Leus: *AMD*, FF 862, at date), both on left bank of the Scarpe in Douayeul. — A conv. for poor beguines "near the house of *Ansel Creke*," at an unknown location, cited in will of March 1328 (*AMD*, FF 862, at date). — In August 1328, Katheline de Dichi, *ditte la Marthine*, left money to women living in her home at the cemetery of Notre Dame and provided funds for f. of small beguine conv. there (*AMD*, FF 862, at date). Conv. of the *Martines* existed in 1338–39 (will of Jehanne li Kesne, *AMD*, FF 862, at date; see also, in the same collection, will of Bietrix li Tripiere, 13 August 1339). — The convents of *Paskendares* and *Fressain(g)*, first documented in will of Marie Graviele, of 15 December 1337 (*AMD*, FF 862; P. A. Plouvain, *Souvenirs à l'usage des habitans de Douai ou Notes pour servir à l'histoire de cette ville* [Douai: Deregnaucourt, 1822], 337, located the conv. of Fressaing in the *rue St. Pierre*; Brassart, *Notes*, 97, placed it in the *rue d'Arras*). — Convents *de Dourges* and *de Souchez* (named after its founder Wautiers de Souchies) cited in 1338–39 (will of Jehanne li Kesne: *AMD*, FF 862, at date); former was close to ch. of St. Amé (*AMD*, FF 862, will of Bietrix li Tripière, 13 August 1339). — A beguine inf. *dou Puch a le Cainne* in the present day *rue St Thomas*, featured in will of Jehane Malarde of 26 January 1355 (*AMD*, FF 862, ed. Jean-Pierre Deregnaucourt, "Le testament d'une douaisienne en 1355," *Linguistique Picarde* 20, 3 [1980]: 39–43; for its probable location, see Brassart, *Notes*, 145). — Few of these institutions lasted beyond the fourteenth c. In 1419 the convents of *Puch a le Cainne* (called the hospital of St. Thomas since 1378), *de le Huge*, and *Paskendares*, were united as new hospital dedicated to St. Thomas; Tertiaries replaced beguines there in 1472 (ibid., 145–48). The convents of Fressaing and Pilate merged in 1700 but had lost their function as beguine houses well before that date (ibid., 97–102). The conv. of Harnes survived as an almshouse until 1794 (ibid., 69–70).

36. Conv. appears only in will of Bartholomew, priest of Dudzele, of January 1269 (*BGSD*, charter no. 1037: *item, conventui beghinarum de Dudzele . . .* ).

37. Shortly before his death in 1290, lord Walter II of Edingen bequeathed money for f. of a chantry in honor of Mary Magdalen in the beg. of Edingen (see confirmation by bishop of Cambrai on 24 March 1293, ed. Matthieu, *His-*

*toire de la ville d'Enghien*, 466, note 3, with different interpretation). In June of that year, Jacques de Hennuyères, also known as Potiers, and his wife, granted land at Hennuyères to the beguines for the construction of their inf. (Jean-Pierre Tytgat, "Archiefstukken betreffende het begijnhof van Edingen, rond 1250–1797," *Het Oude Land van Edingen en Omliggende* 24 (1996): 269–85 and 25 (1997): 3–34, at 14). Traditions that date the f. to 1250 or 1271 (ibid., 269–71; *MCF*, vol. 1, 307) are in error (see also argumentation in August Roeykens, "Het oude Sint-Niklaashospitaal van Edingen," *Het Oude Land van Edingen en Omliggende* 3 (1975): 39–50, at 47). According to statutes of 1612, the beg.'s patrons were the Virgin Mary and Mary Magdalen (Matthieu, *Histoire*, 584), while the ch. was dedicated to the Holy Cross (Brasseur, *Origines*, 427). The last beguine passed away in 1847 (*MCF*, vol. 1, 309).

38. Oldest references to this beg. in records of local collegiate chapter for 1490. Beg. abandoned or destroyed in or before 1567. In 1570, a new beg. was erected on same site, but it did not last (L. G. A. Houben, *Geschiedenis van Eindhoven, de stad van Kempenland*, vol. 1 [Turnhout, 1890, reprint Eindhoven: Hugo Jonkers, 1974], 145).

39. Stephania Erna of Geraardsbergen made a gift to a beguine conv. in her town in October 1247; since she also provided in case the beguines left town, the beg. was probably established just prior to that date (Ronse, Rijksarchief, Onze-Lieve-Vrouwhospitaal Geraardsbergen, Charters, no. 6). It was also cited in a will of 1258 (ibid., no. 10). Although counts of Flanders Guy (in 1285) and Louis (in 1333) extended their special protection to the beg. with reference to a precedent set by countess Margaret (1244–78), we do not know if she played a role in its creation (*ADN*, B 1562, fol. 102r, ed. *MF*, vol. 4, 258–59). For beg.'s patron, see the statutes of 1414, ed. Braekman, "De 'statuten van levene,'" 43. Last beguine died between 1843 and 1846; city acquired cl. beg. in 1865 (Victor Fris, *Geschiedenis van Geeraardsbergen* [Ghent: I. Vanderpoorten, 1911], 433; *MCF*, vol. 1, 364).

40A. Beg.' f. is closely connected to countess Joan of Flanders' establishment in 1228 of a Cistercian nunnery at "Mary's Haven," later known as the Bijloke abbey, with adjacent hospital, on the west bank of the Lys outside city of Ghent (Vleeschouwers, "Het beheer," 13–25; Simons, *Bedelordekloosters*, 72–74). Abbess Elizabeth of Mary's Haven stated in June 1233 that houses and ch., newly erected close to the abbey and hospital, were intended for "religious women who wish to live in chastity and by a rule," but who would be kept segregated from the nuns' community (Ghent, Maria-Middelareskliniek, Archief Bijloke, Charters, no. C 24, ed. *BC*, 302–3, no. 1bis; a *vidimus* of a related charter issued in July 1233 has a dorsal note, "*de beghinis*," in an early thirteenth-c. hand, which confirms identification of those "religious women" as beguines: *RAG*, Sint-Elisabethbe-

gijnhof, charter at date, ed. Luykx, *Johanna van Constantinopel*, 565, no. XXXVI, without dorsal note). Beg. was certainly in use by December 1235 (*SAG*, B, no. 2, ed. *BC*, 1-2, no. 2); the f. date traditionally accepted, that is, 1234, appears correct (D'Huys, "De Gentse begijnhoven," 17). After an exchange of property between countess and city, the beguines relocated in May 1242 to new site on the Broek, marshy land enclosed by canals west of Ghent city walls (*SAG*, Reeks 94, nos. 55–56, ed. *BC*, 3-4, nos. 4-5, and *RAG*, Bisdom, E 374, fol. 4r [June 1242]), where they remained until 1874, when all but one beguine moved to newly constructed beg. in suburb of St. Amandsberg (D'Huys, "De Gentse begijnhoven," 43). Sources documenting erection of beg. at Broek as independent parish in May–July 1242 cite St. Elizabeth as patron of its ch. (*RAG*, Sint-Elisabethbegijnhof, Charters, at date "1242," ed. *BC*, 4-5, no. 6; *RAG*, Sint-Baafsabdij Gent, Charters, no. 274, ed. Vleeschouwers, *Oorkonden*, vol. 2, 290-92, nos. 269-70), although the Virgin Mary is also cited as a patron of beg. in November 1242 (Ghent, Maria-Middelareskliniek, Archief Bijloke, charters, no. E 18, ed. Walters, *Geschiedenis*, vol. 3, 317-19, no. 121). In September 1997 there were still eight beguines at the St. Elizabethbegijnhof in Sint-Amandsberg.

40B. Because an Early Modern rule of Ter Hooie placed the beg.'s f. in 1234, local historiography has generally accepted that year as the f. date (see for instance *HEB: Tome complémentaire*, 479; *PB*, 102-3 and *MBB*, 207-8, suggested "1240;" more recently D'Huys, "De Gentse begijnhoven," 17, 19, and Cailliau, "Soo geluckigh," 41-42, expressed strong reservations about these early dates). In fact, Ter Hooie's Early Modern rule is an adaptation of that of St. Elizabeth, which included a reference to the latter's f. in 1234 (see no. 40A). Ter Hooie is conspicuously absent from wills of 1251 and 1257 that list most local religious and charitable institutions (*RAG*, Sint-Pietersabdij Gent, Charters, 2nd series, no. 530; *RAG*, Sint-Baafsabdij Gent, Charters, no. 368, ed. Vleeschouwers, *Oorkonden*, vol. 2, 397-99, no. 367). The beg. cannot be much older than 3 December 1262, when countess Margaret of Flanders authorized the dedication of its ch., with cemetery, east of city walls in the area known as the *Hooie* (Ghent, Begijnhof Ter Hooie, Charters, ad date); an agreement with the parish authorities of St. John's of Ghent followed on 31 December 1262 (*RAG*, Sint-Pietersabdij Gent, Charters, ad date, ed. *MF*, vol. 3, 685-86). The beg.'s inf. is attested since 1266 (Ghent, Begijnhof Ter Hooie, Charters, nos. 4, 5 [ed. *GC*, I, vol. 1, 88, no. 35], 6, 7). Its patron was (and is) the Virgin Mary (Ghent, Begijnhof Ter Hooie, Charters, nos. 30 [31 May 1301], 157 [15 April 1388], and Van der Haeghen, no. 86 [10 July 1464 and 31 December 1464]. The beg. still exists.

40C. In May 1264 parish authorities of St. John's ceded part of their benefice at Poortakker (*Porthacker*), just west of the Ghent city walls, to the mistresses of the beguinages of St. Elizabeth or Ter Hooie (see nos. 40A and 40B), in order

to establish a refuge for poor beguines who were not supported by these beguinages (SAG, Reeks LXXX, no. 109 (2), ed. De Potter, Gent, vol. 8, 325, note 1; goal of transaction is clarified by charter of June 1278, cited below). This first attempt to create a beg. at Poortakker failed, however; only in June 1278 did the f. succeed thanks to support of countess Margaret of Flanders, who extended her protection to the new institution and may have given it new financial aid (SAG, Reeks LXXX, Charters, no. 1, ed. Luykx-Foncke, "Sint-Aubertus-Gesticht," 83–84). The counts of Flanders later claimed the beg. as their own f. (see for instance SAG, Reeks LXXX, Charters, no. 5 [14 October 1326]). Ch. and cemetery cited on 6 October 1281 (RAG, Sint-Baafsabdij Gent, Charters, nos. 482–83, ed. Vleeschouwers, Oorkonden, vol. 2, 528–30, no. 489). Beg.'s patron was St. Aubert (SAG, Reeks LXXX, charters, no. 4 [August 1281] and ADN, B 1564, fol. 57v [13 April 1281–29 March 1282]); ch. was dedicated to St. Catherine (SAG, Reeks 330, no. 38, fol. 69r; 7 Aug. 1488). It was cl. in 1863 (D'Huys, "De Gentse begijnhoven," 45).

40D. Several independent beguine convents existed in Ghent between the thirteenth and fifteenth c., but they are difficult to localize and most probably were shortlived. A charter of 20 May 1269 alludes to at least two communities other than St. Elizabeth and Ter Hooie with needy beguines (RAG, Bisdom, E 374, fol. 10r-v), some of whom may have found shelter at Poortakker a few years later (see no. 40C). A conv. of "blue beguines" is attested in 1360–61 at the Ajuinlei, in 1386 at the Ketelpoort, and in 1406–22 at Onderbergen (De Potter, Gent, vol. 8, 132–33; according to ibid., 278–79, an almshouse of "blue beguines" existed until late sixteenth c. in nearby Twaalfkameren). Several convents of beguine-like women known in the same neighborhood, close to Dominican and Franciscan convents from mid-fourteenth c. on, were or became houses of Tertiaries (Simons, Bedelordekloosters, 173–85).

41. Canon Arnold of Maldegem made a bequest to the beghinagio de Ghistella in his will of 23 January 1276 (no. 30; ed. Voisin, "Testament," 362).

42. On 27 December 1436, duke Arnold of Gelre gave new statutes to the beg. of Grave, which hitherto had observed the customs of main beg. at 's-Hertogenbosch; he also paid tribute to his ancestor "John" of Cuijk, who had apparently favored and protected the beg. of Grave (J. A. Alberdingk Thijm, "Het begijnenklooster te Grave en zijne dichteresse," in Volks-Almanak voor Nederlandsche Katholieken in het jaar des Heeren 1855 [Amsterdam: C.L. van Langenhuysen, 1855], 170–253, at 177–79). It is not clear whether this ancestor was John I (lord of Cuijk and Grave in 1254–1308), or any of his namesakes who ruled Cuijk and Grave in the fourteenth c.: John II (1308–19), John III (1350–52/53), John IV (1357–63), John V (1363–82), or John VI (1390–94) (see for this thrilling genealogy: J. A. Coldeweij, De heren van Kuyc 1096–1400 [Tilburg: Stichting Zuidelijk

Historisch Contact, 1981]). In 1459 certain beguines became Tertiaries, forming the conv. of Maria Graf, while others did not; both communities coexisted until last beguines joined Tertiaries shortly after 1639 (L. H. C. Schutjes, *Geschiedenis van het bisdom 's Hertogenbosch* [Sint-Michielsgestel: n.p., 1870–76], vol. 3, 800–805; Michael Schoengen, *Monasticon Batavum* [Amsterdam: Noord-Hollandsche Uitgevers Maatschappij, 1941–42], vol. 1, 81–82).

43. *ARA, KAB*, no. 14164 contains documents regarding the appointment in 1496 of chaplain to chantry of St. Michael and St. Agnes in ch. of beg. Legend has that beg. was f. in thirteenth c. by a certain Elizabeth of Péry, hence its name. Existed as a beguine institution distinct from local hospital in 1530, but by the seventeenth c. it had become an almshouse (*MCF*, vol. 1, 368–69).

44. The conv. probably dates from the late fifteenth c. (before 1483?). In 1526, it housed only two beguines (Cuvelier, *Les dénombrements*, cclvi). It was cl. by 1546 (P. J. Maas, *Kort overzicht van de geschiedenis der stad Halen* [Halen: n.p., 1877], 124–30).

45. According to notes left by William Peuskens, parish priest in the late eighteenth c., before most of beg.'s records were lost, the oldest document in its archives contained the decision by the bishop of Liège to grant beg. of Hasselt its own chaplain, between 16 April 1245 and 7 April 1246 (Juliaan Lambrechts, *Het oud begijnhof of beknopte geschiedenis van het begijnhof van Hasselt* [Hasselt: M. Ceysens, 1886], 10, 71). Beg. was located south of Sint-Truiden gate near *Begijnepoel* (Polydore Daniëls, "Notes sur le premier béguinage de Hasselt," *Verzamelde opstellen* 13 [1937]: 25–30). Destroyed in 1567, beg. moved to new location i.m. along Demer (*MCF*, vol. 1, 375). After the move, the ch.'s patron was St. Agnes, whose cult in beg. may have been older (*VH*, I, 210); I have found no evidence supporting the contention that its medieval patron was St. Catherine (as stated in Daris, *Histoire . . . le XIIIe et le XIVe siècle*, 206, and *MCF*, vol. 1, 374); altar dedicated to the Virgin Mary existed in ch. as early as 1318 (Daniëls, "Notes," 27; see also Paquay, *Pouillé*, 69, and De Ridder, "Pouillé" [1864]: 458). Last beguine died in 1886 (*VH*, I, 212).

46. Beg. of Heinsberg, located close to castle in old town, was f. on 17 March 1307 by Geoffrey II of Heinsberg and his wife Mechtild of Loon, who ceded several houses close to their vineyard, which they had acquired from a certain *Haydwigis* (a member of their court, who may have ruled the new beg.), and ordered new members of the beg. to pay 4 s. Brabants. The "girls" (*puellae*) of the new conv., which consisted of at least two or three houses, should "serve God in devotion and chastity according to the rule of beguines, and in obedience of the priest to be appointed by us [the founders]." Last mentioned in 1360 (Deussen, "Beginenhof," 60–61).

47. Beg. housed in a single building behind Helmond inf. and attested from

1426 until 1447; probably cl. by 1496, since not mentioned in hearth tax survey of that year (A. M. Frenken, *Helmond in het verleden*, vol. 2 ['s-Hertogenbosch: Provinciaal Genootschap van Kunsten en Wetenschappen, 1929], 357–58).

48. Small conv. with ch. close to Arrouaisian abbey, f. after the removal of lay sisters in 1257–58 (see Milis, *L'ordre*, vol. 1, 248–51, 515–19). L. Dancoisne, *Recherches historiques sur Hénin-Liétard* (Douai: n.p., 1847), 87, 211, declared to have seen several thirteenth-c. documents (lost since World War I) that mentioned beg.; he published one of 1282 (ibid., P. J. no. 10; see also Delmaire, *Diocèse d'Arras*, vol. 1, 327). Cl. in 1693.

49. Conv. mentioned in charter of 28 September 1296, by which bishop Hugh III of Liège appointed abbot Robert of Villers as "visitor" of "the house or houses of the mistress and beguines of Henis" (Émile Brouette, "L'abbé de Villers visiteur du béguinage de Henis (1296)," *Leodium* 63 [1978]: 64–65). Not to be confused with house or conv. "of Henis" in St. Catherine's beg. at Tongeren (see no. 101).

50. Beg. north of city along Kleine Nete river, erected into separate parish by two Dominicans of Antwerp on 26 December 1270, after authorization by bishop of Cambrai on 4 September 1266; it was f. before 1266 by local priest Arnold and grew rapidly in the first years (ed. of documents in Verellen, "Oorkonden," 54–58, nos. 1–4; see espec. 55, no. 2, for expression *curtis prope Herentals* in charter of 1268). Its patrons were the Virgin Mary and St. Catherine, regarded as main patron by late fifteenth c. (Vriens, 'Het oud begijnhof," 23; Verellen, "Oorkonden," 167–70, nos. 9–13; Floris Prims, "Herentals - Begijnhof," *BG* 32 [1949]: 64–65). Destroyed in 1578, rebuilt in 1586 i.m. (Trooskens, "Begijnen," 33). In September 1997, there was still one beguine at the beg.

51A. First mentioned as beg. with inf. in will of 30 March 1274; on 6 July 1274, it received the right to erect ch. with cemetery and to elect its own priest (ed. Camps, *Oorkondenboek*, I, vol. 1, 431–33, no. 343, and 438–40, no. 348). Financial support of duke John I of Brabant for construction of land is possible but not proven ('s-Hertogenbosch, Stadsarchief, Aanwinsten, no. 8040d). On location (present-day *Parade*), just south of St. John's cathedral, and patronage (Virgin Mary, with St. Nicholas as secondary patron), see Schutjes, *Geschiedenis van het bisdom 's Hertogenbosch*, vol. 4, 359, 362; De Ridder, "Pouillé" [1864]: 271; Timmermans, "Tussen kerk en wereld," 11–12. The last beguine died in 1675 (Schutjes, *Geschiedenis*, vol. 4, 370).

51B. On 8 March 1349, Aleijdis Maelghijs, beguine of the "small beguinage" of 's-Hertogenbosch, made a gift to a friar of local Franciscan conv. ('s-Hertogenbosch, Stadsarchief, Tafel Heilige Geest, Charters, no. 322). This beg., located behind Franciscan conv., is attested until 1591 (Timmermans, "Tussen kerk en wereld," 47).

52. Beg. received bequest in will of Baldwin, lord of Hezecques, in August 1248 (ed. Tailliar, *Recueil*, 163–64, no. 102). There was a "large" and a "small" conv. in 1322. Last mentioned around 1345 (*DB*, 158).

53. Beg. cited in will of Renerus of Tongeren on 31 July 1267 (ed. Paquay, "Regesta de Renier," 73).

54. On 3 March 1380, Henry Immen and his wife Catherine van Boom endowed a chantry in the name of the Virgin Mary in the "new beguinage" of Hoogstraten (Lambrechts, "Het begijnhof," 167–68, no. II). Thirteen beguines lived there in 1381, taking care of needy women, as recorded in charter of John V of Cuijk, lord of Hoogstraten, granting them ownership of the property they held from him (Lambrechts, "Het begijnhof," 31–33, and 169, no. III). The beg. expanded thanks to Catherine of Cuijk (a bastard daughter of Wenemar of Hoogstraten, John's second cousin, see ibid., 98, note 4, and Coldeweij, *De Heren van Kuyc*, 232), a beguine of the young community, who left her home with yard and ch. to beg. in will of 16 October 1382. Beg. became parish in 1400–32; its main dedication was to the Virgin Mary, as in Clement VII's privilege of 20 November 1392 (Lambrechts, "Het begijnhof," 169–94, nos. IV–XXIII). The last beguine of Hoogstraten died in 1972 (Lauwerys, "Het begijnhof," *HOK* 42 [1974]: 42 and *HOK* 44 [1976]: 47).

55. Beg. received gift from count of Flanders in 1295 (*ADN*, B 1505, no. 3721; cf. *ARA*, Rekenkamers, Rolrekeningen, no. 272 [1311]); later, it was mentioned in will of 27 May 1373 (Kortrijk, Rijksarchief, d'Ennetières, charters, no. 51) and lastly in charter of 2 April 1399 or 1400 (*ADN*, B 5321, no. 14001). On chantry in honor of St. Agnes, see *VH*, I, 129. Beg.'s chapel, cemetery (both e.m.), and perhaps other property was handed over to Franciscan Observants for contruction of a new monastery in 1458 (Sint-Truiden, Minderbroedersklooster, Provinciaal Archief van de Franciskanen, Charters, III, conv. Hulst, at date; ed. from papal registers in Ioseph M. Pou y Marti, ed., *Bullarium Franciscanum, Nova Series*, vol. 2 [Quaracchi, 1939], no. 58).

56. Despite considerable archival losses (Pierre Bauwens, "À propos des béguinages à Huy," *Leodium* 79 [1994]: 47–54), we know the following beguinages: Conv. f. by Marie de Montroyal on left bank of Meuse for seventeen beguines in March 1251 (André Joris, "Documents relatifs à l'histoire économique et sociale de Huy au moyen âge," *BCRH* 124 [1959]: 213–65, at 239–41, no. 3). Conv. f. by Philippe de Cerf and his wife Maron in parish of St. Denis on 22 July 1298 (Gaspard, "Étude sur les testaments," 145 and 151); by Henri le Soris in *Bolengierue* in 1337 for thirteen beguines (who moved before 1423 to *Chienrue*); by Agnès de Gauwes in the *Grande Strée* on 28 January 1359 for eight elderly beguines; by master Jean Pochet in *Griange* on 25 July 1363; by Henri le Clokier on 8 August 1363 for six beguines; by Maroie de Bovis, across from Franciscan conv. on

15 January 1365; by Henri de Mont in *Rioul* before 1386; by the beguine Juette de Tahier on 15 November 1388 for three beguines (who would live in her house); by Sibille, widow of Giles Pelaisse on 18 October 1390 in the *rue des Beguines*; by Jean Lempereur of Moxhe in 1463 for five beguines; by Jean de Thiribu in neighborhood *sous-le-Chateau* before 1512, and by Henri de Pailhe near Franciscan conv. before 1559. Other convents, whose f. history is unknown, are mentioned near the ch. of St. Mengold in 1306, near the conv. of the Croisiers (the conv. *des Foulons*) and the Franciscan conv. (the conv. *de Florennes*, and the *Grand Couvent*) around 1559, in the parish of St. Rémy in 1559 and 1596 (conv. *Le Brun*), in the *rue des Esses* before 1563 (conv. *Molulaire*). As far as we can tell, eleven of these convents still existed around 1559 (Joris, *Histoire*, 353; Bauwens, "À propos," 46; and *MCF*, vol. 1, 409–33, which lists even more convents or hospitals that may have been run by, and for, beguines).

57. Beg. attested from 1382 until 1572–73 (R. Hanon de Louvet, *Histoire de la ville de Jodogne*, vol 2 (Gembloux: Duculot, 1941), 639–41; De Ridder, "Pouillé" [1865]: 153).

58. In February 1242 countess Joan of Flanders transferred to the beguines of Kortrijk the ownership of their residence, which she had just acquired from a certain *Riquardus de Halla*. Countess Margaret assigned 60 s. from an annual income of 135 lb. Fl., left by countess Joan in her will of 1244, to the "religious women of Kortrijk called beguines," at her discretion and that of two Dominicans, so that they could pay the annual rent on their dwellings; this suggests an expansion since 1242. A ch. would follow in 1284 (Coulon, *Histoire*, 1–4; see also De Cuyper, "Het begijnhof van Kortrijk," 8–12). Beg. was located on northeastern edge of city, south of the counts' castle. St. Elizabeth was main patron in second half of fourteenth c.; in later c., beg. was commonly known as the *beghijnhof Sente Lisbetten* (ibid., 16). One beguine is still in residence.

59. "The beguines of Lens" received a bequest in will of countess Margaret of Flanders, in November 1273 (see no. 29). I regard this note as the oldest reference to the beguine conv. of Lens in Artois (despite doubts raised by *DB*, 158), further attested in 1285, 1287, and 1298–99 (see also Delmaire, *Diocèse d'Arras*, vol. 1, 327–28; situation of beg. in town of Lens in the modern Belgian province of Brabant, as considered in *MCF*, vol. 2, 445–46, is not possible).

60. Beg. received donation in will of 29 January 1246, now lost but cited in a document of 1351 (*DB*, 158); it also appears in charter of 27 June 1251 (*ADN*, 30 H14, no. 180) and in subsequent documents. For location outside St. Martin's gate and end of beg., see *DB*, 158.

61A. This beg. in the parish of St. Christophe e.m., may have been one of the oldest and largest of all beguine institutions in the Low Countries. Its early history is difficult to reconstruct because of the proliferation of myths surround-

ings its origins since an early date, but also because it grew out of a loose federation of privately funded beguine houses and convents in various parts of the parish, which were slow to adopt a common governance. In addition, some of its records were lost in the destruction of Liège in 1468. The following account must omit a full argumentation on many controversial issues. The beg. is not as old as inf. of St. Christophe (later known as *hôpital des Coquins*), which was f. between 1150 and 1183 in the suburb of Avroy, west of the city; its ch., dedicated to St. Christopher, became a parish ch. in 1183. The inf. was run by master and brethren who in 1199 adopted rule of St. Augustine, reaffirmed in 1241 (De Spiegeler, *Les hôpitaux*, 61–63). At no point in its history did the personnel formally include women (Greven, "Der Ursprung," 313, note 4), but a charter of 4 June 1224 (*AEL*, Abbaye de Saint-Laurent, G. III, fol. 35v), referring to conditions that may be dated between 1207 and 1219, suggests certain "sisters" (*sorores*) lived close to ch. of St. Christophe (Schoolmeesters, "Lambert-le-Bégue,"130–32; Greven, "Der Ursprung," 309–14, and for the date, Émile Schoolmeesters, "Tableau," 3–6, at 4: Thomas of Hemricourt, archdeacon of Condroz, 1207–19); these "sisters" may have been or became the first beguines of St. Christophe (cf. *PB*, 71; *MBB*, 44, with which I disagree in part), but evidence is far from conclusive. Epitaph in ch., recording burial of Aelidis de Vaweriles, misdated by Poswick ("Lambert-le-Bègue et l'origine des béguinages," 66) to "1207" and invoked to claim an even earlier f. date, must instead be read [24 April] 1297 (*Anno Domini M.CC. nonagesimo VII, in nocte Beati Marchi Evangeliste, obiit Domina Aelidis de Vaweriles*, ed. in Léon Naveau de Marteau and Arnold Poullet, eds., *Recueil d'Épitaphes de Henri van den Berch, Héraut d'armes Liège-Looz de 1640 à 1666*, vol. 1 [Liège: Société des Bibliophiles Liégeois, 1925], 254; nor is it certain that Aelidis was a beguine). Beguines of Liège formed groups before 1212, but we do not know where they lived nor what connection, if any, they had with inf. or ch. of St. Christophe in that early, preinstitutional stage. As of September 1241, we are on firmer ground: at that date, a papal legate issued a letter of indulgence "for the enlargement of the church, to be used by the religious women of the St. Christopher parish . . . who, with others who come to worship there, exceed the capacity of the existing church, as they are said to number about 1,500" (ed. Ryckel, *Vita S. Beggae*, 573–74; the charter is now lost). Shortly afterwards, the "beguines of St. Christophe" appeared in local wills, beginning with that of canon Philippe of Liège, in 16 April 1245–8 April 1246 ("Lego etiam sacerdoti sancti Christophori in Leodio xx libras alborum ad opus beginarum pauperum parrochie sue, non ad fabricam ecclesie," *ADN*, 40 H 556, no. 1346). They formed numerous convents or lived alone in parish of St. Christophe (for perimeter of their locations in 1253, see Schoolmeesters, "Lambert-le-Bègue et l'origine des Béguines," 132). Their main inf., *l'hôpital Tirebourse*, is attested since c. 1267 (De

Spiegeler, *Les hôpitaux*, 76–81). Evidence of single governance dates from 12 August 1283 (ed. Van Wintershoven, "Notes et documents," 68–70; for the Latin original, see Brouwers, "Documents," 267, note). Beg. was not fully separated from city until wall was erected in early seventeenth c. (Pissart, "Le béguinage," 79–80; for a list of convents belonging to St. Christophe, see ibid., 79–83 and *MCF*, vol. 2, 452, note 2). The last beguines left or died in 1855–65 (Pissart, "Le béguinage," 96–97).

61B. The following list of beguine convents in Liège outside the St. Christophe complex must be provisional, since they are poorly documented. On 28 August 1241, John, "the abbot," chaplain of St. Giles at cathedral of St. Lambert of Liège, donated his house near ch. of St. Mary Magdalen to Cistercian nunnery of Val-Benoît for twenty-four beguines, some of whom were already living there (Joseph Cuvelier, *Cartulaire de l'abbaye du Val-Benoît* [Brussels: Kiessling & P. Imbreghts, 1906], 93–94, no. 80). This John, "the abbot," who also made a donation to St. Lambert in July 1241 (Bormans, *Cartulaire*, vol. 1, 417), was doubtlessly the son of saintly widow Odilia (d. 1220), the heroine of *VO*. According to this *vita*, she gave birth to a boy, John, nicknamed *abbas*, who became a priest at St. Lambert and was charged with care of ch. of St. Giles, where he buried his mother; he died on August 30, 1241 (*VO*, 212, 243–44, 287). His beguine conv. received a gift in will of June 1254 (Cuvelier, *Cartulaire*, 130–33, no. 103) and was last mentioned in will of March 1272 (*AEL*, Dominicains, charters, no. 29, ed. Halkin, "La Maison," 47). — By will of 24 March 1245, Marie de l'Ile left her house in parish of St. Adalbert to her brother, sister, and two nieces who already lived there as beguines; after their death, house was to be a conv. of "poor beguines" supervised by prior of Dominicans and parish priest of St. Adalbert (*AEL*, Dominicains, charter no. 4); the conv. appears again in joint will of Marie and her husband Henry Damage, of June 1254, in Marie's second will of February 1261 (Cuvelier, *Cartulaire*, 130–33 and 163–66, nos. 103 and 128), and in wills of 1265, 1267, and 1272 (*AEL*, Dominicains, Charters, nos. 19, 24, and 29, ed. Lauwers, "Testaments," 174–79, 182–84, and Halkin, "La Maison," 45–49). — In the parishes of St Servais and St. Martin-en-Ile, beguine convents are attested beginning in 1254 (Cuvelier, *Cartulaire*, 131, no. 103; see also *AEL*, Dominicains, Charters, no. 45, ed. Lauwers, "Testaments," 190, of 1282). — Martin, priest of Tilff, f. another conv. for beguines in the parish of St. Martin-en-Ile in 1263: *AEL*, Dominicains, Charters, nos. 17 and 18 [July 1263 and August 1264]). — Before 1261, alderman Radulf established a conv. named after him on the Ile Radulphe (*domus domini Radulphi*: Cuvelier, *Cartulaire*, 165, no. 128; see also *AEL*, Dominicains, Charters, no. 24, ed. Lauwers, "Testaments," 183 [November 1267]), mentioned until 1315 (*MCF*, vol. 2, 487). — On 9 June 1266, Anne of Dinant, widow of Lambert Ivetain, left her house in the rue St. Jean-en-Ile by will

for use by beguines; their conv., known as *Juprelle*, is last attested in 1352 (ibid., 489). — In 1269, beguines lived at the inf. of St. John the Evangelist (f. for male and female poor before 1252); they soon superseded other residents (De Spiegeler, *Les hôpitaux*, 73–74). — Convents of Sainte Madeleine sur Merchoul and in parish of St. Stephen are mentioned in will of March 1272, cited above (*AEL*, Dominicains, Charters, no. 29, ed. Halkin, "La Maison," 45–49, at 47); they existed until seventeenth–eighteenth c. (*MCF*, vol. 2, 472–73, 524–25). — Conv. *de Grace* (or *St. Pholien*) is attested in 1279 (ibid., 536–37). — In parish of St. John the Baptist, close to ch. and inf. of same name, a certain Renier de Chevalbay (see for him charter of 1277 in Jean Guillaume Schoonbroodt, *Inventaire analytique et chronologique des chartes du chapitre de Saint-Martin à Liège* [Liège:J. Desoer, 1871], 27, no. 95) set up before 1280 a conv. named after him, for thirteen beguines (Hankart, "Le béguinage dit du Cheval Bai," 11–12). — Conv. *près des Ecoliers*, close to monastery of Val des Écoliers, originated before 1337 (De Spiegeler, *Les hôpitaux*, 182), as did those of *Lantin* and *Mailhe* (*MCF*, vol. 2, 490–92), while conv. of *Wavré* is attested in 1338 (ibid., 557). Later foundations include the convents of *Fornier* in the *rue Saint-Rémy* before 1381 (*MCF*, vol. 2, 537); *des Machurées* near the Dominicans before 1383 (ibid., 495–96); *Hors-Chateau*, also known as St. Andrew or *de la Clef*, probably around 1400 (ibid., 471–72); *Hakke de Beyne* in the *rue St. Pholien* before 1416 (ibid., 535); *Saint-Antoine* before 1421 (De Spiegeler, *Les hôpitaux*, 182; cf. *MCF*, vol. 2, 511, who advances 1360 as the oldest reference); *Saint-Thomas* before 1421 (ibid., 540); *de Surlet* before 1425 (ibid., 554–55); *Saint-Hubert* before 1434 (ibid., 526); *Kawin* before 1436 (ibid., 490); *Pixhe Bache* before 1437 (De Spiegeler, *Les hôpitaux*, 182); *Sainte Catherine* or *Jehan de Levrier* before 1447 (*MCF*, vol. 2, 546); *Turkeal* before 1447 (ibid., 555); *Saint-Nicolas outre Meuse* before 1460 (ibid., 534); *Hocheporte* before 1468 (ibid., 485). Many disappeared when Liège was destroyed by Charles the Bold in 1468. "*Béguinages*" f. after that date were probably almshouses. By 1565, only about a dozen true beg. still existed.

62. Local collegiate chapter granted beg. independance from city parish in February 1259 (Goetschalckx, "Het begijnhof van Lier," 42–44); beg. called *curtis sancte Margarete juxta Lyeram* by bishop of Cambrai in confirmation charter of 1–11 April 1259 (ed. in *PB*, 119, note 1, dated April 1258, corrected on p. 434). Incorporated into city walls in 1389 (*MCF*, vol. 2, 561). The last beguine left beg. in early 1970s.

63. Origins of beg. are closely linked to those of nearby Hôpital Comtesse, f. at Lille by countess Joan of Flanders in 1237. Papal bull of 1239, addressed to "the master and brethren of the hospital of the Virgin Mary and St. Elizabeth of Lille, of the order of St. Augustine" (*ADN*, Archives hospitalières de Lille, I, no. 17, 13 January 1239) has long been regarded as f. act of beg. (e.g. Jacques Mar-

seille, "Le couvent des Dominicains de Lille de sa fondation au milieu du XVe siècle," *Archivum Fratrum Praedicatorum* 40 [1970]: 73–93, at 82; the error was first noted in *DB*, 158–59) but really concerns the Comtesse inf., where the male personnel followed St. Augustine's rule. After 1239, the Virgin Mary was the Hôpital Comtesse's sole patron; soon afterward we find St. Elizabeth as patron of the beguinage. It is therefore possible that Hôpital Comtesse originally included a female staff who split away from it shortly after 1239 and f. a beg. (in this, I differ from *DB*, 158–59), first acknowledged as a separate community in March 1245 (*ADN*, B 1528, no. 826 and B 444, no. 825, ed. Denis du Péage, *Documents*, 9–11; also in *MF*, vol. 3, 594–95); in May 1245, countess Margaret identified it as the "hospital of the beguines outside the gate of St. Peter . . . founded by . . . the late countess Joan of Flanders and myself . . . in honor of God and St. Elizabeth" (*ADN*, B 1528, no. 835, ed. Denis du Péage, *Documents*, 11–12; for countess Joan's dispositions for beg. of Lille shortly before her death on 5 December 1244, see *ADN*, Archives hospitalières de Lille, I, no. 96, ed. Denis du Péage, *Documents*, 21–22 [April 1274]). Significantly, Hôpital Comtesse's Augustinian rule was confirmed and supplemented by new statutes in 1244–46, shortly after beg. was formed (*ADN*, 16 G 18, no. 177, ed. Hautcoeur, *Cartulaire . . . Saint-Pierre*, vol. 1, 297–98, no. CCCLII [26 September 1245] and Ed. Le Grand, *Statuts d'Hôtels-Dieu et de léproseries* [Paris: Picard, 1901], 61–96, no. VIII; Simons, *Stad*, 226, note 217). Beg. cl. in 1855 (Denis du Péage, *Documents*, 8).

64A. In August 1232, master Renerus, priest of Louvain, authorized erection of ch. "for the use of the religious women living at Hove" near Louvain (Louvain, Stadsarchief, no. 4623, ed. *Joannis Molani Historiae*, vol. 2, 1191–92, no. XXVI). According to inscription of ca. 1300 in beguines' ch., f. date was 1234 (Bergmans, "De Sint-Jan-de-Doperkerk," 9). In a privilege of 16 August 1245, pope Innocent IV addressed the new community as "magistre ac sororibus de Hovis iuxta Lovanium que beghine vocantur" (*LUB*, XVII, no. 1); oldest property deed in beg.'s archives dates from same year (*ARA*, *AOOL*, Charters, 2nd series, no. 141 [inv. no. 2650]). Beg. acquired semi-parochial status in 1250 (Louvain, Stadsarchief, no. 4623 bis, ed. *Joannis Molani Historiae*, vol. 1, 349–50). It was incorporated into the city fortifications in 1357–63. It is doubtful that beg. ever recognized any one saint as its patron. Ch.'s patron was John the Baptist; St. Catherine was patron of inf. ch. (Bergmans, De Sint-Jan-de-Doperkerk," 8; Olyslager, *Het groot begijnhof*, 29, 77). Last beguine died in 1988 (*MCF*, vol 2, 590).

64B. While local historiography holds that beg. originated around 1230 (Van Even, *Louvain*, 342; A. Struyf, "Kerk en pastoors van het Klein Begijnhof te Leuven," *Mededelingen van de Geschied- en Oudheidkundige Kring voor Leuven en Omgeving* 4 [1964]: 31–44, at 31; cf. *HEB: Tome Complémentaire*, 488; *MCF*, vol. 2, 577–78), there is no evidence for it earlier than a charter of January 1269,

recording a gift by Bertula, beguine of Klein Begijnhof, to nearby abbey of St. Gertrude (*ARA, KAB*, no. 10258, charter 105); inf. is cited in 1275 (*ARA, AOOL*, Charters, 1st series, no. 146 [inv. no. 5042]). For reference to beg. in a letter to countess Beatrice of Brabant, dated by its editor to 1251–52, but probably from about 1270–78, see Appendix II, no. 7. In 1295 the beguines started work on a ch. attached to their inf. (*ARA, AOOL*, Charters, 1st series, no. 273 [Inv. no. 4997]). Although popular speech called it the "beguinage of St. Gertrude" after nearby abbey, beg. ch. was dedicated to St. Catherine (ARA, *AOOL*, Charters, no. 1593 [inv. no. 5000], of 15 October 1392), whom beguines considered their patron. Last beguine died in 1855 (Struyf, "De bevolking," 167).

64C. A "hospital for poor beguines of Wierinck" (*infirmaria pauperum beghinarum site in Wierinck*) is attested in 1278 and 1289, according to Molanus (*Historiae*, vol. 1, 619–20; *ARA, AOOL*, no. 5722 [7 December 1330]). Its ch., dedicated to St. Barbara, existed by 1286 (Lefèvre, "Testaments," 438, no. XI; *ARA, KAB*, no. 1263 (115) [charter of 24 February 1299]). Between 1307 (*ARA, AOOL*, no. 2786) and 1372, beg. was transformed into an almshouse of St. Barbara, governed by male brethren, with a small female staff (Marcel Bourguignon, *Inventaire des Archives de l'Assistance publique de la ville de Louvain* [Tongeren: Imprimerie G. Michiels-Broeders, 1933], xcii–xciii).

65. It is unclear whether a clause in will of John of Maaseik, who before May 1260 left money "for pious uses," referred to this beg., as has been claimed (Polus, "Vijf charters," 458–59, no. 1). In any case, by 1265 beguines of Maaseik, headed by several mistresses (*magistre et begghine*), had begun constructing houses and ch. south of town at Heppeneert. Bishop Henry of Liège, at the request of count Arnold IV of Loon and his wife Joan, granted them autonomy as a parish in September 1265 (*RAH*, Begijnhof Maaseik, charters, no. 1, ed. M. Bussels, "De stichtingsoorkonde van het Maaseiker begijnhof," *Het Oude Land van Loon* 10 [1955]: 73–78, at 77–78); count Arnold also contributed to beguine priest's annual salary in July 1266 (Polus, "Vijf charters," 459, no. 2). Beg. mentioned in master Renerus of Tongeren's will of July 1267 (see no. 53). In 1429 part of beg. was converted into famous Augustinian conv. of St. Agnes (Ernest Persoons, "Prieuré de Sainte-Agnès, à Maaseik," in *Monasticon Belge. Tome VI: Province de Limbourg*, 283–90), but beguines continued to live in beg. with their own priest until 1439, perhaps even as late as 1505 (Olivier Debaere, "Maaseik," *Het Tijdschrift van het Gemeentekrediet* 50 [1996]: 7–50, at 9–10, 34; G. Mersch, "Het voormalige begijnhof te Maaseik," *De Maaseikenaar* 22 [1991]: 112–16, at 114). Contrary to common opinion in the literature (ibid., 115; *MCF*, vol. 2), there is no firm evidence that beg.'s chapel was dedicated to St. Agnes, patron of Augustinian conv., though it is possible. Main altar of beguine ch. was dedicated to St. Barbara in 1348–49 (Mathias J. Wolters, *Notice historique sur la ville de Maeseyck* [Ghent: Imprimerie

F. et E. Gyselynck, 1855], 57–58, 112–14, nos. 6–7, 119–21, no. 10), another altar to the Holy Cross in 1400 (Émile Schoolmeesters, "L'archidiaconé de Campine en 1400," *ASHEB* 32 [1906]: 289–344, at 317; repeated, perhaps without updates, in pouillés of 1497 and 1558, see Paquay, *Pouillé*, 45 and De Ridder, "Pouillé," 281).

66A. In 1251, the two collegiate chapters and parish authorities of Maastricht granted a beg. e.m. the right to appoint its own priest, who would conduct services in their ch. dedicated to St. Catherine. Original location probably between the Lange Grachtje, Kleine Looiersstraat, and St. Pieterstraat; beg. moved further away from city south of Jeker river after 9 March 1264 (Roebroeks, "Van Aldenhof tot Sint-Catharina Bongart," 160). The "newly constructed beguinage outside the walls of Maastricht, in honor of St. Catherine" appears in will of 3 February 1265 as a full-blown court beg. surrounded by a wall (the testator left funds for a conv. for poor beguines to be built inside that enclosure: P. Doppler, "Een testament te Maastricht uit 1265," *De Maasgouw* 17 [1895]: 78–80). It was called "the new court" (*nova curia* or *Nieuwenhof*) from 1269 on, while old site would be known as "the old court" or *Aldenhof* (for the priest of *nova curia* in 1310, see *SAT*, Begijnhof, Charters 1st series, no. 36bis). It was razed to better defend city in 1482. Remaining beguines constructed new conv. i.m., recognized in 1483 as the new beg. of *Sinte Katherinen Bongart* and endowed with ch. built at expense of city in 1485–95; patrons were then St. Catherine and St. Gertrude (or St. Peter? Cf. Paquay, *Pouillé*, 78). Beguines became Tertiaries in 1502 (Roebroeks, "Van Aldenhof tot Sint-Catharina Bongart," 160–67).

66B. Charter of 9 March 1264, mentioned in no. 66A, explicitly stated that beg. near ch. of St. Andrew, in seigniory of St. Peter e.m., remained independent from beg. of St. Catherine. Beguines of St. Andrew formed a conv. attested until 1426 (van der Eerden-Vonk, *Raadsverdragen*, 419, no. 1297).

67. Beg. first recorded in 1343 (Frans De Potter and Jan Broeckaert, *Geschiedenis van de gemeenten der Provincie Oost-Vlaanderen: Arrondissement Eekloo*. Part II: *Maldegem* [Ghent: C. Annoot-Braeckman, 1872], 148–50); probably posterior to 1276, since not mentioned in will of Arnold of Maldegem (see no. 30). Donations to beg. made in 1349–60 describe it as a "convent;" in a document of 1528 (when beg. no longer existed), the term *hof* ("court") appears (De Potter and Broeckaert, *Geschiedenis*, 150–53). Last mentioned in 1413 (Kortrijk, Rijksarchief, Kapittel Harelbeke, F108, fol. 6r).

68. Mentioned in master Renerus of Tongeren's will of 31 July 1267 (see no. 53). A certain *Hannekins* of the *beghinage de Maleve* appears in a document of 1336 (J. Martin, "Les béguinages en Brabant wallon," *Wavriensia* 22 [1973]: 83–84).

69. Beguines of this small town near Calais are listed in royal taxation

documents dated between 1295 and 1302, and benefited from a gift by countess Mathilda of Artois on 31 December 1320 (*DB*, 129).

70. Countess Margaret left 60 s. Fl. for beguines of Masnuy in her will of November 1273 (see no. 29).

71. The inf. of beguines of Maubeuge received a gift in will of countess Margaret of Flanders in November 1273 (*ADN*, B 445, no. 1811, omitted in the edition by Hautcoeur, *Cartulaire . . . Flines*, 194–206, as noted in *DB*, 159). It was part of a court beg. supervised by local canonesses of St. Aldegonde and located south of town walls (Alfred Jennepin, *Histoire de la ville de Maubeuge depuis sa fondation jusqu'en 1790* [Maubeuge: n.p., 1889–1909], vol. 2, 592; see also vol. 1, 28, map). Bull of 1291 acknowledges beguine ch. dedicated to Virgin Mary (Élie Langlois, *Les registres de Nicolas IV*, vol. 2 [Paris: Écoles françaises d'Athènes et de Rome, 1893], no. 5833), but St. Elizabeth named as patron in later years (Gérard Sivéry, ed., *Histoire de Maubeuge* [Dunkirk: Westhoek, 1984], 32). Beg. cl. in 1679 (Jennepin, *Histoire*, vol. 1, 52, and 2, 594; see also *ARA*, *KAB*, no. 16844).

72A. On 28 March 1245 pope Innocent IV authorized "the mistress and sisters of Mechelen who are called beguines" (*magistre et sororibus in Machlinia que beghine vocantur*: *AAM*, Begijnhof Mechelen, Charters, no. 1, ed., with a few errors, by De Ridder, "Documents concernant les béguines," 22, no. I, after a cartulary now lost; *PB*, 117 and *MBB*, 181 dated the bull to 1248) to conduct services behind closed doors in time of interdict; they frequented ch. of St. Catherine in the city and had an inf. (see Geoffrey IV of Breda's will of 25 April 1246, ed. Van den Nieuwenhuizen, *Oorkondenboek*, 44–48, no. 29). Accounts that place f. of beg. in 1207 or earlier (De Ridder, "De oorsprong," 57; Beterams, *Inventaris*, vi), are fictitious. Beguines resided close to home for elderly clerics, dedicated to St. Nicholas and attested in 1242 and in will of 1246, mentioned above (De Ridder, "De oorsprong," 69; for an alternative view, see idem, "Documents," 23, note 2). Archbishop of Rheims authorized special collection of alms for the expansion of St. Catherine ch. in October 1256, which suggests growing beg. population (*SAM*, Archief OCMW, no. 4857). In 1259, beg. moved to larger site e.m., where other beguines, previously living separately in city, were expected to join them, as bishop of Cambrai stated in charter approving the transfer of beguines' chantry on 23 July 1259 (ed. De Ridder, "Documents," 23–24, no. II). New ch. was completed in 1275, whole court surrounded by walls and mote in 1276; beg became a separate parish in 1286 (idem, "De oorsprong," 65–66; *MF*, vol. 4, 572–73). Funding for new court came in part from Mary, lady of Mechelen, and her daughter Sophia of Breda, who by 15 June 1275 left her house near beg. to be used as beguine inf. upon her death (communication by Godfried Croenen, who is

preparing an edition of the Berthout charters). Subsequently they and their lineage, the Berthouts, were honored as founders of beg. (Félix van den Branden de Reeth, *Recherches sur l'origine de la famille des Berthout* [Brussels: Académie royale des Sciences et Belles-Lettres de Bruxelles, 1845], 108–10). After destruction of beg. in 1578, beguines moved back into city; new beg. opened in 1595 (De Ridder, "Mechelen's Groot Begijnhof," 15–43). Original patron saints of beg. were Virgin Mary and St. Catherine (charter of 6 February 1286: *SAM*, Archief OCMW, no. 4922). Last beguine died in 1993 (*MCF*, vol. 2, 622).

72B. When main beg. of Mechelen moved e.m., in 1259, a few beguines stayed behind to serve inf. for elderly clerics in town (see no. 72A). Known as the "hospital" (*ter cranken* in Middle Dutch translation of deed of 1260, now lost, see De Ridder, "De oorsprong," 70), it obviously took in elderly or needy beguines as well. Usually called inf. of St. Mary Magdalen, after patron of ch. attached to it (examples of 1345, 1347, and 1358, ibid., 79–80), until 1550, when the name "small beguinage," (*Cleyen-Beggynhove Magdalenen* in 1562, ibid., 80) gained currency. Beg. cl. in 1798 (*MCF*, vol. 2, 614).

73. Conv. serving hospital of Mesen in *Daalstraat*, close to monastery of Our Lady, possibly f. in thirteenth c. It was very small: ten beguines in 1440, thirteen in 1486. Cl. after death of last beguine in 1553 (Johan Beun, "Mesen: Een kleine stad met een grote geschiedenis," *Tijdschrift van het Gemeentekrediet* 84 [1994]: 5–36, at 34).

74. The "poor beguines" (*pauperibus beginabus*) of Momalle received gift in will of priest Franco of Momalle on 19 November 1256 (*AEL*, Dominicains, charters, no. 11, ed. Lauwers, "Testaments," 170–71, no. 4). Beg. was augmented by canon Nicholas Quaertael, canon of Sainte-Croix at Liège, who between 1341 and 1360 donated his "house adjacent to the beguinage of Momalle" for thirteen beguines aged thirty and older. It survived as a beg. until 19th c. (Suzy Chot, "Le Béguinage de Momalle," *Bulletin de la Société royale "Le Vieux Liège"* 100 [1953]: 206–8).

75A. In the spring of 1245, countess Margaret of Flanders and Hainaut secured permission from collegiate chapters of St. Germain and St. Waudru to construct an inf. for beguines on "meadow of the Virgin Mary," also known as Cantimpret, south of Mons, where beguines had established residences (Devillers, "Cartulaire du béguinage," 217–19, nos. I–II [February–6 June 1245]). Beg. received papal privilege on 23 May 1246 and became separate parish in July 1248, again with the countess's financial support (ibid., 219–22, nos. III–IV). Originally e.m., beg. was included in new fortifications of 1295 (*MCF*, vol. 2, 644). Its inf. was dedicated to St. Elizabeth (Devillers, "Cartulaire," 203; cf. Longnon, *Pouillés*, 307), but beg. appears to have honored as patrons both St. Waudru — to acknowledge its ecclesiastical patron, abbey of St. Waudru (Devillers, "Car-

tulaire," 214) — and the Virgin Mary, probably patron of original beguinage ch. Beg. cl. around 1900 (ibid., 213).

75B. Between 1280 and 1365, thirty-seven beguine convents were f. in Mons. De Keyzer, "Aspects," includes a complete list (also in *MCF*, vol. 2, 647–50; see in addition Devillers, *Chartes du Chapitre de Sainte-Waudru*, 445–48, no. CCCXXV, for f. charter of beguine inf. *de le Taye*, on 7 January 1294; De Keyzer, "L'hôpital le Taye," 131–35; and *MCF*, vol. 2, 647–50). It is difficult to determine how many of these convents lasted beyond the mid-fourteenth c. In 1365, there were only eleven convents left (De Keyzer, "Aspects," 226). All of them became almshouses in later c.; the hospital *de le Taye* was transformed into a conv. of Tertiaries in 1470 (De Keyzer, "L'hôpital," 135).

76. In her will of 11 November 1312, Mahaut de Caurroy left 20 s. to the beguine conv. of Mont-Saint-Éloi (*DB*, 129; Delmaire, *Diocèse d'Arras*, vol. 1, 323).

77. A register of papal taxes collected in diocese of Cambrai about 1362–72 lists a chantry of beguines at Morlanwelz (Longnon, *Pouillés*, 315). The Archives de l'État of Mons preserved three registers related to the beg. for 1650–1779 until their destruction in 1940 (*MCF*, vol. 2, 654).

78A. Beg. originated in 8 April 1235–30 March 1236, when Ava, a widow, gave three houses close to collegiate ch. of St. Aubin outside the walls "to be used as a residence for women with a religious lifestyle commonly called beguines" (ed. Wilmet, "Histoire," 47–48). Medieval and early modern sources cite it as the "beguinage of St. Aubin," after parish in which it was located, as the "beguinage of Géronsart" after priory that supervised it, as "Hors-Postil" (*extra posticum*) after small gate in city walls giving access to it, or as the *grand béguinage*, the main beg. of Namur (ibid., 48, 58; convents of Jean Wiart and Denys de Vedrin, cited by *MBB*, 69–70, are part of this beg.). St. Dionysius was patron of ch., possibly established thanks to a gift by Denys de Vedrin, whom the beguines commemorated as "founder" in 1365. Cl. in 1657 (Wilmet, "Histoire," 52–53, 80, 86–89).

78B. Combined with two hitherto overlooked charters, the *Life of Juliana of Mont-Cornillon* (*VJC*, 466–75) sheds light on origins of beg. in parish of Saint-Symphorien. According to the *Life*, Juliana and her followers, having fled Liège in late 1247, found refuge with "some poor beguines" of Namur near ch. of St. Aubin, possibly at beg. of Hors-Postil (see no. 78A), in a house owned by John, canon of St. Aubin and archdeacon of Liège for the Ardennes (attested in latter function in 1246–52: Schoolmeesters, "Tableau," 4). John then founded an inf. for beguines near ch. of St. Symphorien in Jambes, a suburb of Namur on east bank of Meuse, giving Juliana and her companions land to build a house. Juliana stayed there "for a long time" until Imena, abbess of Cistercian nunnery at Sal-

zinnes near Namur, persuaded her to take up residence at her abbey before 1256 (*VJC*, 468). Beg. at St. Symphorien is independently attested in charter of 23 February 1248 (Van den Haute, "L'hôpital Sainte-Calixte," 190); rest of the story in *VJC* concurs with charter by bishop Henry III of Liège of 17 October 1252, which stated that "because of the multitude of beguines" at Jambes he ordered an inf. f. for the care of poor and infirm beguines. In a rather unusual arrangement—but which would have been familiar to Juliana—inf. was not staffed by beguines but by three men and two women observing rule of St. Augustine; master of inf. would be appointed on the advice of an unidentified archdeacon of the Ardennes (obviously canon John), and after his death by the abbot of Villers (ibid., 196–98; see also De Spiegeler, *Les hôpitaux*, 117, and, for Juliana's relationship with Villers, Chapter 2). This is the beg. "across the Meuse" that received alms from Isabella, countess of Flanders and Namur, during her stay in Namur on 23 November 1293 (*RAG*, Charters van de graven van Vlaanderen, Collectie Gaillard, no. 52) and which her husband, count Guy, cited in his will of 15 April 1299 (*ADN*, B449, no. 4181; codicil of 4 may 1304, *ADN*, B449, no. 4437). For patron saint, see François Baix, *La Chambre apostolique et les "Libri Annatarum" de Martin V (1417–1431)*, vol. 1 [Brussel: Palais des Académies; Rome: Academia Belgica, 1947], 32, no. 105; 13 June 1422). After Carmelite nuns took over inf. in 1478, beg. endured until 1581, when Villers ceded their property to the nuns; at that time, only one beguine was in residence (Wilmet, "Histoire," 60; Van den Haute, "L'hôpital," 191–93, 199–204).

78C. Three beguine convents of Namur were unaffiliated with main beg. or with St. Symphorien (nos. 78A and 78B). The conv. *delle Tour*, close to a tower of city fortifications and not far from beg. of Hors-Postil is attested from 1269 until its integration into the latter in the fifteenth c. (*MCF*, vol. 2, 662).—The conv. founded by *Thomas le Coq* before 1313 in the Basse-Marcelle existed until 1498.—The conv. of *Rhynes* appears in sources from 1420 until 1569 (Wilmet, "Histoire," 51–53, 90 and *MCF*, vol. 2, 661–62). The "beguinage" *Dupont*, mentioned by Wilmet, 53–55, *MBB*, 70, and *MCF*, vol. 2, 663–64, was a conv. of Franciscan Tertiaries.

79. A "residence of beguines" (*steide vanden beghinen*) in the *Hoogstraat* of Nieuwpoort is mentioned in a local land survey of 1314 (R. Degryse, *De vroegste geschiedenis van Nieuwpoort* [Nieuwpoort: De Rode Bles, 1994], 48). According to a late eighteenth-c. history of Nieuwpoort (which mistakenly dates beg.'s foundation to 1486) it consisted of a series of houses arranged around a central square; its patron was probably St. John. It was cl. before 1914 (*VH*, III, 130; *MCF*, vol. 2, 665–66).

80. In his will of 21 September 1333, John Gaylinc recorded a gift to the "community of beguines at Ninove founded by *Johannes Bloc*" (*RAG*, Familie

de Ghellinck, charter no. 15). Ch. attested in 1370-72 (Longnon, *Pouillés*, 337). Tertiaries replaced beguines in 1475 (*MCF*, vol. 2, 66-67).

81. Wills of 24 July 1239, 17 December 1248, and 27 June 1251 contain bequests to the "beguines of Nivelles," presumably conv. formed at St. Sepulchre in 1208 or 1209, as described in *VIN* (Namur, Archives de l'État, Archives Ecclésiastiques, no. 890, at date; partial edition in Roland, "Les seigneurs," 354, note 2; Lemaire, *Archives anciennes*, vol. 1, 48–51, no. 47; and *ADN*, 30 H 14, no. 180); a more explicit reference in two wills of 1282 (Hanon de Louvet, "L'Origine," 32–33 and 66–67). Beg. last mentioned in 1426 (*MCF*, vol. 2, 676). — F. of conv. *le Roine* or "La Royauté" in parish of St. Syr has often been attributed to Mary of Brabant (1275-1321), spouse of King Philip III of France, but as Hanon de Louvet (*Contribution*, 135-36, and "L'Origine," 40–57) demonstrated, conv. already existed in 1261, probably even as early as 1241. Queen Mary only funded a new inf. there in 1280-81, which soon gave its name to the whole conv. Its ch. was dedicated to St. Elizabeth (Paquay, *Pouillé*, 118; De Ridder, "Pouillé" [1865]: 382). — Conv. and inf. in neighborhood of *Goutalle* appears in 1272 (Hanon de Louvet, "L'Origine," 33–35) and is attested until 1534 or possibly 1558 (*MCF*, vol. 2, 677; De Ridder, "Pouillé," *ASHEB* 2 [1865]: 383); its chapel was dedicated to St. Gertrude (Baix, *La Chambre*, 151, no. 414; 4 November 1426). — Presence of an anchoress at *leprosarium* of Willambroux from 1195 until at least 1272, as well as Mary of Oignies's legacy, engendered a small beguine conv. attested in 1282 and 1292 (Hanon de Louvet, "L'Origine," 36–37; correct *MOB*, 259, note 18; see also Chapter 2). — Convents of *Herialmont* and *del Docquet* (or *des Goettes*) were first mentioned in 1426 (*MCF*, vol. 2, 680, note 1). — Canonesses of St. Gertrude of Nivelles centralized governance of first three convents toward end of thirteenth c. (Hanon de Louvet, "L'Origine," 56–57). Local hearth tax survey of 1526 lists only three beguinages, presumably those of La Royauté, Goutalle and *del Docquet* (Cuvelier, *Les dénombrements*, cclviii), which shortly afterwards evolved into almshouses for elderly women. French administration of Nivelles closed surviving institutions in 1796; a new beg., opened in 1814, was transformed into a conv. of Sisters of the Child Jesus before 1862 (Martin, "Les béguinages," 85).

82. Mentioned in Renerus of Tongeren's will of 31 July 1267 (see no. 53).

83. First beguines of Oignies were companions of Mary of Oignies, who lived close to ch. and priory of Oignies from 1207 until her death in 1213 (see Chapter 2). A beguine community is attested there in will of 24 July 1239 (see no. 81). Between 1250 and 1275 the beg. moved to new site farther away from priory (Poncelet, *Chartes*, vol. 1, 127, no. 137; Tihon, "Le testament," 119–23), where it is attested until 1352 (ibid., lxiii).

84. In 1539 Nicholas of Essche bought a house with land for nine "poor, honest virgins" (*arme eerlijcke maegden*) in Oisterwijk; mystic Mary van Hout, with

whom Nicholas had been acquainted for some time, and women of her "circle," were presumably first inhabitants of conv., locally known as Betlehem. It housed twelve beguines in second half of sixteenth c. (Smit, "Het begijnhof van Oisterwijk," 40–51; van der Eycken, "Nicolaas van Essche," 279–80). Nicholas's f. perhaps replaced or augmented pre-existing beguine conv. (Smit, "Het begijnhof," 40–42; Willeumier-Schalij, *De brieven*, 5–7), although evidence is shaky. Betlehem should be distinguished from much larger conv. of Franciscan Tertiaries of St. Catharinaberg at Oisterwijk, f. in fifteenth c. (Van de Meerendonk, *Tussen Reformatie en Contra-Reformatie*, 112, 121, 125). — Beg. was cl. in 1725 (Smit, "Het begijnhof," 43–45, 52–55).

85. The "beguines of Oostburg living together" (*beghinis de Ostburg conventualibus*) received a bequest in will of Bartholomew, priest of Dudzele, in January 1269 (*BGSD*, charters, no. 1037; cf. accounts of St. John's hospital in Bruges for 1280–81, ed. L. Gilliodts-van Severen, "Encore l'hôpital Saint-Jean à Bruges. Ses premiers comptes," *La Flandre* 6 [1874–75]: 265–88, 353–68, at 278). Chantry, attested on 27 April 1277 (*BGSD*, charter no. 1162) and in pouillés of 1362, [late] fourteenth c., and about 1455 (Longnon, *Pouillés*, 405, 449, and Warichez, "État bénéficial" [1911]: 445) suggests a *court* beg. Last mentioned in 1550–51 (Janssen and Van Dale, *Bijdragen*, 339, note 13).

86. Beg. cited in will of counts of Flanders, also lords of Orchies, starting with will of countess Margaret of November 1273 (see no. 29; unlike *DB*, 160, I have not found it in will of countess Mathilda of Béthune, of 1259, nor is it listed in report on execution of that will, ca. 1264 [see no. 15]; both mention hospital of Orchies, not beg.). Located north of city walls; see Warichez, "État bénéficial" (1911): 204, on ch. Replaced by conv. of Grey Sisters in 1538 (*DB*, 160).

87A. Cited in register of rents of Onze-Lieve-Vrouwehospitaal of Oudenaarde, completed in May 1272 (*ante curiam beghinarum de Syon*: *GC*, I, vol. 1, 216, no. 122). Jakemon Cabellau and his wife Mary endowed it with income to found a chantry in 1286. Beg. was clearly a *court*, whose *grootmeesteres* and inf. are cited in document of 1294 (Van der Donckt, "Het Sion te Oudenaarde," 151–52). It is mentioned in fourteenth-century pouillé (Longnon, *Pouillés*, 430) but may have suffered from activities of Ghent militia in 1380–83, for it appears abandoned around 1400; possibly the beguines joined those of the Kluis (see no. 87B). In 1425 a new conv. of Sisters of the Common Life appeared on same site at Eindries. A seventeenth-c. chronicle written at this Augustinian conv. cites Virgin Mary as original patron of beg. (Van der Donckt, "Het Sion," 152).

87B. The register of 1272, mentioned above (see no. 87A), also cites "the beguines of the Vineyard," (*beginarum de Vinea*: *GC*, I, vol. 1, 216, no. 122), probably women who lived within city walls near Franciscan conv. and St. Walburgis ch., on site traditionally known as the "hermitage" (*Kluis*, see *Begijnhof*

*Oudenaarde* [Oudenaarde: n.p., 1978], 4). Beg is mentioned in wills of countess Margaret of Flanders, of November 1273 (see no. 29), Isabella, lady of Heestert, of October 1277 (*ADN*, B 446, no. 1987), and John de Wolf, citizen of Pamele, between 1289 and 15 april 1301 (*GC*, I, vol. 4, 2874–76, no. 1928). Beg. moved in 1384 to a new site in Burgstraat, where it still stands today (Van Lerberghe and Ronsse, *Audenaerdsche Mengelingen*, vol. 5, 245–49). Original patron is unknown; beguines chose S. Begga as patron in seventeenth c. (*Begijnhof Oudenaarde*, 19; *MCF*, vol. 1, 194, suggests patron was St. Roch). Last beguine died in 1960 (*Begijnhof Oudenaarde*, 23).

87C. Mentioned in will of Isabella, lady of Heestert, of October 1277 (*ADN*, B 446, no. 1987). In 1289–1301, John de Wolf, citizen of Pamele, favored "each convent of beguines of Pamele" in his will (*GC*, I, vol, 4, 2874–76, no. 1928). By 1409, however, when oldest recorded statutes for beg. were issued, beguines occupied a single house in the *Baarstraat*. Conv. cl. between 1456 and 1547 (Van Lerberghe and Ronsse, *Audenaerdsche Mengelingen*, vol. 2, 36–39).

88. First cited in Heusden, diocese of Utrecht, in 1390. Beg. (with ch.) was moved before 1393 to parish of Oud-Heusden in diocese of Liège (*capella novi beghinagii*, in pouillé of 1400, ed. Schoolmeesters, "L'archidiaconé," 292), where it is attested until late sixteenth c. (Koorn, *Begijnhoven*, 170–71; Paquay, *Pouillé*, 21; De Ridder, "Pouillé" [1864]: 256).

89. Cited in will of May 1267 (*Item lego beghinis de Valle Beate Marie apud Ysca, xl solidos*: Lefèvre, "Testaments," 425, no. IX). It is identified as a *curia beghinarum* in 1276, and a beguine priest was listed in pouillés of 1362–72 and 1567–69 (Longnon, *Pouillés*, 345 and Reusens, "Pouillé du diocèse de Cambrai... en 1567," 285). It evolved into an almshouse by eighteenth c. (*MCF*, vol. 2, 699).

90. In July 1279, Daniel, priest of St. Christopher in Roermond, authorized establishment of a beg. with its own priest, ch. and cemetery e.m. near ch. of St. Nicholas for beguines previously living at various places in Roermond (M. S. Polak, ed., *Oorkondenboek van Gelre en Zutphen to 1326*, vol. 3 [The Hague: n.p., 1988), no. 1279.07.31). Ch. dedicated to St. Catherine was built around 1294 (ibid., no. 1294.11.13; on patrocinium, see Gastout, *Suppliques*, 331–33, no. 270), but beg. moved to new site within walls between 1311 and 1325 (*nova curia* in charter of 11 March 1325, ed. Sivré, "Geschiedkundige schets," 188–90, no. IV, with a wrong date; see also 191, no. V). Beg. cl. in 1797 (*VH*, III, 102).

91. Conv. originated toward end of fourteenth c.; its statutes date from 1394–1419 (ed. O. Delghust, *Mélanges d'histoire locale. Notices et documents*, vol. 5 [Ronse: M. Spiers, 1948], 24–26; date is suggested by mention of Hendric Renghersfliete, *proost van Haerlebeke*, see Paul Declerck, "Het Sint-Salvatorskapittel van Harelbeke," *De Leiegouw* 18 [1976]: 219–66). Abandoned between 1535 and 1591, conv. was revived briefly but finally cl. before 1612 (Albert Cambier, "Het

begijnhof te Ronse," *Annalen van de Geschied- en Oudheidkundige Kring van Ronse en het Tenement van Inde* 11 [1962]: 41–44).

92. Destruction of local archives in World War I limits our knowledge about beguine communities in this important city. Two documents from 1317 and 1323 list twenty-one beguine convents, of which only the following can be located. The *Grand Couvent*, probably the oldest, on *Estat* river in parish of St. John at Vinkebrouc, where medieval sources locate a *beghinestraet*; conv. at *Sainte-Croix* gate, close to Franciscan conv.; conv. near *Sainte-Aldegonde* ch., attested until 1526; conv. on the *Erbostade*; of *Wissoc* (named after local merchant family) on the *Vieille Teinturerie*; conv. of *Malevaut*, just outside the *Hautpont*, attested in 1315; conv. of Mabile de Soiercapiele, cited around 1307 (*DB*, 160–61; see also Justin de Pas, *À Travers le Vieux Saint-Omer* [Saint-Omer: L'Indépendant, 1914], 95–97, 204). By 1327 there were only sixteen convents left. Beguines of Malevaut were absorbed by Franciscan Tertiaries in 1433 (Alain Derville, ed., *Histoire de Saint-Omer* [Lille: Presses universitaires de Lille, 1981], 97); "beguines" attested in *Lombardie* street during fourteenth c. were Cellites, later Conceptionists (de Pas, *À Travers*, 85, 97).

93. Conv. probably f. in thirteenth c.; by 1309 it had fallen into such state of disrepair that Suzane *li Eskevins* left funds for its restoration in her will. It appears again in a document of 1587 (F. Brassart, "Note sur l'ancien béguinage de Sin-lez-Douai," *Souvenirs de la Flandre wallonne* 7 [1867]: 135–42; *DB*, 130).

94. Several beguines living in separate dwellings since 1253 (Pirenne, *Livre*, 12, 363–64, 367; cf. *RAH*, Nonnemielen, charter no. 25: *in vico qui dicitur vicu beguinarum* [7 March 1257]) settled in Schuurhoven, north of Sint-Truiden, on land bought for them by William of Rijkel, abbot of Sint-Truiden, in (or before) May 1258 (see confirmation of deed by Geoffrey, archdeacon of Liège, in Liège, Bibliothèque de l'Université, MS 27, fol. 73v, and Camille de Borman, ed., *Chronique de l'abbaye de Saint-Trond*, vol. 2 [Liège: n.p., 1877], 206–7). In 1265, abbot William reissued f. charter with additional clauses (*RAH*, Begijnhof Sint-Truiden, Charters, no. 1, ed. Straven, *Notice historique*, 103–7, no. 1, and Charles Piot, *Cartulaire de l'abbaye de Saint-Trond* [Brussels: Commission royale d'histoire, 1870–74], vol. 1, 321–25). Patronage of St. Agnes firmly attested in Clement IV's privilege of 27 November 1267 (*RAH*, Begijnhof Sint-Truiden, Charters, no. 3, ed. Straven, *Notice historique*, 107–8). Last beguine died in 1860 (*MCF*, vol. 2, 715).

95. Jutta, widow of Waleran, lord of Montjoie and Sittard, established a conv. for beguines (*domum conventualem beghinarum*) at Sittard shortly before 18 November 1276, when she freed it from all secular taxes and issued instructions for admission to, or departure from, the conv. (Sittard, Gemeentearchief, no. 1238, ed. M. Jansen, "Bijdragen tot de geschiedenis van Sittard, II, Het Begijnenhof," *Publications de la Société historique et archéologique dans le duché de*

*Limbourg* 14 [1877]: 35–61). It probably perished with the destruction of Sittard in 1677 (*VH*, III, 106–7).

96. According to local legend, beg. originated around recluse, Oda, who lived in Thorembais until her death on 20 August 1220 (see Chapter 2). First mentioned in archival sources in will of Renerus of Tongeren, of 1267 (see no. 53). Village of Thorembais-Saint-Martin (as it was known in 1247, see *MCF*, vol. 2, 737) was called *Torembaiys les Beguines* in 1278 and *Torenbasium Beguinarum* in 1283. Last beguine died in 1825 (Van Haeperen, "Le béguinage," 96–106).

97. A conv. for twelve beguines, f. by Guda of Rennenberg, abbess and lady of Thorn, in 1287 (Habets, *De archieven*, vol. 1, 62–63, no. 70, f. charter of August 24, 1287). Unlike J. Houtmortels, *Thorn hoogadelijke rijksabdij en vorstendom* (Maastricht: Ernest van Aelst, 1948), 36, I believe the beguines were housed in a conv. from the beginning; it is attested in 1338 (Habets, *De archieven*, 187, no. 174). The beguines served canonesses and canons of Thorn as nurses until suppression of abbey in 1797 (ibid., iii and xlvii).

98. Mentioned in pouillés of 1497 and 1558 (Paquay, *Pouillé*, 126; De Ridder, "Pouillé" [1865]: 393: *altare S. Elisabethe in beghinagio*).

99. On 7 May 1342, beguines of Tielt were authorized to erect ch. in honor of the Virgin Mary; ch. is also cited in will of 15 December 1366 and is last mentioned in town accounts of 1492. Tertiaries of St. Francis established a conv. on same site in 1494. Original patron of beg. was probably Virgin Mary rather than St. Margaret, revered as patron in Early Modern age (Warichez, "État bénéficial," [1911]: 94; J. De Vriendt, "Het Begijnhof van Sinte Margriete te Thielt," *Geschied- en Oudheidkundige Kring van Kortrijk. Handelingen* 13 [1934]: 200–226, at 220–25).

100. Beg. gained independence from parish of Hakenover in 1250 (Ryckel, *Vita S. Beggae*, 55; *MF*, vol. 4, 529–30; latter edition includes a charter for Tienen beguines dated in 1202 but probably written in late thirteenth c., see *PB*, 112). Beg. lay e.m. until new fortifications of 1364. Ch. dedicated to Virgin Mary (*MCF*, vol. 2, 741). Last beguine died in 1857 (*MCF*, vol. 2, 746).

101A. On 21 May 1243, two sisters, Ida and Oda of Lauw, beguines, gave their home by inf. of St. James outside the *Kruispoort* to "poor beguines" (*SAT*, Begijnhof, Charters, 1st Series, no. 1, ed. Thijs, *Histoire*, 417–19). Beguines first attended services in inf.'s ch. (*SAT*, Begijnhof, Charters, 2nd series, at date 24 October 1245, ed. Paquay, "Marcuald," 250–53, no. VI), but their growing number and poor state of inf.'s ch. (see petition to pope Innocent IV shortly before 20 April 1247: *SAT*, Sint-Jacobsgasthuis, Charters no. 10, ed. [with many errors] Thijs, *Histoire*, 421–23) prompted move in 1257 to new site along Jeker river on uncultivated land (*dries*) known as the *Mure* (neighborhood around the Moerenpoort), where beg. gained parochial status (*SAT*, Begijnhof, Charters 2nd series, at dates

5 August 1257 and 19 October 1257, ed. Paquay, "Marcuald," 261–66, nos. XVII–
XVIII). In 1264 bishop Henry granted beg. adjacent land previously used as com-
mon pasture, on which beguines had already erected a new inf. (*SAT*, Begijnhof,
Charters 2nd series, at date 1264, ed. Paquay, "Marcuald," 268–70, no. XX); in
1289 city ceded yet more land to beg. (*SAT*, Begijnhof, no. 9, fol. 23r, ed. Thijs,
*Histoire*, 427–28). References to its patron, St. Catherine, are numerous, starting
with will of Gerard Poytevin, citizen of Tongeren, of 17 February 1263 (*SAT*, Be-
gijnhof, Charters, 1 st series, no. 2). Last beguine died in 1856 (*MCF*, vol. 2, 759).

101B. When beg. of St. Catherine moved to new location, in 1257, a few be-
guines remained at old site near inf. and ch. of St. James. They benefited from a
gift in will of Mella, beguine of St. Catherine's, in March 1273 (*pro beghinis sancti
Jacobi xlta sol. Leodienses*: *SAT*, Begijnhof Tongeren, Charters, 1st series, no. 4
(rough draft of will; omitted in final draft, codicil, and in analysis by Thijs, *His-
toire*, 291–93). Conv. probably cl. in 1267, when ch. and hospital of St. James were
razed, see Henri Baillien, *Chronologische Inventaris der Oorkonden van het St.-
Jacobsgasthuis te Tongeren (1233–1619)* (Brussels: Paleis der Academiën, 1958), 11.

102. Mentioned only in will of Arnold of Maldegem, of 23 January 1276 (no.
30, ed. Voisin, "Testament," 362).

103A. In May 1241, Jacques le Tendeur, alderman of Tournai, bought from
city a piece of land outside *Sainte Fontainne* gate "for the use of beguines" (Hoc-
quet, "Le Béguinage," 78–79, no. 1). As I have argued before (*LS*, 29–30), James
probably acted as an agent for bishop Walter of Tournai, who in 1–26 March
1250 helped beg. expand its area (Tournai, Archives de l'État, Cartulaires, no. 68,
fol. 15r-v; document on fol. 28r suggests bishop Walter intervened even earlier,
before 22 August 1246). Sources refer to beg. as the *court des Prés*, or *des Petits
Prés*, after meadows where it was established, or as beg. of the *Madeleine*, after
parish in which it was located (see *LS*, 13–14), but ch. and beg. were dedicated
to St. Elizabeth. Beg. was cl. shortly after 1820 (ibid., 14, 39).

103B. A deed of 28 March 1251 cited property "near [the ch. of] St. Médard,
next to the house of beguines residing there" (Tournai, Archives de la Cathé-
drale, XVII, A, no. 12, fol. 92v, ed. J. Vos, *L'abbaye de Saint-Médard ou de Saint-
Nicolas des-Prés, près Tournai*, vol. 1 [Tournai: Société historique et littéraire de
Tournai, 1873], 279, no. 12). Conv. lay between ch. of St. Médard or St. *Marc*, on
hill south of city walls (but included in fortifications of 1295–96), close to a stone
stairway that led to the Franciscan conv., established before 1235 (Simons, *Bede-
lordekloosters*, 54–56), hence its denomination as conv. "at the Stone Steps of St.
Medard" or, more commonly, "of the High Steps" (*ad Gradus Lapideos, de Altis
Gradibus*, or *des Hauls Degrés*, see *LS*, 15–16). John Sennehart and his wife Mar-
garet funded an addition to conv. of a second house for eight beguines between
1261 and 1280; latter house disappeared between 1350 and c. 1400 (Tournai, Ar-

chives de la Cathédrale, Cartulaire D, fol. 350r, ed. *LS*, 43–45). Last mentioned in 1496 (Tournai, Archives de la Cathédrale, no. 42, fol. 325v). For local institutions of Tertiaries or Augustinian nuns sometimes identified as "beguine" convents, see *LS*, 19–21.

104. Beg. first attested as *curtis beguinarum* in 1340 (F. Verbiest, "De oudste Turnhoutse cijnzen: De cijnsrollen van het Land van Turnhout (1340)," *Taxandria* 1950: 232), but it may be older, since large part of town archives was lost in 1334. A chantry existed by 1372 (Longnon, *Pouillés*, 370). The two main benefices in beg. were devoted to the Virgin Mary and St. Catherine, according to a document of 1399 (Jaak Jansen, *Het kunstpatrimonium van het begijnhof te Turnhout* [Brussels: Koninklijk Instituut van het Kunstpatrimonium; Turnhout: Vrienden van het Begijnhof, 1988], 15). In 1994, there was still one beguine (Trooskens, "Begijnen," 54).

105. Beg. grew around inf. for poor beguines (*hospitale in quo religiose mulieres que begine dicuntur valeant commorari*) f. in December 1239, according to authorization by bishop Guiard of Cambrai, which also refers to many more beguines living in area of the *[rue de] Salice* (today *rue Delsaux*) in parish of St. Nicholas e.m. (*ADN*, 40 H 556, no. 1333, ed. *MF*, vol. 2, 855–86). Mary, daughter of Gerard of Vicoigne, citizen of Valenciennes, and her husband William, donated land for inf. (recorded in later charter: *ADN*, 40 H 556, no. 1344 [August 1244], which mentions assistance by local Dominican, friar Henry of Quesnoy). Countess Joan of Flanders and Hainaut expanded its revenues immediately after f. (*ADN*, 40 H 556, no. 1343B, C, and K [October 1240–April 1243]); she claimed credit for its construction in July 1243 (*ADN*, 40 H 556, no. 1343E); see also execution of her will directed by two Dominicans, including friar Henry (*ADN*, 40 H 556, no. 1345 [February 1245]). In January 1245 the expanded beguine community, described as "the women called beguines, residing in the hospital [of St. Elizabeth] in the Salice street, in the parish of St. Nicholas, as well as in the house owned by the countess next to the hospital, in the parish of [*Notre Dame de*] la Chaussée, and in the neighboring streets of the same parishes," were granted their own ch. and priest (*ADN*, 40 H 630, no. 1839); beg. became independent parish in 1254–66 (*ADN*, 40 H 630, no. 1842; see also Simon Leboucq, *Histoire ecclésiastique de la ville et du comté de Valentienne*, ed. Arthur Dinaux [Valenciennes: A. Prignet, 1840], 74, citing documents now lost). Originally, staff of inf. of St. Elizabeth consisted of men observing rule of St. Augustine (see important bull of Innocent IV, 14 March 1246: *ADN*, 40 H 545, no. 1276, ed. Carpentier, "Béguinage," 175, and charter by prior of St. Saulve, ecclesiastical patron of beg., in January 1254: *ADN*, 40 H 630, no. 1842), but they were soon replaced by beguines, probably as early as 1270 (Carpentier, "Béguinage," 138), certainly by 1355 (*ADN*, 40 H 545, no. 1281). The "beguines *du Sac*" mentioned since 1262 formed

a special community or conv. within beg., residing in a house bought by countess Margaret (*ADN*, 40 H 558, no. 1374); the so-called "statutes" (*MBB*, 134, 418) for the beg. issued in May 1262 (*ADN*, 40 H 552, no. 1334, ed. Carpentier, "Béguinage," 176–77), applied to these beguines only. Conv. *du Sac* lost its distinctive character by late fourteenth c. (*DB*, 161). Beguinage's patron, St. Elizabeth, firmly attested from October 1240 on (*ADN*, 40 H 556, no. 1343B). Beg. cl. in 1795 (*VH*, III, 135).

106. Beg., cited in countess Margaret's will of November 1273 (see no. 29), received comital protection in 1355 (*ADN*, B 1565, fol. 69r). Located in Pannestraat, last mentioned in 1506, probably abandoned before 1511–12 (Frans De Potter, Edmond Ronse, and Pieter Borre, *Geschiedenis der stad en kastelnij van Veurne*, vol. 2 [Ghent: C. Annoot-Braeckman, 1875], 351–52; document of 1566 cited there does not prove beg. still existed).

107. Authorized by bishop Guiard of Cambrai, in October 1239, to construct an inf. for poor and sickly beguines, a beguine community living at ch. of "the Consolation of the Virgin Mary" outside Vilvoorde (*Solatium beate Marie prope Vilfordis*, ed. Hallmann, *Geschichte*, 64–65; see also the extensive discussion in *PB*, 425–27), obtained several papal privileges between 1241 and 1285 (Hallmann, *Geschichte*, 66–79). Beg. became independent parish in 1265–67 (*PB*, 426; see gift to priest *apud Solacium beghinarum juxta Filfordiam*, in will of 1286, ed. Lefèvre, "Testaments," 435, no. XI). In 1469 seven Carmelite nuns from Liège settled in beg., but thirty-nine remaining beguines refused to cede it to them; the two communities lived side-by-side until destruction of beg. in 1578. Reestablished in 1585 on another site, close to parish ch. of Vilvoorde, where last beguine died in 1840 (*PB*, 162, 427–31; *MCF*, vol. 2, 801).

108A. In June 1240, "the poor women called beguines" (*pauperis mulieribus que Beghine vocantur*) acquired a piece of land near ch. of the Virgin Mary *ten Brielen*, north of city, with the help of countess Joan (ed. Feys and Nelis, *Cartulaires*, vol. 2, 102–3, no. 153; on earlier indications of beguine life in city, see Chapter 2). Beg. had inf. by 1254 (*ADN*, B 1562, fol. 84v–85r and B 1563, fol. 20r). In November 1260, chapter of St. Martin authorized beguines to erect a ch. in inf., dedicated to same St. Martin (ed. Feys and Nelis, *Cartulaires*, vol. 2, 143, no. 213); a ch. for all beguines in the court was erected in or after December 1267 (ibid., 168–69, nos. 250–51). Because beg. was destroyed during siege of Ypres in 1383, beguines moved to new site i.m. by 1395 (Marie-Jeanne Tits-Dieuaide, *Lettres de Benoît XIII (1394–1422)* [Brussels and Rome: Institut historique belge de Rome, 1960], 6–7, no. 13; see also Feys and Nelis, *Cartulaires*, vol. 2, 606–11, no. 767; 6 February 1423). Beg.'s patron was St. Christine (Diegerick, *Inventaire*, vol. 7, 29, no. MMCLVI; *KB*, MS II.4881, vol. 5, 219r, 243r). Last beguine died in 1842 (*MCF*, vol. 2, 818).

108B. Conv. f. as inf. in 1271–73 by John Baerdonc, a prominent cloth merchant of Ypres, in the Zonnebekestraat e.m. (ed. *MF*, vol. 3, 606–7; Diegerick, *Inventaire*, vol. 7, 12–13, no. MMCXXIV; Des Marez, "Droit privé," 228–29). According to a charter of countess Margaret, of 1271, now lost, the inf. would serve only poor beguines of local convents (*KB*, MS II.4881, vol. 5, fol. 243v). Its patron was St. Thomas (Feys and Nelis, *Cartulaires*, vol. 2, 198, no. 282 [June 1277], and 200–201, no. 285 [6 July 1278]; St. Margaret mentioned as secondary patron in *KB*, MS II.4881, vol. 5, fol. 243v, analyzing lost dedication charter). After siege of Ypres in 1383 and destruction of conv., beguines joined those of St. Christine in new beg. i.m. (see no. 108A).

108C. At least two other beguine communities existed in Ypres during fourteenth c.: conv. in the *Neiderstraete St. Maertens*, behind St. Martin's ch., f. by beghard Jan van Oudinzele before 4 July 1316 (*KB*, *M*, MS 93, 15 [7 December 1315], 5 [9 June 1337], and Diegerick, *Inventaire*, vol. 7, 47–48, no. MMCXCIII [4 July 1316]), whose subsequent fate is unclear; conv. near St. Peter's ch., known as the "black beguines" (*zwarte beghinne*), mentioned in July 1323 (*KB*, *M*, MS 5 and 93, 440) and incorporated into new beg. in 1416 (*KB*, MS II.4881, vol. 5, fol. 244r; see nos. 108A and 108B).

109. First listed in will of Arnold of Maldegem, canon of Tournai, on 23 January 1276 (see no. 30). Beg. received letter of protection from count Louis I of Flanders on 23 July 1331 (*ADN*, B 1562, fol. 89r, ed. *MF*, vol. 3, 160–61); last mentioned in pouillé of (late) fourteenth c. (Longnon, *Pouillés*, 449). Massive flood of 1404, known as *Sint-Elizabethvloed*, destroyed town of IJzendijke, including beg. (see Monique Vleeschouwers-Van Melkebeek, "De parochies van het bisdom Doornik, 1400–1559," *HSEB* 130 [1993]: 187–220, at 205–6, note 118).

110. A conv. of Franciscan Tertiaries f. at Zichem in 1468 was preceded by a beguine conv. that may date from late fourteenth c. The Tertiaries became Augustinian nuns in 1474 (*MCF*, vol. 2, 825); ch. was still known as *capella beguinarum* in 1497 and 1558 (Paquay, *Pouillé*, 93; De Ridder, "Pouillé" [1865]: 151).

111. The *Life of Beatrice of Nazareth* stated that Beatrice lived for about one year with beguines residing in Zoutleeuw, probably in 1207–8 (*VB*, 24; see Chapter 2). Yet there is no documentary evidence of this beg. until 1242, when it received a piece of land at Grieken, north of town, from a certain Arnold of Schiven and his wife Christine. Shortly afterward a ch. dedicated to St. John the Evangelist was erected (Gastout, *Suppliques*, 578–79, no. 747; 5 February 1394; patronage of the Virgin Mary and St. Catherine is possible, however, see Paquay, *Pouillé*, 84; *ARA*, *KAB*, no. 14722). After destruction of beg. in 1578, beguines acquired old conv. of Grey Sisters of Zoutleeuw, where they established new beg. in 1588 (P. V. Bets, *Zout-Leeuw, beschrijving, geschiedenis, instellingen* vol. 1 [Tienen: H. Vanhoebroeck, 1887], 188–97; corrections in *MCF*, vol. 2, 437–42). Last beguine died

shortly after 1822 (Jan Vanroelen, "Geschiedenis van het Begijnhof van Zout-leeuw," *De Brabantse Folklore* 205 [March 1975]: 313–40, at 338).

## Discarded

Assebroek: The beg. of "Val des Anges" (Engelendale) at Assebroek cited in *MCF*, vol. 1, 188, was actually a conv. of Dominican nuns, f. in 1292–93; see Simons, *Bedelordekloosters*, 145–50.

Axel: Two Ghent wills, of 25 July 1251 and September 1257, favor "the [poor] widows" of Axel (*RAG*, Sint-Pietersabdij Gent, Charters, 2de reeks, no, 530; *RAG*, Sint-Baafsabdij Gent, Charters, no. 368, ed. Vleeschouwers, *Oorkonden*, vol. 2, 397–99, no. 367). Since there is no concrete evidence for a beguine community in Axel, we must assume the wills refer to a hospice for elderly women.

Eppegem: *PB*, 447, cited beg. adjacent to ch. of Eppegem; this was in fact a small inf. run by sisters following an Augustinian rule (*MCF*, vol. 1, 313).

Geel: *PB*, 449 (cf. Trooskens, "Begijnen," 48), cited a beg. at Geel. It was part of local inf., known from 1687 on as the *begijnhof* (see M. H. Koyen and Michel De Bont, *Geel door de eeuwen heen* [Geel: Comité Sint-Dimpnajaar, 1975], 111).

Halle: *MBB*, 538, mentions a beg., following Brasseur, *Origines*, 429. This must be inf. of St. Eloi, staffed by sisters who observed rule of St. Augustine (*MCF*, vol. 1, 371–72).

Herk-de-Stad: Ryckel, *Vita S. Beggae*, 579–81, mentions a beg., dating from thirteenth c. I have not found any confirmation of it in the sources.

Hornaing: *DB*, 130, Delmaire, *Diocèse d'Arras*, vol. 1, 323, and Galloway, "'Discreet and Devout Maidens,'" 98–99, cited beg. at Hornaing, a village be-tween Douai and Valenciennes, on the basis of an entry in tax records for cloth sales at Douai in 1304, which mentions *les beguines de Hornaing* (ed. Dhérent, "L'assise sur le commerce des draps," 390). Other documents show that these were Hauwildis and Pierone de Hornaing, "beguines and citizens of Douai," who with their relative, Mary of Hornaing, enjoyed life-rents from city of Bruges in 1291–99 (*SAB*, Reeks 99, I, no. 1306; Wyffels and De Smet, *Rekeningen*, I, vol. 1, 253, 314, 378, 497, 641, and 760); Pieronne was member of beguine conv. of Wetz at Douai in 1298 (ed. Espinas, *La vie urbaine*, vol. 3, 634, no. 849: for Wetz, see this Appendix, no. 35B). In short, there is no conv. "of Hornaing," which is the surname of these beguines, who probably lived in conv. of Wetz in Douai.

Incourt and Itre: beguinages cited in J. Tarlier and A. Wauters, *Géographie et histoire des communes belges. Province de Brabant, Canton de Jodogne* (Brussels: A. N. Lebègue, 1872), 105, and idem, *Géographie... Canton de Nivelles* (Brussels: A. N. Lebègue, 1860), 43, but evidence is doubtful or lacking.

Lens-Saint-Remy: although a conv. in this small Brabantine village is frequently called a beg. in sources from 1343 until 1497, it was in fact governed by the rule of St. Augustine, comprised both women and men, and was headed by a male superior (Georges Hansotte, "Prieuré de Lens-Saint-Remy," in *Monasticon belge. Tome II: Province de Liège*, vol 3 [Liège: Centre national de Recherches d'Histoire religieuse, 1955], 443–53; Pacquay, *Pouillé*, 61).

Lessines: According to several authors, a beg. preceded conv. of Tertiaries at Lessines, established in mid-fifteenth c. (see *MCF*, vol. 2, 448–49). I have not found any trace of it.

Temse: In 1565 Benonus Schakebard and his wife Anna expressed the desire to f. a conv. for four women "who wish to live according to the rule of beguines" (Van Lokeren, *Chartes*, vol. 2, 417); f. was never accomplished.

Venlo: *VH*, III, 107–8, lists several convents of "beguines" at Venlo. The evidence points rather toward communities of Tertiaries and Augustinian sisters (see also Schoengen, *Monasticon Batavum*, vol. 1, 190–91; vol. 2, 196).

Walcourt and Yves-Gomezée: The "beguines" of Walcourt and neighboring Yves-Gomezée received gifts in will of Robert, priest of Walcourt, of 24 July 1239 (see no. 81). Since the term *beguine* was still poorly defined at that time, it seems likely that the priest intended his gift for women attached as *conversae* to Cistercian nunnery of Jardinet, established between Walcourt and Yves in 1232, and that this source concerns f. of a Cistercian conv. (Ursmer Berlière, "Abbaye du Jardinet," in *Monasticon belge. Tome I: Provinces de Namur et de Hainaut* [Maredsous: Abbaye de Maredsous, 1890–97], 77–81).

Wavre: A modern streetname in Wavre, the *rue du béguinage*, is based on a toponym that can be traced to fourteenth-c. source, listing rent earned on a farm *en beghinaige*, but we do not know what kind of religious community might have existed there (J. Martin, "Le béguinage de Wavre," *Wavriensia* 10 [1961]: 49–51.

Wingene: three sisters, "beguines of Wingene," leased land at Wingene to a farmer in 1287–88 (*GC*, I, vol. 2, 1279–80, no. 781). Wingene was birth place of these beguines living at Wijngaard in Bruges (*GC*, I, vol. 4, 2297–98, no. 1512; correct Simons, *Stad*, 219, note 267).

# Appendix II: The Population of Select Court Beguinages

In Chapter 2, I reviewed data regarding the population of several beguinages. In some cases, that information is directly available from the sources or can be gathered with a few computations in a simple procedure; in others, we must combine several records that yield indirect evidence and are often difficult to interpret. The purpose of this appendix is to discuss and explain how population figures have been calculated in those more complex cases.

## 1. Bruges, Wijngaard (St. Elizabeth).

Accounts books of the grand mistress and schola of Wijngaard in Bruges for the period between 1438–39 and 1453–54 (*AOCMWB*, Begijnhof, H2, and Diversen, Rekeningen), recorded expenditures for new entries (professions) of, and funeral services for, beguines in the court. Combined with charter records and the accounts of the Guild of the Virgin Mary, which registered most deaths in the beguinage between 1454 and 1467, they yield the names of 213 beguines living in the beguinage between 1439 and 1454. Like Desmet, "Het Begijnhof," 244, who first analyzed these records, I do not think many beguines residing at the Wijngaard between 1439 and 1454 are missing from the list: only those beguines who professed before 1438–39 and died after 1467 or who left the community voluntarily or by expulsion (events that would not be recorded by any of these materials), would be absent (Table A).

Table A: Minimum Population
Figures for the Beguinage of the
Wijngaard in Bruges, 1439–55

| Years | Number of Beguines |
|-------|--------------------|
| 1439–40 | 152 |
| 1440–41 | 153 |
| 1441–42 | 152 |
| 1442–43 | 151 |
| 1443–44 | 146 |
| 1444–45 | 142 |
| 1445–46 | 138 |
| 1446–47 | 142 |
| 1447–48 | 146 |
| 1448–49 | 146 |
| 1449–50 | 146 |
| 1450–51 | 144 |
| 1451–52 | 140 |
| 1452–53 | 142 |
| 1453–54 | 137 |
| 1454–55 | 138 |

The average population in 1439–54 was 144.56; the average number of professions per year was 3.8; deaths in the community were recorded at an average of 5.25 per year. The average number of professions each year, expressed in relation to a population of 100, was therefore 2.6 (or 2.6 "percent"). The discrepancy between professions and deaths probably explains the slow decline of the overal population figures, but other factors may of course have played a role.

This profession ratio approximates that registered in institutions of religious women with a comparable social background during the fifteenth and sixteenth centuries. The Windesheimer nunnery of St. Ursula of Louvain, which had an average population of 46.5 sisters between 1420 and 1520, had, on average, 1.25 professions per year in that period, or a profession ratio of 2.7 percent per year (Ernest Persoons, "De bewoners van de kloosters Betlehem te Herent en Ten Troon te Grobbendonk," *Arca Lovaniensis* 5 [1976]: 221–40, at 238). At Louvain's Groot-Ziekengasthuis, the average annual number of professions between 1500 and 1599 was 0.73; there were then on average 22.6 sisters, which suggests a profession ratio of 3.2 percent per year (Leo Van Buyten, "Kwantitatieve bijdrage tot de studie van de 'Kloosterdemografie' in het Leuvense. De priorij 's-Hertogeneiland te Gempe, het Zwartzustersklooster en de communauteit van het Groot-Ziekengasthuis te Leuven (16de–18de eeuw)," ibid., 241–76, at 249 and 268).

## 2. Brussels, Wijngaard

In an undated letter to lady Beatrice of Kortrijk (1225–88), former countess of Flanders, a certain brother Amalricus informed her of new liturgical services and prayers to be conducted by various religious institutions in Brabant for the soul of her deceased husband, William of Dampierre, the son of Countess Margaret of Flanders, who was briefly associated with Margaret's rule until his death in May or June 1251 (*RAG, SG*, no. 400, ed. H. Kervyn de Lettenhove, "Béatrix de Courtrai," *Bulletins de l'Académie royale de Belgique* 22 [1855], 1: 382–400, at 395–96, emended below). It contains oblique references to the population of the beguinages of Brussels and Louvain. The relevant section of the letter reads:

Illustri matrone domine B[eatrici] juniori Flandrie comitisse, suus frater Amalricus suas orationes, se ipsum et si quid poterit amplius. Nobilitati vestre, domina mi, significo quod in crastino postquam a vobis recessi karissimo quondam domino meo a singulis beginis de Vinea juxta Bruxellam .vij. psalmos vel officium defunctorum, que ad duo fere milia estimantur, et a singulis sacerdotibus ordinum Fratrum Minorum, Carmelitarum, Saccitarum ibidem missas singulas procuravi. In crastino vero Palmarum idem a singulis beginis de Hovis juxta Lovanium et de Sancta Gertrude ibidem similiter procuravi; et a sacerdotibus ordinum Predicatorum, Fratrum Minorum, Augustinorum, missas similiter singulares; de abbatiis duabus ibidem officium defunctorum. Missas his acquisitas estimavi ad centum et .vij. psalmos cum officiis defunctorum ad .ii.m.cc. Insuper, Valle Ducis habuit de singulis monialibus psalterium et in disciplinis et aliis observantiis quod valuit duplo amplius. Insuper in Villari habuit de singulis sacerdotibus tres missas, quas estimavi ad novies .xx. Habemus enim amplius quam .lx. sacerdotes, et a singulis monachis non sacerdotibus et conversis psalterium unum, que ad .cc^ta. et quatuor .xx. psalteria estimavi.

Kervyn de Lettenhove ("Béatrix," 394–95) identified the author as Amalricus of Marchiennes and dated the letter to April 1251; Gastout (*Béatrix*, 228–29, no. 16) thought the date was March 1252. Both are incorrect. The convents of the Carmelites and Friars of the Sack in Brussels, mentioned in the text, were established around 1264 and shortly before 1270, respectively; the convent of the Augustinian Hermits of Louvain was founded shortly before 1265 (Simons, *Stad*, 99). As the expression "*habemus enim amplius quam . . .*" shows, the author was a monk of Villers. He may be identified with brother Amalricus who became abbot of Villers in 1268 and abdicated in 1270 but probably continued to reside at Villers (*Chronica Villariensis . . . Continuatio Prima*, in *MGH, SS*, vol. 25, 210; cf. Brouette, "Abbaye de Villers," 377). This brother Amalricus came from the Champagne, which would explain his association with the Dampierre family. Another Amalricus is mentioned as cellarer of Villers in 1287, 1289–90, and 1298 (De Moreau, *L'abbaye de Villers*, 274). The letter was certainly written before

countess Margaret's death in 1280, since it addresses Beatrice as *juniori comitisse*. In sum, the letter dates from around 1270–80.

The letter is important because of Amalricus's careful accounting of the number of masses and services he acquired for Count William's soul. His estimate for the number of priests in the convents of the Franciscans, Carmelites, and Sack Friars of Brussels and the Dominicans, Franciscans, and Augustinian Friars of Louvain, namely, "one hundred" in all may have been a good one, since some of those convents, recently established, must have been very small. His assessment of the number of monks and lay brothers in Villers (more than sixty priests among the monks, and 280 lay brothers and monks in lower orders) was also relatively accurate, as far as we can tell (see *Chronica Villariensis monasterii*, in *MGH*, vol. 25, 211). Was he also right when he guessed there were "about 2,000" beguines in Brussels? This is harder to believe. Apart from the dubious figure of twelve hundred beguines in 1372, reported nearly three centuries later by Antonius Sanderus (*Chorographia Sacra Brabantiae*, vol. 1, *Chorographia Sacra Beginagii Bruxellensis* [Brussels: Philip Vleugaert, 1659], 3–4; the source of this information in not cited), we know nothing about its size in the thirteenth and fourteenth centuries, but later indications show that it was quite large. In 1526, the beguinage had seventy-five houses, eighteen convents, and an infirmary, with a grand total of 329 beguines (Cuvelier, *Dénombrements*, 240). That number rose to 510 in 1717 and — perhaps — to 610 in 1730 (Simons, "Een zeker bestaan," 144). We must assume, then, that Amalricus assessed the beguinage's population as considerably larger than that of the monasteries and nunneries he encountered on his trip, but that he did not know its exact size. It is certainly possible that the number of beguines in his days approached or surpassed the eighteenth-century figures, but we simply cannot say so with any certainty.

## 3. Dendermonde, Virgin Mary/St. Alexis

Using profession records for St. Alexis from 1461 to 1480, records of the guild of Our Lady in the beguinage from 1450 until 1833, and charters, M. Bovyn, "Sint-Alexiusbegijnhof," 191–97, compiled the names of 369 beguines who lived at the beguinage from ca. 1450 until 1519. Since not all beguines became members of the guild, the list is not complete. Yet, we do know that 136 beguines professed between 1461 and 1480 (an annual average of 7.15). If we assume the annual profession rate was similar to that of the Wijngaard in Bruges in 1439–54, that is, 2.6 percent, the average population of the beguinage of Dendermonde over the years 1461–80 may be estimated at 275; an annual profession rate of 3.2 percent (compare no. 1) would yield an average of 223 beguines. These are rough, but

plausible figures. At the height of the Counter Reformation in the second half of the seventeenth century, the population fluctuated between 200 and 250 beguines (Stroobants, *700 jaar begijnhof*, 18–19).

## 4. Gent, Groot Begijnhof (St. Elizabeth)

Sources from the thirteenth century onward testify to the rapid growth of this beguinage, one of the largest in the southern Low Countries. In a request for aid addressed to count Guy of Flanders, submitted shortly before 30 April 1284, the beguines observed that their ranks had swelled with "about 300 poor beguines," whom they supported through their charitable "Table" funded by the wealthier beguines of the court (*RAG*, Sint-Elisabethbegijnhof, Charters, ad date 30 April 1284). At that time, the beguinage had about thirty convents (*SAG, B,* nos 50 and 51, ed. *BC,* 39–40, nos. 50–51 [shortly before 10 October 1284]), an infirmary, and an unspecified number of houses for individual beguines. By 1425 there were only eighteen convents (*SAG, B,* no. 205, ed. *BC,* 143–45, no. 205) and that number remained constant until the nineteenth century. In 1584–98, in the wake of the religious and political crisis brought about by the revolt, the total population of the beguinage was estimated at about 530 beguines (*SAG, B,* no. 333, ed. *BC,* 234, no. 333). In 1670, when the beguinage had grown again during the Counter Reformation, there were "900 beguines," according to the grand mistress (D'Huys, "De Gentse begijnhoven," 28). In his study of the sale of houses at the beguinage in the early modern age, Peter Welvaert concluded that a theoretical mean of 756 beguines lived in the beguinage between 1617 and 1797, and that a considerable number of outsiders, perhaps as many as 150, resided with them temporarily; there were, in addition to the eighteen convents, exactly one hundred "houses" for individual or small communal life (Welvaert, "1617–1797: 180 jaar wonen," 224–25).

In 1798, fifteen of the eighteen convents each housed an average of thirty-four beguines (ibid., 227; the population of the three other convents is not known). The average number of beguines per convent may have been somewhat smaller in previous centuries. The convent of Ter Caerden, for instance, which had thirty-four beguines in 1798 (ibid., 227), originally housed twelve beguines, who in 1424 received funding to lodge four more (*SAG, B,* no. 204, ed. *BC,* 141–42, no. 204). In her will of 1543, the beguine Mary vanden Gracht left money for the distribution of bread at her anniversary in her own convent of ter Caerden and other convents, for which she envisaged an average population of twenty beguines (*SAG, B,* no. 304, ed. *BC,* 200–202, no. 304). The total surface area of the beguinage did not change between 1245 and 1797.

Under these circumstances, we can only make an educated guess of the population in 1284, when thirty convents existed in the beguinage. Assuming that an average of sixteen beguines lived in the thirty convents and that more than one hundred houses for individual beguines or small groups existed at that time, with an additional thirty beguines housed in the infirmary (cf. *SAG, B*, no. 333, ed. *BC*, 234, no. 333), the total population would be at least 610; if we adopt an average of twenty beguines per convent, the total would be at least 730.

## 5. Gent, Klein Begijnhof (Ter Hooie)

The foundation of an anniversary for Simon Borluut and his wife Lysbette sGruters on 14 February 1500 included the distribution of bread to seventeen beguines at the infirmary of Ter Hooie and to 252 beguines residing in the seven convents of the beguinage; the total number of beguines was thus 269, and the average population per convent was thirty-six (Cassiman, "Drie verdwaalde stukken," 327; see also Ghent, Begijnhof Ter Hooie, Charters, at date *1499 sprokkel 14*, and its uncatalogued summary). That number is consistent with population figures for the seventeenth and eighteenth centuries: 238 beguines (minimum) in 1643 (Ghent, Begijnhof Ter Hooie, Van der Haeghen, no. 86), about 300 in 1691, 1695, 1704 (Cailliau, "*Soo geluckigh*," 176), 316 in 1748 (Ghent, Begijnhof Ter Hooie, Van der Haeghen, no. 85).

## 6. Liège, St. Christophe

In 1253 the parish priest of St. Christophe and his superiors at Avroy reached an agreement on the ministration of extreme unction to the beguines of St. Christophe. Before that date, Avroy's parish priest alone enjoyed the right to administer the unction in the parish of St. Christophe, for which he was paid 4 d. liégeois per service. The new agreement gave the priest of St. Christophe the right to serve unction to beguines (and only to them) living in the neighborhood, in return for an annual fee of 13 s. liégeois, to be paid to the parish of Avroy (Schoolmeesters, "Lambert-le-Bègue," 131–32; in his introduction to the text, the editor incorrectly referred to the fee as "30 sous"; the text clearly indicates *tredecim solidos*). The new fee was of course intended to compensate the priest of Avroy for a loss of revenue, real or projected, from St. Christophe's priest ministration to beguines, i.e. for a total of thirty-nine services of the unction per year (4 d. x 39=156 d.=13 s.).

Demographers usually consider thirty to forty deaths annually in a popu-

lation of one thousand a "normal" rate for the late middle ages, see Barbara Harvey, *Living and Dying in England, 1100–1540: The Monastic Experience* (Oxford: Clarendon Press, 1993), 122–27; Herlihy and Klapisch-Zuber, *Tuscans*, 270, for the general population of the Florentine region in the fifteenth century; and Stabel, *De kleine stad*, 54–62, for late medieval Flanders, with slightly lower figures; our data for the beguinage of Bruges (no. 1), admittedly a relatively small sample of well-to-do beguines, indicate a rate of 36.3 deaths per thousand. If Avroy's priest usually administered unction to thirty-nine beguines annually in 1253, the total number of beguines at St. Christophe must have been about 1,000. The figure is plausible, given the large number of convents in the parish (*MCF*, vol. 2, 452, note 2, lists thirty-five convents; we noted a contemporary, though unverifiable, reference to "1,500 beguines" in 1241 [Appendix I, no. 61A]). Other evidence for the population of St. Christophe dates from after the destruction of the city in 1468, which evidently disrupted and greatly diminished the original community: there were only ninety-two beguines left at St. Christophe in 1533; in 1740, there were 127 beguines (Simons, "Een zeker bestaan," 145).

### 7. Louvain, Groot Begijnhof (Ten Hove) and Klein Begijnhof (St. Gertrude)

The letter of brother Amalricus to countess Beatrice from about 1270–80, discussed above (no. 3), states that he obtained a commitment to recite the seven Penitential psalms or the office of the dead for count William from every beguine of the beguinages of Ten Hove and St. Gertrude, and the office of the dead from the members of "two abbeys" of Louvain, presumably those of Vlierbeek and Park. He estimated the total number of services at "2200" (*estimavi . . . vii psalmos cum officiis defunctorum at ii.m.cc*). It should not have been difficult for brother Amalricus to establish the number of monks at the abbeys of Vlierbeek and Park: each must have had only twenty-five monks or so, see Ursmer Berlière, "Le nombre des moines dans les anciens monastères," *Revue Bénédictine* 41 (1921): 231–61; 42 (1930): 19–42 and Van Uytven, ed., *Leuven*, vol. 1, 246. The beguinage of St. Gertrude, only a few years old when Amalricus visited it, must have been small. The largest recorded population dates from 1690, when it numbered 90 beguines (A. Struyf, "De bevolking van het Klein Begijnhof te Leuven gedurende de XVIIde en XVIIIde eeuw," *Mededelingen van de Geschied- en Oudheidkundige Kring voor Leuven en Omgeving* 5 [1965]: 149–68). Consequently, brother Amalricus must have believed that the population of Louvain's largest beguinage, Ten Hove, stood at about two thousand. As in his estimate of the beguine population in the Wijngaard of Brussels (see no. 2), he obviously exag-

gerated their number. Ten Hove had at least sixty-five houses (including a few convents) and an infirmary in 1526, with a population of 125 beguines (Cuvelier, *Les dénombrements*, 317); there were 298 beguines in 1697 (Olyslager, *Het groot begijnhof van Leuven*, 18). Although Ten Hove thus undoubtedly formed a large community, its population in the thirteenth century probably fell well below the figures mentioned by Amalricus; two hundred or three hundred beguines is a fair estimate, given the number of houses in the beguinage.

## 8. Mechelen, Groot Begijnhof

We possess a complete list of beguines who made professions in the beguinage of Mechelen between 1486 and the first months of 1551 (see Table B, based on *SAM*, Archief OCMW, no. 9442; registration for the year 1551 is incomplete because the beguines' priest, Antonius van den Voorde, who presided over the profession ceremonies conducted at Easter and Pentecost of 1551, died shortly afterward: see De Ridder, "De pastoors van het Oud Begijnhof," 72).

Table B: Annual Number of Professions in the Groot Begijnhof of Mechelen, 1486–1550

| Year | Professions | Year | Professions | Year | Professions |
|------|-------------|------|-------------|------|-------------|
| 1486 | 73 | 1508 | 60 | 1530 | 41 |
| 1487 | 64 | 1509 | 45 | 1531 | 36 |
| 1488 | 27 | 1510 | 55 | 1532 | 43 |
| 1489 | 30 | 1511 | 53 | 1533 | 47 |
| 1490 | 37 | 1512 | 48 | 1534 | 44 |
| 1491 | 47 | 1513 | 53 | 1535 | 49 |
| 1492 | 42 | 1514 | 49 | 1536 | 53 |
| 1493 | 64 | 1515 | 50 | 1537 | 49 |
| 1494 | 60 | 1516 | 78 | 1538 | 41 |
| 1495 | 59 | 1517 | 59 | 1539 | 36 |
| 1496 | 41 | 1518 | 52 | 1540 | 44 |
| 1497 | 41 | 1519 | 53 | 1541 | 50 |
| 1498 | 47 | 1520 | 61 | 1542 | 42 |
| 1499 | 107 | 1521 | 53 | 1543 | 32 |
| 1500 | 44 | 1522 | 37 | 1544 | 46 |
| 1501 | 52 | 1523 | 40 | 1545 | 49 |
| 1502 | 59 | 1524 | 55 | 1546 | 61 |
| 1503 | 51 | 1525 | 39 | 1547 | 65 |
| 1504 | 66 | 1526 | 33 | 1548 | 54 |
| 1505 | 57 | 1527 | 33 | 1549 | 50 |
| 1506 | 56 | 1528 | 35 | 1550 | 46 |
| 1507 | 40 | 1529 | 31 | 1551 | 28 (incompl.) |

Except for the years 1488–90, 1496–97, 1522–23, and especially 1526–31, the an-
nual number of professions remained fairly constant, with an absolute mean of
49.13 for the whole period; the years 1499, 1504–06, 1516–17, and 1546–48 were
particularly successful. The five-year averages in Table C confirm that the late
fifteenth and early sixteenth century were a prosperous time for the beguinage,
but new entries fell dramatically in the 1520s; the beguinage was somewhat more
attractive again by 1550.

Table C: Annual Professions in the
Groot Begijnhof of Mechelen,
1486–1551, by Five-Year Period

| Years | Annual Average |
|-------|----------------|
| 1486–90 | 46.2 |
| 1491–95 | 50.4 |
| 1496–1500 | 56 |
| 1501–05 | 57 |
| 1506–10 | 51.2 |
| 1511–15 | 50.6 |
| 1516–20 | 60.6 |
| 1521–25 | 44.8 |
| 1526–30 | 34.6 |
| 1531–35 | 43.8 |
| 1536–40 | 44.6 |
| 1541–45 | 43.8 |
| 1546–50 | 55.2 |

Given the relative stability of the profession rate over a sixty-five-year period, it
is fair to attempt an estimate of the overal (average) population of the beguinage
on the basis of the average annual number of professions, or 49.13. If we assume
a profession ratio of 2.6 percent, the overall population may be estimated at 1889
beguines; if we apply the more conservative profession ratio of 3.2 percent (see
no. 1), the total figure would be 1535 beguines.

These figures are confirmed by several contemporary sources. Guicciardini
recorded in 1567 that the beguinage housed about fifteen to sixteen hundred be-
guines; the Spanish Jesuit Martin-Antonio del Rio cited the number of twelve
hundred beguines in 1578 (Van Uytven, *Mechelen*, 130). A chronicle describing
the destruction of the beguinage in 1578 noted that about twelve hundred be-
guines and two- to threehundred novices and staff were forced to seek shel-
ter elsewhere (De Ridder, "Mechelen's Groot Begijnhof," 16). Finally, it is well
established that the beguinage had ninety-five convents in 1555, in addition to

an infirmary and an unknown number of houses for individual or small group residence (De Ridder, "De Conventen," 66–69); its size is also evident from the "View of the Old Beguinage" (figure 5) showing about 150 buildings within the walled compound outside the city.

## 9. Tongeren, St. Catherine

A list of convents and houses in the beguinage of Tongeren from 1322 cites forty-six residences and an infirmary for beguines (*SAT*, Begijnhof, no. 68, a). As wills by beguines and other documents of that age testify, the houses were usually shared by four to six beguines (*SAT*, Begijnhof, Charters, 1st series, nos. 3–64); we may assume that the infirmary and a few houses that served as convents lodged a greater number of needy and elderly beguines. The population of the beguinage in 1322 can therefore be estimated at 230 beguines, at the very least, and may even have approached that of the Counter Reformation years: in 1627, when the beguinage started to recover from the turmoil of the late sixteenth century, it housed 135 beguines; their number rose to 247 in 1676 and 301 in 1716, when the beguinage had 91 houses (Baillien, "Het begijnhof van Tongeren," 58–61).

# Index